CONSTABLE

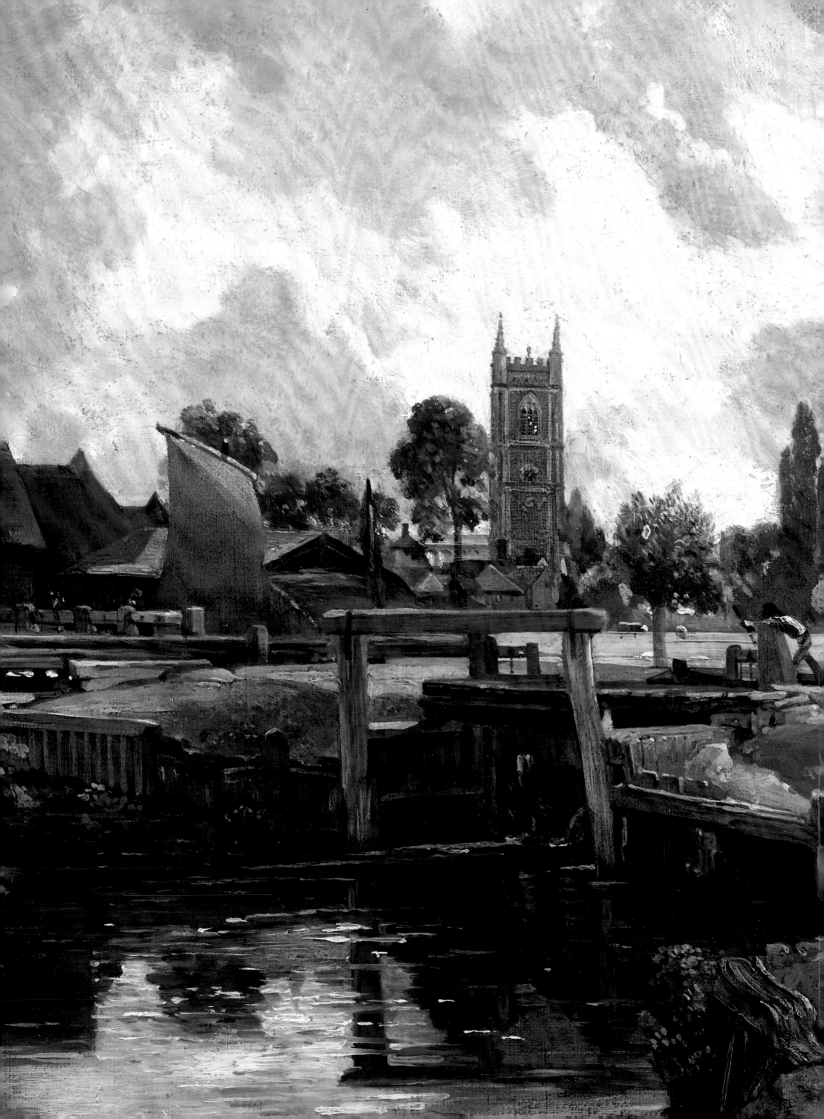

CONSTABLE

LESLIE PARRIS AND IAN FLEMING-WILLIAMS

TATE GALLERY

front cover/jacket
'Stratford Mill' 1819–20
(detail, no.100)

frontispiece
'Dedham Lock and Mill' ?exh.1818
(detail, no.94)

ISBN 1 85437 070 7 paper
ISBN 1 85437 071 5 cloth

Published by order of the Trustees 1991
for the exhibition of 13 June – 15 September 1991
Copyright © 1991 The Tate Gallery. All rights reserved
Published by Tate Gallery Publications, Millbank, London SW1P 4RG
Designed by Caroline Johnston
Typeset in Monophoto Ehrhardt by Servis Filmsetting Ltd, Manchester
Printed and bound in Great Britain by Balding + Mansell plc,
Wisbech, Cambridgeshire on 150gsm Parilux Matt

Contents

Foreword

Constable is one of the great masters not only of British but of European art. His closest friend, John Fisher, predicted that he would one day 'join the society of Ruysdael Wilson & Claude' but generally his compatriots were slow to recognise Constable's stature. As early as the 1820s the French, however, responded enthusiastically. After seeing 'The Hay-Wain' at the Paris Salon of 1824 the young Delacroix is reported to have retouched parts of his own 'Scenes of the Chios Massacres'. Thirty years later, acknowledging Constable's profound influence on the Barbizon group, he proclaimed him the father of modern French landscape. Today few would question Constable's greatness. In Britain, indeed, we have tended to take his achievement a little for granted.

Over the past twenty years the Tate Gallery has mounted several Constable exhibitions. In their different ways they have all helped to revise our image of this most familiar, perhaps too familiar, master. The sequence began in 1971 with a small but influential show – *Constable: The Art of Nature* – in which Conal Shields and Leslie Parris presented him as a rather more sophisticated character than the epithet of 'natural painter' had usually suggested. Following a general introduction to the whole field in 1973–4 (*Landscape in Britain c.1750–1850*) and the great Turner exhibition of 1974–5, the Gallery mounted in 1976 the first major survey of Constable's work since the centenary celebrations of 1937. This 1976 bicentenary show did much to establish a more accurate chronology of the artist's work, displayed aspects of it that were not generally known and touched on vexed questions of attribution. Some of the latter were subsequently resolved, enabling the Gallery in 1982 to devote a small exhibition to the work of Constable's son Lionel, work that had previously passed under his father's name. Four years later the Tate explored, in a display of its recently acquired set of *English Landscape* mezzotints, Constable's underrated collaboration with the engraver David Lucas.

Our 1991 *Constable* lies firmly within this exploratory tradition and it offers many surprises. Like the 1976 show, it will doubtless prompt further revision of the currently received image of the artist. At the same time it is an exhibition chosen very much for the visitor's pleasure. This commitment to furthering both knowledge and enjoyment reflects the personal concerns of the two organisers. Leslie Parris, Deputy Keeper of the British Collection, has brought his customary enthusiasm and eloquence to bear on Constable. I am delighted that he has been joined again by Ian Fleming-Williams in the conception, selection and cataloguing of this new exhibition. Like my predecessors, I am thankful that twenty years ago Mr Fleming-Williams decided to devote his 'retirement' to Constable rather than to any of his many other interests. I am grateful also to Sarah Cove for her valuable contribution to the catalogue.

We owe at least an equal debt to the many private and institutional owners who have lent to the exhibition. I thank them all most warmly for helping us to make it possible. Large demands have been made on the National Gallery, the Victoria and Albert Museum and the British Museum, among which the majority of Constable's paintings

and drawings are distributed. We are very grateful for the unreserved support they have given to our attempt to bring together the artist's finest works. The Royal Academy and the Fitzwilliam Museum have also been most generous with their loans. Elsewhere in the world our thanks go especially to the Yale Center for British Art at New Haven and the great museums of Washington, New York, Philadelphia and Boston. As for private collectors, there can be no doubt that without David and Mary Lou Thomson's generosity this would have been a rather different show. I am grateful for the whole-hearted support they have given us. We are also very much indebted to one of our very greatest friends who, with typical modesty, wishes to remain an anonymous New York private collector.

It is a great pleasure to welcome Barclays Bank in its first major association with the Tate Gallery. Without Barclays' sponsorship an exhibition on this scale and with such important foreign loans would not have been possible.

Nicholas Serota
Director

Sponsor's Foreword

'Constable Country' is an especially evocative phrase to all who know and love England and the English countryside. Barclays' roots in that part of the world are particularly deep. Our modern world of high finance and international banking shows a proper concern for all aspects of our environment, but especially for the countryside.

John Constable, surely Britain's best-loved painter, captured as no one else the essential spirit of the English landscape. Barclays is delighted to be able to sponsor this major exhibition of John Constable and to support the Tate Gallery. The Tate is not only an admirable centre of scholarship for British painting but is also a source of delight for all visitors both British and overseas. We hope as many as possible will benefit from this unique opportunity to share this experience themselves and to continue to enjoy it for many years through this splendid catalogue.

Sir John Quinton
Chairman, Barclays Bank PLC

Acknowledgments

A great many people have helped in all sorts of ways with this exhibition and its catalogue. We would especially like to thank the following: Phillipa Alden, for help with drawings in the Courtauld Institute Galleries; John Bull for information and advice on a range of technical matters (and for his good company and expert driving in Scotland and Switzerland); Marina Cano for her assistance at the Museo Lázaro Galdiano, Madrid, and Edmond Charrière for his at the Musée des beaux-arts de la Chaux-de-Fonds; John and Richard Constable, whose continued support of Tate Gallery exhibitions of the work of their great-great-grandfather is much appreciated; Sarah Cove for her substantial contribution to the catalogue and for many useful discussions; Jack Elam for answering questions about East Bergholt; Jane Farington for help with no.163; John Flower for drawing the maps on pp.531–3; John Frisk, who drew our attention to no.126 and arranged for it to be seen in Philadelphia; Susan Foister for making special arrangements for viewing nos.137 and 165 at the National Gallery; Andrea George for help over no.332; Craig Hartley, who put up with our several invasions of the print-room at the Fitzwilliam Museum; Judy Ivy for information about contemporary press reviews of Constable's work; Michael Jaye and his colleagues for bringing no.167 from Detroit to New York for their 1987–8 Wordsworth exhibition; Celia Jennings for advice on Suffolk topography; Lee Johnson, who alerted us to no.20; David Kiehl for help in the Metropolitan Museum print-room; Vic Knowland, to whom we turned for advice on agricultural matters; Alastair Laing in connection with no.57; Susan Lambert and Lionel Lambourne for their assistance with drawings in the Victoria and Albert Museum; Jane McAusland for information on other drawings; Gill and Katy Parris for secretarial help; Edward Pearson of the Suffolk Water Board, who advised on the technology of the Stour locks; Graham Reynolds and Charles Rhyne for much information and encouragement; Joe Rishel and Marigene Butler for their assistance in Philadelphia; Kate Robinson, who prepared the index; Larry Salander and Bill O'Reilly for their help in New York; Nick Savage for information about Constable and the Royal Academy; Norman Scarfe, who knew all about Suffolk breeches (see no.246); J. Murray Smith for smoothing the way in Perthshire; Sheenah Smith for helping to reunite nos.127–9 in Glasgow; David Sullivan for information about Constable and Well Walk; David Thomson, who has supported his generous loans with much information about them and whose enthusiasm for the whole project has been a tremendous encouragement from the very beginning; Dick Thune for putting us in touch with several American collectors; Christopher Wade, who at short notice read the Hampstead entries in the catalogue and put us right on many points; Nicholas Wadham for his help in connection with no.91.

As always, the directors and staff of the London salerooms and galleries have been very helpful in dealing with our enquiries. We would like to thank, among others, Colin Anson, Margie Christian, Hattie Drummond, Evelyn Joll, Charles Leggatt, James Miller, Henry Wemyss and Andrew Wyld.

This exhibition would not have been possible without the vital contribution made by

several Tate Gallery departments, especially Art Handling, Conservation, Press and Information, the Registrar's Department and, of course, the Exhibitions Department itself, where Ruth Rattenbury, Sarah Tinsley, Helen Sainsbury and their colleagues have been unfailingly supportive. Within the British Collection, Lindsey Candy and Karen Hearn have relieved us of some of the burden of preparing final copy for the catalogue. Without Iain Bain, Caroline Johnston, Jo Ennos, Judith Severne and other members of the Publications Department, there would be no catalogue at all: we are grateful for the care they have taken over it.

Extracts from R.B. Beckett's edition of *John Constable's Correspondence* are quoted by kind permission of the Suffolk Records Society; for permission to quote from *The Diary of Joseph Farington* we are indebted to Yale University Press.

L.P.

I.F.-W.

John Constable 1976–1991

Fifteen years is a short time in the posthumous history of an artist who died over a century and a half ago. Nevertheless, a lot has happened since the Tate Gallery last mounted a large Constable exhibition in 1976, more than enough to justify a fresh display of his work and one that this time ignores portraits, altarpieces and the like to concentrate on his essential work in landscape.

When we first proposed another Constable exhibition to the Trustees in 1986, it was primarily with a view to showing the considerable number of 'new' paintings and drawings that had emerged since the bicentenary ten years before. Many of these were, in some ways, modest works: small oil sketches that had been acquired at the Constable family sales, or sometimes directly from the family, and which ever since had hung quietly in private collections, passing from one generation to another until for one reason or another they resurfaced in the 1970s and '80s. Larger works were also reappearing, some of considerable importance. As for drawings, hardly a month went by without some new discovery being made.

Even when the original existence of such works was known, in many instances there was no record of their survival and no knowledge of what they looked like until the moment they made their reappearance. This was the case, for example, with the splendid group of five small oil sketches given by Constable's last-surviving child, Isabel, to her friend Alice Fenwick in the 1880s and which descended to her grandson Major Maffett. Until they were brought to the Tate Gallery in 1981, two of them were for us merely names in an 1889 exhibition catalogue while of the other three we had no knowledge whatsoever. Sold a year or so later, all five disappeared again into private collections, though not, of course, before being more thoroughly documented. Four are included in the present exhibition. Two (nos.206–7) are important preliminary sketches for one of Constable's greatest paintings, 'Salisbury Cathedral from the Meadows' (no.210). Another, the so-called 'Stoke-by-Nayland' sketch (no.47), throws new light on a well-known late watercolour (no.344). The fourth (no.60) is a novel image of Willy Lott's house and one of Constable's earliest depictions of the rainbow. In short, beautiful and exciting in themselves, these sketches added much to our knowledge of other works and to our understanding of Constable generally. Many other instances of this kind could be cited, including the appearance of two more oil sketches (nos.10–11) leading up to Constable's first major painting of his native scenery, the 1811 'Dedham Vale: Morning' (no.14), and another (no.97) that was to be the starting point for his second six-foot Stour canvas, 'Stratford Mill' (no.100).

The larger paintings that had come to light (or were shortly to do so) ranged from sketches and unfinished canvases to exhibited pictures: an intriguing reworking (no.6) of Constable's famous 1802 image of the view of Dedham Vale from Gun Hill (no.2); the lovely 'Fen Lane' (no.91), brought to our attention in 1985; an unexpected large version of 'Dedham from Langham' (no.20), which had been quietly moving round France from about 1900 until acquired by a Swiss collector in 1946 – this appeared in an exhibition of

his collection at La Chaux-de-Fonds in 1986, where the Delacroix expert Lee Johnson spotted it; the long-awaited 'Wheatfield' (no.76), exhibited by Constable in 1816 and the subject of much speculation in recent literature on the artist, but not known to specialists until 1988 when it was shown to Charles Rhyne; another exhibited work, the 1817 'Cottage in a Cornfield' (no.78), which came to light soon after, and as a result of, the 1976 exhibition; the 1825 exhibit 'Child's Hill' (no.126), lost to sight after 1918, though in fact languishing since the 1960s in a small Pennsylvania museum (and kindly brought to Philadelphia for one of us to see in 1989); and so on.

Approximately fifty of the 125 drawings and watercolours selected for the present exhibition were unknown to us in 1976. Notable finds in this area have included drawings from all periods of Constable's career discovered in the 'Hornby Album' and sold by Lawrence of Crewkerne mostly in 1979 (see nos.244, 266–8, 271, 274, 290, 334), and a large number of drawings dating from 1809, previously an almost totally unrepresented year, which appeared at Sotheby's and Christie's in 1987–8 (see nos.240–1).

There were also many fine and important works that were known about in 1976 but which were not included in the bicentenary exhibition, either because they were not then available for loan or because we still had to see them ourselves – sometimes because we *had* seen them but were unsure what to make of them. We are very happy to be able to include in the present exhibition a number of works in this category, ranging from such celebrated canvases as 'Wivenhoe Park' (no.79) through significant but rarely seen ones like 'The Ferry' (no.65) to large sketches that once seemed more problematic than they do today – the Guildhall 'Salisbury Cathedral from the Meadows' (no.209), for example, or the Chicago 'Stoke-by-Nayland' (no.218).

The emergence of fresh paintings and drawings affected our ideas about Constable in a number of ways. At the simplest level, the inscription on a drawing often provided new biographical information. Two dated drawings of Salisbury Cathedral (nos.267–8), for example, told us for the first time that the Constables began their honeymoon by staying with Bishop Fisher and his wife before going on to join the younger Fishers on the Dorset coast. From the inscription on the back of another new drawing (no.241) we learned – something more than a biographical detail – that Constable may have painted the Tate Gallery 'Malvern Hall' (no.70) in the space of a day. More light was shed on the development of his exhibition pictures by the discovery of further studies used in their painting. We could better appreciate the importance Constable placed on the 1811 'Dedham Vale: Morning' (no.14) when we saw that there were at least four oil sketches directly related to it (nos.10–13) instead of the two known in 1976; our ideas about the development not just of its composition but of the whole idea behind it were qualified by the realisation that Constable may first have contemplated an evening view of the valley.

Sometimes the process operated in reverse. In 1976 various oil sketches used in the painting of Constable's next major exhibit, the 1812 'Flatford Mill from the Lock' (no.54), were known but the picture itself was not, to us at least, except from old photographs. Now that it had re-emerged, Constable's work on this project could at last be understood and its importance in his oeuvre appreciated. In yet other instances, there was no connected material to prepare one for the appearance of a new image. When the miniature 'Brightwell' (no.75) turned up, unattributed, in a minor auction in 1978,

nobody present recognised the hand of the master and the tiny panel achieved what must be a record for the least amount ever paid in modern times for a genuine and superlative Constable: £41.80 plus VAT. Only through the diligent researches of William Drummond was it subsequently recognised. Here was a picture that at first seemed remote from the Constable that anyone knew but which could now be seen as representing one brilliant extreme of his approach to landscape painting. Even with 'The Wheatfield' (no.76), where the subject matter could be guessed and where there were drawings thought to be connected with the composition, first sight of the painting itself was a breath-catching experience: nobody had prepared us for so many carefully delineated figures in one Constable landscape. In the large sketch of 'Flailing Turnip-heads' (no.38), which surfaced in 1986, Suffolk labourers were even more the focus of Constable's attention.

Faced with such a mass of previously unknown material, we were delighted that the Trustees of the Tate Gallery responded to our original proposal by saying that they would welcome a grander exhibition in which such works could be placed in a larger context. This is obviously the best way to make sense of them. And it provides the opportunity to see how our perception of the more familiar paintings and drawings is altered by the new arrivals. But, of course, fresh material or not, ideas about Constable have been changing since 1976.

The last fifteen years have seen the publication of two large-scale monographs, Michael Rosenthal's stimulating account of the artist's relationship with his native scenery (*Constable: The Painter and his Landscape*, 1983) and Malcolm Cormack's comprehensive *Constable* of 1986. Research on the artist has been immeasurably aided by the publication of two catalogues of his work. It is to a Belgian scholar and his Italian publisher that we owe the first illustrated catalogue of Constable's paintings, Robert Hoozee's *L'opera completa di Constable* of 1979. Despite its brief entries and small illustrations, this served – and continues to serve – as an invaluable reference. For the first detailed and generously illustrated catalogue raisonné of the artist's work we had to wait until 1984, when Graham Reynolds's *The Later Paintings and Drawings of John Constable* appeared. This, a skilful ordering of over a thousand paintings and drawings made by the artist from 1817 onwards, was a real landmark in Constable studies and a worthy successor to the author's pioneer catalogue of the Victoria and Albert Museum collection. New works were included, familiar ones reassessed. More generally, Reynolds invited a fresh look at the work of Constable's last years, too often dismissed, he said, as 'an unfruitful period in which Constable was too grief-stricken to be creative'. As well as preparing the companion catalogue of the artist's work before 1817, Charles Rhyne has written valuable papers on a variety of Constable topics. Like Reynolds, he has argued for a reassessment of the artist's late works, especially the Chicago 'Stoke-by-Nayland' (no.218). In other articles he has drawn attention to the importance of Constable's Lake District drawings, published for the first time an unsuspected six-foot painting (see under no.9) and discussed the way in which Constable's work and our attitudes to it have been affected by a range of physical and cultural changes. In 1990 Rhyne made available two useful tools for further research, *John Constable: Toward a Complete Chronology* and a chronological compilation of references to Constable's working methods and related

topics. Another compilation awaited with great interest is Judy Ivy's edition of contemporary press reviews of Constable's work, *Constable and the Critics 1802–1837*, due for publication in 1991. Recent publications by the present authors are listed on pp.47–8.

Welcome contributions have been made in recent years by those who are not primarily art historians. Some of Attfield Brooks's valuable topographical researches appeared in 1976 (sadly, Col. Brooks did not live long enough to advise on the present exhibition). A paper published in 1978 by the meteorologist John Thornes examined the accuracy of Constable's cloud studies and established the years of a number of partially dated examples. Among conservators, John Bull and Jane McAusland in particular have worked extensively on Constable's paintings and drawings in recent years and have made numerous discoveries. Another conservator, Sarah Cove, has been minutely examining Constable's paintings with the aid of x-radiography, infra-red reflectography, pigment analysis and other techniques. A mass of new information is emerging from her researches into Constable's materials and the use he made of them. Already traditional ideas about the appearance of certain works have had to be modified. We are delighted to be able to include in this catalogue a survey by Sarah Cove of her findings to date, as well as two detailed case studies.

A variety of literary and sociological readings of Constable have also been offered by scholars in recent years. Karl Kroeber drew detailed analogies in 1975 between the work of Constable and Wordsworth. Bringing in Turner and Coleridge as well, James Heffernan in 1984 widened the discussion of 'the interdependence of space and time in romantic poetry' and 'the temporalization of space in romantic painting'. In 1982 Ronald Paulson revealed the literary meanings he believed had been 'suppressed' in Constable's landscapes. For John Barrell, two years earlier, it had been the labouring poor, excluded from or disguised in the landscapes, who had been suppressed by Constable. Some of these themes have been taken up more recently by Ann Bermingham but few of them have found their way into the main body of Constable scholarship. Michael Rosenthal's *Constable: The Painter and his Landscape* remains the only substantial specialist work to have adopted and extended such readings.

Because many problems of attribution and dating were unresolved in 1976, the bicentenary exhibition assumed a rigorously chronological approach (in two parallel sequences of public and private work) and devoted a concluding section to paintings and drawings by Constable's friends, followers and imitators. Later it was possible to sort out some of the confusions of identity that remained – to establish an oeuvre for Lionel Constable, for example, and to draw more precisely the lines that separate the work of his father from that of George Frost, F.W. Watts and others. Attribution is still a live issue but we are certainly clearer today about what is and what is not by John Constable. Similarly, the chronology of his work is now better understood, though a few spectacular differences of opinion remain (see under no.64, for instance) and some of the early oil sketches have so far resisted precise dating. The danger of employing simple models of 'development' in this area is illustrated by the oil sketch of a lane shown here as no.43, a work restrained in handling and colour, which the present authors were inclined to think predated the more lively lane sketch of 1811, no.41, until it was possible to examine it out

of its frame in Madrid and read the date Constable had scratched in the corner with the end of his paint brush, '9 July 1812' (this Spanish Constable, incidentally, is another example of an 'unknown' work found in a public collection).

The chronological ordering of the 1976 show to some extent masked Constable's real concerns. This time we have dispensed with a rigid date order so that his interest in particular themes or places can be more clearly shown. The work of Constable's early Suffolk years has been laid out in three geographical divisions, The Valley, The Village, The River (i.e. Dedham Vale, East Bergholt, Flatford), corresponding to the areas and types of subject the artist himself was most drawn to. Within each of these sections, individual subjects are examined in groupings of oil sketches and, where they exist, more finished paintings. Sometimes Constable is seen repeatedly sketching the same view and then taking his ideas further in a larger painting of it; at other times, we find less homogenous groups of sketches, as Constable skirts round a subject without discovering enough to really focus on. This part of the exhibition concentrates on the years 1802–14. A few later works are included but not the large set-pieces of the 1820s and '30s which, despite their frequent dependence on the early material, are best looked at in the context of Constable's London years.

Having tried to show the variety of Constable's initial responses to his native scenery, we apply a more chronological approach to the work of the years 1814–17, years in which Constable's early commitment to 'natural painting' found its fullest expression. Instead of painting pictures in the studio on the basis of oil sketches and drawings made outdoors, he now moved towards painting finished pictures as far as possible on the spot. Perhaps because few people have ever seen both 'The Ferry' (no.65), Constable's major exhibit in 1814 – a work painted entirely in the studio – and 'The Stour Valley and Dedham Village' (no.74), begun outdoors later that year, the significance of this move – a leap, in fact – has never been properly appreciated. The reappearance of 'The Wheatfield' (no.76) and 'Brightwell' (no.75) has contributed to our understanding of these years, as has the discovery of Constable's use of a drawing device (see under no.89, also nos.49, 90), employed, for example, in the preparation of the 1816–17 'Flatford Mill' (no.89), the most ambitious exhibition picture that he worked on outdoors. The appearance of fresh material – the Durban 'East Bergholt Church' (no.90) and 'Fen Lane' (no.91) – has also helped us to identify more fully another crucial episode in the artist's development: his last long visit to Suffolk, now as a married man, in 1817, when he appears to have been bent on starting as many new canvases as possible directly from the motif, perhaps realising that this might be his last chance to work there in this way. By the following year, now firmly settled in London, he had abandoned any attempt to paint big pictures outdoors but had devised new procedures for making even larger ones entirely in the studio.

Constable's work of the 1820s is represented in the exhibition by groups of these large set-pieces, some accompanied by preliminary sketches and source material, interspersed with sections on his work at Hampstead, Salisbury and Brighton, the three principal places where he found fresh subject matter during the decade. Unfamiliar items are included in all these sections and we are pleased that it has been possible to bring together for the first time substantial groups of works to represent the development of, for

example, the 'Lock' composition (nos.157–60) and 'Chain Pier, Brighton' (nos.152–6). Before closing with a large room devoted to Constable's paintings of the 1830s we give special prominence to the series of *English Landscape* mezzotints that he began work on with David Lucas in 1829. These have never been given their due, nor have Constable's remarkable powers as a landscape draughtsman: the chronological series of 125 drawings and watercolours, including sketchbooks, shown here (in a more concentrated way than in 1976) will, we hope, convert those who still think of drawing as a minor aspect of Constable's activity.

Within this part-thematic and part-chronological framework, we have tried to show the kind of problems Constable set himself as a landscape painter and draughtsman and the solutions he found or sometimes failed to find. We hope the exhibition will convey a sense of the artist at work and, more than this, that it will encourage a closer examination and enjoyment of the objects themselves. Although it is clear that Constable in 1991 is not exactly the same artist he appeared to be fifteen years ago, it would be rash to predict what sort of image or images of him this new exhibition will suggest. Visitors often feel that they are missing out if they do not read the catalogue of an exhibition in advance, but the authors of catalogues are always disadvantaged by having to write them before seeing the show. Almost all the works in this exhibition have been seen by us at one time or another but neither we nor anyone else has ever had the chance to view them all together. Who knows what will emerge when so many long-separated works are reunited?

Leslie Parris
Ian Fleming-Williams

Chronology

1764–1795

1764: Golding Constable (fig.2) inherits copyhold of Flatford mill. *1767:* Golding Constable marries Ann Watts (fig.1), eldest daughter of William Watts, cooper, of Upper Thames Street; they have six children, Ann (1768–1854), Martha (1769–1845), Golding (1774–1838), JOHN (1776–1837), Mary (1781–1865) and Abram (1783–1862). *1772:* Golding admitted to copyhold of property in middle of East Bergholt, where he soon builds their future home, East Bergholt House. *Circa 1783:* John sent to school at Fordstreet, Essex; later to a school at Lavenham, where the boys are left to the care of a brutal usher; taken away and instead attends Dedham Grammar School as a day boy. Dr Grimwood, the headmaster, tolerant of his dreamy pupil whom he calls 'honest John', though believing him to be too much of a 'genious' for a merchant. *1787:* 'Golden Constable, gent' granted a pew in middle aisle of East Bergholt church. *Circa 1792:* Constable begins to work for his father in the family business – corn and coal trade, etc. *1794:* goes on a sketching tour of Norfolk with Parmenter, one of his father's clerks. *1795:* is introduced to Sir George Beaumont, Bt, whose mother lives at Dedham.

1796

Summer: visits relations, the Allens, at Edmonton, where he meets J.T. Smith (at this time preparing his *Remarks on Rural Scenery*), John Cranch and a circle of antiquarians and bibliophiles. Is given a reading list of art books by Cranch. Receives advice and instruction by letter from Smith, for whom he has made some drawings of cottages. Paints a 'Moonlight', a 'Chymist' and an 'Alchymist' in the style of Cranch. This year or the next meets for the first time Canon Fisher, later Bishop of Salisbury and a future mentor.

1797

January: makes his first etchings (see fig.118 on p.388). *March:* acknowledges Smith's advice to attend to the family business; obtains subscriptions for Smith's *Remarks* from local friends. *May:* at Smith's request, makes enquiries about Gainsborough in Ipswich. *September:* visits Smith in London. *2 October:* in a letter to Smith, Mrs Constable hopes her son John will attend to business when he returns.

1798

Autumn: Smith a visitor at East Bergholt House; is introduced to local friends. Constable makes a number of sketches out-of-doors in pencil, pen and ink and wash (see no.221).

1799

Obtains parental consent to study art in London, with a small allowance from his father. *29 January:* at the Cobbolds' in Ipswich meets Priscilla Wakefield who gives him a letter of introduction to Joseph Farington RA. *25 February:* presents the letter to Farington and next day shows him

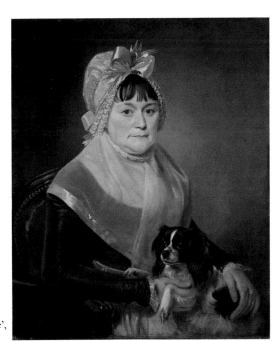

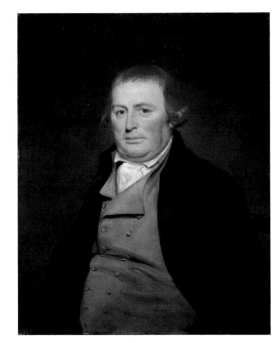

left
fig.1 'Ann Constable',
?c.1815, *Tate Gallery*
right
fig.2 'Golding Constable',
1815, *Tate Gallery*

some sketches made around Dedham. Prepares figure study from the Antique. *4 March:* admitted to Royal Academy Schools as probationer. *16 April:* shows Farington copy of Ruisdael; is lent a Wynants. *9 May:* is listed by Farington as among many other artists at Beckford's house to see the Altieri Claudes. *17 May:* calls on Farington with a new friend, R.R. Reinagle; copies from memory a Wilson belonging to Beaumont. *August:* in Suffolk. *18th:* staying with Cobbolds in Ipswich; tells Smith he fancies he sees Gainsborough 'in every hedge and hollow tree'. Reinagle a visitor at East Bergholt House; heavy rain and serious flooding (in 1801 Reinagle exhibits at RA 'View of Dedham vale, during the floods in 1799', fig.32). *19 December:* Farington records, Constable 'Resides with young Reinagle'.

1800

29 January: Farington lends him Wilson's 'Adrian's Villa' to copy. *March:* in a letter of about this time, tells Dunthorne he has copied A. Caracci, Wilson and Ruisdael and is copying a Claude at the Beaumonts' in Grosvenor Square. *22 May:* dines at the Beaumonts' with Farington, Daniell and Smirke. *29th:* copying Claude's 'Hagar and the Angel' (fig.19) at the Beaumonts'. *21 June:* receives card of admission to the Life Academy. *25 July:* writes to Dunthorne from the parsonage at Helmingham, 'quite alone amongst the Oaks and solitudes' of the park (see no.224). *November:* presents Lucy Hurlock with four panoramic drawings of Dedham vale on the occasion of her marriage on 22nd (see no.222).

1801

Leaves Reinagle and takes rooms at 50 Rathbone Place. *March:* calls frequently on Farington, talks of his melancholy state of mind; much discouraged by some of Reinagle's remarks, though not acknowledging their justice. *13th:* tells Farington he has been with Beaumont and is animated to proceed with resolution. *April–June:* spends much time with his married sister, Martha Whalley, and family at her home in the Minories. *30 April:* tells Farington he thinks highly of Turner's 'Dutch Boats in a Gale'. *29 June:* tells Farington, 'His Father has consented to his practising in order to profess Painting, but thinks He is pursuing a Shadow. – Wishes to see him employed'. *13 July:* shows Farington a painting of 'Mr. Reads house' (Old Hall, East Bergholt); is told he should not ask less than ten guineas. *23rd:* start of seventeen-week stay with sister Martha's in-laws, the Whalleys, at Fenton, Staffordshire. *31st:* sets out on Derbyshire tour with Daniel Whalley Junior. *August:* drawings plot the tour – Matlock, Derwentdale, Dovedale, Baslow, Chatsworth, Edensor. *19th:* chance meeting with Farington at entrance to Dovedale. *20th:* back to Fenton. *28th:* visits Trenton, and again on *10 September. 17 November:* leaves Fenton for London.

1802

7 January: inscribes his name in copy of Innes's *A Short Description of the Human Muscles. 8th:* tells Dunthorne he is attending Joshua Brooke's lectures on anatomy – 'no study is really so sublime, or goes more to carry the mind to the Divine Architect'; has copied a portrait and painted a background for a needlework picture for Mary Linwood, the embroideress. *21 March:* Dunthorne learns that Constable has been 'doing something in the portrait way' that does him credit. *6 April:* Farington views his Academy picture (?no.1), which 'has a great deal of merit but is rather too cold'. *8th:* Farington recommends him 'to Study nature & *particular* art less'. *17 May:* at Windsor with Canon Fisher to be interviewed for post at Marlow Military Academy as drawing master; makes several drawings of and from the castle. *29th:* in a much quoted letter, tells Dunthorne that had he accepted the post 'it would have been a death blow to all my prospects of perfection in the Art I love ... I shall shortly return to Bergholt where I shall make some laborious studies from nature ... There is little or nothing in the [RA] exhibition worth looking up to – there is room enough for a natural painture'. *9 September:* admitted to copyhold of small property in East Bergholt, bought for him by his father for use as a studio; for oil studies dated this month see nos.2, 5. *3 October:* a drawing of Brantham mill (no.225) so dated. *16th:* 'Valley Scene' (no.3) so dated.

1803

23 March: shows Farington 'several small studies which He painted from nature'. *1 April:* Farington lends him Wilson's 'Maecenas's Villa' to copy. Spends nearly a month on the East Indiaman *Coutts* on the first leg of her outward voyage, during which he goes ashore at Gravesend, walks to Chatham and draws the assembled fleet, including the *Victory*, from a hired boat. *May:* leaves the *Coutts* at the Downs before she sails for China on the 6th. *23rd:* gives Dunthorne full account of the voyage; is now convinced that he will 'some time or other make some good pictures. Pictures that shall be valuable to posterity'. *4 June:* dines next to Francis Towne at RA banquet. *20th:* takes leave of Farington before setting off for Suffolk for the summer. *5 October:* dates two drawings so, 'Washbrook' (no.226) and a view of shipping in Ipswich, sketched in company with George Frost.

1804

9 February: tells Farington he has no wish to exhibit in competition with 'works which are extravagant in colour & bad taste wanting truth'; Farington thinks it would help him to see his own work with a 'fresh eye'; does not exhibit. *10th:* sees Beaumont's 'Château de Steen' by Rubens, thinks it 'the finest of the Master that he had seen'. *1 April:* Lady Beaumont asks Farington about Constable, 'She sd. He seemed to be a weak man';

he becomes less of a regular visitor at Grosvenor Square. *1 June:* tells Farington he has been painting portraits (in Suffolk) of farmers and members of their families 'large as the life for which He has *with a hand* 3 guineas, – without 2 guineas'; says he has a house of his own 'where he works hard and has time in the afternoons to cultivate Landscape painting'. Paints the ten-figure 'Bridges Family' (Tate Gallery).

1805

30 March: asks Farington to come and see two pictures intended for the Academy. Only one exhibited (Constable told Leslie many years later that he was disappointed by the rejection of a view of 'Flatford Mill' but was encouraged by Benjamin West, who told him to remember that 'light and shadow *never stand still*'). *22 April:* Society of Painters in Water-Colours opens its first exhibition, visited by 20,000 people. *1 June:* tells Farington he has been commissioned to paint an altarpiece for a country church (i.e. Brantham, in the parish of East Bergholt). *November:* paints a number of watercolours, e.g. nos.228–9.

1806

March: draws a self-portrait (fig.4), the first work of a year's output that in quantity he was never to surpass. *10 April:* tells Farington he has sent a picture (watercolour) of 'Ld Nelson's engagement [Trafalgar] to the Exhibition'. *9 June:* the first dated watercolour of the year, a view of East Bergholt church. *12th:* sketches in pencil two of

the Cobbold daughters, the first of about a hundred such figure drawings, mostly of attractive young women. *July:* stays with the Hobson family at Markfield, Tottenham. *August:* while staying with relatives, the Gubbinses, at Epsom, makes a number of drawings and watercolours (see no.230). *27th:* dates a drawing of Manchester. *1 September:* makes a drawing of Kendal Castle, the first of his seven-week tour of the Lake District. Stays first at Storrs, on east side of Windermere, then a guest of new friends, the Hardens, at Brathay at north end of lake; 'a genteel handsome youth', his hostess notes. *13th:* 'the gentlemen went out sketching'. *14th–15th:* paints portrait of Jessy Harden, her husband sketches him. A day or two later sets out with a companion, George Gardner (son of the portrait painter), on a tour of the northern fells and lakes. *23rd:* 'Derwentwater' (no.233). *26th:* 'Taylor Gill' (no.234). *3 October:* 'Gardner left his friend Constable in Borrowdale', Jessy Harden writes, 'drawing away at no allowance, but he got tired of looking on, so came off here'. *12th:* 'Esk Hause' (no.239). *16th:* Jessy Harden notes his return to Brathay; makes last dated drawing of tour, a view of Langdale. At some time during his stay, has met the poet Charles Lloyd of Old Brathay and through him Wordsworth and Coleridge. *November:* paints at least five members of the Lloyd family in Birmingham; 'Is M^r Constable gone yet? I do hope he will not become troublesome', Charles Lloyd writes to his brother Robert in Birmingham.

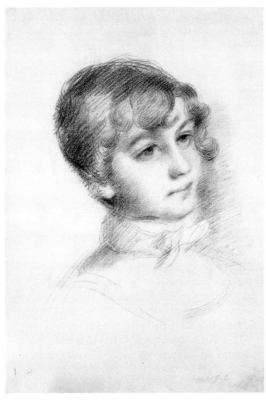

left
fig.3 'Maria Bicknell', *c*.1806, *Tate Gallery*
right
fig.4 'Self-Portrait', 1806, *Tate Gallery*

1807

7 January: a pencil and watercolour portrait of Amy Whitmore so dated. *13 March:* Farington calls to see a kit-kat (28 × 36 in) view of 'Keswick Lake', i.e. Derwentwater. *4 April:* Farington calls to see his two pictures for the RA, in one of which he said he thought 'he had got something original'; two Lake District oils are shown at the RA. *7–9 May:* the St James Chronicle comments on his 'View in Westmoreland', the earliest known press notice. *23 June:* the first extant letter from his mother, addressed to Percy Street; has told her he will have little time to spend this summer from his profession. *6 July:* asks Farington about putting his name down for Associateship of the Academy. *30 August:* Firmin, a Dedham solicitor, provides him with an introduction to the Earl of Dysart; is commissioned to make copies of family portraits by Hoppner and Reynolds. *16 November:* tells Farington he is at the life-class every evening; has worked on the Tollemache portraits the past three months; and feels settled in his profession, his father now reconciled to it. Constable's uncle D.P. Watts gives a dinner party to further his nephew's career; guests include Farington, West (PRA), Stothard and Northcote.

1808

19 January: Mrs Fisher (wife of the Bishop of Salisbury) thinks Constable's countenance 'is like one of the figures in the works of Raphael', his appearance that of one guileless. *6 February:* a clerk in the Middlesex Militia certifies that Constable has found a substitute for himself in the militia. *1 April:* asks Farington to come to see his Academy entry. *4 May:* appears for his father before the Commissioners of the Stour Navigation to report and complain of the tow-paths, locks, gates, etc. at Flatford and Dedham. *18th:* poses for the physician in a picture by Wilkie, 'The Sick Lady'; features in a number of entries in Wilkie's diary over the next few months. *September:* in Suffolk; only two small oils have survived from this period. *25 November:* Wilkie sees some sketches 'of Constable with which I was much pleased'.

1809

12 January: his mother sends a Christmas hamper to him in London. *3 April:* Farington advises against sending in a five-foot picture of Borrowdale to the RA as 'being in appearance only like a preparation for finishing'. *25 June:* at Twyford, Berkshire (see no.240). At Epsom this month (see no.67). *15 July:* leaves town for Malvern Hall, Warwickshire (see nos.68–70). *1 August:* paints 'Malvern Hall' (no.70); the main purpose of the visit is to paint a portrait of Mary Freer, ward of Henry Greswolde Lewis, the owner of Malvern Hall; makes a number of drawings in the area – Solihull, Temple Balsall, etc. During his subsequent stay at Bergholt, renews an acquaintance with Maria Bicknell (fig.3), twenty-one-year-old daughter of Charles Bicknell (solicitor to the

Regent and the Admiralty) and grand-daughter of Dr Rhudde, rector of East Bergholt; he and Maria see much of each other and he declares his love. Still at Bergholt in December, by which time there are many callers asking for him in London.

1810

18 January: a dinner invitation from D.P. Watts indicates he is back in town. *7 February:* his mother is pleased to hear that he has called on the Bicknells. *20th:* she refers to an altarpiece for Nayland church on which he has begun work. *March:* moves to new lodgings at 49 Frith Street. *28th:* shows Farington three landscapes intended for RA (two only are exhibited). *8 April:* dines with Bishop of Salisbury. Stays with relatives, the Gubbinses, for Easter. *May:* the Nayland altarpiece now a regular topic in his mother's letters. *20th:* dines with Dr Monro, Hearne a fellow guest. *8 June:* Stothard thinks he should put his name down as candidate for Associateship of RA; Farington agrees. *10th:* overjoyed at Lord Dysart's purchase of one of his landscapes at RA (a kit-kat) for 30 guineas. *17 July:* has changed the subject of the Nayland altarpiece from 'The Agony on the Mount of Olives' to 'The Consecration of the Elements'. His mother visits his rooms, considers them not respectable enough for the money he pays. *27 September:* 'View on the Stour' (no.48). *5 November:* his name among 31 unsuccesful candidates when George Arnald elected ARA. *11th:* calls on D.P. Watts; appears to have arrived from Suffolk the previous day. *24th:* long letter from Watts with detailed criticism of the Nayland altarpiece. *22 December:* Watts asks if he has touched 'the small "Flatford Mill" ... let it be *worked up* to bear a close eye as a small Cabinet Picture'.

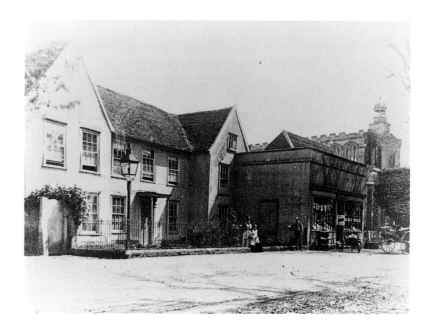

fig.5 Mr Barnard's house and shop, with East Bergholt church beyond, *?c.*1880, *The East Bergholt Society*

1811

18 January: his mother asks him to copy a view by him of East Bergholt church as a gift to Dr Rhudde. *25th:* Watts gives another of his dinner parties – Lawrence, Stothard, Owen, Thomson, Crotch and Constable among the guests. *16 March:* is thanked by Dr Rhudde for the watercolour of the church. *5 April:* Farington calls to see his new picture for the exhibition (no.14). *23rd:* tells Farington he is 'in much uneasiness of mind', having heard his picture is hung very low, proof, he thinks, that he has fallen in the opinion of the Academicians; Farington says that Lawrence 'had twice noticed His picture with approbation'. *9 May:* to East Bergholt with his mother; paints several oil sketches (e.g. no.41). *3 June:* returns to London. *4th:* tells Farington he has been three weeks in the country 'and had there been painting from nature'. *6th:* talks with Farington about the 'particular circumstances of His situation in life'. He and Maria had been seeing each other and he had been a welcome visitor at her home. She was now in the country, having been sent to stay with her half-sister, Mrs Skey, at Spring Grove, Worcestershire. *27 August:* his mother writes to him in London (he had just returned from Suffolk) and talks of his intended journey to Salisbury. *September–October:* a three-week stay with Dr and Mrs Fisher at the Palace, Salisbury; makes drawings of the cathedral (fig.72 on p.257) and Old Sarum (no.242); meets John Fisher, the Bishop's nephew, who becomes his closest friend. *2–3 October:* makes drawings of Stourhead while on a visit there with the Bishop and his party. *23rd:* the first of his letters to Maria Bicknell; asks for a few lines from her. *26th:* reluctantly, she attempts to end their relationship. *December:* moves to 63 Charlotte Street. *17th:* after further exchanges, Maria entreats him to cease to think of her. *19th or 20th:* in desperation, takes a coach for Worcester and presents himself at Spring Grove; appears to have been well received by Mrs Skey and Maria. *24th:* on his return writes that some of the happiest hours of his life were spent at Spring Grove, 'mixed as they were with moments of unutterable sadness'. *31st:* a solemn letter from his father, who considers the situation critical.

1812

January: his sister Mary comes to stay and keep him company; makes several drawings of her. *16 February:* his mother writes tenderly of Maria, but urges him to paint with energy and spirit. *20th:* Maria back in London, they have been seeing each other clandestinely; now in a distressed state, she is leaving for Worcestershire again. *21 March:* writes to Maria about the pictures he intends for the exhibition; work and an endeavour to follow her advice must support him 'in this gloom of solitude' he finds London to be. *26th:* asks Farington to come and see his pictures. *May:* exhibits a view of Salisbury, 'Flatford Mill from the Lock' (no.54), 'Summer Evening'

(no.33) and another landscape; his work praised by Benjamin West. *8th:* the first of many letters from John Fisher, who is to be ordained on 7 June. *27th:* tells Maria he hopes to spend the greater part of the summer in Suffolk; 'You know I have succeeded most with my native scenes . . . I have now very distinctly marked out a path for myself and I am desirous of pursuing it uninterruptedly'. *5 June:* a long walk with Stothard – Wimbledon, Coombe Wood, Richmond and home by the river. *7th:* 'A Water-mill [no.54] is his best performance, but it wants a little more carefulness of execution' (*The Examiner*). *9th:* completes a portrait of the Bishop of Salisbury, is to make a duplicate for Exeter. *18th:* dines at Farington's with Lawrence, West and others. *19th:* with his mother to Suffolk; paints numerous oil sketches, e.g. nos.18, 34–5, 43, also several drawings of the village fair (see nos.245–6). *August:* a short visit to London to see Maria; returns on *28th*; tells Maria he is being urged to leave a profession 'so unpropitious – but that You know is impossible'. *7 September:* to Wivenhoe to paint portrait of daughter of General Slater-Rebow. *22nd:* returns to Bergholt, the portrait finished, 'a large picture comprehending the whole figure – and a good deal of Landscape' (its present whereabouts unknown). His father offers him a house in Dedham if he will quit London; tells Maria his father's ideas are 'most rational – but You know Landscape is my mistress – 'tis to her I look for fame – and all that the warmth of the imagination renders dear to Man'. *3 November:* returns to London with uncle Watts. *5th:* calls on Farington, 'being returned from the country, where he has been studying landscape and painting some Portraits'. *10th:* a fire at his lodgings. *December:* manages to see Maria a number of times before leaving for Suffolk to paint a portrait.

1813

15 January: tells Maria he has completed portrait of Captain Western at Tattingstone. Back in London by *23rd:* Maria reproves him for writing so frequently – her father disapproves. By the end of the month not received at Spring Gardens, Maria's home. *9 April:* Farington tells him that his landscape (no.57) is much approved, i.e. by the selection committee. *3 May:* West (PRA) tells him the whole council thinks he has made a very great advance this year. *8th:* attends a banquet at the opening of the Reynolds exhibition at the BI. *24th:* visits Turner's gallery with Farington; they see the father only. *4 June:* he and Maria manage to meet; she is worried at his appearance. *14th:* Fisher tells him he likes only one picture better than his – Turner's 'Frosty Morning'. *28th:* sits next to Turner at the RA banquet, 'he is uncouth but has a wonderful range of mind'. *30th:* tells Maria he is leaving that afternoon for Suffolk for the only time 'in my life with my pockets full of money', free from debt. Had written to Mr Bicknell for permission to write to Maria and for an interview – neither granted. The ensuing weeks

recorded only by dated drawings in a little pocket sketchbook, no.247. *12 July:* sketches Dedham from Gun Hill in oils, no.21 – the only known fully dated oil of this summer. *24 August:* Maria sends her only letter of this summer, knowing only too well she is breaking the rules prescribed by her parents. *22 October:* the last dated drawing in the little sketchbook. *6 November:* makes an outline drawing of Flatford lock from downstream. *23rd:* breakfasts with his uncle Watts in London. *24th:* he and Maria have met, briefly; he writes, 'I am trying all in my power to compose myself to painting (which is indeed what I ought seriously to do)'. *15 December:* Maria writes of another brief meeting. *23rd:* he tells her of a sight of her he had the previous day as she entered her door. He had been at his post close under the railings opposite for many hours. Says he detests the sight of his pictures when he returns to his room though he ought to 'love them almost entirely'. This year, his mind in no fit state to receive the Sacrament. *27th:* receives an invitation from Fisher to dine at the Charterhouse with the Master (Fisher's father) and family.

1814

January: he and Maria fail to meet; she suggests that he might write a little each day and after a few weeks 'it would be a delightful journal'. *3 February:* spends the day with Bishop Fisher and family. *9th:* declines an invitation to a party at his uncle Watts's, 'the fact is [he tells Maria] such scenes only *disturb* me – and I find my melancholy only encreased by them – could I see you there the case would then be different'. *19th:* has asked Dunthorne to send his son Johnny (aged sixteen), 'he will be very amusing to me and I intend he should be usefull', to stimulate him to work 'by setting my palate &c'. *22nd:* tells Dunthorne about finishing 'Summerland' (no.71), 'I am determined to finish a small picture on the spot for every one I intend to make in future'; quotes Shakespeare, 'I have been too infirm of purpose'. *March:* in a letter to Maria, 'You once talked to me about a journal – I have a little one that I ⟨kept⟩ made last summer that might amuse you could you see it' – he means his little sketchbook, no.247. *2 May:* returns to London from a short holiday in Suffolk. *3rd:* 'Summerland' at the RA is praised in the *London Chronicle* for 'neatness and spirit'. *4th:* tells Maria he took several beautiful walks in Suffolk 'in search of food for my pencil this summer when I hope to do a great deal in Landscape'; feels hopeful and confident. *5 June:* writes to her from Bergholt; the village, trees and fields 'in great beauty'. *17th:* the first dated drawing in a small, now dismembered sketchbook. *18th–30th:* drawings and a letter to Maria record a visit to Feering (Essex) and a short tour of south Essex with his host, Revd W.W. Driffield, an old family friend (see nos.250–1). *9 July:* the first dateable drawing in his second (intact) sketchbook (no.248). In London by *13th;* paints two portraits. *23rd:* discusses his chances of election as Associate

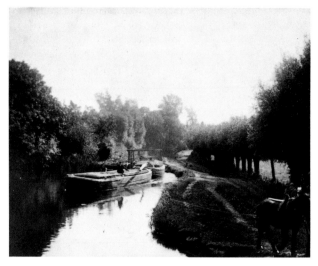

fig.6 Flatford lock, *c.*1890, *Private Collection*

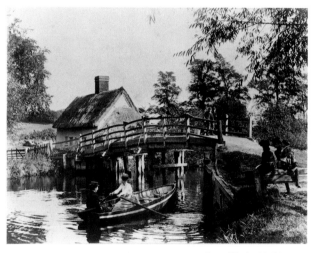

fig.7 Flatford bridge, *c.*1890, *Private Collection*

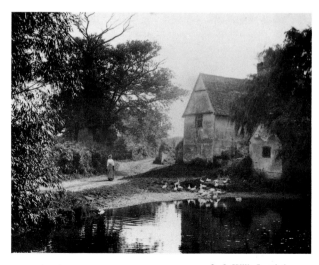

fig.8 Willy Lott's house, *c.*1890, *Private Collection*

with Farington; the Academician tells him 'the objection made to His pictures was their being unfinished'; recommends a study of Claude. *27th:* goes to see the two Angerstein Claudes. *1 August:* the first dated drawing in the little intact sketch-book. *5 September:* a painting of the Stour valley (no.73) so dated. *7th:* the initial pencil sketch for 'Boat-Building' (no.72). *2 October:* tells Maria, 'it is many years since I have pursued my studies so uninterruptedly and so calmly – or worked with so much steadiness & confidence [.] I hope you will see me an artist one time or other'. *2nd, 3rd & 5th:* makes three drawings of East Bergholt House (see no.255). *25th:* 'the studies which I have made this summer', he tells Maria, 'are better liked than any I have yet done'. *4 November:* back in London. *7th:* Farington calls and sees his studies; that evening Reinagle and Collins elected Associates. *12th:* expresses disdain for honours in a letter to Maria, 'when I was more youthful I was a little on tiptoe both for fame and emolument'. *15th:* is roundly scolded by Maria for his attitude, 'it is certainly paying me a very ill compliment, if you like to remain single it will do very well'! In a letter to his mother, says he will be 'resolute in not allowing my Nerves to be shaken & my Mind irritated as it has been'.

1815

6 January: a letter from his mother; hopes he will try hard for 'Fame and Gain'. *23 February:* Maria writes to say they have permission to meet at her home. *7 March:* his mother rejoices; her last letter. *9th:* she is taken ill while gardening; he pays a short visit to Bergholt. *?29th:* death of Ann Constable. *4 April:* her funeral; he does not attend. *9th:* his brother Abram writes understand-ingly about this. *May:* exhibits maximum per-missible number of works at the RA, i.e. eight. *12th:* death of Mrs Bicknell; Maria now runs the house. *21st:* 'more than ever do I now feel the loss of your society', he writes to Maria from Bergholt; has begun a portrait of his father (fig.2). *29th:* back to London. *8 June:* tells Farington he is painting a landscape background for the portrai-tist George Dawe. *17th:* tells Maria he is working twelve hours a day on this, the sooner to get back 'to my dear Bergholt'. *30th:* has completed work on Dawe portrait of Eliza O'Neill. During this time he has been seeing Maria with some regular-ity at Putney, where her father has a house. *1 July:* still complaints in the press that his exhibits are 'rather sketches than pictures'. *6th:* calls on Farington before leaving for Suffolk that day; means to pursue his studies from nature. *10th:* makes a pencil sketch of Glebe Farm (no.259). *31st:* to Brightwell (see no.75). *27 August:* tells Maria he lives almost wholly in the fields and sees nobody but the harvest men (see no.76). *9 Sep-tember:* she replies, 'How charmed you must be with this long continuance of fine weather ... nature and you must be greater friends than ever'. *14th:* has been much out-of-doors, 'could you see me you would not want to be told that – I am so

perfectly bronzed'. *1 October:* 'A Barn', a pencil drawing dated so; tells Maria he is still working in the fields. *19th:* has put 'rather a larger landscape on hand' than he ever did before. *29th:* the last dated drawing of the season (no. 261). *?6 November:* to London. *10th:* calls on Farington; says he has done more studies than before; receives no vote when Mulready and Jackson elected Associates. *14th:* returns to Bergholt; intends to stay there until he has 'secured such picture[s] as I mean for the exhibition'. A distance from Maria 'removes the anxious desire ... to meet perhaps to[o] often at least for each others comfort'. *3 December:* the weather so mild 'I was painting in the feild from a donkey I wanted to introduce into a little picture' (? for no.77). *31st:* father seriously ill, but recovers.

1816

14 January: the village 'quite in a bustle', he tells Maria, over the enclosure of the common; some have shown extreme greediness and rapacity to 'lay Feild to Feild'. *20th:* in London over the weekend with two pug puppies for an aunt. *25th:* writes from Bergholt on his return, his father greatly altered and 'sadly'. *February:* Dr Rhudde, the rector and Maria's grandfather, always much against the possible marriage, finds out that Constable is still a visitor at the Bicknell home and writes in a rage, considers Maria no longer his grand-daughter. (Her possible non-inheritance of part of his supposed wealth causes concern.) *18th:* tells Maria the sooner they are married the better. *30 March:* writes from his London lodg-ings, Charlotte Street. *1 April:* talks to Farington about his father and his prospects from the will; Farington sees his pictures for the exhibition. At the end of the month pays a brief visit to Bergholt. *14 May:* death of Golding Constable. *20th:* attends the funeral. *June:* back in London. A comment on his 'Wheatfield' in *Ackermann's Repository of Art*: 'From extreme carelessness this artist has gone to the other extreme, and now displays the most laboured finish'. *2 July:* tells Farington that John Fisher was married that day and that he himself has made up his mind to marry without delay; they would have about £400 p.a. *16th:* leaves London for Suffolk. *22nd:* makes pencil sketch of Dedham lock and mill. *28th:* tells Maria he has been to Feering (Revd Driffield's) and spent a day with the Slater-Rebows at Wivenhoe Park. *30th:* paints 'Stoke-by-Nayland' (no.47). *3 August:* to London with spaniel puppy for Maria. *6th:* sketches at Battersea and Putney (nos.265, 266). *12th:* returns to Suffolk. *17th:* to Wivenhoe for two days. *26th:* to Wivenhoe to paint two landscapes for Gen. Slater-Rebow (see no.79). *6 September:* still at Wivenhoe; sends Maria a letter from Fisher who is ready to marry them. *19th:* writes to Maria from Bergholt; has just returned, having finished the picture of the park. *28th:* to London. *29th:* tells Farington he has come to London 'for the purpose of being married to Miss Bicknell'; has written a letter to

Dr Rhudde. *1 October:* 'warm words' pass between Maria and her father. *2nd:* Constable and Maria are married by John Fisher in St Martin's-in-the-Fields. Dated drawings record the couple at Salisbury (4th), Southampton (11th–12th), Osmington (17 October–3 December), Binfield, Berkshire (6–9 December). *10 December:* calls on Farington in Charlotte Street 'after passing six weeks with the Revd. John Fisher, in Dorsetshire, some days at Salisbury, with the Bishop and his family, and a few days with the Revd. Dr. Cookson [Fisher's father-in-law] at Binfield'. *25th:* Farington is told that as Dr Rhudde has 'not yet expressed any favorable disposition towards them', they are not going to Bergholt this time.

1817

1 January: the Constables among Farington's guests at dinner. *2nd:* Farington sees 'several painted studies from nature made by Him last Summer & Autumn; also a large Landscape [no.89] . . . I exhorted him to compleat them'. *19th:* brother Abram has seen the Rector and a conciliatory letter from Constable 'has done a great deal of good'. *1 February:* Farington takes tea with the Constables and some friends. *18th:* Ann (a sister) writes sympathetically on hearing Maria has miscarried. *5 March:* tells Farington that Dr Rhudde 'is still in a state of anger, – & shows no disposition to reconciliation'. *?11 April:* a short visit to Bergholt; his arrival kept a secret. Writes another letter to the Rector. *May:* with three other paintings (nos.78, 79, 89) shows a portrait of John Fisher at the RA (fig.9), the only portrait he ever exhibited there. *9th:* discusses taking a house in Charlotte Street; tells Farington 'in case of having children, a certain prospect before Him', it would be inconvenient to remain in lodgings. *6 June:* tells Farington he has taken a house, 1 Keppel Street (Bloomsbury). *18th:* the ceremonial opening of Waterloo Bridge by the Prince Regent, witnessed almost certainly by Constable. *27th:* writes to Maria at Putney, 'the more I see of the house the better I like it – I think it will suit us exactly'. *6 July:* calls on the Bishop of Salisbury, who is poorly. *14th:* 'I am now in the plight of moving', he tells Maria, 'all well – my largest things are gone & safely got up stairs'. Soon after this, he and Maria begin a holiday of some three months at Bergholt – her last in Suffolk. *25th:* makes a pencil sketch of the entrance to Fen Lane (fig.63 on p.185). Sketches record a visit to Feering and Wivenhoe around the end of August (no.277). *17 October:* 'Trees on the Towpath, Flatford' (no.281), the last dated work of the holiday. Probably returns to London in time for the results of the elections for Associate on *3 November*; for the first time receives some votes in the three elections, Bailey, Cooper and H.B. Chalon successful. *11th:* Farington notes, 'Constable called, and told me He had passed 10 weeks at Bergholt' and had painted many studies. 'He was well satisfied with the good disposition shewn towards Him at the Election of Associates

though He was not successful'. *4 December:* 9 a.m., Maria gives birth to their first child, John Charles, at 1 Keppel Street. *9th:* Ann Constable writes her congratulations; on being told he was a great-grandfather, Dr Rhudde says he intends to leave 'it [the child] something'. *16th:* Fisher writes to say the portraits of he and his wife are much admired; has just been installed as Archdeacon of Berkshire.

1818

22 January: makes a pencil portrait of his cousin Capt. Allen – this is to be a year for portraiture. *31st:* Farington calls – 'I saw several of His painted sketches and drawings done last Summer, but He had not any principal work in hand'. *19 March:* John Charles christened; Mr Bicknell a godparent. *21st:* 'Flatford Mill' (no.89) at the British Institution praised in the *Literary Gazette*: 'quite a magical effect . . . a perfect panorama . . . The character of the painting is no less extraordinary'. *30th:* James Pulham, Woodbridge solicitor, acknowledges arrival of portrait of his wife. *14 May:* elected a Director of the Artists' General Benevolent Institution (AGBI) when Turner is in the chair. *15 June:* tells Farington he had been discussing his chances at the next election for Associate with Thomson RA. *22nd:* Revd J. Wingfield writes to arrange sittings for a second portrait. *1 July:* gives painting lesson to Dorothea, daughter of Bishop of Salisbury – one of many such lessons. *11th:* writes to Maria from Bergholt, 'I hope this day has nearly settled all our family affairs'. *13 August:* dates so a drawing of Bristol House and Terrace, i.e. the Bicknell summer residence, one of several drawings of Putney, Barnes and Thames-side scenes made this sum-

mer (see nos.283–5). *5 October:* the Bishop writes to invite them to Salisbury for two or three weeks; 'You may take that opportunity to paint my portrait again – you & Dorothea also may paint together'. *21st:* writes to Maria on arrival at Bergholt; he is there to agree about the sale of the house. *25th:* the sale nearly completed; Abram and Mary (the youngest) to live at Flatford; Golding and Ann, the other unmarried pair, to live separately in the village. *27th:* makes his last drawing of the house from the fields at the back (no.286). *8 November:* Abram, in reply to a letter, refers to his brother's 'Acct of Dr. Andrew's busines'; portraits of Dr Andrew and his wife by Constable dated November 1818 are in the Tate Gallery. *11th:* receives only one vote in the election for Associate; Washington Alston successful. *30th:* tells Farington he has been in town nearly the whole summer and autumn 'and had forwarded several pictures'. *1 December:* attends his first meeting of the Directors of the Artists' General Benevolent Institution. *18th:* attends AGBI meeting; Turner in the chair.

1819

6 or 8 January: Abram writes about the division of family linen, plate, etc. 'I don't know how your profession goes on, but mine is nothing to boast of'. *5 March:* Abram writes to say they are expecting him at Bergholt on the 7th. *16th:* first of a three-day sale of the contents of East Bergholt House with livestock (mares, geldings, cows, sheep, hogs), also waggon, tumbrel, timber carriage (? the hay-wain), etc. *10th:* dines with Farington; Dr Fisher and his daughters discussed, 'one of them paints prettily in Oil – landscapes'. *12th:* an invitation to dine with the Bishop on the 14th. This month John Fisher is installed as Prebendary, which entitles him to Leadenhall, a residence in the south-west corner of the Close. *2 April:* Farington comments on Constable's 'large landscape ['The White Horse'] which He said He would attend to'. *May:* 'The White Horse', his first completed six-foot canvas, exhibited at the RA. *2nd:* tells Farington he 'had heard a good report of his picture'. *6th:* writes to Maria at Putney having just arrived at Bergholt for the conclusion of the sale of the house. *9th:* tells her that the sale of the house is settled; writes ecstatically about the landscape, 'every step I take & on whatever object I turn my Eye that sublime expression in the Scripture ⟨seems verified before⟩ "I am the resurrection & the life" &c – seems verified ⟨before⟩ about me'. *12th:* attends AGBI meeting; Turner in the chair. *18th:* tells Farington that Dr Rhudde (who died on the 6th) has left £120 p.a. to each of Mr Bicknell's children. *4 June:* Maria, at Putney and in her eighth month, talks of returning to 'hated London let the sheets be well aired on the nursery bed, & a nice piece of roast beef for our dinner'. *27th: Examiner* on 'The White Horse', 'He has none of the poetry of Nature like MR. TURNER, but he has more of her portraiture'. *2 July:* Fisher writes, as

if for an acquaintance, to ask the price of the picture in the exhibition ('The White Horse'). 'We will call it if you please "*Life* and the ⟨white⟩ pale Horse", in contradistinction of Mr Wests painting ['Death on the Pale Horse']'. *9th:* makes a sky study in crayon on blue paper, one of a small group. *13th:* copies a number of Old Masters at the BI in a small sketchbook. *17th:* prices 'The White Horse' at 100 guineas in a reply to Fisher's enquiry. *19th:* birth of Maria Louisa ('Minna'), their second child. Fisher writes to say he wishes to 'become the purchaser' of 'The White Horse'. *11 August:* shows Farington an oil sketch of the opening of Waterloo Bridge. Towards the end of the month rents Albion Cottage, Upper Heath, Hampstead for the sake of Maria's health. *10 October:* sketches the Heath looking towards Harrow in the smallest of his intact sketchbooks (no.287). *24th:* at Bergholt for the division of family linen, silver, etc. *28th:* draws his parents' tomb (no.289). *1 November:* discusses the forthcoming election with Farington; is elected Associate that evening by one vote. *8 December:* he and Maria call on Farington to thank him for his assistance in the election.

1820

11 March: attends a meeting for stewards for a forthcoming AGBI dinner. *1 April:* tells Farington about 'a picture he has prepared for the Exhibition ['Stratford Mill', no.100] but has not and does not intend to consult opinion about it'; hitherto Farington had always been consulted. *27th:* Fisher writes to say 'The White Horse' has arrived at Leadenhall – 'It looks magnificently. My wife says that she carries her eye from the picture to the garden & back & observes the same sort of look in both'. *9 June:* shows Farington 'a very flattering Criticism published in a newspaper highly paneygerising his Landscape in the Exhibition'. *22nd:* Fisher writes to say they are expecting him and his family on 7 or 8 July. *13 July:* with his family at Leadenhall and makes his first drawing of the visit. *15th:* visits Stonehenge (see no.291). *29th:* draws the bridge at Gillingham, Dorset, on a brief trip with Fisher. *22 August:* sketches the west doors of Salisbury Cathedral, the last dated drawing of the stay. *1 September:* tells Fisher that he has settled his wife and family at Hampstead, that his Salisbury sketches are 'much liked', and that he is putting his 'river Thames ['Waterloo Bridge'] on a large canvas'. *10th–11th:* sketches in pencil while on a short stay with H.G. Lewis at Malvern Hall, Warwickshire. *8 October:* a note from Dorothea Fisher; the Bishop hopes he will finish the view he took from their garden of the Cathedral (no.139) as well as the 'Waterloo'. *20th:* paints a stormy sunset at Hampstead – the first known dated oil sketch at Hampstead with weather notes. *21 November:* shows Farington 'a new begun' view on the Thames – a 'Waterloo'; Farington recommends him to paint a subject 'more corresponding with his successful picture exhibited last May' (no.100).

1821

20 January: Fisher tells him to finish 'Stratford Mill' (no.100), which the Archdeacon is intending to give to his lawyer, Tinney, who had won him a case. *22nd:* reports to Farington the progress of a picture intended for the exhibition, i.e. 'The Hay-Wain'. *14 February:* Fisher writes 'And how thrives the "hay Wain"', the first recorded use of the painting's present title. *25th:* Abram writes to say that he will be sending the 'outlines of a Scrave or harvest Waggon' that young Johnny Dunthorne had made, 'he had a very cold job but the old Gentleman [?Dunthorne Snr] urged him forward saying he was sure you must want it as the time drew near fast'. *Undated:* tells Fisher the painting is 'getting on' and says 'I should almost faint by the way when I am standing before my large canvasses was I not cheered and encouraged by your friendship and approbation'. *29 March:* birth of Charles Golding, their third child (subsequently, the only one of his seven offspring to marry and have children). *9 April:* Farington sees 'The Hay-Wain' in its frame; William Collins had seen it and regretted that it was not finished more accurately. *?17th:* to East Bergholt. *20th:* writes to Maria, 'How sweet and beautifull is every place & I visit my old Haunts with renewed delight ... nothing can exceed the beautiful green of the meadows – which are beginning to fill with butter Cupps – & various flowers – the birds are singing from morning till night but most of all the Sky larks – How delightfull is the Country'. *1 May:* Varnishing Day at the RA; Constable among those working on their pictures. *27th:* a very long review by Robert Hunt in the *Examiner* of 'The Hay-Wain', a picture 'which we think approaches nearer to the actual look of rural nature than any modern landcsape whatever'; some reviews comment on the sparkle and spottiness. *2–9 June:* accompanies Fisher on his visitation in Berkshire; the itinerary is Newbury, Reading, Abingdon, Oxford, Blenheim; makes many drawings en route (see no.303). *2 July:* Abram writes to tell him of a £200 commission for an altarpiece. *14 July:* the first of this season's dated oil sketches, a Hampstead view. *17th:* asked by the dealer Martin Colnaghi to paint a companion piece to a Turner. *19th:* Fisher advises him to begin his next picture earlier in the year '& let your mind have time to work. You never allow yourself opportunity for correction & polish'. *4 August:* writes to Fisher from 2 Lower Terrace, Hampstead – has cleared a small shed in the garden and made it a workshop '& a place of refuge'. *21st:* draws a cart and horses (no.304); paints numerous sky studies this month, e.g. nos.119–21. *23 October:* tells Fisher 'I have not been idle and have made more particular and general study than I have ever done in one summer', but anxious to get to his London painting room, 'for I do not consider myself at work without I am before a six foot canvas – I have done a good deal of skying'. A much-quoted letter: 'the sound of water escaping from Mill dams ... Willows, Old rotten Banks, slimy posts,

& brickwork. I love such things ... Painting is but another word for feeling', etc. *3 November:* tells Fisher the family hope to be at Keppel Street on the 6th; he hopes to be at Salisbury on the 8th. *10th:* makes an early morning pencil and wash sketch of Leadenhall and the cathedral. *12th–13th:* a visit to Winchester; tells Maria on the *15th* he thought the cathedral 'more impressive but not so beautiful as Salisbury'. *30 December:* death of Joseph Farington.

1822

2 January: an invitation to come to Paris in June from Fisher, who adds 'I wish a new good picture this year'. *9 February:* receives, in all, thirteen votes in two elections for Academician (the largest number before his election in 1829). *16th:* Fisher attempts to console him, 'You are painting for a name to be remembered hereafter: for the time when men shall talk of Wilson & Vanderneer & Ruisdale & Constable in the same breath'. With Maria, looks over Farington's now unoccupied house, 35 Charlotte Street; tells a friend, 'I could scarcely believe that I was not to meet the elegant and dignified figure of our departed friend, where I have been so long used to see him'. *13 April:* tells Fisher he has sent his 'large picture' to the Academy ('View on the Stour', fig.66 on p.195). 'I never worked so hard before ... it wanted much – but still I hope the work in it is better than any I have yet done'; has had some 'nibbles' from a French dealer, Arrowsmith, at 'The Hay-Wain', at present on show at the BI; asks Fisher for a loan 'as painting these large pictures have much impoverished me'. *16th:* Fisher sends him 'the only disposeable £5' he has in the world. *23rd:* an inventory taken of the contents of 35 Charlotte Street. *7 May:* the *Morning Chronicle* praises his 'View on the Stour' while finding 'too much minuteness in the pencilling of the trees in the middle distance, and too much positive greenness

in the general character'. *11th:* Maria writes to him at Bergholt, 'Yesterday the Bishop & Miss Fisher called he was quite in raptures with your Waterloo sat down on the floor to it . . . he rummaged out the Salisbury & wanted to know what you had done'. *11 June:* a gallery at 9 Soho Square advertises drawings for sale by Constable and, among others, Turner, Wilson, etc. *15th:* a letter from Fisher re-addressed from Keppel Street to 35 Charlotte Street. *4 July:* paints the first of this year's dated cloud studies; this becomes a fruitful season for sketching at Hampstead – see no.116, etc.; sometimes paints two sky studies in a day (see nos.122–4). *23 August:* birth of Isabel, their fourth child, at '2 Upper Terrace' (the last of the children to die, it was from her bequest that the nation so richly benefited). *?1 October:* apparently the last dated cloud study of the season. *6th:* Fisher writes to say he will be expecting him at Osmington. *7th:* tells Fisher that he will not be able to get away owing to pressure of work; writes of the house in Keppel Street, where 'the 5 happiest & most interesting years of my life were passed . . . I got my children and my fame in that house. neither of which would I exchange with any other man'; now has two six-footers in hand. *10 November:* the Bishop 'glad to find that you are about your View of Sarum for me'. *12th:* Fisher urges him 'to get on with the Bishop's picture [no.140]. He is quite eager about it'. *6 December:* gloomy about his chances of election; 'I have nothing to help me but my stark naked merit', he tells Fisher, 'and though that (as I am told) exceeds all other candidates – it is not heavy enough. I have no *patron* but Yourself – and you are not the Duke of Devonshire – or any other great ass'.

1823

1 February: illness in the house; both servants and all children laid up as well as himself; 'I have not seen the face of my Easil since X'mas', he tells Fisher. *10th:* Reinagle elected Academician; Constable receives three out of twenty-eight votes. *21st:* tells Fisher he is at work again but 'weak and much emaciated – they took a good deal of blood away from me which I could ill spare'. *March:* becomes involved in a sad mix-up with Linnell, having gossiped unwisely. *19–21 April:* three drawings record a short visit to Flatford (see no.305). *8 May:* a note from the Bishop, 'As *applause* will not pay Bills – I enclose to you another Draft on account', payment for the painting of the cathedral from his grounds (no.140), now an exhibit in Somerset House. *9th:* comments on the exhibition to Fisher: his 'Cathedral . . . the most difficult subject in Landscape I ever had upon my Easil . . . Turner is stark mad – with ability'. Quotes Fuseli, 'I *like* de *Landscape* – Constable – but he makes me call for my great coat'. *4 June:* Fisher to his wife, 'Constable has put the Bishop & Mrs F[isher] as figures in his ⟨. . .⟩ view very like & characteristic'. Takes lodging for the family at Stamford Lodge, Hampstead. *3 July:* tells Fisher he is anxious to come to him this year. *5th:* Fisher, from Gillingham, 'When *real* business is to be done you are the most energetic and punctual of men: In small matters, such as putting on your breeches, you are apt to lose time in deciding which leg shall go in first'; he would like to possess the 'wain', but 'cannot now reach what it is worth & what you *must have*'. *3 August:* the Bishop commissions a smaller version of no.140 as a wedding present for his daughter. *19th:* takes coach for Salisbury. *22nd:* he and Fisher leave for Gillingham (see no.306). *5 September:* tells Maria that he has not done much 'in the sketching way . . . but I have done something from one of the Old Mills that you will like'. *10th:* returns to London. *10 October:* receives an invitation from Lady Beaumont to stay at Coleorton, Leicestershire. *20th:* journeys to Coleorton. *21st:* 'O dear this is a lovely place', he writes to Maria, 'Such Grounds – such trees such distances . . . Only think that I [am] now writing – here in a Room full of Claudes – (not Glovers) real Claudes and Wilsons & Poussins &c. almost at the summit of my earthly ambitions'. *27th:* writing to Maria, describes how the day is spent: a.m., in the painting room with his host; p.m., riding; after dinner, drawing and looking through portfolios while Sir George reads aloud, 'on Saturday Evg it was "*As You Like It*" – and the seven ages I never heard so before'; has begun to copy a little Claude. *2 November:* has finished 'the little Claude – the sunset' and begun on another. *5th:* 'You would laugh to see my bed room', he tells Maria, 'I have draged so many things into it. books portfolios – paints canvases – pictures &c. and I have slept with one of the Claudes every night – You may indeed be jealous'. Maria becomes impatient at his long absence, 'your friends begin to wonder what is become of you'. *21st:* 'I shall expect you the *end of next week*', she writes, 'certainly, it was complimentary in Sir George to ask you to remain the Xmas, but he forgot at the time you had a wife'. *28th:* makes a drawing of the cenotaph to Sir Joshua Reynolds (fig.144 on p.459). *2 December:* attends AGBI meeting, Turner in the chair. *12th:* Fisher writes; there is much agitation to have him paint his father, Dr Philip Fisher, 'But there is much difficulty in getting the Ox to the Slaughter-house'.

1824

6 January: Beaumont is sorry to hear he has been unwell, wants Maria to know that he never failed to propose daily rides or walks, 'I am quite sure Artists save time in the end by allowing the necessary interuptions for air & exercise'. *15th:* Richard Payne Knight calls on Constable – and enrages him. *17th:* tells Fisher Arrowsmith is after the 'Hay Cart . . . he would I believe have both that and the bridge', i.e. 'View on the Stour' (fig.66); he is told he already has a great reputation in Paris. *18th:* Fisher advises him to let the 'Hay Cart' go to Paris; 'The stupid English public, which has no judgement of its own, will begin to

think that there is something in you if the French make your works national property.' *10 February:* receives total of four votes in elections for two Academicians. The 'Salisbury' (no.140) at the BI favourably noticed in the *European Magazine*, 'It looks like *ivory* among emeralds'. *13 April:* an advance notice of 'The Lock' (no.158) in the *Morning Post*, 'a landscape composition, which for depth, sparkling light, freshness and vigorous effect, exceeds any of his former works'. *15th:* agrees with Arrowsmith on a price – £250 – for 'The Hay-Wain' and 'View on the Stour' and 'a small seapiece Yarmouth into the bargain'. *May:* 'The Lock' bought on the opening day of the exhibition by James Morrison, a wealthy merchant. *8th:* Maria a good deal hurt by the warm weather, he tells Fisher, 'and we are told we must try the sea'. *13th:* with Maria and the children to Brighton; they take lodgings in Western Place, on the edge of the town; begins a journal, to be sent to Maria in instalments; the entries increase in length as he warms to the task. *22nd:* Arrowsmith calls with Schroth, a fellow dealer from Paris. *23rd:* Johnny Dunthorne arrives, to live-in and act as an assistant. *30th:* visits Lady Dysart at Ham House, 'Had a long confab with her Ladyship . . . we walked arm in arm – into the Garden & feilds'. *8 June:* joins Maria at Brighton. *10th:* paints two oil sketches of beach scenes (nos.145–6). *14th:* returns to London. *16th:* a visit from the Vicomte de Thulluson and wife, a picture is ordered. *21st:* William Collins calls, tells Constable that he is a great man in Paris. *7 July:* is shown a favourable review of his pictures in Paris; he is flattered, but writes in his journal that he 'will never forsake old England, the land of my happiness' and quotes four lines from Wordsworth. *9th:* dines with C.R. Leslie, his future biographer. *18th:* writes to Fisher from Brighton 'whither I am come to seek some quiet with my children'; is harassed by a number of small commissions. *19th:* paints 'Brighton Beach with Colliers' (no.147). *29 August:* writes to Fisher disparagingly about Brighton, 'nothing here for a painter but the breakers – & sky'. *1 September:* the first of a series of drawings of Brighton beach (see no.309). *18 October:* the last dated sketch of Brighton this season. *13 November:* Fisher says he hopes he will diversify a little this year 'as to *time of day*', Thomson wrote four seasons not four summers, 'People are tired of Mutton on top Mutton at bottom & Mutton at the side dishes, though of the best flavour'. *17th:* tells Fisher he is at work again with Johnny, who cheers him up; is planning a large picture; does not believe in varying plans to 'keep the Publick in good humour . . . I imagine myself driving a nail. I have driven it some way - by persevering with this nail I may drive it home'. *3 December:* tells Golding that Johnny is so useful, 'he will do any thing he will copy any of my pictures beautifully or go of the most trifling errand'. *13th:* a letter from William Brockedon about the pictures in Paris, 'I saw one man draw another to your pictures with this expression, "Look at these landscapes by an Englishman – the ground appears to be covered with dew"'. *17th:* Arrowsmith asks him to make twelve drawings of Brighton beach scenes to be engraved (this scheme was never executed); 'The Hay-Wain' in Paris would have been bought for the nation, but Arrowsmith would not sell singly.

1825

5 January: Fisher, in Bath, had asked for some sketchbooks for his wife to copy; sends instead 'a portfolio of a Dozen of my brighton oil sketches – perhaps the sight of the sea may cheer Mrs F – they were done in the lid of my box on my knees as usual'. *21st:* at Woodmasterne, near Epsom, with the Lambert family; has started a portrait, 'it is to consist of the two boys a donkey and the little girl upon it'. *22nd:* Maria forwards a letter from Arrowsmith informing Constable he has been awarded a gold medal by Charles X, king of France; 'You see that in our country merit is rewarded, come from where it will'. *23rd:* tells Fisher of the award and also describes 'The large subject now on my Easil' – 'The Leaping Horse' (see no.162). *25th:* comments laconically to Maria on the award, 'How funny to have a Gold medal from the King of France. they seem determined to make a frenchman of me'. *9 March:* chairs a meeting of the Directors of the AGBI. *29th:* Maria gives birth to their fifth child, Emily. *8 April:* tells Fisher he has received the medal from the French Ambassador; Maria 'in a sad weak condition', the child has been premature. Has received orders for eight more pictures from France. *5 May:* the *Morning Chronicle* on 'The Leaping Horse' at the Academy, 'the composition has all the pleasing peculiarities of this artist's style, who describes aquatic scenery with the minute and picturesque fidelity of Crabbe'. *8th:* death of the Bishop of Salisbury. *17th:* a letter from the dealer Schroth so dated, delivered in person (?) by Eugène Delacroix, 'M. Delacroix, a young artist of remarkable talent is bringing this letter . . . He will tell you all the pleasure that the pictures you have done for me have given'; begs him to make his skies as simple as possible and to finish the foregrounds. *July:* a copy of a drawing by Claude 'done at Hook's cottage', near Fenton House, Hampstead, where Maria and the children were staying this summer. *24 August:* writes to Francis Darby, of Coalbrookdale, 'I have a wife . . . in delicate health – and five infant children. I am not happy apart from them even for a few days – or hours. and the Summer months separate us too much – and disturb my quiet habits at my Easil'. Has had pressing invitations from Paris, 'but I cannot speak a word of the language – and above all I love England and my own home. I would rather be a poor man here than a rich man abroad'. *31st:* takes Maria and the children to Brighton. *1 September:* returns to London. *10th:* 'I am now thank God', he tells Fisher, 'quietly at my easil again I find it a cure for all ills besides it being the source "of all my joy and all my woe"'.

?17th: joins his family in Brighton for a few days. *14 October:* draws coal brigs on Brighton shore. *21st:* back in London. *31st:* writes in his journal, 'am at work getting in the large picture of the Waterloo – on the Real canvas'. *3 November:* to Brighton again. *12th:* just back from Brighton, he tells Fisher, 'I am hard and fast on my *"Waterloo"* which *shall be done* for the next exhibition – saving only the fatalities of life'; says he is uncommonly well. *15th:* quarrels with Arrowsmith. *19th:* tells Fisher that Arrowsmith was so excessively impertinent 'and used such language as never was used to me before' that the agreements have been broken off. *3–5 December:* a brief visit to Brighton. *12th:* at work on the 'intricate outline of the Waterloo'. *24th:* to Brighton.

1826

1 January: paints a view of the sea: *4th:* Auguste Hervieu, artist, writes to say Constable has been awarded a gold medal by the Society of Fine Arts, Lille. *14th:* tells Fisher about the new medal; 'My large picture [Waterloo] is at a Stand – owing in some measure to the ruined state of my finances'. *?18th:* tells Maria (in Brighton) of a visit by Sir Thomas Lawrence to see the Waterloo; 'I never saw him admire anything of mine so much'. *10 February:* receives only three votes in the election of three Academicians – Wilkins, Leslie and Pickersgill successful. *12 April:* takes night mail to Suffolk as Abram seriously ill. *16th:* returns to London. *26th:* describes Varnishing Day to Fisher, 'Turner never gave me so much pleasure – and so much pain before'. *May:* 'The Cornfield'

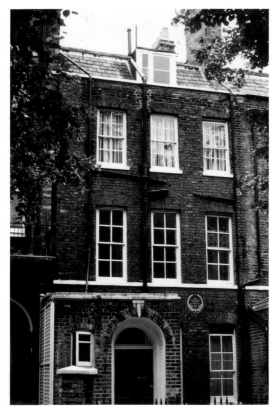

fig.11 40 (formerly 6) Well Walk, Hampstead, 1980, *Hampstead Museum*

(no.165) well received by the press. *16th–24th:* a letter/journal to Maria at Putney; is painting a portrait of a Mrs Treslove. *15 June:* a drawing of cottages at East Bergholt so dated; the visit otherwise unrecorded. *1 July:* Fisher writes to report the safe arrival of 'The White Horse' (after its trip to Lille) and a 'Cathedral' (no.140); the latter, he says, 'requires a room full of light. Its internal splendour comes out in all its power, & the spire sails away with the thunderclouds'. *7th:* tells Fisher he has made several visits to the terrace at Lord Pembroke's (for his Waterloo), 'it was the spot of all others to which I wanted to have access. I have added two feet to my canvas'. *1 September:* writes to Maria at 2 Langham Place, Hampstead from Brighton; has taken their eldest boy, John, to a school there. *8th or 9th:* the earliest surviving letter to C.R. Leslie, 'I left one of my boys at Brighton – my poor Wife is very far from well. we are in a nice little house. no 2 Langham Place'. *9th:* to Fisher, 'you once said – "life is short – let us make the most of friendship while we can"'; is working on 'Glebe Farm' (no.167), 'It is one of my best – very rich in color – & fresh and bright – and I have "pacified it" – so that it gains much by that in tone & solemnity'. *27th:* Fisher discusses the question of Constable writing an article; 'Throw you thoughts together, as they arise (in a book that they be not lost) when I come to see you we will look them over put them into shape & do something with them'. *14 November:* Maria's sixth child, Alfred Abram, born at Langham Place. *28th:* writes about his six children to Fisher, 'I am willing to consider them as blessings – only, that I am now satisfied and think my quiver full enough'. Says he is endeavouring to secure a permanent small house in Hampstead, 'to prevent if possible the sad rambling life which my married life has been, flying from London to seek health in the country'. *23 December:* writes to Leslie, 'My wife is by no means strong and it trys her to be a nurse'.

1827

7 February: death of Sir George Beaumont. *5 April:* Fisher spends the day with him at Downshire Hill and thinks his 'Chain Pier, Brighton' (no.156) will be a 'usefull change of subject'. *6th:* writes to the dealer Dominic Colnaghi; has just completed the 'Brighton Coast' and is intending to bring it to London (from Hampstead) for sending-in day on the 10th. *11th:* Fisher writes enthusiastically to his wife about the picture, 'It is most beautifully executed ... Turner, Calcott and Collins will not like it'. The *Times* strongly approves of the work; Constable 'is unquestionably the first landscape painter of the day, and yet we are told his pictures do not sell'. *20 June:* the *Morning Post* thinks the colouring of the 'Brighton' 'singularly defective; one would say that there were *streaks of ink* across it'. *12 August:* death of William Blake. *14th:* writes to Linnell about the widow, 'if the Case of the poor widow is urgent an especial meeting of the directors [of the

AGBI] ⟨must⟩ can be held immediately'. *26th:* tells Fisher that he has 'at last fixed up in a comfortable little house' in Well Walk, Hampstead; has let part of the Charlotte Street house; 'our little drawing Room commands a view unequalled in Europe – from Westminster Abbey to Gravesend'. *30th:* sends a small picture as a gift to the Comte de Forbin, Director-General of the Royal Museums in France, 'in grateful remembrance of past favors'. *3 September:* Bannister, the actor, accepts an invitation to dinner, 'Your Painting and Venison being perfectly to my Taste'. (Haunches of venison were usually a gift of the Countess of Dysart.) Fisher, in reply to a missing letter, writes, 'I am utterly destitute of money; & I have endeavoured to borrow £100 for you. I have failed'. *30th:* Abram, on the subject of his brother bringing the two elder children to Flatford for a holiday, 'If it was possible to receive you at Flatford with your little ones. I think a more dangerous place for children could not be found upon earth. it would be impossible to enjoy your company. as your mind would be absorb'd & engross'd with the Children & their safety'. *4 October:* writes to Maria from Flatford, the children 'are much admired indeed it is very interesting to see the 4th generation of our family here ... [John] is crazy about fishing – he caught 6 yesterday and 10 to day some of which we are going to have for dinner'. Constable makes a number of drawings in pencil or pen and wash; mostly they are by the river – while he was keeping an eye on the children? *10th:* 'The children have been so entirely well behaved that it has greatly added to the pleasure of having them with me'. *14th:* sketches a willow tree and cattle – the last dated drawing of the trip. *2 & 17 November:* chairs meeting of the Directors of the AGBI. *30th:* a note from Fisher; intends to spend two days with Constable at Hampstead, 6–7 December; 'I will bring you up £30 which is all that I can at present command'.

1828

2 January: birth of Lionel Bicknell, their seventh child, at Well Walk. *24th:* a letter from sister Mary, 'There has been a very large Flood and when I behold the beautiful display of Water and Golden Clouds and sea Birds and *such like* from this *window* [in Flatford mill house] I always think of you, and your dear Boy and Girl'. *29th:* to Leslie, from Well Walk, 'I feel the absence of my friends most of all in this my pretty house, its distance from London – but the good overbalances – and I am not wholly out of hearing the "din of the Great Babel" – and can soon plunge into the midst of it'. *1 February:* is 'pounced upon' at the BI by two RAs – Shee and Phillips. *2nd:* writes a long letter to Phillips about his position as an artist and his eligibility as a candidate in the forthcoming elections for Academician; 'my object in writing to you at all is that I may be placed in your mind – fairly – on the list of my worthy brother candidates'. *9th:* final voting for Academ-

ician: Etty 18, Constable 5. *9 March:* death of Maria's father, Charles Bicknell; Maria inherits about £20,000. *30th:* a letter from Abram; will be coming to town; 'I earnestly hope your own picture of the Valley from Langham, that well known (to me & us) beautiful view ['Dedham Vale', no.169], will be ready for the 8th April ... I somehow think they must elect you next time'. *May:* sister Mary refers in a letter to 'the little ones at Brighton'. An undated letter to Samuel Lane written at about this time: 'My poor wife is still very ill at Putney, and when I can get her home I know not. We talk of Brighton, but we only talk of it. She can't make such a journey'. *29th–30th:* at Brighton with Maria, makes some drawings of vessels on the shore (see nos.318–22). *11 June:* writes to Fisher, 'My wife is sadly ill at Brighton – so is dear dear Alfred: my letter today is however cheerfull. Hampstead – sweet Hampstead that cost me so much, is deserted'. Plans to go to Brighton on the *10th. 20 July:* paints a stormy sea. *23rd:* writes to dealer James Carpenter, 'I am here accompanied (with my Easil) attending a very sick wife and afflicted child. Brighton has done them very little good, but we have had most untoward weather – & we must leave it next week'. *22 August:* writes to Johnny Dunthorne from Hampstead, 'I believe Mrs. Constable to be gaining ground. Her cough is pretty well gone and she has some appetite, and the nightly perspirations are, in a great measure, ceased. All this must be good'. Letters of *September* and *October* tell of Maria's increasing weakness. *23 November:* death of Maria Constable at Well Walk. Leslie describes a visit to Well Walk a few days before her death: 'She was then on a sofa in their cheerful parlour, and although Constable appeared in his usual spirits in her presence, yet before I left the house, he took me into another room, wrung my hand, and burst into tears, without speaking.' The depth of Constable's grief is expressed in a number of letters, the last of which (*19 December*) is to his brother Golding: 'hourly do I feel the loss of my departed Angel – God only knows how my children will be brought up ... I shall ⟨I⟩ never feel again as I have felt – the face of the World is totally changed to me'.

1829

21 January: to Leslie, 'I have been ill – but I have endeavoured to get to work again – and could I get afloat on a canvas of six feet – I might have a chance of being carried away from myself'. *10 February:* is elected Academician by one vote – Constable 14, Danby 13. The news is brought to him by his friend Alfred Chalon. 'After he left me last night', Constable tells Chalon's brother, 'there came, "though last not least", Turner and Jones [George Jones RA]. We parted at one o'clock this morning. mutually pleased with one another'. (This is the only time Turner is known to have visited Constable.) *11 February:* Fisher considers it a double triumph: 'It is in the first place the triumph of real Art, over spurious Art: and in the

second place, of patient moral integrity over bare chicanery ... The event is as important to me, as to yourself, since my judgement was embarked in the same boat with your success.' *5 April:* to Leslie from Well Walk: 'Since I saw You I have been quite shut up here – I have persevered on my Castle ['Hadleigh', see no.170] ... Can You oblige me with a call to tell me whether I can or ought to send it to the ⟨pandemonium⟩ Exhibition – I am greviously nervous about it'. *8 May:* the *Sun* on 'Hadleigh Castle': 'Full of nature and spirit, and graceful easy beauty; though freckled and pock-marked, after its artist's usual fashion.' *17 June:* Fisher leaving Charterhouse for Salisbury, hopes to see him there soon. *4 July:* tells Fisher he has booked places on the coach (for himself and the two eldest children, John and Minna) and will be at Leadenhall for tea on the 7th. *12th:* the first dated work of this trip, an oil sketch of the view from Fisher's library; makes a number of oil and pencil sketches during his stay, e.g. nos.141 and 323. *28th:* the last dated work of this trip – a watercolour. *?29th:* returns to London, without the children; shortly after, John is fetched home. *9 August:* Fisher reports that Minna 'skips about like a gazelle', also that 'the great easil has arrived & awaits his office. Pray do not let it be long before you come & begin your work'. *28th:* sends a note to David Lucas, who is about to engrave the first plate for Constable's *English Landscape* – the first letter in an extensive correspondence. *3 September:* Fisher tells him he 'yearns' to see him tranquilly at work on his next great picture, 'I long to see you do, what you are fully capable of, ⟨...⟩ "touch the top of English Art." To put forth your *power* in a *finished polished* picture; which shall be the wonder & the imitation-struggle of this & future ages'. *21 October:* from Fisher, 'You have said for the last three months that you were coming here, & I have been patiently expecting you ... come soon.' *24th:* from Abram, 'There is a chance for the weather being fine for your Salisbury Journey'. *?11 November:* a drawing of the cathedral from Long Bridge (fig.107 on p.363). *26th:* a drawing of a house by a river is the last dated drawing of the trip. *10 December:* receives his Diploma from the President of the Royal Academy. *15th:* Fisher writes to ask if he would buy back 'The White Horse' and 'Salisbury Cathedral from the Meadows' (no.210), and in a letter of the *29th* says 'I am greived to part with them; but with six children I cannot afford to retain such valuable luxuries'.

1830

8 January: a note to Leslie with news of the death of Thomas Lawrence, the President of the Royal Academy. *9th–20th:* attends various Council meetings and General Assemblies. *25th:* attends General Assembly when Martin Archer Shee is elected President. *26th:* Fisher acknowledges receipt of £200. *15 February:* sends William Carpenter, dealer, 'a few proofs [of the *English Landscape* mezzotints] as a mark of my esteem'.

26th: writes to Lucas about various proofs; on a 'Summerland' (fig.100 on p.321), 'It has never recovered from its trip up, and the sky with the new ground is and ever will be as rotten as cow dung.' *7–26 April:* attends five RA Council meetings and also serves on the Hanging Committee (the 'Committee of Arrangement') for the forthcoming exhibition; in a note postmarked *30th* (Friday), tells Lucas he will finish his business at the RA 'this week'. *3 May:* a sly reference to the Bicknell inheritance in the *Morning Chronicle* when noting his 'Helmingham Dell' (no.172): 'he has certainly not improved in art as he has in fortune, to which latter he entirely owes the obsequiousness of the Academy'. *24th:* writes to Fisher, 'My duty as "Hangman" has not been the most enviable – it may account for some of the scurrillities in the newspapers, the mouths of which who can escape who has others to please?' *19 June:* buys the palette of Sir Joshua Reynolds at the Lawrence sale; this he later presents to the Academy. *26th:* a long review of *English Landscape* in the *Athenaeum:* the subjects more varied than expected from the productions of 'Mr. Constable; who appears to have fed his genius, like a tethered horse, within a small circle in the homestead'. The review describes a visit to Constable's 'Gallery' (figs.14–15 on p.43) where there were to be seen 'The Cornfield', 'The Lock' and a watercolour of 'Jaques and the Wounded Deer'. *6 July:* a letter from Fisher at Abingdon suggesting a meeting at Windsor on the 10th or 11th (his last known letter). *?10th:* Constable scribbles a note to his son John to say he is going to Windsor. 'I go at 3 this afternoon and Mr Fisher will I know take it very kind of me to meet him and pass a few hours as he has been so very ill'. *23rd:* presents a copy of *English Landscape* to the antiquary John Britton; 'my first object in these things is to attempt the "chia'oscuro" of nature'. *September:* paints some skies in watercolour from the back windows of 6 Well Walk (see no.325). *4 October:* writes to Leslie at Petworth; is preparing the third number of *English Landscape* and 'improving my Wood [a 'Helmingham'] greatly'. (John Charles had been sent down to Brighton for his health some time in the summer and, probably towards the end of October, Constable paid him a visit.) *12 November:* to Leslie, 'When I left my boy at Brighton he was decidedly better – I took Charley with me and left him – and I expect my servant and both of them tomorrow ... I hope to have my seven at home on Sunday at Ham^d – and I am preparing to winter here with them all'. *25 December:* Part II of *English Landscape* advertised in the *Athenaeum. 29th:* tells Leslie he was much delighted with his day in London; 'It was a continuous delight to me from the moment of knocking at your door to our parting at "Tyburn" turnpike, & to complete the day, I passed the evening with Turner at Mr. Tomlinsons.'

1831

As an Academician, Constable is this year a Visitor at the Academy Schools and he takes his duties most seriously. *4 January:* to Leslie, 'I sett my *"maiden"* figure yesterday and it is exceedingly liked . . . it is the same Girl I had with me when You called – She makes a most delightfull Eve – and I have put her in paradise – (leaving out Adam) I have dressed up a bower – of laurels'. Tells how his men were stopped twice by the police when they were bringing the 'green boughs' down from Hampstead. *27th:* tells Leslie that he has set his last model, an Amazon, at the Academy, 'My labours finish there Saturday Evening [*29th*]'. *2 February:* to Lucas: 'My cold plays the devil with me – and I am making sad work on my canvas', presumably 'Salisbury Cathedral from the Meadows'. *26th:* the *Spectator* reviews Parts I and II of *English Landscape*; the engravings have two faults – 'extreme blackness and coarseness', although they 'display great feeling'. *8 March:* an initial payment made to Charles Boner, a sixteen-year-old, who is to tutor his sons. *12th:* still 'very ill', he tells Lucas, 'I cough all night, which leaves me sadly weak all day'; follows this with another letter reviewing their enterprise somewhat gloomily. *23rd:* tells Lucas he has done a drawing for the 'Title' (the Frontispiece) and has 'made a great impression to my large canvas', the 'Salisbury' (no.210). *28 April:* Charles, aged 10, to Minna, 'Papa is painting a beautiful Picture of Salisbury Cathedral' (his earliest surviving letter); Constable again serves on the Committee of Arrangement. *6 May:* the *Times* on 'Salisbury Cathedral from the Meadows', 'A very vigorous and masterly landscape, which somebody has spoiled since it was painted, by putting in such clouds as no human being ever saw, and by spotting the foreground all over with whitewash.' *2 June:* tells Leslie of a review 'in which they speak highly & very properly of your pictures – & perhaps fairly of my "chaos" as they term the Salisbury. They say (after much abuse & faults) "it is still a picture from *which it is impossible to turn without admiration"'. ?27th:* takes his three daughters to stay with his married sister, Martha Whalley, at Dedham. *4 July:* returns to London. *5th:* tells Leslie he has just returned from Suffolk; 'Nothing can exceed the beauty of the country – it makes pictures seem sad trumpery, even those that possess most of nature – what must be those which have it not.' *25th:* tells Martha he intends to be with them on the *28th.* *1 August:* makes a watercolour of a dog watching a watervole; is back in London by the *5th. 25th:* entertains Shee, Bannister, Howard, Leslie and Eastlake to dinner; Lady Dysart had sent 'half a buck which is unusually fine'. *8 September:* attends coronation of William IV in Westminster Abbey. *12th:* sends Leslie Part III of *English Landscape*. *23rd:* spends a night with Richard Digby Neave, an ex-pupil, at Epsom. *25th:* dismisses Charles Boner as the boys' tutor (this was subsequently revoked and Boner became an invaluable factotum-cum-secretary).

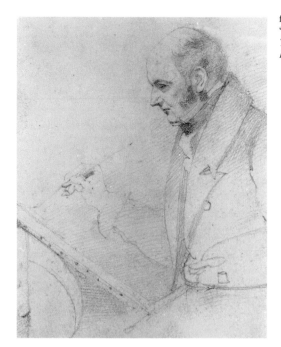

fig.12 Daniel Maclise, 'John Constable', ?1831, *Trustees of the National Portrait Gallery, London*

'Towards the end of October', Leslie says in his biography, 'Constable became very unwell, and was greatly depressed in spirits . . . The Reform fever was then at its crisis, and he talked much of all that was to be feared from the measure'. *6 November:* enters the names of all his children with full details of their births in the family Bible; at about this time Part IV of *English Landscape* is published. *4 December:* writes two long and despairing letters about his and Lucas's work on the mezzotints. *17th:* to Leslie, 'My sad ill has a good deal returned . . . accompanied by an acute attack of rheumatism which has quite disabled me'. *29th:* to the same, 'I am still a poor devil and greivously the worse for age – rheumatism, "carking care" and various ailments'.

1832

9 January: a note from Shee; shocked to hear that he was so severely ill and disabled. *14th:* dictates a letter to Leslie at Petworth: 'I passed last night almost wholly free from pain, the first I beleive for these three weeks . . . As to meeting you in these grand scenes [i.e. Petworth], dear Leslie, remember the Great were not made for me, nor I for the Great . . . My limited and abstract art is to be found under every hedge, and in every lane, and therefor nobody thinks it worth picking up, but I have my admirers, each of whom I consider a host.' *17 February:* to Leslie, 'I sat up yesterday – dressed, by the fire – and ate a small fish for my dinner'. *21st:* asks Lucas to send back all the sketches and drawings which relate to the 'Waterloo', 'which I am now about'. *3 March:* has the new picture, 'Waterloo', beautifully strained on a new 'frame' (i.e. stretcher). *24th:* at a private view

of the Society of British Artists exhibition.
9 April: to Leslie, on the 'Waterloo', 'The Lord
Mayor's state barge looks very well. Mrs. Pulham
said to her husband yesterday, "Pulham – come
here – I am quite in love with the Lord Mayor's
bottom" – the boat sits very beautifully on the
water'. *24th:* quotes Stothard on the 'Waterloo',
'"Very unfinished Sir – much to do – figures not
made out Sir" – and this being I fear the general
opinion'; never more restless about a picture, 'it
has not my redeeming voice ("the rural")'. *8 June:*
an appreciative review of the 'Waterloo' in the
Morning Post, 'It requires to be viewed at a proper
distance, and during the fashionable visiting hours
of the Academy a clear space between a spectator
in the middle of the room and the walls is not
always to be had.' *22nd:* Johnny Dunthorne
seriously ill. *July:* the fifth and final part of *English
Landscape* published. *28th:* takes Minna down to
Suffolk; a drawing of cottages at East Bergholt is
dated the *31st. 24 August:* makes pencil studies of
Englefield House, Berkshire for a commissioned
painting of the subject. *25th:* death of Archdeacon
John Fisher in Boulogne. *4 September:* writes to
Leslie, 'this very sudden and awfull event has
strongly affected me. The closest intimacy had
subsisted for many years between us', etc. *2
November:* death of Johnny Dunthorne aged 34.
5th: tells Lucas he is going to Suffolk for the
funeral. *10th:* a drawing of Bridge Cottage, Flat-
ford dated so, one of several made on this short
trip. *14th:* tells Lucas that in the coach coming
back the day before there were two gentlemen,
strangers. 'In passing through the valley about
Dedham, one of them remarked to me – on my
saying it was beautifull – "Yes Sir – this is
Constable's country!" I then told him who I was
lest he should spoil it.' *13 December:* George
Constable (no relation), a brewer, writes from 58
Charlotte Street; has seen the *English Landscape*
and wants to take a copy home with him to
Arundel. *17th:* tells Leslie he is making changes
on his 'Englefield House'; says that it is strange,
but he has never seen anything in landscape with
which he was satisfied. "All that I have seen of
even the greatest names, are either "pictures" or
nothing.'

1833

7 January: has called on the Chalon brothers.
'They are both of them', he tells Leslie, 'adopting
the palette knife just as I have laid it down – but
which I did not do 'till I had cut my throat with
it.' In an undated note of around this time to
Leslie, says: 'I have got the Great Salisbury into
the state I always wished to see it – and yet have
done little or nothing – "it is a rich and most
impressive canvas" if I see it free of self-love'.
15 February: Abram writes after a visit, 'I think
your House Picture [Englefield] will be beautifull,
a faithful representative of "9 o'ck in the morn-
ing"'. *2 March:* 'Do not pass my door', he tells
Leslie, 'if you come here. I have licked up my
Cottage [no.77] into a pretty look, and my *Heath* is

almost safe – and I must stand and fall with my
great House'. *6th:* writes to Charles who has been
sent to a school in Folkestone. *10th:* writes to
Leslie, 'Poor Museum Smith [J.T. Smith] died on
Friday [8th] a miserable sufferer – & in great debt,
and poverty ... I knew him from 1796'. *16th:*
Boner to Charles, 'Your papa has nearly finished
the house [Englefield], there are some more deer
on the Lawn, and swallows flying about'. An
undated note to Lucas of about this time, written
despairingly: 'This dreadfull book must be my
ruin ... *You do nothing right* – not one thing that
you say you will ... it was the devil himself who
first led me *step* by *step* to do it – thus to waste the
sacred property of my children' [the Bicknell
capital]. *20th:* apologises to Lucas for his last
letter, 'you are not to blame'. *4 May:* a full page
advertisement for *English Landscape* appears in
the *Literary Gazette. 12th:* an invitation from Sir
Robert Peel to 'meet some friends of the arts' who
are coming to see his pictures. *11 June:* to Leslie,
who is about to leave for America and a post at
West Point: 'The loss of you is a cloud casting its
shade over my life, now in its autumn'. *17th:*
delivers a lecture, 'An Outline of the History of
Landscape Painting', to the Literary and Scien-
tific Society of Hampstead. *3 August:* takes John
and Charles to Suffolk for a holiday. *16th:* 'I had a
delightful visit into Suffolk. We ranged the woods
and feilds, and searched the clay pits of Suffolk for
the bones, and skulls, & teeth of fossil animals, for
John – & Charles made drawings and I did
nothing at all – but I felt happy to [see] them
enjoy themselves.' (John is to join Charles at the
school in Folkestone.) 'To part with John is
breaking my heart – but I am told it is for his
good.' *2 October:* writes a worried letter to John at
Folkestone, 'We are all sadly at a loss to hear from
you ... I much regret You having left me – at all –
because of the great additional anxious such as
distance must make'. (There was cause for alarm.
John had injured his leg sleepwalking and was
confined to bed.) *10th:* to Folkestone to be with
his son; makes several watercolours of the area (see
nos.330–1). *23rd:* returns to London. *12
November:* tells a friend (Revd H.S. Trimmer)
that he has planned another large picture, but has
little outdoor stimulus. 'I have some notion of
giving a little book on Landscape in the form of a
life of Sir G. Beaumont.' *4 December:* writes a long
letter to John, now up from his bed. Much talk of
geology and fossils: 'I am sorry You found nothing
on Your first walk to fossil bank – better luck next
time.' *17th:* writes to George Constable of Arun-
del. Does not want to part with a 'Salisbury'. 'I am
also unwilling to part with any of my standard
pictures; they being all points with me in my
practice'. *20th:* to the same; John delighted with a
gift of fossils.

1834

20 January: writes to Leslie in America with a
mind so depressed 'that I have scarcely been able
to do any one thing ... I am however busy on a

large landscape'; finds it hard 'to touch a pencil now that you are not here to see'. *15 February:* confined to his bed with 'Rheumatic fever'; dictates a letter to Boner for Dominic Colnaghi. *14 March:* Leslie writes from West Point; is expecting to leave for England on 10 April. *15 April:* signs and dates a watercolour of a country church for Mary Atkinson, the daughter of a friend. *May:* exhibits only watercolours at the RA. *17th:* a review in the *Spectator*, 'The exhibition is not rich in Landscape this year; which makes us miss CONSTABLE the more: he spoils better landscapes than many can paint.' *7 June:* a 'Landscape with Figures' by Constable at Christie's bought in at 50 guineas. *July:* in the Hampstead Rate Book for this month, 6 Well Walk is entered as 'Empty, late Constable'. *9th:* travels down to Arundel to join his son at the George Constables'. *10th:* the first dated drawing of the trip, 'Bignor Park'. *12th:* makes a large drawing of 'North Stoke' (no.333). *14th:* visits Petworth with the Constables and meets the Earl of Egremont. *19th:* 'View on the Arun' (no.334), with a sketch of the castle, the last of the drawings made on this trip. *22nd:* attends an RA Assembly. *29th:* asks a friend, William Purton, to come and see the 'Salisbury' (no.210): 'I have been preparing it for Birmingham, and I am sure I have much increased its power and effect . . . I have no doubt of this picture being my best.' *30 August:* writes to Leslie at Petworth; feels unable to invite himself (the Earl had made an open invitation when they met in July), 'tell me if I can, really without impropriety, write to Lord Egremont – I do not know how. It will be so much like a *self* invitation'. *10 September:* joins the Leslies and a houseful of other guests at Petworth. In his biography, Leslie says that 'Lord Egremont, with that unceasing attention which he always paid [to his guests] . . . ordered one of his carriages to be ready every day, to enable Constable to see as much of the neighbourhood as possible'. Makes numerous drawings, including several of Cowdray, visited on the *14th.* Back in London by *4 October* for meeting of AGBI Directors. *16th:* takes his two elder sons to see the Houses of Parliament on fire. *10 November:* Charles sails from London for Flatford in the family vessel, captained by a cousin. *25 November – 4 December:* correspondence with A.A. Watts about an eventually aborted article on landscape. *13th:* at Ham House with Lady Dysart. *15th:* sits to Wilkie for the head of the physician, Garcia Fernandez, in the artist's painting of 'Christopher Columbus Explaining the Project for the Discovery of the New World'. *16th:* to Lucas, 'My Glebe Farm is going away – sold to Mr Constable of ⟨Edin⟩ Arundel – the picture is a favourite but it chose its possessor' (see, however, under no.168). *27th:* *Literary Gazette* lists Lucas's engravings of 'The Lock' (no.158) and 'The Cornfield' (no.165) among new publications, 'Two powerful and noble mezzotint prints'.

1835

3 January: a note from James Reeve about the forthcoming election in Ipswich, 'the elections are warmly contested, and somewhat dubious: if you have a vote pray go down, Ipswich election is on Tuesday [7th]'. *8th or 9th:* writes to Boner from Suffolk, the Blues triumphant, 'What a fine season, the birds are singing, the rooks busy, the meadows green, & the water & skies blue. I make a long visit. The chairing, is on Saturday [17th]'. *18th:* tells John he may not be home until the 21st. *14 February:* asks old Dunthorne for the loan of two of Johnny's studies 'of the ashes in the town meadow' and a study of plants. 'I am about an ash or two' – i.e. in his 'Valley Farm' (no.216). *March:* Robert Vernon buys 'The Valley Farm' on seeing it in the artist's studio. *8 April:* tells George Constable, 'Mr Wells, an admirer of common place, called to see my picture [no.216], and did not like it at all, so I am sure there is something good in it. Soon after, Mr Vernon called, and bought it, having never seen it before in any state'. *23rd:* Abram writes about the sale of the picture, 'there are but few people can make a piece of canvass worth £300'. *17 April: Bell's Weekly Messenger* reviews 'Valley Farm', 'we can scarcely look at the picture without laughing at the whim and caprice of the artist splashing all over with white what would otherwise be a very pleasing view of nature'. *22 May:* a repeated invitation from George Constable to come to Arundel 'as soon as you can . . . for the scenery about us is now looking most beautiful'. *23rd:* the *Athenaeum*, 'CONSTABLE is an original in everything; he must be compared with nature, and not with art.' *22 June:* delivers his second lecture to the Literary and Scientific Society at Hampstead. *26th:* to Boner, in Germany, the lecture 'went off immensely well. I was never flurried – only occasionally referring to notes – spoke what I had to say off hand – was an hour and a half – and was "*novel, instructive* and entertaining", as the committee told me'. *30th:* writes to Lucas about proofs of the 'Great Salisbury' (no.211); Leslie so impressed, he wants one, 'and so am I . . . it can never or will be grander that it is now'. *2 July:* writes to George Constable, 'panting for a little fresh air'; proposes to come to Arundel with John and Minna on the *7th. 9th–19th:* makes numerous drawings of Arundel, Chichester, etc. – see nos.338–40. *27th:* at Canbury House, Kingston-upon-Thames to fetch Minna, who has been staying with John Fisher's parents. *August:* the fourteen-year-old Charles now entered as midshipman on the East Indiaman the *Buckinghamshire*. In an undated letter to Leslie of about this time, Constable writes, 'The ship sails this week . . . Poor dear boy – I try to joke, but my heart is broken'. *6 September:* 'My Charley boy is gone', he tells Lucas, 'he is on the wide sea, with heaven to be his guide. God Almighty bless and preserve him'. *29th:* writes to E. Leader Williams about arrangements for a course of lectures at Worcester. *6, 8 & 9 October:* delivers three lectures at the Worcester

Athenaeum. *6th, 10th & 11th:* makes pencil sketches of Worcester. Stays with Maria's half-sister at Spring Grove, Bewdley (which he had last seen in 1811) and makes several pencil sketches in the area – see no.342, possibly his last study from nature, dated the *15th. 30th:* asks Robert Vernon if he can keep 'Valley Farm' a little longer, 'it is day by day receiving improvement = my wish is to make it – as perfect as I can'. *10 December:* apologies to Vernon for still keeping the picture, 'My *only motive* is to make it as good as I possibly can for both our sakes'. Spends Christmas with John at Flatford.

1836

26 January: Mary Constable writes with a scheme for the purchase of land. *3 February:* attends the Private View at the BI; 'Valley Farm' his only exhibit. *11th:* Mary sends details of the property for sale, 'a small portion of *England in East Bergholt*, I trust, would prove a *harmless Link* of worldly pleasure'. *15th:* one of the many letters to Lucas on the mezzotint of 'Salisbury Cathedral from the Meadows': 'we must bear in recollection that the sentiment of the picture is that of solemnity, not gaiety – nothing garish, but the contrary – yet it must be bright, clear, alive, fresh, and all the front seen'. *16th:* Michael Faraday writes to say that the Managers of the Royal Institution received with thanks Constable's offer of a series of lectures on landscape. *18 March:* tells Leslie about a recent visit to Samuel Rogers, 'I never had such a morning in my life . . . He was pleased with my pointing out the falling or shooting star in his exquisite Rubens . . . What pictures he has got! the best in London'. *22nd:* Mary writes, 'as to the *Farm* . . . you may say

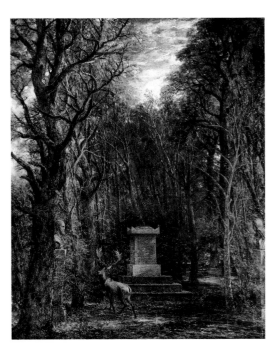

anything *you wish upon the subject before we close upon it*, by *assenting to the price of 4000 pounds*, as we have offered *3800* & it is refused. The "Rail Road" will not pass over *any part of the Estate*'. *9 April*: the *Times* advertises Constable's forthcoming lectures at the Royal Institution. *3 May: Morning Post* on 'The Cenotaph' (fig.13), 'Like all the pictures of Mr. Constable, the present is marked by peculiarities, but they are the peculiarities of an original style, without the tricks of mannerism.' *20th:* Abram tells him 'you have got the Farm and the old House . . . I have paid £200 deposit'. *26th:* delivers the first of his lectures at the Royal Institution, 'The Origins of Landscape' (Dürer, Titian, etc). *2 June:* the second RI lecture, 'Establishment of Landscape' (the Poussins, Claude, etc.). *4th: Literary Gazette* on 'Stonehenge' (no.345), 'The effect with which Mr. Constable has judiciously invested his subject, is as marvelous and mysterious as the subject itself.' *9th:* third RI lecture, 'Landscape of the Dutch and Flemish Schools' (Rubens, Rembrandt, Ruisdael, etc.). *15th:* writes to Wordsworth and sends him a copy of *English Landscape*; his indebtedness to Beaumont, 'it was from his hands that I first saw a Volume of Your poems . . . I shall always reflect with pride that – You – was at one of my lectures'. *16th:* fourth RI lecture, 'The Decline and Revival of Art' (Wilson, Gainsborough, etc.). *25 July:* delivers his last lecture to the Hampstead Literary and Scientific Society. *30 August:* Charles back from his voyage in the *Buckinghamshire. 16 September:* tells George Constable about Charles's hard life at sea, the ship sails again in November. 'We are preparing to move the Royal Academy, and to take possession of the new buildings in the square opposite St Martin's Church.' *29 October:* to Leslie; John at Cambridge, Charles at sea. 'O what a melancholy, dirty, life is a sailor's.' *11 November:* asks Lucas for the 'Dedham Vale' back, 'as Charley wants to see it, *if the threads are off*' (Lucas is in the process of engraving no.169). *27 November:* the *Buckinghamshire* sails for China with Charles aboard. *8 December:* tells Leslie that Sheepshanks 'means to have my Glebe farm . . . this is one of the pictures on which I rest my little pretensions to futurity'. *12th:* to George Constable, 'My observations on clouds and skies are on scraps and bits of paper, and I have never yet put them together so as to form a lecture, which I shall do, and probably deliver at Hampstead next summer.' *30th:* invites the Leslies to dine on *4 January:* '"Prithee come – life is short – friendship sweet." These were the last words of poor Fisher to me, in his last invitation.'

1837

19 January: writes to Lucas; has cleared the whole of the rainbow in a proof of the 'Salisbury', the 'bow', the rainbow, forms the subject of the picture and 'must be clear, & tender, though conspicuous . . . How I wish I could scratch & tear away at it with your tools on the steel'.

17 February: tells George Constable he is at work 'on a beautiful subject, Arundel Mill, for which I am indebted to your friendship. It is, and shall be, my best picture'. *25th:* writes to Leslie about his pending tour of duty as Visitor at the Royal Academy Schools, 'when I shall set Titian's figure of the assassination of St Peter Martyr'. *18 March:* sends Lucas another proof of the 'Salisbury', with instructions for improvements; in a note to his deaf friend, Lane, talks of the bitter easterly winds – 'I am out every evening from five to nine at the old Academy, visitor in the Life'. *25th:* takes the last Life Class to be held in the old studios in Somerset House; makes a speech to the students; 'At the close of the address', it is reported in the *Morning Herald* (3 April), 'the students arose and cheered most heartily, never suspecting that this would be his last address'. *27th:* settles an account with Dominic Colnaghi and expresses regret at having been so long without seeing him; 'I have never been out – I have been sore perplexed with my secular concerns my children & my Art.' *29th:* in his last note to Lucas, comments on a new proof of the 'Salisbury'; says he is going to a general meeting at the Academy next day; 'I dine at the Charter House on Saturday [1 April]'. *30th:* attends a General Assembly of the Academy in the evening; after, walks away with Leslie; in Oxford Street gives a shilling to a beggar child – 'we parted at the west end of Oxford Street, laughing', Leslie afterwards recalled, 'I never saw him again alive'. *31st:* works all day on 'Arundel Mill and Castle' (no.220); in the evening, walks out on a charitable errand; reads himself to sleep; a servant removes the candle. John, in the next bedroom, hears him call out in pain; complains of giddiness and is sick; drinks copiously of hot water; moves from his bed to a chair, then back to the bed, twists over on his side and 'after this he never spoke the extremeties became cold and after a gasp or two he expired' (from an account of his father's death given by John to Thomas Churchyard on 11 April; see W. Morfey, *Painting the Day: Thomas Churchyard of Woodbridge*, 1986, pp. 59–60). Leslie describes the scene next morning: 'I went up to his bedroom, where he lay, looking as if in tranquil sleep; his watch, which his hand had so lately wound up, ticking on a table by his side, on which also lay a book he had been reading scarcely an hour before his death. He had died as he lived, surrounded by art, for the walls of the little attic were covered with engravings, and his feet nearly touched a print of the beautiful moonlight by Rubens, belonging to Mr. Rogers.'

Constable's Exhibited Works 1802–1837

1802 RA 19 A landscape [see no.1]

1803 RA 59 A study from Nature [see under no.2]
624 A study, from Nature [see under no.2]
724 A landscape
738 A landscape

1805 RA 148 A landscape: Moon-light

1806 RA 787 His Majesty's ship Victory, Capt. E. Harvey, in the memorable battle of Trafalgar, between two French ships of the line [watercolour, Victoria and Albert Museum, Reynolds 1973, no.65]

1807 RA 52 View in Westmoreland
98 Keswick Lake
150 Bow Fell, Cumberland

1808 BI 380 A mountainous scene in Westmorland [frame 40 × 48 in]
480 Moon-light, a study [frame 23 × 20 in]

RA 52 Winander-meer lake
100 A scene in Cumberland
103 Borrowdale

1809 BI 80 Windermere lake [frame 14 × 16 in]
248 Borrowdale [frame 31 × 27 in]
260 A cottage scene, a study [frame 25 × 22 in]
282 Keswick Lake [frame 22 × 29 in]

RA 26 A landscape
28 A landscape
183 A landscape

1810 RA 74 A landscape
116 A church-yard [no.30]

1811 BI 185 A church porch [frame 25 × 22 in; no.30]

RA 71 Twilight
471 Dedham Vale: Morning [no.14]

1812 RA 9 A water-mill [no.54]
72 Landscape: Evening [no.33]
133 Landscape: A recent shower
372 Salisbury: Morning [see under no.134]

1813 BI 104 Landscape, a scene in Suffolk [frame 43 × 62 in; no.14]

RA 266 Landscape: Boys fishing [no.57]
325 Landscape: Morning

Liverpool Academy
94 Landscape [price 40 gns]

1814 BI 98 Landscape; a lock on the Stour [frame 49 × 59 in; no.57]
216 Martin Cats [frame 36 × 52 in]

RA 28 Landscape: Ploughing scene in Suffolk [no.71]
261 Landscape: The ferry [no.65]

Liverpool Academy
9 A Landscape – Ploughman [price 25 gns; no.71]

1815 BI 115 Landscape [frame 32 × 41 in; no.71]

RA 20 View of Dedham [no.74]
146 Landscape: A sketch
215 Boat building [no.72]
268 Village in Suffolk
310 Landscape
415 A drawing [see under no.254]
446 A drawing [see under no.254]
510 A drawing [see under no.254]

1816 RA 169 The wheat field [no.76]
298 A wood: Autumn [see under no.172]

1817 BI 132 A Harvest Field: Reapers, Gleaners [frame 33 × 42 in; no.76]

RA 85 Wivenhoe Park, Essex, the seat of Major-General Rebow [no.79]
141 A cottage [no.78]
216 Portrait of the Rev. J. Fisher [fig.9 on p.26, Fitzwilliam Museum, Cambridge; Reynolds 1984, no.17.3]
255 Scene on a navigable river [no.89]

1818 BI 91 Scene on the Banks of a River [frame 58 × 68 in; no.89]
129 A Cottage in a Cornfield [frame 19 × 17 in; no.78]

RA 11 Landscape: Breaking up of a shower [see no.94]
34 Landscape
142 Landscape: A study
304 Landscape: A study

446 A Gothic porch [drawing, Huntington Library and Art Gallery; Reynolds 1984, no.17.31]

483 Elms [drawing, no.282]

1819 BI 44 Osmington Shore, near Weymouth [frame 40 × 48 in; see no.86]

78 A Mill [frame 39 × 47 in; no.94]

RA 251 A scene on the river Stour [fig.65, 'The White Horse', Frick Collection, New York; Reynolds 1984, no.19.1]

1820 RA 17 Landscape [no.100]

148 Harwich light-house [see Reynolds 1984, no.20.6]

1821 RA 89 Hampstead Heath [see under nos.107–8]

132 A Shower

135 Harrow

339 Landscape: Noon [no.101]

1822 BI 197 Landscape; Noon [frame 68 × 91 in; no.101]

RA 111 Hampstead-heath [see under nos.107–8]

183 View on the Stour, near Dedham [fig.66 on p.195, Huntington Library and Art Gallery; Reynolds 1984, no.22.1]

219 Malvern Hall, Warwickshire [see Reynolds 1984, no.22.5]

295 View from the Terrace, Hampstead [see ibid., no.22.4]

314 A study of trees from Nature [see no.115]

'Gallery of Splendid Drawings', W.B. Cooke's Gallery, 9 Soho Square

280 South Porch of East Bergholt Church, Suffolk [not for sale; 1818 RA no.446]

296 Study of a Group of Elms [not for sale; no.282]

1823 BI 35 Landscape [frame 68 × 90 in; 1822 RA no.183]

148 Yarmouth Jetty [frame 20 × 27 in; probably Reynolds 1984, no.22.36]

RA 59 Salisbury Cathedral, from the Bishop's grounds [no.140]

179 Study of trees

244 A cottage

1824 BI 46 Salisbury Cathedral, from the Bishop's Grounds [frame '36 × 57' in, presumably a mistake for 46 × 57; no.140]

RA 180 A boat passing a lock [no.158]

Salon, Paris

358 Une charette à foin traversant un gué au pied d'une ferme; paysage [no.101]

359 Un canal en Angleterre; paysage [1822 RA no.183]

360 Vue près de Londres; Hampstead Heath

1825 RA 115 Landscape [no.125]

186 Landscape [no.126]

224 Landscape [no.162]

BI loan exhibition

114 Landscape; a Water-mill, with Children angling [no.100]

118 Landscape; a River Scene [1819 RA no.251]

129 The Lock [no.158]

Salon, Lille

98 Deux vues des Canaux d'Angleterre [1819 RA no.251 and one other]

1826 RA 122 A mill at Gillingham, in Dorsetshire [no.143]

225 Landscape [no.165]

1827 BI 101 Landscape; Noon [frame 70 × 63 in; no.165]

314 The Glebe Farm [frame 31 × 37 in; no.167]

321 A Mill at Gillingham, Dorset [frame 30 × 34 in; no.143]

RA 48 Mill, Gillingham, Dorset [no.144]

186 Chain Pier, Brighton [no.156]

290 Hampstead Heath [see Reynolds 1984, no.27.6]

Salon, Paris

219 Paysage avec figures et animaux [no.165]

Salon, Douai

73 Vue prise sur un canal en Angleterre. On voit sur le premier plan des barques et des personnages [1822 RA no.183]

1828 BI 64 The Beach at Brighton, the Chain Pier in the distance [frame 68 × 99 in; no.156]

RA 7 Landscape [either no.169 or 'Hampstead Heath: Branch Hill Pond', Victoria and Albert Museum, Reynolds 1984, no.28.2]

232 Landscape [either no.169 or Reynolds 1984, no.28.2]

Birmingham Institution

31 Mill at Gillingham, Dorset [probably no.144]

1829 BI 38 Landscape and Lock [frame 58 × 67 in; no.160]

348 Landscape; a Cottage Scene [frame 40 × 51 in]

RA 9 Landscape

322 Hadleigh Castle. The mouth of the Thames – morning, after a stormy night [fig.84 on p.312, Yale Center for British Art; Reynolds 1984, no.29.1]

Birmingham Society of Arts

122 Noon [no.165]

1830 RA 19 Dell scene, in the park of the Right Hon. the Countess of Dysart, at Hatmingham [i.e. Helmingham], Suffolk [no.172]

94 Landscape

248 A heath [no.129]

1831 RA 123 Yarmouth pier [see Reynolds 1984, no.31.6]

169 Salisbury cathedral, from the meadows [no.210]

1832 RA 147 Sir Richard Steele's cottage, Hampstead [probably Reynolds 1984, no.32.6]

152 A romantic house at Hampstead [see no.130]

279 Whitehall stairs, June 18th, 1817 [no.213]

286 Moonlight

492 Jaques and the wounded stag [watercolour; see Reynolds 1984, no.32.10]

632 A church [see under no.328: probably Reynolds 1984, no.32.14, watercolour]

643 A mill [watercolour]

644 Farm-house [see no.328]

Birmingham Society of Arts

171 The Ferry

1833 BI 155 Salisbury from the meadows [frame 72 × 82 in; no.210]

156 Dell scene [frame 38 × 46 in; fig.89, J.G.Johnson Collection, Philadelphia Museum of Art; Reynolds 1984, no.26.21]

RA 34 Englefield house, Berkshire, the seat of Benyon de Beovoir, Esq. – morning [private collection, Reynolds 1984, no.33.1]

94 A heath, showery – noon

344 Cottage in a corn-field [no.77]

402 Landscape – sunset

639 An old farm-house [watercolour; see no.328]

645 A miller's house [watercolour]

647 A windmill – squally day [watercolour; see no.329]

Exposition Nationale des Beaux Arts, Brussels

A Barge Passing a Lock [see Reynolds 1984, no.25.33]

Society of British Artists (Winter Exhibition)

236 Landscape – a Sketch

1834 BI 128 A Cottage in a Field of Corn [frame 34 × 30 in; no.77]

174 A Heath scene, showery day [frame 32 × 42 in]

329 The Stour Valley, which divides the Counties of Suffolk and Essex; Dedham and Harwich Water in the distance [frame 72 × 63 in; no.169]

RA 481 The mound of the city of Old Sarum, from the south [watercolour, Victoria and Albert Museum; Reynolds 1984, no.34.1]

548 Study of trees, made in the grounds of Charles Holford, Esq., at Hampstead [see no.332]

582 Stoke Pogis Church, near Windsor, the scene of *Gray's Elegy* – also where he was buried [watercolour; see Reynolds 1984, no.34.4]

586 From *Gray's Elegy*, stanza 11 [watercolour; see ibid., no.34.5]

Royal Hibernian Academy, Dublin

46 Landscape, morning, valley of the Stour, which divides the county of Suffolk and Essex, Dedham and Harwich, water in the distance [no.169]

56 A Sea Piece, Yarmouth Pier, Norfolk, morning [? 1831 RA no.123]

92 A Heath

241 Jacques and the wounded stag [watercolour, 1832 RA no.492]

Worcester Institution

26 Salisbury Cathedral – from the Bishop's Grounds [no.140]

141 Landscape – a Barge passing a Lock on the Stour [see Reynolds 1984, no.25.33]

Birmingham Society of Arts

194 Warwick [lent by Charles Birch]

317 Salisbury Cathedral, from the Meadows, Summer Afternoon, A retiring Storm [no.210]

1835 RA 145 The valley farm [no.216]

Worcester Institution

50 Harvest – Noon; a Lane Scene [no.165]

		62	A Heath Scene
		68	A Water Mill [no.144]
		171	The Glebe Farm [no.168]
		185	Valley of the Stour – Morning [no.169]

1836 BI 43 The Valley Farm [frame 73 × 65 in; no.216]

RA 9 Cenotaph to the memory of Sir Joshua Reynolds, erected in the grounds of Coleorton Hall, Leicestershire, by the late Sir George Beaumont, Bart. [fig.13 on p.37, National Gallery; Reynolds 1984, no.36.1]

581 Stonehenge [no.345]

Worcester Institution

2 Salisbury Cathedral from the Meadows – Summer Afternoon – A retiring Tempest [no.210]

32 Sir Richard Steele's Cottage, Hampstead [see 1832 RA no.147]

48 A Farm Yard near a navigable River in Suffolk – Summer Morning

61 Summer Evening [? no.33]

141 Effect of Moonlight through Trees

156 A River Scene – Noon

157 An Early Study – Painted in the Wood – Autumn

219 Portrait of a Gentleman ['Thomas Simcox Lea'; private collection, Reynolds 1984, no.30.18]

227 Portrait of a Lady and Children ['Mrs Elizabeth Lea with her Three Children'; private collection, ibid., no.30.19]

1837 RA 193 Arundel mill and castle [no.220]

Note. During his lifetime Constable's work could also be seen very occasionally at the premises of London dealers (Beckett IV 1966, p.132) and, for a year or so following his success at the Salon of 1824, in the Paris galleries of Arrowsmith and Schroth (ibid., pp.177–211). In addition, Constable showed work to visitors at his Charlotte Street house, at some time making more formal arrangements by issuing printed cards to admit visitors to 'Mr. Constable's Gallery of Landscape' or to see 'Mr Constable's Pictures' (examples of such cards, dated 1830 and 1831, are still in the family collection). The 'Gallery' was housed in the passage connecting the house with the studio at the rear of the building: see figs.14–15. (The 1822 Cooke's Gallery and 1827 Douai Salon references in the above list were kindly supplied by Judy Ivy and Lee Johnson respectively.)

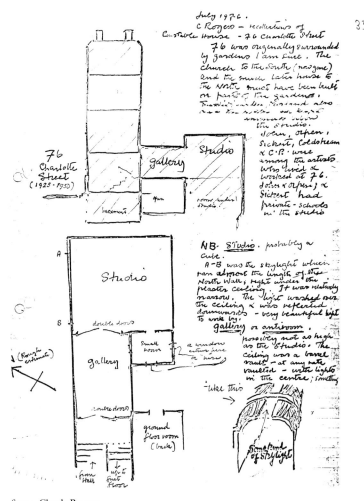

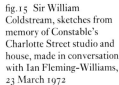

fig.14 Claude Rogers,
diagrams of Constable's
house, gallery and studio, 76
(formerly 35) Charlotte
Street, drawn from memory
1976, *Whereabouts Unknown*

fig.15 Sir William
Coldstream, sketches from
memory of Constable's
Charlotte Street studio and
house, made in conversation
with Ian Fleming-Williams,
23 March 1972

Coldstream was at 76 Charlotte Street from 1929 to 1931, Rogers apparently from 1939 to 1940. The house was damaged during the Second World War and was demolished shortly afterwards. Figure 14 is taken from a faded photocopy of a drawing made in 1976 in response to a request from Ian Fleming-Williams for a plan of Constable's house as Rogers remembered it. The text reads: 'July 1976. C Rogers – recollections of Constable House – 76 Charlotte Street 76 was originally surrounded by gardens I am sure. The church to the South (now gone) and the much later house to the North must have been built on part of the gardens. Traditionally, Morland also [. . .] and kept animals below the studio. John, Orpen, Sickert, Coldstream & C.R. [Claude Rogers] were among the artists who lived & worked at 76. John & Orpen, & Sickert had private-schools in the studio NB. *Studio*. probably a cube. A – B was the skylight which ran almost the length of the North Wall, right under the plaster ceiling. It was relatively narrow. The light washed over the ceiling & was reflected downwards – very beautiful light to work by. *Gallery* or *antiroom*. possibly not as high as the Studio. The ceiling was a barrel vault – at any rate vaulted – with lights in the centre; something like this', followed by sketch with 'some kind of skylight' indicated.

CATALOGUE

Explanations

For details of medium, support, size, inscriptions and provenance, we have taken what appeared to us the most reliable information available. A good deal of this is the result of our own observation and research but it has not been possible for us to re-examine, measure or research the provenance of all 345 items in the exhibition.

MEASUREMENTS. Height is given before width, millimetre size before inches (the latter in parentheses); for irregularly shaped surfaces, the maximum extent is cited.

INSCRIPTIONS are by the artist unless otherwise stated. The following signs are used in transcripts of inscriptions and manuscripts:

[landscape]	editorial insertion
[?landscape]	doubtful reading
[...]	missing or undeciphered word or words
⟨landscape⟩	deleted word
⟨...⟩	undeciphered deletion

When possible, letters to and from Constable have been transcribed from the original manuscripts, our readings sometimes differing from those given in R.B. Beckett's edition.

PROVENANCE ('PROV'). At the beginning of a provenance line three full points are used to indicate ignorance of the work's history before the first owner named; the same device is used for gaps in our knowledge of its later history.

EXHIBITION HISTORY ('EXH'). With the exception of the 1837 RA, in which he was posthumously represented, only exhibitions in Constable's lifetime and those from 1976 onwards are listed.

LITERATURE ('LIT'). With the exception of standard catalogues of Constable's work, only books and articles from 1976 onwards are listed and these selectively. Earlier literature is sometimes cited within the text of the catalogue entries. Exhibition catalogues are not listed under 'LIT' if the exhibitions in question have already been cited under 'EXH'.

CATALOGUE TEXTS. Where appropriate these include summaries of Sarah Cove's researches into Constable's materials and techniques, with references to where her own fuller account can be found. Throughout the catalogue 'ground' is used to refer to a layer *beneath* a 'primer' or 'priming layer' (see p.496).

ILLUSTRATIONS. The frame shadows on some of the transparencies supplied to us have been reproduced when not too distorting to the image; otherwise they have been masked. Wherever possible the full-page colour details are approximately life-size.

Abbreviations

ABBREVIATIONS: GENERAL

BI	British Institution	exh.	exhibited
b.l.	bottom left	exh. cat.	exhibition catalogue
b.r.	bottom right	RA	Royal Academy
bt	bought	repr.	reproduced
col.	colour	t.l.	top left
ESRO	East Suffolk Record Office, Ipswich	t.r.	top right

ABBREVIATIONS: EXHIBITIONS

Bloomington and Chicago 1988	Bloomington and Chicago showings only of New York, Bloomington, Chicago 1987–8, q.v.
Grosvenor Gallery 1889	*A Century of British Art (Second Series) from 1737 to 1837*, Grosvenor Gallery 1889
Japan 1986	*John Constable*, Isetan Museum of Art, Tokyo, Jan.–Feb. 1986, Fukuoka Prefectural Museum of Art, March 1986, Yamanashi Prefectural Museum of Art, Kofu, April–May 1986, Sogo Museum of Art, Yokohama, May–June 1986 (catalogue by Graham Reynolds, essays by Denys Sutton, Graham Reynolds and Nobuyuki Senzoku)
Leggatt 1899	*Pictures & Water-Colour Drawings by John Constable, R.A.*, Leggatt's Gallery, 77 Cornhill, Nov. 1899
Madrid 1988–9	*Pintura Británica de Hogarth a Turner*, Museo del Prado, Madrid, Oct.1988–Jan.1989 (Constable entries by Andrea Rose, essay by Andrew Wilton)
Milwaukee 1976	*Constable*, University of Wisconsin, Milwaukee, April 1976
New Haven 1982–3	*Presences of Nature: British Landscape 1780–1830*, Yale Center for British Art, New Haven, Oct.1982–Feb.1983 (catalogue and text by Louis Hawes)
New York 1983	*Constable's England*, Metropolitan Museum of Art, New York, April–Sept. 1983 (catalogue and essay by Graham Reynolds)
New York 1987–8	New York showing only of New York, Bloomington, Chicago 1987–8, q.v.
New York 1988	*John Constable, R.A. (1776–1837)*, Salander-O'Reilly Galleries, Inc., New York, May–June 1988 (catalogue entries by Charles Rhyne on selected works, essay by Graham Reynolds)
New York 1989	*John Constable, R.A. (1776–1837)*, Salander-O'Reilly Galleries, Inc., New York, Nov.–Dec.1989 (essay by Sir Lawrence Gowing)
New York, Bloomington 1987–8	New York and Bloomington showings only of New York, Bloomington, Chicago 1987–8, q.v.
New York, Bloomington, Chicago 1987–8	*William Wordsworth and the Age of English Romanticism*, New York Public Library, Oct.1987–Jan.1988, Indiana University Art Museum, Bloomington, Jan.–March 1988, Chicago Historical Society, April–June 1988 (catalogue and texts by Jonathan Wordsworth, Michael C. Jaye, Robert Woof, Peter Funnell)

Paris 1976	*John Constable (1776–1837): Esquisses et dessins du Victoria and Albert Museum de Londres*, Musée du Louvre, Paris, June–Aug. 1976 (essays by C.M. Kauffmann and M. Sérullaz)
Tate Gallery 1976	*Constable: Paintings, Watercolours & Drawings*, Tate Gallery, Feb.–May 1976 (catalogue by Leslie Parris and Ian Fleming-Williams, essay by Conal Shields; references are to the third printing of of the catalogue, April 1976)
Tate Gallery 1986	*The 'English Landscape' Prints of John Constable & David Lucas*, Tate Gallery, April–June 1986 (catalogue and essay by Leslie Parris)

ABBREVIATIONS: LITERATURE

Barnard 1984	Osbert H. Barnard, 'Lucas-Constable: *English Landscape*, Revised List of States', *Print Quarterly*, vol.1, no.2, June 1984, pp.120–3
Barrell 1980	*The Dark Side of the Landscape: The Rural Poor in English Painting, 1730–1840*, Cambridge 1980
Beckett I 1962	R.B. Beckett (ed.), *John Constable's Correspondence: The Family at East Bergholt 1807–1837*, London and Ipswich 1962
Beckett II 1964	R.B. Beckett (ed.), *John Constable's Correspondence: II: Early Friends and Maria Bicknell (Mrs Constable)*, Ipswich 1964
Beckett III 1965	R.B. Beckett (ed.), *John Constable's Correspondence: III: The Correspondence with C.R. Leslie*, Ipswich 1965
Beckett IV 1966	R.B. Beckett (ed.), *John Constable's Correspondence: IV: Patrons, Dealers and Fellow Artists*, Ipswich 1966
Beckett V 1967	R.B. Beckett (ed.), *John Constable's Correspondence: V: Various Friends, with Charles Boner and the Artist's Children*, Ipswich 1967
Beckett VI 1968	R.B. Beckett (ed.), *John Constable's Correspondence: VI: The Fishers*, Ipswich 1968
Beckett 1970	R.B. Beckett (ed.), *John Constable's Discourses*, Ipswich 1970
Bermingham 1987	Ann Bermingham, *Landscape and Ideology: The English Rustic Tradition, 1740–1860*, 1987 (first published in USA 1986)
Boulton 1984	Sue Boulton, 'Church under a Cloud: Constable and Salisbury', *Turner Studies*, vol.3, no.2, Winter 1984, pp.29–44
Cormack 1986	Malcolm Cormack, *Constable*, Oxford 1986
Cove 1988a	Sarah Cove, 'An Experimental Painting by John Constable R.A.', *The Conservator*, no.12, 1988, pp. 52–6
Cove 1988b	Sarah Cove, 'The Constable Project: Current Research into Materials and Techniques' in *Preprints of UKIC 30th Anniversary Conference*, 1988, pp.59–63
Cove (thesis)	Sarah Cove, 'The Materials and Techniques of John Constable's Oil Paintings 1802–1837', Ph.D thesis in progress, Courtauld Institute of Art, University of London
Day 1975	Harold Day, *Constable Drawings*, Eastbourne 1975
Farington I [etc.]	*The Diary of Joseph Farington*, ed. Kenneth Garlick and Angus Macintyre (vols. I–VI), Kathryn Cave (vols. VII–XVI), New Haven and London 1978–84
Fleming-Williams 1976	Ian Fleming-Williams, *Constable: Landscape Watercolours & Drawings*, 1976

Fleming-Williams 1980 Ian Fleming-Williams, 'John Constable at Flatford', *Connoisseur*, vol.204, July 1980, pp.216–19

Fleming-Williams 1981 Ian Fleming-Williams, 'The Early Constable: New Watercolours & Drawings', *Connoisseur*, vol.206, Jan. 1981, pp.58–61

Fleming-Williams 1983a Ian Fleming-Williams, 'Constable Drawings: Some Unfamiliar Examples', *Burlington Magazine*, vol. 125, April 1983, pp.218–20

Fleming-Williams 1983b Ian Fleming-Williams, 'The Fenwick Oil-Sketches and Constable's "Salisbury Cathedral from the Meadows"' in John Herbert (ed.), *Christie's Review of the Season 1983*, Oxford 1983, pp.34–8

Fleming-Williams 1986 Ian Fleming-Williams, 'John Constable: The Honeymoon Sketch-book', *Old Water-Colour Society's Club*, vol.61, 1986, pp.5–25

Fleming-Williams 1990 Ian Fleming-Williams, *Constable and his Drawings*, 1990

Fleming-Williams and Parris 1984 Ian Fleming-Williams and Leslie Parris, *The Discovery of Constable*, 1984

Gadney 1976 Reg Gadney, *John Constable R.A. 1776–1837: A Catalogue of Drawings and Watercolours . . . in the Fitzwilliam Museum, Cambridge*, London and Cambridge 1976

Hawes 1982 Louis Hawes, *Presences of Nature: British Landscape 1780–1830*, exh. cat., Yale Center for British Art, New Haven 1982

Heffernan 1984 James A.W. Heffernan, *The Re-Creation of Landscape: A Study of Wordsworth, Coleridge, Constable and Turner*, Hanover, New Hampshire, and London 1984

Hill 1985 David Hill, *Constable's English Landscape Scenery*, 1985

Hoozee 1979 Robert Hoozee, *L'opera completa di Constable*, Milan 1979

Leslie 1843 C.R. Leslie, *Memoirs of the Life of John Constable, Esq. R.A.*, 1843

Leslie 1845 C.R. Leslie, *Memoirs of the Life of John Constable, Esq. R.A.*, 2nd ed., 1845

Leslie 1951 C.R. Leslie, *Memoirs of the Life of John Constable*, ed. Jonathan Mayne, 1951

Parris 1981 Leslie Parris, *The Tate Gallery Constable Collection*, 1981

Parris 1983 Leslie Parris, 'Some Recently Discovered Oil Sketches by John Constable', *Burlington Magazine*, vol.125, April 1983, pp.220–3

Parris and Fleming-Williams 1985 Leslie Parris and Ian Fleming-Williams, review of Reynolds 1984, *Burlington Magazine*, vol.127, March 1985, pp.164–70

Parris, Fleming-Williams, Shields 1976 Leslie Parris, Ian Fleming-Williams and Conal Shields, *Constable: Paintings, Watercolours & Drawings*, exh. cat., Tate Gallery 1976

Parris, Shields, Fleming-Williams 1975 Leslie Parris, Conal Shields and Ian Fleming-Williams, *John Constable: Further Documents and Correspondence*, London and Ipswich 1975

Paulson 1982 Ronald Paulson, *Literary Landscape: Turner and Constable*, New Haven and London 1982

Reynolds 1973 Graham Reynolds, *Victoria and Albert Museum: Catalogue of the Constable Collection*, 2nd ed., 1973

Reynolds 1977 Graham Reynolds, *John Constable: Salisbury Cathedral from the Bishop's Grounds*, Masterpieces in the National Gallery of Canada, no.10, Ottawa 1977

Reynolds 1981 Graham Reynolds, 'Constable's *Salisbury Cathedral*' in *A Dealer's Record: Agnew's 1967–81*, 1981, pp. 132–42

Reynolds 1984 Graham Reynolds, *The Later Paintings and Drawings of John Constable*, New Haven and London 1984

Rhyne 1981 Charles Rhyne, 'Constable Drawings and Watercolours in the Collections of Mr and Mrs Paul Mellon and the Yale Center for British Art: Part I, Authentic Works', *Master Drawings*, vol.19, no.2, Summer 1981, pp.123–45

Rhyne 1986 Charles Rhyne, 'The Drawing of Mountains: Constable's 1806 Lake District Tour' in *The Lake District: A Sort of National Property: Papers Presented to a Symposium Held at the Victoria & Albert Museum, 20–22 October 1984*, 1986, pp.60–70

Rhyne 1987 Charles Rhyne, 'A Slide Collection of Constable's Paintings: The Art Historian's Need for Visual Documentation', *Visual Resources*, vol.4, no.1, Spring 1987, pp.51–70

Rhyne 1988 Charles Rhyne, 'Discoveries in the Exhibition' in *John Constable, R.A. (1776–1837)*, exh. cat., Salander-O'Reilly Galleries Inc., New York 1988, pp.11–27

Rhyne 1990a Charles Rhyne, 'Constable's First Two Six-Foot Landscapes', *Studies in the History of Art*, vol.24, National Gallery of Art, Washington 1990, pp.109–29

Rhyne 1990b Charles Rhyne, 'Changes in the Appearance of Paintings by John Constable' in *Appearance, Opinion, Change: Evaluating the Look of Paintings*, United Kingdom Institute for Conservation 1990, pp.72–84

Rosenthal 1983 Michael Rosenthal, *Constable: The Painter and his Landscape*, New Haven and London 1983

Rosenthal 1987 Michael Rosenthal, *Constable*, 1987

Schweizer 1982 Paul Schweizer, 'John Constable, Rainbow Science, and English Color Theory', *Art Bulletin*, vol.64, no.3, Sept. 1982, pp.424–45

Shirley 1930 Andrew Shirley, *The Published Mezzotints of David Lucas after John Constable, R.A.*, Oxford 1930

Smart and Brooks 1976 Alastair Smart and Attfield Brooks, *Constable and his Country*, 1976

Thornes 1978 John Thornes, *The Accurate Dating of Certain of John Constable's Cloud Studies 1821/22 Using Historical Weather Records*, Occasional Papers, no. 34, Department of Geography, University College London 1978

Walker 1979 John Walker, *John Constable*, 1979

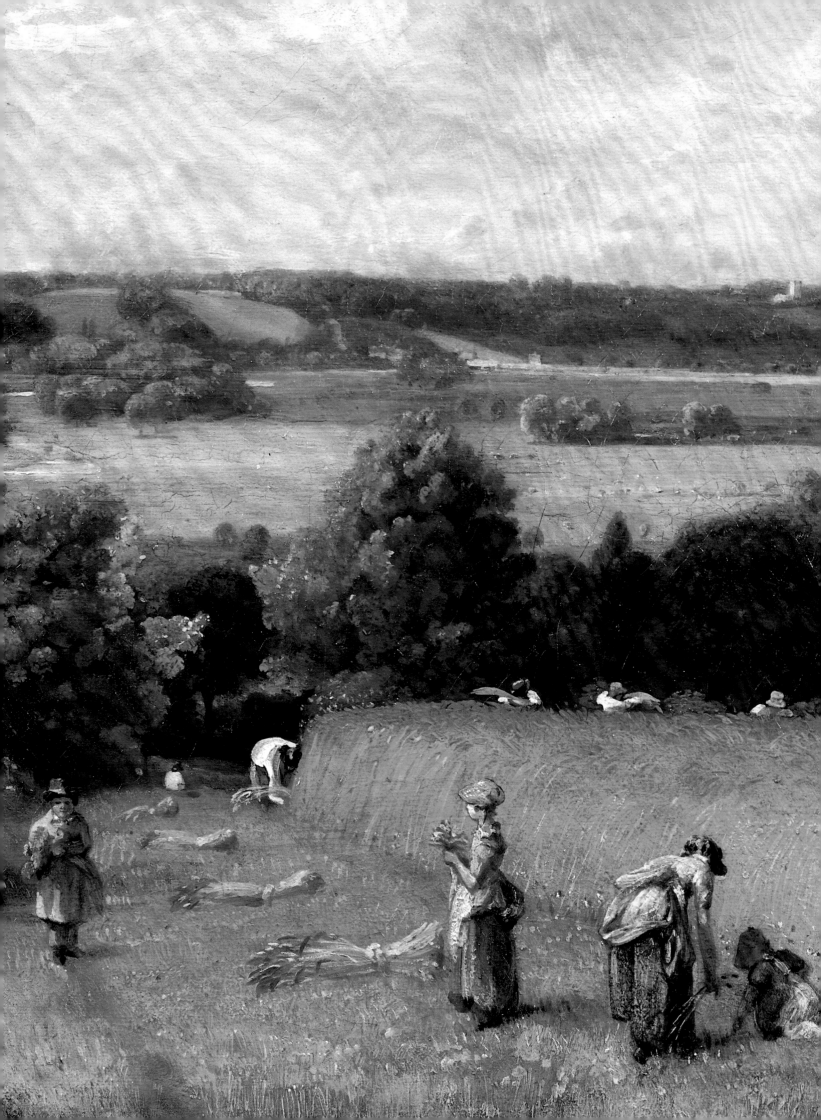

THE SUFFOLK YEARS

The division of this exhibition into 'The Suffolk Years' and 'The London Years' is not meant to suggest that Constable lived or worked solely in his native county during the first part of his career and in London thereafter. He began making contact with the London art world in the 1790s, obtaining introductions to such influential figures as Sir George Beaumont in 1795 and Joseph Farington in 1799. In the latter year he entered the Royal Academy schools and in 1802 exhibited at the Academy for the first time. Until the death of his father in 1816, however, and his own marriage later that year, Constable continued to regard his birthplace, East Bergholt House, as his home and to spend large parts of each year there, generally during the summer months. During these years his art was focused very firmly on local subjects: Dedham Vale, the fields and lanes of East Bergholt and scenes around his father's watermill on the river Stour nearby at Flatford. Having declared his commitment to 'natural' painting in 1802, by 1814 he was not only sketching in oils outdoors but attempting to make finished pictures on the spot. The work of the year 1814 has never been given its due as marking a turning point in Constable's pursuit of the aims he set himself twelve years earlier, aims pursued with mounting determination until 1816. Nor have the years 1817 to 1818 been fully recognised for the watershed they were in his art. Having taken on-the-spot painting as far as he could, he soon realised its limitations. On settling in London following his marriage, Constable began to recast his East Anglian material in more ambitious ways that did not depend on direct contact with the original subjects. In this manner, with invention and imagination increasingly playing a part, Suffolk lived on through the London years, while contact with new places provided fresh inspiration.

Detail from 'The Wheatfield', no.76

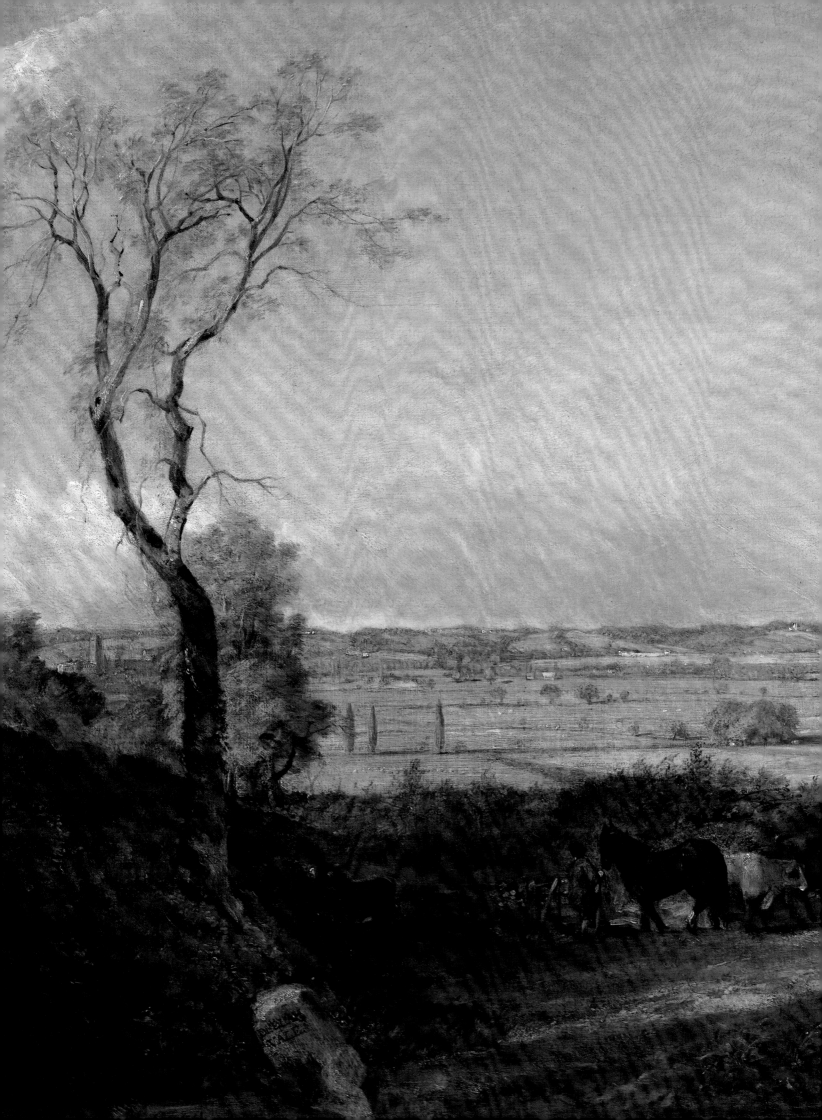

The Valley

From its source in Cambridgeshire, the River Stour makes its way eastwards for some fifty miles before it meets salt water and begins to open out into the estuary that has Harwich at its mouth. For much of its length it forms the boundary between Suffolk, on the left bank, and Essex, on the right. In the early years of the eighteenth century the lower half of the river, from Sudbury to Brantham, was rendered navigable – the depth and flow of water controlled largely by a series of locks, fourteen all told. It was the last stretch of the river, wending its way down through the locks at Stratford St Mary, Dedham, Flatford and Brantham, with the watermeadows and sloping hillsides on either hand, that became known as Dedham Vale (see fig.215 on p.531).

Stratford was a village strung out along the main London road, from the toll-bridge that spanned the river at the bottom of Gun Hill to the church of St Mary on rising ground to the north. The lock, with the mill beside it, was to become the subject of one of Constable's important six-foot canvases. Both the toll-bridge and St Mary's figure regularly in his paintings: the former in views from Gun Hill looking down the valley towards Dedham and the sea; the latter usually in the middle distance in paintings of the valley looking westwards from the fields on the Suffolk side. Dedham, also on the valley floor, but on the Essex side of the river, was a market town possessing a grammar school, a number of fine houses, a mill and a church, the 130-foot tower of which is such a feature in Constable's drawings and paintings of the Vale. From Dedham on the southern bank, it was a mile and three-quarters by water across the meadows to Flatford, with its lock, mill and little group of dwellings. As far as this the Stour remained sweet; below, high spring tides brought salt water to the tail of the lock. Brantham lock was a further mile and a half downstream. Here, at some distance from the village, there stood two mills, one driven by wind, the other by the fall of tidal water. After this there only remained Cattawade bridge for the descending river traffic to pass under before reaching open water and the quays at Mistley on the Essex shore. Between Cattawade and Stratford there were three bridges over the river: the footbridge at Flatford (many times drawn and painted by Constable); Fen bridge (by which he crossed the river on his way to school at Dedham); and the bridge near Dedham mill by which vehicular traffic from the town could reach Stratford without having to go round by the toll-bridge.

Through Constable's paintings Dedham Vale is now familiar to many who have never visited it. But though we may feel that he made this stretch of the valley peculiarly his own – in his lifetime it became known as 'Constable's country' – he was by no means the first to view it with an appreciative eye. He himself prefixed his own attempt to describe the view from Langham with Edmund Spenser's lines:

> And Sture, that parteth with his pleasant floods
> The Eastern Saxons from the Southern nigh,
> and Clare, and Harwich both doth beautify.

A lesser poet, William Hurn, in his *Heath Hill: A Descriptive Poem* (1777) wrote at some

length about the Stour and its charms. In the following passage he reveals his knowledge
of the river when it divides below Dedham:

> Where STOUR rolls on to meet the swelling tide;
> Where, seen slow-wandering thro' the vale below,
> In two slow streams the winding waters flow
> Two shining streams divide the peaceful mead,
> Where flowerets spring, and browsing cattle feed:

Since the middle of the eighteenth century, views of the vale and its 'ambient Air' had
been recognised as saleable assets by estate agents. A house in East Bergholt (almost
certainly West Lodge, see no.31) was advertised in 1756 as standing on the brow of a hill,
'remarkable for good Air', the back overlooking 'a pleasant Vale and River'. In 1775 a
house was to let in Dedham 'in a remarkably beautiful country'; and in 1797 an estate
'lying in the healthy and pleasant village of Dedham' was described as 'most delightfully
situated upon a hill commanding one of the finest prospects in England'. The Vale was
beginning to prove attractive to artists too. Since 1787 the distinguished amateur Sir
George Beaumont had been a regular visitor to Dedham (where his mother, the
Dowager, was a resident) and as a sketching companion sometimes brought with him one
of his friends in the profession. In 1794, for example, it was the Academician Joseph
Farington, who recorded in his diary for 15 September (I, p.233):

> Fine day. – After breakfast walked with Sir George, and made a sketch of Dedham
> Vale from the grounds above the Revd Mr. Hurlocks, – afterwards went towards
> Langham and made sketches – we then went in the Carriage to Mistley, and the village
> of Thorn, and crossing a Bridge returned through Bergholt and Stratford.
> The country about Dedham presents a rich English Landscape, the distance
> towards Harwich particularly beautiful.

It was to this same sketching-ground, with its views of the Stour winding its way past
Dedham towards the sea, that Constable was to return again and again (see nos.2, 7, 8,
17–19, etc.)

Farington said he sketched 'Dedham Vale'. Only one of Constable's paintings
originally bore that title, his 'Dedham Vale: Morning' of 1811 (no.14). Taken from a
viewpoint on the opposite, Suffolk, side of the valley, looking towards Langham, this was
an almost reciprocal view. In a letter of 26 July 1810, Mrs Constable, the artist's mother,
talks of 'the beauties of the Langham – Dedham & Bergholt Vales – now so rich &
delightful' (Beckett I 1962, p.47). This, it has been pointed out (Rosenthal 1983, p.6),
suggests that the Stour valley here was then seen severally, as three vales.

It is now nearly two hundred years since Constable began drawing the Vale. In some
ways it has changed. There are fewer vistas from the slopes on either side as hedges are
now no longer cut down annually to waist-height and there are many more trees. But
much remains comparatively unchanged. Constable's path to school from East Bergholt
to Dedham can still be walked. Willows along the river banks, the 'crack' willows he often
drew, are still occasionally pollarded and from a few of his more distant viewpoints one
can still see the 'elegant' tower of Dedham church high above the trees.

Constable in 1802

The year 1802 has long been recognised as the essential starting-point of Constable's career, the year in which he set himself on the course of his life's work. In April that year he first exhibited at the Royal Academy, in May he made his famous resolve to be 'a natural painter', around June he returned to his native Suffolk to put his resolution to the test.

Before 1802 Constable's work in landscape was eclectic in style and not yet clearly focused on the native scenes that were to form the core of his subject matter. Very little work in oil survives and probably not much was ever executed. A handful of canvases are known, not all of certain attribution, including two commissioned house portraits, a moonlit landscape in the manner of his early friend John Cranch, and a view from the back of his father's house. There are many more drawings, including groups strongly influenced by two other early mentors, J.T. Smith (see nos.221–3) and Sir George Beaumont.

Between July and November 1801 Constable spent seventeen weeks staying with his relations the Whalleys in Staffordshire, a visit which, he told his friend John Dunthorne, had done him 'a world of good' because of 'the regularity and good example in all things' he saw practised there. He now found his own mind 'much more decided and firm' and felt that he had acquired 'what I have so long and ardently desired – patience in the pursuit of my profession' (Beckett II 1964, pp.29–30). The 'kit-cat' size picture he told Dunthorne he was going to paint for the 1802 Royal Academy, having settled on his 'subject and effect', may be 'Edge of a Wood' (no.1). This 'patient' study of oak trees and bracken owes much to the example of Gainsborough's early work, for example the 'Cornard Wood' which later belonged to Constable's uncle D.P. Watts (fig.16, National Gallery, London) or the print of 'The Gipsies'. Constable had been a devoted student of Gainsborough's work since the 1790s, when he undertook research on the artist for a book by J.T. Smith. By 1799 he fancied he could 'see Gainsborough in every hedge and hollow tree' (Beckett II 1964, p.16).

Whether or not it was painted on the spot, 'Edge of a Wood' conveys less of a feeling of natural light and space than Constable's later oils of 1802 (nos.2–5). Nor does particularity of place seem so important. Constable, as he told Dunthorne, was after an 'effect', in this case an autumnal one, heightened with picturesque Gainsboroughian donkeys and a rustic figure collecting firewood.

fig.16 Gainsborough, 'Cornard Wood', *c*.1748, *Trustees of the National Gallery, London*

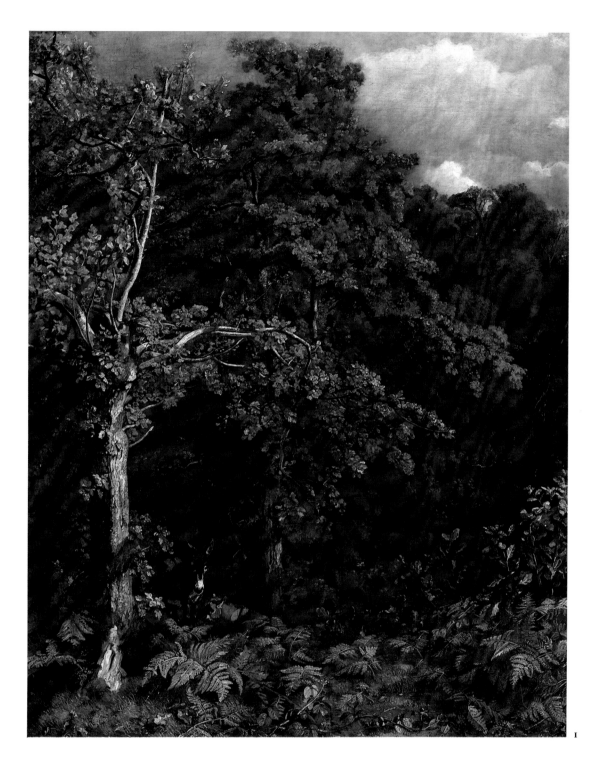

I

1 **Edge of a Wood** ?exh. 1802

Oil on canvas 921 × 722 ($36\frac{1}{4}$ × $28\frac{7}{16}$)
Inscribed in a later hand on a label on the
stretcher 'Bought by Revd J.H. Smith | late
Vicar of Milverton Warwickshire | from
Artist Sale' (legible under ultra-violet light:
see Taylor 1980, p.566 fig.38)
PROV: Artist's administrators, sold Foster 16
May 1838 (51, 'Study of Trees and Fern;
from natur with Donkies, &c.') bt Revd John
Henry Smith; by descent to Mrs Violet
Becket Williams, from whom bt by Leggatt
before 1936, when sold to Art Gallery of
Ontario
EXH: ? RA 1802 (19, 'A landscape')
LIT: Hoozee 1979, no.273, repr.; David G.
Taylor, 'New Light on an Early Painting by
John Constable', *Burlington Magazine*,
vol.122, Aug. 1980, pp.566–8, repr.;
Rosenthal 1983, p.25, fig.23 (col.); Cormack
1986, p.23, pl.16

*Art Gallery of Ontario, Toronto, Gift of
Rueben Wells Leonard Estate, 1936*

Although this painting was published as early as
1937, it was David Taylor who first drew attention
to its importance in his 1980 article, convincingly
establishing its provenance and suggesting that it
may have been Constable's first exhibit at the RA,
'A landscape' shown in 1802. In an undated letter
to John Dunthorne written early in 1802 (Beckett
II 1964, pp.29–30), Constable said he hoped to be
able to visit East Bergholt 'in about a month, in
which time I hope to compleat some little perfor-
mance for the exhibition. I have concluded on my
subject and effect – it will be a kit-cat size, that is
two feet and a half, by three feet'. As Taylor points
out, the Toronto picture is very close to this size
and a true kit-cat – 36 × 28 inches – would fit it
more or less exactly.

Taylor identifies the clothes worn by the figure

fig.17 Detail from no.1

as a riding cloak typical of the first half of the
eighteenth century and a tricorne, a type of hat that
had gone out of fashion by about 1780 except as
part of military uniform or livery. The clothes
would therefore seem to be old-fashioned articles
such as the very old or perhaps the poor might wear
(but would either wear gloves to collect firewood?).
As Taylor also points out, a similarly dressed figure
appears in 'The Church Porch', exhibited in 1810
(no.30), though here the setting is more genteel.
Constable's friend and biographer C.R. Leslie calls
the red-cloaked figure in that painting a woman,
perhaps having heard the artist so describe it
(Leslie 1843, p.10, 1951, p.21: it is impossible to tell
simply by looking). When David Lucas came to
engrave the picture under Leslie's supervision after
Constable's death, the figure became quite defini-
tely female, wearing a bonnet instead of an ancient
tricorne (Shirley 1930, no.42). In the Toronto
painting the figure remains ambiguous in this and
other respects.

Constable re-used the tree at the left in 'The
Cornfield', exhibited in 1826 (no.165), where it was
again placed in proximity to a figure wearing red
and to donkeys.

*　　*　　*　　*

Constable's first exhibit at the Royal Academy
helped him define his position: 'it shows me where
I am, and in fact tells me what no body else could',
he wrote to Dunthorne on 29 May 1802 in what has
become probably the most celebrated letter he ever
wrote (Beckett II 1964, pp.31–2). Although
Constable found in the exhibition 'fine pictures
that bring nature to mind – and represent it with
that truth that unprejudiced minds require', on the
whole there was 'little or nothing . . . worth looking
up to', empty bravura being the 'great vice of the
present day'. In concluding that 'there is room
enough for a natural painture [? painter]' Constable
was marking out the position to which he himself
now aspired.

Although it was to have revolutionary conse-
quences, Constable's declaration was entirely orth-
odox, as the circumstances of its expression
suggest. Constable wrote his letter to Dunthorne
immediately after returning from one of his many
visits to the old master collection of Sir George
Beaumont, a leading figure of the art establish-
ment, and with his mind full of the bible of British
art, Reynolds's *Discourses*: 'I am returned with a
deep conviction of the truth of Sir Joshua
Reynolds's observation that "there is no *easy* way
of becoming a good painter." It can only be
obtained by long contemplation and incessant
labour in the executive part'. And, Constable
continued, 'however one's mind may be elevated,
and kept up to what is excellent, by the works of the
Great Masters – still Nature is the fountain's head,
the source from whence all originality must spring'.

In the course of his letter Constable quotes from
memory or paraphrases passages from three separ-
ate *Discourses*. The first President's remarks on the

necessity of hard work and study (the *Discourses* were originally delivered to the students of the Royal Academy) and his understanding of the inter-relationship of art and nature were especially relevant to Constable in 1802. 'For these two years past I have been running after pictures and seeking the truth at second hand', he told Dunthorne, echoing advice given him the previous month by the Academician Joseph Farington 'to Study nature & *particular* art less' (Farington v, p.1764): 'I am come to a determination to make no idle visits this summer or to give up my time to common place people. I shall shortly return to Bergholt where I shall make some laborious studies from nature – and I shall endeavour to get a pure and unaffected representation of the scenes that may employ me with respect to colour particularly and any thing else – drawing I am pretty well master of'.

Nos.2–5 and 32 below are five examples of the studies Constable is thought to have made in Suffolk that summer. Utterly lacking in the 'bravura' he so despised, they are 'laborious' without being laboured. Every brush-stroke seems deliberated, as do the areas where no paint has been applied over the coloured priming: Constable knows, in Sir Joshua Reynolds's phrase, 'not only what to describe, but what to omit' (*Discourses on Art*, ed. R. Wark, 1975, p.199). Allowing the priming layer to act as part of the image was to become a major feature of Constable's practice. Early Gainsborough, as seen for example in the Tate's 'Wooded Landscape with Peasant Resting' (fig.18), is still the general model, though Claude also comes to Constable's mind (see no.2). But Constable is now, as it were, doing Gainsborough from nature, by and large painting direct from the motif rather than from drawings in the studio. More concerned even than the young Gainsborough was with the individuality of what he paints, Constable, as Ann Bermingham has observed (1987, p.119), differentiates one ash from another rather than simply ashes from oaks. He also uses chiaroscuro more effectively, both overall and in detail, to model forms and suggest space. Instead of the more or less uniform tonality with which Gainsborough paints the foliage of a particular tree in his 'Wooded Landscape', Constable introduces a lively variety of light and dark tones which are further set off by his reddish-brown priming.

Almost all the studies in this 1802 group (including those not exhibited here) are of Stour valley subjects and show Constable making a first determined effort to come to grips as a painter with the scenery that held so strong a place in his affections.

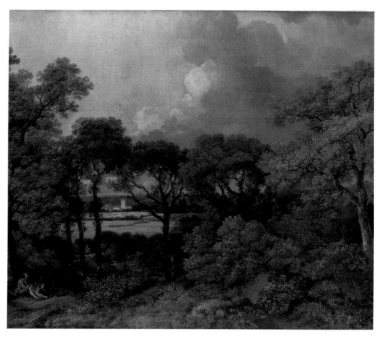

fig.18 Gainsborough, 'Wooded Landscape with a Peasant Resting', *c*.1747, *Tate Gallery*

2 Dedham Vale 1802

Oil on canvas 435 × 344 ($17\frac{1}{8}$ × $13\frac{1}{2}$)
Inscribed in a later hand on stretcher, presumably copying Constable's original inscription 'Sep 1802 – John [. . .] Isabel Constable' (part of the inscription covered by a later label)
PROV: By descent to Isabel Constable, by whom given to the South Kensington (later Victoria and Albert) Museum 1888
EXH: Tate Gallery 1976 (33, repr.); Paris 1976 (6, repr.); *Painting from Nature*, Fitzwilliam Museum, Cambridge, Nov. 1980–Jan. 1981, RA, Jan.–March 1981 (60, repr.); Japan 1986 (1, repr. in col.)
LIT: Reynolds 1973, no.37, pl.21; Hoozee 1979, no.15, pl.1 (col.); Rosenthal 1983, pp.30, 34, fig.31 (col.); Cormack 1986, pp.41–3, pl.32 (col.); Bermingham 1987, pp.119–21, pl.3 (col.); Rosenthal 1987, pp.38–40, ill.24 (col.)

Board of Trustees of the Victoria and Albert Museum, London

Three of the paintings attributed to Constable's intensive period of study in the Stour valley in 1802 are dated: no.32 below (July), the present work (September) and no.3 (16 October). Others, including nos.4–5 (the latter partially dated), a further canvas in the Victoria and Albert Museum (Reynolds 1973, no.40) and one of Willy Lott's house in a private collection (Tate Gallery 1976, no.35), are associated with these because of their similarity of style and size. The 'several small

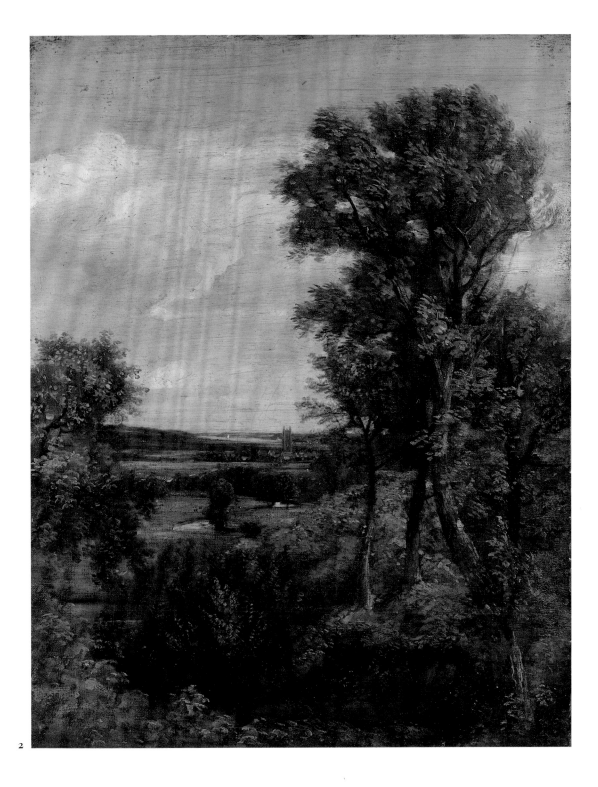

2

studies...painted from nature in the neighberoud of Dedham' which Constable took to show Farington on 23 March 1803 (Farington V, p.1998), and collected the following day, were undoubtedly from this group, and one or more of Constable's four RA exhibits in 1803 may have been also: two were titled 'A study from Nature', two 'A landscape'.

The view in no.2 is from near Gun Hill, Langham, looking eastwards to Dedham with the Stour estuary in the distance. The subject became a favourite with Constable and can be seen again, in different forms, in nos.6–9, no.262 and in the large 'Dedham Vale' exhibited in 1828 (no.169).

The composition is loosely derived from Claude's small painting 'Hagar and the Angel' (fig.19, National Gallery, London), which Constable had admired since the time of his first meeting with its owner, Sir George Beaumont, in 1795. As Rosenthal suggests, Constable was probably drawn to the scene in the first place because it reminded him of Claude's picture. What Constable could not, of course, include in his work was the prominent pair of figures that give Claude's painting its title. Aspiring to 'a pure and unaffected representation', the most he could admit by way of staffage in any of these studies was the Gainsboroughian rustic seen in no.4. The problems Constable subsequently encountered with the bottom left-hand corner of his various 'Dedham from Gun Hill' paintings (nos.6–9) may well be related to his expulsion of Hagar and the angel.

Rosenthal has pointed out the relevance of another of Beaumont's small Claudes, 'Landscape with a Goatherd and Goats' (fig.20, National Gallery, London), which is closer in handling than the 'Hagar' to the way Constable was painting in 1802. By 1823, at least, Constable believed the work to have been painted from nature (see Tate Gallery 1976, no.223, for one of Constable's copies of the Goatherd picture).

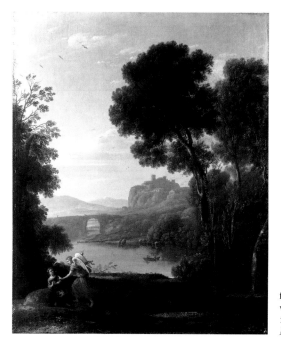

fig.19 Claude, 'Landscape with Hagar and the Angel', 1646, *Trustees of the National Gallery, London*

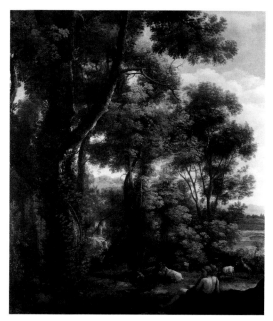

fig.20 Claude, 'Landscape with a Goatherd and Goats', *c*.1636, *Trustees of the National Gallery, London*

3

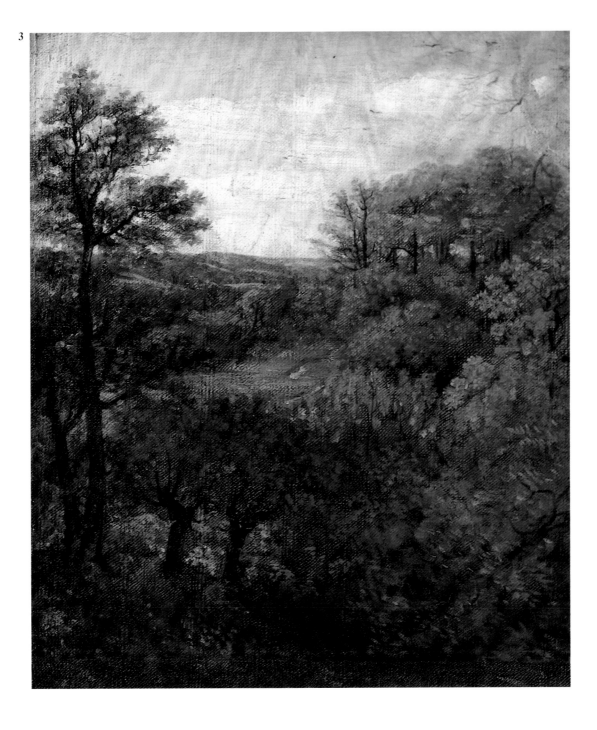

3 Valley Scene 1802

Oil on canvas 359 × 326 ($14\frac{1}{8}$ × $12\frac{7}{8}$)
Inscribed 'Oct 16. 1802' on the back
PROV: As for no.2
LIT: Reynolds 1973, no.39, pl.20; Hoozee
1979, no.16, repr.; Rosenthal 1983, p.30,
fig.27

*Board of Trustees of the Victoria and Albert
Museum, London*

Unlike no.2, this study is not obviously dependent
for its composition on previous artistic models and
it is perhaps less clearly structured as a result. Part
of a painted-out tree is clearly visible at the top
right, the remains of an earlier composition. Sarah
Cove reports that this continues onto the right
tacking-edge of the canvas and that parts of the first
image are also incorporated in the present one (see
p.495 and fig.154).

It has been suggested that the valley shown here
is too narrow to be that of the Stour and that it may
be the nearby valley of the Brett (Rosenthal 1983).

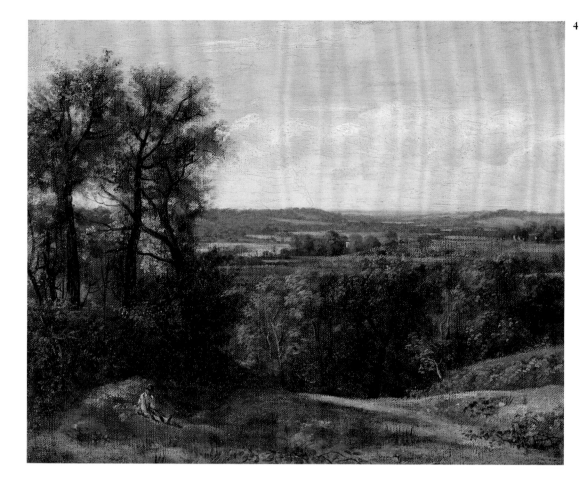

4 Dedham Vale 1802

Oil on canvas 343 × 427 ($13\frac{1}{2}$ × $16\frac{13}{16}$)
PROV: . . .; Skirwith Abbey, Cumberland; . . .;
H.E.M. Benn; . . .; Horace Buttery, from
whom bt by Mr and Mrs Paul Mellon 1962
and given to the Yale Center 1981
(B1981.25.131)
EXH: Tate Gallery 1976 (34, repr.); New
Haven 1982–3 (IV.21, repr.)
LIT: Hoozee 1979, no.17, repr.; Rosenthal
1983, p.30, fig.25 (col.); Cormack 1986,
pp.41–3, pl.33 (col.); Bermingham 1987,
pp.119–20, fig.52; Rosenthal 1987, pp.38–9,
ills.22 (col.), 23 (col. detail)

*Yale Center for British Art, Paul Mellon
Collection*

This study, with its *repoussoir* of trees at one side, is
the forerunner of such panoramas of the Stour
valley as nos.14 and 74, though Constable had
made panoramas in drawing and watercolour at an
earlier date (see no.222). The seated man, almost
certainly added in the studio (see p.511), is also an
early instance of Constable's discreet peopling of
his landscapes with small figures, either going
about their business or, as here, taking a rest from
it. A comparable seated figure appears in Gainsbor-
ough's 'Wooded Landscape with Peasant Resting'
(fig.18 on p.58), though there he seems to be taking
a more lively interest in his surroundings, watching
the flight of a bird.

The view in no.4 has not been precisely iden-
tified.

5

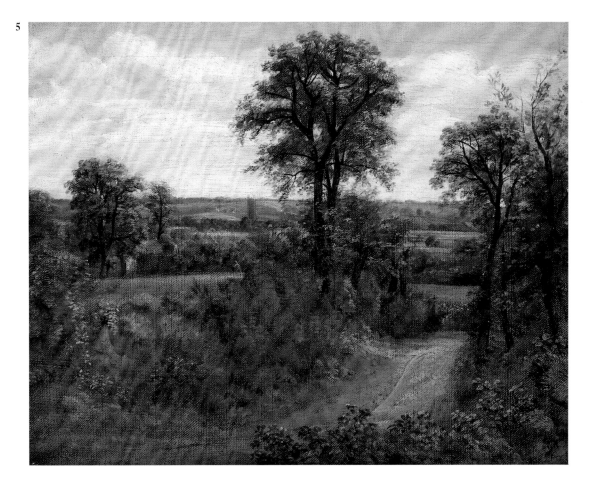

5 A Lane near Dedham 1802

Oil on canvas 343 × 426 ($13\frac{1}{2}$ × $16\frac{3}{4}$)
Inscribed 'Sepʳ' on back of stretcher, t.l.
PROV: As for no. 4 but accession no.
B1981.25.130
EXH: New York 1983 (1, repr. in col.)
LIT: Smart and Brooks 1976, p.107; Hoozee
1979, no.18, repr.; Rosenthal 1983, p.34,
fig.32 (col.); Rhyne 1987, pp.55–6

*Yale Center for British Art, Paul Mellon
Collection*

Dedham church is seen in the middle distance.
Whether or not Rosenthal is correct in identifying
the track as Fen Lane, which leads down to Fen
Bridge from the Bergholt-Flatford road, no.5 can
be seen as an antecedent of the 1817 'Fen Lane'
(no.91) and the 1826 'Cornfield' (no.165), Con-
stable's most ambitious depiction of the same lane.

Constable's use of his brown priming to repre-
sent the actual ground is especially conspicuous in
this study. The inclusion of a tiny figure of a man
with a scythe in the field to the left of the lane is
another instance of Constable's evident desire to
humanise his landscapes, however discreetly.

Sarah Cove discovered the inscription when she
examined the painting in 1989. This work and no.4,
she reports, are painted on two adjacent pieces of a
cut-up stretched canvas (see p.495). Remarkably,
the two pieces seem to have stayed together ever
since.

Dedham from Gun Hill

Constable's intensive period of outdoor work in oil in 1802 was not repeated for a number of years. On present knowledge, 1803–4 was a comparatively unproductive period both in oil painting and drawing, at least where landscape was concerned (we know that portraits took up some of his time in 1804). The next major developments occurred in 1805 and 1806, this time in drawing and watercolour painting. Nevertheless, the work he did in 1802 was a crucial foundation. Apart from lessons learned about the business of painting from nature, Constable had fixed on subjects that were to assume great importance later in his career. One of these was the view of Dedham Vale from Gun Hill, Langham which he had studied in September 1802 (no.2). Constable began a new version of this (no.6) perhaps around 1805 but seems not to have tried to finish it until about 1817. Only in the large picture exhibited in 1828 (no.169) did he resolve his ideas on the subject in this format. In the meantime, however, he produced several treatments of it in a horizontal format, both in pencil (see no.262) and oil (nos.7–9), going on to begin and then abandon a six-foot version, his first landscape on this scale (see under no.9). Around 1812 he also began painting a related subject, 'Dedham from Langham' (nos.17–20). The dating of the various 'Dedham from Gun Hill' works is far from certain and the relationships between them difficult to establish. The problems Constable faced in trying to develop his little 1802 study are, however, clear enough.

6 **Dedham Vale (Dedham from Gun Hill)** *c.*1805–17

Oil on canvas 557 × 457 (21$\frac{15}{16}$ × 18)
PROV: By descent to Isabel Constable, who died 1888; sold anonymously, presumably on behalf of her heirs, by Ernest Alfred Colquhoun, Christie's 28 May 1891 as one of the works 'Exhibited at the Grosvenor Gallery, 1889 [254], as the Property of Miss Isabel Constable, deceased' (150) bt Colquhoun himself; his son Dr Gideon Colquhoun, from whom bt by Leggatt 1949 and sold that year to Robert Coe, Cannes (later US Ambassador, Copenhagen), who died 1986; by descent to his nephew, USA, from whom bt by Richard Thune, New York, and sold to a private collector 1987, from whom bt by David Carritt Ltd and sold to the present owners 1989
LIT: *Artemis 88–89*, 1990, no.11, repr. in col.

Tochigi Prefectural Museum of Fine Arts, Japan

This is a reworking of the study made in September 1802 (no.2). Constable has now included Stratford bridge with the buildings on either side of it and opened up the foreground to show the hillside sloping down to the river. The bridge acts as a visual stepping-stone to the tower of Dedham church, a role performed in no.2 by a tall tree, suppressed in this new picture, at the bend of the river. In Claude's 'Hagar and the Angel' (fig.19 on p.60), which was in Constable's mind when he painted no.2, a bridge similarly leads the eye on to a distant town with a prominent tower. Constable appears to have worked on no.6 at different times.

The globular trees and bushes on the hillside are unlike anything in the original study but can be matched in drawings and watercolours of 1805 (see nos.227–9). On the other hand, the very precise painting of the foliage of the large tree at the right is only paralleled in oil paintings of around 1816–18, for example nos.76 and 94. Sarah Cove (thesis) takes a different view of the likely commencement date of the work because, she reports, the canvas is primed with several colours not found in Constable's priming layers before about 1811.

Constable's intention in reworking his 1802 study appears to have been to produce a more highly finished and more complete account of the subject. The forms are generally given more substance and some of the spatial relationships are more fully explained. The original study does not, for example, describe the connection between the tree seen at the left edge and the ground in the bottom left corner, which seems simply to run up into it. In no.6 the ground in the corner is more clearly made out and the tree shown growing beside a sandy outcrop. Variations on this solution to what appears to have been a problem area in the composition can be seen in nos.8 and 169 below.

Nevertheless, some areas of the painting are not fully resolved. While the foliage of the main tree is worked up to a high pitch of detail, the trunk is left curiously bare, as are the trunks of the subsidiary trees and the bank behind them. The present frame masks a one-inch strip across the top which appears to have been folded back by Constable during his work on the picture but which during a later relining was re-incorporated in the picture surface together with the tacking edges on the other three sides (Cove, thesis). This accounts for the slightly

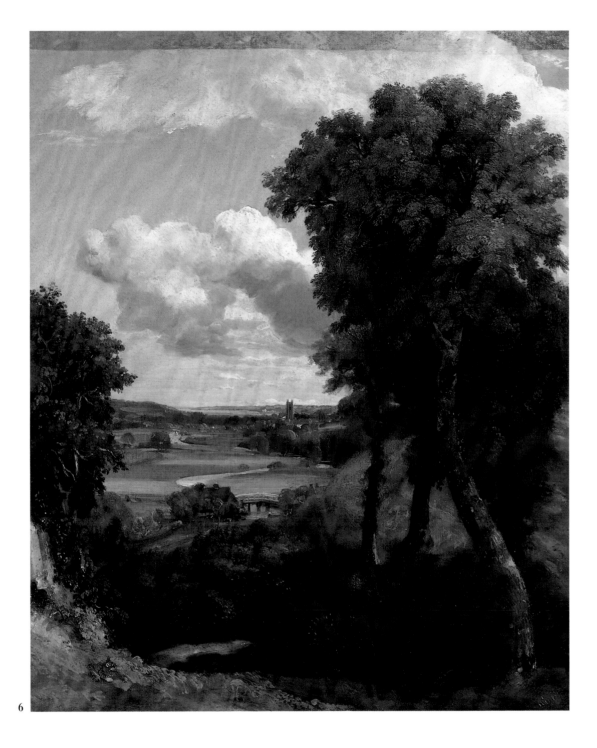

6

larger dimensions – 24 × 20 in – given in the catalogue of the 1889 Grosvenor Gallery exhibiton. The strip folded back by Constable bears traces of a more thinly painted sky. Constable may have repainted the sky in its present bolder form about the time that he worked up the foliage of the tree at the right. The main cloud formation in no.6 reappears in one of his horizontal versions of the composition, no.9 below. According to Cove (thesis), x-radiography reveals the presence towards the bottom right of indistinct shapes which, when viewed through drying-cracks, can be seen to be coloured red, pink and yellow. She suggests that they may have been figures, such as are found in the corresponding area of the 1828 'Dedham Vale' (no.169).

7 The Valley of the Stour (Dedham from Gun Hill) *c.*1805–9

Oil on paper laid on canvas 488 × 598 (19⅛ × 23½)
PROV: By descent to Lionel Bicknell Constable, sold Christie's 17 Feb. 1877 (195, sale stencil and lot number still on stretcher) bt in; given by Isabel Constable to the South Kensington (later Victoria and Albert) Museum 1888
EXH: Tate Gallery 1976 (55, repr.); Japan 1986 (2, repr. in col.)
LIT: Reynolds 1973, no.63, pl.35; Smart and Brooks 1976, pp.120–1, 123, 139–40, pl.72; Hoozee 1979, no.31, pls.II (col.), III (col. detail); Reynolds 1984, p.xvi; Cormack 1986, p.50, pl.42 (detail); Rhyne 1990a, pp.112–13, 116, 122, 123, 126–7 n.16, figs.5, 7 (detail)

Board of Trustees of the Victoria and Albert Museum, London

Judging from the amount and character of new information it contains, Constable went back to the spot to paint this horizontal version of the composition seen in nos.2 and 6 above. The use of paper as a support may also point to outdoor work. As Sarah Cove notes (p.499), the holes left by the pins with which Constable attached the paper to his board can still be seen. Constable appears to have adopted a slightly lower and closer viewpoint than the one he took up in 1802, putting the large trees at the right of no.2 behind him. Smart and Brooks publish a photograph taken from a helicopter hovering over Gun Hill to show 'how accurate the landscape details are' in no.7. The hillside is now too wooded to allow a view from ground level.

As with no.6, the globular and ovoid tree forms might suggest a date around 1805, when similar forms appear in Constable's drawings and water-colours. In his 1990 article, however, Charles Rhyne reasonably proposes a date around 1808–09, finding similarities with Constable's Epsom and Malvern paintings (nos.67, 70 below).

7

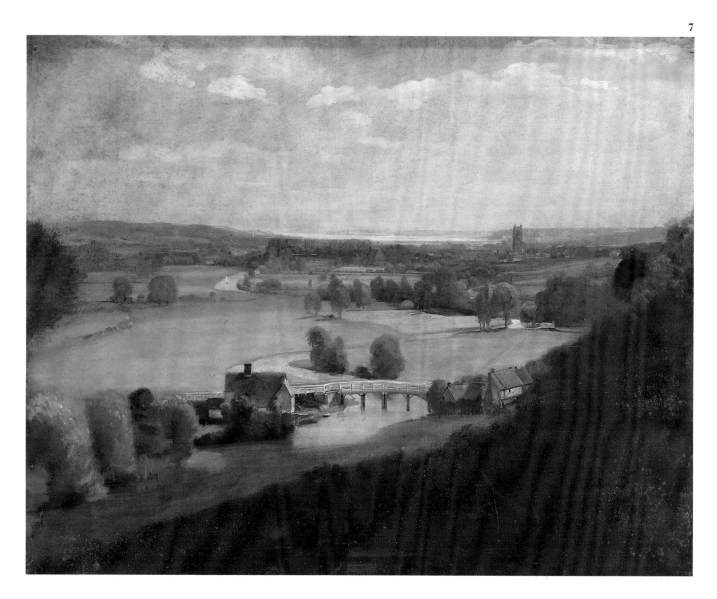

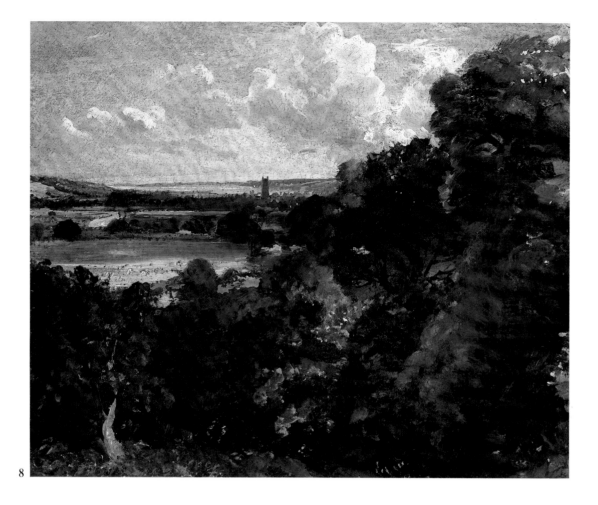

8

Constable abandoned no.7 before adding the foreground framing devices which he considered necessary for a well-composed picture. What might have occupied the unfinished areas at the bottom and right and the smaller area at the left edge can be imagined from no.9.

Sarah Cove notes (thesis) that no.7 has suffered from extensive small damages and retouchings.

fig.21 'Dedham from Gun Hill', ?1815, *Syndics of the Fitzwilliam Museum, Cambridge*

8 **Dedham from Gun Hill** *c*.1815

Oil on paper laid on canvas 251 × 305 ($9\frac{7}{8}$ × 12)
PROV: . . .; bequeathed by Henry Vaughan to the National Gallery 1900; transferred to the Tate Gallery 1962 (N 01822)
LIT: Hoozee 1979, no.78, repr.; Parris 1981, no.8, repr. in col.; Cormack 1986, pp.62–3, pl.55

Tate Gallery

With its screen of trees rising high on the right, this outdoor study is related to four sketchbook drawings of the subject, probably ranging in date from 1810 to 1815 (see under no.262). In its sculptural treatment of the clouds it is especially close to the Fitzwilliam Museum drawing (fig.21; Gadney 1976, no.8), which is probably from a sketchbook of 1815. Although dated in Parris 1981 to *c*.1810, a later date now seems more likely for no.8. Thickly painted all over with a loaded brush, it has much in common with the so-called 'Stoke-by-Nayland' of 1816 (no.47).

However, no.8 differs from the drawings mentioned above, and from the other painted versions, in its treatment of the bottom left corner and edge. Instead of closing the composition with a tree at the left edge Constable uses the light coloured trunk of

a tree placed somewhat in from the corner to balance the dark masses at the right of the study. The two strokes of reddish paint above and to the right of this tree presumably stand for the buildings at either end of Stratford bridge. The bird seen against the trees towards the right – hardly more than a flash of light – reappears in no.9 below, where it is more completely described.

9 Dedham from Gun Hill ?*c*.1815

Oil on canvas 489 × 597 (19¼ × 23½)
PROV: By descent to Lionel Bicknell Constable, sold Christie's 17 Feb. 1877 (194, sale stencil still on stretcher) bt ?Noseda, perhaps for J.P. Heseltine, who certainly had it by 1914; . . .; H.L. Douglas 1932; . . .; H.L. Fison 1934, sold by his executors, Christie's 6 Nov. 1959 (24, repr.) bt Agnew, from whom bt by a private collector 1960 and sold anonymously, Sotheby's 17 June 1981 (55, repr. in col.) bt in, sold Sotheby's 13 July 1988 (70, repr. in col. and col. detail) bt Salander-O'Reilly Galleries, New York
EXH: New York 1989 (3, repr. in col. with col. detail on cover)
LIT: Gadney 1976, pp.17–18, pl.3; Hoozee 1979, no.32, repr.; Parris 1981, p.53, fig.2; Rhyne 1990a, pp.122, 123, 129 n.60, fig.13; Rhyne 1990b, p.74

Salander-O'Reilly Galleries Inc., New York

This studio painting draws together elements seen in Constable's other treatments of the subject. The composition is close to that of the Tate Gallery oil study, no.8, and of some of the small drawings (see no.262) but Stratford bridge and its adjoining buildings are now clearly reinstated as in the upright painting, no.6. The solution adopted in no.6 to the problem of the left foreground and edge is also followed, or perhaps anticipated, here: the chronological relationship of the two paintings is difficult to establish. The cloud formations in nos.6 and 9 appear to be derived one from the other or from a common source.

The sandy bank, caught in sunlight, in the bottom left corner of no.9 acts as an effective foil to the mass of trees at the right. Between them and the sloping foreground a deep, shadowed valley is opened up. The whole area of the foreground and middle-ground is now clearly articulated by opposing diagonals in a way not seen in the other 'Dedham from Gun Hill' paintings, though suggested in one or two of the drawings of the subject (no.262 and the Fondazione Horne drawing mentioned there) and used in the related 'Dedham from Langham' composition (nos.17–20).

This work is less precisely and less completely painted than, for example, nos.6 and 7 but it is difficult to say whether it should be regarded as a sketch or as an unfinished picture. Hoozee (1979) and Parris (1981) saw the palette-knife work in the bottom left corner as later reworking but there seems no reason now (especially after the discovery of no.6 with its similar sandy bank) to doubt that it

fig.22 Composite x-radiograph of 'Sketch for "The White Horse"', *National Gallery of Art, Washington, Widener Collection*

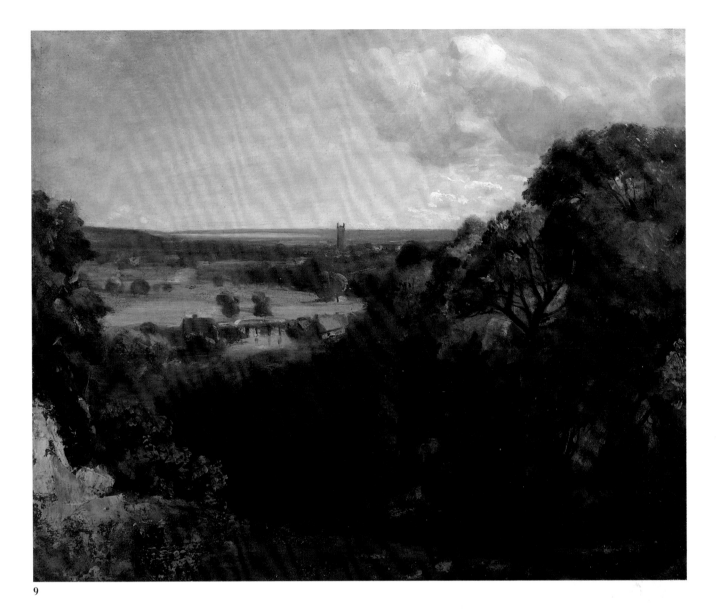

9

is contemporary with the rest of the work and, indeed, that this area is a vital part of the whole conception.

Nos.7 and 9 are shown together again in this exhibition for the first time since 1877, when they formed consecutive lots in one of Lionel Constable's sales of his father's work. One version of the subject which cannot be seen at all with the naked eye, let alone shown here, is an unfinished six-foot picture (fig.22) over which Constable painted his full-size sketch for 'The White Horse' (National Gallery of Art, Washington; Reynolds 1984, no.19.2). The existence of this abandoned 'Dedham from Gun Hill' only came to light when the canvas was x-rayed at Charles Rhyne's instigation in 1984. Rhyne, whose full account of this major discovery has recently been published (1990a; see also 1990b, p.74), notes that the Washington painting is based on the Victoria and Albert Museum work, no.7, but extends the composition on the right, where a large tree mass is introduced. Two other features not present in no.7,

a diagonal tree trunk at the bottom left and a cow seen below the building at the left of the bridge, reappear in the large upright version of the subject exhibited in 1828 (no.169). A diagonal timber, Rhyne observes, is also used to close the bottom left corner of the 1816–17 'Flatford Mill' (no.89). The tree mass at the right of the Washington picture, he suggests, was probably derived from the Salander-O'Reilly canvas (no.9) or from one of the small drawings of the subject, while the diagonal tree trunk may also be connected with the treatment of the bottom left corner of no.9 (or of no.6, unknown to Rhyne when he wrote his article). Rhyne places the unfinished picture in the years 1817–18, though possibly slightly earlier, and sees it as a studio work executed in London. There are, however, intriguing references in Constable's letters from East Bergholt in October and November 1815 to 'a larger landscape ... than ever I did before' (Beckett II 1964, pp.156, 159). Rhyne thinks it unlikely that these could refer to the Washington canvas but the question seems open.

Dedham Vale: Morning

Exhibited at the Royal Academy in 1811, 'Dedham Vale: Morning' (no.14) was Constable's first large-scale exhibition picture and his most ambitious portrayal to date of his native scenery. David Lucas, his engraver, later recalled that Constable often told him 'this picture cost him more anxiety than any work of His before or since . . . that he had even said his prayers before it' (Parris, Shields, Fleming-Williams 1975, p.55). Constable staked much on the success of the work, both personally and professionally. Still supported financially by his parents, he was by early 1810 contemplating marriage. It was essential that he should establish himself in his profession, seeking as a first step election as an Associate of the Royal Academy. On Farington's advice he entered his name in the lists in June 1810 for the annual election that November. In August he returned to Suffolk to prepare for a painting that would, he hoped, support his claim for election, if not that year, then the following one.

The preliminary material for 'Dedham Vale: Morning' introduces us to a major change that occurred in Constable's procedures around 1810. Before that year he appears to have painted outdoors comparatively rarely and, when he did so, to have handled paint in a studied and restrained manner, both in small sketches like the 'View at Epsom' of 1809 (no.67) and in larger works such as the earlier 'Dedham from Gun Hill' (no.7). From 1810 the small outdoor sketch began to assume a more central role in his art, becoming a regular means of collecting pictorial material whether or not it was ultimately used in any other way. The character of such sketches changed dramatically. Little more than than a year separates the quiet Epsom view of 1809 from the highly charged Flatford and Bergholt sketches dated September 1810 (nos.23, 48) and the undated but contemporary examples seen in this section. Compared to the few earlier examples that are known, the sketches of 1810 and subsequent years are more rapidly painted, often suggestive rather than descriptive, more colourful, better able to capture transient effects of light. They suggest a new confidence on Constable's part, a new urgency towards the business in hand.

So far, five sketches related to 'Dedham Vale: Morning' have been found. With one exception, a sketch made in October 1809, they seem all to date from the summer of 1810 but their order of execution is uncertain because they do not represent a simple progression towards the final painting. Some may have been made before Constable had even decided to paint a large canvas of the subject. In these sketches we see him returning several times to an idea, each time exploring some new aspect of it. The exhibited painting of 1811 depends on the variety of experience gained through the small sketches and extracts something from one, something else from another. Drawings also played an important part in the final work (see under no.14).

The 'Dedham Vale: Morning' composition is based on the view of the valley from near the top of Fen Lane, which runs down to the Stour from the East Bergholt–Flatford road. We look westwards from the Suffolk side of the valley, not eastwards from the Essex side as in the previous group of Dedham from Gun Hill paintings. Constable's panoramic view is an extension of the type seen in no.4 above. A very wide angle of vision became the norm for Constable's later depictions of the valley and of other open landscapes.

Two fine sketches (nos.15–16) not related to the painting are also included in this section. They were made in the same area and stand here for the many sketches which Constable did not develop further.

10 **Dedham Vale** 1810

Oil on paper laid on board mounted on panel
154 × 260 ($6\frac{1}{16}$ × $10\frac{1}{4}$)
PROV: . . .; anon. private collector, from whom bt by Lloyd and Day, Effingham, Surrey and from them by the present owner 1983
EXH: New York 1988 (9, repr. in col.)
LIT: Rosenthal 1983, p.52, fig.54

Private Collection, New York

Although not closely related to the final painting, the origin of the 'Dedham Vale: Morning' composition is probably an oil sketch (fig.23) dated 13 October 1809 of a man resting by the road to East Bergholt, painted on the reverse of the Malvern Hall sketch shown here as no.68. Many of the ingredients of the 1811 painting are to be found in this 1809 sketch but the view is more directly westwards, focused as much on the road as on the valley. Stratford St Mary church appears in the distance to the left of centre, not towards the right

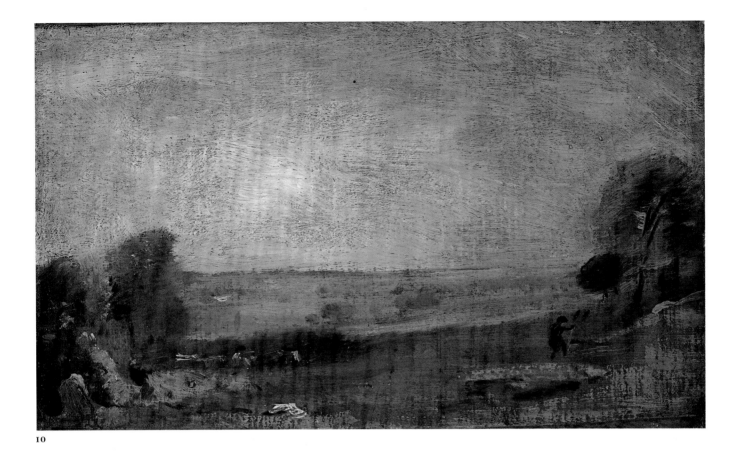

10

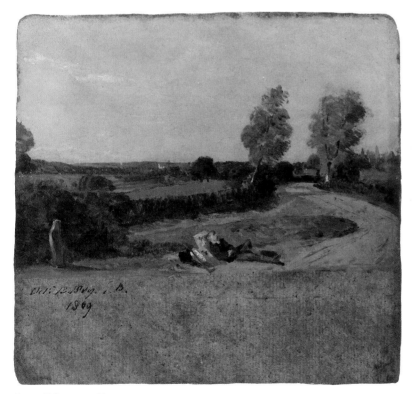

fig.23 'A Lane near East
Bergholt with a Man
Resting' (reverse of no.68),
1809, *Private Collection*

as in the works shown in this section, while
Dedham church is too far off to the left to be
included at all.

No.10 is placed first in this group of four
sketches because unlike the others it represents the
scene towards sunset rather than in the early
morning. This does not necessarily mean that it
was painted first, though it is possible that
Constable did originally think of an afternoon view
before deciding on a morning one. In his catalogue
entry for the 1988 exhibition, Rhyne places it early
in the sequence, which he reads as becoming
increasingly panoramic, and 'perhaps just preced-
ing' the more panoramic sketch shown here as
no.12.

The top of Dedham church tower appears
between the trees at the left. Just to the right of
these a touch of light indicates a distant bend in the
river. Below, a group of cows can be made out. The
bent figure of a man with a stick walking up the
road to Bergholt – perhaps a returning labourer –
reinforces the elegiac mood of the sketch. In the
final painting a girl and a man walk purposefully
down the road, presumably on their way to work.

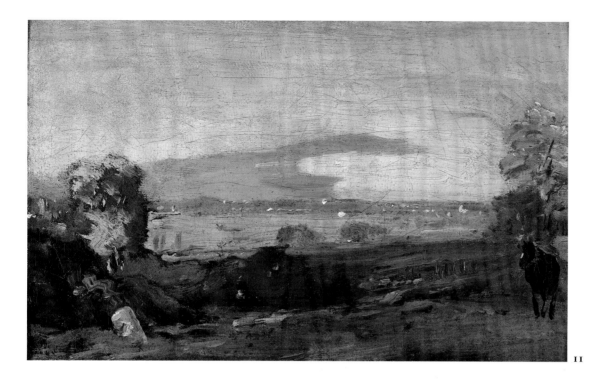

11

11 **Dedham Vale** 1810

Oil on canvas laid on panel 170 × 218
($6\frac{11}{16} × 8\frac{9}{16}$)
PROV: . . .; Sir Kenneth Clark, by whom
donated to the Lord Baldwin Fund for
Refugees, sold Christie's 24–25 May 1939
(237) bt Vaz Diaz; . . .; anon. sale, Christie's
19 July 1985 (44, repr. in col.) bt Agnew; bt
by present owners 1987
EXH: *British Painting of Three Centuries*,
Agnew, June–July 1987 (39, repr.)
LIT: Rhyne 1988, pp.15, 26 n.33

Mr and Mrs David Thomson

In this sketch of the scene by morning Constable
places the leaning stone (usually but probably
incorrectly called a milestone) in the position it
occupies in the final painting. Instead of the cattle
seen in no.10, a figure is introduced at the top of
Fen Lane. A black horse appears at the right; in the
1811 painting a similar horse is shown to the left of
the cattle.

The smallest of the known sketches of the
composition, no.11 conveys Constable's excite-
ment at the beauty of the scene as revealed in early
morning light, with the valley floor still covered in
mist. It may represent a moment of discovery and
be the earliest of his morning sketches of the
subject.

12 **Dedham Vale** 1810

Oil on panel 210 × 413 ($8\frac{1}{4} × 16\frac{1}{4}$)
PROV: . . .; Shepherd Brothers, from whom bt
by T.W. Bacon 1896; by descent to present
owner
LIT: Hoozee 1979, no.83, repr.; Rhyne 1988,
p.15

*Private Collection (on loan to Birmingham
Museums and Art Gallery)*

This is the most panoramic of the sketches and the
closest both in mood and topographical detail to the
final picture.

13 **Dedham Vale** 1810

Oil on board 215 × 318 ($8\frac{1}{2} × 12$)
PROV: . . .; Alexander Young; . . .; Stephen
Raphael, sold Sotheby's 14 July 1976 (92,
repr.) bt Agnew; . . .; E.V. Thaw & Co., New
York, from whom bt by present owner
EXH: Tate Gallery 1976 (93a, repr.); *Three
Centuries of British Paintings*, Agnew,
March–April 1978 (26, repr.)
LIT: Hoozee 1979, no.84, repr.; Rosenthal
1983, p.52, fig.53; Rhyne 1988, pp.15, 26
n.31

Private Collection, Ohio

Unlike the other sketches but like the final picture,
no.13 includes a large tree at the left, which may, as
Rhyne suggests, indicate that it was painted in the
studio. The figure of the woman carrying a basket

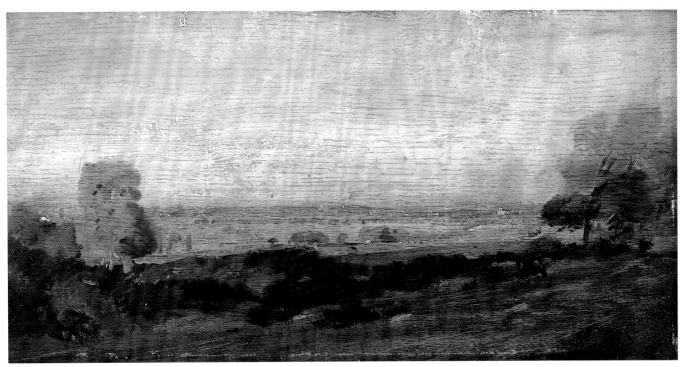

12

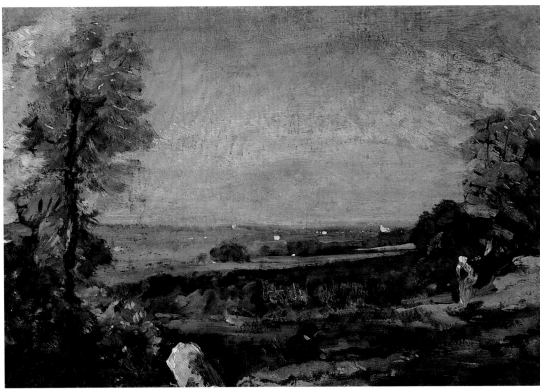

13

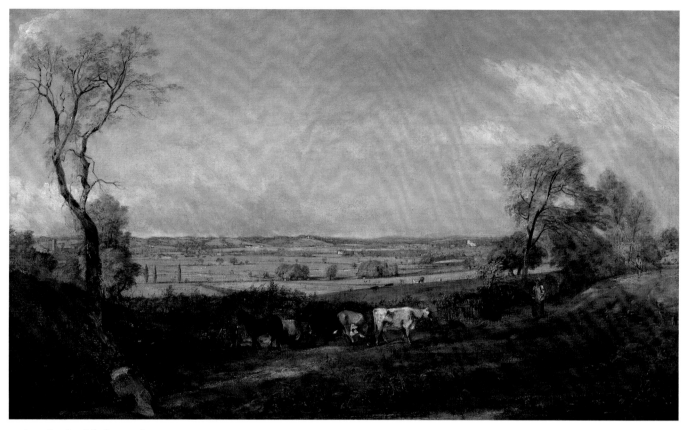

14 (see also detail facing p.53)

seen in the finished painting also makes its first appearance in this sketch. The likelihood that it was derived from a small drawing in the 1810–11 sketchbook (Louvre, RF 11615, fol.3r; Parris 1981, p.62 fig.2) supports the idea of no.13 being a studio work. The same sketchbook also includes a drawing of a reclining man looking at a woman carrying a bundle on her head (fol.2v; ibid., p.62 fig.4). Although the figures in the oil sketch are different, the idea may have come from this drawing (which was used more directly in the 'Stoke-by-Nayland' sketches: see Parris 1981, pp.60–1).

14 **Dedham Vale: Morning** 1811, exh.1811

Oil on canvas 788 × 1295 (31 × 51)
Inscribed 'John Constable pinxt. 1811' b.l. and 'DEDHAM VALE.' on the stone b.l.
PROV: ? Artist's administrators, sold Foster 16 May 1838 (65, 'Dedham Vale') bt Norton; . . .; George Oldnall, Worcester by 1846, sold Christie's 16 June 1847 (111) bt Colls; . . .; W. Fuller Maitland, sold Christie's 10 May 1879 (71) bt Daniel; . . .; Agnew 1907–8; 5th Earl of Carysfoot 1908; his nephew Col. D.J. Proby 1918–31; thence by descent to present owner
EXH: RA 1811 (471, 'Dedham Vale: Morning'); BI 1813 (104, 'Landscape, a scene in Suffolk', frame 43 × 62 in); Tate Gallery 1976 (100, repr.; also col. detail opp. p.64)
LIT: Smart and Brooks 1976, pp.16, 28, pl.18; Hoozee 1979, no. 122, repr.; Rosenthal 1983, pp.47, 51–9, figs.39 (col. detail), 55 (col.); Cormack 1986, pp.69–72, pl.67 (col.); Bermingham 1987, pp.123, 219 n.97, fig.54; Rosenthal 1987, pp.67–9, ill.48; Rhyne 1988, p.15

W.H. Proby, Elton Hall

As suggested above, Constable used his oil sketches in different ways when he came to paint this final picture of the subject, exhibited at the Royal

Academy in 1811. The cattle already appear in no.10, the black horse in no.11, the advancing woman and the tall tree in no.13. The so-called milestone is prominent in nos. 11 and 13, less so in no.10. No.12 captures the early morning light and the atmosphere of stillness tinged with expectancy. In the painting itself Constable draws together these elements. The horse, the cattle and the figure at the top of the lane now come together in an everyday incident of the kind he depicts in all his subsequent large Suffolk canvases, in this case – a subject Claude himself might have chosen – a herdsman bringing in cattle from the fields.

What none of the 1810 oil sketches does is to

extend the composition on the right to give the view up the Bergholt road that we see in the final painting. Only in the 1809 'Man Resting' (fig.23 on p.71) is this part of the road seen, though from a different angle. Beyond the furthest turn in the road in both this work and the large painting Constable allows a glimpse of rising meadow dotted with animals (fig.24). In painting this vignette on the 1811 canvas he appears to have turned to a page in the sketchbook used in 1810–11 (fig.25, Louvre RF 11615, fol.4r), which also contains drawings related to other parts of the picture: on fol.16r (fig.26) a study of the large tree at the left; on fol.4v (fig.27) studies of cows including the one at the right of the group in the painting; on fol.1v a sketch of trees possibly connected with those at the right of the picture; on fol.4r, below the vignette mentioned above, a sketch of donkeys but not matching the one in the painting. Since the sketchbook has leaves missing from it, we may suppose that other drawings of donkeys, trees, cattle and so on were detached by Constable while working on the painting and have since been lost. There is likely to have been, for example, a drawing corresponding more exactly to the donkey in the picture, a drawing which Constable would have used again when painting 'The Cornfield' (no.165), where the same animal reappears.

The topographical accuracy of the distant view in 'Dedham Vale: Morning' has often been re-marked upon, as has the way Constable placed his local subject in a broader context by relating it, most obviously through the framing device of the large tree at the left, to Claude and the tradition of ideal landscape. Certainly, Constable was making

fig.24 Detail from no.14

below left
fig.25 1810–11 sketchbook, fol.4r, *Musée du Louvre, Paris*

below centre
fig.26 1810–11 sketchbook, fol.16r, *Musée du Louvre, Paris*

below right
fig.27 1810–11 sketchbook, fol.4v, *Musée du Louvre, Paris*

claims for the importance of his subject and of his treatment of it. The prominent inscribed stone, now looking as much like an antique fragment as a humble milestone, announces (what no milestone would) that this is 'DEDHAM VALE', as though inviting us to enter some region of Arcadia. But the classical overtones do not compromise the basic naturalism of Constable's vision. The large tree, whether or not it actually grew at that spot, is a miraculous piece of observation.

The subtitle 'Morning' alerts us to an equally important way in which Constable raised his painting above mere topography. His feeling for the special characteristics of different times of day (as well as different times of the year) was already acute. Later, in the *English Landscape* prints (see nos.173–205), he was to characterise some of his favourite subjects largely in such terms, describing them as images of 'Summer Morning', 'Summer Evening', 'Autumnal Sun Set' and so on. 'Dedham Vale: Morning' can be seen as his first attempt to epitomise the appearance of, and the sensations aroused by, an English summer morning.

In the texts he composed to accompany the *English Landscape* prints Constable wrote that 'every recollection associated with the Vale of Dedham must always be dear to him' because it was among its scenes that 'the happy years of the morning of his life were passed'. The 1811 painting is surely also Constable's private meditation on that morning, on the years when he walked to school at Dedham, following the route taken by the figures at the right of the painting and turning down Fen Lane, through the gate the red-jacketed boy is closing.

'Constable called, in much uneasiness of mind,' Farington recorded in his diary on 23 April 1811, 'having heard that his picture ... was hung very low in the Anti-room of the Royal Academy. He apprehended that it was proof that he had fallen in the opinion of the members of the Academy. – I encouraged him & told him Lawrence had twice noticed his picture with approbation' (Farington XI, p.3916). The picture remained in the Anteroom and few others noticed it. It was, Leslie said, 'too unobtrusive for the exhibition' (Leslie 1843, p.10, 1951, p.22).

15 Dedham Vale with a Shepherd 1812

Oil on panel 149 × 251 ($5\frac{7}{8}$ × $9\frac{7}{8}$)
Inscribed '21! Octr 1812' on back
PROV: By descent to Isabel Constable, who died 1888; sold anonymously, presumably on behalf of her heirs, by Ernest Alfred Colquhoun, Christie's 28 May 1891 as one of the works 'Exhibited at the Grosvenor Gallery, 1889 [exhibit no. not identified], as the Property of Miss Isabel Constable, deceased' (137) bt Colquhoun himself; thence by descent to the present owner
LIT: Parris 1983, p.223, fig.39; Fleming-Williams and Parris 1984, p.90, pl.38

Private Collection

Although not related to 'Dedham Vale: Morning', this sketch shows the valley from a viewpoint which is probably not far away from that adopted for the 1811 picture. Dedham church appears on the extreme left. In the foreground a flock of sheep is glimpsed above a hedge, tended by a boy who looks as though he has just caught sight of the artist.

Constable made two long visits to Suffolk in the summer and autumn of 1812, from 19 June to late August and from early September to 3 November. This sketch and nos.36 and 60 appear to be the only dated examples from the second visit.

16 Dedham Vale with a Shepherd and a Flock of Sheep

Oil on paper laid on canvas 150 × 293 ($5\frac{7}{8}$ × $11\frac{1}{2}$)
PROV: ...; Colnaghi, from whom bt by Mr and Mrs Paul Mellon 1965 and given to the Yale Center 1981 (B1981.25.149)
LIT: Hoozee 1979, no.85, repr.

Yale Center for British Art, Paul Mellon Collection

This is another sketch painted in the same area as the 'Dedham Vale: Morning' group. The viewpoint is probably a little further down the road to Flatford and may be in the field depicted in the foreground of 'Ploughing Scene in Suffolk' (no.71). Stoke-by-Nayland church can be seen on the distant hills at the right. The shepherd is shielding his eyes against the rays of the setting sun.

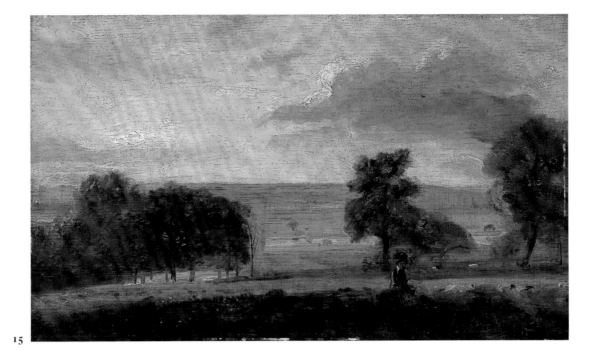

15

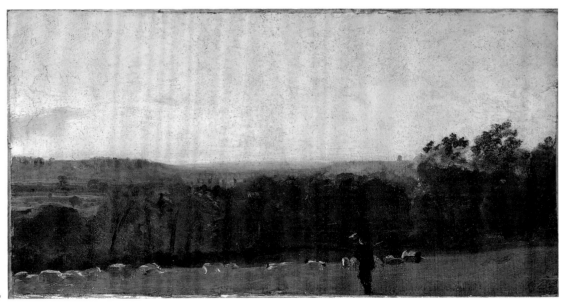

16

Dedham from Langham

The paintings of the Stour valley seen from Gun Hill, Langham described above (nos.6–9) were made at various times between about 1805 and 1817. Within this period, around 1812–13, Constable became particularly interested in a slightly different view of the valley, seen from closer to Langham church. The oil sketches he made of this subject (nos.17–19) present wide views, though none is quite so panoramic as a contemporary drawing of it (no.249). Having exhibited 'Dedham Vale: Morning' (no.14) in 1811, Constable may have been planning a complementary panorama of the valley, seen this time from the Essex side.

By moving closer to Langham church Constable found more open prospects than those he had chosen on Gun Hill. Instead of the foreground screen of trees adumbrated in no.7 and painted in nos.8–9, the sketches in this section show an open field in the foreground. Here Constable finds or introduces a variety of 'business' to set the scene: in no.17 some timber at the left, a small figure disappearing over the brow of the hill and a conspicuous cow with attendant cowherd; in no.18 a pair of horses being led down the slope; in no.19 a solitary cow.

Although Constable did not follow up these sketches with a finished painting, he returned to the subject later in life and began a medium-sized canvas of it (no.20). He also included the subject in his *English Landscape* prints, where it was used to epitomise 'Summer Morning' (see nos.186–190).

17 **Dedham from Langham** *c.*1812

Oil on canvas 216 × 305 (8½ × 12)
PROV: As for no.2
EXH: Japan 1986 (10, repr. in col.)
LIT: Reynolds 1973, no.332, pl.241; Hoozee 1979, no.86, repr.; Parris 1981, pp.65–6, 68 n.5, fig.3; Rosenthal 1983, pp.218–19, fig.249; Hill 1985, p.101, pl.6 (col.); Fleming-Williams 1990, pp.292–4, fig.267

Board of Trustees of the Victoria and Albert Museum, London

This is probably the earliest of the known oil sketches of the scene. It was certainly the one to which Constable turned first when he asked David Lucas to engrave the subject for *English Landscape* (see no.186). One of his instructions to Lucas, 'Make the butterfly' (Beckett IV 1966, p.454), enables us to identify the small white shape on the timber in the bottom left corner. The figure of the boy (fig.28) has been variously interpreted as holding a scythe or a gun and even as playing a violin or a flute. He seems in fact to be supporting a bottle from a stick slung over his shoulder. With his black hat he looks very like the boy seen in nos.15–16 above. An area of disturbed paint immediately to the left of him suggests that Constable changed his position.

fig.28 Detail from no.17

[78]

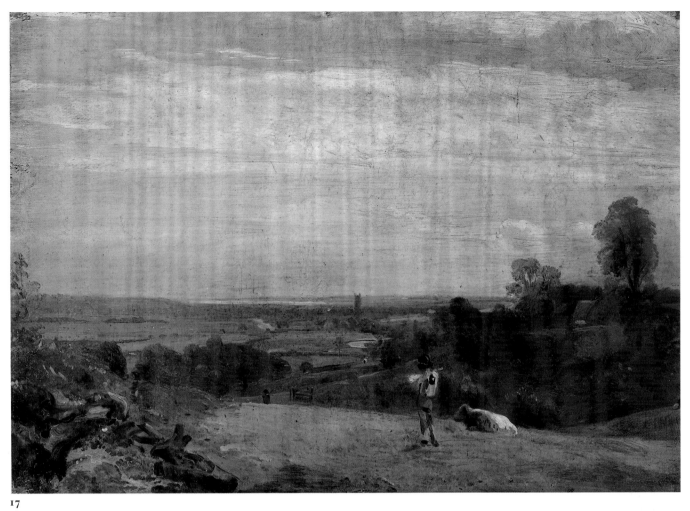

17

18 **Dedham from Langham** 1812

Oil on canvas 190 × 320 ($7\frac{1}{2}$ × $12\frac{5}{8}$)
Inscribed '13 July 1812' b.l.
PROV:...; Revd W. Fothergill Robinson, by
whom bequeathed to the Ashmolean
Museum 1929
EXH: Tate Gallery 1976 (112, repr.); New
York 1983 (11, repr. in col.)
LIT: Hoozee 1979, no.155, repr.; Parris 1981,
pp.65–6, fig.1; Rosenthal 1983, p.60, fig.62;
Cormack 1986, p.77, pls.71 (col.), 71a (col.
detail); Rosenthal 1987, p.74, ill.56; Fleming-
Williams 1990, pp.292–4, fig.268

Visitors of the Ashmolean Museum, Oxford

More vigorously handled than no.17, this dated
sketch is also very different in colour and is more
emphatically articulated. The shadowed gully,
here enclosing horses, a man and some distant
cows, has become the central feature, leading the
eye directly into the landscape. In no.17 less is
made of this feature and the eye is held longer in the
foreground by the timber and the boy and cow.
No.18 also gives a wider view, further trees being
added at the right. Constable appears to have
extended his original surface here and at the top by
turning up the tacking-edges of the canvas.

Although the 'Summer Morning' mezzotint was
begun from no.17, the detail of the man leading
horses down the hill was later added from the
Ashmolean Museum sketch (see no.189).

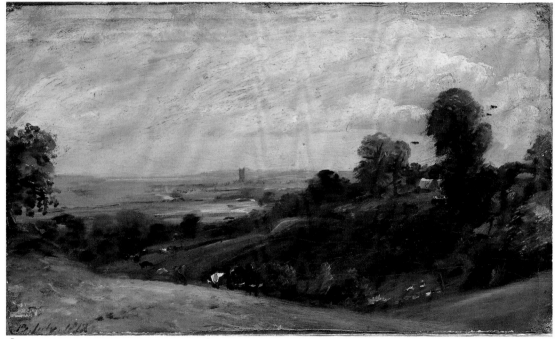

18

19

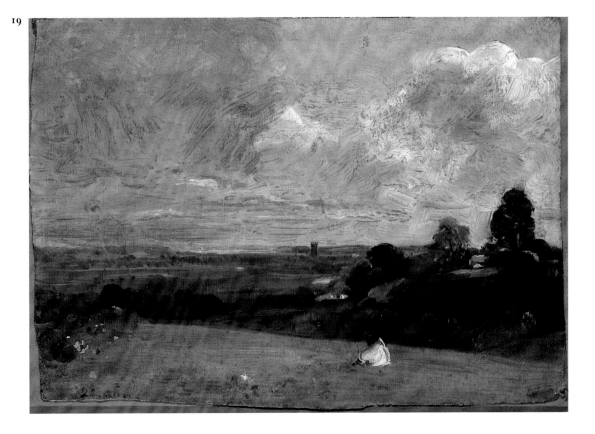

19 Dedham from Langham ?1813

Oil on canvas 137 × 190 (5⅜ × 7½) formerly
laid on card but transferred to synthetic panel
1969
Inscribed '24. Au[...]' b.l.
PROV: ...; George Salting, probably by 1883;
bequeathed by him to the National Gallery
1910; transferred to the Tate Gallery 1951
(N 02654)
EXH: Tate Gallery 1976 (113, repr.)
LIT: Hoozee 1979, no.162, repr.; Parris 1981,
no.12, repr. in col.; Rosenthal 1983, p.60,
fig.63

Tate Gallery

fig.29 1813 sketchbook
(no.247), p.39, *Board of
Trustees of the Victoria and
Museum, London*

The year is missing from Constable's inscription.
1812 can be ruled out because he was in London on
24 August that year, as can 1814, when he was
probably at Tattingstone on 24 August (see Parris
1981). 1811 is a possibility, following the discovery
of an oil sketch of Stratford mill dated 17 August
that year (no.97). On balance, however, 1813 seems
the most likely year. On 22 August 1813 Constable
drew in his sketchbook a cow which closely
resembles the one in this painting (see fig.126 on
p.410). As he almost certainly carried his sketch-
book with him each day that summer, Constable
may have referred to this two-day-old drawing on
the spot when painting no.19.

Constable's 1813 sketchbook also contains three
studies of the whole subject (pp.39, 51, 52 of
no.247). The first and most fully worked-up of
these (fig.29) is inscribed 'Dedham from Lang-
ham'. Apart from the panoramic drawing shown
here as no.249, there are also drawings of the
subject at the Yale Center for British Art (Rhyne
1981, no.38) and the Royal Albert Memorial
Museum, Exeter. A small pen sketch dated 23
December 1830 (fig.104 on p.339) belongs to the
period of Constable's work with Lucas on the
'Summer Morning' mezzotint (see under no.187).

20 Dedham from Langham late 1820s

Oil on canvas 610 × 990 (24 × 39)
PROV: ? Artist's administrators, sold Foster
16 May 1838 (in 43, 'Two – Chain Pier at
Brighton, and Dedham Church') bt James
Stewart; ? his sale, Christie's 20 April 1839
(in 3, 'The Original Sketch of Brighton Pier,
and a View from Hampstead Heath [sic: see
text below]; an unfinished picture') bt Reeve,
presumably Henry Reeve (1813–95), by
whom lent to *Old Masters*, RA 1890 (58,
exhibition label still on back); . . .; Sir Henry
Davies; . . .; Sedelmeyer, Paris, by 1902
(included in *Illustrated Catalogue of . . . 100
Paintings by Old Masters*, Sedelmeyer
Gallery 1902) and sold (?16) May 1907 (23;
provenance from this point on given in letter
from Galerie George Moos to René Junod, 4
Feb. 1946); . . .;John Jaffet, Paris, sold at
unidentified auction, Nice, June 1943, bt
Perdoux, Paris and sold to Felix Mockers,
from whom bt by Pierre Garsonnin and from
him by Galerie Georges Moos, Geneva; bt
from the latter by René Junod, La Chaux-de-
Fonds, Switzerland 1946; bequeathed to the
Musée des beaux-arts, La Chaux-de-Fonds
by his widow, Madeleine Junod, who died
1986
EXH: *Collection René et Madeleine Junod*,
Musée des beaux-arts, La Chaux-de-Fonds,
Aug.–Oct. 1986 (2, repr.)
LIT: *The Tate Gallery: Illustrated Catalogue
of Acquisitions 1984–86*, 1988, p.32

*Musée des Beaux-Arts de la Chaux-de-Fonds,
Collection René et Madeleine Junod*

This is either an unfinished painting or a sketch for
another, probably never executed, picture. The
outlines of the design have been drawn on a
squared-up canvas and thin layers of brown, green
and white paint added to broadly define the forms.
Some parts are taken further than others, including
the group of trees on the left and the figures. These
feathery trees appear in none of the small oil
sketches (nos.17–19) or drawings, though a single
tree just edges into some of them, nor do the second
cow, the milkmaid, the harvesters further down the
slope or the plough in the foreground (fig.103 on
p.338). No.20 also enlarges the field of the
composition, combining the breadth of the Copen-
hagen drawing (no.249) with something like the
height of sky seen in nos.17 and 19.

The date of the painting is uncertain but must be
considerably later than the period during which
nos.17–19 were executed. Constable does not
appear to have begun paintings by outlining the
design in this way until the 1820s (see Reynolds
1984, nos.21.61, ?21.105, 22.67, ?23.3, 24.72, 24.79,

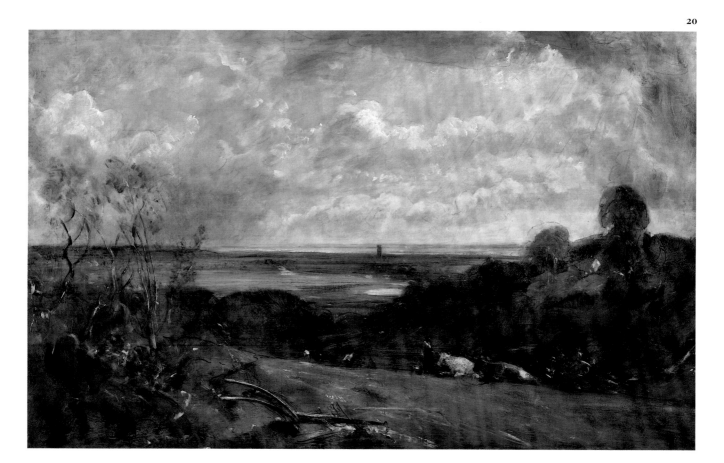

20

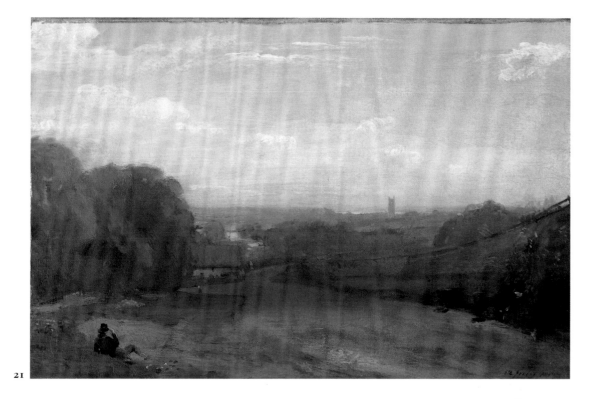

21

etc.). Earlier examples of unfinished pictures, for instance nos.7 and 93, have no visible under-drawing.

A particularly relevant comparison is with the sketch for 'Chain Pier, Brighton', no.155 below, where thin layers of paint from a limited palette have been similarly added over drawn outlines. This Brighton sketch appears to have spent much of its life in company with no.20. The two works, which are more or less the same size, were probably sold together in the 1838 studio sale (see 'Prov.' above), reappearing again together in the auction room the following year, when no.20 seems to have been mistaken for a Hampstead view. They parted company after the death in 1895 of their then owner Henry Reeve, whose family had long been asso-ciated with Constable (see Parris, Shields, Flem-ing-Williams 1975, pp.124–6).

Although Constable and Lucas began the 'Sum-mer Morning' mezzotint from no.17 above, the print was probably finished from no.20, from which the second cow, the milkmaid with her pail, the plough and the figures of the harvesters appear to have been taken. However, the relationship of the print to no.20 may be more complicated. The possibility that Constable worked on both at the same time cannot be ruled out (see no.187 for further comment).

21 Dedham from Gun Hill 1813

Oil on canvas 222 × 345 ($8\frac{3}{4}$ × $13\frac{9}{16}$)
Inscribed '12 July 1813' b.r.
PROV: . . .; James Staats Forbes, who died 1904; . . .; sold Fleischmann, Munich 21 March 1906 (12); . . .; bt by Staatsgalerie, Stuttgart 1909
LIT: Hoozee 1979, no.154, repr.; Parris 1981, p.53 n.2

Staatsgalerie, Stuttgart

Not directly related to the other works in this section, no.21 was painted a short distance to the south-east, looking down the road on Gun Hill. The reclining man with his black hat is someone we will encounter again in Constable's sketches made in the lanes around East Bergholt (nos.42–3, 45).

At one time uncertain, the year in the date has been convincingly read as 1813 by Charles Rhyne, who (in correspondence) has pointed out the similarity of the '3' to the same digit as it appears on no.18 above. (He has also kindly supplied details of size, etc.).

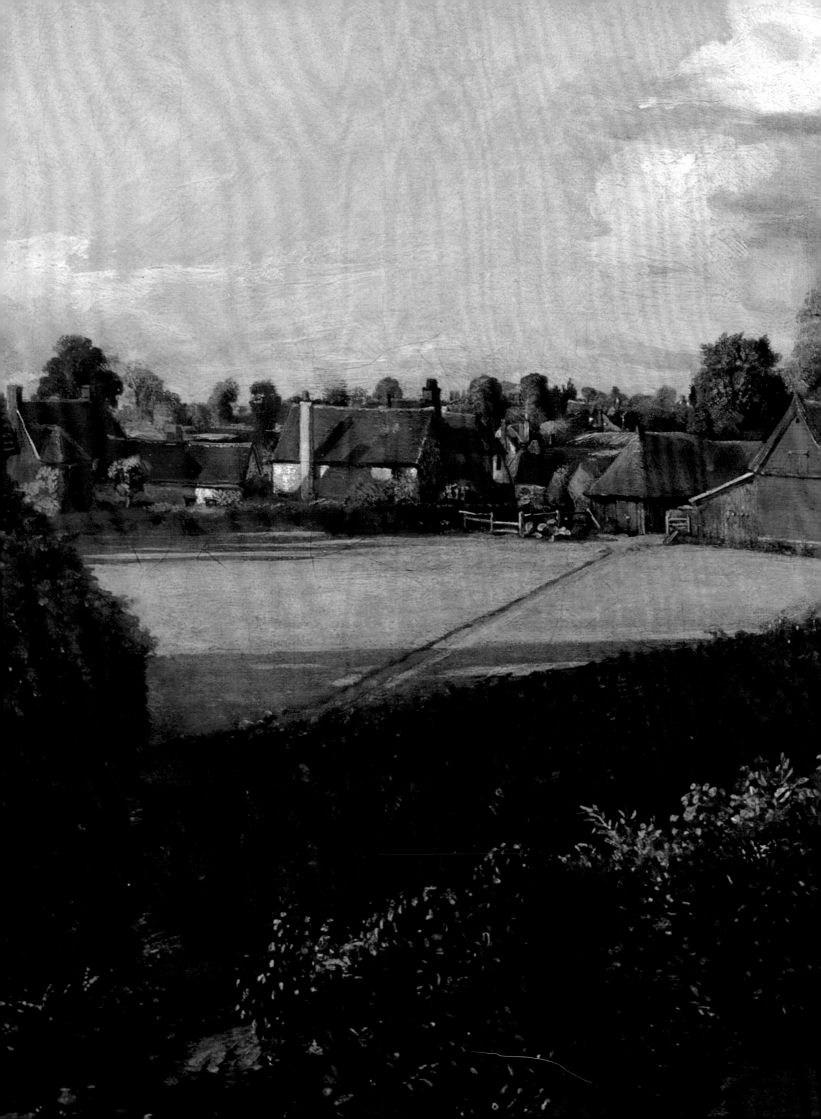

The Village

East Bergholt, in 1801 a village of 970 inhabitants, is sited a mile to the south-east of the London road, almost equidistant between Ipswich and Colchester. Its main street, from which various lanes run outwards, is shaped rather like a hairpin that has been opened out to about 60 degrees, the south arm of which runs east and west, the other approximately north-east (see fig.216 on p.531). The church, St Mary's, is situated by the bend and just opposite it is the entrance to the lane to Flatford (see nos.90, 279). In the Enclosure map of 1817 the somewhat flattened bend in the 'hairpin' is called Church Street and where it broadened out into 'the Green' there was annually held a fair (see nos.245–6). There were four houses in the inside of the bend: Mr Barnard's, with his general store attached (next to the church, fig.5 on p.22); the residence of a farmer, John Gosnall; East Bergholt House, the Constables' home; and a cottage with a workshop (no.258) belonging to the village constable, plumber and glazier, John Dunthorne, a keen amateur artist who became Constable's first mentor and painting companion. Diagonally across the Green from East Bergholt House was West Lodge, the residence of a widow, Mrs Sarah Roberts, who befriended the artist and allowed him to paint in her grounds, in the fields behind the house that sloped down into the Vale (see nos.31–5). Immediately opposite East Bergholt House was a complex of small cottages, one of the smallest of which Golding Constable bought for his son to use as a studio. Houses and cottages lined the inner sides of the arms of the 'hairpin'. The road that led off to the east, now known as Rectory Hill, dipped down into a little valley that had been formed by a brook flowing southwards, the Ryber. The grounds of the Rectory were on the left of the road as it climbed the little hill. Here, until his death in 1819, lived Dr Rhudde, the Rector, a powerful figure, the grandfather of Maria Bicknell, whom Constable courted and won, much against the Doctor's will.

The village itself was on a plateau above the Stour valley. From the backs of only a few of the houses were views to be obtained to the south, of the Vale. West Lodge and, on the other side of the lane to Flatford, Old Hall, one of the three manors of the village, were best favoured with what Arthur Young considered to be 'one of the finest views, to be seen in Suffolk' (*Annals of Agriculture*, vol. 23, 1795, p.48). From the houses that backed on to the land between the two main streets of the village (the arms of the hairpin), there was a pleasant if more limited prospect: fields and hedges descending in rounded slopes down to the miniature Ryber valley. Beyond, to the east, was common land and, prominent on the open ground, there stood a windmill.

In the *Ipswich Journal* for 10 August 1771 appeared the following advertisement: 'To be LET or SOLD at EAST BERGHOLT in Suffolk And Enter'd upon at MICHAELMAS next [26 September] A large copyhold Messuage, with a Malting of twenty-five combe steep, with a Horse-mill there unto belonging also a barn and Stable, and two Acres of rich Feeding Land'. Golding Constable's admittance to this property as a copyhold tenant was entered in the Old Hall Manor Court Book for 8 July 1772 (ESRO HA6 51/4/43). On this site, in the very centre of the village, Golding built himself the above-

mentioned East Bergholt House: a red brick, three-storey building, forthright in character, with pedimented entrance, a Venetian window immediately above, and with the attic storey articulated by a moulding (see no. 255). Attached to one side was the single-storey counting-house and laundry; on the other, to the rear, was the stabling. According to the inscription on several drawings (e.g. no.255) and the letterpress of the 'Frontispiece' to *English Landscape* (see no.178), here, in the new house, on 11 June 1776, was born John, Golding and Ann Constable's fourth child.

An oil of the back of the house is no.22 in this exhibition. The view from the windows at the back may be seen in the superb pair of oil paintings (nos.25–6) and the drawing of 1814 (no.254). In these last three we are looking down on the flower and vegetable gardens that the Constables created for themselves, and beyond to the fertile fields, some thirty or so acres, that Golding farmed. From these windows could also be seen the Rectory, backed by a copse, where Maria Bicknell used to stay as a child and later as a young woman, when she and Constable fell in love. On the horizon, about a mile away, stood the windmill that also belonged to Golding. It had been advertised as for sale in 1769: 'An exceeding good WINDMILL, 20 feet long by 12, draws full 10 Yards of Cloth [on its sails] . . . one pair of French Stones, (the Burrs edgewise) esteem'd the best in the Country . . . all built in the Year 1767: situate on an extensive Common in EAST-BERGHOLT', etc. (*Ipswich Journal*, 29 July 1769, p.4). Golding is down in the Overseers' Account Book as having paid his poor rate on the windmill for the first time in April 1770 – three shillings and nine pence (ESRO EG 3/GI/1/4). From those fields belonging to his father, where he could work undisturbed, Constable painted a number of views; three are in the present exhibition, 'Malthouse Field' (no. 37), 'Flailing Turnip-heads' (no.38) and 'Houses at East Bergholt from the Fields' (no.39).

By the 1780s Golding had become a leading figure in the life of the village. In 1785 a fellow miller, John Crozier of Malden, Essex, described him as a man of fortune, a miller, who 'had a very elegant house in the street and lives the life of a country squire' (A.E.J. Brown, ed., *Essex People*, 1972, p.32). In the East Bergholt Vestry Book (ESRO FB 191/A2/1) he heads a list of those who, in 1790, passed a resolution to exempt seventy-four of the poor from parish rates. With very few breaks he was either overseer, surveyor or churchwarden from 1760 until the year of his death, 1816, and (perhaps a shade suspiciously) was both a director of the local poorhouse at Tattingstone and one of its chief suppliers of coal, wheat and flour.

In 1787 'Golden Constable, gent, proprietor & occupier of [a] certain mansion house in E. Bergholt' was granted a faculty for a pew in the church on the north side of the middle aisle, a pew behind that of the Constables' friend William Travis, the apothecary, and next to the pew of Mrs Roberts of West Lodge (Norwich Faculty Book 6 FCB/4). The church – only three doors away from their house – its priests, its services and the members of its congregation, meant a great deal to all the Constables. Described by Pevsner as 'entirely Late Perp, partly flint and partly brick', St Mary's is built on the wide, open plan typical of the period. The exterior is remarkable for three features: a sundial over the south porch, with the motto 'Ut umbra sic vita' (Even as a shadow is our life); a little eighteenth-century cupola above a clock at the brick, west end (the bells are hung in a sort of roofed cage in the churchyard); and an ambitious west tower of which

only the first storey was built (see no.278). Of the exterior, Constable made more drawings and paintings than of any other specific subject – well over forty, including several exhibition works (see nos.30, 278).

For some way after it left the village, the lane to Flatford ran along with the boundary of the park in which stood Old Hall, from 1804 the residence of Peter Godfrey, the lord of the manor (after the death of Mrs Roberts in 1811), whose wife was a keen supporter of Golding Constable's artist son. It was in this park that Constable made the magnificent pencil drawing of elm trees in 1817 (no.282). At the junction of Flatford Lane (as it is called at the other end) and Fen Lane, Constable found subjects for three important paintings: 'Dedham Vale: Morning' of 1811 (no.14), 'The Stour Valley and Dedham Village' (no.74), a painting commissioned as a wedding present for the Godfreys' daughter, Philadelphia, and the recently discovered 'Fen Lane' (no.91). Further along the lane, from a nearby field, Constable made sketches for 'Summerland' (no.71), 'the landscape from the park pales', as he called it (Beckett 1 1962, p.101). Just before it descends down into the little Ryber valley there is a bend in the lane. Here Constable made a number of oil sketches; five of them are in the present exhibition (nos.40–4).

East Bergholt House

Constable's birthplace, East Bergholt House, figures in his art both as a visible subject and as the unseen vantage point from which he painted and drew the East Bergholt landscape. The view of the back of the building shown here (no.22) is one of only a handful of oil sketches of it. Despite the enormous affection, reverence even, that he felt for the house, Constable only gave it a conspicuous place in his work towards the end of his life, when he had a painting or drawing of it engraved as the 'Frontispiece' to *English Landscape*, declaring in the inscription 'This place was the origin of my Fame' (see nos.173–80 below).

The views from East Bergholt House (see nos.23–6, 254) played a larger role in Constable's work. The windows at the back, clearly visible in no.22, were sufficiently elevated for the fields behind the house to become tractable painterly material. More than this, the fields themselves, separating East Bergholt House from the rectory where Maria Bicknell stayed with her grandfather, were doubly charged with meaning for Constable, the scenes both of his childhood and of the early stages of his long courtship.

22

22 East Bergholt House ?*c*.1809–10

Oil on board laid on panel 182 × 502 ($7\frac{1}{8}$ × $19\frac{3}{4}$)
PROV: As for no.2
LIT: Reynolds 1973, no.102, pl.61; Hoozee 1979, no.90, pl.VIIB (col.); Parris 1981, p.44, fig.1

Board of Trustees of the Victoria and Albert Museum, London

A view from the fields behind the house, painted towards sunset. East Bergholt church appears at the left, the house itself to the right of centre and its stable block further to the right. A more distant view from a slightly different angle is in the Tate Gallery (Parris 1981, no.6, where other depictions of the house are mentioned).

The painting was evidently folded at some point in its history and has suffered considerable damage, especially at the left.

The Constable family left East Bergholt House in 1819. It was pulled down in 1840 or 1841 but the stable block and another outbuilding still survive in altered form.

23 The Rectory from East Bergholt House 1810

Oil on canvas laid on panel 153 × 245 (6 × $9\frac{5}{8}$)
Inscribed '30 Sep | 1810 | E.Bergholt | Common' vertically at top of right edge
PROV: . . .; ? John Wilson; . . .; John G. Johnson by 1914; bequeathed by him to the city of Philadelphia 1917 and later housed in the John G. Johnson Collection, Philadelphia Museum of Art (no.856)
EXH: Tate Gallery 1976 (93, repr.); New York 1983 (3, repr. in col.)
LIT: Hoozee 1979, no.110, repr.; Rosenthal 1983, p.45, fig.43 (col.); Cormack 1986, p.60, pl.52; Rhyne 1987, pp.64, 69–70 n.41; Rosenthal 1987, p.59, ill.44 (col.); Rhyne 1990a, p.127 n.19

John G. Johnson Collection, Philadelphia Museum of Art

Having already painted a panoramic landscape of the view from the back of East Bergholt House (Downing College, Cambridge, Tate Gallery 1976, no.26), Constable began making oil studies of parts

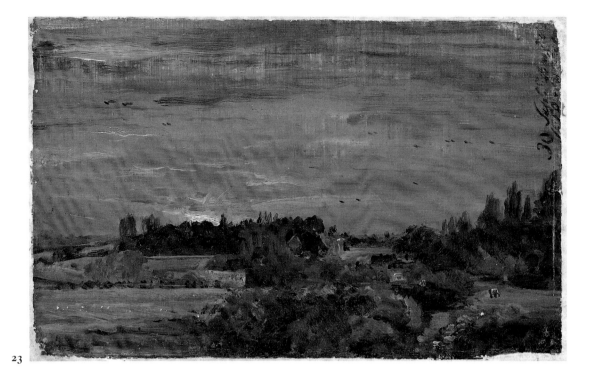

23

of that view, focusing on East Bergholt rectory with its distinctive group of trees. The first known of these studies was painted in 1808 and from ground level nearer the rectory (Fitzwilliam Museum, Cambridge, ibid., no.83). Painted at sunrise on Sunday 20 September 1810, no.23 is the earliest dated study of the view as seen from a window of East Bergholt House. By that time the subject was firmly associated for Constable with Maria Bicknell, to whom he had declared his love the previous year during one of her visits to her grandfather, Dr Rhudde, Rector of East Bergholt. As the letters quoted in the entry on no.24 make clear, their courtship was conducted in the fields that we see here. In 1810 the couple were optimistic about their future and Constable's view of the 'sweet feilds' at sunrise seems to match the mood.

Cove reports (p.522) that no.23 is painted on a fragment cut from a larger canvas, which also supplied the support for no.42.

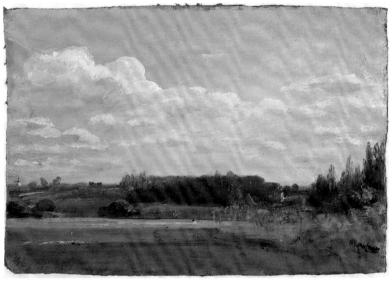

24

24 The Rectory from East Bergholt House c.1813

Oil on canvas laid on board 149 × 217 $(5\frac{7}{8} \times 8\frac{9}{16})$
PROV: By descent to Lionel Constable, from whom bt by the Revd R.C. Lathom Browne 1874 (according to a label on the back); . . .; anon. sale, Sotheby's 23 Nov. 1966 (95) bt J.A. Clough; . . .; Spink and Son Ltd 1979; . . .; anon. sale, Christie's 11 July 1986 (44, repr. in col.); present owners
LIT: Hoozee 1979, no.180, repr.; Fleming Williams and Parris 1984, pp.71–2, 251 n.5

Mr and Mrs David Thomson

Apart from no.23, there are two other dated sketches of the view, one made on 18 August 1813, the other at sunrise the following day (Hoozee 1979, nos.178–9). No.24, which includes East Bergholt windmill and a tiny figure submerged in the wheatfield, is not dated but may belong to about

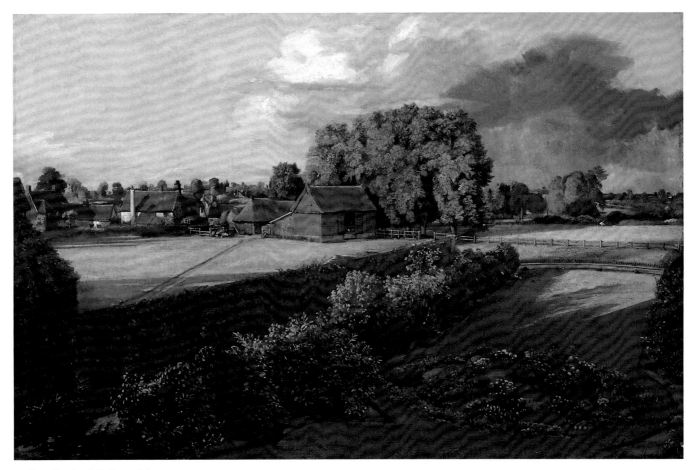

25 (see also detail facing p.85)

the same time. Partly because of Dr Rhudde's opposition, Constable's and Maria's prospects were less hopeful by then and the view to the rectory had taken on a further shade of meaning. 'From the window where I am writing', he told her in June 1812, 'I see all those sweet feilds where we have passed so many happy hours together. It is with a melancholy pleasure that I revisit those scenes that once saw us so happy – yet it is gratifying to me to think that the scenes of my boyish days should have witnessed by far the most affecting event of my life' (Beckett II 1964, p.78). In September 1814 he expressed a similar sentiment: 'I can hardly tell you what I feel at the sight from the window where I am writing of the feilds in which we have so often walked. A beautifull calm autumnal setting sun is glowing upon the gardens of the Rectory and on adjacent feilds where some of the happiest hours of my life were passed' (ibid., p.132). Maria asked him in August 1813 which he had thought of most that summer, 'landscape or me' (ibid., p.111). When painting the view towards the rectory the two must have been almost inseparable in Constable's thoughts.

25 Golding Constable's Flower Garden 1815

Oil on canvas 330 × 508 (13 × 20)
PROV: By descent to Charles Golding Constable and sold by court order after his death, Christie's 11 July 1887 (86) bt Agnew for Sir Cuthbert Quilter; his sale, Christie's 26 June 1936 (18) bt Gooden & Fox; . . .; Ernest Cook, by whom bequeathed to Ipswich through the National Art-Collections Fund 1955
EXH: Tate Gallery 1976 (134, repr.); Madrid 1988–9 (51, repr. in col.)
LIT: Hoozee 1979, no.212, repr.; Barrell 1980, pp.144–6, 175 n.26, repr. with detail p.145; Paulson 1982, pp.116, 126–8; Rosenthal 1983, pp.10–11, 91, 92–3, 97–101, figs.112 (col.detail), 128 (col.); Fleming-Williams and Parris 1984, pp.82, 83–4, 129; Cormack 1986, pp.89, 92, pl.88 (col.); Bermingham 1987, pp.103, 126, fig.39; Rosenthal 1987, p.85, ill.73 (col.); Fleming-Williams 1990, pp.152–3, fig.146

Ipswich Museums and Galleries, Ipswich Borough Council

See no.26

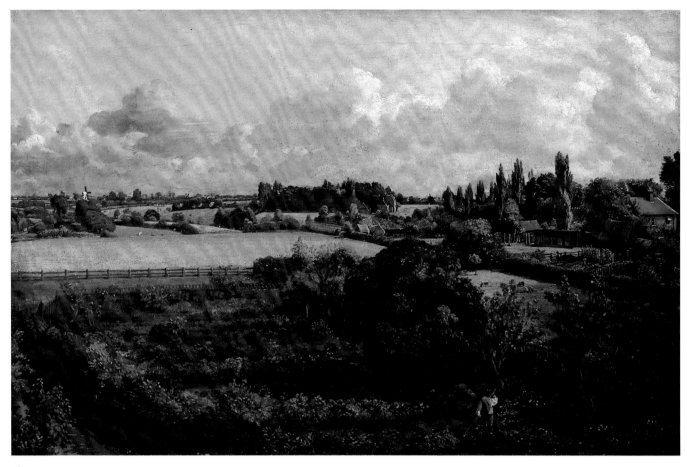

26

26 Golding Constable's Kitchen Garden 1815

Oil on canvas 330 × 508 (13 × 20)
PROV: As for no.25 (1887, lot 85; 1936, lot 19)
EXH: Tate Gallery 1976 (135, repr., and col. detail opp. p.65); Madrid 1988–9 (50, repr. in col.)
LIT: Hoozee 1979, no.213, pls. XV (col.), XVI (col. detail); other lit. as for no.25 with illustration refs. as follows: Paulson 1982, figs.65, 65a (detail); Rosenthal 1983, figs.130 (col.), 132 (col. detail); Cormack 1986, pl.89 (col.); Bermingham 1987, fig.40; Rosenthal 1987, ill.74 (col.); Fleming-Williams 1990, fig.145

Ipswich Museums and Galleries, Ipswich Borough Council

Constable made two drawings in 1814 of the view from the back of East Bergholt House, one in his sketchbook (see fig.129 on p.412) and a large, finished drawing that was almost certainly shown at the RA the following year (no.254 below). Unlike nos.25 and 26, these drawings do not centre on the rectory, which appears only at the extreme right, but rather – if distantly – on Golding Constable's windmill on East Bergholt Common. The lower half of the large drawing is a detailed delineation of

the flower and kitchen gardens of the house with the threshing barn off to the left. The two Ipswich paintings, nos.25–6, are an expansion of the subject as presented in this drawing, extending it sideways in both directions so that the threshing barn is central in no.25, and some of the village buildings to the left of it are included, and the rectory is more or less central in no.26, with other buildings shown in the middle distance to its right (fig.30). In other words, Constable has now, as it were, split the drawing into two separate views, one over the flower garden and the other the kitchen garden. The two pictures do not, however, add up to a continuous panorama. Both were painted from windows on the upper floors of the house but no.26 was viewed from a window on a floor above the other. Nor were they painted at the same time. It was Michael Rosenthal who first showed that while both must have been painted in 1815, no.26 was probably made in July (and accordingly depicts unripe wheat in the field beyond the garden fence) and no.25 in August, by which time the wheat, as we can see, was ready for harvesting ('Golding Constable's Gardens', *Connoisseur*, vol.187, Oct. 1974, pp.88–91). Between the two works Constable was called away to Brightwell to paint the miniature 'Brightwell Church and Village' shown here as no.75.

Constable never exhibited or attempted to sell

these two paintings. Uniquely, they are highly finished yet completely private works – painstaking records of the physical appearance of a landscape that was precious to him and which he may have sensed (following his mother's death earlier in 1815 and with his father's health failing) he would not enjoy much longer. A special impulse to record and to memorialise may explain the degree of fine observation and detailed painting that we see here and which is remarkable even within the context of Constable's painting in the years 1814–17.

The significance of the view towards the rectory has already been mentioned. Unlike the various oil studies of it, including nos.23 and 24, the 1815 painting, no.26, also describes what lay in the foreground of Constable's view, the garden of his birthplace. His attention is focused equally on these two elements, thus making more explicit that association of the scenes of his boyhood with those of his courtship expressed in his letter of June 1812. The other view, an evening one over the flower garden (no.25), may have been particularly associated for him with his mother. Ian Fleming-Williams has pointed out (1990) that it was while gardening that Ann Constable was overcome with the giddiness that marked the onset of her fatal illness (see Beckett 1 1962, pp.116–17). It seems likely, although we do not know for sure, that she was working in the flower garden at the time. Whether or not this was the case, it seems probable that she had had a hand in, perhaps had even

fig.30 Detail from no.26

instigated, the major reorganisation of the flower garden that we can tell had lately taken place by comparing the 1814 drawing (no.254) with the 1815 painting. As Fleming-Williams says, 'a picture of the garden in an evening light, with the newly-planted bed in deep shadow, might well have seemed a fitting tribute to her memory'.

East Bergholt Church

Partly surrounded by trees and lacking a tower (or all but the lower stages of one), East Bergholt church is not a conspicuous feature of the local scene in the way that Dedham or Stoke-by-Nayland churches are. It is difficult to obtain distant views of the building and thus to see it as part of a wider landscape. Although Constable made many drawings and watercolours of the church during his early years (see, for example, nos.243–4, 278–9), it had comparatively little to offer as a subject for landscape painting, in this respect resembling East Bergholt House. Nevertheless, the church and its churchyard provided Constable with the subject for one of his earliest exhibited canvases (no.30) and he was later to develop the allusions made in this work when designing illustrations to Gray's *Elegy*; in his later work more generally there is a strain of elegiac musing on the past.

27

27　East Bergholt Church from Church Street 1809

Oil on paper on panel 190 × 146 ($7\frac{1}{2} \times 5\frac{3}{4}$)
Formerly inscribed 'Oct. 10th 1809' on the back
PROV: By descent to Hugh Constable, from whom bt by Leggatt 1899; . . .; Sir Michael Sadler by 1913 and still his in 1937; . . .; N.L. Hamilton-Smith by 1950; . . .; John Baskett Ltd, from whom bt by Paul Mellon 1980
LIT: Hoozee 1979, no.69, repr.; Rhyne 1987, p.59, fig.5 (back of panel)

Paul Mellon Collection, Upperville, Virginia

The west end of the church with its little cupola is seen here from somewhere near the Constable family house, looking south-east down Church Street. Partly obscuring the church is the house and shop of the auctioneer Mr Barnard, seen again in a drawing of 1812 (no.244; see also fig.5 on p.22). Three days after painting this sketch Constable made the study of a man resting by the lane from East Bergholt to Flatford which is on the other side of no.68 below.

When included in Leggatt's 1899 exhibition the painting bore the title 'A Shower, East Bergholt'.

28

28 **East Bergholt Church and Churchyard, Evening** *c.*1810

Oil on canvas 244 × 301 ($9\frac{5}{8}$ × $11\frac{7}{8}$)
Inscribed in a later hand on the relining stretcher 'Church Porch evening J. Constable R A.'
PROV: As for no.2
LIT: Reynolds 1973, no.99, pl.59; Hoozee 1979, no.98, repr.

Board of Trustees of the Victoria and Albert Museum, London

Figures are seen walking through the churchyard on the path leading to and from the south porch. The figure by the porch catches the light of the moon. Although not directly connected with 'The Church Porch' exhibited in 1810 (no.30), this study similarly focuses as much on the graveyard as on the church, creating a mood of quiet reflection.

29

29 The West End of East Bergholt Church

Oil on canvas 165 × 120 (6½ × 4¾)
PROV: According to a label (Leggatt *c.*1899)
on the back, acquired at one of Isabel
Constable's sales (not identified); . . .; W.G.
Saunders, sold Sotheby's 20 March 1974 (25)
bt Agnew, from whom bt by present owner
LIT: Hoozee 1979, no.100, repr.

Private Collection

Part of the unfinished tower appears at the left;
beyond it is the window at the west end of the south
aisle and beyond that the south porch. The bent
figure of a man with a stick adds a note of
melancholy and raises this little work above the
level of an architectural study.

Two related drawings are in the Witt Collection
at the Courtauld Institute Galleries (nos.1007 and,
less close, 3564).

30 The Church Porch, East Bergholt 1810,
exh.1810

Oil on canvas 445 × 359 (17½ × 14⅛)
PROV: By descent to Isabel Constable, by
whom presented to the National Gallery
1888; transferred to the Tate Gallery 1951
(N 01245)
EXH: RA 1810 (116, 'A church-yard'); BI
1811 (185, 'A church porch', frame 25 × 22
in); Tate Gallery 1976 (99, repr.); Japan 1986
(4, repr. in col.)
LIT: Hoozee 1979, no.99, repr.; Parris 1981,
no.7, repr. in col.; Rosenthal 1983, pp.47–8,
51, fig.47 (col.); Cormack 1986, p.60;
Rosenthal 1987, pp.60–2, ill.45 (col.);
Fleming-Williams 1990, pp.160–1, fig.153

Tate Gallery

Constable entitled this painting 'A church-yard'
when he exhibited it at the Royal Academy in 1810.
As well as representing a specific local scene, the
work belongs to a tradition of churchyard imagery
that goes back to Gray's *Elegy Written in a Country
Churchyard* and to Bentley's illustrated edition of
Gray's *Six Poems* of 1753. There the *Elegy* is
represented by the image of a man leaning on a stick
to contemplate a grave shown him by a second man;
the inevitability of death is underlined by the
shadow of the first man falling squarely on the
grave he contemplates. Similar imagery occurs in
Gainsborough's work, especially in his soft-ground
etching 'Wooded Landscape with a Peasant Read-
ing a Tombstone' of *c*.1780.

Around 1806 Constable made a drawing which
was engraved as the frontispiece to *A Select
Collection of Epitaphs and Monumental Inscriptions*,
published that year by J. Raw of Ipswich (fig.31).
In this a man leaning on a stick by a tombstone in
East Bergholt churchyard addresses two girls, one
of whom kneels before the tombstone to read the
opening lines inscribed on it of the 'Epitaph' to
Gray's *Elegy*. The 1810 painting departs from the
more obvious imagery of this tradition by grouping
the figures – a clergyman-like figure addressing two
others, one in a red cloak – more casually with their
backs to two tombs. This group catches the eye but
the sundial marking off time on the porch is equally

fig.31 Frontispiece to *A
Select Collection of Epitaphs
and Monumental
Inscriptions*, 1806, *Trustees
of the British Museum,
London*

prominent. Only local observers of Constable's
painting would have known that the motto on the
dial was 'Ut umbra sic vita' ('Life is like a shadow'),
a tag that Constable later used on the closing
'Vignette' of his *English Landscape* mezzotints (see
no.205).

A similar red-cloaked figure appears in the early
painting 'Edge of a Wood' (no.1 above). In 1833
Constable made watercolour illustrations to Gray's
Elegy which were engraved on wood for Martin's
edition of 1834. At the RA in 1834 he exhibited two
Elegy watercolours, one of which was probably
used for the additional wood-engraving that
appears on the title-page of Martin's second edition
of 1836 (see Tate Gallery 1976, nos.298–302).

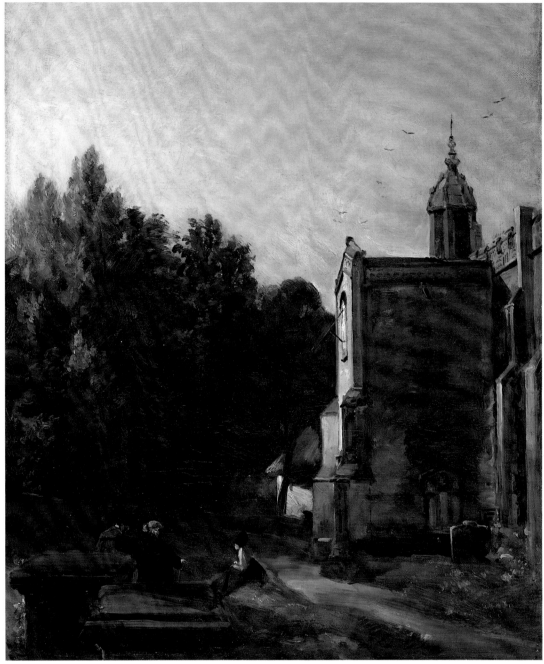

30

West Lodge

The residence of Mrs Sarah Roberts (*c*.1723–1811), West Lodge lay on the west side of Church Street, diagonally opposite East Bergholt House. Constable was attracted to the meadows behind the house from an early date. They offered views over the Stour valley unobtainable from his parents' house and gave him the opportunity especially to paint sunsets, not something he could do from East Bergholt House. He was painting there by 1802 and possibly by 1799 but seems to have been most active at West Lodge in 1811–12, just before and after Mrs Roberts's death. His definitive painting of the view from behind the house (no.33) was exhibited at the Royal Academy in 1812 but the subject remained a favourite of his and was chosen to epitomise 'Summer Evening' in his series of *English Landscape* prints (see nos.191–2).

31 **West Lodge, East Bergholt** ?1811

Oil on canvas laid on panel 104 × 208 (4⅛ × 8³⁄₁₆)
PROV: ...; Mrs Heywood Lonsdale; ...; Leger, from whom bt by Howard Bliss; ...; Dr H.A.C. Gregory, sold Sotheby's 20 July 1949 (117) bt Ian L. Phillips; ...; James Kirkman, from whom bt by present owners 1988
LIT: Hoozee 1979, no.95, repr.

Mr and Mrs David Thomson

Philip and Sarah Roberts may have moved to West Lodge in 1756, when a house closely corresponding to it was described for sale in the *Ipswich Journal* (22 May 1756). Roberts's occupation, if any, is not known; he died on 9 October 1778 (*Ipswich Journal*, 10 Oct. 1778). Mrs Roberts survived until her eighty-eighth year, dying on 2 December 1811. The Constable family got on well with her, Mrs Constable typically refering to her as 'our good neighbour' or 'good Mrs Roberts' when writing to her son in London. As will be seen later, Mrs Roberts appears to have been particularly fond of John. An obituary in the *Ipswich Journal* (7 Dec. 1811) described her death as 'an irreparable loss to the poor of her parish, and to her friends; to the former of whom she was a mother, and to the latter a sincere and faithful adviser'. (Kindly communicated by Judy Ivy.)

West Lodge is seen here from the front garden of East Bergholt House. A figure in red towards the left side is about to pass through the garden gates. The sun is setting, casting long shadows on the lawn and bathing the west side of the Lodge in light. Meanwhile the moon is up, edging round the trees at the right.

Sarah Cove suggests (see p.525) that this study of West Lodge was painted on a fragment of canvas cut from a larger one which also supplied the supports for one of the 'Flatford Mill from the Lock' sketches, no.52 below, and the Victoria and Albert Museum 'Village Fair, East Bergholt' (Reynolds 1973, no.101). The latter is dated 1811 and the former was almost certainly painted the same year.

Constable painted at least two other studies of the front of West Lodge: a comparable work in the collection of Mr and Mrs Paul Mellon (Hoozee 1979, no.94, repr.) and a small upright study showing part of the house with the hatchment John Dunthorne Snr made for it after Mrs Roberts's death (private collection; ibid., no.163, repr.) and which, Constable reported, 'gave the house a melancholy aspect' (Beckett II 1964, p.79). West Lodge can also be seen in oil studies in the Victoria and Albert Museum (Reynolds 1973, no.101, pl.60), the Ashmolean Museum (Hoozee 1979, no.131, repr.) and perhaps one in the William A. Farnsworth Library and Art Gallery, Rockland, Maine (New York 1988, no.33, repr. in reverse).

31

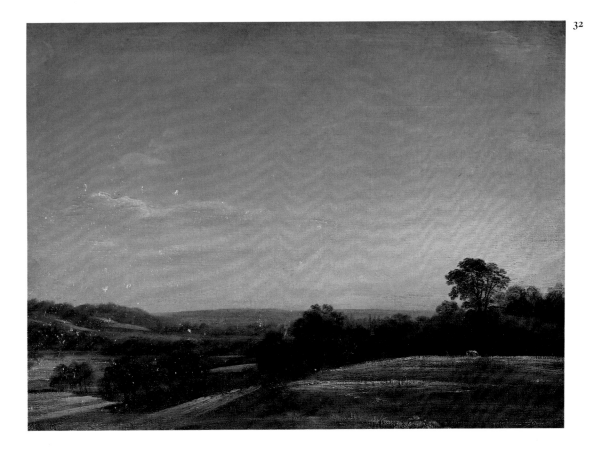

32 Dedham Vale, Evening, from West Lodge 1802

Oil on canvas 318×432 ($12\frac{1}{2} \times 17$)
Inscribed in pencil in a later hand on the
stretcher 'Towards Evening painted by | J.
Constable RA 1802' and 'July 1802'
(presumably based on Constable's original
inscriptions, covered by relining canvas)
PROV: As for no.2
EXH: Tate Gallery 1976 (32, repr.)
LIT: Reynolds 1973, no.36, pl.18; Hoozee
1979, no.14, repr.; Rosenthal 1983, p.30,
fig.26 (col.)

*Board of Trustees of the Victoria and Albert
Museum, London*

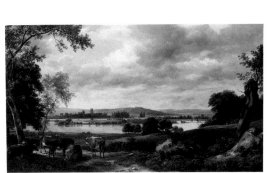

fig.32 Ramsay Richard
Reinagle, 'View of Dedham
Vale during the Floods in
1799', exh.1801, *Private
Collection*

This is one of the studies Constable made in the
summer of 1802 after taking his momentous
decision to become 'a natural painter' (see nos.2–
5). The view is from a meadow behind West Lodge
– Mrs Roberts's lawn, as Constable called it –
looking over the Stour valley to the hills at
Langham on the left. The prominent tree at the
right appears in all Constable's treatments of the
subject and also in the related study 'Autumnal
Sunset' (no.181). From E.E. Leggatt's comments
on the latter, thought to be based on David Lucas's
remarks, we know that Constable and Dunthorne
called it the 'wig' tree because of its shape (see
Catalogue of the Complete Works of David Lucas,
Gooden and Fox, May 1903, pp.33–4).

Unlike most of Constable's 1802 studies, this
one is closely painted, leaving no priming showing
through. Dated July, it seems likely to precede all
the others in the group, three of which are known to
have been painted in September and October.
Cove (thesis) observes that there is a painted-out
crescent moon at the top left and another painting
on the back of the canvas, now visible (but not
intelligible) only through x-radiography, the origi-
nal canvas having been relined in 1893.

Constable introduced the painter Ramsay
Richard Reinagle, with whom he shared lodgings
in London, to this spot in 1799 and two years later
reported that Reinagle had 'painted a Landscape,
Dedham, from the sketch he took from Mrs

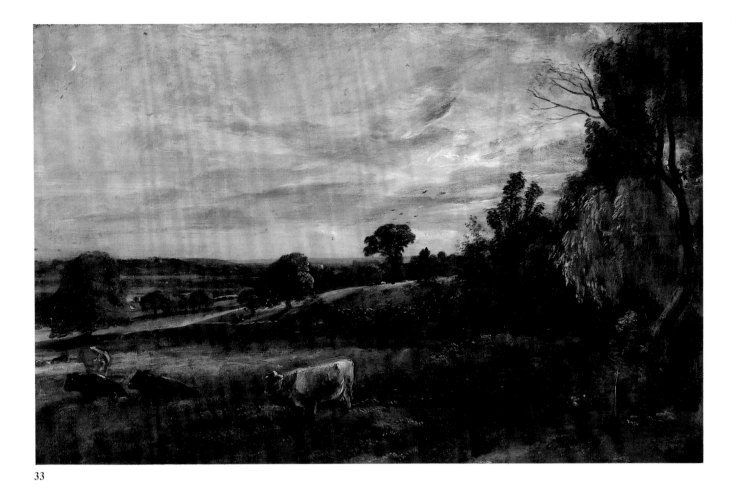

33

Roberts's. He calls it his best picture. It is very well pencilled, and there is plenty of light without *any light at all*' (Beckett II 1964, p.25). The painting in question (fig.32, private collection) was exhibited at the Royal Academy in 1801 as 'View of Dedham vale, during the floods in 1799'. Despite Constable's not entirely favourable opinion of the picture, it can hardly have failed to have been instructive to him at this early stage in his career, perhaps even suggesting the potential of panoramic views of the Stour valley.

Among other early treatments of the view by Constable are a watercolour of June 1806 (British Museum; Tate Gallery 1976, no.59, repr.) and an oil sketch in the Prince of Wales Museum of Western Art, Bombay (not seen by the compilers).

33 **Summer Evening** 1811–12, exh. 1812

Oil on canvas 317 × 495 ($12\frac{1}{2}$ × $19\frac{1}{2}$)
Inscribed in a later hand in ink on the stretcher 'Varnished with Fields lack varnish by C.R. Leslie R.A. in 1840' (for other inscriptions see Reynolds 1973)
PROV: By descent to Lionel Constable, sold Christie's 22 May 1869 (104) bt in by Bourne; given by Isabel Constable to the South Kensington (later Victoria and Albert) Museum 1888
EXH: RA 1812 (72, 'Landscape: Evening'); Tate Gallery 1976 (103, repr.)
LIT: Reynolds 1973, no.98, pl.58; Hoozee 1979, no.121, repr.; Rosenthal 1983, pp.59, 60, fig.60 (col.)

Board of Trustees of the Victoria and Albert Museum, London

This is a more panoramic treatment of the scene depicted in no.32, with the 'wig' tree, still with a cow at its foot, now more or less in the centre rather than at the right. The churches of Langham, on the hills at the left, Stratford St Mary, catching the light in the centre distance, and Stoke-by-Nayland, on the skyline to its right, are now all indicated. The foreground is also considerably enlarged, taking in a nearer field in which ruminating cattle are introduced. Together with a repoussoir tree at the right, the cattle help frame the smaller area originally studied in 1802. They also contribute to the picture's mood of repose and reflection.

On 12 November 1811 Constable told Maria Bicknell what he had been painting that summer: 'I have tried Flatford mill again – from the lock . . . and some smaller things – one of them (a view of Mrs Roberts's Lawn – by the summer's evening) – has been quite a pet with me' (Beckett II 1964, p.54).

There are good reasons to think that the painting of Flatford mill is no.54 below, that the smaller picture of Mrs Roberts's lawn is the present work and that both were exhibited at the Royal Academy in 1812 (see Tate Gallery 1976, under nos. 96, 103). After Mrs Roberts's death, Constable's mother wrote to him on 17 December 1811 to say amongst other things that she had got back 'the Picture – you did for Mrs Roberts – our late Friend and Neighbour which is is of great Value to me, because it is your Performance and so well done in every respect' (Beckett 1 1962, p.72). It seems very likely that this picture was of the view from Mrs Roberts's lawn, a subject which she particularly associated with Constable. In the summer of 1809 Mrs Constable reported to her son that Mrs Roberts 'says she always thinks of you, at the setting sun, thro' her trees. Surely this is a kind retention at 86 –' (ibid., p.36). If it were of this subject, Mrs Roberts's painting may even have been the present work, which Constable then decided to submit to the next Royal Academy exhibition. It would have been a fitting tribute to her. Whether she thought of Constable himself or his works (or both) as she watched the sun set through her trees, Mrs Roberts must have been a remarkably perceptive old lady, perhaps one of the first people to look at the English landscape through Constable's eyes.

The crescent moon suppressed in no.32 is allowed to shine in this picture, though Cove notes (thesis) that Constable changed its position, which was originally higher and more to the left. She also observes pentimenti in the foreground: at one time there was a cow facing right behind the present foremost animal, whose own back was also re-aligned at some stage (see p.511 and fig.180).

Constable had no.33 engraved for his *English Landscape* series under the title 'Summer Evening' (see nos.191–2).

34 A Hayfield behind West Lodge, Sunset 1812

Oil on paper laid on canvas 160 × 318 (6¼ × 12½)
Inscribed 'July 4 1812' b.r.
PROV: As for no.2
EXH: New York 1983 (10, repr. in col.); Japan 1986 (9, repr. in col.)
LIT: Reynolds 1973, no.115, pl.70; Hoozee 1979, no.151, pl.XIA (col.); Rosenthal 1983, p.60, fig.59 (col.); Cormack 1986, p.77, pl.69

Board of Trustees of the Victoria and Albert Museum, London

Nos.34 and 35 were painted within a few days of each other in July 1812 and show Constable returning again to this 'pet' subject. Rosenthal suggests that Constable did so because he was dissatisfied with his exhibited painting of the scene, no.33. Whether or not that was the case, he would surely have welcomed the opportunity to paint landscape during a week when he was 'wholly engaged on a portrait of Mr William Godfrey which was just compleated in time', as he told Maria Bicknell on 10 July (Beckett 11 1966, p.80). No doubt the only time left for other work was the evening, when he would naturally have resorted to the lawn of West Lodge or somewhere else near his studio on the west of the village.

The influence of Rubens has long been noted in nos.34–5 and other sketches of the period. More recently a specific borrowing from Rubens has been observed in an earlier oil sketch, 'The Edge of a Heath by Moonlight', dated by Rhyne *c.*1810 (New York 1988, no.1; see Helen Braham and Robert Bruce-Gardner, 'Rubens's "Landscape by Moonlight"', *Burlington Magazine*, vol.130, Aug. 1988, pp.589–90).

Constable returned again to the field behind West Lodge in 1813 when he made a daylight drawing of the view in his sketchbook (p.46 of no.247 below) and on 24 August 1815 when he made a dramatic drawing of the 'wig' tree in a now dismembered sketchbook (Victoria and Albert Museum, Reynolds 1973, no.143, pl.117), inscribing it 'Lawn – EB –'.

35 Fields behind West Lodge, Sunset 1812

Oil on canvas 165 × 337 (6½ × 13¼)
Inscribed '7 July 1812' b.l. and on the back in a later hand 'M.L.' (Maria Louisa Constable, through whom it descended to her sister Isabel)
PROV: As for no.2
LIT: Reynolds 1973, no.116, pl.70; Hoozee 1979, no.153, repr.; Rosenthal 1983, p.60, fig.64 (col.)

Board of Trustees of the Victoria and Albert Museum, London

See the entry on no.34 above, painted three days earlier. The oil sketch engraved as 'Autumnal Sunset' (no.181), which may have been painted later in 1812, is closely related in subject to all the works in this group. It and no.35 were also painted on adjoining pieces taken from the same larger canvas (see Cove on p.495). The flattened tacking edges of the larger canvas are very prominent in no.35.

34

35

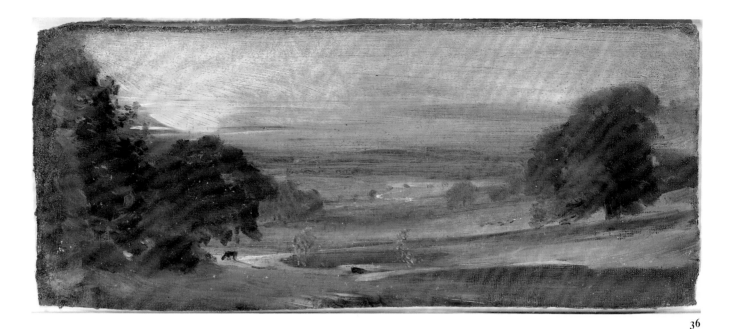

36

36 **The Valley of the Stour, Sunset** 1812

Oil on canvas 117 × 284 (4$\frac{5}{8}$ × 11$\frac{3}{16}$)
Inscribed '31. Octr 1812' on the back
PROV: . . .; Percy Moore Turner by 1937; by
descent to vendor at Sotheby's 16 Nov. 1988
(92, repr. in col.); present owners
LIT: Hoozee 1979, no.147, repr.

Mr and Mrs David Thomson

The Stour can be seen winding through the valley
in the centre distance. Just to the right of the right-
hand tree is Stratford St Mary church but the exact
viewpoint has not yet been established. The date of
the work was only discovered when the canvas was
removed from its old backing after the 1988 sale,
though the similarities with nos.34–5 above were
fairly clear before then.

East Bergholt Fields

Many of the works shown earlier in this part of the exhibition – paintings of and from East Bergholt House and West Lodge and those of the church – have been well known for a number of years. Until recently the three paintings that follow have been known, if at all, only in a very limited way. All were painted in Golding Constable's fields to the east of the village, on the slopes of the Ryber valley. Their reappearance suggests that we may still have something to learn about the extent of Constable's activities as a painter in his native village.

37

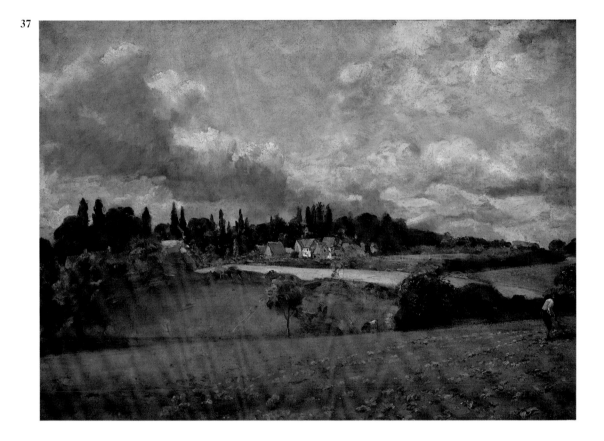

37 Malthouse Field, East Bergholt ?1814

Oil on canvas 546 × 772 (21½ × 30⅜)
PROV: . . .; Sedelmeyer, Paris; P.A. Chéramy, Paris, by 1898 (according to *Illustrated Catalogue of 300 Paintings by Old Masters*, Sedelmeyer Gallery 1898) and sold Georges Petit, Paris, 5 May 1908 (7) bt for Otto Gerstenberg, Berlin; his grandson, Walther Scharf, Obersdorf; Wolfgang Wittrock, Düsseldorf, from whom bt by present owners 1985
LIT: Hoozee 1979, no.214, repr.; Rhyne 1988, pp.18, 27 n.52

Mr and Mrs David Thomson

The field in the foreground can be identified as Malthouse Field from Brasier's East Bergholt map of 1731. It adjoined the grounds of the rectory, out of sight at the left, and gave views of the backs of the houses on Rectory Hill, seen here in the middle distance. At the extreme right is East Bergholt church.

The man in the field is hoeing mangolds. This was done in May when the new crop was 'singled' to reduce to one the two or more plants that may have grown from the seed, and again in June, when 'second hoeing' cut away unwanted plants missed the first time. The ground between the plants was weeded each time, the whole blade of the hoe being used for this purpose instead of the tips used for cutting out. The quantity of leaf on the plants in Constable's painting suggests that second-hoeing is taking place. (Information kindly supplied by Mr V.H.I. Knowland). A drawing in the Victoria and Albert Museum shows a man carrying the same

sort of hoe over his shoulder with a keg threaded on it (Reynolds 1973, no.182, pl.144).

This painting is too large to be regarded as a sketch but insufficiently finished for Constable to have intended it for exhibition, at least in its present form. The nearest tree at the left edge and the area around the cattle in the centre are particularly unresolved. He may himself have been uncertain of his intentions. The paint appears to have been quickly brushed in, leaving a good deal of the brown priming visible. The latter is used in a positive fashion to create shadows, especially on the deftly blocked-in buildings in the centre distance.

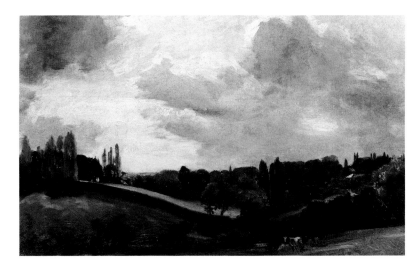

fig.33 'View at East Bergholt', c.1812–15, *Yale Center for British Art, Paul Mellon Collection*

38 Flailing Turnip-heads c.1812–15

Oil on canvas 350 × 442 (13¾ × 17⅜)
A faint inscription in a later hand on the stretcher appears to read 'Mr Carpenters Collection'
PROV: . . .; Mr Carpenter; . . .; bt in London in early 1900s by father of vendor at anon. sale, Sotheby's 12 March 1986 (96, repr. in col.) bt Leger Galleries, from whom bt by present owner the same year
EXH: New York 1988 (8, repr. in col. in reverse)
LIT: Ian Fleming-Williams, review of New York 1988 in *Burlington Magazine*, vol.130, Aug. 1988, p.654, fig.87

Private Collection, New York

The labourers here are threshing or flailing dried turnip-heads or rape (cole, as it was then known) to remove the seeds. In his *General View of the Agriculture of the County of Suffolk* (1813, p.94), Arthur Young described such threshing as taking place 'in the field on cloths', the reason for this being that the seeds fell out if the heads were moved far.

When this painting came to light in 1986 it was apparent that the slate-roofed building at the right corresponded to one in the distance at the right side of the Yale Center sketch 'View at East Bergholt' (fig.33, Tate Gallery 1976, no.121). This more extensive view, spanning the Ryber valley, enables the building in question to be identified as one on Rectory Hill, a little to the east of the buildings seen in 'Malthouse Field' (no.37). In his catalogue entry for the 1988 exhibition, Rhyne points out that the Yale Center sketch includes two figures tending a fire in what seems the same place as the two seen in no.38. From their similarity of size and handling he

proposes that the two works were painted within a few days of each other one summer between 1812 and 1815.

No.38 is unusual among Constable's sketches for its size but more so for the equal attention it pays to figures and landscape. Here the figures are not details in the landscape but Constable's reason for painting the scene in the first place.

39 Houses at East Bergholt from the Fields

Oil on paper laid on canvas 137 × 247 (5⅜ × 9¾)
Inscribed in a later hand on a label on the back 'Study of Landscape'
PROV: . . .; private collection, Amsterdam; anon. sale, Christie's 14 July 1989 (54, repr. in col.); present owners

Mr and Mrs David Thomson

The buildings shown here may be on Rectory Hill and the left-hand one is just possibly the slate-roofed house that appears in no.38 (though the chimney stack does not exactly correspond). The identity of the sites of such sketches is important because it was important to Constable himself. As noted under nos.23–4, the fields between East Bergholt House and the rectory held many associations for the artist. Disguised as 'Study of Land-scape' (as this sketch was once called), 'Freeton [i.e. Freston] Tower, près Ipswick' (the puzzling title given no.37 in 1908) or as 'Highgate' (as the Yale Center sketch mentioned under no.38 was known until the 1960s), such works lose much of their meaning.

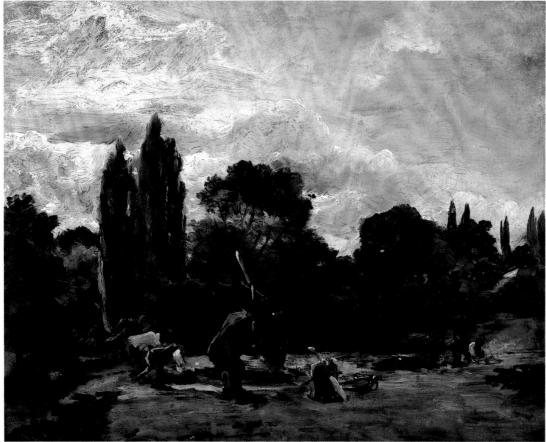

38

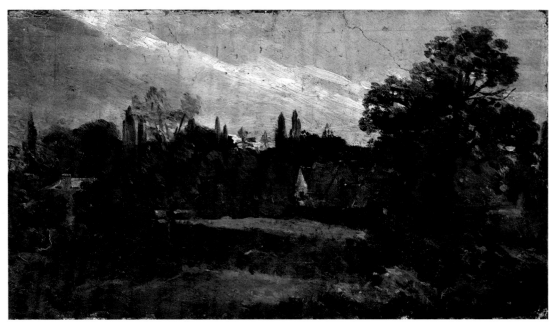

39

East Bergholt Lanes

As we have seen in earlier sections, Constable's view of his local landscape by no means excluded its human inhabitants. In sketching the lanes around East Bergholt he appears almost to have been on the lookout for some approaching figure, perhaps recalling the advice given him by J.T. Smith not to 'set about inventing figures for a landscape taken from nature, for you cannot remain an hour in any spot, however solitary, without the appearance of some living thing that will in all probability accord better with the scene and time of day than will any invention of your own' (Leslie 1843, p.4, 1951, p.6). Lanes and footpaths being what they are, Constable was more likely to encounter 'some living thing' there than anywhere else. What actually happened in such encounters, we can only guess. Did he, for example, ask the man in the black hat seen in nos.42 and 43 to sit down a moment while he sketched him? Was the man perhaps a willing accomplice, some friend like John Dunthorne? But the extent to which such figures were in fact painted on the spot remains uncertain: we may have paid more attention to Smith's advice than Constable did. Some of the works in this section, as in others, especially nos.42 and 46, raise the larger question of just how many ostensible outdoor studies were indeed painted on the spot.

No major work resulted directly from any of the studies of country lanes shown here (those used for 'Dedham Vale: Morning' have a section to themselves) but no.46 and possibly no.47 later gave Constable ideas for the large 'Cornfield' of 1826 (no.165), which can be regarded as his definitive 'lane' picture.

40　Dedham Vale from the East Bergholt to Flatford Lane　c.1809

Oil on paper laid on canvas 239 × 302
($9\frac{3}{8} \times 11\frac{7}{8}$)
PROV: As for no.2
LIT: Reynolds 1973, no.109, pl.64; Smart and Brooks 1976, p.29, pl.20; Hoozee 1979, no.87, repr.; Cormack 1986, p.64, pl.57

Board of Trustees of the Victoria and Albert Museum, London

Painted on the lane from East Bergholt to Flatford after it has passed the top of Fen Lane (the trees on the far side of the ploughed field are probably on Fen Lane), this study includes Dedham church on the left and Stratford St Mary church in the further distance to the left of the main tree. The four sketches that follow (nos.41–4) appear to have been painted from the bend seen at the top of the lane at the right.

41　A Cart on the Lane from East Bergholt to Flatford　1811

Oil on paper laid on canvas 153 × 212
($6 \times 8\frac{3}{8}$)
Inscribed by Lionel Constable on a label on the stretcher '17 May, 1811.|L.B.C.', presumably copying his father's original inscription on the back of the paper
PROV: As for no.2
EXH: Tate Gallery 1976 (102, repr.); New York 1983 (4, repr. in col.)
LIT: Reynolds 1973, no.100, pl.60; Hoozee 1979, no.126, pl. v (col.); Cormack 1986, p.68, pl.61

Board of Trustees of the Victoria and Albert Museum, London

This and the following three studies appear to have been painted a few yards up the lane from the viewpoint adopted for no.40, with Constable now looking in the opposite direction towards Flatford. Whether or not the large tree at the right is the same one that appears in no.40, Constable obviously now sees and paints trees in a very different way, superimposing a bold framework of trunk and branches over rapidly brushed-in foliage. This is a classic example of the more lively and colourful oil-sketching style which he developed around 1810–11. The patches of red each side of the approaching horse are the crimson fringes of its harness.

Reynolds (1973) reports Attfield Brooks's suggestion that the smoke seen rising from the valley comes from Flatford mill or some nearby building and that the wooded area on the hills – seen most clearly in this work and no.42 – is on the Lawford Hall estate.

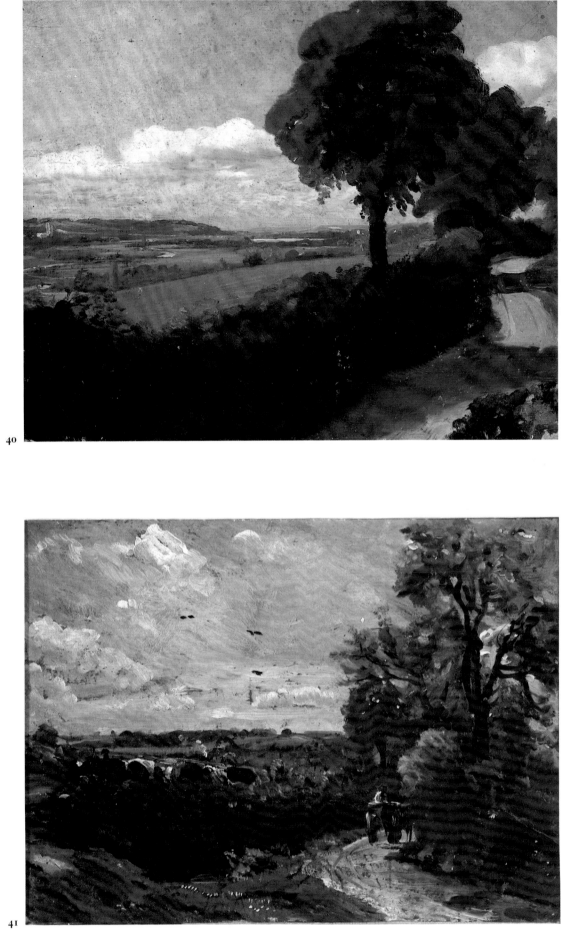

40

41

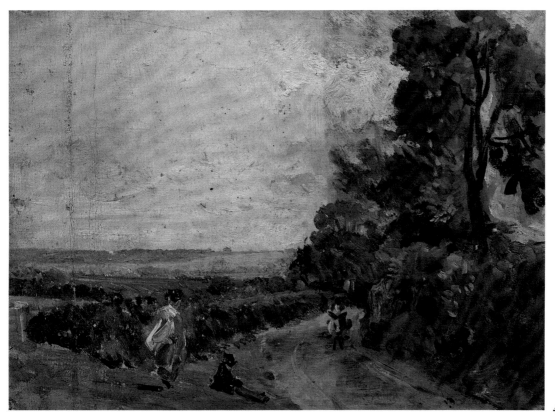

42

42 Figures and a Donkey on the Lane from East Bergholt to Flatford *c.*1811–12

Oil on canvas 242 × 335 (9½ × 13⅛)
PROV: As for no.2
LIT: Reynolds 1973, no.329, pl.239; Hoozee 1979, no.128, repr.; Cove 1988a, pp.52–6, figs.1, 3 (diagram of support), 5 (diagram of layers), 6 (cross-section)

Board of Trustees of the Victoria and Albert Museum, London

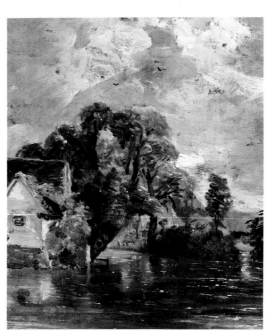

fig.34 'Willy Lott's House' (obverse of no.42), ?1810, *Board of Trustees of the Victoria and Albert Museum, London*

Here Constable paints on a slightly larger scale the subject seen in no.41 but substitutes for the cart two figures watching a third approach on a donkey. The figure of the woman in white is particularly effective, her slight detachment from her own shadow suggesting a step forward to meet the oncoming rider. Apart from these changes to the figuration, no.42 seems to embody a degree of fresh observation of the landscape, especially in the left-hand two-thirds of the canvas, where Constable notes quite different aspects of, for example, the foreground bank and hedge.

No.42 is painted on a fragment of canvas, on the other (front) side of which Constable painted a study of Willy Lott's house (fig.34, Reynolds 1973, no.329a). Sarah Cove (1988a and pp.520–1) describes the complicated paint layers found on both sides of the canvas, most notably the multi-coloured priming of the side shown here, ranging from left to right in bands or areas of sky blue,

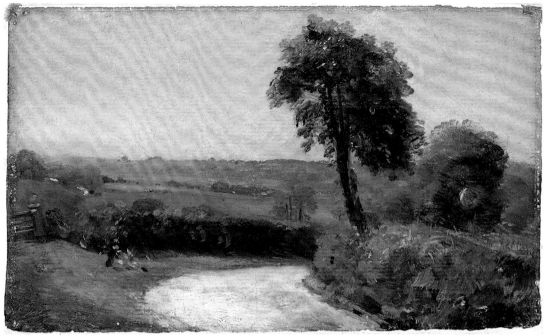

43

lemon yellow, dark grey-green, mushroom, olive green and light pinkish-brown (see p.521, fig.197). As she says, Constable appears to have been experimenting with the effects of different coloured primers, seeking to expand the limited range (reddish-brown or dull pink) he had employed earlier. Whether he intended to relate these bands to the image in this case and chose their colour accordingly is less clear. The effect of the varied coloured bands is most conspicuous to the naked eye about two-thirds of the way from the left, in a vertical line (which originally would have been less visible) just to the left of the donkey, where the blue underlying the foreground and the yellow under the sky give way to a band of dark grey-green priming. The other conspicuous vertical line, towards the left edge, is a crease made, Cove suggests, when Constable first used the canvas, folding it over his paint box to sketch Willy Lott's house. This is at right angles to the lane image and the folded top section is left blank. No.23 above, Cove reports (p.522), is painted on another fragment cut from the same larger canvas as no.42.

The earliest dated oil study found by Cove in which any of the new priming colours detected in this work are used is no.35 above, 'Fields behind West Lodge, Sunset' of 7 July 1812, which is painted over a blue layer (see p.498). She therefore proposes that the present 'experimental' work dates from before July 1812 (but not earlier than 1810, the likely date of the painting on the original front side).

43 **The Lane from East Bergholt to Flatford** 1812

Oil on paper 165 × 280 ($6\frac{1}{2}$ × 11) laid on card
Inscribed '9 July 1812' b.l.
PROV: By descent to Isabel Constable (according to a label on the backing board, probably in the hand of her nephew Hugh); ...; Sedelmeyer Gallery, Paris (red seal on backing board, also cutting from a Sedelmeyer or other French catalogue giving no. and title: 52, 'Le Chemin tournant'); bt from Sedelmeyer in early 1900s by José Lázaro Galdiano, Madrid, who died 1947, leaving his collection to the Spanish nation
LIT: José Camón Aznar, *Guía del Museo Lázaro Galdiano*, 8th ed., Madrid 1988, p.117

Museo Lázaro Galdiano, Madrid

This sketch has not previously been published in the Constable literature, despite the fact that it has been on public display in Madrid since 1951. The date, scratched in the wet paint with the end of the paint brush and only completely visible when the work is seen out of its frame, may seem surprising in relation to the more lively example of 1811, no.41, but Constable's oil sketching in the summer and autumn of 1812 appears to have encompassed a variety of approaches and moods (see nos.15, 18, 34–6, 60).

The viewpoint is more or less identical to those used for nos.41–2 above. The gate at the left of no.42 reappears here, as does a man in a black hat. The angle of vision, however, is closer to no.41. It is more difficult to relate the trees seen here to those in nos.41–2, partly because Constable is again (cf. nos.40 and 41) looking at them in a different way.

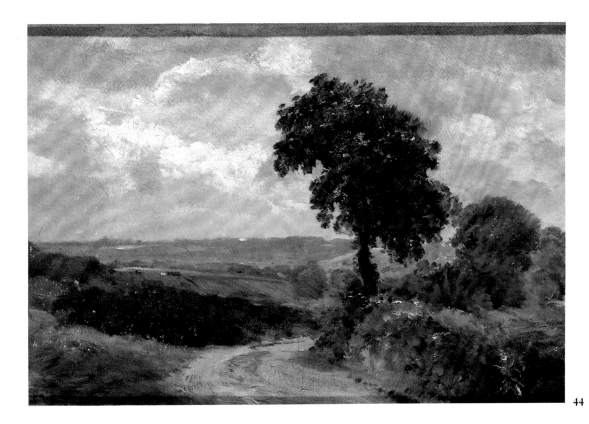

44

44 The Lane from East Bergholt to
Flatford ?*c*.1812

Oil on canvas laid on panel 155 × 225
($6\frac{1}{8}$ × $8\frac{7}{8}$)
Inscribed in Stuart Tidey's hand on paper on
the back of the panel with details of the
work's provenance
PROV: By descent to Isabel Constable, who
gave it to Alfred Tidey *c*.1888; thence by
descent to Dr Stuart Tidey; . . .; R.F.
Goldschmidt; . . .; Agnew, from whom bt by
Charles Russell 1941 and sold Sotheby's 30
Nov. 1960 (102) bt Agnew, from whom
acquired by father of present owner
LIT: Hoozee 1979, no.88, repr.

Private Collection

In many ways very similar to no.43 above, this
sketch is the only one in this section, except no.40,
that does not include a human figure. Was
Dunthorne, or whoever the man in the black hat
was, not available, or did Constable feel that a
human presence would be detrimental to the mood
of his sketch?

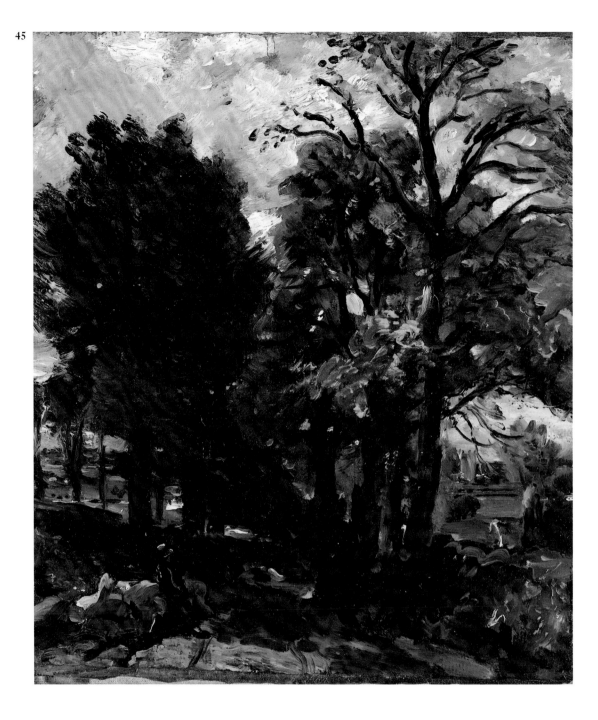

45

45 **Fen Lane** *c.*1811

Oil on paper laid on canvas 220 × 195
($8\frac{11}{16} \times 7\frac{11}{16}$)
PROV: . . .; bt by Mr and Mrs Paul Mellon
1972 and given by them to Yale Center 1981
(B1981.25.142)
EXH: New York 1983 (8, repr. in col.)
LIT: Cormack 1986, p.68, pl.66 (col.);
Rosenthal 1987, p.59, pl.47

*Yale Center for British Art, Paul Mellon
Collection*

A sketch made on Fen Lane, which leads down to
the Stour and Fen Bridge from the East Bergholt-
Flatford lane (see also the 'Dedham Vale: Morning'
section above and no.91 below). The tower of
Dedham church can be seen across the meadows at
the right.

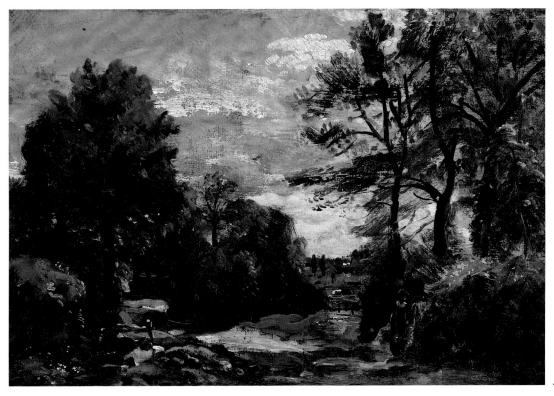

46

46 A Lane near Flatford *c*.1811

Oil on paper laid on canvas 203 × 303
(8 × 11$\frac{15}{16}$)
PROV: . . .; Henry Vaughan, probably by 1875
and bequeathed by him to the National
Gallery 1900; transferred to the Tate Gallery
1951 (N 01821)
EXH: New York 1983 (6, repr. in col.); Japan
1986 (7, repr. in col.); *The Pastoral
Landscape: The Legacy of Venice and the
Modern Vision*, National Gallery of Art and
Phillips Collection, Washington, Nov. 1988 –
Jan. 1989 (86, repr. in col.)
LIT: Smart and Brooks 1976, pp.107–8,
pl.65; Hoozee 1979, no.144, repr.; Barrell
1980, p.144, repr. with detail p.142; Parris
1981, no.10, repr. in col.; Rosenthal 1983,
p.177, fig. 207; Cormack 1986, p.63, pl.56;
Lawrence Gowing, 'The Modern Vision' in
R. Cafritz, L. Gowing, D. Rosand, *Places of
Delight: The Pastoral Landscape*, Washington
1988, pp.220, 223, fig.180 (col.)

Tate Gallery

This is probably a scene on Fen Lane. Smart and
Brooks argue for the viewpoint being close to the
one adopted for 'The Cornfield' (no.165), in which
Constable re-used the figure of the drinking boy
seen first in this sketch. The other figure, a girl
apparently holding a water-jug, does not reappear
in any other known work.

Lawrence Gowing has proposed that this is not
an outdoor oil sketch but 'an endeavor to evoke
painting from nature in the studio', a 'sketch-type'

picture which Constable 'painted out of his head'
with his 'memory and encyclopaedic knowledge of
pastoral convention for guides'. More particularly
Gowing suggests an engraving in reverse after
Poussin's 'Landscape with Diogenes' (Louvre;
Anthony Blunt, *The Paintings of Nicolas Poussin*,
1966, no.150, pl.188) as a possible source for the
work. He also thinks that no.46 may have been
'painted in the course of evolving the design that
became *The Cornfield*'. This is a radical rethinking
of what has usually been seen as a typical, if
exceptionally fine, example of Constable's outdoor
work in the years around 1811. It seems debatable
that even Constable's highly retentive memory
could have produced so detailed and vivid a sketch
as this, for which no drawings are known, and the
reason for him wanting to recreate in the studio
what he could so much more easily paint on the
spot is far from clear. Around 1811, a date
apparently accepted by Gowing, Constable was
still very much committed to the idea of painting
from the motif. Nor does it seem likely that he
already had 'The Cornfield' in view at this date.
The figures may possibly be inventions, either
made up on the spot or added in the studio but they
could just as well be additions made on the spot
from sketchbook drawings (cf. the cow in no.19) or
direct painterly notations of actual figures encoun-
tered on the lane, not necessarily simultaneously,
during the hour or so Constable spent there.
Whether the boy was encouraged to drink from the
stream because Constable recollected an appropri-
ate print after Poussin (or, as Rosenthal suggests,
Claude's painting of 'Narcissus'), we will never
know.

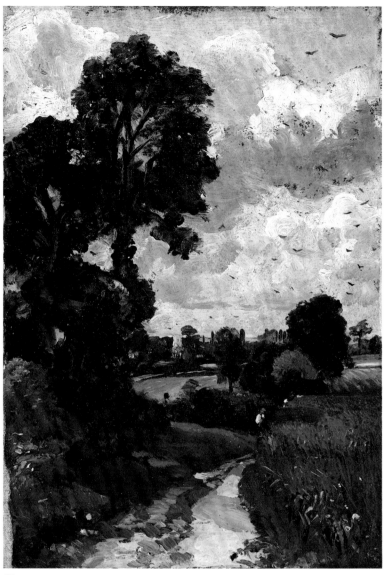

47

47 'Stoke-by-Nayland' 1816

Oil on paper laid on canvas 267 × 184
($10\frac{1}{2} \times 7\frac{1}{4}$)
Inscribed in a later hand on paper edging of
lining canvas at top centre 'J Constable RA.';
inscribed by Lionel Constable on a label on
the stretcher '30ᵗʰ July 1816.|L.B.C.'
(presumably copying his father's original
inscription) and in a different hand on the
back of the lining canvas 'Stoke by Neyland|
Suffolk|By John Constable R A'
PROV: By descent to Isabel Constable who
gave it to Alice Fenwick, neé Ashby,
probably in the 1880s; thence by descent to
Major C.W. Maffett; Trustees of the Mrs
D.H. Maffett Will Trust, sold Christie's 18
Nov. 1983 (88, repr. in col.); present owners
LIT: Parris 1983, pp.220–3, fig.36; Fleming-
Williams and Parris 1984, pp.89, 133, repr.
frontispiece (col.)

Mr and Mrs David Thomson

The old identification of the church as Stoke-by-
Nayland is incorrect but its true identity has not yet
been established. The late watercolour shown here
as no.344 is based on this oil sketch, which was
painted the day after the Ipswich 'Willy Lott's
House' (no.62).

The massing of trees on the left, the central,
sandy lane and the view of the church across fields
parallel some of the key features of 'The Cornfield'
(no.165), though this, we later argue, was based
principally on an oil sketch made the following
year, 1817 (no.163).

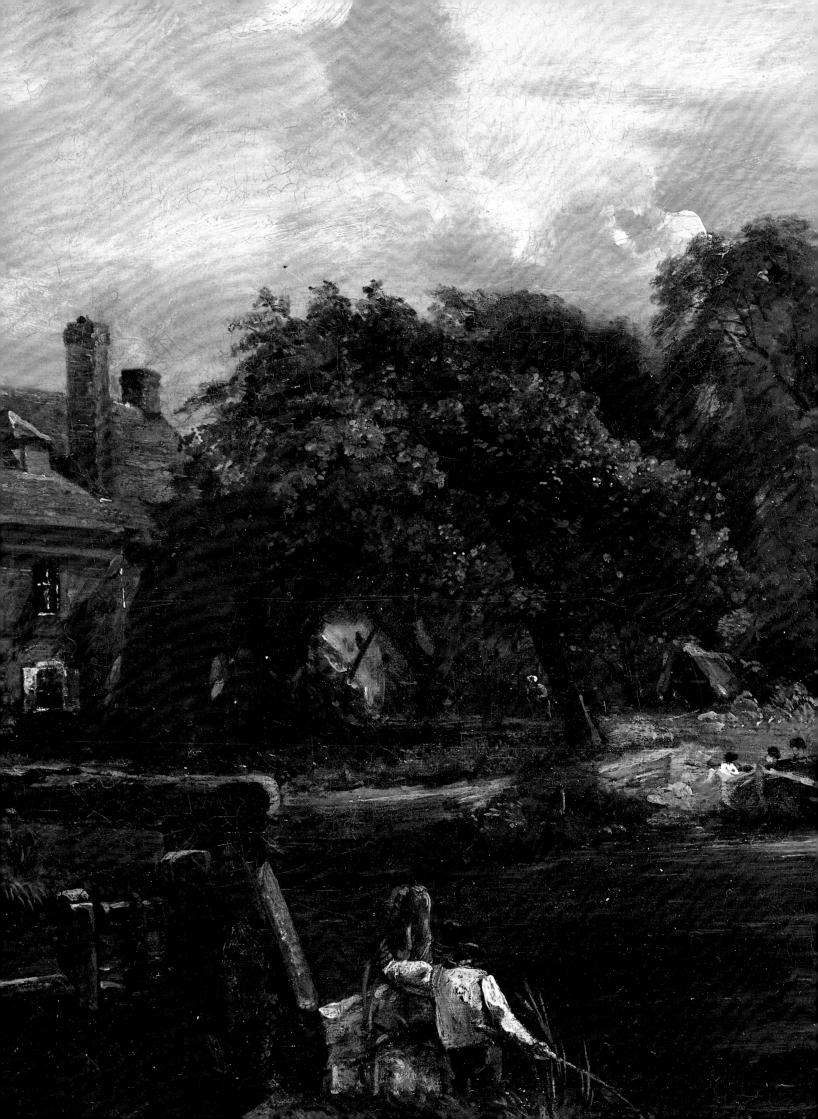

The River

The Act of Parliament for making the 'River Stower' navigable was passed in 1705. Work on the construction of the waterway was begun in 1708 and appears to have been completed by 1713. Commissioners were appointed to see to the running of the Stour and its traffic and it is in the minutes of their meetings that we find members of the Constable family making their first appearance in the history of the river. In 1744 it was ordered that Abraham Constable 'be allowed to Navigate' from Flatford to Manningtree for the sum of five guineas, apparently the annual charge (ESRO E 11 1324/1). This was the great-uncle of the artist, from whom his father, Golding, inherited the copyhold of Flatford mill. Another great-uncle, Daniel, in 1755 appears as the joint owner of a coal-yard at Cattawade, at the mouth of the river, a business Golding later took over. Golding succeeded to the tenancy of Flatford when Abraham died in 1764. By the 1780s he had become a figure of some consequence in the management of the river. He had family backing, four of his brothers-in-law being Commissioners. In 1782, with a colleague, William Strutt, he was asked to make a survey of the entire length of the river, from Sudbury to Brantham. Their most comprehensive report on the condition of the river, with its shoals, staunches, locks, etc., – two feet five inches was the depth of water they recommended – was received on 30 September 1782. When Golding died in 1815, Abram, the artist's younger brother, took over the business and the running of Flatford mill.

The Stour was rendered navigable from Sudbury to Brantham, a distance of twenty-three and a half miles. It took about two days for a barge to reach Manningtree from Sudbury, having passed through thirteen locks. In 1797 eighteen pairs or 'gangs' of barges and three single ones (thirty-nine vessels) were working the river. Tolls were paid at the locks according to the type of cargo – at Flatford, wheat was 1s, barley 9d, malt 6d and clover-seed 1s 4d. Other cargoes, bricks, oil, butter, pitch, paper, etc., were taken downstream; coal, marl and London night-soil were brought upstream from the quays at Manningtree.

For locomotion the barges were mostly dependent on horse power, though some skippers made square-sails for their craft out of sacking as an aid, and many of the smaller vessels were properly equipped with masts and sails (see no.162). Each horse had its 'leader'; boys or smaller men (see no.89) were preferred for the job – towing was tiring work for the animals. Where the tow-paths (known on the Stour as haling-paths) crossed over from one bank to the other, the horses were trained to leap on to the barge to be ferried across and then to leap off onto the opposite bank. There were thirty-three crossings between Sudbury and Brantham. As the haling-path on the right bank below Flatford had become dangerous, in 1798, on Golding's suggestion, the Commissioners ordered that 'a new haling Path for the towing and hailing of Boats, Barges, Keels, Lightors, or other Vessels' should be made on the other side, on land 'in the Occupation of John Lott the younger'. Constable depicted this crossing in 'The White Horse' of 1819 (fig.65 on p.194). To prevent cattle from straying, 'jumps', barriers three feet high, were

built across the haling-paths at field conjunctions. William Cardy (born 1863), when he was a leader as a boy, remembered falling off many times when attempting a jump on a horse's back (Ambrose J.R. Waller, *The Suffolk Stour*, Ipswich 1957, p.19). In Constable's 'Leaping Horse' (no.162) horse and rider seem to be negotiating the jump reasonably successfully.

Flooding and the effects of general wear and tear required constant vigilance along the banks of the Stour. Flatford lock was entirely rebuilt in 1776, yet two new gates had to be built there in 1791 and in 1793 there were repairs to 'several, Galley Beams, Posts & warfing' and a 'New Gate next the House', i.e. the mill-house (ESRO EE 501, 'Book of Repairs'). Abram Constable made his first appearance before the Commissioners in September 1815 to complain about the ruinous state of the lock, also that 'the Float Jump in Float Meadows over the County River is very dangerous, and in decay – and that Dedham Lock is also in great decay'. The Float Jump, where the old county river left the navigable Stour, was the scene of no.162, 'The Leaping Horse'. Abram was plainly agitated about Flatford when he returned to make a series of complaints to the Commissioners in 1820, 1821 and 1822 (see the entry for no.158) and again in May and September 1828 and September 1829, when the lock was losing a lot of water and the shoal below the lock was impeding navigation. Of particular interest in our context is the entry in the Stour Commissioners' Minutes for a meeting on 4 May 1808, which records Constable standing in for his father with complaints about the condition of the haling-paths on the sea-wall at Brantham, the shoal below Flatford and the loss of water in the lock, about the condition of Dedham lock and its gates and also about the Float Jump over the county river, this last seemingly a perpetual source of trouble (ESRO E 11 395/1).

Constable was attracted by rivers and canals wherever he went, whether it was the Thames (nos.283–5), the Wiltshire Avon and Nadder (nos.135, 138, 292), the Arun (no.334) or the Severn (no.341). But it was his native stream, the Stour he knew so well, that became the prime source of subject matter for his set-pieces. The list of paintings he made of scenes from its banks, or from the surrounding slopes with the river below, represents the greater proportion of his major exhibited works. He once said, 'a man sees nothing in nature but what he knows' (Beckett VI 1968, p.113). Certainly, nature is seen best when most understood, and for Constable there was nothing he understood better (having worked and played there long before he became a painter) than the Essex/Suffolk Stour and the life it bore.

In one of John Fisher's letters to Constable he tells of a fishing expedition that he had recently enjoyed. 'I had nearly forgotten to tell you', he wrote, 'that I was the other day fishing in the New Forest in a fine, deep, broad river, with mills, roaring back-waters, withy beds, &c. I thought often of you during the day. I caught two pike, was up to the middle in watery meadows, ate my dinner under a willow, and was happy as when I was a

"careless boy"' (Leslie 1845, p.91, 1951, p.84). This simple yet evocative account touched Constable deeply and released in his reply a small flood: a broken chain of associated ideas that in its entirety makes more sense of the several passages from it that are so often quoted separately:

How much I can Imagine myself with you on your fishing excursion in the new forest, what River can it be. But the sound of water escaping from Mill dams, so do Willows, Old rotten Banks, slimy posts, & brickwork. I love such things – Shakespeare could make anything poetical – he mentions "poor Tom's" haunts among *Sheep cots* – & *Mills* – the Watermist & the Hedge pig. As long as I do paint I shall never cease to paint such Places. They have always been my delight – & I should indeed have delighted in seeing what you describe ⟨with you⟩ in your company "in the company of a man to whom nature does not spread her volume or utter her voice in vain" [Dr Johnson: see Rosenthal 1983, p.137].

But I should paint my own places best – Painting is but another word for feeling. I associate my "careless boyhood" [Gray] to all that lies on the banks of the *Stour*. They made me a painter (& I am gratefull) that is I had often thought of pictures of them before I had ever touched a pencil, and your picture ['The White Horse'] is one of the strongest instances I can recollect of it.

(Beckett VI 1968, pp.77–8)

The Stour

With two exceptions, Constable exhibited a major painting of a river Stour subject every year at the Royal Academy from 1812 to 1825. He appears to have begun working purposefully at Flatford in 1810, having earlier – as we have seen – chosen upland subjects in which the Stour is no more than a distant glimmer. The river and the people who worked on it soon became as central to his art as they had long been to the life of his family. Flatford mill, in particular, became, as Ann Bermingham says, 'as much Constable's business as his father's' (1987, p.105).

This section devoted to Constable's early work at Flatford begins with two oil sketches made in or around 1810. One (no.49) was taken up again briefly a few years later, the other image appears to be unique; neither led to further paintings. With the studies he made soon afterwards of Flatford mill from the lock, however, Constable found a more promising subject.

48 **View on the Stour** 1810

Oil on canvas 267 × 267 ($10\frac{1}{2}$ × $10\frac{1}{2}$)
Inscribed '27. Sep.ʳ 1810.' t.r.
PROV: By descent to Isabel Constable, who died 1888; sold anonymously, presumably on behalf of her heirs, by Ernest Alfred Colquhoun, Christie's 28 May 1891 as one of the works 'Exhibited at the Grosvenor Gallery, 1889 [298], as the Property of Miss Isabel Constable, deceased' (118) bt Colnaghi; French Gallery, where bt by John G. Johnson 1891; bequeathed by him to the city of Philadelphia 1917 and later housed in the John G. Johnson Collection at the Philadelphia Museum of Art (no.857)
EXH: Tate Gallery 1976 (92, repr.); New York 1983 (2, repr. in col.)
LIT: Hoozee 1979, no.109, repr.; Cormack 1986, pp.61–2, pl.53

John G. Johnson Collection, Philadelphia Museum of Art

In recent years this study has been identified as a view looking upstream towards Flatford lock but if that were the case the trees on the far bank would be those seen at the right of no.54 below. In the latter the trees in question are in a row at right angles to the river, whereas here they follow the bank. The identification is therefore uncertain, though it does seem likely that the sketch was painted somewhere at Flatford. A label on the back signed by Ella Constable (niece of Isabel and one of her heirs) gives the title 'On the Stour' and this is repeated in the catalogues of the 1889 exhibition and 1891 sale.

Like the study of sunrise painted three days later (no.23), this sunset study is one of the earliest works to reveal Constable's newly acquired mastery of the rapid outdoor oil sketch. The transience of the natural effect studied here suggests that Constable would have had very little time indeed to put the image on canvas.

The casual prominence of the date, writ large on

the front of the work, and the scrappy nature of the canvas Constable used, underline the private, note-taking aspect of his sketching activity. Like nos. 31, 35, 52 and other sketches, this work is painted on a fragment cut from a larger stretched canvas, two tacking edges of which remain at the left and bottom of the sketch (Cove, thesis). These would have been turned up and flattened in the studio to increase the available painting surface. (It would hardly have been practical to enlarge a freshly painted canvas in this way on the spot, as is implied in the catalogue of the New York exhibition.)

49 **A Barge below Flatford Lock** ?1810

Oil on (? paper laid on) canvas 197 × 324 ($7\frac{3}{4}$ × $12\frac{3}{4}$)
PROV: By descent to Isabel Constable, who died 1888; her heirs, sold Christie's 17 June 1892 (246) bt Leggatt; . . .; Leicester Galleries, from whom bt by Burton Mansfield, New Haven, 1906; his sale, American Art Association, Anderson Galleries, New York 7 April 1933 (8, repr.) bt Leo Elwyn & Co.; . . .; private collector, New York, sold Sotheby Parke-Bernet, New York 29 May 1980 (4, repr. in col.); present owner
LIT: Hoozee 1979, no.119, repr.; Fleming-Williams 1980, pp.217, 219, fig.4 (col.)

Paul Mellon Collection, Upperville, Virginia

The lock is seen here from the north bank of the Stour near Flatford mill. The trees with rounded tops at the left of the group are the pair that grew close to the footbridge and which figure promi-nently in the 1817 'Flatford Mill' (no.89). A towing horse waits on the bank, presumably to take on the barge which has just been poled away from the lock.

In his 1980 article Fleming-Williams pointed out that Constable returned to the subject of this

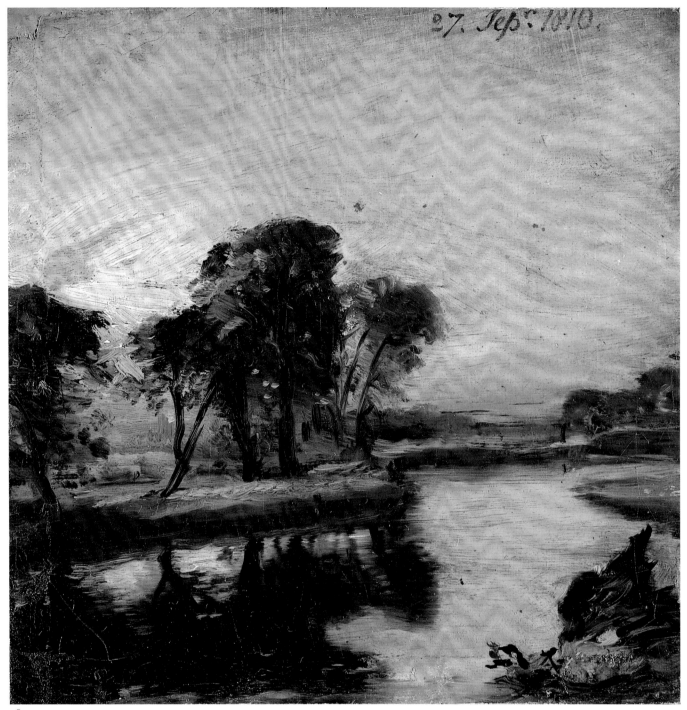

48

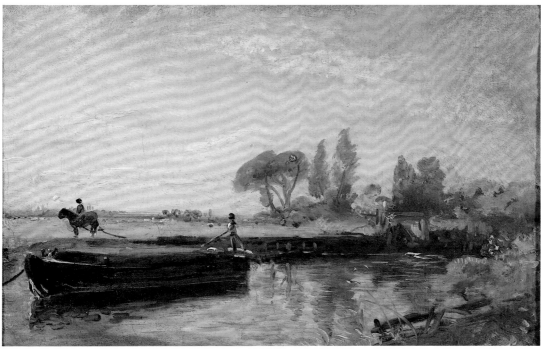

49

painting in three drawings made in his 1814
sketchbook (pp.25, 48, 51 of no.248 below; see
fig.35 for p.25). These appear to be compositional
studies made on the spot but no painted compo-
sition is known to have resulted from them:
'Possibly the original sketch [no.49] was too
complete a statement and the event too slight in
content to be developed'. As Fleming-Williams
notes, Constable was later to find a more satisfying
subject involving a barge and a towing horse, 'The
White Horse' (fig.65 on p.194, Frick Collection,
New York).

One of the features of the sketchbook drawings
mentioned above is the introduction of a large tree
in the right foreground. In no.49 there appears to
be an area of disturbed paint in the same place but it
is difficult to assess this before seeing the painting
itself again.

Two further related drawings have recently
come to light (Christie's 12 July 1988, lots 26–7).
One (lot 26) is a tracing of an image made on glass in
front of the scene itself (see under no.89 for this
technique); the other also appears to be a tracing
but not made in the same way. Neither includes the
barge and figures seen in no.49 but both present a
similar account of the landscape. The first of the
two is inscribed with two dates, 14 and 24
November 1813, the second is dated 6 November

fig.35 1814 sketchbook
(no.248), p.25, *Board of
Trustees of the Victoria and
Albert Museum, London*

that year. The relationship of these drawings to the
oil sketch has still to be properly investigated. If it
were thought that they were made as preparations
for it, both the dating of no.49 and our ideas about
the way Constable painted some, at least, of his oil
studies would need revising. On the other hand,
these new drawings may, like the 1814 sketchbook
pages, represent a later attempt to develop the
subject first observed in no.49.

Flatford Mill from the Lock

In retrospect in seems natural that Constable's first coherent group of river Stour paintings should have focused on his father's mill at Flatford. Whatever the psychology of the choice, the artistic possibilities of the site Constable chose were considerable: in the middle distance at the left, mill buildings seen across water, with trees to act as a balance at the right; in the foreground, often a plane Constable found difficult to articulate, lock gates and other timbers and the possibility of introducing figures around them. How to organise this material to best advantage is the problem we see him tackling in the four oil sketches that follow (nos.50–3). His solution was the painting entitled 'A Water-mill' exhibited in 1812 (no.54).

50
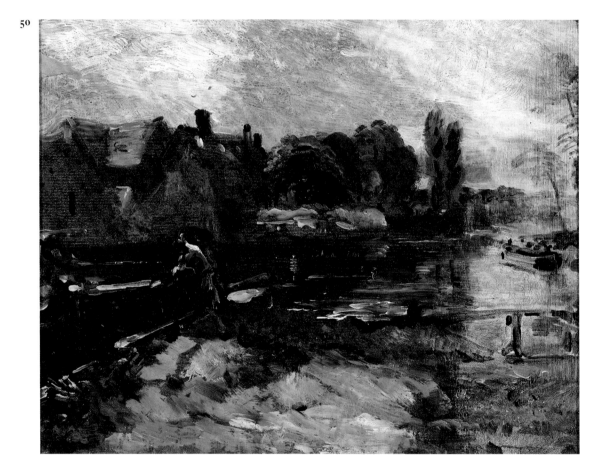

50 Flatford Mill from the Lock ?1810

Oil on paper 184 × 235 (7¼ × 9¼)
PROV: . . .; Spink & Son Ltd 1983; present owner
LIT: Fleming-Williams 1980, pp.217, 219, fig.1 (col.); Bermingham 1987, pp.129–34, fig.56

By Kind Permission of His Grace the Duke of Westminster DL

The four sketches shown here, nos.50–3, are placed in the order suggested by Fleming-Williams in his 1980 article. This presupposes that Constable began by focusing on the mill to the exclusion of the right-hand bank of the river and then 'panned' right. No.50, in which more of the mill buildings are visible than in any of the other sketches and the right-hand bank is hardly visible, seems in any case, from its comparatively tentative handling, to be the earliest of the group and may date from 1810. References in the Constable correspondence show that he painted more than one sketch of Flatford mill that year and that his uncle David Pike Watts wanted him to work up one into a small cabinet picture (Beckett 1 1962, p.55,

IV 1966, p.24). It seems likely that these sketches were of the view we see in nos.50–3.

The lock-keeper or boatman at the left of this sketch is winching up the paddles of the lock gates to empty the lock, probably for the barge waiting downstream at the right.

51 Flatford Mill from the Lock ?1811

Oil on paper laid on canvas 260 × 355 (10¼ × 14)
PROV: By descent to Isabel Constable, by whom given to the Royal Academy 1888
EXH: Tate Gallery 1976 (94, repr.); *Paintings from the Royal Academy: Two Centuries of British Art*, USA touring exh. (International Exhibitions Foundation, Washington) 1983 (27, repr. in col.); Japan 1986 (5, repr. in col.)
LIT: Hoozee 1979, no.114, repr.; Fleming-Williams 1980, p.219; Rosenthal 1983, p.59, fig.57; Bermingham 1987, pp.129–34, fig. 57; Rosenthal 1987, p.72, ill.52

Royal Academy of Arts, London

Constable shows less of the mill buildings here than in no.50 but, using a more horizontal format, is now able to include more of the right-hand bank. In the meadow beyond the trees reapers are at work. A similar sketch in the Huntington Library and Art Gallery (fig.203 on p.524, Tate Gallery 1976, no.95; Fleming-Williams 1980, fig.2 in col.) was presumably painted soon after since it shows haycocks in the same field. An inscription on the back indicates that it was painted in 1810 or 1811. The second year is more likely.

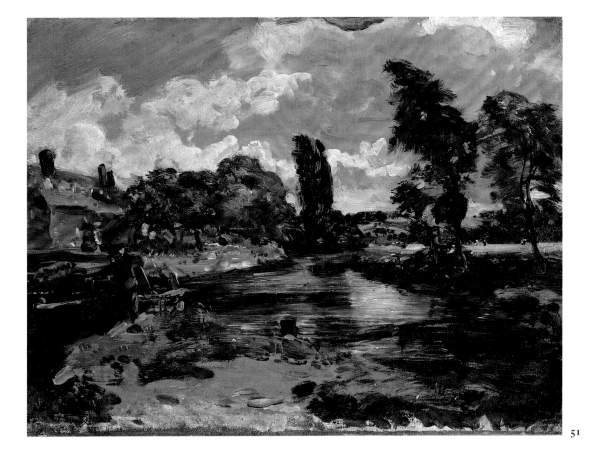

51

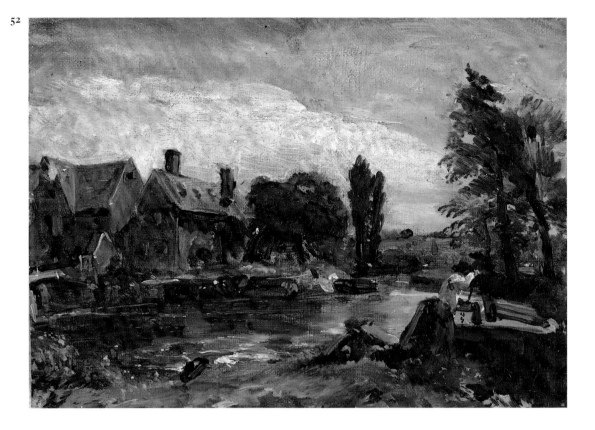

52

52 Flatford Mill from the Lock ?1811

Oil on canvas laid on board 152 × 212
(6 × 8⅜)
PROV: By descent to Isabel Constable, by
whom given *c*.1888 to R.A. Thompson, who
died 1909; by descent to Mrs Bell Duckett,
sold Morrison McChlery & Co., Glasgow 18
March 1960 (100, repr.) bt Agnew and sold to
a private collector; thence by descent to anon.
vendor at Christie's 24 April 1987 (46, repr.
in col.); present owners
EXH: Tate Gallery 1976 (96, repr. in col. opp.
p.49); New York 1983 (7, repr. in col.)
LIT: Hoozee 1979, no.115, repr.; Fleming-
Williams 1980, p.219, fig.3 (col.); Cormack
1986, p.64, pl.58; Bermingham 1987,
pp.129–34, fig.59; Cove 1988b, pp.59–63,
figs.1, 3 (raking light)

Mr and Mrs David Thomson

For this sketch Constable moved his position to the
other side of the lock, which now appears at the
right instead of the left. The mill buildings are back
in view but less of the meadow (where cattle are
now grazing) is visible. A barge is introduced again,
this time waiting at the left bank of the river. The
touch of blue and white near the barge reappears in
no.53 and probably represents a figure washing
clothes or filling a jug such as is found in some of
Constable's paintings of Willy Lott's house, for
example nos.58 and 62 below.

This sketch is painted on a fragment cut from
the same larger, stretched canvas as 'A Village Fair
at East Bergholt', dated 1811, in the Victoria and
Albert Museum (Reynolds 1973, no.101; see Cove
1988b and pp.524–5 below). A flattened tacking
edge and tack holes from the earlier stretching are
clearly visible in a band running across the sky
(fig.204 on p.524). The canvas used for the village
fair sketch originally abutted the left side of no.52.
Cove reports (p.525) that no.31 was probably also
painted on a fragment of the same larger canvas.

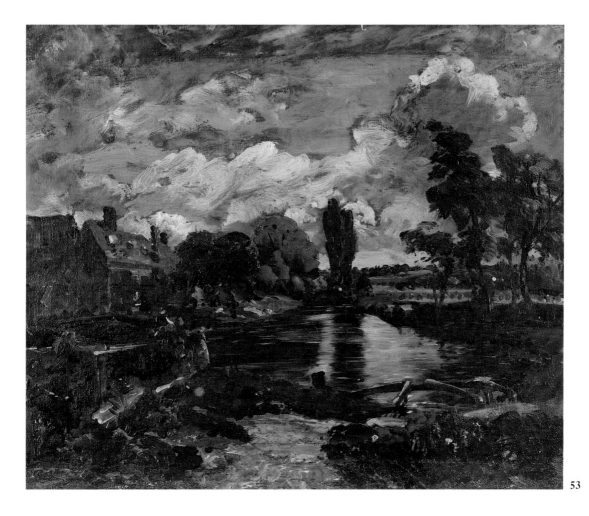

53

53 **Flatford Mill from the Lock** ?1811

Oil on canvas 245 × 295 ($9\frac{5}{8}$ × $11\frac{5}{8}$)
Inscribed on the stretcher in a later hand
'Minna Decr 27th 47', i.e. Maria Louisa
Constable's property at that date
PROV: As for no.2
EXH: Paris 1976 (16, repr.)
LIT: Reynolds 1973, no.103, pl.62; Smart and
Brooks 1976, p.138, pl.I (col.); Hoozee 1979,
no.113, pl.IX (col.); Barrell 1980, p.144, repr.
with detail p.143; Fleming-Williams 1980,
p.219; Rosenthal 1983, p.59, fig.56 (col.);
Cormack 1986, p.65, pl.63 (col.);
Bermingham 1987, pp.129–34, fig.60; Rhyne
1987, p.63, fig.9 (detail); Cove 1988b, pp.59,
61, 62, fig.4

*Board of Trustees of the Victoria and Albert
Museum, London*

This has been proposed as a studio sketch in which
Constable brought together elements from his
other studies of the subject (Fleming-Williams
1980, Cove 1988b, and see pp.525–6 below). It is
the most panoramic of all the sketches, including
on the left nearly as much of the mill buildings as
nos.50 and 52 and on the right as much of the
meadows as no.51 and the related Huntington
sketch. The timber framework in the right fore-
ground is now painted in more completely than
before and the height of the sky increased. Strips
along the top and bottom edges are later additions
(see p.526).

Whether or not painted in the studio, no.53 is
certainly the last in the series as we know it and the
direct basis for Constable's large painting of the
subject (no.54).

Apart from the Huntington sketch mentioned
under no.51, there are two others not exhibited
here which are related to the series: a squarish,
rather blond painting which excludes the mill and
shows a boy sitting by the edge of the lock
(Grosvenor Gallery 1889, no.274, Tate Gallery
1976, no.96a, repr.); and a study of the mill
buildings on the back of 'Miss Constable in her
Garden', sold Phillips 11 December 1984 (59, both
sides repr. in col.). There is also a drawing of the
subject dating from 1816 (Fleming-Williams 1990,
p.131, fig.123).

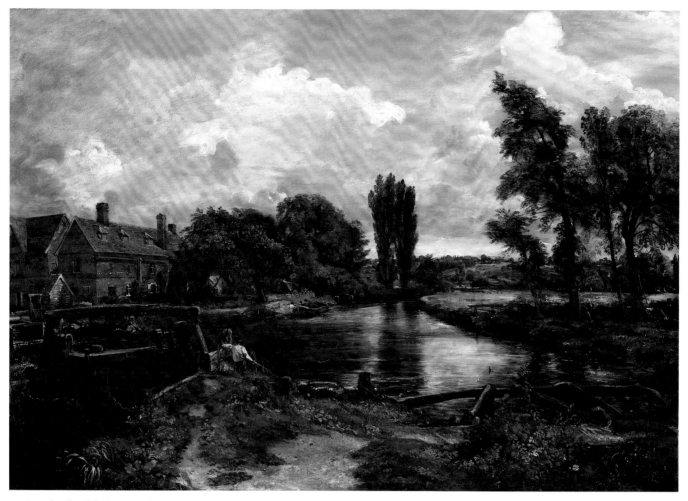

54 (see also detail facing p.117)

54 Flatford Mill from the Lock 1811–12, exh.1812

Oil on canvas 635 × 902 (25 × 35½)
PROV: ? Artist's administrators, sold Foster
16 May 1838 (67, 'View of Flatford Mills') bt
John Allnutt; . . .; R. Newsham by 1862; . . .;
Henry McConnell, sold Christie's 27 March
1886 (65) bt Brooks; . . .; Senator W.A. Clark,
New York, sold American Art Association,
New York 12 Jan. 1926 (99, repr.) bt in by
R.H. Lorenz; by descent to the Beneficiaries
of the Estate of K. Clark Morris, sold
Christie's 21 Nov. 1986 (105, repr. in col.);
present owners
EXH: RA 1812 (9, 'A water-mill'); New York
1983 (9, repr. in col.)
LIT: Hoozee 1979, no.124, repr.; Fleming-
Williams 1980, p.219; Charles Rhyne, 'The
Substance of Constable's Art', unpublished
lecture, College Art Association, San
Francisco, Feb. 1981; Rosenthal 1983,
pp.59–60, fig.58 (col.); Cormack 1986, pp.65,
73–6, pl.60 (col.); Bermingham 1987,
pp.129–34, pl.4 (col.); Rhyne 1987, p.63,

fig.10 (detail); Rosenthal 1987, pp.72–4,
ill.53; Cove 1988b, pp.59–63, fig.2; Rhyne
1990b, pp.77, 79, 83 n.32, figs.8–9 (details
before and after cleaning)

Mr and Mrs David Thomson

Like the 1811 'Dedham Vale: Morning' (no.14),
Constable's main exhibit at the following year's
Academy was preceded, as we saw in nos.50–3, by
a programme of oil sketching, culminating in
no.53. In painting his 1812 exhibit Constable at
first closely followed the composition of the latter
but then decided to paint out the figure of the red-
jacketed man at the lock. Traces of him can still be
seen on the surface and he is clearly visible through
infra-red reflectography (see figs.211, 213). A boy
fishing was introduced in his place and another
young angler, taking a nap while waiting for a bite,
was added at the right. X-radiography and infra-
red reflectography reveal another painted-out
figure at the right-hand side, a standing figure not
seen in any of the sketches. The roofs of the mill
buildings were originally painted higher up the
canvas and their original position is now clearly

visible again to the naked eye. These and other changes are discussed in detail by Sarah Cove (1988b and pp.526–7 below).

A barge, seen by the left bank in no.52, appears again in a similar place in the final painting. In or beside it are three figures while another is seen under the nearby trees, making for the mill buildings. Tiny figures also appear in the distant field on the right bank. While all these people may be supposed to be engaged in labour, the principal figures are clearly not. Constable's decision to reject the labouring lock-keeper and substitute two idling boys might seem like a failure of nerve, a concession to contemporary taste. But it might also represent a desire to heighten the autobiographical content of the picture. It was hearing his aptly named friend John Fisher talk of an angling expedition that prompted Constable in 1821 to make his now famous statement, 'I associate my "careless boyhood" to all that lies on the banks of the *Stour*' (Beckett VI 1968, p.78). Boys fishing were an integral part of Constable's next Stour painting (no.57) from its inception and provided the work with its title. Young anglers are also prominent in such later works as 'The Mill Stream' (no.61), 'Flatford Mill' (no.89) and especially 'Stratford Mill', also known as 'The Young Waltonians' (no.100). It is reasonable to suppose that fishing was very much part of Constable's own childhood. The man opening the lock was by no means forgotten, however, becoming the central figure in Constable's lock paintings of the 1820s (nos.157–60).

The Constable correspondence suggests that no.54 was well advanced by the autumn of 1811. In a letter of 26 October Mrs Constable told her son that his father 'rode down to Flatford on Friday – Your pretty View from thence is so forward – that you can sit by the Fireside and finish it – as highly as you please – & I am certain it will gain applause – for every one approves it – as it now is' (Beckett I 1962, p.67). Constable returned to Bergholt in late November for a few weeks and presumably took the picture back to London with him afterwards. No doubt the changes mentioned above were made there. By comparison with the sketches, the painting certainly has 'finish'. Unlike no.53, for example, the liveliness of which owes much to the jumps the eye is invited to make from one area of paint to another across the exposed priming colour, the surface of the final picture is painted all over with small, restrained strokes (see Cove 1988b and p.526 for a fuller discussion). Nevertheless, and despite its approval by the President, Benjamin West (Beckett II 1964, p.65), Constable's painting failed to sell at the Academy. Lost sight of for many years in an American collection, it has only recently been reinstated as a key work in Constable's early development.

Boys Fishing

Constable followed his 1812 'Flatford Mill' (no.54) with another painting based on a view from Flatford lock, this time looking in the opposite direction, upstream to the footbridge and Bridge Cottage (no.57). As well as including the lock in their foregrounds, both pictures take as one of their focal points a building seen across water and both include the figures of boys fishing. There are, however, striking differences between the works, partly because the 1813 picture was prepared in a new way.

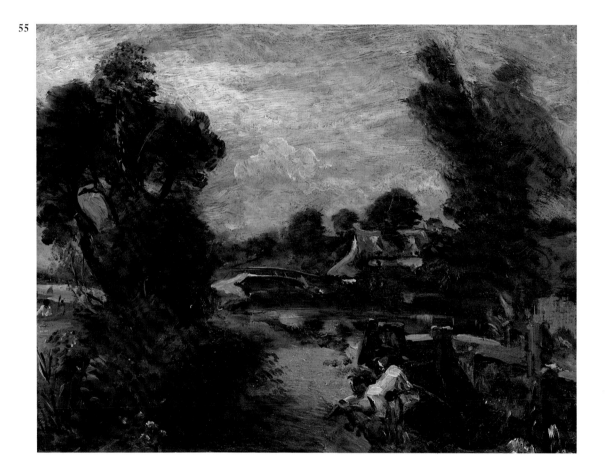

55

55 Study for 'Boys Fishing' ('A Lock on the Stour') ?1812

Oil on canvas 266 × 318 (10½ × 12½)
PROV: By descent to Isabel Constable, who died 1888; according to Christie's 1980 catalogue, bt from her by Francis Gibson, but more likely to have been included in the 1889 Grosvenor Gallery exhibition (?293) as the property of Isabel's heirs and sold for them at Christie's 28 May 1891 or 17 June 1892; Francis Gibson, by descent through Lewis Fry and Mrs Hugo Mallet to anon. vendor, Christie's 21 Nov. 1980 (69, repr. in col.); present owner
EXH: Milwaukee 1976 (17)
LIT: Hoozee 1979, no.173, pl.X (col.)

Merz Collection, Pal, Andorra

See no.56

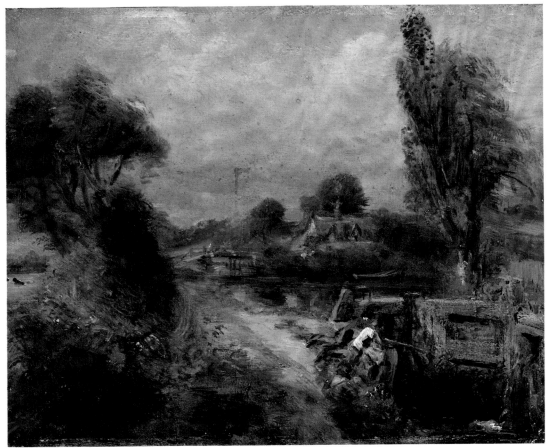

56

56 Study for 'Boys Fishing' ?1812

Oil on canvas 178 × 228 (7 × 9) sight
measurement
PROV: By descent to Isabel Constable
(according to label in Hugh Constable's hand
on the back, giving title as 'A Lock on the
Stour'); . . .; private collection

*Private Collection on loan to the Laing Art
Gallery, Newcastle upon Tyne (Tyne and
Wear Museums Service)*

Although half-a-dozen oil sketches are known for
the 1812 'Flatford Mill' (no.54), only three appear
to survive for 'Boys Fishing'. With the obvious
exception of the change in position of the boys, the
two sketches shown here depict the subject much as
in the finished painting: Constable is not exploring
angles of vision as he did in the 'Flatford Mill'
sketches, though no.56 presents a more open
version of the composition seen in no.55. A third
sketch, in the Louvre (RF 1937.23, Hoozee 1979,
no.172), has not been seen recently by the present
authors but is accepted by Rhyne (1990b, pp.79–
80). The composition is more or less identical to
that seen in nos.55–6 but no figures are included
and the handling is much more free.

While nos.55 and 56 appear to have been used to
establish the overall composition of the painting,
Constable relied on drawings for the detailed

fig.36 'Trees at Flatford',
*c.1812, Fondazione Horne,
Florence*

structure of the trees at the left and the lock gates. These drawings are, respectively, in the Fondazione Horne, Florence (fig.36, Tate Gallery 1976, no.117) and a private collection (fig.37, ibid., no.116, Fleming-Williams 1976, pl.13). Both are squared-up and more or less on the same scale as the painting; one is spattered with oil. These large working drawings mark a change in Constable's procedure, no doubt inspired by the scale of the canvas he was tackling.

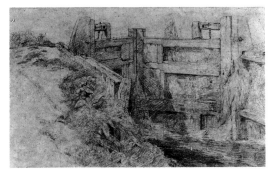

fig.37 'Flatford Lock', *c.*1812, *Private Collection*

57 Boys Fishing 1813, exh.1813

Oil on canvas 1016 × 1258 (40 × 49½)
PROV: Bt from the artist by James Carpenter 1814; . . .; Col. Unthank, sold Robinson & Foster 28 May 1897 (229); . . .; William Hartree, sold Christie's 25 April 1918 (96) bt in; . . .; Leggatt; 1st Baron Fairhaven, by whom bequeathed to the National Trust 1966
EXH: RA 1813 (266, 'Landscape: Boys fishing'); BI 1814 (98, 'Landscape; a lock on the Stour', frame 49 × 59 in); Tate Gallery 1976 (118, repr.)
LIT: Robert Hoozee, 'Constable's "Lock on the Stour" and John Dunthorne', *Connoisseur*, vol.191, Feb. 1976, pp.107–9, fig.4; Michael Kitson, 'John Constable at the Tate', *Burlington Magazine*, vol.118, April 1976, pp.251–2, fig.73; Graham Reynolds, 'John Constable: Struggle and Success', *Apollo*, vol.103, April 1976, p.324; Hoozee 1979, no.174, repr.; Rosenthal 1983, pp.63,

57

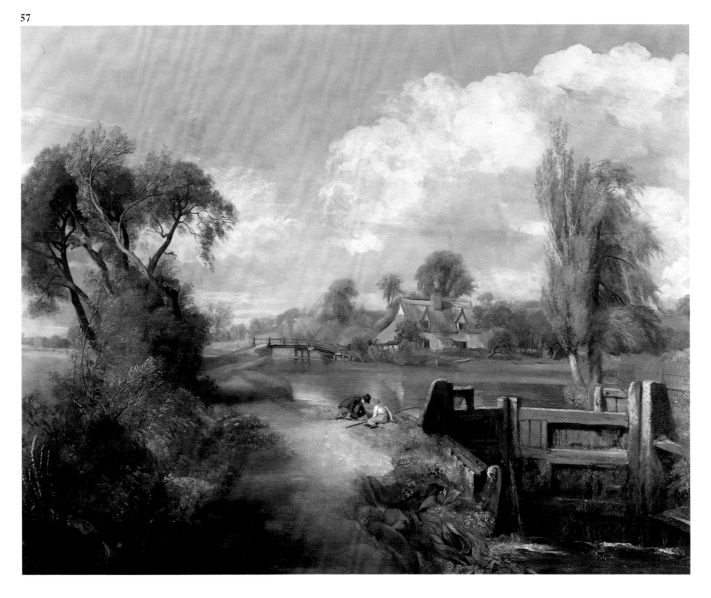

69, 243 n.59, fig.70 (col.); Cormack 1986,
p.80; Rosenthal 1987, pp.74–5, ill.57 (col.);
Fleming-Williams 1990, pp.191–2, fig.177

*Anglesey Abbey, The Fairhaven Trust (The
National Trust)*

With the exception of a five-foot Lake District
painting which is now untraced, 'Boys Fishing' was
the largest landscape, in terms of canvas area, that
Constable had so far painted. As suggested under
no.56 above, he appears to have felt a need to
approach the task in a new way by making large,
detailed drawings of key areas instead of relying
entirely on oil sketches as he did for 'Flatford Mill
from the Lock' (no.54) or oil sketches supple-
mented by sketchbook drawings as for 'Dedham
Vale: Morning' (no.14). The resulting contrast
between very informative areas – the trees at the
left especially – and comparatively bland passages
has, not unreasonably, worried recent commenta-
tors. Rosenthal, for example, finds that 'obtrusively
detailed work clashes with areas of matt green'
(1983). Some have rejected the picture altogether,
seeing nothing of Constable in its 'tired, flat and
weakly coloured surface' (Reynolds 1976). What is
generally overlooked is the present condition of the
painting. As a recent examination by Sarah Cove
has confirmed, the appearance of the work is
severely distorted by discoloured varnish, by thin,
smeary overpainting, especially in the sky and
trees, and by a number of thicker retouchings in the
foreground areas. It is hoped that cleaning and
restoration will return it to something like its
original and undoubtedly more lively appearance:
'silvery, sparkling, and true to the greyish-green
colouring of our English summer landscapes',
according to Robert Hunt's review in 1813 (*Exa-
miner*, 30 May 1813, p.348).

'Boys Fishing' was the first picture Constable
sold to a stranger. The Bond Street bookseller
James Carpenter bought it at the close of the 1814
British Institution exhibition, paying twenty gui-
neas and 'Books to a certain amount beyond that
Sum' (see Tate Gallery 1976). Carpenter later
purchased 'A Boat Passing a Lock', no.160 below,
and was the publisher of Leslie's biography of
Constable in 1843.

Willy Lott's House

Between them the 1812 'Flatford Mill' and the 1813 'Boys Fishing' introduce us to the larger part of the Flatford landscape that Constable was to make so peculiarly his own. One major Flatford site has not yet come into view, however: Willy Lott's house, just to the south-east of Flatford mill and hidden by it in the 1812 picture.

Lott was a tenant farmer but little is known of his activities. When his farm was put on the market in 1824 the artist's brother Abram thought it overpriced, its greatest value to the Constables at Flatford mill being 'to keep disagreeable people away, or else neither the quality of the land nor its situation is by any means desirable' (Beckett I 1962, p.216). The sale fell through and Lott remained in the house until after Constable's death, having been born in it and having, C.R. Leslie heard, 'passed more than eighty years without having spent four whole days away from it' (Leslie 1843, p.18, 1951, p.45). Lott appears to have been as picturesque as the house he lived in. According to David Lucas he used his deafness as an excuse for complaining and cursing after attending church one Sunday. Mrs Lott told him it was shocking: 'Shocking[,] replied Willey[,] why I never heard a word the parson said' (Parris, Shields, Fleming-Williams 1975, p.62).

Constable painted Willy Lott's house from across the river as early as 1802 (Tate Gallery 1976, no.35) but only started to explore the subject around 1811–12. From then on it became one of the key images in his art, the subject of, or setting for, some important early paintings seen in this section and later for 'The White Horse' (fig.65 on p.194, Frick Collection, New York), 'The Hay-Wain' (no.101) and 'The Valley Farm' (no.216). Three oil sketches of the house from different angles, describing part of a circle, are shown here first, not necessarily in chronological order (nos.58–60), before we see how Constable developed his ideas for paintings of it.

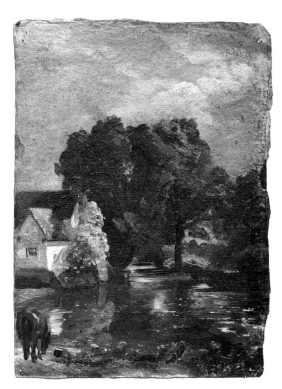

fig.38 'Willy Lott's House'
(reverse of no.58), ?c.1811,
*Board of Trustees of the
Victoria and Albert Museum,
London*

58 Willy Lott's House ?c.1811

Oil on paper 241 × 181 (9½ × 7⅛)
PROV: As for no.2
EXH: Japan 1986 (8, repr. in col.)
LIT: Reynolds 1973, no.110, pl.65; Smart and Brooks 1976, pp.82–8, 135–7, pl.45; Hoozee 1979, no.185, repr.; Rosenthal 1983, p.129, fig.172; Cormack 1986, p.128, pl.128 (col.)

Board of Trustees of the Victoria and Albert Museum, London

In nos.58–60 we look from behind Flatford mill towards Willy Lott's house. No.58 shows the water in the mill stream at a low level, exposing a sandy, shelving bank along which a dog is running. By Lott's house a woman is either collecting water in a jug or washing clothes. Between her and the large trees (which were on an island called 'The Spong') runs the main channel connecting the mill stream with the Stour (see fig.217 on p.532). At the right a more direct cutting through to the river can be seen.

This sketch corresponds fairly closely with the left-hand side of 'The Hay-Wain' (no.101). A similar sketch on the back (fig.38), painted further away from the house, shows a higher water-level and includes a horse instead of a dog. Both a dog and a horse appear on the bank in the full-size sketch for 'The Hay-Wain' (fig.68 on p.204, Victoria and Albert Museum), the horse being removed by Constable during his work on the final picture.

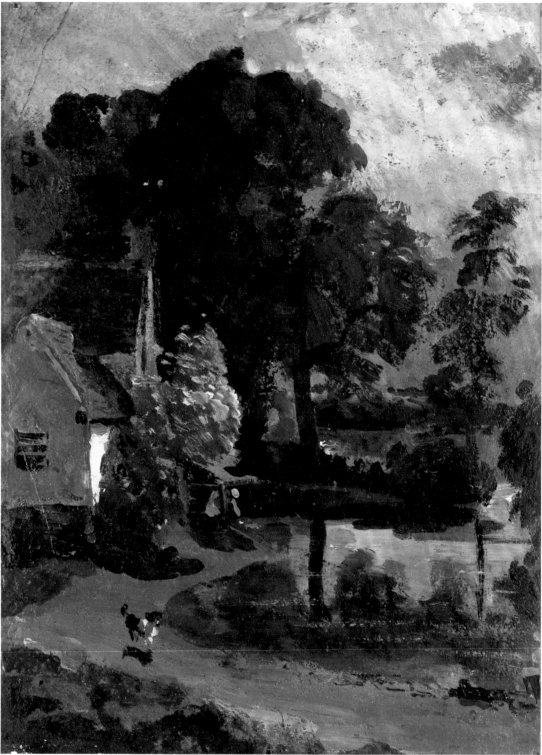

58

59

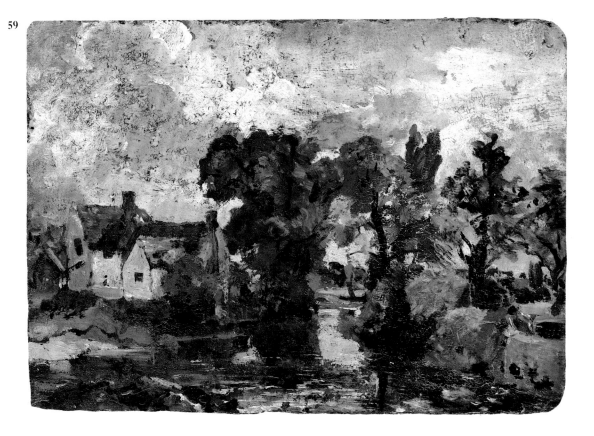

59 The Mill Stream *c.*1811–14

Oil on board 208 × 292 ($8\frac{3}{16}$ × $11\frac{1}{2}$)
PROV: By descent to Lionel Constable, sold
Christie's 2 March 1874 (164) bt Wigzell for
Henry Vaughan and bequeathed by him to
the National Gallery 1900; transferred to the
Tate Gallery 1919 (N 01816)
EXH: *Chiaroscuro and Constable*, Minories,
Colchester, June–July 1983 (no cat.)
LIT: Smart and Brooks 1976, pp.64–5, 82,
135–7, pl.32; Hoozee 1979, no.183, repr.;
Parris 1981, no.9, repr. in col.; Rosenthal
1983, p.69, fig.79 (col.); Cormack 1986, p.84,
pl.78; Rosenthal 1987, pp.77–8, ill.61 (col.)

Tate Gallery

Willy Lott's house is seen here from the forecourt
of Flatford mill, that is to say, from further away
than in no.58 and from a point further to the right.
The full extent of the mill stream is now visible,
with the main channel through to the Stour in the
centre but the short-cut out of sight at the right. A
boy leans over the mill parapet with a fishing rod
while smaller figures can be seen near Willy Lott's
house. The Ipswich 'Mill Stream' (no.61) was
based on this sketch.

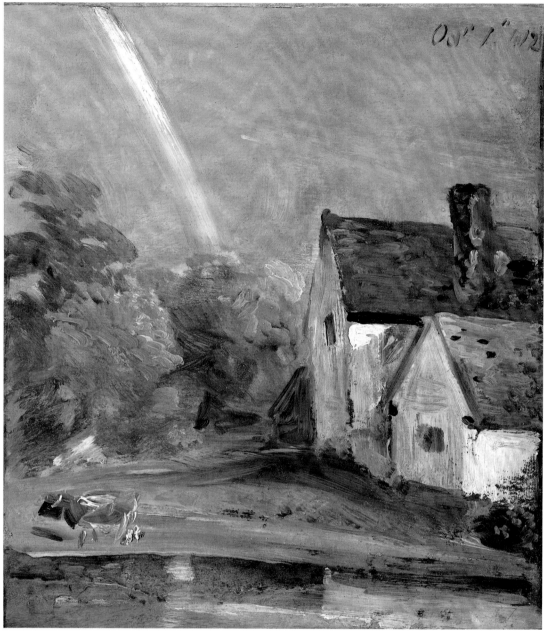

60

60 Willy Lott's House with a Rainbow 1812

Oil on paper laid on canvas 245 × 222
$(9\frac{5}{8} × 8\frac{3}{4})$
Inscribed 'Octr 1st 1812' t.r. and in later
hands on the stretcher 'J. Constable RA' and
on a label 'For Mrs Fenwick | from Isabel
Constable'
PROV: By descent to Isabel Constable who
gave it to Alice Fenwick, née Ashby,
probably in the 1880s; thence by descent to
Major C.W. Maffett; Trustees of the Mrs
D.H. Maffett Will Trust, sold Christie's 19
Nov. 1982 (46, repr. in col.) bt Leger, from
whom bt by present owner
LIT: Parris 1983, p.220, fig.35

Private Collection

Here Willy Lott's house is depicted from the right-
hand side of the mill stream as it appears in no.59.
The bull (a bizarre animal to find here) is standing
roughly where the dog does in no.58. Constable's
viewpoint was somewhere between the mill and the
short-cut through to the Stour mentioned in the
previous entries. In his 'Valley Farm' series (see
nos.63–6) Constable looked at Willy Lott's house
through the cut, thus moving further round the
circle described by nos.58–60.

This is an early instance of Constable's interest
in the rainbow, only preceded in his dated oil
sketches by 'Landscape with a Double Rainbow' of
28 July 1812 (Victoria and Albert Museum,
Reynolds 1973, no.117).

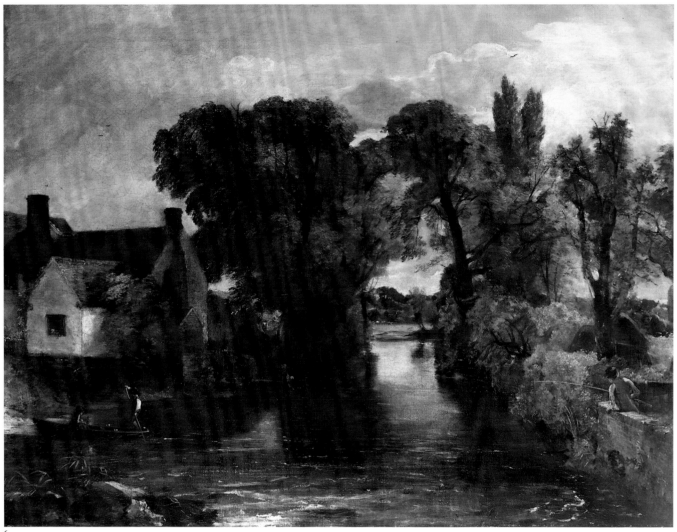

61

61 The Mill Stream *c*.1814

Oil on canvas 711 × 915 (28 × 36)
PROV:...; Thomas Turton (1780–1864),
Bishop of Ely, sold Christie's 15 April 1864
(149) bt S. Dunning, sold Christie's 3 May
1884 (137) bt Agnew and sold the same year
to Frederick Fish, sold Christie's 24 March
1888 (280) bt Lesser from whom bt the same
year by Henry Yates Thompson, sold
Sotheby's 2 July 1941 (210) bt present
owners
EXH: Tate Gallery 1976 (129, repr.)
LIT: Smart and Brooks 1976, pp.64–5, 82,
135–7, pl.31; Hoozee 1979, no.191, pl.XIII
(col.); Parris 1981, pp.54–6, fig.1; Rosenthal
1983, p.69, fig.80 (col.); Cormack 1986, p.84,
pl.77; Rosenthal 1987, pp.77–8, ill.62 (col.)

*Ipswich Museums and Galleries, Ipswich
Borough Council*

The three preceding oil sketches, as well as nos.62–6 below, show Constable looking at Willy Lott's house from a greater variety of angles than he applied, for example, to Flatford mill when sketching it from the lock (nos.50–3). Although the house always appears, there is no key foreground feature, like the lock, to anchor the viewpoint. The foreground is, in fact, nearly always occupied by water. We have a sense of Constable walking about and exploring a subject more fully than usual, albeit on different occasions.

The material he gathered through his oil sketches of Willy Lott's house served as the basis for a number of important pictures, beginning with two painted in or about 1814, nos.61 and 65. Of these, 'The Mill Stream' seems to represent his procedures at their most straightforward: a medium-sized canvas based closely on an oil sketch (no.59) executed not more than a few years before, with additional details taken from sketchbook drawings. Constable decided to cut the left-hand side of Willy Lott's house as it appears in the sketch but the composition is otherwise the same. The ferryman in his boat was probably taken either from a drawing now in the Royal Albert Memorial Museum, Exeter (fig.39) or from another sheet from the same sketchbook (Day 1975, pl.213).

Judging from Constable's paintings, the ferry plied between the far bank of the Stour and the bank of the mill stream by Lott's house, using the short-cut mentioned in previous entries. The 'Valley Farm' sketches and paintings (nos.63–6, 216) show it at various points on its journey. The woman reaching down to the water by Lott's house in no.61 is not included in the small sketch but appears, for example, in no.58.

'The Mill Stream' has not been identified as one of Constable's exhibited works (though it was once thought to be the 1814 'Ferry', no.65 below) but is certainly the sort of picture he would have hoped to sell. No work with this title appeared in the Administrators' sale after his death and, having been engraved as the 'Mill Stream' for *English Landscape*, it would almost certainly have been thus titled if it had been included. According to the *Dictionary of National Biography*, Thomas Turton (1780–1864), mathematician and theologian and the earliest recorded owner of the picture, was 'well known' for his 'taste in the fine arts' but at what date he developed a taste for Constable has still to be discovered.

fig.39 'A Ferryman', *Royal Albert Memorial Museum, Exeter*

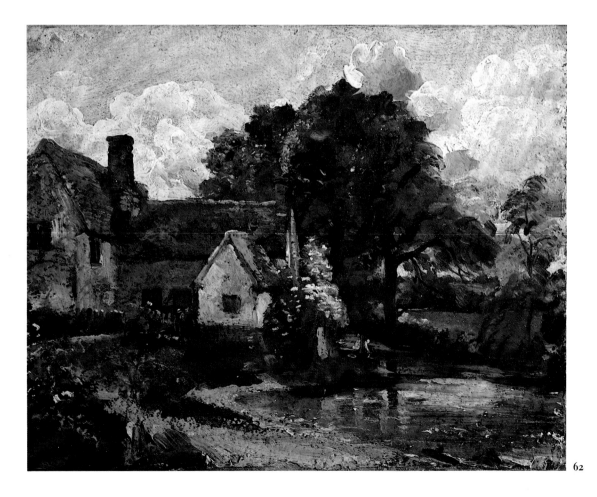

62

62 Willy Lott's House 1816

Oil on paper laid on canvas 194 × 238
($7\frac{5}{8}$ × $9\frac{3}{8}$)
Inscribed 'J. Constable – 29 July 1816' on the
back
PROV: . . .; C.R. Leslie, sold Foster 25 April
1860 (90) bt Thomas Churchyard, who died
1865; . . .; S. Herman de Zoete, sold
Christie's 8 May 1885 (159) bt McLean; . . .;
Benjamin Williams Leader, who died 1923;
his widow, sold Christie's 8 April 1927 (34)
bt Blaker; . . .; anon. sale, Christie's 15 Feb.
1929 (57) bt for present owners
EXH: Tate Gallery 1976 (144, repr.); New
York 1983 (16, repr. in col.)
LIT: Smart and Brooks 1976, pp.82–8, 135–
7, pl.49; Hoozee 1979, no.221, repr.;
Rosenthal 1983, pp.129–32, fig.169 (col.);
Cormack 1986, pp.96, 128, 129, pl.90;
Rosenthal 1987, p.117, ill.113

*Ipswich Museums and Galleries, Ipswich
Borough Council*

Although Constable worked through his idea for a
'Mill Stream' painting (nos.59, 61) fairly quickly,
he had by no means exhausted the possibilities of
the site. This dated sketch shows him looking at
Willy Lott's house again from a position similar to
the one he adopted when painting no.58 a few years
earlier. This time, using a horizontal format, he
extended the composition to the left to include
more of the house. The presence in both sketches of
the woman leaning over the water raises questions
about what he actually saw and what he chose to
add when painting no.62, which is usually assumed
to be an outdoor study because of the precise date it
bears. Like no.58, it was part of the material
Constable used when he came to paint 'The Hay-
Wain' (no.101).

As pointed out in the 1976 exhibition catalogue,
three artists connected in one way or another with
Constable owned the sketch after his death. One of
them, Thomas Churchyard, made his own copy of
it (Fleming-Williams and Parris 1984, p.220).

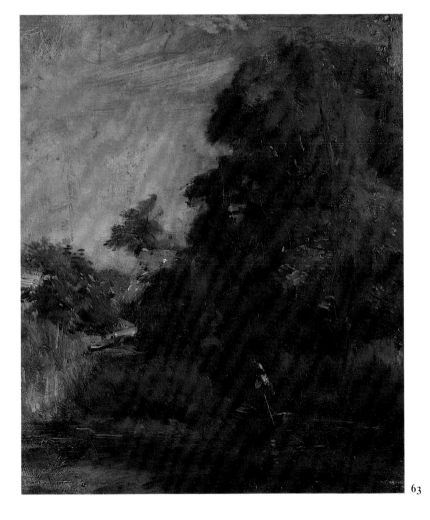

63

**63 Willy Lott's House from the Stour (The
Valley Farm)** *c*.1812–13

Oil on canvas 340 × 280 ($13\frac{3}{8}$ × 11)
PROV: As for no.2
LIT: Reynolds 1973, no.373, pl.268; Smart
and Brooks 1976, pp.126, 128, pl.80; Hoozee
1979, no.187, repr.; Parris 1981, pp.157, 162
n.4, fig.5; Rosenthal 1983, pp.69, 236, fig.78;
Cormack 1986, p.229, pl.216; Reynolds 1984,
no.35.2, pl.988 (col.); Parris and Fleming-
Williams 1985, p.166

*Board of Trustees of the Victoria and Albert
Museum, London*

See no.64

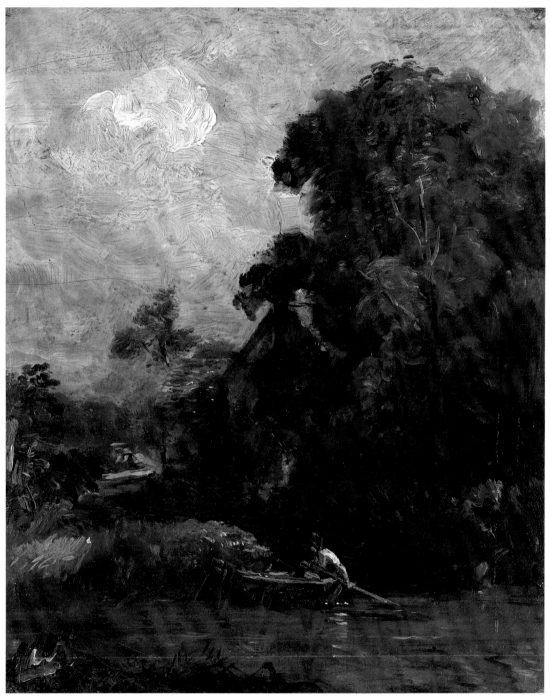

64

64 **Willy Lott's House from the Stour (The Valley Farm)** *c.*1812–13

Oil on canvas 254 × 210 (10 × 8¼)
PROV: As for no.2
LIT: Reynolds 1973, no.374, pl.269; Smart
and Brooks 1976, p.126; Hoozee 1979,
no.188, pl.XII (col.); Parris 1981, pp.157, 162
n.4, fig.6; Rosenthal 1983, p.236; Cormack
1986, p.229; Reynolds 1984, no.35.3, pl.989
(col.); Parris and Fleming-Williams 1985,
p.166

*Board of Trustees of the Victoria and Albert
Museum, London*

Willy Lott's house is viewed in nos.63–4 from the
south bank of the Stour, looking through the short-
cut to the mill stream (see fig.217 on p.532). The
large trees at the right are seen from the other side
to the right of the house in nos.58 and 62 above.

Constable painted Lott's house from this angle
in one of his 1802 studies (Tate Gallery 1976,
no.35, repr.) but there it is only a detail in a broader
view. A large and informative drawing made about

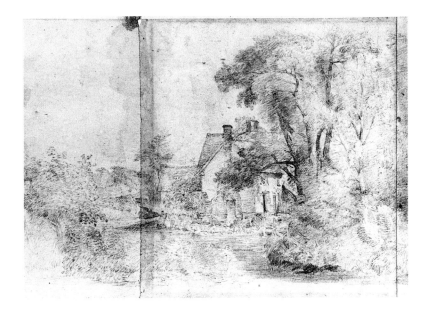

fig.40 'Willy Lott's House', c.1812–13, *Courtauld Institute Galleries*

1812–13 (fig.40, Courtauld Institute Galleries, ibid., no.115) appears to be the first version of the composition that Constable titled 'The Valley Farm' on its last appearance in 1835 (no.216). There are also two slight pencil sketches of the subject in his 1813 sketchbook (pp.31, 70 of no.247 below), the first including a boat on the bank by Lott's house, the second the suggestion of a ferry nearing the bank. Nos.63–4 appear to date from the same period, around 1812–13, and to be the immediate forerunners of Constable's 1814 exhibit 'The Ferry' (no.65), though Reynolds prefers to see them as late studio sketches made when Constable was working on 'The Valley Farm'.

fig.41 Detail from no.65

65 The Ferry 1814, exh.1814

Oil on canvas 1257 × 1003 (49½ × 39½)
PROV: ? Artist's administrators, sold Foster 16 May 1838 (additional lot, 83, 'Sketch Valley farm') bt in by C.R. Leslie for the family; by descent to Charles Golding Constable and sold by court order after his death, Christie's 11 July 1887 (87) bt Shepherd; . . .; Arthur Sanderson, anon. sale, Christie's 3 July 1908 (26) bt Lane; . . .; ? Heilbuth, Copenhagen; . . .; Mrs George Rasmussen, USA and Denmark, sold Christie's 25 Feb. 1938 (57) bt Leggatt; . . .; present owner by 1956
EXH: RA 1814 (261, 'Landscape: The ferry')
LIT: Parris, Fleming-Williams, Shields 1976, under nos.129, 137, 320; Hoozee 1979, no.192, repr.; Parris 1981, pp.54–6, 158, 159 fig.7; Rosenthal 1983, pp.69, 243 n.67; Cormack 1986, p.84; Reynolds 1984, under nos.35.1, 35.2

Private Collection

No.65 is now generally accepted as Constable's 1814 exhibit 'Landscape: The ferry', which is known from references in Farington's *Diary* to have been an upright landscape and larger than Constable's other exhibit that year, no.71 below (see Tate Gallery 1976 and Parris 1981 for discussion of the evidence). Constable himself also referred to the painting as being large and it is in fact the same size as his previous year's exhibit, 'Boys Fishing' (no.57 above), which was the biggest canvas he had by then exhibited. For 'The Ferry' Constable turned his 40 by 50 inch canvas the other way up, the first time he had painted an upright landscape on this scale. So far as we know, he did not use a large upright format again until he worked on 'The Lock' in the 1820s (see nos.157–8).

As with 'Boys Fishing', the scale of the 1814 picture seems to have created problems for Constable. Writing to John Dunthorne in February that year he confessed himself 'anxious about the large picture of Willy Lott's house, which Mr Nursey says promises uncommonly well in masses &c., and tones – but I am determined to detail but not retail it out' (Beckett I 1962, p.101). Constable could translate a small oil study into a medium-sized canvas, for example no.59 into 'The Mill Stream', no.61, without needing to add a great deal of detail. Adding sufficient but not too much to a large canvas like no.65 was a more difficult balancing act. His uncle David Pike Watts, who had criticised 'Boys Fishing' on the same score, thought he had not succeeded: 'in this *Boat Landscape*, where there is much to admire, there is this sad Trait to lament, namely hurry and slight of finish' (Beckett IV 1966, p.38). We may think differently. Watts did, however, reckon the work Constable's best 'except the small copy of Claude formerly painted', a suggestive remark since no.65 returns to the sort of Claudean formula used for the

1802 'Dedham Vale' (no.2), in which a group of tall trees acts as a repoussoir at the right. Like both the small Beaumont Claudes (figs.19–20 on p.60) which he copied, 'The Ferry' also includes a prominent foreground figure, a feature Constable was not ready to introduce in 1802.

When painting 'The Ferry' Constable appears to have relied principally on the two oil studies shown above (nos.63–4). The large drawing (fig.40 on p.141) mentioned under no.64 would have been less useful because it all but suppresses features of the tree group that Constable decided to emphasise in the painting: the hanging branch, like a forelock, that partially obscures the chimney, and the foremost tree on the right, only faintly seen in the drawing as Constable looks through it to the trees beyond. Neither the highest roof shown in the drawing nor the sunlit right-hand side of the cottage appear in the oil studies or the painting. As can still be seen with the naked eye, Constable originally painted the ferryman further to the left and apparently seated upright in the boat.

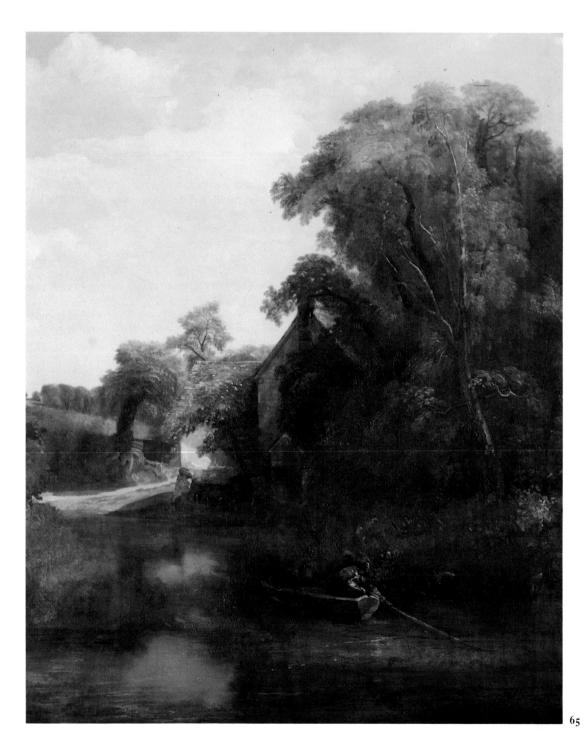

65

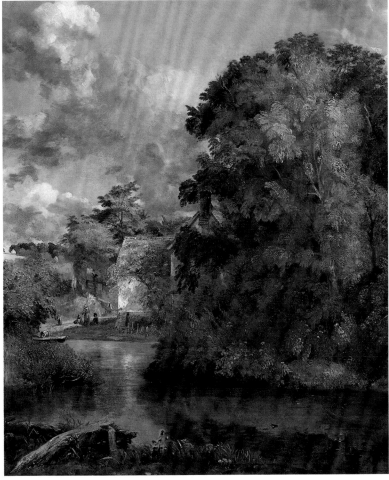

66

66 Willy Lott's House from the Stour (The Valley Farm) *c.*1816–18

Oil on canvas 610 × 508 (24 × 20)
PROV: . . .; Jonathan Peel, sold Christie's 11
March 1848 (47) bt James Lenox, New York
and given by him to the Lenox Library, later
part of the New York Public Library, for
whom sold by Parke-Bernet, New York 17
Oct. 1956 (41) bt Agnew; bt from Agnew and
Tooth by present owner's father 1956
EXH: Tate Gallery 1976 (137, repr.)
LIT: Hoozee 1979, no.210, repr.; Parris 1981,
p.158, fig. 8; Cormack 1986, p.229; Reynolds
1984, under nos.35.1, 35.2

Private Collection

Just as 'The Mill Stream' was not to be Constable's
definitive image of Lott's house seen across the tail-
water of the mill, so 'The Ferry' did not exhaust his
ideas for a picture of the house viewed from the
river. This smaller version of the subject was made
a few years later, perhaps around 1816–18, when
comparably detailed painting of foliage can be
found, for example in nos.76 and 94. A number of
the features introduced in it were used again in the
1835 'Valley Farm' (no.216), Constable's final
treatment of the subject: the timberwork in the left
foreground, the figures on the far bank and the boat
just by it, the man at the gate and the bird
skimming the water. Constable originally included
a ferry, still faintly visible towards the bottom
right, in the same place that it occupies in the 1835
picture. The timberwork appears also in 'The
White Horse' of 1819 (fig.65 on p.194). Constable
presumably based this detail of both paintings on a
drawing comparable to those of posts found on
pp.76–7 of the 1813 sketchbook (no.247, see
fig.127 on p.410).

Although in retrospect no.66 seems in many
ways a halfway stage between 'The Ferry' and 'The
Valley Farm', we do not know how Constable
regarded it and can only guess what his purpose in
making it was. Possibly it represents an attempt to
find a more satisfactory solution to the 'detailing
out' of masses, the problem he faced when painting
'The Ferry'.

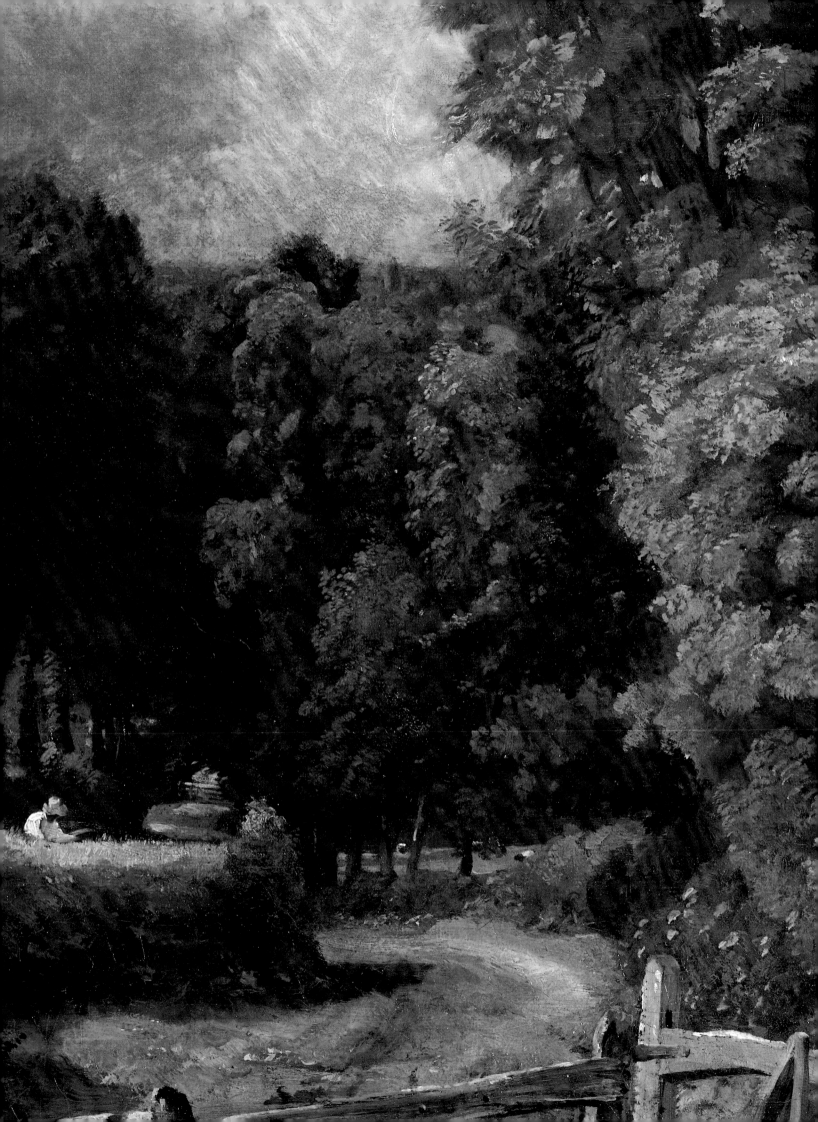

Paintings from Nature

In the first three sections of the exhibition we looked at Constable's early work in Suffolk and Essex, grouping sketches and paintings to bring out more clearly his interest in particular subjects and sites. The business of being 'a natural painter' was touched on from time to time and questions asked about outdoor painting and studio work and the relationship between the two. In this concluding section of 'The Suffolk Years' such topics are addressed more directly, just as Constable himself addressed them from about 1814 onwards. The paintings we have seen so far have generally been either small outdoor studies and sketches or larger works painted from them or from drawings in the studio. In 1814 Constable began to break down this distinction by painting pictures, as opposed to sketches, outdoors. He persevered for a few years, with remarkable results, before changing his methods again. The period marks the climax of his naturalism at its most literal.

Before proceeding with the story, we look back to Constable's work at Epsom and Malvern Hall, Warwickshire in 1809. Although his art was firmly rooted in his native landscape, visits to other places acted as a spur to Constable's early development. His Lake District tour of 1806 is perhaps the strongest instance of this (see nos.232–9). The 1809 works included here show him on the eve of his new dedication to oil sketching but also suggest that he was already trying, in 'Malvern Hall' (no.70), to make a complete painting from nature.

Detail from 'Fen Lane,
East Bergholt', no.91

Epsom and Malvern Hall 1809

67 **View at Epsom** 1809

Oil on board laid into synthetic panel
299 × 359 ($11\frac{3}{4}$ × $14\frac{1}{8}$)
Formerly inscribed on the back 'Epsom June.
1809' in pencil and 'Epsom. June. 1809 –' in
ink, the second inscription now separately
preserved
PROV: By descent to Lionel Constable, sold
Christie's 14 June 1873 (119) bt Henry
Vaughan and bequeathed by him to the
National Gallery 1900; transferred to the
Tate Gallery 1919 (N 01818)
EXH: Tate Gallery 1976 (87, repr.)
LIT: Hoozee 1979, no.65, repr.; Parris 1981,
no.4, repr. in col.

Tate Gallery

Earlier sections of the exhibition have included examples both of the 'laborious studies' in oil that Constable made in Suffolk in 1802 (nos.2–5) and of the remarkably vivid sketches he produced there in 1810 (for example, nos.23 and 48). What happened between 1802 and 1810 is still something of a mystery but we know that he had taken up oil sketching by 1808, the year inscribed on two surviving examples (Tate Gallery 1976, nos.82–3, repr.). The following year he made this study at Epsom and the double-sided Malvern–Bergholt work shown below as no.68. What prompted his

67

68

new interest in oil sketching is not known, though it is conceivable that he saw, as Farington did in April 1808, some of the 'small pictures in oil painted upon *paperboard*' made by Sir George Beaumont at Keswick in 1807 (Farington IX, p.3260: see fig.42 for a likely example).

Unlike the 1810 sketches, those of 1809 are restrained in handling and subdued in colour. In 'View at Epsom' paint is applied in the manner of flat watercolour washes and the trees are still seen as rounded masses, not dissimilar to the water-colours of 1805 (see nos.227–9).

Constable paid several visits to Epsom between 1806 and 1812 to see his aunt and uncle Mary and James Gubbins.

68 **Malvern Hall from the North-West** 1809

Oil 140 × 300 ($5\frac{1}{2}$ × $11\frac{13}{16}$) on board 308 × 327 ($12\frac{1}{8}$ × $12\frac{7}{8}$)
Inscribed on the reverse, 'Oct.ʳ 13. 1809. E.B.' and '1809' referring to the sketch of 'A Lane near East Bergholt with a Man Resting'
PROV: By descent to Isabel Constable, who died 1888; sold anonymously, presumably on behalf of her heirs, by Ernest Alfred Colquhoun, Christie's 28 May 1891 as one of the works 'Exhibited at the Grosvenor Gallery, 1889 [290], as the Property of Miss Isabel Constable, deceased' (135) bt Miley; . . .; H.A.C. Gregory, sold Sotheby's 20 July 1949 (116) bt C. Cookson; . . .; Agnew 1976; present owner
EXH: Tate Gallery 1976 (90, other side exhibited); *Painting from Nature*, Fitzwilliam Museum, Cambridge, Nov. 1980–Jan. 1981, RA, Jan.–March 1981 (62, other side exhibited)
LIT: Hoozee 1979, no.71, repr.; Parris 1981, p.40, fig.2

Private Collection

See no.69

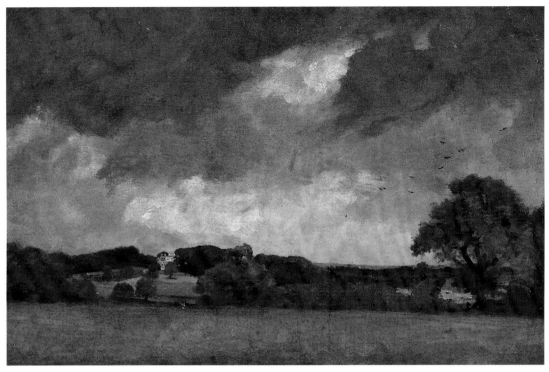

69

69 Malvern Hall from the South-West 1809

Oil on paper laid on canvas 317 × 495
($12\frac{1}{2}$ × $19\frac{1}{2}$)
PROV: . . .; James Warren; by descent to
present owner
LIT: Fleming-Williams 1990, p.94

Private Collection

Constable left for Malvern Hall, Solihull, on 15
July 1809 (see under no.241) and was still there on
1 August, the date inscribed on no.70 below. This
was the first of his two visits to the seat of Henry
Greswolde Lewis, brother of Magdalene, Dowager
Countess of Dysart, the second taking place in 1820
(see no.299). Lewis and the Dysarts employed
Constable on a variety of portrait, landscape and
miscellaneous artistic work over a period of twenty
or so years.

The purpose of Constable's 1809 visit appears to
have been to paint a portrait of Lewis's thirteen-
year-old ward Mary Freer but he clearly found
time to work for himself as well. A good number of
drawings made at or around Malvern Hall on this
visit are known, including no.241 below. In
addition, there are three oils, all exhibited here.

No.68 shows the house from the north-west with
the stable block towards the right. The technique is
similar to that of 'View at Epsom' (no.67), painted a
month or so earlier. Constable's economical use of
the board is conspicuous: one wonders whether he
intended to paint another sketch below this one or
had simply failed to take landscape-shaped boards
with him. On 13 October he used the other side of
the same board to paint the better-known sketch of
'A Lane near East Bergholt with a Man Resting'
(fig.23 on p.71), a forerunner of the 1811 painting
'Dedham Vale: Morning' (see no.10). This
October sketch is more confident and shows
Constable moving towards the freer technique of
the 1810 examples.

In no.69, exhibited and published here for the
first time, we see Malvern Hall from the south-
west, with the distinctive sloping line of trees, to
the right of the house in the small sketch, now seen
from the other side. This is a very different sort of
work, a small painting rather than a sketch, and
remarkable for its lowering sky. It seems not only
more ambitious than no.68 but also more assured.
It is tempting to imagine Constable gradually
working himself up to the still greater assurance of
the Tate 'Malvern Hall' (no.70) – gradually but
quickly, since he was there only for two weeks or so.

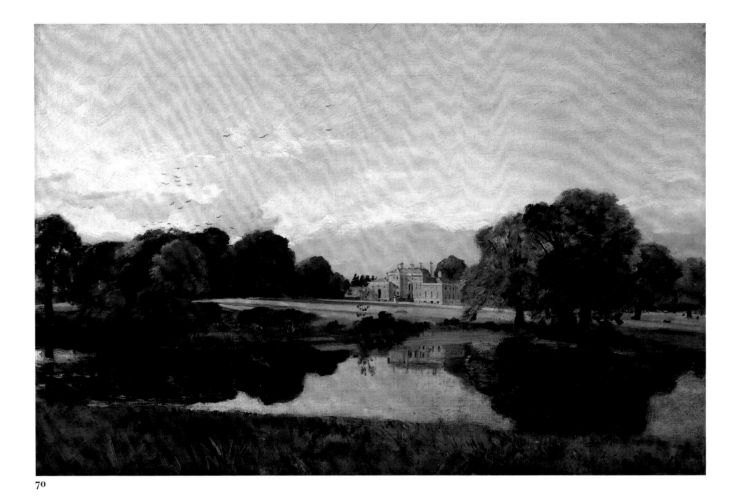

70

70 Malvern Hall 1809

Oil on canvas 515×769 ($20\frac{1}{4} \times 30\frac{1}{4}$)
Variously inscribed on the stretcher by J.H.
Anderdon, including 'Lined in 1840 \div | NB
on the original stretcher | was written in red
chalk | Malvern Hall Warwickshire | Augt1.
1809 | × apparently in the autograph of the
painter'
PROV: . . . ; James Hughes Anderdon by 1840
and sold Christie's 30 May 1879 (111) bt
George Salting and bequeathed by him to the
National Gallery 1910; transferred to the
Tate Gallery 1968 (N 02653)
EXH: Tate Gallery 1976 (88, repr.)
LIT: Hoozee 1979, no.67, pl.VI (col.); Parris
1981, no.5, repr. in col.; Rosenthal 1983,
pp.16, 44, fig.9; Reynolds 1984, under
nos.21.80, 21.81, 22.5; Cormack 1986, pp.32,
56, 99, pl.49 (col.); Rosenthal 1987, pp.15,
60, ill.4; Fleming-Williams 1990, p.94

Tate Gallery

Malvern Hall is seen this time from the south-east,
across the lake. The inscription on the back of the
drawing of the house shown below as no.241
confirms the date said to have been inscribed on the
original stretcher: '2 | August the first made the |
picture of the House from the | great pool'. It also
suggests that the painting was the work of one day,
a remarkable feat even allowing for the cursory
treatment of the foreground. Constable would have
had to work very quickly to capture the fading
afternoon light, though possibly he had done some
preparatory work on previous days. Despite the
unfinished foreground and the sketchy handling of
some other parts of the painting, it seems intended
as a complete statement and is possibly Constable's
first attempt to paint a picture, as opposed to a
study or a sketch, outdoors.

Following his second visit to Malvern Hall in
1820 Constable was commissioned by Magdalene,
Dowager Countess of Dysart to paint two views of
the house. One, now in the Museo Nacional de
Bellas Artes, Havana (Reynolds 1984, no.21.80,
pl.282), is a version of no.70 with various refine-
ments and additions.

A flight of rooks appears in all three of the

Malvern works shown here. Constable's fondness for this bird is attested by his concern when Lucas 'fooled with the rooks' while engraving 'Autumnal Sunset' (see no.184) and by his comment to Fisher in 1826 that the cawing of a rook was 'a voice which instantaneously placed my youth before me' (Beckett VI 1968, p.219). No doubt their presence at Malvern Hall in 1809 gave Constable that link with home territory that he always seems to have required.

fig.43 Details from no.70

Suffolk 1814–1816

71 **Ploughing Scene in Suffolk**
(A Summerland) 1814, exh.1814

Oil on canvas 505 × 765 (19⅞ × 30⅛)
PROV: Bt from the artist by John Allnutt at
the 1815 BI exhibition; reacquired from him
by Constable *c*.1825; . . .; ? George Simms by
1846; . : .; bt from a London dealer by Miss
Atkinson 1891; her niece Mrs L. Childs
c.1941–54; . . .; Leggatt, from whom bt by a
private collector and sold Christie's 16 July
1982 (29, repr. in col.) bt Leggatt; present
owners
EXH: RA 1814 (28, 'Landscape: Ploughing
scene in Suffolk'); Liverpool Academy 1814
(9, 'A Landscape – Ploughman', price 25
gns); BI 1815 (115, 'Landscape', frame
32 × 41 in); Tate Gallery 1976 (123, repr.)
LIT: Hoozee 1979, no.193, repr.; David
Blayney Brown, *Augustus Wall Callcott*, exh.
cat., Tate Gallery 1981, pp.75–6; Hawes
1982, pp.81–2, 185–6; Rosenthal 1983,
pp.18–21, 69–78, 83, figs.81 (col.), 91 (col.
detail); Reynolds 1984, under no.24.81;
Cormack 1986, pp.80–4, 88, 91, pl.75 (col.);
Rosenthal 1987, pp.76–81, ill.63 (col.);
Rhyne 1990b, p.76

Mr and Mrs David Thomson

fig.44 1813 sketchbook
(no.247), p.12, *Board of
Trustees of the Victoria and
Albert Museum, London*

'Ploughing Scene' was shown at the RA in 1814
together with 'The Ferry' (no.65 above). As will
shortly be explained, the problems Constable
encountered in painting the two works were among
the factors that inspired the new approach to
landscape painting he adopted later in 1814.

The picture presents a view of Dedham Vale
from just outside the grounds of Old Hall, East
Bergholt, with Langham church seen on the hills at
the left, Stratford St Mary church in the valley
towards the right and Stoke-by-Nayland church on
the skyline behind it. The field in the foreground is
shown being ploughed in the summer to stand
fallow until autumn manuring and winter sowing.
'A Summerland', the term applied to such a field,
was the title Constable gave to Lucas's print based
on the painting (fig.100 on p.321, Shirley 1930,
no.10). Relieving an otherwise bare foreground,
the dog sleeping on a blanket or coat and the
ploughmen's bottle resting against a clump of
weeds form a vignette of a kind that Constable was
to elaborate in the 1816 'Wheatfield' (no.76).

The painting was derived from a drawing
(fig.44) Constable made on p.12 of his 1813
sketchbook (no.247), which also contains, on
pp.52, 71 and 72, studies used for the two
ploughing teams. No oil studies are known. It
seems likely that further preliminary material,
perhaps in the form of more detailed drawings, is
missing. The ploughmen were added in February
1814. The letter from which we learn this is the one
Constable wrote to Dunthorne on 22 February,
which has already been quoted in connection with
'The Ferry'. After expressing his anxiety about the
latter ('I am determined to detail but not retail it
out'), Constable continued: 'I have added some
ploughmen to the landscape from the park pales
which is a great help, but I must try and warm the
picture a little more if I can. But it will be difficult
as 'tis now all of a peice – it is bleak and looks as if
there would be a shower of sleet, and that you know
is too much the case with my things' (Beckett 1
1962, p.101). Clearly, Constable was trying to pull
the picture together at a late stage, trying to
recreate summer at East Bergholt while working at
Charlotte Street in winter. The problems of
detailing the well-massed 'Ferry' and of warming
the 'Ploughing Scene' could not be satisfactorily
solved in the studio. 'I have much to say to you
about finishing of my studies more in future–', he
was led to conclude in the same letter, 'but I look to
do a great deal better in future. I am determined to
finish a small picture on the spot for every one I
intend to make in future. But this I have always
talked about but never yet done – I think however
my mind is more settled and determined than ever
on this point'. In the event, Constable skipped the
intermediate stage proposed here (though no.73 is a

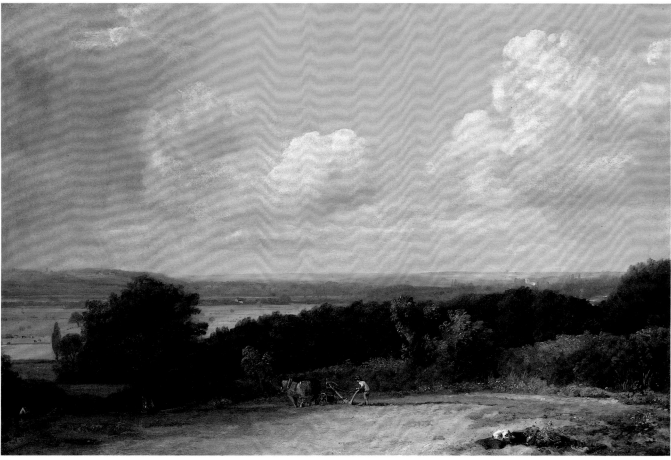

71

possible exception) and later in 1814 began work-
ing directly from nature on his final canvases.

The present condition of no.71 requires some
explanation. The painting was bought in 1815 by
the wine merchant and art collector John Allnutt of
Clapham. In a letter to C.R. Leslie, who published
it in his biography of Constable, Allnutt later
explained how he 'did not quite like the effect of the
sky' and 'was foolish enough to have that obliter-
ated and a new one put in by another artist, which,
though extremely beautiful, did not harmonize
with the other parts of the picture' (Leslie 1843,
p.116, 1951, p.47). 'Some years after' he asked
Constable to restore the painting to its original state
but at the same time to reduce its height to match a
painting by Callcott with which he wished to pair
it. Because he felt obliged to Allnutt for being the
first stranger to buy one of his pictures (he must
have reckoned Carpenter's acquisition of no.57 as
something less than a purchase), Constable decided
to paint a new version of the required size for
Allnutt and to retain the original for himself.
Annotating this account in his own copy of Leslie's
book, David Lucas identified the artist who
repainted the sky as John Linnell (Parris, Shields,
Fleming-Williams 1975, p.62), while in 1981
David Brown identified the Callcott painting as
'Open Landscape: Sheep Grazing', exhibited as 'A

study from nature' at the BI in 1812 and now in
York City Art Gallery.

Allnutt's second version of Constable's painting
is now at the Yale Center for British Art (fig.45,
Reynolds 1984, no.24.81; see also p.508). As well
as being smaller (425 × 760 mm) than no.71, it
includes a hawk hovering in the sky towards the
right, mobbed by smaller birds. The top of the oak

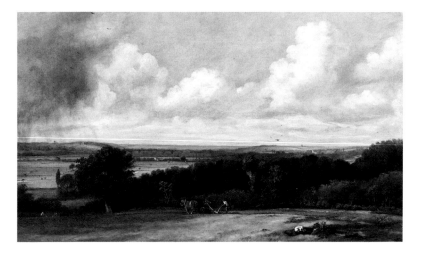

fig.45 'Ploughing Scene in
Suffolk (A Summerland)',
1825, *Yale Center for
British Art, Paul Mellon
Collection*

tree at the left is contained by the horizon rather than slightly projecting above the hills as it does in no.71. The exact date of the replica has been debated, Reynolds suggesting it was finished before January 1825, Brown proposing 1826. In the letter to Leslie quoted above, Allnutt said that 'the first interview [he] ever had' with Constable was when he called to see the new (or, as he initially thought, the restored) picture. Maria Constable's account of a visit by the Allnutts to Constable's studio on 21 or 22 January 1825, when the artist was absent, suggests that Allnutt and Constable had not yet met, since she took the trouble to inform her husband – what he would otherwise have known – that Allnutt was 'very deaf but a very good natured countenance' (Beckett 11 1964, p.375). They certainly met on 4 October that year, when Constable recorded a visit from Allnutt in terms that suggest that it was not the first (ibid., p.398). The second version of the 'Ploughing Scene' would therefore seem to have been finished in 1825.

The question of what Constable did with the original picture, no.71, when he retrieved it has hitherto been neglected. Comparisons of the two versions have been made on the assumption that Constable was responsible for the sky in no.71 as it appeared until recently, Linnell's repainting being quietly forgotten. On this basis, the sky in the Yale Center version has generally been judged more dramatic than that of the original picture. Since the latest sky in no.71 had none of Linnell's characteristics but was not altogether convincing as Constable's work, Sarah Cove was asked to carry out a technical investigation in 1989. John Bull had already noticed that the sky continued onto the paper edging of the relining canvas. Neither Linnell nor Constable is likely to have relined the picture so soon after its original execution. In addition, x-radiography revealed an underlying sky that was much closer to the stormier sky of the second version. The most probable explanation appears to be that Constable scrubbed off Linnell's sky when he took back the picture but did not attempt to make good the resulting damage, and that at some time after his death a third party relined the canvas and repainted the damaged sky. John Bull has now removed this third sky and made minimal restorations to Constable's original one, which is indeed very close to that of the Yale Center version. Since Allnutt asked Constable 'to restore the picture to its original state', one would of course expect the sky in the replica that he supplied in its place and the sky in the original picture to be more or less identical. In order to make them so, Constable would have needed to remove Linnell's sky to remind himself of the one he had painted in the first place, some eleven years earlier.

'Ploughing Scene in Suffolk' was the first work Constable exhibited with an accompanying quotation in the catalogue, in this case lines 71–2 of Robert Bloomfield's *The Farmer's Boy*: 'But unassisted through each toilsome day, | With smiling brow the ploughman cleaves his way'.

72 Boat-Building 1814–15, exh.1815

Oil on canvas 508 × 619 (20 × 24⅜)
PROV: Artist's administrators, sold Foster 16 May 1838 (59, 'View at Flatford, with barge building') bt Smith, Lyall Street; . . .; John Sheepshanks by c.1850 and presented by him to the South Kensington (later Victoria and Albert) Museum 1857
EXH: RA 1815 (215, 'Boat building'); Tate Gallery 1976 (132, repr.); Japan 1986 (15, repr. in col. and col. detail)
LIT: Reynolds 1973, no. 137, pl.95; Smart and Brooks 1976, pp. 66–8, pl.33; Hoozee 1979, no.208, pl.XVII (col.); Rosenthal 1983, pp.78, 82–9, figs.105 (col.detail), 107 (col.); Cormack 1986, pp.88–9, pl.85 (col.); Rosenthal 1987, pp.84–5, ill.72 (col.)

Board of Trustees of the Victoria and Albert Museum, London

'Boat-Building' shows a barge under construction in Golding Constable's dry dock near Flatford bridge, which is out of sight at the right. Flatford lock is glimpsed at the left. The dock was drained by a pipe running under the river and discharging into the gully seen at the right of the 1817 'Flatford Mill', no.89 below (see articles by Ted Gittins and Douglas Barrett in *Lock Lintel*, no.81, Winter 1985–6, p.4, no.87, Summer 1987, p.6). In no.72 timber is seen in various stages of preparation, pitch is being heated in a cauldron and the ground is littered with the tools of the trade. As Rosenthal suggests, there is something of the instruction manual about Constable's picture. The drawing in the 1814 sketchbook (fig.46; p.57 of no.248), dated 7 September, upon which the composition is based gives a busier account of the scene, with many more figures actually engaged in the construction of the barge and no tools left lying idle. Two slighter pages of figure studies precede this drawing. The painting itself originally had one more figure, stirring the cauldron, and there were two extra timbers, lying against the side of the dock to the right of the steps (see Cove on p.511 and fig.181).

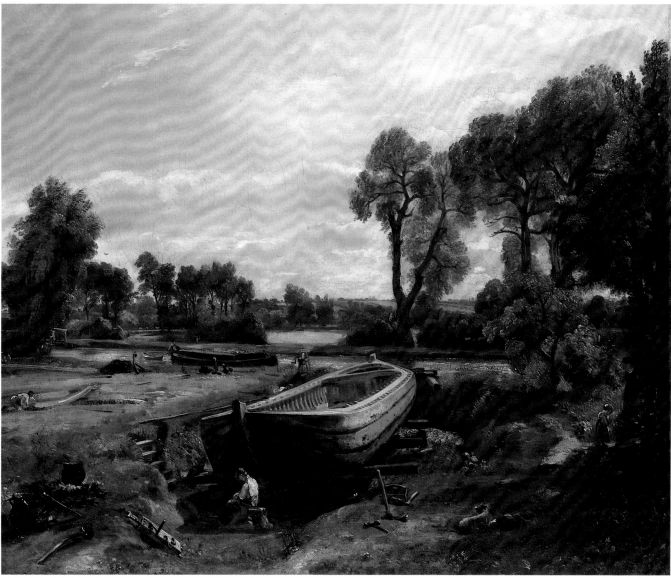

72

The little girl dressed in red, white and blue at the right reappears in 'Stratford Mill' (no.100).

'Boat-Building' occupies a celebrated place in the story of Constable's naturalism, being the only painting, as opposed to sketch or study, that he is recorded as having said was painted completely outdoors: in Leslie's words, it was 'one which I have heard him say he painted entirely in the open air' (Leslie 1843, p.19, 1951, p.49). Almost equally celebrated is the advice Farington offered him on 23 July 1814, a week before Constable left for Suffolk: 'I told Him the objection made to His pictures was their being unfinished; that Thomson [Henry Thomson RA] gave Him great credit for the taste of His design in His larger picture last exhibited ['The Ferry', no.65 above], & for the indication shewn in the Colouring, but He had not carried His finishing far enough. -- I recommended to Him to look at some of the pictures of *Claude* before He returns to His Country studies, and to attend to the admirable manner in which all parts of His pictures are completed. He thanked me much for the conversation we had, from which He sd. He shd. derive benefit' (Farington XIII, p.4564). On the day of his departure for Suffolk Constable reported to Farington that he had been studying the Angerstein Claudes, later to be purchased for the National Gallery (ibid., p.4567).

Constable himself was already well aware of his need to 'detail out' his pictures, and was certainly ever willing to learn from Claude's example. As we have seen, he was also determined to work more closely from nature, having conceived the idea of making small pictures on the spot instead of sketches. He made the most of an exceptionally fine summer and autumn and was able to report to

Maria on 18 September: 'This charming season as you will guess occupies me entirely in the feilds and I beleive I have made some landscapes that are better than is usual with me – at least that is the opinion of all here' (Beckett II 1964, p.131).

'Boat-Building' and 'The Stour Valley and Dedham Village' (no.74) appear to have been painted concurrently that summer and autumn, the latter in the mornings, the former in the afternoons (see Ian Fleming-Williams, 'John Dunthorne's "Flatford Lock"', *Connoisseur*, vol.184, Dec. 1973, pp.290-1). The shadows in 'Boat-Building' indicate that the time of day intended is not long after noon. From Lucas we learn that Constable worked through the afternoon until he saw from 'the film of smoke ascending from a chimney in the distance [presumably on Flatford mill] that the fire was lighted in preperation of supper' (Parris, Shields, Fleming-Williams 1975, p.56). Constable does not in fact appear to have made a small finished painting of the subject but rather to have moved directly from his sketchbook drawing to the final canvas. The picture is not in any case a large one, only slightly larger, indeed, than the study (no.73) for 'The Stour Valley and Dedham Village', which may have been the sort of intermediate stage he had in mind when he wrote to Dunthorne earlier in the year.

According to Sarah Cove (see pp.508, 512), the only detectable underdrawing on the canvas is a graphite line that defines the shape of the top of the barge. The paint was applied in two stages, the first with a limited palette of smooth, opaque quick-drying colours, the second with better, more granular pigments, which were used to add detail on top of the first layer: details of foliage, foreground plants, and so on. Both layers could have been painted outdoors, though several days would have been needed for the first to dry sufficiently before the second was applied.

Working directly from nature did not mean that Constable forgot the lesson of Claude. The careful delineation especially of the trees and of the barge in 'Boat-Building' can surely be related to his study of the Angerstein pictures, while the overall 'grey and green' colouring (as Leslie described it) has long been recognised as Claudean. The three seaport pictures in Angerstein's collection may well have directed Constable's attention to the subject matter he chose in no.72. The 'Seaport' which is now National Gallery no.5 (fig.47) is particularly relevant here, since it includes similar figures to those introduced in 'Boat-Building' (as Charles Rhyne has also noted in unpublished lectures). In his 1833 lecture at Hampstead Constable declared that Claude 'is nowhere seen to greater advantage than in his sea ports, which while they possess many of the most charming qualities of his more sequestered landscapes, are full of business and bustle' (Leslie 1843, p.134, 1951, p.298). The sketchbook drawing of 7 September (fig.46) suggests that Constable originally had in mind a busier and more bustling scene than the more sequestered one he finally painted.

fig.47 Claude, 'A Seaport', 1644, *Trustees of the National Gallery, London*

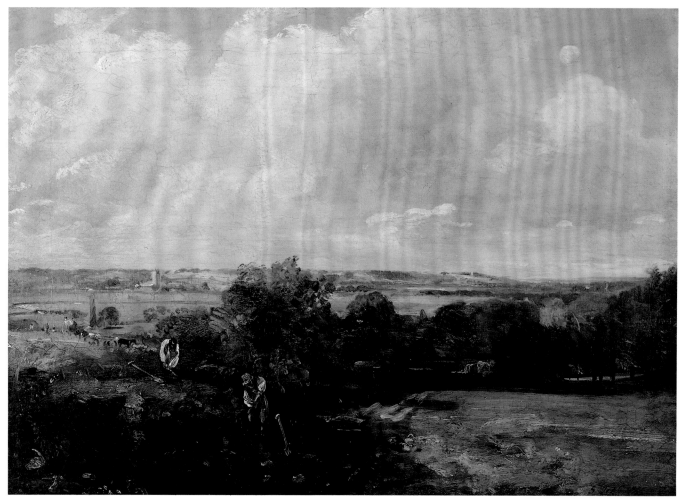

73

73 **The Stour Valley and Dedham
 Village** 1814

Oil on canvas 394 × 559 (15½ × 22)
Inscribed '5 Sep.ʳ 1814' b.r.
PROV: . . .; J.N. Drysdale; . . .; Tooth's, from
whom bt by Leeds City Art Galleries 1934
EXH: Tate Gallery 1976 (127, repr.); New
York 1983 (13, repr. in col.); Japan 1986 (12,
repr. in col.); New York 1987 (220, repr. in
col.)
LIT: Hoozee 1979, no.202, repr.; Rosenthal
1983, p.83, fig.93; Cormack 1986, pp.87–8,
pl.80; Rosenthal 1987, p.84, ill.66

Leeds City Art Galleries

See no.74

74 The Stour Valley and Dedham Village 1814–15, exh.1815

Oil on canvas 553 × 781 (21¾ × 30¾)
Inscribed 'N°2 View of Dedham – John
Constable.' on a label on the back,
presumably applied at the time of the 1815
exhibition
PROV: Commissioned by Thomas Fitzhugh
for his bride Philadelphia Godfrey 1814; she
died 1869; . . .; acquired by James McLean,
USA, c.1885–1900; his daughter, Mrs Alice
T. McLean; . . .; John Mitchell, New York,
from whom bt by Boston Museum of Fine
Arts 1948
EXH: RA 1815 (20, 'View of Dedham'); Tate
Gallery 1976 (133, repr.); *Romance and
Reality: Aspects of Landscape Painting*,
Wildenstein, New York, Oct.–Nov. 1978 (17,
repr.); New York 1983 (15, repr. in col. with
col. detail on cover)
LIT: Hoozee 1979, no.207, pl.XIV (col.);
Barrell 1980, pp.149–51, repr. pp.148, 149
(detail); Paulson 1982, pp.130–1, 132, fig.66;
Rosenthal 1983, pp.78–87, figs.95 (col.
detail), 103 (col.); Cormack 1986, pp.87–8,
pl.84 (col.); Rosenthal 1987, pp.84–5, ills.65
(col.), 69 (col. detail)

*Museum of Fine Arts, Boston, Warren
Collection*

The Boston picture, no.74, was commissioned by
Thomas Fitzhugh of Plas Power (1770–1856),
Deputy Lieutenant and High Sheriff of Denbigh-
shire, as a present for his bride Philadelphia,
daughter of Peter Godfrey of Old Hall, East
Bergholt. The marriage took place on 11
November 1814. Constable must have received the
commission some time before 5 September, the
date on the preparatory oil, no.73. As in 'Ploughing
Scene in Suffolk' (no.71), the view is from just
outside the grounds of Old Hall but this time

fig.51 Detail from no.74

looking more to the south so that Fen bridge and
Dedham are included; Langham church appears
on the hills at the right. Philadelphia would have
been familiar with the scene from her childhood
but she may have been surprised by Constable's
unusual treatment of it. The foreground of the
painting is occupied not by the sort of conventional
staffage seen, for example, in Reinagle's view of the
valley (fig.32 on p.100) but by the figures of
labourers excavating a large dunghill for autumn
manuring. Such mounds were known locally as
'runover dungles' because a cart could be run up
them to empty its load and then run down the other
side (Ian Fleming-Williams, 'A Runover Dungle
and a Possible Date for "Spring"', *Burlington
Magazine*, vol.114, June 1972, pp.386–93).
Although a fair amount is known about the
Godfreys and their early encouragement of
Constable, we do not know whether they – or
Thomas Fitzhugh – had any part in the choice of
the painting's subject matter, nor do we know how
any of them reacted to the finished work. 'I have
almost done a picture of "*the Valley*" for Mr
Fitzhugh – (a present for Miss G. to contemplate in
London)', Constable wrote on 25 October 1814
(Beckett II 1964, pp.134–5), but in what spirit did
he expect her to contemplate it? Was she – or, for
that matter, was Constable – as alive as Professor
Paulson to its georgic aspects and thus able to see in
the foreground 'clumps of decomposition and
decay like the bovine corpse of Virgil's fourth
Georgic out of which bees and nations regenerate',
or as aware as Michael Rosenthal of the picture's
Christian symbolism, willing 'to see that even in
the melancholy of Autumn there is the seed of new
life'? Had Constable written to John Fisher about
the painting, Paulson speculates, 'we might find a
ribald connection between the muck heap and the
money of the elderly husband, if not the husband
himself'. Perhaps, after all, the muck heap has
received too much attention. May not Constable
and his landowning patrons have seen it simply for
what it was, a perfectly normal and unremarkable
part of good husbandry ?

As suggested in the two previous entries, the oil
study made on 5 September (no.73) may have been
the sort of 'small picture' that Constable told
Dunthorne in February 1814 he intended to finish
on the spot for every one of his paintings. Certainly
it is larger and more finished than his earlier
outdoor studies. In the field beyond the 'dungle'
harvesters are at work; long shadows cast from the
east indicate early morning. Having painted this
study, and possibly shown it to the Godfreys,
Constable proceded to make a number of drawings
in his sketchbook (no.248): on p.54 men loading a
cart; on p.60 men digging out the dungle; on p.62,
at 8.30 a.m. on 26 September, the whole landscape,
this time unpeopled; on p.65 the landscape again
but with Dedham church now seen for the first
time more to the right of the view, as in the final
painting, and with a rudimentary tree introduced at
the left; on pp.68, 73 and 74, the first dated 1
October, sketches of the cart and horses, the last

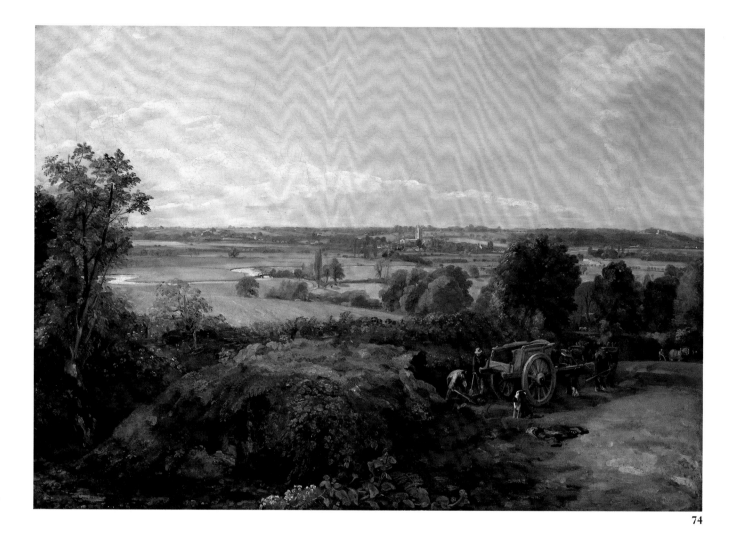

74

(fig.48) corresponding more closely than the others to the painting; on p.81, dated 9 October, a vigorous chiaroscuro sketch of the landscape with an emphatic tree at the left (fig.49). In addition Constable made two oil studies of the cart and horses, one dated 24 October, the other (fig.50) undated but closely related to the painting (Victoria and Albert Museum, Reynolds 1973, nos.134–5).

Many of the drawings Constable made in his 1813 and 1814 sketchbooks were later developed as paintings but in this case we see him making drawings specifically for a painting to which he was already committed. Taken with the two oil studies directly related to the painting, they add up to an unusual amount of preparatory work, no doubt inspired both by the complexity of the task and by the fact that he had actually been commissioned, probably for the first time, to paint a landscape of any pretensions.

The direction of the light in the various preparatory studies and in the final painting shows this to be a morning subject. We have already seen that 'Boat-Building' (no.72) was painted in the afternoons at the same period, the sketchbook drawing of its composition being made on 7 September, two days after the Leeds oil study for 'The Stour Valley and Dedham Village'. It seems reasonable to suppose that if 'Boat-Building' was painted outdoors, as the artist claimed, so too was the Boston picture. The subtle understanding of the distant landscape seems hardly accountable otherwise, though the cart would presumably have been painted indoors from the oil study Constable had made of it. While the Leeds study (no.73) shows harvesting in progress in early September, in the final painting, 'almost done' Constable said by 25 October, ploughing is underway. Turning to watch one of the teams, the dog by the cart (fig. 51) directs our attention to the destination of the manure being dug out by the two men, while a second ploughing team is glimpsed in a further field. Constable was to re-use the dog, first seen in the separate oil study of the cart, in his 1816 exhibit 'The Wheatfield' (no.76), a picture of the same size and closely related in other ways to this one.

fig.48 1814 sketchbook
(no.248), p.74, *Board of
Trustees of the Victoria and
Albert Museum, London*

fig.49 1814 sketchbook
(no.248), p.81, *Board of
Trustees of the Victoria and
Albert Museum, London*

fig.50 'Study of a Cart and
Horses', 1814, *Board of
Trustees of the Victoria and
Albert Museum, London*

75 Brightwell Church and Village 1815

Oil on panel 155 × 228 ($6\frac{1}{8}$ × 9)
Inscribed in a later hand on the back
'Brightwell N.ʳ Ipswich (?)'
PROV: Commissioned by the Revd Frederick
Henry Barnwell (later Turnor Barnwell)
1815; presumably acquired from him by Sir
Robert Harland Bt, who had it by 1829; he
died 1847 and his widow 1860 but it is not
known whether she inherited it; . . .; the
Lewis-May family by *c*.1915; C. Lewis-May,
sold Bonham's (Old Chelsea Galleries) 6
June 1978 (414, as English School) bt
Nicholas Drummond and sold to William
Drummond, Covent Garden Gallery Ltd,
from whom bt by Tate Gallery 1980 with
assistance from the Friends of the Tate
Gallery, the National Art-Collections Fund,
the Wolfson Foundation and the National
Westminster Bank (T 03121)
EXH: *Summer Exhibition*, William
Drummond, Covent Garden Gallery Ltd.,
June–July 1980 (1, repr. in col.)
LIT: Ian Fleming-Williams, 'John Constable
at Brightwell: A Newly Discovered Painting',
Connoisseur, vol.204, June 1980, pp.130–3,
repr. in col. p.131; Parris 1981, no.12a, repr.
in col.; Rosenthal 1983, p.91, fig.113;
Fleming-Williams and Parris 1984, pp.130,
133, pl.58

Tate Gallery

As in the previous year, Constable spent a very
productive summer and autumn at East Bergholt in
1815. The weather was again exceptionally fine.
Unusually he decided to spend the winter there as
well, to be near his father whose health was now
rapidly declining. Apart from short visits to
London in November 1815 and January 1816,
Constable remained in Suffolk from July to March.
During this time he painted, in July and August,
the views from his father's house shown earlier in
the exhibition (nos.25–6). 'I think I never saw dear
old Bergholt half so beautifull before as now – the
weather has been so delightfull', he wrote to Maria
on 13 July (Beckett 11 1964, p.146), adding: 'You
know that I do not like to talk of what I am about in
painting (I am such a conjuror)' – perhaps magic is
as good an explanation as any for his work at this
time.

At the end of his letter Constable announced:
'On monday 31.ˢᵗ inst I am going for a day or two
from home – to meet a Gentleman (the R.ᵈ Mr
Barnwell of Bury) at a village (Brightwell) near
woodbridge to take a view for him – of the Church
as it appears above a wood' (Beckett 11 1964,
pp.146–7). Barnwell was an antiquary with a
particular interest in the village of Brightwell near
Ipswich, about which he later wrote an article for
the *Gentleman's Magazine*. From dated drawings
recording Constable's journey home from Bright-
well we can deduce that the picture he made for
Barnwell, no.75, was painted on 1 and 2 August.

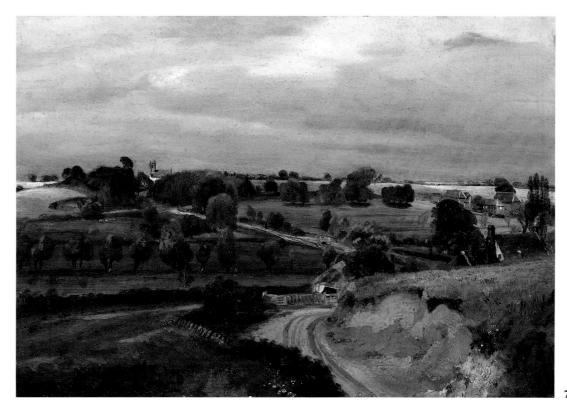

75

The view is from the south side of the village, looking north to the church 'as it appears above a wood' and including on the right a farm formed from the outbuildings of the demolished Brightwell Hall. As Fleming-Williams noted in his 1980 article, this little work falls chronologically between the two paintings of Golding Constable's gardens (nos.25–6) and has much in common with them: 'In all three sunlight plays an important part, curiously moving round from right to left – morning to evening through noon – in the order in which the pictures were painted. In all three there is the same tension, a heightening of visual acuity, along the horizon. They share the same rich, jewel-like quality of paint. In each, while minutiae receive the most careful attention, Constable never loses sight of the uniformity of the whole composition'. No other commissioned landscape by Constable is known on this miniature scale and he would not normally have responded to a request 'to take a view' for an antiquary. It was fortunate that Barnwell caught him when his eye was attuned to minutiae and when a short excursion from Bergholt was clearly not unwelcome.

Barnwell was 'most pleased with the little picture' (Beckett II 1964, p.150) but later parted with it to Sir Robert Harland, who inherited the Brightwell Hall estate around 1818. Because of its unusual character the painting was not recognised as Constable's when, catalogued as 'English School', it came on the market in 1978. It was subsequently identified by William Drummond, initially on the basis of documentary evidence.

76 The Wheatfield 1815–16, exh.1816

Oil on canvas 537 × 772 (21⅛ × 30⅜)
Inscribed 'Iohn Constable.│1816.' at bottom centre
PROV:...; acquired, probably in late 19th century, by ancestor of present owner
EXH: RA 1816 (169, 'The wheat field'); BI 1817 (132, 'A harvest field; Reapers, Gleaners', frame 33 × 42 in)
LIT: Parris, Fleming-Williams, Shields 1976, under nos.139–41; Rosenthal 1983, pp.95–7, 100; Rosenthal 1987, pp.99–100

Private Collection

The whereabouts of no.76, Constable's 1816 exhibit 'The Wheatfield', only became known to Constable scholars in 1988–9; before then no idea could be formed of its appearance, though it was suspected that drawings of gleaners in the Louvre were connected with the painting (see Tate Gallery 1976, nos.139–40). So far as is known, this important picture is now being exhibited for the first time since it appeared at the British Institution in 1817. (We are grateful to Charles Rhyne for telling us of the painting and for showing us his draft catalogue entry on it.)

The field depicted here is the same one seen in the right foreground of the Boston 'Stour Valley and Dedham Village' (no.74), though Constable is now looking more to the west so that Dedham is out of sight at the left and more of the field itself is included. The overgrown mound in the bottom left

corner may be the remains of the 'dungle' seen in no.74. Finished in the autumn of 1814, the Boston painting showed the start of ploughing in preparation for the sowing of the wheat which is seen being harvested in this 1815 picture. Four harvest-

fig.52 Detail from no.76

ers are at work at the bottom of the field while a fifth seems otherwise engaged further down the slope. Nearer to us a woman and two girls, perhaps her daughters, glean what the harvesters have left. A boy with an armful of wheat walks up the side of the field towards us while another reclines in the foreground beside the labourers' refreshments (fig.52); by him, exactly reproduced, sits the watchful dog seen in the previous year's painting. The boy and his dog are separate from the other figures and seem to invite us to follow their gaze over the sea of wheat. A ploughman is glimpsed at work in the next field on the left. These figures engage our immediate attention but the eye is also drawn to the distant landscape, beautifully painted with the same precision that we saw in the Boston picture (no.74). At the foot of the hill below Langham church individual buildings in Stratford St Mary can be made out; to their left is the white-painted Stratford bridge, familiar from Constable's early pictures of the views from Gun Hill, for example no.7.

'The Wheatfield' was almost certainly painted largely on the spot during August 1815. Although not related to it, a drawing of wheatsheaves inscribed '15 Augst 1815. East Bergholt' (Victoria

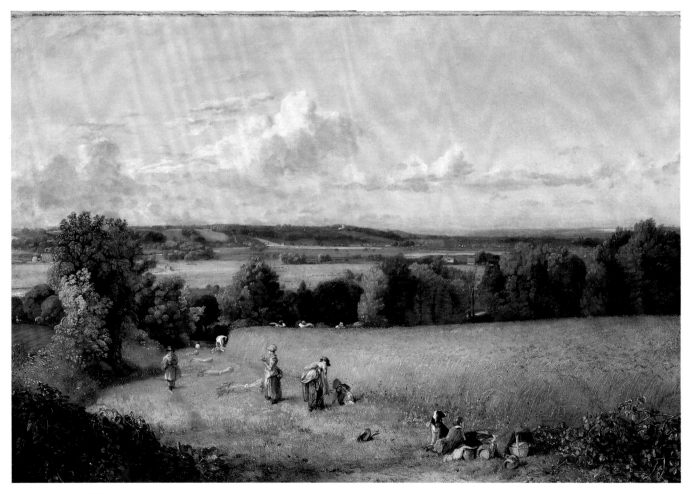

76 (see also detail facing p.51)

and Albert Museum, Reynolds 1973, no.140, pl.118) indicates roughly when harvesting took place that year, while on the 27th of the month Constable wrote to Maria: 'I live almost wholly in the feilds and see nobody but the harvest men. The weather has been uncommonly fine though we have had some very high winds that have disconcerted the foliage a great deal' (Beckett II 1964, p.149). Constable's description of himself is reminiscent of one of his, undated, references to Claude, who 'lived in the fields all day' but drew at the Academy at night (Leslie 1843, p.121, 1951, p.276).

The drawings in the Louvre mentioned earlier as being connected with the painting are: RF 6099 (fig.53), which includes a figure very similar to the standing gleaner facing left in the picture, and RF 6103 (fig.54), which relates to the figure of the bending gleaner to her right, a similar figure also appearing in reverse on the first sheet. Another sheet, RF 6101 (Tate Gallery 1976, no.140, repr.), is less directly connected with the picture. The back of RF 6099 was used by Constable to draft a letter to Maria in February 1816, when he was still at Bergholt (see Tate Gallery 1976, no.139), which suggests that he may have been doing some work on the figures in the painting at that time. The precise role of such pencil sketches is unclear since they are by no means simply copied in the painting. Were they a sufficient basis for Constable to work from when adding figures to the picture or did he also have oil sketches or perhaps the models themselves? The results of a recent technical examination of the picture by Sarah Cove may throw light on such questions.

A small upright painting of reapers shown in the 1976 exhibition (no.141, repr.; Rosenthal 1983, fig.118, and related drawing, fig.115) and thought then to be possibly connected with 'The Wheatfield' can now be seen to be related only in subject matter.

With its eleven figures, animals apart, 'The Wheatfield' is the most densely populated landscape Constable had so far painted. Re-exhibiting the work at the British Insitution in 1817, he chose for the catalogue lines from Bloomfield that drew attention to the figures as much as the landscape:

> Nature herself invites the reapers forth;
> ...
> No rake takes here what heaven to all bestows:
> Children of want, for you the bounty flows!
> *The Farmer's Boy*, lines 132, 137–8

The figures are not only more numerous than usual but also more conspicuous and, at least in the case of the boy approaching up the side of the field, more particularised. At the same time that

Constable was painting his 'Wheatfield' G.R. Lewis was at work on twelve small and two larger harvest pictures 'Painted on the Spot' in Herefordshire, including the 'Harvest Scene, Afternoon' in the Tate Gallery (N 02961). Even within his own terms the contrast drawn by John Barrell (1980, pp.117, 133–4, etc.) between the bold figuration of the latter and the – to him – nearly invisible workers in Constable's landscapes of the period clearly requires some qualification now.

fig.53 'Gleaners', ?1815, *Musée du Louvre, Paris*

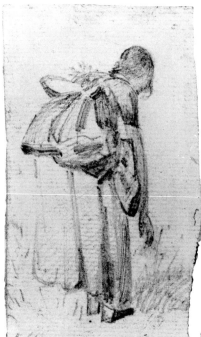

fig.54 'A Gleaner', ?1815, *Musée du Louvre, Paris*

77 A Cottage in a Cornfield 1815, finished
and exh.1833

Oil on canvas 620 × 515 (24$\frac{1}{2}$ × 20$\frac{1}{4}$)
Formerly inscribed on a label on the back
(applied for 1833 RA, now separately
preserved): 'No 3. Cottage in a Corn field--
John Constable 35 Charlotte Street [. . .]'
PROV: Artist's administrators, sold Foster 16
May 1838 (52, 'Cottage in a Corn Field') bt
in by Burton for Constable family; by descent
to Isabel Constable and bequeathed by her to
the South Kensington (later Victoria and
Albert) Museum 1888 as the gift of Maria
Louisa, Isabel and Lionel Bicknell Constable
EXH: RA 1833 (344, 'Cottage in a corn-field');
BI 1834 (128, 'A Cottage in a Field of Corn',
frame 34 × 30 in); Tate Gallery 1976 (297,
repr.)
LIT: Reynolds 1973, no.352, frontispiece
(col.); Ian Fleming-Williams, 'A
Rediscovered Constable: The Venables
Cottage in a Cornfield', *Connoisseur*, vol.198,
June 1978, pp.135–7, fig.1; Hoozee 1979,
no.550, repr.; Paulson 1982, pp.117, 122,
fig.52; Rosenthal 1983, pp.91, 92, 218, 236,
fig.119 (col.); Fleming-Williams and Parris
1984, pp.87, 133–43, pls.61, 66 (detail);
Reynolds 1984, no.33.3, pl.868 (col.); Parris
and Fleming-Williams 1985, pp.166–7;
Rosenthal 1987, p.88, ill.75

*Board of Trustees of the Victoria and Albert
Museum, London*

See no.78

78 A Cottage in a Cornfield 1817, exh.1817

Oil on canvas 314 × 264 (12$\frac{3}{8}$ × 10$\frac{3}{8}$)
PROV: ? Bought from the artist in 1818 by
William Venables, who died 1840; . . .;
Leggatt, from whom bt *c.*1890 by Alexander
C. Ionides; by descent to his grand-daughter,
from whom bt by the National Museum of
Wales 1978 with assistance from the National
Art-Collections Fund
EXH: RA 1817 (141, 'A cottage'); BI 1818
(129, 'A Cottage in a Cornfield', frame
19 × 17 in)
LIT: Ian Fleming-Williams, 'A Rediscovered
Constable: The Venables *Cottage in a
Cornfield*', *Connoisseur*, vol.198, June 1978,
pp.134–7, fig.A (col.); Hoozee 1979, no.233
bis, repr.; Rosenthal 1983, pp.91, 92, 113,
fig.120 (col.); Fleming-Williams and Parris
1984, pp.117, 130, 133–43, pls.60, 64 (detail);
Reynolds 1984, no.17.2, pl.1 (col.); Parris and
Fleming-Williams 1985, pp.166–7;
Rosenthal 1987, p.88, ill.76

National Museum of Wales, Cardiff

Constable's two paintings of 'A Cottage in a
Cornfield', one rediscovered only in 1978, raise
interesting questions about his working methods in
the years 1815–17. With the exception of one area,
the larger of the two, no.77, appears to have been
painted on the spot in the summer of 1815, around
the time of the small pencil drawing of the subject,
no.257 below. The corn is still green in places,
pointing to a date in July rather than August (cf.the
August harvesting scene, no.76). A cat sitting on
the cottage fence, and a donkey, wagtail and two
butterflies in the foreground compensate for the
absence of human figures. The donkey may have
been added in December 1815, when Constable
told Maria that the weather was 'so very mild that I
went painting in the feild from a donkey that I
wanted to introduce in a little picture' (Beckett II
1964, p.162), though it is not certain that he was
referring to this picture. What surely was painted
later, but evidently in an unsuccessful attempt to
work in an earlier manner, is the tree at the right,
which is in the looser style of the 1820s or 1830s.
We know that he 'licked up' this version in March
1833 (Beckett III 1965, p.94) to show at the
Academy, being short of exhibits that year. In the
view of the present authors at least, the 'licking up'
comprised the addition or repainting of a tree
which he had been unable to cope with in 1815,
either because the tree itself, recorded in the pencil
drawing (no.257), was unsuitable in some way or
because, as Rosenthal (1983) suggests, Constable
was called away on his Brightwell visit and
abandoned the painting for the time being. (For a
different dating of the picture see Reynolds 1984,
where the whole work is attributed to 1833, a view
debated in Parris and Fleming-Williams 1985.)

The Cardiff version (no.78), exhibited at the
Royal Academy in 1817, differs in a number of
ways from no.77. It is half the size, has a reduced
foreground and a different sky, shows the corn (less
ripe than in no.77) growing higher against the
cottage but not surrounding it, and includes a
figure in the cottage garden and a donkey and foal
to the right of the gate. Most conspicuously, the
tree at the right resembles neither the one added
later to no.77 nor the tree shown in the pencil
drawing. What in some respects it does resemble,
especially in its foliage, is the main tree in Martino
Rota's engraving after Titian's 'Peter Martyr', a
work Constable greatly admired (Fleming-
Williams and Parris 1984, pls.63–5). Constable,
like Titian, also placed an elder bush at the base of
his tree. It seems very possible that he turned to
this favourite print when trying to solve on a
smaller canvas the problem that had for the time
being defeated him on the larger. The problem
may, in fact, have seemed soluble only on a smaller
scale, hence the necessity of starting again.

The small version is much tidier, more formal
than no.77. The cottage is now aligned with the
gate and the windows of the cottage aligned with
one another. In place of the peculiar junction of the
main part of the cottage and its timber addition
noted in the other painting, the two parts are now

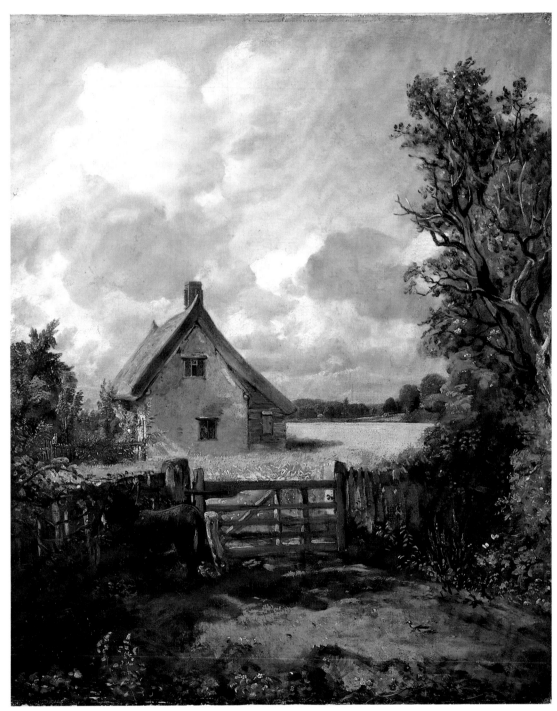

77

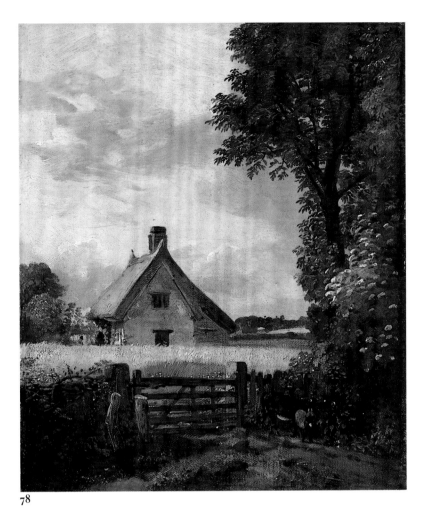

78

made more distinct and given separate thatched roofs. The gate posts and the fence are more regular, the trees to the left of the cottage more generalised. The glancing light on the cottage wall in no.77, suggestive of a brief moment in time, has given way to a diffused light and a sense of stillness. These modifications seem very much in keeping with the formal tree introduced at the right. We do not know whether Constable had the larger version by him when he painted no.78 (it may have been left behind at Bergholt when he got married in October 1816) or whether he relied on the drawing and his memory, but the end result is a simplified, abstracted version of the scene as presented both in the drawing and the other picture. It has been suggested that Constable may have returned to the site in the summer of 1816 and painted no.78 then (Rosenthal 1983 and 1987) but, assuming that he was as observant the second time round, we would have to suppose that a certain amount of rebuilding and rethatching of the cottage had taken place in the meantime, an unlikely explanation and one that cannot be used to account for the appearance of the tree at the right.

A comparison of the two paintings should, perhaps, serve to remind us that even at the height of his most 'naturalistic' period Constable was always willing to manipulate his material in the interests of picture-making. In this case, he produced in no.78 an appealing little cabinet picture such as a connoisseur might appreciate, and one that did in fact soon find a buyer. The work was probably purchased for twenty guineas in 1818 by William Venables, paper-maker, stationer and later Lord Mayor of London (see Beckett IV 1966, pp.165–6, and Fleming-Williams 1978), though *Annals of the Fine Arts*, possibly not reliable on this occasion, named a certain Thomas Barber as the buyer (see Parris 1981, p.75 n.11). The donkey and foal reappeared in reverse in 'The Cornfield' (no.165), suggesting that Constable painted them in no.78 from a separate study which he used again after the sale of the latter.

79 Wivenhoe Park, Essex 1816, exh.1817

Oil on canvas 561 × 1012 (22⅛ × 39⅞)
PROV: Commissioned by Major-General
Francis Slater-Rebow 1816; by descent until
1905; . . .; Nardus, Belgium, from whom bt
by P.A.B. Widener and bequeathed by him
to the National Gallery of Art, Washington
1942
EXH: RA 1817 (85, 'Wivenhoe Park, Essex,
the seat of Major-General Rebow'); New
York 1983 (27, repr. in col.)
LIT: Hoozee 1979, no.218, pls.XX–XXI (col.);
Rosenthal 1983, pp.16–17, 104, 108–10,
figs.12 (col.), 16 (col. detail); Reynolds 1984,
no.17.4, pl.6 (col.); Cormack 1986, pp.96–9,
pl.91 (col.); Rosenthal 1987, pp.93–5, ill.83
(col.)

*National Gallery of Art, Washington, Widener
Collection*

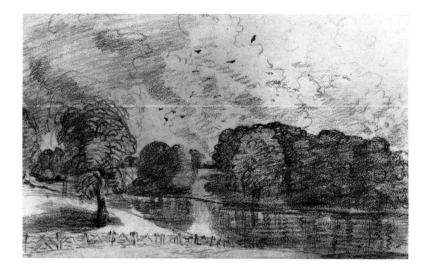

fig.55 'Wivenhoe Park',
?1817, *Private Collection*

In Suffolk in the summer of 1816 Constable
worked principally on his large canvas of 'Flatford
Mill' (no.89). He found time nevertheless to
execute a commission for Major-General and Mrs
Slater-Rebow of Wivenhoe Park near Colchester,
who asked him, as he reported to Maria on 21
August, for 'two small landscapes . . . views one in
the park of the house & a beautifull wood and peice
of water, and another scene in a wood with a
beautiful little fishing house' (Beckett II 1964,
p.196). The first of these, not quite so small as
originally intended, is no.79, the second 'The
Quarters, Alresford Hall' (National Gallery of
Victoria, Melbourne; Tate Gallery 1976, no.146,
repr.; Rosenthal 1983, fig.8). The Slater-Rebows
knew that Constable and Maria intended to marry
shortly and were 'determined to be of some service'
to them: 'This my love', Constable wrote in the
same letter, 'is just such a commission as can be of
real service to us'. Slater-Rebow apparently paid
him one hundred guineas for the two pictures (see
Reynolds 1984).

Constable left Bergholt for Wivenhoe on 26
August and described the progress of his work to
Maria four days later: 'I am going on very well with
my pictures . . . the park is the most forward – the
great difficulty has been to get so much in as they
wanted to make them acquainted with the scene –
on my left is a grotto with some Elms – at the head
of a peice of water – in the centre is the house over a
beautifull wood and very far to the right is a Deer
House – what it was necessary to add. so that my
view comprehended to many degrees – but to day I
got over the difficulty and I begin to like it *myself*'.
In a postscript he added: 'I live in the park and Mrs
Rebow says I am very unsociable' (ibid., p.199).
Constable returned to Bergholt on 7 September
and then went back to Wivenhoe for two days on
the 17th in order to complete no.79. Assuming that
he also completed the companion picture but spent
more time on 'Wivenhoe Park', the latter can have
occupied him for little more than a week. He must
indeed have had to 'live in the park'.

In order to accommodate the deer-house as
requested, Constable added a strip about 3⅛ inches
wide at the right side and, presumably to preserve
the central position of the house, another, about 3⅞
inches wide, at the left. The right seam runs
through the boat on the lake, the left through the
cow nearest the fencing. These features were no
doubt placed so as to distract the eye from the joins
in the canvas. Constable had already made a rapid
pencil sketch of fishing on the lake on a previous
visit, on 27 July that year (Victoria and Albert
Museum, Reynolds 1973, no.146, pl.118). One tiny
detail of this drawing is followed on the canvas: the
men on the far bank at the extreme right who are
hauling in the net, attended by another man
standing in the water. On the left-hand strip
Constable introduced another figurative detail to
balance them: the Slater-Rebows's daughter out
driving in her donkey cart. Another drawing,
previously unpublished (fig.55, private collection,
USA), shows much of what we see in the painting
(and includes a tree that Constable appears to have
suppressed in its left foreground) but is drawn with
the same sort of coarse pencil as a later Wivenhoe
drawing, of 1817, in the Victoria and Albert
Museum (Reynolds 1973, no.159, pl.129) and may
postdate the painting. Constable does not appear to
have made the kind of detailed drawing that he did
for the companion picture of 'The Quarters', a
drawing sufficiently informative for him to have
finished the painting from if he did not in fact
complete it on the spot (Royal Institution of
Cornwall, Truro; Tate Gallery 1976, no.145, repr.;
Rosenthal 1983, fig.10).

Looking back to another country house paint-
ing, the 'Malvern Hall' of 1809 (no.70), we can see
how Constable's powers had increased in seven
years. The two works have features in common. In
both the house is placed centrally, surrounded by
trees and seen across a lake which reflects the house
in a central corridor of light. But 'Wivenhoe Park'
has a complicated construction far removed from
the simple symmetry of the earlier work (which can

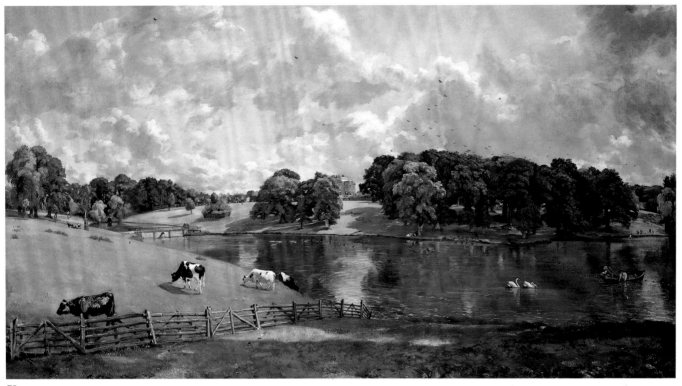

79

be read, after a fashion, upside-down, so nearly does the reflected image follow the direct one). Even before Constable increased the width of no.79 it encompassed a very wide angle of vision. The final panorama invites, even obliges, the viewer to turn his own head and thus gives him a greater sense of being in a real space, one in which perspectives change. Although admittedly a smaller painting, 'Malvern Hall' is by comparison flat and static, lacking the great curves upon which the composition of 'Wivenhoe Park' depends. Nor does it unite as 'Wivenhoe Park' does a bold design with a wealth of totally convincing detail: only two or so years after 'The Ferry' (no.65), 'detailing out' the masses is no longer a problem, or, at least, not a problem the viewer needs be aware of. The unresolved foreground of the 1809 painting contrasts with the sloping bank broken up by shadows, fencing and judiciously placed cattle of 'Wivenhoe Park', and there is equally little comparison between the skies of the two works.

In 1832–3 Constable painted 'Englefield House' (Reynolds 1984, no.33.1) for Richard Benyon de Beauvoir, a less sympathetic patron than General Slater-Rebow. After its exhibition at the Academy in 1833 Constable was asked to substitute deer for the prominent cattle he had painted in the foreground and which, De Beauvoir said, made it look as though 'he had his farm yard before his Drawing Room windows'. He was also criticised by the Academy for submitting what was taken to be merely a picture of a house, to which he replied that it was 'a picture of a summer morning, *including a house*'. In his Suffolk years Constable was fortunate to find patrons like the Slater-Rebows who, while requiring the extension of the Wivenhoe canvas to include a (barely visible) deer-house, did not insist on stags figuring incongruously in the foreground but accepted in this 'picture of a summer day' the rustic fencing and cattle more appropriate to an East Anglian scene.

Dorset 1816

Following their marriage by John Fisher at St Martin's-in-the-Fields on 2 October 1816, Constable and Maria spent most of their honeymoon with the Fishers at their vicarage at Osmington, near Weymouth. Fisher had received the living of Osmington, in the gift of his uncle the Bishop of Salisbury, on the occasion of his own marriage earlier in the year to Mary Cookson. It was on this visit to Dorset that Constable began painting beach scenes (see nos.81–2, 84–5). The Suffolk coast seems to have held no interest for him, though he later painted two compositions based on other parts of the east coast, 'Harwich Lighthouse' and 'Yarmouth Jetty'. At Osmington the sea was inescapable, half-a-mile away over the hill seen at the left of his little picture of the village, no.80. He worked high up on the downs as well, drawing and painting panoramas of Osmington and Weymouth Bays (nos.83, 270). Although Constable never returned to the area, he continued making paintings of it, exhibiting a 'Weymouth Bay' in 1819 (see no.86) and several versions of an Osmington subject in the 1820s (see under no.81). He was able to pursue his new-found fascination with the sea when he started visiting Brighton in 1824.

80 Osmington Village 1816

Oil on canvas 257 × 305 ($10\frac{1}{8}$ × 12)
PROV: Painted for John Fisher and received by him after 15 Dec. 1817; by descent to his great-grand-daughter, Hilda M. Burn; . . .; Hazlitt, Gooden and Fox, from whom bt by Paul Mellon 1966
LIT: Hoozee 1979, no.225, repr.

Paul Mellon Collection, Upperville, Virginia

No.80 depicts the village of Osmington from the east, with the vicarage, its chimney smoking, seen towards the left. This is clearly a small finished painting rather than a sketch and appears to have been based on, or at least to have been painted after, the drawing shown below as no.272, with which it closely tallies. It may be the work Fisher mentioned in a letter to Constable over a year later, on 15 December 1817: 'You painted me a little picture of Osmington which was not in your box? Do you want it? or may I claim my own? Perhaps Mrs Constable has taken a fancy to it. If so I must waive my right' (Beckett VI 1968, p.35). The box had probably been used by Constable to return his portraits of John and Mary Fisher, painted on the honeymoon visit and now in the Fitzwilliam Museum, Cambridge (fig.9 on p.26 and Reynolds 1984, no.17.3, pl.2 for John Fisher, Cormack 1986, pl.96 for Mary). A reference to the portraits in the same letter suggests that they had recently arrived in Osmington, the portrait of John Fisher having been exhibited at the Academy earlier in the year.

81 Osmington Mills 1816

Oil on canvas 241 × 324 ($9\frac{1}{2}$ × $12\frac{3}{4}$)
PROV: By descent to Eustace Constable; . . .; Mrs Eugene A. Perry, by whom given to City Art Museum, St Louis, Missouri 1928; deaccessioned 1985 and bt by William F. Reighley, from whom bt by present owners
EXH: Milwaukee 1976 (16)
LIT: Hoozee 1979, no.229, repr.

Mr and Mrs Richard M. Thune

During his stay Constable made a number of drawings on the beach nearest to the village, at Osmington Mills, where this oil sketch of lobster fishermen and their boats, with Portland Island on the horizon, was also painted. Very similar scenes are recorded in pencil drawings of 22 October (Ipswich Borough Council, Rosenthal 1983, fig.139) and, without any figures, 7 November 1816 (Victoria and Albert Museum, Reynolds 1973, no.151, pl.123; see also nos.152a, 154a). A modern photograph of the spot is reproduced in Fleming-Williams 1976, fig.40.

In this brilliant sunlit sketch we are looking southwards. Constable later painted two or three versions, one of them in 1824 for the French dealer Arrowsmith, of a composition based on an oil sketch or drawing of Osmington Bay looking to the west (Reynolds 1984, nos.24.5 – 24.7). The original sketch, whether in pencil or oils, is missing but a copy exists by John Fisher of a drawing Constable made of a similar view which originally formed a panorama with the 7 November drawing mentioned above (Fleming-Williams and Parris 1984, pls.103–4).

80

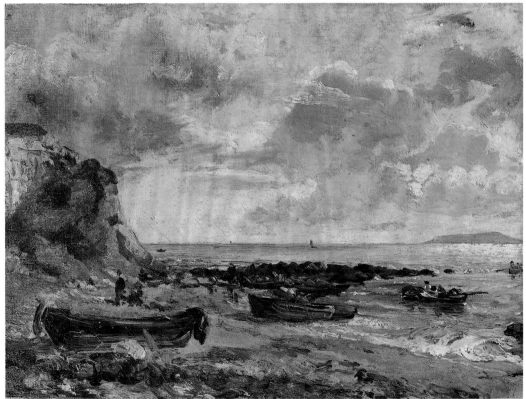

81

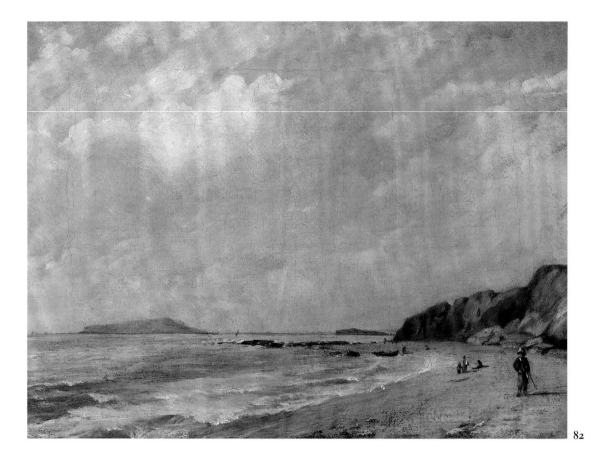

82

82 Osmington Bay 1816

Oil on canvas 227 × 305 (8$\frac{15}{16}$ × 12)
PROV: Given by the artist to John or Mary
Fisher; by descent to their great-grand-
daughter Hilda M. Burn; . . .; Hazlitt,
Gooden and Fox, from whom bt by a private
collector 1973; . . .; anon. sale, Christie's 21
Nov. 1980 (73, repr. in col.) bt Spink and Son
Ltd, from whom bt by present owner 1981
EXH: Tate Gallery 1976 (147, repr. in col.)
LIT: Hoozee 1979, no.226, repr.

Private Collection, New York

The scene here is presumed to be somewhere in
Osmington Bay but the exact location has not been
determined. Portland Island again figures on the
horizon, this time with the stretch of Chesil Beach
that connects it to the mainland. There are a few
fishermen near the rocks but this is a more leisurely
scene than no.81. A woman walks along the beach
hand-in-hand with a child. A boy wearing a yellow
hat, perhaps a straw hat, and carrying a crook
(presumably an off-duty shepherd) saunters to-
wards the painter, who appears to have changed his
mind more than once about the exact position of
this figure on his canvas. By masking him in a
reproduction we can see just how crucial a role he
plays in the composition.

Like the picture of the village, no.80, this beach
scene is a complete painting rather than a sketch.
Constable probably gave it to the Fishers at
Osmington in 1816. For some reason he later
borrowed it back. In a letter of 1 October 1822
Fisher asked for the return of '*my* little Novr
Salisbury' and 'my *wifes* coast scene' (Parris,
Shields and Fleming-Williams 1975, p.118), sar-
castically thanking him on the 30th for 'returning
so punctually the Osmington Coast & my little
Salisbury Cathedral. I am quite resigned. I shall
never have them again' (Beckett VI 1968, p.105).
They had been returned to him, however, by 18
August 1823, when Constable told Fisher, who had
been enquiring after his seascapes: 'I have not a sea
peice . . . they are much liked – you have my sketch
of Osmington' (ibid., p.128). In 1822 Constable
may have been considering making a larger version
of one of his Osmington works, in the event
choosing the subject that Arrowsmith com-
missioned in 1824 (see under no.81).

83 Osmington and Weymouth Bays 1816

Oil on canvas 560 × 773 (22$\frac{1}{16}$ × 30$\frac{7}{16}$)
PROV: ? Artist's administrators, sold Foster
16 May 1838 (in 45, 'Four – Weymouth Bay;
Waterloo Bridge; Dedham Mill, and one
other') bt in by Burton for Constable family;
by descent to Charles Golding Constable and
sold by court order after his death, Christie's
11 July 1887 (75) bt Agnew, from whom bt
by W.H. Fuller 1888; his sale, Chickering
Hall, New York 25 Feb. 1898 (20); Mr and
Mrs W.C. Loring 1898 and bequeathed by
them to Boston Museum of Fine Arts 1930
EXH: Tate Gallery 1976 (149, repr.); New
York 1983 (29, repr. in col.); New York and
Bloomington 1987–8 (276, repr. in col.)
LIT: Hoozee 1979, no.230, repr.; Fleming-
Williams 1990, p.141, fig.135

*Museum of Fine Arts, Boston, Bequest of Mr
and Mrs William Caleb Loring*

As well as working on the beaches, Constable made
a number of drawings of Osmington and Wey-
mouth bays from the downs (for example, no.270

below). Here he also painted this medium-sized
canvas, obviously feeling a need even on his
honeymoon to work on the sort of scale he had
become accustomed to in Suffolk. It seems unlikely
that he would have taken canvases of this size with
him on this occasion but Fisher had promised him
'brushes paints & canvass in abundance' when
proposing Osmington for the honeymoon (Beckett
VI 1968, p.29).

The view is from a point just south of Os-
mington village, looking down on Osmington Bay
at the left and, separated from it by Redcliff Point,
Weymouth Bay in the distance towards the right.
Portland Island and the stretch of Chesil Beach
connecting it with the mainland at Weymouth
again appear on the horizon. Constable describes
the undulations of the downland and the perspec-
tive of the sea with total assurance, as though he
were long familiar with the feel of this sort of
landscape. In Suffolk, most recently at Wivenhoe
(see no.79), he had painted panoramas but none so
extensive as this and none that combined breadth
with distances of the kind shown here. His ability to
see, let alone paint, the details of this great open
landscape is remarkable: the surf breaking on

83

fig.56 Detail from no.83

Redcliff Point a mile below him (fig.56); the calmer surface of the water this side of Chesil Beach – some five miles off – contrasted with the rougher open sea beyond it; distant stone walls; ruined buildings; flocks of sheep; the tiny figure of a man standing on the cliff-top, silhouetted against the sea above the valley leading down to it at the left of the painting. The picture is actually more populated by humans and animals than at first appears to be the case but of course the eye fixes immediately on the shepherd boy with his crook and his dog. Even more crucially than in the beach scene, no.82, they set the scene and its scale. Having moved from them to survey Constable's panorama we are finally drawn back to these figures and perhaps only then become aware of the closing distance between them and the artist, whose position we have unconsciously assumed.

The shepherd, who resembles the one in no.82, appears to have been based on the fainter of two figures discovered on the back (fig.57) of 'Cottages', a drawing from one of Constable's 1816 sketchbooks (private collection, New York, Fleming-Williams 1986, no.32, fig.18), when it was lifted from its mount in 1990. The darker figure, in ink as well as pencil, shows a similar figure of a shepherd, this time with his back to the spectator and his crook over his shoulder. (For another drawing crossed through and inscribed in the same hand, see Rhyne 1981, no.25, pl.9a.)

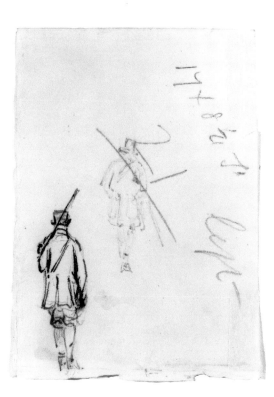

fig.57 Verso of 'Cottages', 1816, *Private Collection, New York*

84

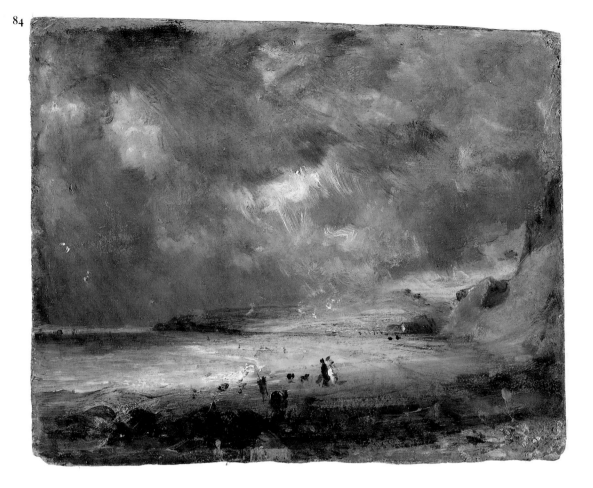

84 **Weymouth Bay (Bowleaze Cove)** 1816

Oil on board 203 × 247 (8 × 9¾)
Inscribed 'JC' in monogram on the back
PROV: As for no.2
EXH: New York, Bloomington, Chicago
1987–8 (275, repr.in col.); Madrid 1988–9
(53, repr. in col.)
LIT: Reynolds 1973, no.155, pl.127; Hoozee
1979, no.227, pl. XIX (col.); Rosenthal 1983,
p.111, fig.138 (col.); Reynolds 1984, under
nos.19.9, 19.10; Cormack 1986, p.102

*Board of Trustees of the Victoria and Albert
Museum, London*

See no.85

85 **Weymouth Bay (Bowleaze Cove)** 1816

Oil on canvas 530 × 750 (21 × 29½)
PROV: ? Artist's administrators, sold Foster
16 May 1838 (41, 'Weymouth Bay, a sketch')
bt Swabey; . . .; W. Fuller Maitland, sold
Christie's 10 May 1879 (72) bt Daniel; . . .;
acquired by George Salting 1890 and
bequeathed by him to the National Gallery
1910 (2652)
LIT: Hoozee 1979, no.433, pl. XLVI (col.);
Rosenthal 1983, pp.111–13, fig.141 (col.);
Reynolds 1984, no.19.10, pl.74 (col.); Parris
and Fleming-Williams 1985, p.167 under
no.17.30; Cormack 1986, p.102, pl.94 (col.)

Trustees of the National Gallery, London

Nos.84–6 depict Bowleaze Cove in Weymouth
Bay. The river Jordan crosses the beach to join the
sea at this point; beyond is Furzy Cliff and Jordan
Hill.
Although very different in character, the first
two, nos.84–5, of these three works both appear to
have been painted on the honeymoon visit in 1816.
The small storm sketch gives the impression of
having been executed very rapidly, perhaps during
an interval of bad weather while Constable was
working on the larger picture, no.85, and would

therefore have had materials immediately to hand. (Technical evidence supports this suggestion: see pp.501–4.) It is difficult to see how Constable could have captured the effect of the storm so convincingly had he not been painting on the spot, though the figures of the man and woman (the Fishers?) with their dogs appear to have been almost too conveniently at hand. Constable had rarely painted such dramatic weather before but was to become increasingly attracted to it.

The descriptive quality of the larger picture, no.85, suggests that it too was painted on the spot. Although not taken so far, it has many of the characteristics of 'Osmington and Weymouth Bays' (no.83) and is painted on a canvas of the same size which appears to have been prepared with the same priming colour. This warm tone is left uncovered over large areas to represent sand. The passage of the river cutting a shallow channel across the sand and partly shadowed by a passing cloud is beautifully observed, as are the variegated greens and browns of Furzy Cliff and Jordan Hill, its top covered with dry bracken. Much has been made of the fact that a shepherd and his flock are clearly depicted by the wall towards the right of no.85 and that comparable marks in the small sketch, no.84,

are barely decipherable: 'a line of white pigment, not differentiated into the form of a man and a flock of sheep, and perhaps representing distant water, mist or smoke' (Reynolds 1973); a 'watersplash caused by the River Jordan, or a plume of smoke' (Reynolds 1984). It has been argued that Constable derived no.85 from the small sketch, transforming these ambiguous marks into the shepherd and his flock, and that the larger work must therefore be later than the smaller and painted after the Osmington visit. The vague marks in no.84 may have suggested the inclusion of a shepherd and his sheep in no.85 – indeed, they may always have been intended for such (as no.86 below seems to confirm) – but the latter cannot in any other sense be based on the small sketch, which simply does not contain enough of the right kind of information about the appearance of the place. As suggested above, it is even possible that Constable had already painted the shepherd and sheep in no.85 before making the small oil sketch and that the white marks in the latter are echoes of the more fully formed figures in the larger painting. The main point is that both paintings have equal but different claims to have been painted on the spot in 1816.

85

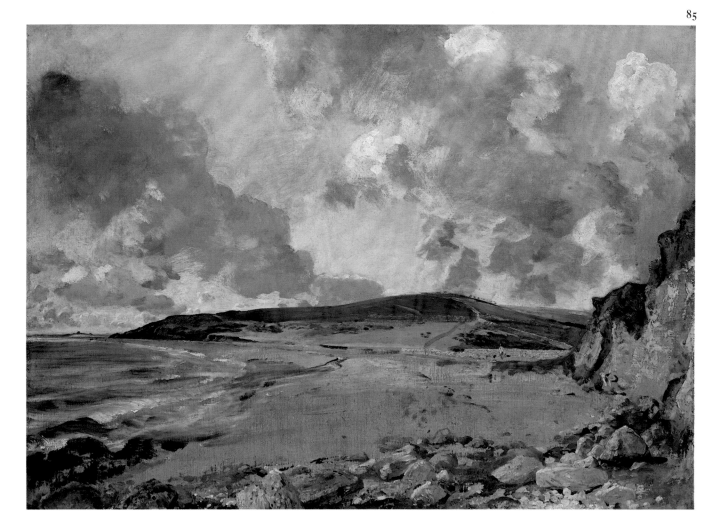

86 Weymouth Bay ?exh.1819

Oil on canvas 880 × 1120 (34¾ × 44)
PROV: ? Artist's administrators, sold Foster
16 May 1838 (in 47, 'Five – Weymouth Bay,
and four others') bt Williams; . . .; Edwin
Bullock by 1855 and sold Christie's 21 May
1870 (86) bt Cox; . . .; Joseph Gillott, sold
Christie's 26 April 1872 (198) bt for but 'not
delivered' to Metropolitan Museum of Art,
New York; . . .; 'Marquis de la
Rochebousseau' (pseudonym), sold Paris 5–8
May 1873 (36) ? bt John W. Wilson, by
whom presented to the Louvre the same year
(RF 39)
EXH: ? BI 1819 (44, 'Osmington Shore, near
Weymouth', frame 40 × 48 in)
LIT: Parris, Fleming-Williams, Shields 1976,
under no.150; Hoozee 1979, no.616, repr. (as
doubtful); Reynolds 1984, no.19.9, pl.73
(col.); Cormack 1986, p.102 (as doubtful);
Rosenthal 1987, p.98, ill.86

Musée du Louvre, Paris

This painting, clearly related to nos.84–5 above, has
been the subject of controversy in recent years but
Reynolds, in his 1984 catalogue, successfully dis-
posed of most of the objections raised against it and
made a good case for it having been the work Con-
stable exhibited at the British Institution in 1819. As
he points out, the canvas was enlarged to its present
size from about 740 × 950 mm (29¼ × 37¼ in), which
tallies well with the framed measurements given in
the British Institution catalogue, indicating a frame
a little over five inches wide. The enlargement,
which can be seen with the naked eye and is con-
firmed by x-radiography, was made by turning up
the original tacking edges and adding extra strips at
the top and left. Constable must have made the
alterations before David Lucas engraved the work in
its present format for *English Landscape* in 1830 (see
no.197). As well as corresponding to the print, the
painting is known to have belonged to Edwin
Bullock, who is named as the owner of the original in
the 1855 edition of the mezzotints. Hoozee and
Cormack have suggested that the painting is a copy

86

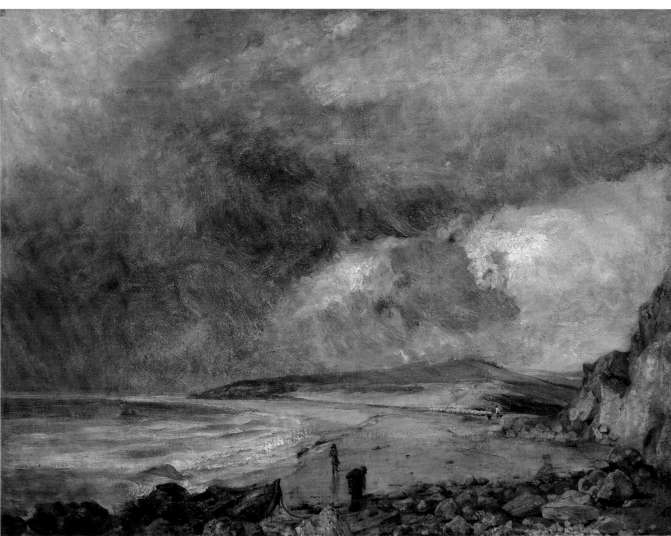

from the print but this view ignores the quality of the work, its provenance and the fact of its enlargement from a size appropriate to the 1819 exhibit.

No.86 depends from both the earlier paintings of the subject, taking detailed information about the landscape (especially the cliffs at the right and the rocks) from the National Gallery work, no.85, but borrowing the atmospheric effects of the small Victoria and Albert Museum sketch, no.84. The beached rowing boat and the two figures nearest the sea are also taken from the latter. Two dark marks near the shepherd in the National Gallery painting are now clearly identified as dogs. Looking again at the debated details in the small sketch, we can also see two dark marks near the white shape, suggesting that the latter was always Constable's shorthand for the figure of a shepherd. Constable appears originally to have included another figure in no.86, sitting on the rocks in the right fore-ground and now visible again because the upper paint layers have become transparent.

Later in life, at least, Constable associated this subject with the death of Captain John Wordsworth, the poet's brother and Mary Fisher's cousin, who drowned off Portland Bill in 1805. When sending Leslie's wife an impression of the Lucas mezzotint in 1830 he quoted from Wordsworth's 'Elegiac Stanzas, suggested by a picture of Peele Castle in a storm, painted by Sir George Beaumont': 'That sea in anger | and that dismal shoar' (his own version of the text), adding 'I think of "Wordsworth" for on that spot, perished his brother in the wreck of the Abergavenny' (Beckett III 1965, p.29). Constable probably heard the story and Wordsworth's poem during his honeymoon visit but by 1830 the subject's associations – with the Fishers, Wordsworth and Beaumont – had been intensified by his own recent loss of Maria.

Suffolk 1816–1817

87 **Flatford Mill from beside the Bridge** *c.*1814–16

Oil on canvas 241 × 190 (9½ × 7½)
PROV: By descent to Isabel Constable, who died 1888; sold anonymously, presumably on behalf of her heirs, by Ernest Alfred Colquhoun, Christie's 28 May 1891 as one of the works 'Exhibited at the Grosvenor Gallery, 1889 [245], as the Property of Miss

Isabel Constable, deceased' (129) bt in by Bourne; by descent to present owner
EXH: Tate Gallery 1976 (131, repr.)
LIT: Hoozee 1979, no.232, repr.; Parris 1981, pp.72, 75 n.6, fig.6; Rosenthal 1983, p.105, fig.134; Reynolds 1984, under no.17.1

Private Collection

See no.89

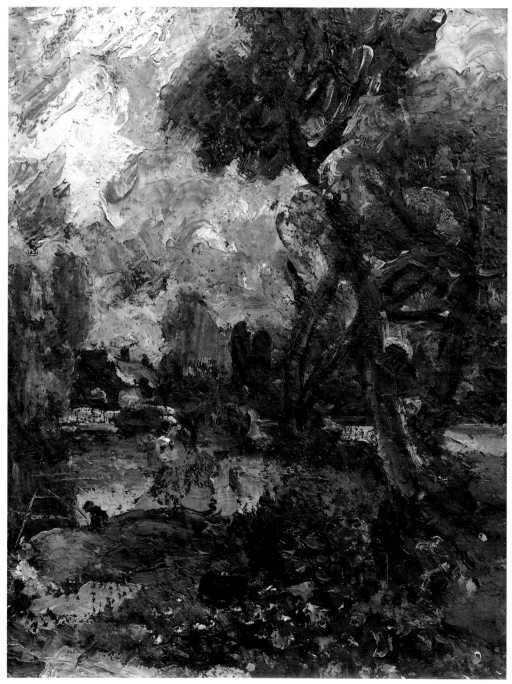

87

88 **Flatford Mill from the Bridge** *c.*1814–16

Oil on paper laid on board 116 × 156
($4\frac{9}{16}$ × $6\frac{1}{8}$)
PROV: . . .; Alexander Young, from whom bt
by Agnew and sold *c.*1914 to Mrs Warren;
her daughter, Mrs Charles S. Band, Toronto,
from whose heirs bt by present owners 1982
EXH: Tate Gallery 1976 (130, repr.)
LIT: Hoozee 1979, no.231, repr.; Parris 1981,
p.72, fig.5; Reynolds 1984, under no.17.1;
Hill 1985, p.42, ill.12 (col.)

Mr and Mrs David Thomson

See no.89

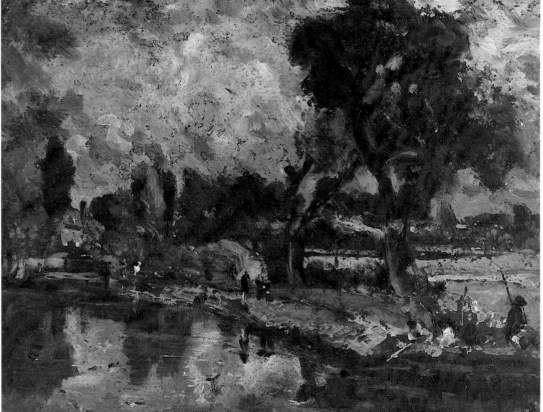

88

89 Flatford Mill ('Scene on a Navigable River') 1816–17, exh.1817

Oil on canvas 1017 × 1270 (40 × 50)
Inscribed 'Jon Constable. f: 1817.'
PROV: Artist's administrators, sold Foster 16
May 1838 (54, 'Flatford Mills, Horse and
Barge') bt in by Leslie for Constable family;
by descent to Isabel Constable and
bequeathed by her to the National Gallery
1888 as the gift of Maria Louisa, Isabel and
Lionel Bicknell Constable; transferred to the
Tate Gallery 1957 (N 01273)
EXH: RA 1817 (255, 'Scene on a navigable
river'); BI 1818 (91, 'Scene on the Banks of a
River', frame 58 × 68 in); Tate Gallery 1976
(151, repr.; also x-ray detail p.102, col. detail
opp. p.81)
LIT: Smart and Brooks 1976, pp.68–72,
pl.35; Hoozee 1979, no. 233, pl.XXII (col.);
Parris 1981, no.14, repr. in col., also x-ray
detail; Anna Southall, 'John Constable . . .
"Flatford Mill (Scene on a Navigable
River)"' in Stephen Hackney (ed.),
Completing the Picture, 1982, pp.34–8;
Rosenthal 1983, pp.104–8, figs.135 (col.), 136
(col. detail); Reynolds 1984, no.17.1, pl.5
(col.); Hill 1985, pp.11, 13, 112, pl.27 (col.);
Cormack 1986, pp.89, 96, 99, 102–5, pls.95
(col.), 97 (col. detail), 98 (col. detail);
Bermingham 1987, pp.104–5, fig.41;
Rosenthal 1987, pp.89–93, ills.77 (col.), 78
(col. detail); Rhyne 1990a, pp.116, 122,
fig.11; Fleming-Williams 1990, pp.118, 130

Tate Gallery

fig.58 1814 sketchbook
(no.248), p.61, *Board of
Trustees of the Victoria and
Albert Museum, London*

Constable's campaign of painting directly from his
native scenery came to an end in the summers of
1816 and 1817, the last occasions upon which he
spent any length of time at East Bergholt. 'Flatford
Mill', no.89, begun in 1816 and exhibited at the
Royal Academy the following year, was very likely
the largest, though not the last, of the canvases he
worked on outdoors in Suffolk. (Some doubt exists
about when and where the even larger, abandoned
'Dedham from Gun Hill', mentioned under no.9,
was painted.)

Constable's earlier 'Flatford Mill' (no.54), exhi-
bited in 1812, depicted the mill as seen from the
lock. In his 1813 exhibit 'Boys Fishing' (no.57) he
looked in the opposite direction, from the lock to
the bridge. Moving gradually upstream, like one of
his father's barges, Constable was ready by the
summer of 1813 to study the mill and the lock from
the bridge and points nearby. His sketchbooks of
this and the following years show him examining
various viewpoints: p.10 of the 1813 sketchbook
(no.247), drawn upstream from the bridge on the
north bank of the river (for an oil related to this
drawing see Parris 1981, p.72, fig.4; sold Sotheby's
13 March 1985, lot 92, repr. in col.); p.61 of the
1814 book (no.248), dated 14 August, drawn from
the tow-path at the south end of the bridge (fig.58);
p.63 of the same sketchbook, drawn from the dock
on the north bank; a detached sketchbook page in
the Hornby Library, Liverpool (B62–18), made
from a similar position to the 14 August 1814
drawing but later because a large branch noted on
the foremost tree that day is missing (fig.59). The
absence of this branch, its stump only remaining,
also enables the two oil sketches shown here,
nos.87–8, to be dated after August 1814. The
upright sketch, no.87, otherwise corresponds very
roughly with the 14 August drawing. A vigorous
piece of painting, this work is one of the earliest
examples known of Constable's use of the palette
knife (seen also, for example, at the right of the
1816 'Weymouth Bay', no.85). Like the Hornby
Library drawing, the other oil, no.88, is horizontal
in format but the viewpoint is slightly different,
Constable painting from the bridge rather than at
the end of it. Instead of the solitary fisherman in the
upright sketch a colourful group of anglers appears
at the bottom right while other figures are seen
walking along the tow-path.

These drawings and oil sketches show Constable
thinking around the subject that he finally painted in
no.89 rather than making studies for it. The only oil
study (if that is what it is) in which the composition
appears as in the 1817 exhibit, though with
variations in the staffage, is a work whose status is
not sufficiently clear to the present authors for it to
be usefully introduced here (for an old reproduction
of this painting, which has recently come to light
again, see Parris 1981, p.74 fig.7; see also Rhyne
1990b, pp.80, 83 n.52). The only undoubted direct
preparatory study is a drawing acquired by the Tate
Gallery in 1988 (fig.60, verso fig.61, T 05493)
measuring 255 × 312 mm ($10\frac{1}{16} × 12\frac{5}{16}$). This is no
ordinary drawing but a pencil tracing of an image

made with brush and, probably, printing ink on a sheet of glass held on an easel in front of the subject itself. The tracing was made by placing a piece of paper over the image on the glass, which because it was still wet produced an accidental offprint on the back of the paper. Squared for transfer to the canvas, the drawing includes the two barges but none of the figures seen in the painting. Although he does not explain the process fully, Arthur Parsey describes Constable using such a method in his book *The Science of Vision; or, Natural Perspective* (1840). A number of such tracings have come to light in recent years (for another see under no.49) but the full implications of their discovery have still to be assessed (see Fleming-Williams 1990, pp.118–23 for the most detailed account to date). We should not be surprised, however, to find Constable using this ultimate weapon in the armoury of the 'natural painter' to establish the perspective of so large a canvas as no.89.

fig.59 'Flatford Mill', *c.*1814–16, *Hornby Library, Liverpool*

The tracing was probably made in August or September 1816. On 12 September, anxiously trying to reconcile the demands of his painting with his wish to be married as soon as possible, Constable wrote to Maria from Bergholt: 'I am now in the midst of a large picture here which I had contemplated for the next exhibition – it would have made my mind easy had it been forwarder – I cannot help it – we must not expect to have all our wishes complete' (Beckett II 1964, p.203). Some tactless remarks in the letter provoked a swift response from Maria followed by an exchange in which both tried to make amends, Maria remarking on 16 September: 'Your landscape too gives me some uneasiness, is there a chance of its being sufficiently forward, to do without *your copy?*' (ibid., p.205). As Reynolds suggests, by 'copy' Maria appears to have meant the actual scene, the thing being copied rather than the copy of it (cf. Mr Rochester to Jane Eyre on her watercolours: 'Where did you get your copies?', 'Out of my head.'). The absence of direct preparatory studies, other than the tracing, and the quantity of close observation in the painting support the idea of its being largely executed on the spot. The distance is especially rich in beautifully observed detail: a barge moored by the mill at the left, the boys fishing in the lock (one hanging round a lintel post), an inviting bend of the tow-path with a half-obscured horse, a glimpse of the river winding downstream at the centre of the painting, and cattle grazing in the field at the right beyond the hayfield and its solitary reaper.

fig.60 'Study for "Flatford Mill"', 1816, *Tate Gallery*

A very deliberate organisation, only partly established in the tracing, was necessary to keep the whole scene under control and stop us from totally dissecting the picture in this way. Waiting for the barges to be disconnected so that they can be poled under Flatford bridge, the boy on the horse acts as a pivot for the diagonals used to articulate the composition. Neither this central pair of figures, thrown into sharper relief by the tree shadow behind them, nor the carefully placed timberwork in the foreground (the end of the bridge and the

fig.61 Verso of 'Study for "Flatford Mill"', 1816, *Tate Gallery*

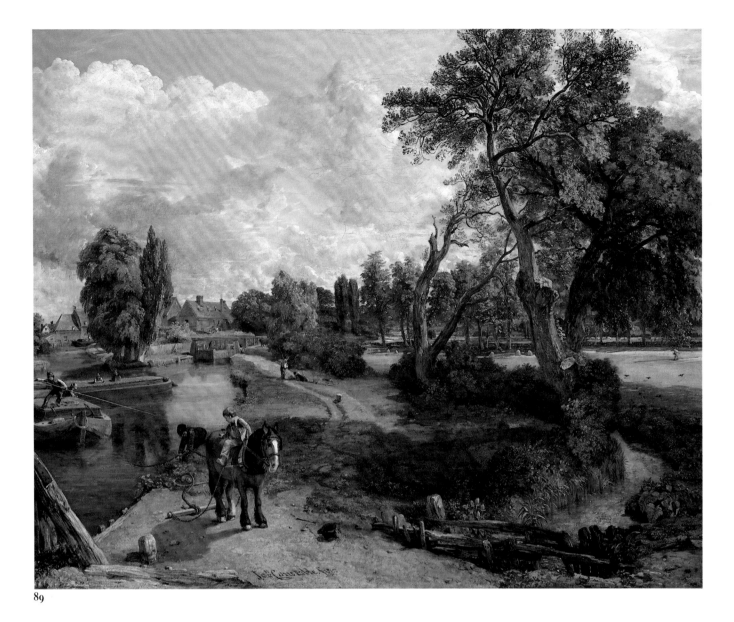

89

mooring-post at the left, the sluice at the right echoing the bargee's pole on the other side) appear in the tracing. These are the sort of things that Constable almost certainly added in the studio. There too he painted out a horse on the tow-path and substituted the figures of two boys, while leaving the horse's collar and towing gear on the ground beside them (see the x-radiograph detail in Parris 1981). More substantial changes are known to have taken place after 17 October 1817 when Constable made a large and very detailed drawing from nature of the two trees at the right (no.281), using this to repaint the tops of the trees in the picture. At the same time he repainted the entire sky, first laying a mushroom coloured priming over

the original one (see cross-sections in Southall 1982). These alterations were presumably made in time for the picture's second showing at the British Institution in January 1818.

It is tempting to see 'Flatford Mill', largely executed on the eve of his marriage and move to London, as Constable's valediction to his '"careless boyhood" ... on the banks of the *Stour*' (Beckett VI 1968, p.78) and the figure on the horse as an epitome of that boyhood. But the painting was also a prelude to the even more ambitious recreation of those scenes that he embarked upon in 1818, this time working in his London studio and approaching the whole business in a very different way.

90 East Bergholt Church from the South-West ?1817

Oil on canvas 536 × 438 (21⅛ × 17¼)
PROV:...; Lady Bradford, London
(according to label on back); ...; W.A.
Harding Trust, sold Christie's 16 March
1984 (42, repr. in col.) bt for Durban Art
Museum
LIT: Reynolds 1984, no.17.30, pl.30; Parris
and Fleming-Williams 1985, p.167, under
no.17.30

Durban Art Museum, South Africa

Early oil sketches of East Bergholt church, one of
1809, and the painting of it exhibited in 1810 are
shown above as nos.27–30. Probably a few years
later Constable made two oil sketches of the church
seen, as in no.90, from the lane leading to Flatford
(Hoozee 1979, nos.134–5, repr.). He returned to
this viewpoint in a drawing of 1817, no.279 below.
1817 is also the likely date of the present painting.
As Reynolds points out, there are several references
in Farington's *Diary* to Constable having painted a
number of 'studies' or 'sketches' in the summer of
1817, when he was holidaying in Suffolk with
Maria. When he returned he called on Farington
on 11 November 'and told me He had passed 10
weeks at Bergholt in Suffolk with His friends & had
painted many studies' (Farington XIV, p.5103),
while on the 24th of that month the Academician
W.R. Bigg spoke to Farington 'very favorably of
some painted studies which Constable made last
Summer' (ibid., p.5111). Farington himself
inspected them on 31 January 1818: 'I saw several
of His painted sketches and drawings done last
Summer, but He had not any principal work in
hand' (Farington XV, p.5148). One such sketch, not
traced today, was in C.R. Leslie's sale, a 'Sketch in
Suffolk, near East Bergholt' dated October 1817
and described by Leslie as seeming 'to have been
painted entirely in the open air and at one sitting',
implying that it was a fair size (Foster 25 April
1860, lot 92; Reynolds 1984, no.17.24). The close
connection between no.90 and the 1817 drawing of
the church (no.279) and also between nos.91 and 93
below and two other 1817 drawings raises the
possibility that the paintings as well as the drawings

were made that year and that they are examples of
the 'studies' or 'sketches' mentioned by Farington.
All three combine areas of sketchy handling with
passages of closely observed work of a kind seen in
Constable's outdoor paintings of 1814–16. In
no.90, for example, the frame of trees is conspi-
cuously less worked up than the central image of
the sunlit church. The sketch of 'A Cornfield'
(no.163) also has these characteristics.

Although it does not bear on the dating of no.90,
the existence of a tracing of the subject similar in
character to the one used for 'Flatford Mill' (no.89)
may support the idea that it was painted on the spot
(fig.62, private collection, New York). There are
differences between it and the painting but the
viewpoint and perspective are almost identical and
the description of the trees at the left of the tracing
is closer to the painting than is the corresponding
part of the 'conventional' 1817 drawing, no.279.

fig.62 'East Bergholt
Church from the South-
West', *c.*1817, *Private
Collection, New York*

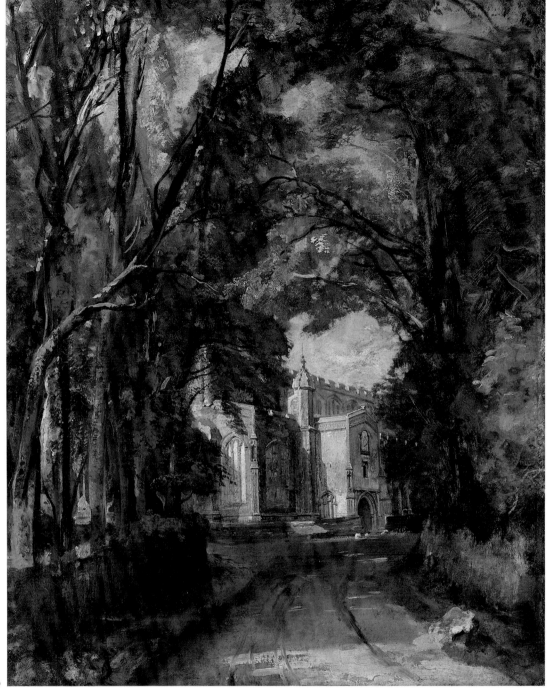

90

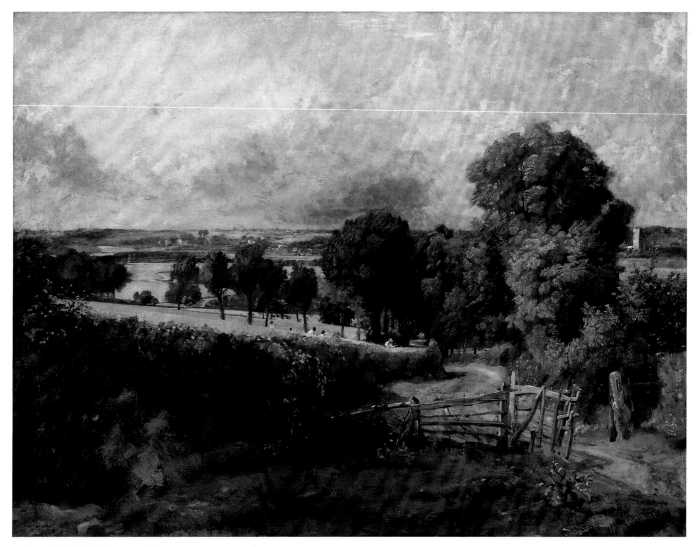

91 (see also detail facing p.145)

91 Fen Lane, East Bergholt ?1817

Oil on canvas 692 × 925 (27¼ × 36⁷⁄₁₆)
PROV: . . .; Sir Donald Currie by 1894; he
died 1909; . . .; private collector; by descent
until sold anonymously, Phillips 11 Dec.
1990 (75, repr. in col., with col. details) bt in
EXH: Japan 1986 (18, repr. in col.)
LIT: Ian Fleming-Williams, 'Tokyo:
Constable', *Burlington Magazine*, vol.128,
May 1986, p.384, fig.77; Malcolm Cormack,
'Constable in Japan', *Apollo*, vol.123, June
1986, p.428, fig.1

Private Collection

For Fen Lane, running down to Fen bridge from
the East Bergholt to Flatford road, see nos.10–14
and 45–6 above. In this large unfinished painting,
which was unknown to Constable scholars until
1985, we look directly south-west down the lane, as
in the small oil sketch no.45. A gang of reapers at
the edge of the field to the left of the lane appears to
have just started harvesting, standing deep in the
wheat with the man on the right probably wielding
a sickle and the pair to his left tying sheaves. This
area of the picture is painted up to a fair degree of
finish, as is the landscape in the middle-distance,
the lane itself and the gate – this latter a remarkable
piece of rustic timberwork, seen foreshortened and
with all its working parts fully explained by
Constable. Other areas are much sketchier, for
example the top right of the foremost tree and the
rather perfunctory tower of Dedham church
behind it. The foreground, especially the left
corner, is the least complete part of all.

As suggested under no.90, this may be one of the
'studies' or 'sketches' Constable made in the
summer of 1817 and which Farington and Bigg
subsequently saw. As with no.90, there is a
corresponding drawing made that year (fig.63,
Victoria and Albert Museum, Reynolds 1984,
no.17.8), a drawing which has the incidental
interest of having been copied both by John Fisher
and Lionel Constable (see Fleming-Williams and
Parris 1984, pls.148–50). But the painting tells us
far more about the appearance of the place and can

only have been made on the spot. If this was the sort of work Farington saw, the terms 'sketch' and 'study' are not really appropriate since no sketch or study would contain so much detailed painting or be on such a large scale. This is an unfinished picture and we must ask why it, like the other works in this group, was left incomplete. Did the weather suddenly change? Was Constable short of time? Or did he perhaps feel that he had secured enough information to be able to complete the picture in London? The least finished area of 'Fen Lane', the foreground, is the part that he would probably count on painting indoors in any case, perhaps introducing a donkey as he had done in his 1811 painting of the top of Fen Lane (no.14). If he suspected that his 1817 holiday would be his last opportunity to gather a quantity of pictorial material in Suffolk, it would have been natural to work in this way, saving time by taking his paintings just far enough. In the event Constable finished neither this work nor the picture of East Bergholt church, no.90. Two of the other paintings that we believe he began on this last long visit were, however, finished, though not on the canvases Constable had with him in 1817. It is to one of these, and its dependent canvases, that we now finally turn in 'The Suffolk Years'.

(As this catalogue goes to press, we are pleased to find that Michael Rosenthal has reached similar conclusions about the place of no.91 in Constable's work: see his article 'A Constable Re-appearance: *Fen Lane* and the Road to Damascus', *Apollo*, vol.132, Dec.1990, pp.402–6.)

92 Dedham Lock and Mill ?1816

Oil on paper 181 × 248 (7⅛ × 9¾)
PROV: As for no.2
EXH: Paris 1976 (19, repr.); Japan 1986 (11, repr. in col.)
LIT: Reynolds 1973, no.113, pl.68; Hoozee 1979, no.182, pl.XXVI (col.); Parris 1981, p.80, fig.1; Rosenthal 1983, p.115, fig.145; Reynolds 1984, under no.20.10; Cormack 1986, p.106, pl.99; Fleming-Williams 1990, p.133, fig.126

Board of Trustees of the Victoria and Albert Museum, London

See no.93

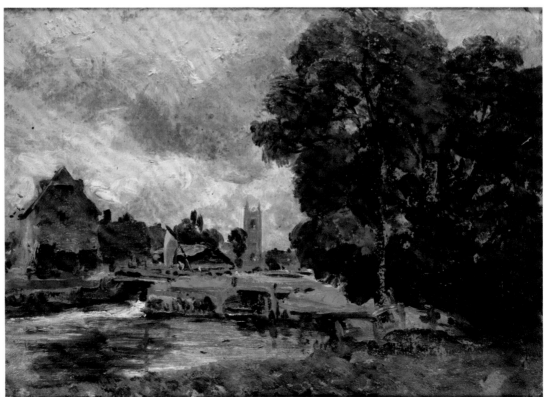

92

93 Dedham Lock and Mill ?1817

Oil on canvas 546 × 765 (21½ × 30⅛)
PROV: By descent to Isabel Constable and
possibly bequeathed by her to her niece Ella
Constable; probably included in the
anonymous sale, presumably on behalf of
Isabel's heirs, by Ernest Alfred Colquhoun,
Christie's 28 May 1891 as one of the works
'Exhibited at the Grosvenor Gallery, 1889
[263], as the Property of Miss Isabel
Constable, deceased' (134) bt Wigzell; . . .;
Louis Huth, sold Christie's 20 May 1905 (39)
bt Agnew for George Salting, by whom
bequeathed to the National Gallery 1910;
transferred to the Tate Gallery 1919
(N 02661)
EXH: *Paint & Painting*, Tate Gallery, June-
July 1982 (no number)
LIT: Hoozee 1979, no.255, repr.; Parris 1981,
no.17, repr. in col.; Reynolds 1984, no.20.13,
pl.140 (col.); Parris and Fleming-Williams
1985, p.167 under no.17.30; Cormack 1986,
p.106, pl.100; Fleming-Williams 1990, p.133,
fig.127

Tate Gallery

The earliest known study by Constable of his
father's mill at Dedham is a pencil drawing of about
1809 (Mr and Mrs David Thomson, Fleming-
Williams 1990, fig.124). This shows the mill, lock
and church much as in nos.92–3 but from further
away and with the landscape extending beyond the
trees at the right. A smaller drawing of 22 July 1816
included in this exhibition (no.264) brings the eye
closer and omits the right-hand section of the
landscape. Less is also shown to the left of the mill,
while Dedham church, barely noticed in the earlier
drawing, has become a central feature. This 1816
drawing has much in common with the Victoria
and Albert Museum oil sketch shown here, no.92.
In both the sluice is given as much, if not more,
prominence than the opening to the lock. In the oil
sketch the white foam of water rushing from the
sluice immediately catches the eye, breaking
through the dark reflection of the mill. Both the
drawing and the oil sketch also pick out the triangle
of the warehouse gable just above and between the
sluice and the lock entrance, and they depict the
fence in the right foreground in a similar way.
These correspondences in the way Constable
looked at the scene suggest that no.92 may be
similar in date to the 1816 drawing. There is a
suggestion in Maria's letter of 20 July 1816 that
Constable was at least thinking of painting a
Dedham subject that year: 'You must lament this

rain very much, there can be no going on with
Dedham' (Beckett II 1964, p.188).

The unfinished Tate Gallery painting, no.93, is
also related to a drawing, this time of 1817 (fig.64,
Huntington Library and Art Gallery, San Marino,
Reynolds 1984, no.17.25). Both open up the
landscape to the left of the mill and both focus on
the lock entrance rather than the sluice. The latter
is shown more or less dry in the painting, with no
rush of water to disturb the mill's dark reflection.
What catches the eye now is the pool of light in
front of the lock. Both the painting and the 1817
drawing also describe the foreground bank in a way
not seen in the earlier works, with a small inlet
immediately to the left of the foremost tree and the
fence reduced to a couple of posts to its right.

As with nos.90–1 above, we have a painting
corresponding in its interpretation of the subject
with a drawing made in 1817. The Tate Gallery
painting also resembles nos.90–1 in its combi-
nation of close observation and sketchiness. Here
the contrast is more extreme. While the middle-
distance contains a fair amount of detail – for
example, the two men talking at the left of the mill,
the water cascading from the mill-wheel, the
detailing of the church tower or the beautifully
expressed figure of the man levering up the pad-
dle of the lock gate – the trees and foreground are
only lightly brushed in over the brown priming of
the canvas. There is an additional reason for think-
ing that no.93 was painted in 1817, or at least no
later, since it served as the basis for a completed
version that appears to have been exhibited in 1818
(no.94).

fig.64 'Dedham Lock and
Mill', 1817, *Henry E.
Huntington Library and Art
Gallery, San Marino*

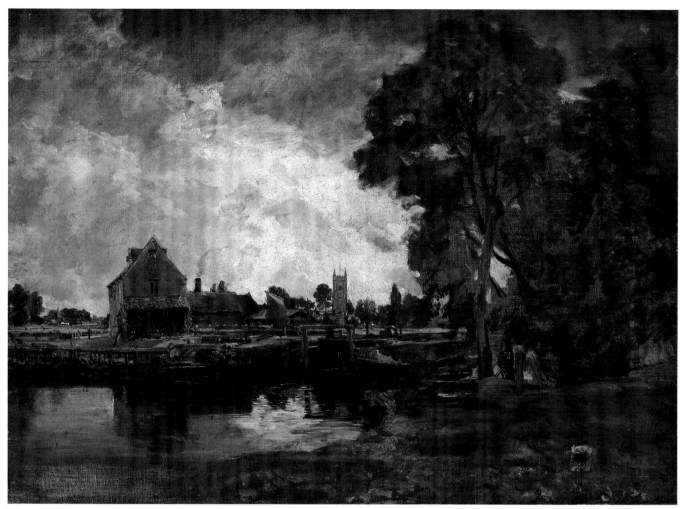

93

94 Dedham Lock and Mill ?exh.1818

Oil on canvas 700 × 905 ($27\frac{9}{16} \times 35\frac{5}{8}$)
PROV: ? J. Pinhorn (named as purchaser at
1819 BI) or James Pulham (as suggested by
Reynolds); . . .; ? Thomas Miller *c*.1850;
T. Horrocks Miller; Thomas Pitt Miller, sold
Christie's 26 April 1946 (17) bt Leggatt;
private collection; acquired by present
owners 1985
EXH: ? RA 1818 (11, 'Landscape: Breaking up
of a shower'); BI 1819 (78, 'A Mill', frame
39 × 47 in); Tate Gallery 1976 (166, repr.)
LIT: Hoozee 1979, no.256, repr.; Parris 1981,
pp.80–3, fig.3; Rosenthal 1983, p.115;
Reynolds 1984, no.20.12, pl.139; Parris and
Fleming-Williams 1985, p.167 under
nos.18.1, 18.2, 20.12; Cormack 1986, p.106;
Rosenthal 1987, p.112, ill.104; Fleming-
Williams 1990, p.133, fig.128

Mr and Mrs David Thomson

See no.96

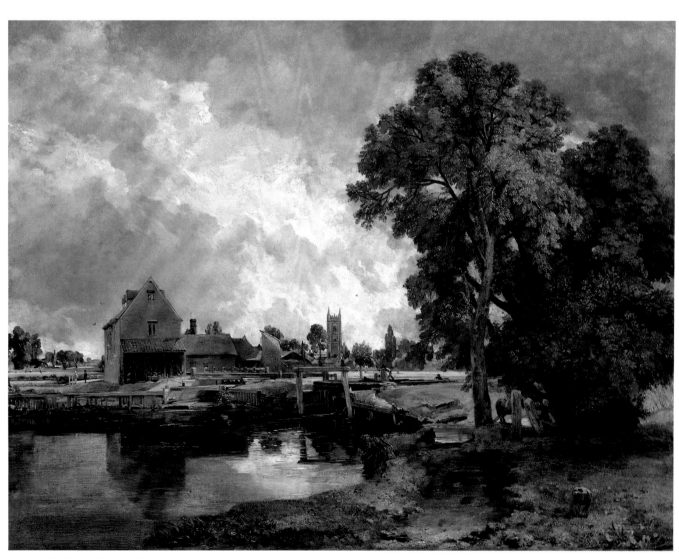

94 (see also frontispiece detail)

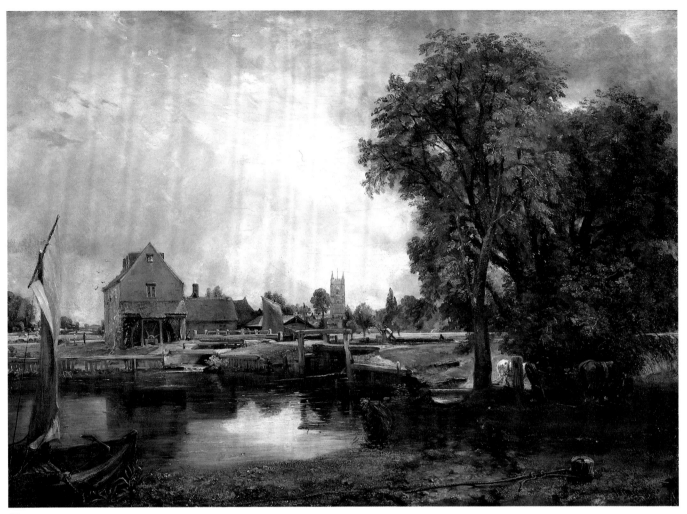

95

95 Dedham Lock and Mill 1820

Oil on canvas 546 × 775 (21½ × 30½)
Inscribed 'John Constable|London' b.r.
PROV: By descent to Maria Louisa
Constable, from whom acquired by Miss
Spedding probably in 1841; by descent until
bt by Agnew and from them by Knoedler,
New York, who sold it to the Currier Gallery
1949
EXH: Milwaukee 1976 (4); *Romance and
Reality: Aspects of Landscape Painting*,
Wildenstein, New York, Oct.–Nov. 1978 (18,
repr.); New York 1983 (17, repr. in col.);
New York 1988 (13, repr. in col.)
LIT: Parris, Fleming-Williams and Shields
1976, under no.166; Hoozee 1979, no.275,
repr.; Parris 1981, pp.82–4, fig.5; Reynolds
1984, no.20.11, pl.138 (col.); Cormack 1986,
p.106;

*Currier Gallery of Art, Manchester, New
Hampshire*

See no.96

96 Dedham Lock and Mill 1820

Oil on canvas 537 × 762 (21⅛ × 30)
Inscribed 'John Constable. ARA. | pinx.ᵗ
1820' b.r.
PROV: ? Artist's administrators, sold Foster
16 May 1838 (80, 'Dedham Mill and
Church') bt Brown; . . .; John Sheepshanks,
by whom presented to the South Kensington
(later Victoria and Albert) Museum 1857
EXH: Tate Gallery 1976 (180, repr.)
LIT: Reynolds 1973, no.184, pl.145; Smart
and Brooks 1976, p.32, pl.22 (detail); Hoozee
1979, no.274, pl.XXCV (col.); Parris 1981,
pp.82–3, fig.4; Rosenthal 1983, p.115,
fig.147; Reynolds 1984, no.20.10, pl.137
(col.); Cormack 1986, p.106, pl.101;
Rosenthal 1987, p.112

*Board of Trustees of the Victoria and Albert
Museum, London*

The Thomson painting, no.94, is taken here to be
the first of the three finished versions of 'Dedham
Lock and Mill'. Like the unfinished Tate Gallery
canvas, no.93, it lacks the large boat and the second
horse introduced as compositional refinements in
the other two, nos.95–6, and has a more overcast
sky. It also corresponds more closely in detail with
the unfinished painting. Unlike his counterparts in
nos.95–6, the man opening the lock bends so far
over that his arms and back are almost in one plane,
while the bottom edge of the roof over the mill
wheel is straight, without the lip seen in nos.95–6
(this modification was probably based on the small
oil sketch, no.92). Larger and squarer, however, it
differs both in size and format from all the other
canvases.

The subject and measurements of no.94 allow it
to be identified with Constable's 1819 British
Institution exhibit 'A Mill'. Since Constable
frequently sent to the BI works that had failed to
sell at the previous year's Academy, it may also be
the 'Landscape: Breaking up of a shower' exhibited
there in 1818. The title is entirely appropriate: the
sun is seen here breaking through departing rain
clouds. As a reviewer of the 1818 exhibit said, the
picture 'has something . . . of the glittering fresh-
ness congenial to the effect of summer rain'
(*Literary Gazette*, 20 June 1818, p.394). Cormack
points out Leslie's reference to the 1819 BI picture
as 'not before exhibited' (Leslie 1843, p.24, 1951,
p.73) but Leslie may have reached this conclusion
simply on a comparison of titles.

In the catalogue of the 1976 Constable exhibi-
tion the present authors commented on the tight
handling of the tree foliage at the right, suggesting
that it was unlike anything known by Constable at
this period. Since then works with comparable
passages have come to light, for example 'The
Wheatfield' (no.76) and 'A Cottage in a Cornfield'
(no.78). Reynolds, however, was still sufficiently
worried about the foliage in question (and a few
other features) to propose in his 1984 catalogue that
the picture might be a later repetition, perhaps
made with John Dunthorne junior's help, of a
missing original. The hypothesis does not explain
why Constable, having elaborated the composition
in nos.95–6, would want to borrow the original
from its owner and copy it. This apart, no.94 has a
freshness that one would not expect so late in a
series of replicas. Taking only one small area, the
distant landscape to the left of the mill not only
preserves the immediacy of this scene as observed
on the Tate canvas (no.93) but actually seems to
heighten it by supplying more information. The
two figures who face one another at the front of this
miniature vista also gain by being more fully
described: we can now see that the man in dark
clothes is talking to the miller, whose white hat we
see again reflected in the water. In nos.95–6 these
two figures are, by comparison, poorly described
and the vignette loses much of its point; by the time
no.96 was painted the miller's hat was no longer
worth a reflection. The other figures – the man
opening the lock and the figure in the barge – are
similarly less well described in the later versions.

The second of the three finished paintings of
'Dedham Lock and Mill' would appear to be the
Currier Gallery picture, no.95. The visible penti-
menti around the bottom of the sail of the boat now
introduced in the left foreground suggest that this
is its first, slightly uncertain, appearance and Sarah
Cove's microscopic examination of the painting in
1989 confirms this: Constable had already painted
the water before he decided to introduce the boat.
Originally he may also have included a figure in the
vessel but then painted it out (see Cove, thesis).
The diagonals of the boat and its sail break up the
strong horizontal and vertical lines of nos.93–4,
which Constable may have thought too severe. The
lip on the roof over the mill wheel and the small tree
nearby may have been introduced for similar
reasons – or, rather, re-introduced in the case of the
tree, which is present in the unfinished painting.
Other differences between the Currier Gallery
painting and the earlier versions have already been
mentioned. In 1841 Leslie told its new owner that it
was painted in 1820 (Parris 1981, p.84 n.8). By
then, as Reynolds points out, Constable would
have been entitled to add 'A.R.A.' to his signature,
as he did on the dated version of 1820, no.96 below.
He did not invariably do so, however, and Cove
notes that there is in any case an area of damage
after Constable's name on no.95 (the 'e' of
'Constable' is partly missing and 'London' has
been retouched).

Dated 1820, the Victoria and Albert Museum
picture, no.96, appears to be the last of the finished

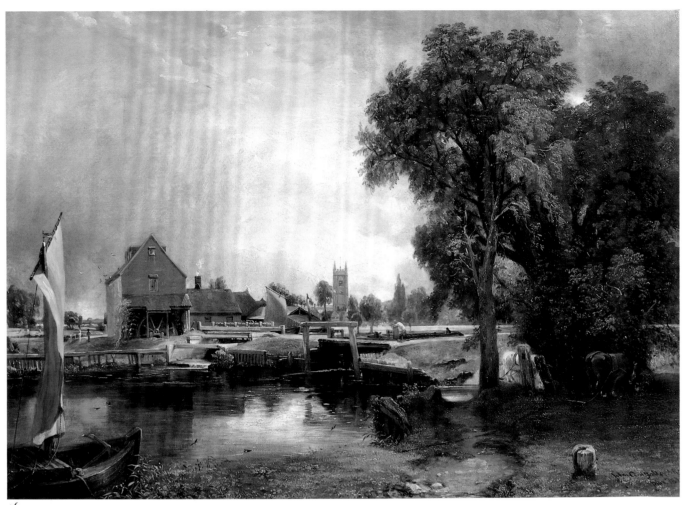

96

versions of the subject. Instead of painting the boat on top of the water, Constable planned to include it from the outset and left room accordingly. Cove's examination shows not only that the water was painted up to the boat but that the whole design was drawn out in paint first and then filled in (see p.508). The rope from the boat is now shown still connected to the foremost towing-horse rather than to the mooring-post as in no.95, and there are smaller changes to the ropes on the boat and to the figures. The man operating the windlass to open the paddle of the lock gate seems to have made the task more difficult for himself by getting on the wrong side of the post.

The existence of three finished versions of 'Dedham Lock and Mill' introduces us to a new phase in Constable's practice. Having sold the first, no.94, he must have hoped to find further buyers for the subject and therefore repeated it, taking the opportunity at the same time to make what he saw as improvements to the composition. In the event he seems to have been left with the last two canvases on his hands but he presumably saw himself as adopting a more realistic, commercial attitude towards his art. He was now, as the inscription on no.95 tells us, a 'London' artist and more keenly aware of the potential and the pressure of the market place.

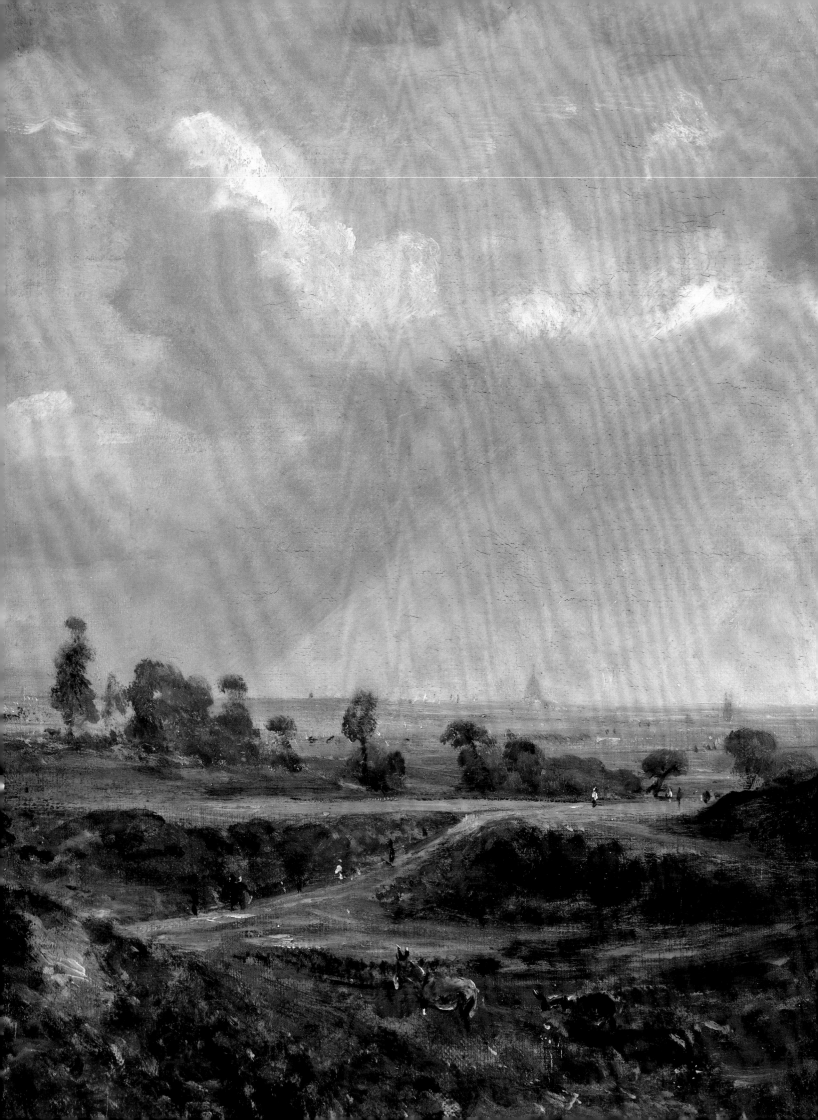

THE LONDON YEARS

After a long holiday with Maria in Suffolk in 1817 Constable returned only for comparatively brief visits, usually on family or other business. Maria never went back and it was not until 1827 that any of their children saw the Stour valley. Other places had begun to claim Constable's attention.

Living first in his bachelor lodgings at 63 Charlotte Street, the Constables moved in 1817 to 1 Keppel Street (which Fisher promptly named 'Ruysdale House') near the British Museum, before moving in 1822 to a more spacious house in Charlotte Street, no.35, which had become vacant on the death of their old friend Farington. From 1819 onwards they also took a house at Hampstead most summers; there a whole range of new subject matter opened up for Constable (see nos.106–30). Visits to the Fishers at Salisbury (nos.131–44) and long stays at Brighton (nos.145–56), where Constable took Maria when her health began to fail, further extended the range of his subject matter.

Suffolk was never forgotten, however. The mass of drawings, oil sketches and paintings Constable had made there from his earliest years up to 1817 were the source for the most important of his later canvases. With this store of material, working directly from his native scenes may have seemed no longer necessary and would certainly have been impractical on the six-foot canvases which he adopted in 1818 (he may even have discovered this for himself at an earlier date: see under no.9). More than this, he seems to have felt the need to distance himself further from his subjects in order to shape them better. Something of this process at its simplest has already been seen in the sequence of 'Dedham Lock and Mill' paintings (nos.93–6), which spans the move from Suffolk to London. At Hampstead and elsewhere he continued to make oil sketches and small to medium sized exhibition pictures directly from nature but his large Suffolk paintings became very indirect indeed, the final canvas being approached through an intermediary full-size sketch. This unprecedented method was first employed for 'The White Horse' (fig.65, Frick Collection, New York; the sketch is in the National Gallery of Art, Washington), begun in 1818 and exhibited the following year. The change was sudden: at the beginning of 1818 Constable had exhibited the amended 'Flatford Mill' (no.89), a large painting executed in great part on the spot. Although they did not always serve the same purpose, the full-size sketches gave Constable the opportunity to resolve problems of articulating a large-scale composition before he put it on the final canvas, as well as to draw some unity from the often disparate material he used as a reference.

The move to painting on six-foot canvases represented a new bid for recognition both of his subject matter and of himself as an artist. Believing passionately in the value of 'natural landscape', Constable now sought to project it on a scale more in keeping with the achievements of classical landscape painting. A life-long and highly discriminating student of the old masters, he seems to have redoubled his attention to them in the early 1820s, culminating in a long visit to the Beaumonts at Coleorton in 1823 where, surrounded by Claudes, Poussins and Wilsons, he saw himself at school again (Beckett 11

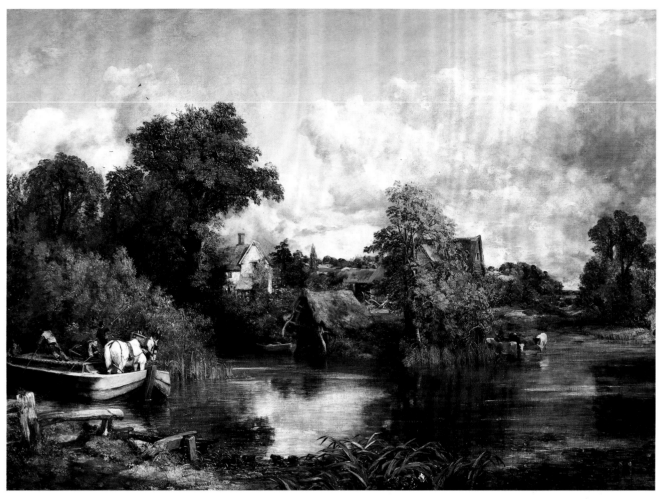

fig.65 'The White Horse', 1819, *Frick Collection, New York*

1964, p.304). The large canvas now became the real testing ground of his ambitions. 'I do not consider myself at work without I am before a six foot canvas', he told Fisher in 1821 after he had been making small studies at Hampstead (Beckett vi 1968, p.76). Works on this scale were also necessary if Constable was to command attention at the Royal Academy. Now with a wife and family to support, sales and professional recognition were more than ever essential. With the exhibition of 'The White Horse' in 1819 he achieved a fair measure of success on both counts. The picture was, said C.R. Leslie, 'too large to remain unnoticed' and 'attracted more attention than anything he had before exhibited' (Leslie 1843, p.24, 1951, p.73). Fisher – apparently the only one willing to spend money

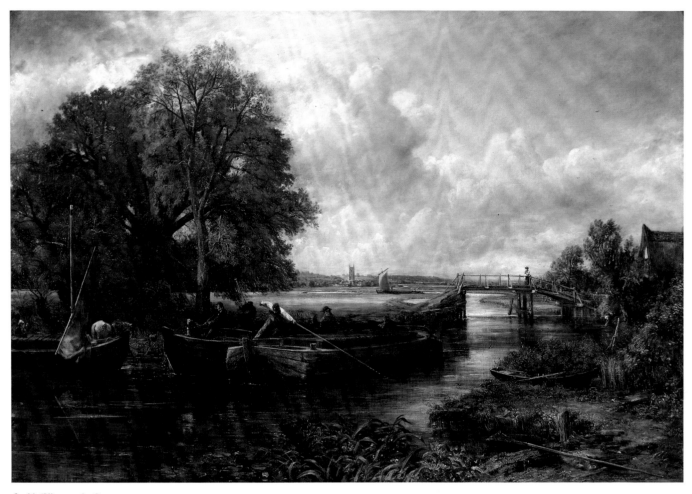

fig.66 'View on the Stour
near Dedham', 1822, *Henry
E. Huntington Library and
Art Gallery, San Marino*

on it – bought the painting at its original asking price of 100 guineas. In November 1819 Constable was at last elected an Associate of the Royal Academy.

This second part of the exhibition intersperses Constable's large Academy canvases of the 1820s and 1830s with groups of his Hampstead, Salisbury and Brighton works. Some preparatory material for the former is shown alongside the final paintings but, because the subjects were often drawn from Suffolk, relevant earlier material will sometimes already have appeared in the first part of the exhibition. As a London-based artist Constable went on using the images of his Suffolk years, forever casting them in new perspectives.

Early Set-Pieces

For his first two six-foot exhibition pictures Constable chose subjects that he had not made much of before: an unusual view of the Stour and Willy Lott's house for 'The White Horse' (fig.65 on p.194), for 'Stratford Mill' (no.100) a setting that lay outside his normal territory altogether. At the outset more familiar subjects may have seemed too difficult to project on the new grand scale he had adopted – as suggested earlier, the success of the six-foot canvases depended on Constable distancing himself from his material in order to put it in a new perspective. In 'The Hay-Wain' (no.101) and 'View on the Stour near Dedham' (fig.66), the third and fourth of the series, he returned to subjects that had long been important to him, at the same time bringing a new weight to bear on the figures in his compositions. In 'Stratford Mill' our attention wanders round the scattered figures of the rider, the anglers and the men with the barge: in 'The Hay-Wain' it is immediately captured by the central wain and its two occupants. Constable was now well aware that his large paintings needed strong figurative incidents of this kind. After making numerous changes to the composition of 'View on the River Stour' he concluded 'The picture has now a rich centre, and the right-hand side becomes only an accessory' (Beckett VI 1968, p.89). This shift of emphasis, with figures increasingly giving meaning to the landscape instead of being incidental occupants of it, reached a climax in some of the later set-pieces.

Since the conditions governing the Frick Collection's ownership of 'The White Horse' prohibit its loan, the sequence of Constable's six-foot paintings shown here begins with his second great River Stour subject, 'Stratford Mill', exhibited in 1820 (no.100). 'The Hay-Wain', shown in 1821, is also present (no.101) but the Huntington Library and Art Gallery 'View on the Stour near Dedham', the 1822 exhibit, is subject to the same restriction as the Frick painting. This section also represents the beginnings of a major set-piece that was not to reach its final, exhibited form until 1832, 'The Opening of Waterloo Bridge'.

Detail from 'Stratford Mill', no.100

Stratford Mill

Unlike Flatford and Dedham mills, the watermill at Stratford St Mary had no connection with the artist's family. The mill appears to have served a variety of purposes. Constable called it an oil mill on the back of no.97, while according to Beckett (II 1964, p.260) it was used to manufacture paper. Smart and Brooks, who publish a modern photograph of the site, record its replacement about 1850 by a macaroni mill, the structure of which survived until 1947 (1976, p.78). The mill, however, was peripheral for Constable, only just appearing at the left of his composition. The painting centres on the tree-lined Stour itself, with the Langham hills in the distance to the south, and on the people using the river for leisure and work: anglers in the foreground, men engaged with a barge beyond. The anglers, studied on the spot in 1811 (no.97), gave Constable the idea for the picture. Taking up this study again later, he extended the composition to the right in a quarter-size studio sketch (no.98) before proceeding to a full-size sketch (no.99) and the final painting (no.100). Drawings were also used in various ways.

97 Anglers at Stratford Mill 1811

Oil on panel 187 × 146 ($7\frac{3}{8}$ × $5\frac{3}{4}$)
Inscribed '17th Augt 1811. | Stratford | Oil Mill' on the back of the panel and in a later hand on a label 'From the collection of Miss Isabel Constable', together with other inscriptions (see Parris 1983)
PROV: By descent to Isabel Constable, who died 1888; ? her nephew Clifford Constable, sold Christie's 23 June 1894 (51) bt Tooth; . . .; Galerie Sedelmeyer, Paris; . . .; anon. sale, Christie's 19 Nov.1982 (100, repr. in col.) bt Adams for present owners
LIT: Parris 1983, p.223, fig.38; Rosenthal 1983, pp.120–4, fig. 164 (col.); Reynolds 1984, under nos.20.1, 20.2; Cormack 1986, pp.114, 116, pl.112; Rosenthal 1987, p.109, ill.51; Fleming-Williams 1990, p.290

The Hart Collection

See no.98

97

98

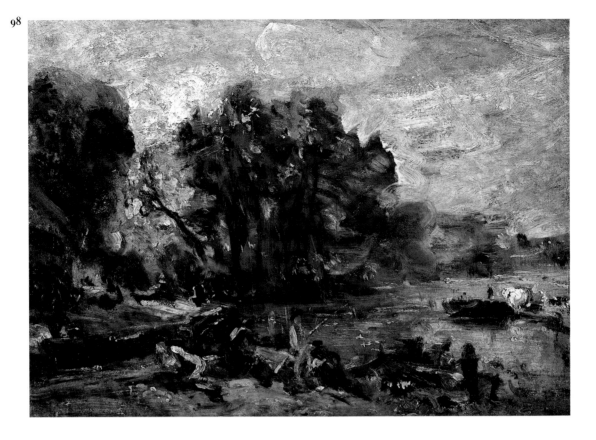

98 Sketch for 'Stratford Mill' ?c.1819

Oil on canvas 305 × 420 (12 × 16$\frac{9}{16}$)
PROV: Artist's administrators, sold Foster 16
May 1838 (in 15, 'Five sketches for pictures')
bt George Field, sold Adams & Son,
Isleworth 24 April 1855 (56) bt ancestor of
one of the present owners
EXH: *George Field and his Circle*, Fitzwilliam
Museum, Cambridge, June–Sept. 1989 (32,
repr.)
LIT: Smart and Brooks 1976, p.76; Hoozee
1979, no.268, repr.; Reynolds 1984, no.20.3,
pl.131; Cormack 1986, pp.114–16, pl. 113;
Fleming-Williams 1990, p.290

Private Collection

Packed with seven figures, six of them involved in
one way or another with angling, the little 1811 panel
(no.97) is probably Constable's most densely
populated early oil sketch. He appears to have been
especially fond of peopling his landscapes with
anglers around 1811–13. As we have seen, in the
1812 'Flatford Mill' (no.54) two boys fishing were
substituted for the man opening the lock who figures
in the original sketches, while fishing formed the
central image of, and provided the title for, 'Boys
Fishing' of 1813 (no.57). When he decided to work

up the Stratford subject for a large painting,
presumably around 1819 but possibly earlier,
Constable quickly transcribed the essentials of
no.97 on the left-hand side of a larger canvas (no.98),
making only small alterations: the mill wheel is now
indicated and the angler at the right turns towards
us. The major development was to extend the
composition towards the right by the same amount
again, adding the river, barge and distant hills.
Constable's first thought for the barge was to
associate it closely with a white horse, perhaps an
echo of his previous six-foot painting (fig.65 on
p.194). A small compositional 'blot' drawing
(Reynolds 1984, no.20.4, pl.132, Fleming-Williams
1990, pp.290–2, pl.34) appears to show this horse,
no longer white, further away from the barge, while
in the two full-size paintings (nos.99–100) we see its
gradual removal from the scene altogether.

As a type of rapid compositional sketch, no.98
has much in common with a group of small to
medium-sized sketches in which Constable tried
out ideas for a Dedham lock and church picture
that was never realised on a large scale. Reynolds
has reasonably dated these to around 1820 (1984,
nos.20.90–20.92).

No.98 was acquired at Constable's sale by his
friend George Field, artists' colourman and author
(see Cove on pp.506–7 for comment on Constable
and Field).

99 Sketch for 'Stratford Mill' *c.*1819

Oil on canvas 1310 × 1840 (51½ × 72½)
Inscribed (perhaps not by the artist: see
below) 'John Constable RA|London' b.r.
PROV: . . .; ? Wynn Ellis, sold Christie's 5
July 1876 (44) bt Renson; . . .; Alice
Schoenfeld *c.*1920; by descent to anon.
vendor, Sotheby's 6 July 1983 (267, repr. in
col.) bt Baskett and Day for Yale Center (B
1983.18)
EXH: Japan 1986 (27, repr. in col.)
LIT: Graham Reynolds, '*Stratford Mill* by
John Constable, RA' in *Art at Auction: The
Year at Sotheby's 1982–83*, 1983, pp.48–53,
fig.1 (col.); Reynolds 1984, no.20.2, pl.130
(col.); Cormack 1986, pp.113, 116, 117,
pl.110 (col.); Rhyne 1990a, pp.119–20, 121,
128 n.53; Rhyne 1990b, p.73; Fleming-
Williams 1990, p.290, fig.265

*Yale Center for British Art, Paul Mellon
Collection*

Looking from the quarter-size sketch (no.98) to the
full-size one (no.99), we are aware not only of the
increase in scale but of how much Constable has
now added to his composition. The trees on the
right of the far bank which were not included in the
little 1811 study (no.97) and were only vaguely
suggested in the quarter-size sketch are now
described in some detail and shown to be separated
from the main group by an inlet of water. A shaft of
sunlight illuminates the corridor between the two
groups of trees, revealing a mysterious gate and a
figure in a red bonnet. Just to the right another
corridor is revealed with a building at its far end.
Still further over we now see meadows and hills
barely hinted at before. The amount of new
information contained in the full-size sketch sug-
gests that other preliminary material is now
missing, perhaps another early oil sketch like no.97
(the existence of which was unknown to scholars
until 1982) and one or more drawings.

The figures in the foreground have undergone a
few changes since the quarter-size sketch. The
kneeling or lying man who peers into the water at
the left has been replaced by a large curving length
of uprooted tree trunk while one of the figures
opposite him at the extreme left has been painted
out, leaving an unsupported fishing rod still in
place. The standing angler now faces the water
again, as in no.97. Clearly visible pentimenti show
that he was originally painted with his arms and rod
held higher. The angle of the barge has now been

99

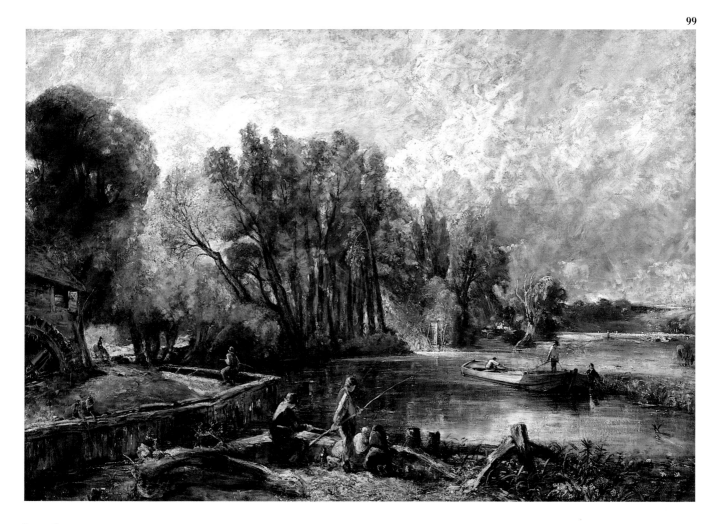

changed and the figures associated with it made out. Rising from the water near the barge is a moorhen not seen in any of the other versions of the subject and perhaps based on a oil sketch now in the British Museum (Reynolds 1984, no.24.87, pl.565 in col.).

Despite the amount of detail it contains, no.99 is still a sketch, though not nearly so sketchy as the preliminary versions of 'The Hay-Wain' (fig.68) or 'The Leaping Horse' (no.161). No part is treated so carefully or so finely as in the finished painting, no.100. Constable's concern is to try out the image on its new large scale, to establish the chiaroscuro that will articulate the design and to experiment with the figuration of the foreground. The whole thing is very bold and there are some brilliant passages, for example in the painting of the water and the distant landscape at the right. There are also passages that can only be described as crude: although now about five times larger, the patch of sunlight on the back of the angler to the left of the central standing figure is treated as baldly as it was – and on that scale had to be – in the tiny 1811 study; the recumbent figure behind the standing angler is a sack-like lump, painted on either side of his legs, rather than a vigorous approximation to human anatomy; the timberwork further to the right is described in some detail but its structure is poorly explained by the artist's usual standards; and so on. Constable is working for his eyes only and does not need to spend time refining the details and solving every problem at this stage. It has taken students of the artist some time to accept this fact. Reynolds (1983) and Rhyne (1990b) have recorded their initial reservations, fully shared by the present authors, about no.99 but have led the way to its reappraisal. The discovery of the 1811 sketch (no.97), clearly used in the painting of the full-size sketch, acted as a spur here.

In the inscription on no.99 Constable is described as an RA, a position to which he was not elected until 1829. It seems highly unlikely, in any case, that he would have signed a private sketch of this kind. Reynolds (1984) regards the inscription as the work of another hand but Rhyne (1990a and 1990b) suggests that Constable may have reworked the sketch after his election and added the signature himself then. It is difficult to imagine, however, why Constable would have wanted to touch the sketch again, let alone sign it as though he regarded it as a complete work of art.

100 Stratford Mill 1819–20, exh.1820

Oil on canvas 1270 × 1829 (50 × 72)
PROV: Bought from Constable by John Fisher 1821 to give to John Pern Tinney; sold by his widow to C.F. Huth 1848; his sale, Christie's 6 July 1895 (77) bt Agnew; . . .; Sir Samuel Montagu (later 1st Baron Swaythling) 1896; 2nd Baron Swaythling, sold Christie's 12 July 1946 (19) bt Ellis & Smith for Walter Hutchinson; Hutchinson & Co. (Publishers) Ltd, sold Christie's 20 July 1951 (85) bt Major Sir Reginald Macdonald-Buchanan; presented to the National Gallery under the acceptance-in-lieu procedure 1987 (6510)
EXH: RA 1820 (17, 'Landscape'); *Living Artists of the English School*, BI 1825 (114, 'Landscape: a Water-mill, with Children angling'); Tate Gallery 1976 (177, repr.)
LIT: Smart and Brooks 1976, pp.76–7, 78–9, pl.41; Hoozee 1979, no.269, repr.; Rosenthal 1983, pp.120–4, fig.163 (col.); Reynolds 1984, no.20.1, pl.129 (col.); Cormack 1986, pp.114–17, pl.111 (col.); Rosenthal 1987, pp.109–11, ill.105 (col., miscaptioned as being no.99 above); Rhyne 1990b, p.73; Fleming-Williams 1990, p.290

Trustees of the National Gallery, London

Comparison of the 1817 'Flatford Mill' (no.89) with the finished 'Stratford Mill' shows how far Constable's ideas about picture-making had developed in the intervening three years. 'Flatford Mill' is a more enclosed and intimate work with no long open vistas and with the emphasis placed on things close to the spectator's eye: the principal group of trees in the right foreground, the boy on his horse, the timbers that push against the left and bottom edges of the canvas. In 'Stratford Mill', as in the 1819 'White Horse' (fig.65 on p.194), the composition opens at the right to give a view of distant landscape. The main tree group in both these later works is placed in the middle-distance on the left and assumes a new grandeur, which may be partly because it requires to be less precisely described at that distance but is also the result of Constable increasing the height of the trees relative to the figures. This can be seen by comparing the relative heights of the boy in the red waistcoat and the trees behind him in the 1811 study (no.97) with the same features in the finished painting. Chiaroscuro is now used to greater effect, both to dramatise and to unify the composition, which in 'Flatford Mill' is still something of an aggregation of parts. The succession of pools and shafts of sunlight, deep shade and glancing shadows is one of the great beauties of 'Stratford Mill'. Just below the centre line of the painting we move from the rider watering his horse in full sunlight at the left to the darkest shade in the river below the main group of trees and then on to the barge, caught both in light and shade and lying, as C.R. Leslie nicely put it, 'with extreme elegance of perspective on the

[201]

smooth river' (1845, p.84, 1951, p.77). Constable's ideas about chiaroscuro developed during the 1820s and found their fullest expression in his work with David Lucas on the *English Landscape* mezzotints (see nos.173–205), by which time the opposition of light and dark had become a central tenet of his philosophy of art and nature.

The composition of the final painting follows the full-size sketch (no.99) in most respects but figures and other foreground details are changed or refined. Most conspicuously, the standing angler has been banished, no doubt because his central position was too obvious and too eye-catching. The principal figures are now reduced to three, placed as a charming group slightly left of centre. The former sack-like figure is replaced by a version of the better articulated red, white and blue girl from 'Boat-Building' (no.72). The remaining figure on the bank nearest the mill has also disappeared, leaving only three of the original band of seven seen in the 1811 oil sketch. Constable has now turned to his 1813 sketchbook (see fig.127 on p.410) for a better version of the timberwork in the right foreground and to another leaf (p.55) of the same book for the water lilies in the bottom right corner. The same page appears to have been used earlier for the similar group of lilies in 'The White Horse' (fig.65 on p.194). There are numerous other small

changes and refinements but the principal difference between the large sketch and the final painting lies in the degree of finishing.

Like 'The White Horse', 'Stratford Mill' was bought by John Fisher, this time as a present for his lawyer John Pern Tinney, who had won a lawsuit for him. Sir George Beaumont (who in 1821 had painted his own 'Stratford Mill': Felicity Owen and David Blayney Brown, *Collector of Genius: A Life of Sir George Beaumont*, 1988, p.202, pl.88) admired the picture and helped Constable 'a good deal in toning & improving' it in June 1824, thinking the work 'one of my best & admirable in color & light & shade' (Beckett II 1964, p.324). Possibly the toning was in response to objections to the sky mentioned by Fisher in September 1821 as having been raised by a 'grand critical party' at Salisbury and which he had countered by producing prints after Wouvermans and Van der Neer 'where the whole stress was laid on the sky' (Beckett VI 1968, pp.75–6). Fisher's defence prompted Constable's well-known reflections on the role of skies, quoted more fully on pp.228–9: 'Certainly if the Sky is *obtrusive* – (as mine are) it is bad, but if they are *evaded* (as mine are not) it is worse, they must and always shall with me make an effectual part of the composition' (ibid., p.77).

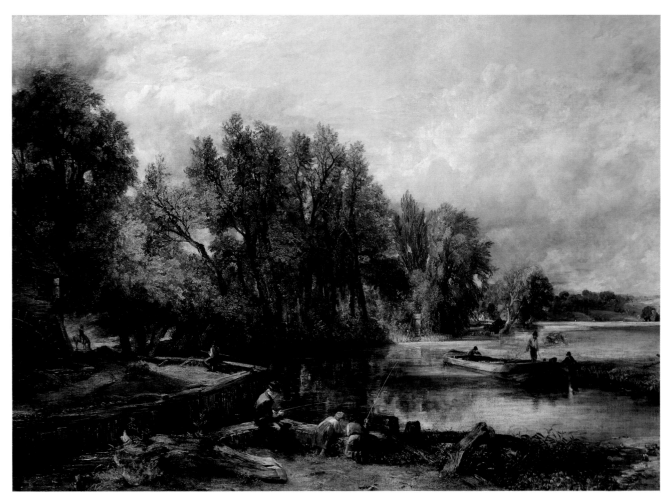

100 (see also detail facing p.197)

The Hay-Wain

101 The Hay-Wain 1820–1, exh.1821

Oil on canvas 1305 × 1855 (51¼ × 73)
Inscribed 'John Constable pinx! London
1821' along bottom
PROV: Bought from Constable by John
Arrowsmith, Paris 1824 and sold by him to
an unknown French collector 1825; . . .; anon.
sale, Henry, Paris 31 March–1 April 1828
(additional, unnumbered lot) bt Jean-
François Boursault, with whose collection bt
c.1838 by Henry Artaria for Edmund
Higginson; his sale, Christie's 4 June 1846
(77) bt Rought; . . .; D.T. White, from whom
bt by George Young by 1853 and sold
Christie's 19 May 1866 (25) bt Cox for Henry
Vaughan, by whom presented to the National
Gallery 1886 (1207)
EXH: RA 1821 (339, 'Landscape: Noon'); BI
1822 (197, 'Landscape; Noon', frame 68 × 91
in); Salon, Paris, Aug.1824– Jan.1825 (358,
'Une charrette à foin traversant un gué au
pied d'une ferme; paysage'); Tate Gallery
1976 (192, repr. with col. detail opp. p.113)
LIT: Smart and Brooks 1976, pp.80–91,
135–7, pl.11 (col.); William Vaughan,
Romantic Art, 1978, pp.201–3; Hoozee 1979,
no.293, pls. XXVIII–XXIX (col.); Barrell
1980, pp.146–9, repr. pp.146, 148 (detail);
Paulson 1982, pp.112, 117–18, 120–1, fig.54;
Rosenthal 1983, pp.124–32, figs.171 (col.),
175 (col. detail); Reynolds 1984, no.21.1,
pl.213 (col.); Cormack 1986, pp.128–33,
pl.125 (col.); Bermingham 1987, pp.138, 139,
pl.5 (col.); Rosenthal 1987, pp.116–20,
ills.109 (col.), 111 (col. detail); Fleming-
Williams 1990, pp.42, 118

Trustees of the National Gallery, London

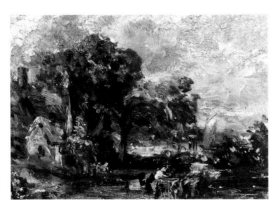

fig.67 'Sketch for "The
Hay-Wain"', *c*.1820, *Yale
Center for British Art, Paul
Mellon Collection*

In 'The Hay-Wain', the third of his six-foot Stour
canvases, Constable turned to a subject close to his
heart and one which he had often painted in the
past, Willy Lott's house seen from behind Flatford
mill. He did not, of course, expect his original
audience (friends apart) to recognise the place or
his own close association with it. As his title for the
picture – 'Landscape: Noon' – suggests, Constable
wanted the image to be seen as typical rather than
topographical, universal rather than personal. It
was, in the words of the title of his mezzotint
collection, a landscape 'Characteristic of English
Scenery' and characteristic in particular of an
English summer noon.

As well as marking a return to his most personal
imagery, 'The Hay-Wain', as we have said, shows
Constable placing a new weight on the figurative
element of his six-foot canvases. The cart and its
occupants are at the heart, though not quite at the
centre, of the composition, unlike the marginalised
barge in 'The White Horse' (fig.65 on p.194) or the
diverse and far-spread figures in 'Stratford Mill'
(no.100). The later six-foot river pictures continue
and develop this emphasis.

Some of the antecedents of 'The Hay-Wain'
have been shown earlier in the exhibition. Particu-
larly relevant are the oil sketches of *c*.1811 (no.58)
and 1816 (no.62), both roughly corresponding with
the left-hand two-thirds of the final painting. The
first of these two sketches shows less of Willy Lott's
house but includes a dog, the second includes more
of the house than appears in the finished painting
but lacks a dog. Both include the figure of the
woman collecting water or washing clothes.
Constable's first experiment in extending the
composition towards the right appears to have been
a small oil sketch now at the Yale Center for British
Art (fig.67, Reynolds 1984, no.21.3). The hay cart
itself first appears in this. There is also a boat with
its sail up in the distance, a feature that was quickly
dropped but which, as Reynolds has shown, links
the sketch to those in which a composition of
Dedham lock and church was tried out (1984,
nos.20.90–20.92; see also under no.98 above).

A full-scale sketch (fig.68, Victoria and Albert
Museum, Reynolds 1984, no.21.2) was used to
develop the composition further, introducing a
figure on a horse (first seen, riderless, on the back of
no.58 above) on the bank in the foreground,
reintroducing but repositioning the dog seen in
no.58, and bringing on at the right a rowing boat
based on a pencil drawing now in the Courtauld
Institute Galleries (Tate Gallery 1976, no.191,
repr.). Economic with his source materials,
Constable had previously used the same drawing to
paint the rowing boat in 'The White Horse' (fig.65
on p.194) and was to use it again much later in
'Salisbury Cathedral from the Meadows' (no.210).

The final painting, no.101, follows the composition established in the large sketch in most respects but there are a few changes. The trace-horse on the bank has now been moved to join those pulling the hay-wain. In its place Constable first painted a barrel and then painted it out again but with age these upper paint layers have become transparent. At the right a figure with a fishing rod has appeared in the undergrowth near the boat and the end of the parapet is now clearly depicted. A similar figure had already been used in 'The Mill Stream' (no.61), where he is shown leaning over the parapet with his rod. At the left a tall chimney, suppressed in the full-size sketch, has been restored to Willy Lott's house. Details of the cart have changed. At the last moment Constable found himself short of information about this and got his brother Abram to ask Johnny Dunthorne to make 'outlines of a Scrave or harvest Waggon'. When he wrote to Constable on 25 February 1821 to make arrangements to get the drawing to him, Abram reported that Dunthorne 'had a very cold job but the old Gentleman [Dunthorne senior] urged him forward saying he was sure you must want it as the time drew near fast'. 'I hope you will have your picture ready', Abram added, 'but from what I saw I have faint hopes of it, there appear'd everything to do' (Beckett I 1962, p.193). In his previous letter, of 28 January, Abram said that he hoped to call on his brother in London soon, so he may have seen the picture in early February.

Even more so than with 'Stratford Mill' (see nos.99–100), the main difference between the full-size sketch and the final version of 'The Hay-Wain' lies in the way the two works are painted. A generally monochromatic and suggestive sketch gives way to a more richly coloured and descriptive picture. Constable himself was surprised by the transformation, telling Fisher on 1 April 1821 that the 'picture is not so grand as Tinny's ['Stratford Mill'] owing perhaps to the masses not being so impressive – the power of the Chiaro Oscuro is lessened – but it has rather a more novel look than I expected' (Beckett VI 1968, p.65). He does not say in what way he found it novel but the painting in at a late stage of the hay-wain must have drawn together the whole landscape. Whatever the difference in their powers of chiaroscuro, 'The Hay-Wain' has a narrative dimension lacking in 'Stratford Mill', which is more anecdotal (as David Lucas acknowledged when he titled his print of it 'The Young Waltonians'). The narrative, of course, hinges on the passage of the hay-wain. Having delivered its load of hay, in the process leaving wheel marks on the sandy bank below the mill, the empty cart is turning – as the angle of the front wheel indicates – to travel through the cut on the right that leads to the main river. At this point there was the 'flat ford' that gave the place its name, crossing the river to the meadows that we see on the other side. In these meadows haymakers, one sharpening his scythe, are at work while a loaded cart is got ready for its journey, to be replaced by the one crossing the mill stream in the foreground.

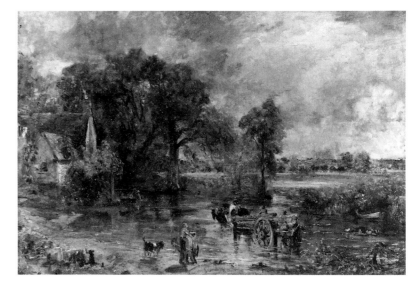

This narrative, modest enough in any case, is not insisted on by Constable and, indeed, is to some extent obscured by his need to position the cart to best pictorial effect. But the viewer cannot help noticing that something is going on in this summer landscape, that the cart is going somewhere: the more observant spot the distant figures and the second hay-wain and make a connection between the two. In Constable's subsequent river Stour pictures the central figurative action becomes first more strenuous, as in the 1822 exhibit 'View on the Stour near Dedham' (fig.66 on p.195) and the 1824 'Lock' (no.158) and then – in 'The Leaping Horse', shown in 1825 (no.162) – positively dramatic.

The distant hayfield with its mowers is one of the most felicitous passages in 'The Hay-Wain' but, as with the right-hand side of 'Stratford Mill', no study or drawing used for it is known today. Nor is there any known source material for the right side of the first six-foot exhibition work, 'The White Horse'. All three compositions began life as small upright studies in oil or pencil of areas that eventually formed the left-hand sides of their respective pictures. Constable's method at this time was to develop his original idea by extending the image to the right, using the right-hand side also to add a distant vista to the comparatively enclosed area that he had studied in the first place. As we shall see, different methods were used in later works.

Constable appears to have painted the full-size sketch and the final version of 'The Hay-Wain' in less than five months. On 21 November 1820 he showed Farington a 'new begun picture' of the opening of Waterloo Bridge (see nos.102–3, 212–13) but was advised 'to proceed on & complete for the Exhibition a subject more corresponding with' his previous year's exhibit, 'Stratford Mill' (Farington XVI, p.5582). Abram Constable, as we have seen, thought 'The Hay-Wain' very far from complete in February 1821 and Constable himself reckoned he still had 'much to do to it' on 1 April,

nine days before it was due to go to the Academy (Beckett VI 1968, p.65). He made up for the last-minute rush by continuing work on the picture when it returned from exhibition. As Reynolds and others have suggested, the painting may have benefited at this stage from Constable's sky studies at Hampstead (see nos.119–24). Certainly the clouds in the painting as we see it now reveal a greater understanding of structure than the clouds in 'Stratford Mill'.

The enthusiasm of the French for Constable's 'Hay-Wain', beginning with Nodier's and Geri-cault's visit to the 1821 RA and culminating in the picture's inclusion in the 1824 Paris Salon, where it received a gold medal from Charles X, is well documented in the literature and does not need to be rehearsed here. Ironically, considering the subject matter of the picture, Fisher confessed himself on this occasion 'too much pulled down by agricultural distress to hope to possess it' (Beckett VI 1968, p.151) and advised Constable to accept the Parisian dealer Arrowsmith's offer of £250 for it and two others. Generally overlooked in the literature, Constable's comments on the French critics of 1824 are worth repeating here for what they tell us about the artist. 'They are very amusing and acute', Constable told Fisher, '– but very shallow and feeble. Thus one – after saying, "it is but justice to admire the *truth* – the *color* – and *general vivacity* & richness" – yet they want the objects more formed & defined, &c, and say that they are like the rich preludes in musick, and the full harmonious warblings of the Aeolian lyre, which *mean* nothing, and they call them orations – and harangues – and highflown conversations affecting a careless ease – &c &c &c – Is not some of this *blame* the highest *praise* – what is poetry? – What is Coleridge's Ancient Mariner (the very best modern poem) but something like this?' (ibid., p.186). During his Suffolk years Constable twice quoted the local pastoral poet Robert Bloomfield in connection with his RA and BI exhibits (nos.71, 76 above). That he could now, almost casually, invoke one of the great works of the Romantic imagination suggests that his own art was indeed set on a new and more complex course.

101

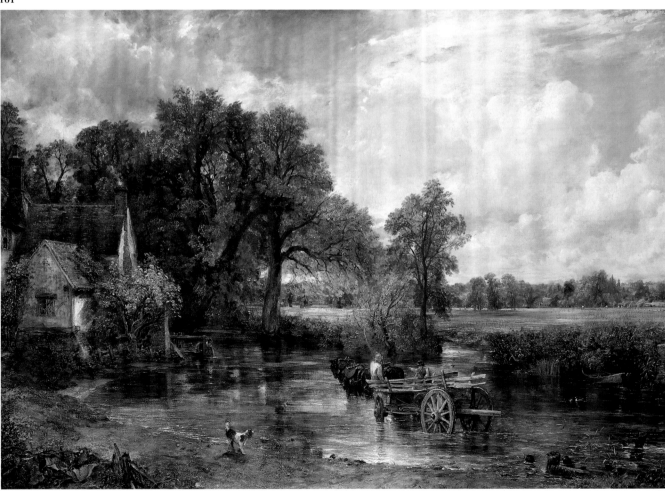

Waterloo Bridge

Within a few years of settling there, Constable began planning a large picture of a London subject, the ceremonial opening by the Prince Regent of Rennie's Waterloo Bridge on the second anniversary of the battle. He appears to have made drawings on the day of the opening, 18 June 1817, but not to have produced oil sketches of the scene for another two years. By September 1820 he was working up the idea for an Academy picture but was persuaded by Farington in November to paint another Suffolk subject instead. This turned out to be 'The Hay-Wain' (no.101).

Constable continued working on the idea through the 1820s, several times expecting to finish a large painting for the Academy but not finally doing so until 1832. Numerous drawings and oils of the subject survive and there are many references to it in the artist's correspondence; correlating the surviving works and the documentation proves far from easy. In this exhibition we show two oil sketches (nos.102–3) and a drawing (no.288) dating from the inception of the project and, in the context of Constable's late works, the final painting (no.213) and a half-size sketch for it (no.212). Also included in the present section are two oils (nos.104–5) representing a different Waterloo Bridge composition, without the ceremonial opening events.

It may seem odd that in 'The Opening of Waterloo Bridge' Constable chose a subject so far outside his usual field and that he persisted with it against all odds over a period of thirteen or so years. There are a number of reasons why he should have done so, however. As Cormack says (1986, p.215), Constable the patriot and royalist would have been attracted by the original event and may have thought a painting of such an historic occasion (in which the home of the Royal Academy itself, Somerset House, featured) would further his Academic career; such a painting would also show him capable of a greater variety of subjects; above all, as he now lived in London, 'why shouldn't he translate his Suffolk river scenes into a view of the Thames, the greatest river of them all?' It has also been suggested (Fleming-Williams 1976, p.68) that Constable's father-in-law, a solicitor to the Regent, may have given him the idea of courting royal patronage just as Turner had (though with no more success) in his 'England: Richmond Hill, on the Prince Regent's Birthday' shown at the RA in 1819.

It seems likely that Constable's main impulse to paint the subject was the opportunity it offered to unite human activity and natural beauty on a grander scale than his Suffolk scenes allowed, to produce not just a metropolitan version of a Suffolk barge scene but a great 'historical' landscape such as Claude had painted in his seaports with their scenes of embarkation. The first reference in Constable's correspondence to the Waterloo Bridge subject comes four days after he had copied one such Claude at the British Institution (Reynolds 1984, no.19.19, and see Fleming-Williams 1990, pp.165, 169). During the years he worked on the composition Constable's focus changed. Beginning as a setting for the scene of royal embarkation, the landscape elements – water, trees and sky – gradually assumed greater importance, natural pageantry finally taking precedence over human pomp and ceremony.

102

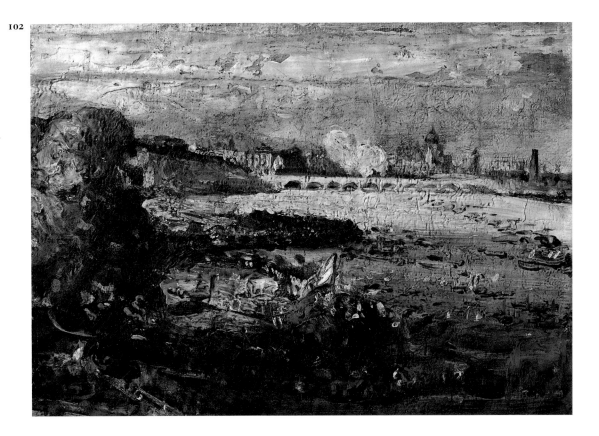

102 Sketch for 'The Opening of Waterloo Bridge' ?1819

Oil on canvas 152 × 223 (6 × 8¾)
PROV: . . .; anon. sale, Sotheby's 30 Nov.
1960 (122) bt Leggatt; private collector; by
descent to present owner
EXH: New York 1983 (55, repr. in col.)
LIT: Hoozee 1979, no.262, repr.; Reynolds
1984, no.19.22, pl. 86 (col.); Cormack 1986,
p.215;

Private Collection

See no.103

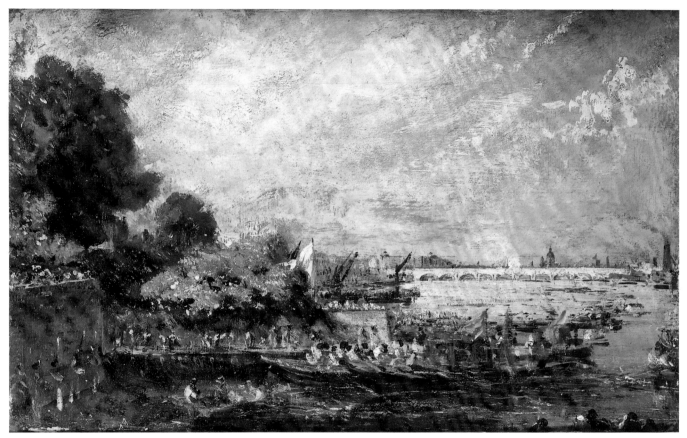

103

103 Sketch for 'The Opening of Waterloo Bridge' *c.*1819

Oil on board 292 × 483 (11½ × 19)
PROV: As for no.2
LIT: Reynolds 1973, no.174, pl.138; Hoozee 1979, no.263, repr.; Reynolds 1984, no.19.23, pl.87 (col.); Cormack 1986, p.215, pl. 207 (col.); Rosenthal 1987, p.103, ill.93

Board of Trustees of the Victoria and Albert Museum, London

The scene chosen by Constable to represent the ceremonies of 18 June 1817 was the embarkation of the Prince Regent at the foot of Whitehall Stairs for the short river journey, through a vast assembly of craft, to the southern end of the new bridge. Escorted by the Dukes of York and Wellington, the Regent had then crossed the bridge, lined with Waterloo veterans, before returning in his barge to Whitehall Stairs. (The fullest account of the day's events is given by Denys Sutton in his pioneering article 'Constable's "Whitehall Stairs" or "The Opening of Waterloo Bridge"', *Connoisseur*, vol.136, Dec. 1955, pp.248–55.) In no.103 the royal barge can be seen drawn up at Whitehall Stairs with the Regent and his entourage on the quay. Behind them is the garden wall of Fife House, then the home of the Prime Minister Lord Liverpool. Soldiers line the wall of Grantham House in the left foreground. A puff of smoke on the bridge indicates the firing of a salute. At the left of the bridge is Somerset House, in the distance St Paul's.

One of Constable's initial problems in tackling this subject was to decide from what height and angle it should be depicted. Nos.102 and 103 explore two possibilities. In no.102 a very high viewpoint is used, corresponding to the one adopted for the detailed topographical drawing shown below as no.288. The latter was made from an upper floor of 5 Whitehall Yard, the bow-fronted house eventually included in the picture itself (see nos.212–13), looking down into the garden of Fife House. The larger sketch, no.103, presents the scene from lower down and from more to the right. The viewpoint here seems to have been the garden of Michael Angelo Taylor's house, which adjoined the bow-fronted building but had a garden that ran much further out into the river. The large tree at the left and the soldiers lined up against the wall appear in a drawing probably made in 1817 (private collection, Reynolds 1984, no.17.6, pl.4).

On 17 July 1819 Constable told Fisher that he had 'made a sketch of my scene on the Thames ⟨embankment⟩ – which is very promising' (Beckett VI 1968, p.45). This could refer either to no.102 or no.103 or perhaps to the large drawing, no.288. The following month, on 11 August, Constable showed Farington 'a painted sketch of his view of Waterloo bridge &c and the river as it appeared on the day of the *opening the Bridge*. I objected to his having made it so much a *"Birds eye view"* and thereby lessening magnificence of the bridge & buildings. – He sd. he would reconsider his sketch' (Farington XV, p.5396). Because it gives the most bird's-eye type of view, no.102 may be the work in question here, though Reynolds has suggested that the larger sketch (no.103), which could still be called a bird's-eye view, is more of a size that Constable would have taken to Farington to explain his plans. In the latter case, however, we would have to suppose that Constable eventually rejected Farington's criticism, since the final picture (no.213) adopts a viewpoint slightly higher than no.103.

Although the early and final stages of Constable's work on the Waterloo Bridge project are relatively clear, the period from 1820, when he began his first large picture of the subject, to early 1832, when the definitive version was being got ready for the Academy, is less easy to reconstruct. This middle phase is discussed in the entry on nos.212–13.

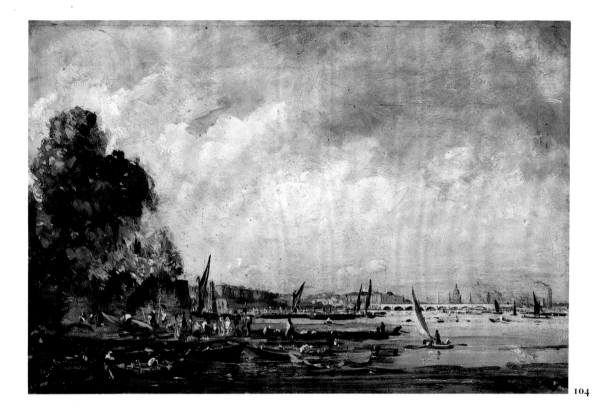

104

104 The Thames and Waterloo Bridge *c*.1820

Oil on paper laid on canvas 210 × 317 (8¼ × 12½)
PROV: By descent to Isabel Constable, by whom given to the Royal Academy 1888 (no.74)
EXH: Tate Gallery 1976 (176, repr.); *Paintings from the Royal Academy: Two Centuries of British Art*, USA touring exh. (International Exhibitions Foundation, Washington) 1983 (31, repr. in col.); Japan 1986 (26, repr. in col.); New York, Bloomington, Chicago 1987–8 (221, repr. in col.)
LIT: Hoozee 1979, no.264, repr.; Reynolds 1984, no.19.26, pl. 89 (col.); Cormack 1986, p.125

Royal Academy of Arts, London

See no.105

105 The Thames and Waterloo Bridge *c*.1820

Oil on canvas 552 × 781 (21¾ × 30¾)
PROV: . . .; collection of Helen J.S. Nightingale, sold Robinson and Foster 2–4 July 1928 (106) bt for Mary Hanna, Cincinnati and given by her to Cincinnati Art Museum 1946
EXH: New York 1983 (54, repr. in col.)
LIT: Hoozee 1979, no.265, repr.; Fleming-Williams and Parris 1984, p.59n; Reynolds 1984, no.19.27, pl.90 (col.); Cormack 1986, p.215; Fleming-Williams 1990, pp.168–9, fig.163

Cincinnati Art Museum, Gift of Mary Hanna

One of the drawings of Waterloo Bridge that Constable is thought to have made in 1817 shows the bridge from near water-level and without any of the opening ceremonies (private collection, Reynolds 1984, no.17.5, pl.3). This is on the other side of the drawing of the large tree and the soldiers mentioned under no.103, suggesting that from the outset Constable had two distinct ideas about painting the scene. The Royal Academy oil sketch, no.104, closely follows this drawing while extending the composition on the left to include more of the wall of Fife House and the large tree in its garden. In turn, the Cincinnati painting, no.105, closely follows the oil sketch.

In place of the colourful ceremony depicted in nos.102–3, we now see, from an appropriately lower viewpoint, the day-to-day activities of

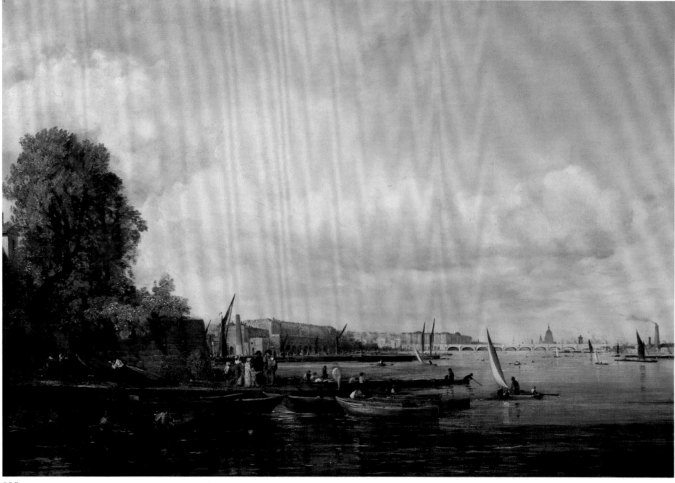

105

Thames boatmen, bathers and other river users –
activities long since noted by Canaletto, Scott and
the Thames artists who followed them, including
Constable's mentor Joseph Farington. The Cin-
cinnati painting owes much to this tradition, which
it acknowledges also in its smooth finish and
delicate handling.

Constable's concern over the height of the
viewpoint for his 'ceremonial' Waterloo Bridge
composition has been mentioned above. He was
equally anxious to settle the most effective horizon
line for the composition shown here. On a visit to
the British Institution on 13 July 1819 he made
several pencil copies of old master paintings,
including two marines by or attributed to Willem
van der Velde the younger, whose sizes and horizon
levels he measured and noted on the backs of his
drawings (Fleming-Williams 1990, pp.165–6,
pls.20, 21, fig.158). These appear to have con-
firmed him in his decision to adopt the very low

horizon seen in nos.104–5. An upright drawing of
Waterloo Bridge, corresponding to the central part
of the drawing upon which the Royal Academy
sketch was based, seems to have been made
specifically to test the horizon line (Ackland Art
Museum, Chapel Hill, North Carolina; on the back
of a watercolour cloud study, no.81.32.1, the
attribution of which has been questioned).

The Cincinnati painting may be the 'London
and Westminster view' which Fisher asked
Constable on 19 April 1820 not to part with without
telling him: 'I rather think I shall like to have it, in
case I am strong enough in purse' (Beckett VI 1968,
p.53). Alternatively, it may be the 'little Waterloo
bridge' he had just completed on 17 January 1824
and which a few days later he described as 'a small
balloon to let off as a forerunner of the large one'
(ibid., pp.150, 152). Possibly these references are
all to the same work, seen unfinished by Fisher in
1820 and not finally completed until 1824.

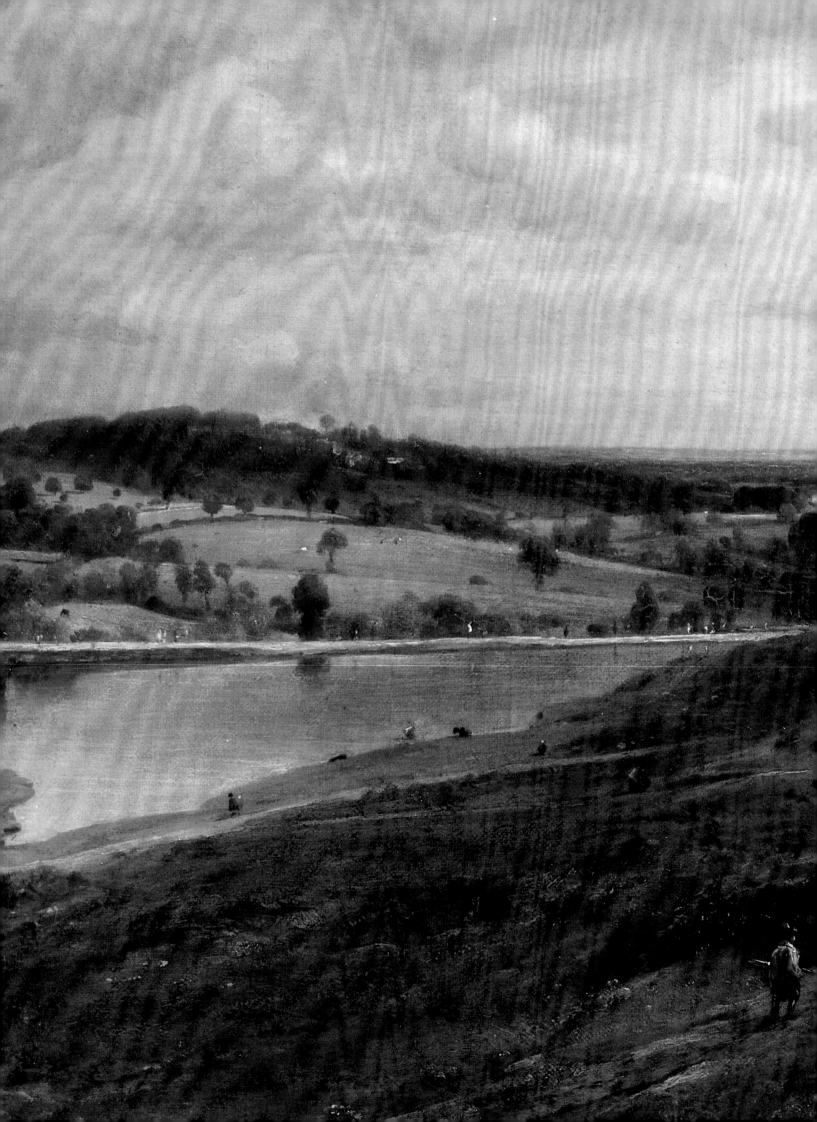

Hampstead

From 1819 to 1826 the Constables rented a house at Hampstead every summer except that of 1824. In 1827 they moved there more permanently, leasing 6 (now 40) Well Walk and letting part of their own house in Charlotte Street. Announcing this last arrangement to Fisher, Constable boasted that he was 'three miles from door to door – can have a message in an hour – & I can get always away from idle callers – and above all see nature – & unite a town & country life' (Beckett VI 1968, p.228). The idea of enjoying country air and village life while remaining in touch with London attracted a number of writers and artists to Hampstead in this period. Leigh Hunt moved to the Vale of Health in 1815, Keats to Well Walk in 1817. John Linnell was at Collins's (later Wyldes) Farm, North End from 1824 and was frequently visited there by William Blake. The painter William Collins was also at North End and later Pond Street in the 1820s and F.W. Watts, whose work was to be confused with Constable's during the latter's lifetime, was in the High Street from at least 1821. Coleridge moved to nearby Highgate in 1816.

It was for the health of Maria and the children that Constable originally arranged the summer migrations to Hampstead but the place soon attracted him as an artist. His earliest dated works made there are drawings in the 1819 sketchbook (no.287 below) and an oil sketch painted at the end of October 1819 (no.106). At Hampstead Constable began oil sketching again with a fervour not seen since his earlier Suffolk years, directing his attention especially to the sky, the most conspicuous feature of this upland landscape. For a few years he also resumed making exhibitable paintings more or less entirely on the spot. Some subjects quickly became favourites, to be repeated and developed in the studio. The composition established in the 1819 'Branch Hill Pond' sketch (no.106) was used many times during the 1820s and finally in 1836 (no.219). What he did not find at Hampstead was material for a six-foot canvas, the scale he reserved for his most important paintings – material he found at Brighton (see no.156), Salisbury (no.210) and in London itself (no.213). While Hampstead gave him skies in abundance, it lacked those striking conjunctions of trees, water and buildings upon which his largest paintings depended. Nor did the figures in the Hampstead landscape – donkeys and their keepers, sand-diggers and hole-fillers, townspeople out strolling – inspire the sort of central figurative incident Constable generally required for his six-foot canvases after 1820.

The various houses the Constables occupied at Hampstead were in different parts of the village, a fact that has a bearing on the work the artist did there (the one taken in 1820 has not been identified): Albion Cottage (1819) at the northern end of the village near Whitestone Pond; 2 Lower Terrace (1821 and 1822) near Judges Walk, which overlooks West Heath; Stamford Lodge (1823) nearer the centre of the village; Hooke's Cottage (1825) near Fenton House; 25 Langham Place, Downshire Hill (1826) at the southern edge of Hampstead; and 6 Well Walk (1827 onwards) on the east of the village. (See fig.219 on p.533.)

Detail from 'Hampstead Heath (The Vale of Health)', no.108

Hampstead 1819–1822

106 Branch Hill Pond, Hampstead 1819

Oil on canvas 254 × 300 (10 × 11⅞)
Inscribed 'End of Octr. 1819' on stretcher
PROV: As for no.2
EXH: Paris 1976 (26, repr.)
LIT: Reynolds 1973, no.171, pl.136; Hoozee
1979, no.267, pl. XXX (col.); Parris 1981,
p.114, fig.1; Rosenthal 1983, p.120, fig.162
(col.); Reynolds 1984, no.19.32, pl.122 (col.);
Cormack 1986, p.113, pl.108; Rosenthal
1987, p.108, ill.97 (col.)

*Board of Trustees of the Victoria and Albert
Museum, London*

This is Constable's first known dated oil of a
Hampstead subject, a view to the west over Branch
Hill Pond from near Judges Walk. It is remarkable
that he should so soon have found a subject that
attracted him sufficiently for it to become one of his
standard Hampstead compositions, repeated with
variations in a painting of *c.*1825–8 (Tate Gallery,
Parris 1981, no.29, Reynolds 1984, no.28.4), one
exhibited in 1828 (Victoria and Albert Museum,
ibid., no.28.2), a repetition of the latter (Cleveland
Museum of Art, ibid., no.28.3) and his last
Hampstead picture, the 1836 'Hampstead Heath
with a Rainbow' (no.219). Prominent figurative
elements are introduced in all these to break up the
unadorned bank at the right of the sketch, which,
richly impasted with the help of a palette knife, is
perhaps the most attractive part of it to modern
eyes (according to Sarah Cove, the sketch was
painted in two stages, the palette knife work being
added later: see p.515). A variant composition, in
which a view is given over the bank, is seen in
no.125 below and the canvases related to it.

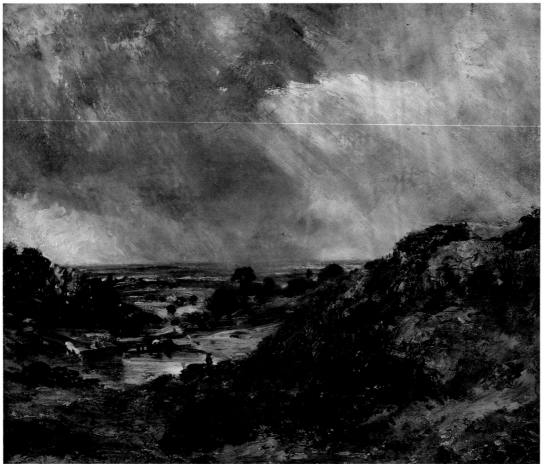

106

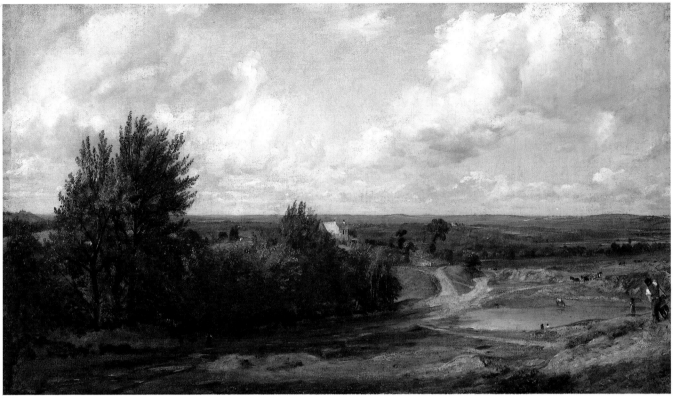

107

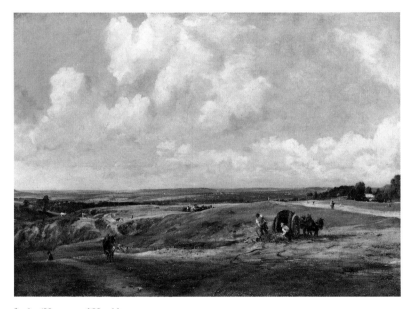

fig.69 'Hampstead Heath',
c.1819–20, *Syndics of the
Fitzwilliam Museum,
Cambridge*

107 Hampstead Heath with the House Called 'The Salt Box' c.1819–20

Oil on canvas 384 × 668 ($15\frac{1}{8}$ × $26\frac{5}{16}$)
Inscribed in a later hand on a damaged label
on the stretcher 'Salt Box Hampstead Heath |
Painted by John Consta[ble] | Lined [. . .]'
PROV: By descent to Isabel Constable, by
whom presented to the National Gallery
1887; transferred to the Tate Gallery 1962
(N 01236)
EXH: Tate Gallery 1976 (186, repr.)
LIT: Hoozee 1979, no.288, repr.; Parris 1981,
no.19, repr. in col.; Reynolds 1984, no.21.7,
pl.217 (col.); Cormack 1986, pp. 124–5,
pl.121 (col.)

Tate Gallery

This painting shares a number of characteristics
with the 'Hampstead Heath' in the Fitzwilliam
Museum (fig.69, Reynolds 1984, no.21.8) and the
Victoria and Albert Museum picture, no.108
below. The viewpoints for all three were close to
Albion Cottage, rented by the Constables in 1819;
where they stayed the following year is not
recorded. In no.107 and the Fitzwilliam picture we
look north-westwards, in no.108 to the east. The
three works are finished up to the exhibition
standards of the day and all, but perhaps especially
the larger Fitzwilliam and Victoria and Albert
Museum pictures, are candidates for Constable's
earliest exhibited paintings of the area, both called
simply 'Hampstead Heath', one shown at the RA in

1821, the other in 1822. A 'Harrow' was also shown in 1821 but Harrow figures only distantly in no.107 and the Fitzwilliam painting. In addition, all three pictures look as though they were painted largely on the spot – C.R. Leslie thought no.107, at least, appeared to have been wholly so painted. Leslie's long account of the picture also confirms its dating to about 1820 (Leslie 1845, pp.78–9, 1951, pp.72–3; see also Parris 1981).

The view in the Tate painting, no.107, is north-westwards from near the junction of Judges Walk and the Branch Hill road, which is shown entering the picture at the left. The road runs past Branch Hill Pond, seen from a different angle in no.106 above, and later the house called The Salt Box, before leading off towards Child's Hill. Harrow appears in the distance at the extreme left.

The figure of the red-jacketed labourer with a wheelbarrow at the right of the picture is repeated in, or repeated from, the Fitzwilliam Museum painting mentioned above (fig.69). In the latter it makes good sense as part of the main figure group of two men emptying a cart but is difficult to read in isolation, squeezed in at the edge of the Tate painting. The attribution to Constable of this figure and the other work on the conspicuous strips at the left and right of the picture has been doubted in the past (see Parris 1981). A new technical examination of the painting carried out at the Tate Gallery in 1990 (prior to cleaning) by Anna Southall, with pigment analysis by Joyce Townsend, showed that these doubts were unfounded. Their conclusions were, briefly, that unprimed canvas at the left and right edges was unfolded by Constable early on in his work on the picture, to extend the surface available for painting, and that these additions were then primed but with a different preparation from the rest of the work. Harrow Hill at the left and most of the right side, including the labourer, were then painted with identical pigments and mixtures to those used for the main part of the picture. For the cloud at the top right and the sky on the left edge, however, the more expensive ultramarine rather than Prussian blue was used, perhaps indicating, Sarah Cove suggests, that Constable completed these areas in the studio. (See also Cove on pp.498, 504.)

108 Hampstead Heath (The Vale of Health) c.1819–20

Oil on canvas 533 × 776 (21 × 30½)
PROV: ? Artist's administrators, sold Foster 16 May 1838 (53, 'Hampstead Heath, at the Ponds') bt Tiffin (if so, probably bt for Sheepshanks); John Sheepshanks, certainly by c.1850 and given by him to the South Kensington (later Victoria and Albert) Museum 1857
EXH: Tate Gallery 1976 (188, repr.); Japan 1986 (32, repr. in col.)
LIT: Reynolds 1973, no.323, pl.238; Hoozee 1979, no.290, repr.; Reynolds 1984, no.21.10, pl.219 (col.); Cormack 1986, pp.124, 125; Rosenthal 1987, p.113, ill.108

Board of Trustees of the Victoria and Albert Museum, London

As mentioned under no.107, this may be one of the two paintings entitled 'Hampstead Heath' that Constable exhibited at the Royal Academy in 1821 and 1822. Reynolds (1984, under no.27.6) also suggests that if it was not shown then, it may be the work of the same title exhibited in 1827, though painted earlier. A handlist of Sheepshanks's collection, drawn up about 1850, gives 1827 as its date of exhibition.

The view is eastwards looking over the Vale of Health Pond with Highgate Hill in the distance towards the left. Unlike the Fitzwilliam Museum picture (fig.69 on p.215), this one seems to be peopled entirely with leisure-takers, unless the small boy with a stick towards the bottom left is a donkey-keeper. Ahead of him on the track Constable originally had a horse and cart but then changed his mind and painted them out. According to Cove (thesis), there were figures dressed in red, blue and yellow in the cart.

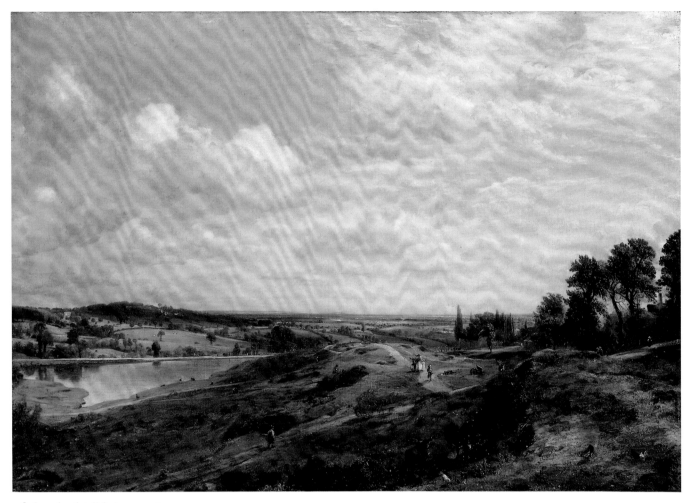

108 (see also detail facing p.213)

109 West End Fields, Hampstead ?*c*.1821–2

Oil on canvas 332 × 524 ($13\frac{1}{16}$ × $20\frac{5}{8}$)
PROV: By descent to Charles Golding
Constable and sold by court order after his
death, Christie's 11 July 1887 (81) bt Agnew
for Sir Cuthbert Quilter, sold Christie's 9
July 1909 (50) bt Gibson for the Felton
Bequest, National Gallery of Victoria
EXH: Japan 1986 (64, repr. in col.)
LIT: Hoozee 1979, no.442, repr.; Reynolds
1984, no.30.20, pl. 787; Hill 1985, p.100, pl.4
(col.); Ian Fleming-Williams, 'Tokyo:
Constable', *Burlington Magazine*, vol.128,
May 1986, p.384

National Gallery of Victoria, Melbourne,
Felton Bequest, 1909

'West End Fields' is one of three Hampstead
subjects engraved for *English Landscape*, where it
was titled 'Noon' (fig.92 on p.320, Shirley 1930,
no.16). On a proof now in the Fitzwilliam Museum
(Gadney 1976, p.138, 'B') David Lucas identified
the subject as 'West end fields Hampstead. Berk-
shire and Windsor Castle in the extreme distance
the windmill on the hill is at Kilburn'. Reynolds
suggests that the painting (or 'sketch' as he calls it)
was made about the time of the engraving, that is,
1830, but the present authors believe it to be a
finished picture from Constable's early years at
Hampstead, perhaps from 1821–2 when he stayed
at nearby Lower Terrace. With its prominent tree,
the shepherd with his dog and flock, and the view to
the fields below with its minutely observed figures
and cattle, this is one of Constable's more Suffolk-
looking Hampstead works. His cabinet pieces, as
works such as this should perhaps be called, tend to
be overlooked in favour of the oil sketches and
larger set-pieces. 'West End Fields', with its sunlit
windmill and its sky masterfully integrated with
the landscape, suggests that they warrant a degree
of attention normally reserved for the more familiar
formats.

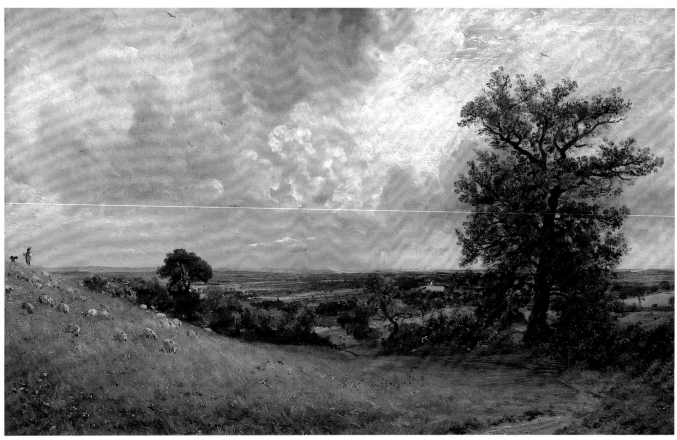

109

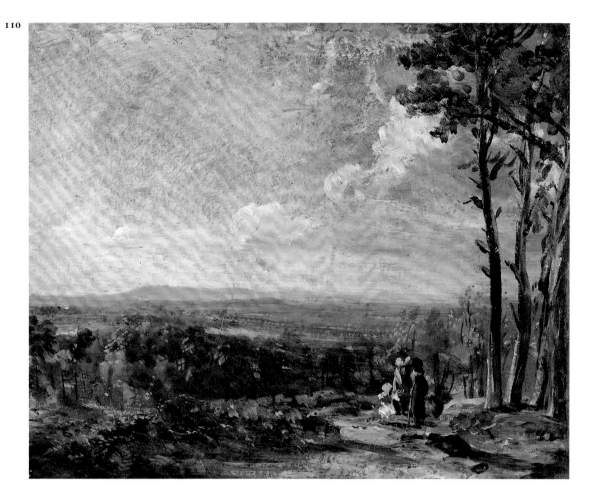

110 Hampstead Heath, Looking towards Harrow 1821

Oil on paper laid on canvas 260 × 325 ($10\frac{1}{4}$ × $12\frac{3}{4}$)
Inscribed in a later hand (probably C.G. Constable's) on a label on the stretcher, copying Constable's original inscription: 'Hampstead 31st Oct. 1821. Very fine afternoon of a beautiful day, it began with rain. Wind fresh from West'; also inscribed with details of C.G. Constable's gift to Stiffe
PROV: By descent to Charles Golding Constable, by whom given to A.W. Stiffe 1863; by descent to Mrs A.C. Stephens, sold Christie's 21 June 1974 (115, repr.) bt Baskett for Mr and Mrs Paul Mellon, by whom given to the Yale Center 1976 (B1976.7.103)
EXH: New Haven 1982–3 (IV.23, repr.); New York 1983 (41, repr. in col.)
LIT: Hoozee 1979, no.319, repr.; Reynolds 1984, no.21.64, pl. 267 (col.); Cormack 1986, p.137, pl.142 (col.); Rhyne 1990b, p.77, fig.6 (detail)

Yale Center for British Art, Paul Mellon Collection

Many of Constable's Hampstead oil sketches are views westwards towards Harrow. Few of them, however, include such prominent figures as the family group shown here enjoying the view. Constable elaborated his comments on the back of the sketch in a letter to Fisher on 3 November 1821: 'The last day of Octr was indeed lovely so much so that I could not paint for looking – my wife was walking with me all the middle of the day on the beautifull heath. I made two evening effects' (Beckett VI 1968, p.81). This is presumably one of them. The other may be no.111 below, which uses a similarly audacious palette and also includes figures admiring the view. Another oil sketch given by Captain Constable to Arthur Stiffe in 1863, 'Sunset through Trees', has also been proposed as the second sketch but appears to have been made on a less clear evening (Christie's 26 April 1985, lot 53, repr. in col.).

Reynolds identifies the viewpoint as Judges Walk. If correct, this might be another reason to associate nos.110 and 111. However, the trees at the right look like firs and the spot seems more likely to be The Firs at North End or at The Spaniards (cf. Simon Jenkins and Jonathan Ditchburn, *Images of Hampstead*, 1982, nos.134–55). Christopher Wade, Curator of the Hampstead Museum, thinks North End most likely.

111 Judges Walk, Hampstead *c.*1821–2

Oil on paper laid on canvas 300 × 352
($11\frac{13}{16}$ × $13\frac{7}{8}$)
PROV: . . .; Mrs Hand (according to an old
label on the stretcher); . . .; Spink & Son Ltd
1976; . . .; anon. sale, Christie's 17 Nov. 1989
(36, repr. in col.); present owners
LIT: Hoozee 1979, no.397, repr.(as 391);
Reynolds 1984, no. 21.118, pl.320

Mr and Mrs David Thomson

Judges Walk runs north-east from Branch Hill
towards Whitestone Pond and is a few yards from
Lower Terrace, where the Constables stayed in
1821 and 1822. The figures admiring the view from
the tree-lined Walk (known at the time as Prospect
Walk) are presumably looking out over West
Heath, with the sun somewhere in the west.
Because he believes the sun to be in the south-east
in this sketch and the time of day to be morning,
Reynolds rejects his own suggestion that it may one
of the 'two evening effects' Constable painted on 31
October 1821, the other being no.110 above. As he
says, the Judges Walk sketch rivals no.110 'in
breadth and intensity of colour'.

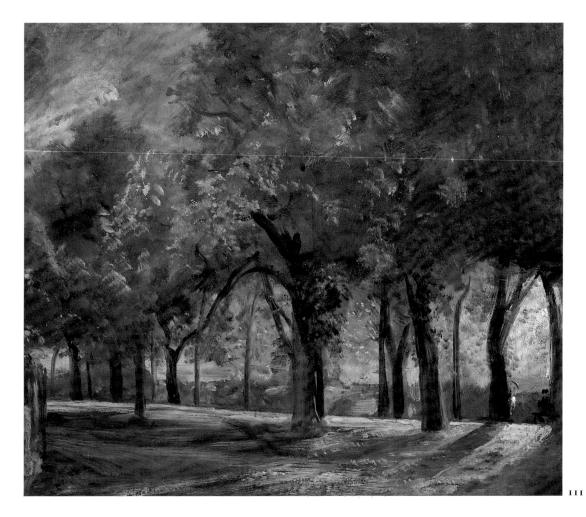

111

112

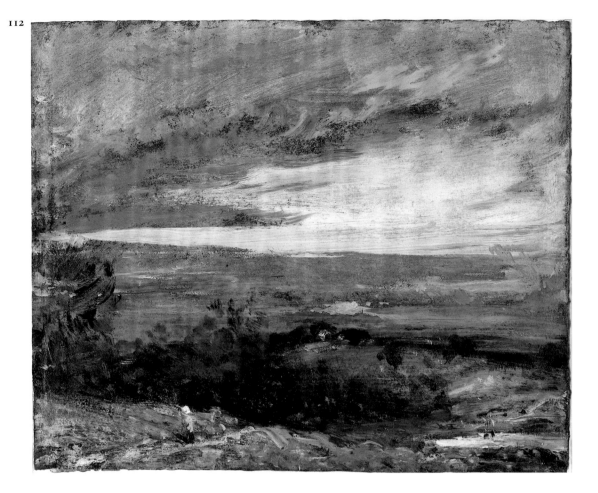

112 Hampstead Heath, Sun Setting over Harrow 1821

Oil on paper laid on board 247 × 305
(9¾ × 12)
Inscribed on the back 'Sep.ʳ 12. 1821. Sun setting over Harrow | This appearance of the Evening was ⟨...⟩ | just after a very heavy rain | more rain in the night and very | [? light] wind which continued all the | day following (the 13tʰ) while making | this sketch observed the Moon rising | very beautifully ⟨in the⟩ due East over the | heavy clouds from which the late showers | had fallen.' and 'Wind Gentle rather ⟨...⟩ increasing | from the North West. rather [...]'. These two inscriptions are visible through separate windows cut in the backing board; it is not clear whether they are written on the back of the painted paper or on a separate sheet or sheets. The final word of the second inscription, now covered, is given as 'North' in the catalogue of a Barbizon House exhibition in 1935.
PROV: By descent to Isabel Constable, who died 1888; sold anonymously, presumably on behalf of her heirs, by Ernest Alfred Colquhoun, Christie's 28 May 1891 as one of the works 'Exhibited at the Grosvenor Gallery, 1889 [262], as the Property of Miss Isabel Constable, deceased' (141) bt in by Colquhoun; ...; D.W. Freshfield by 1903 and sold Christie's 2 Nov. 1934 (46) bt Barbizon House; ...; Sir Gervase Beckett by 1937; thence by descent until sold Christie's 22 Nov.1985 (44, repr. in col.); present owners
EXH: Tate Gallery 1976 (195, repr. in col. opp. p.128)
LIT: Thornes 1978, pp.20–1, no.5; Hoozee 1979, no.302, repr.; Reynolds 1984, no.21.49, pl.254 (col.)

Mr and Mrs David Thomson

Nos.112–14 are three sunset sketches made from similar viewpoints in 1821 and 1822, looking west to Harrow from near Branch Hill Pond. They have been chosen to give some indication of the range of late afternoon and early evening skies Constable studied while staying at Lower Terrace on the western side of the village. He had made few studies of sunsets since those done at East Bergholt in 1812 (nos.34–6).

The inscription on the back of this work is particularly interesting for the light it throws on

Constable's method of annotating his sketches at Hampstead. He records not only the weather experienced at the time of making the sketch but also the 'very heavy rain' that preceded his work, presumably delaying it, and the weather on the following day. This must mean, of course, that he made separate notes on the weather of the two days and later copied them onto the back of the sketch. It would not have been easy to do this until the paint had dried in any case. As Reynolds has pointed out, on at least one occasion Constable started copying out the wrong meteorological details, beginning those for 10 September 1821 on the back of a 12 September sketch before realising his mistake and deleting the details for 10 September (1984, nos.21.46, 21.48). The later of these two sketches, 'Study of Sky and Trees with a Red House', was made around noon on the same day as the present sunset study and Constable's notes on the back confirm those on the present work: 'Sun very Hot. looking southward exceedingly bright vivid & Glowing, very heavy showers in the Afternoon but a fine evening. High wind in the night.' They suggest that the word doubtfully read as 'light' in the inscription on no.112 should be 'high'.

The meteorological notes Constable made before transcribing them onto the backs of his oil sketches may be the 'observations on clouds and skies . . . on scraps and bits of paper' which he was hoping to work up for a lecture at the end of his life (Beckett V 1967, p.36). What these annotations and, of course, the works themselves reveal is a heightened awareness on Constable's part of nature as a process.

113 **Hampstead Heath, Looking to Harrow, Sunset** 1821 or 1822

Oil on paper laid on canvas 295 × 485 (11⅝ × 19)
PROV: Presumably from Isabel Constable's heirs by gift or sale to Ernest Alfred Colquhoun; by descent to Mrs G. Colquhoun, sold Sotheby's 15 July 1964 (112, repr.) bt Colnaghi; . . .; Mr and Mrs Paul Mellon 1965 and given by them to the Yale Center 1981 (B1981.25.141)
LIT: Hoozee 1979, no.321, repr.; Reynolds 1984, no.22.42, pl. 360 (col.); Cormack 1986, p.137, pl.138 (col.)

Yale Center for British Art, Paul Mellon Collection

Although, literally, seen in a very different light, the view here appears to be more or less identical to that in no.112 above, with the same foreground features. Instead of being silhouetted against a fiery sunset, Harrow Hill is now bathed in a diffuse and watery light a little while before sunset. This appears to be the largest of Constable's studies of Harrow from Hampstead, painted on paper of a size he is more likely to have used in 1822 than 1821. It may be the 'Harrow from Hampstead Heath (Sunset)', size 12 × 19 in, that Isabel Constable's heirs lent to the Grosvenor Gallery in 1889 (no.269).

114 **Hampstead Heath, Looking to Harrow, Stormy Sunset** 1822

Oil on paper 162 × 305 (6⅜ × 12)
Inscribed on the back 'July 31. 1822 Stormy sunset'
PROV: As for no.2
LIT: Reynolds 1973, no.248, pl.187; Thornes 1978, p.23, no. 18; Hoozee 1979, no.336, repr.; Reynolds 1984, no.22.15, pl. 348 (col.)

Board of Trustees of the Victoria and Albert Museum, London

One of Constable's darkest and stormiest sunset sketches, this was probably painted immediately after Reynolds 1984 no.22.14, the inscription on which refers to a 'Shower approaching'. Here it has arrived, with 'falling rain expressively painted' as Thornes says. For the moment Harrow, seen between the two tree groups at the left, remains untouched. The year before, acknowledging his new responsiveness to scenes such as this, Constable told Fisher 'I have likewise made many *skies* and effects – for I wish it could be said of me as Fuselli says of Rembrandt, "he followed nature in her calmest abodes and could pluck a flower on every hedge – yet he was born to cast a stedfast eye on the bolder phenomena of nature". We have had noble clouds & effects of light & dark & color' (Beckett VI 1968, p.74).

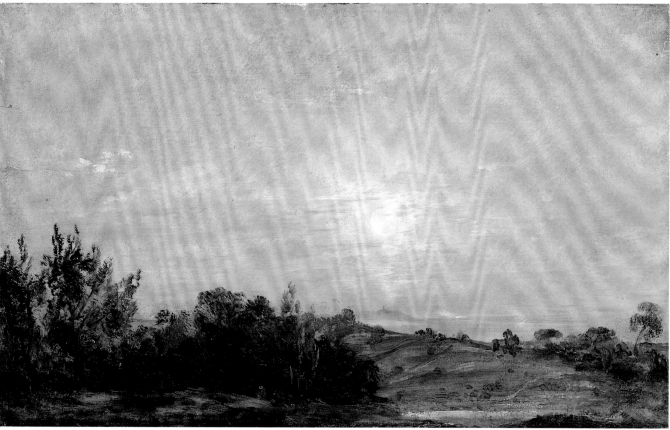

113

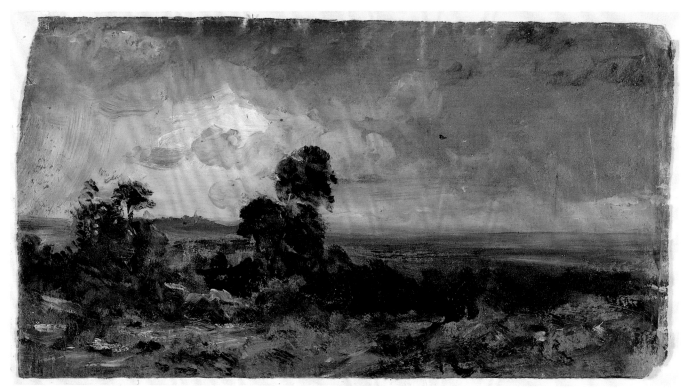

114

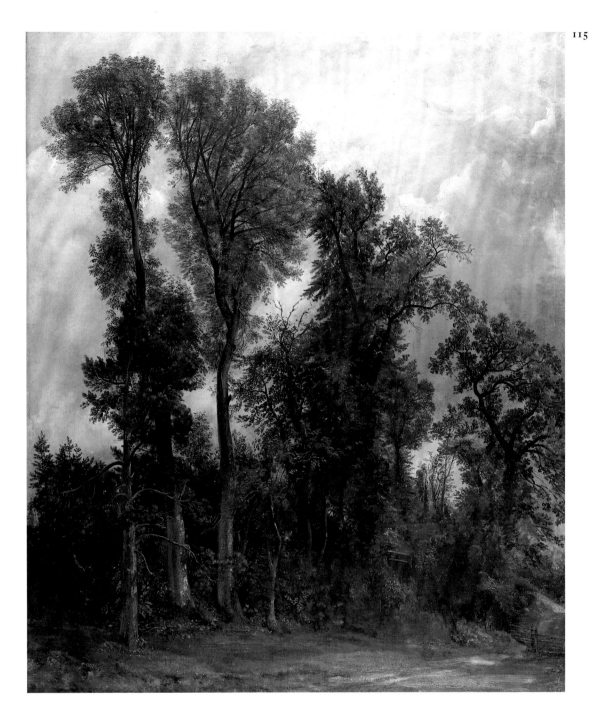

115 Trees at Hampstead 1821–2, ?exh.1822

Oil on canvas 914 × 724 (36 × 28½)
PROV: By descent to Isabel Constable, by
whom bequeathed to the South Kensington
(later Victoria and Albert) Museum 1888 as
the gift of Maria Louisa, Isabel and Lionel
Bicknell Constable
EXH: ? RA 1822 (314, 'A study of trees from
Nature'); Tate Gallery 1976 (203, repr.);
Japan 1986 (44, repr. in col.); New York,
Bloomington, Chicago 1987–8 (165, repr. in
col.); Madrid 1988–9 (54, repr. in col.)
LIT: Reynolds 1973, no. 223, pl. 168; Hoozee

1979, no. 310, pl. XXXIII (col.); Reynolds
1984, no. 22.6, pl. 336 (col.);

*Board of Trustees of the Victoria and Albert
Museum, London*

Constable made many small oil sketches of trees
seen against the sky during his early years at
Hampstead. This large, finished painting is his
most ambitious Hampstead tree 'study', the word
he himself appears to have used to describe it. 'I
have done some studies,' he told Fisher on 20
September 1821, 'carried further than I have yet
done any, particularly a natural (but highly elegant)

group of trees, ashes, elms & oak &c – which will be of quite as much service as if I had bought the feild and hedge row, which contains them, and perhaps one time or another will fetch as much for my children. It is rather larger than a kit-cat [36 × 28 in: it is only marginally larger, in fact], & upright' (Beckett VI 1968, p.73). As has long been recognised, the painting referred to is almost certainly no.115, which with almost equal certainty can be identified as the work entitled 'A study of trees from Nature' that Constable exhibited the following year. Although Hampstead church is squeezed in at the extreme left, there is no attempt to divert attention from the trees themselves. The picture remains in Constable's terms 'a study', one so

detailed in its description that he could hope to use it for his own future reference. He must have felt confident about it not being sold at the Royal Academy – the addition of figures would surely have been necessary to achieve a sale. By the time Isabel Constable bequeathed the painting to South Kensington such figures had in a sense been added, the alternative title for it then being 'The Path to Church', suggesting something in the manner of Thomas Creswick's 'The Stile (The Way to Church)' with its young lady admiring nature on her way to Sunday service (Tate Gallery N 00429).

According to Christopher Wade, the trees were in Montagu Grove, seen also in William Collins's 'As Happy as a King' (Tate Gallery N 00351).

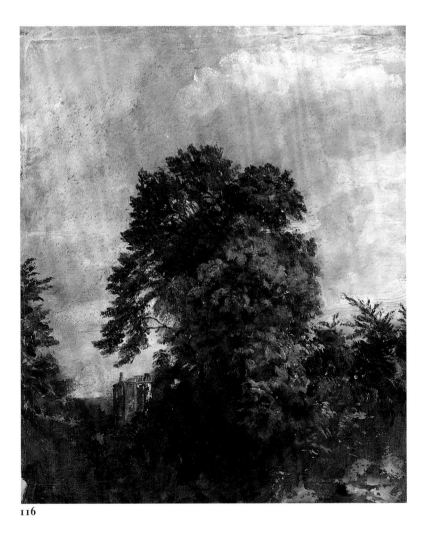

116

116 Study of a Tree with 'The Grove' or Grove House in the Distance 1822

Oil on paper laid on canvas 292 × 241 ($11\frac{1}{2}$ × $9\frac{1}{2}$)
Inscribed in a later hand on a label on the stretcher, presumably copying Constable's original inscription: '29 July 1822 looking east 10 in the morning – silvery clouds'
PROV: By descent to Isabel Constable, by whom presented to the Royal Academy 1888
EXH: Tate Gallery 1976 (205, repr.)
LIT: Thornes 1978, p.23, no.15; Hoozee 1979, no.333, pl. XLIII (col.); Reynolds 1984, no.22.12, pl.344 (col.)

Royal Academy of Arts, London

Constable made several oil studies at Hampstead of buildings glimpsed through or above trees. The house in the distance here has been identified as The Grove, later known as Admiral's House, because of the railings on its roof, a distinct feature of that building (see no.130 for this house). Christopher Wade, however, has recently suggested that the railings are of the wrong sort and that the building is more likely to be Grove House nearby.

As can readily be appreciated from no.116, few painters of English landscape were more keenly aware than Constable of the forms of trees as volumes in space. The problems involved in the realisation of this aspect of his art greatly exercised his mind in the early stages of his career: see the entry on nos.227–9.

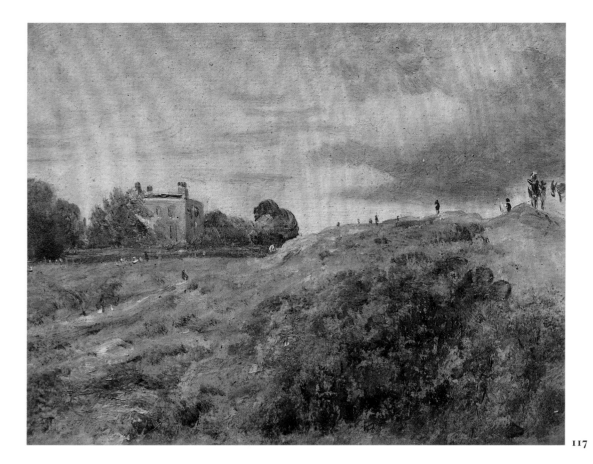

117

**117 Anthony Spedding's House,
Hampstead** *c.*1822

Oil on board 178 × 228 (7 × 9)
Inscribed in a later hand on a label on the
back 'View of Hampstead. | House of Anth'y
Spedding Esq. | Painted by John Constable
RA.'
PROV: Presumably given by the artist to
Anthony Spedding (otherwise by one of
Constable's children to one of Spedding's);
thence by descent
EXH: *Treasured Possessions*, Sotheby's,
Dec.1983–Jan.1984 (in section 9)
LIT: Reynolds 1984, no.22.48, pl.367 (col.)

Private Collection

The building shown here, adjoining Jack Straw's
Castle, is now known as The Old Court House but
in Constable's day apparently had no individual
name. It was the house of his solicitor, Anthony
Spedding (1776–1837), partner to Maria's father
Charles Bicknell. Constable consulted Spedding
on various legal matters, including the leases of 1
Keppel Street and 35 Charlotte Street. Christo-
pher Wade (to whom the identification of the
building is due) reports that there are local records
showing Spedding as the occupier from 1813
onwards. He suggests that it may have been the
Speddings who first introduced Constable to
Hampstead. As in no.118 below, Constable makes
effective use in this little-known sketch of figures
silhouetted against the sky.

118 A Road across Hampstead Heath *c*.1822

Oil on canvas 328 × 500 (12⅞ × 19¾)
PROV:...; Tooth;...; Blanche Barclay, by
whom bequeathed to Yale University 1949
EXH: New Haven 1982–3 (IV.26, repr.)
LIT: Hoozee 1979, no.534, repr.; Reynolds
1984, no.22.47, pl.369

*Yale University Art Gallery, Bequest of
Blanche Barclay, George C. Barclay
Collection*

Reynolds identifies the road in question as Spa-
niards Road and points to resemblances between
this work and 'The Road to the Spaniards' of July
1822 in the John G. Johnson Collection, Philadel-
phia (1984, no.22.10). Both are divided by a
sweeping horizon broken by trees and figures seen
against the sky. In his catalogue of the 1982–3 New
Haven exhibition Louis Hawes notes (p.65) that
the horizon in no.118 is in fact a ruled line.
Silhouetted figures first feature in Constable's
Hampstead work in the 1819 sketchbook (see
fig.140 on p.440); glimpses of distant ridges with
such figures on them establish the scale in
Constable's close-up studies of Hampstead sand-
banks (Reynolds 1984, nos.21.66, 21.67).

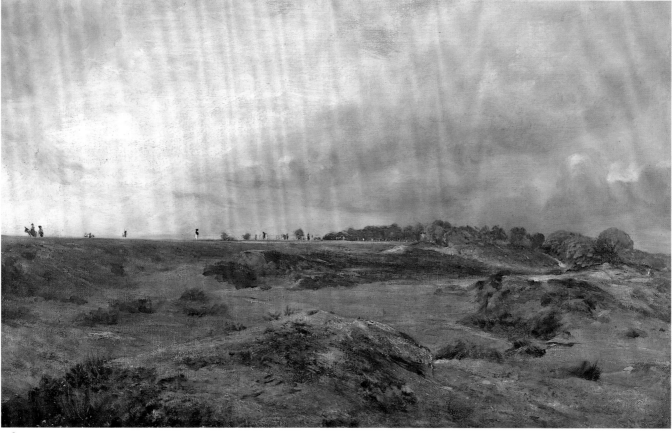

118

Hampstead Cloud Studies

While Constable was by no means the first artist to make oil studies of cloud formations, those he painted at Hampstead in 1821 and 1822 are unique in their quantity, in their understanding of the structure and movement of clouds and in their pictorial effect. Taking only the works in which sky is seen alone or above foreground trees, that is, excluding such landscape and sky studies as nos.112–14 above, it seems reasonable to estimate that Constable made up to a hundred studies in the two years. In October 1821 he told Fisher that he had 'done a good deal of skying' (Beckett VI 1968, p.76) and twenty-five or more examples dated, or datable to, 1821 survive to bear him out. In October 1822 he again reported to Fisher, this time that he had made 'about 50 carefull studies of *skies* tolerably large, to be carefull' (ibid., p.98). Presumably he was referring only to studies made that summer and to those in which the sky was the only or principal element; of these about half are known today. Because many of the studies are dated to the hour, we can see just how intensely Constable applied himself to the business, painting skies for several days on end and frequently making two studies in rapid succession. Each took about an hour. While this may seem no time at all in which to create such powerful images, the clouds depicted would of course have changed out of all recognition in considerably less time. On no.122 Constable noted that the wind was 'very brisk' and the clouds 'running very fast'. How he actually worked in these circumstances is a question that Constable scholars have not yet faced.

As already noted under no.112, the meteorological details frequently given on the backs of the studies indicate that Constable added his inscriptions after the event, since they often refer to subsequent (as well as previous) states of the weather. Constable's interest went beyond painting the study itself. As John Thornes wrote, the sky studies 'represent a unique, albeit spasmodic, pictorial weather diary' (1978, p.4). A few months before he began his 'skying' in 1821, Constable was introduced by Fisher to the work of the great nature diarist Gilbert White, which, Fisher told him, 'is in your own way of close natural observation', White having 'occupied himself with narrowly observing & noting down all the natural occurrances that came within his view: and this for a number of years' (Beckett VI 1968, p.64). There is a good deal of the eighteenth-century naturalist in Constable's approach to 'skying' but the understanding of meteorology displayed in his cloud studies goes beyond narrow observation. 'We see nothing truly till we understand it', he announced in a lecture to the Royal Institution in 1836 (Leslie 1843, p.144, 1951, p.318). Dr Thornes's comparison of the cloud studies and their inscriptions with contemporary weather records confirms the accuracy of Constable's observations (Thornes 1978) but it is Constable's ability to differentiate in paint a variety of cloud types, to suggest the pace and direction of their movement and to give them convincing three-dimensional forms without losing their lightness and brightness that speaks most for his understanding. To what degree this understanding was informed by knowledge of contemporary meteorological theory is uncertain but we do know that at some point in his life, probably later than 1821–2, he owned and made critical annotations in a copy of Thomas Forster's *Researches about Atmospheric Phaenomena*, which he was able to recommend in 1836 as 'the best book – he is far from right, still he has the merit of breaking much ground' (Beckett V 1967, p.36; for Constable and Forster see Parris, Shields, Fleming-Williams 1975, pp.44–5 and John Thornes, 'Constable's Clouds', *Burlington Magazine*, vol.121, Nov. 1979, pp.697–704).

In his wide-ranging survey of the circumstances surrounding Constable's sky studies of 1821–1 Louis Hawes discusses many relevant factors, including the artist's early experience of windmilling, the role of Hampstead Heath as a 'natural observatory' and Constable's knowledge of sky studies by other artists ('Constable's Sky Sketches', *Journal of the Warburg and Courtauld Institutes*, vol.32, 1969, pp.344–65). It is only possible in this brief introduction to mention one of the most immediate and most familiar reasons for Constable's campaign of 'skying', the anonymous criticisms made at Salisbury in 1821 of the supposedly overdominant sky in 'Stratford Mill' (no.100), retailed by Fisher in a letter to the artist. Constable's reply to Fisher suggests that he had already thought long and hard about the problems and was well aware of his own deficiencies as a sky painter:

> That Landscape painter who does not make his skies a very material part of his composition – neglects to avail himself of one of his greatest aids. Sir Joshua Reynolds speaking of the "Landscape" of Titian & Salvator & Claude – says "*Even their skies seem to sympathise with the Subject*". I have often been advised

to consider my *Sky* – as a "*White Sheet drawn behind the Objects*". Certainly if the Sky is *obtrusive* – (as mine are) it is bad, but if they are *evaded* (as mine are not) it is worse, they must and always shall with me make an effectual part of the composition. It will be difficult to name a class of Landscape, in which the sky is not the "*key note*", the *standard of* "*Scale*", and the chief "*Organ of sentiment*" . . . The sky is the "*source of light*" in nature – and governs every thing. Even our common observations on the weather of every day, are suggested by them but it does not occur to us. Their difficulty in painting both as to composition and execution is very great, because with all their brilliancy and consequence, they ought not to come forward or be hardly thought about in a picture . . .

(Beckett VI 1968, pp.76–7)

Constable's determination to overcome the difficulty of painting skies (and his use of the word 'composition' raises interesting questions) was clearly the result of his own dissatisfaction as much as a response to the remarks of the 'grand critical party' at Salisbury. Hampstead proved the ideal place to learn more about this aspect of his art. Although, as Hawes suggests, the pure cloud studies do not address the problem Constable mentions of balancing skies and landscapes, paintings made subsequent to the cloud studies do appear to solve this problem more satisfactorily. Thornes sees the 1817 'Flatford Mill' (no.89) as having a 'flat and distant' sky whereas in 'The Hay-Wain' (no.101) 'there is full integration of light between the sun, the clouds and the landscape' ('Landscape and Clouds', *Geographical Magazine*, vol.51, 1979, pp.495, 496). With a unique collection of sky studies to hand, Constable might be expected to have used them more directly in his subsequent work but so far no instance of him working in this way has been discovered. The knowledge gained in 1821–2 seems to have been sufficient for him to improvise convincing skies for his studio pictures.

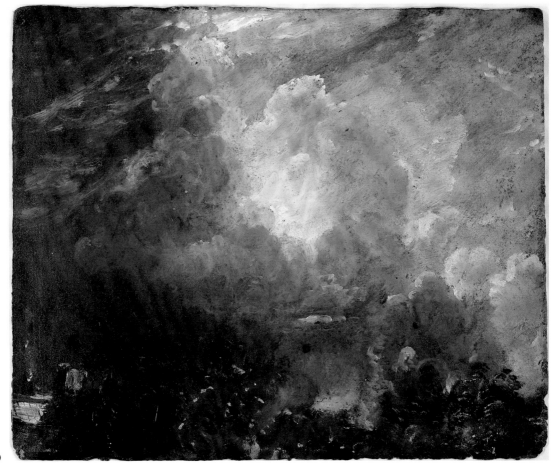

119

119 Cloud Study with Tree Tops and Building 10 September 1821

Oil on paper 248 × 302 (9¾ × 11⅞)
Inscribed on the back 'Sepr 10. 1821, Noon.
gentle Wind at West. | very sultry after a
heavy shower with thunder. | accumulated
thunder clouds passing slowly away | to the
south East. very bright & hot. all the foliage |
sparkling ⟨with the⟩ and wet'; also inscribed
in a different hand 'LC', i.e. the property of
Lionel Constable, on back t.l.
PROV: By descent to Lionel and thence
probably to Isabel Constable; . . .; discovered
in a market near Paris c.1986; anon. sale,
Sotheby's 19 Nov. 1986 (96, repr. in col.);
present owners

Mr and Mrs David Thomson

As with most of the 1821 cloud studies, this one
includes a margin of tree tops at the bottom (and
also part of a house). It is one of the earliest sketches
– possibly the earliest – in which Constable focuses
principally on the sky. In a study dated 3
September (Victoria and Albert Museum, Rey-
nolds 1984, no.21.45) attention is divided equally
between the sky and the tops of trees. The next
recorded example (ibid., no.21.46) was made on the
same day as no.119 but its whereabouts are
unknown and no photograph of it has come to light.
Reynolds has deduced that it was originally
inscribed 'Sepr. 10 1821 Eleven o'clock Sultry with
warm gentle [?rain] falling large heavy clouds [. . .]
a heavy downpour and thunder' (transcription
taken from Reynolds 1973, which differs from his
1984 version), this being the inscription Constable
deleted on the back of a 12 September 1821 study
(ibid., no.21.48) when he realised he was copying
out the wrong details (see also under no.112 above).
The first, missing, study was therefore made
around 11 am when rain was falling, the second,
no.119, around noon after the rain, which had
become a 'downpour', and the thunder had passed,
leaving the 'foliage sparkling and wet'.

120 Cloud Study 25 September 1821

Oil on paper laid on panel 212 × 290
(8⅜ × 11½)
Inscribed on a piece of paper affixed to the
back '25th. Septr 1821 about from 2 to 3
afternoon looking to the north – Strong Wind
at west, bright light coming through the
Clouds which were lying one on another'
PROV: By descent to Charles Golding
Constable; his widow Mrs A.M. Constable,

later Mrs Edward Ashcroft, who died 1889,
sold Christie's 23 June 1890 (95) bt
Hooper; . . .; Potter; . . .; Gilbert Davis; . . .;
Colnaghi; . . .; Mr and Mrs Paul Mellon 1965
and given by them to the Yale Center 1981
(B1981.25.147)
EXH: New York, Bloomington, Chicago
1987–8 (162, repr. in col.)
LIT: Thornes 1978, p.21, no.6; Hoozee 1979,
no.304, repr.; Rosenthal 1983, p.136, fig.177;
Reynolds 1984, no.21.52, pl.256 (col.);
Rosenthal 1987, p.122, ill.119

*Yale Center for British Art, Paul Mellon
Collection*

Not all Constable's pure cloud studies were made
in 1822, as was once supposed. This dated example
of the previous year is preceded by a partially dated
one (13 September) which Thornes ascribes to
1821 on the basis of contemporary weather records
(Yale Center for British Art, B1981.25.156, Rey-
nolds 1984, no.21.50). Reynolds has attributed
other pure cloud studies to 1821 on the grounds of
their small size, the dated 1822 examples all being
on larger sheets of paper.

121 Cloud Study with Birds 28 September
1821

Oil on paper laid on board 255 × 305
(9⅞ × 12)
A typed label on the back presumably copies
Constable's original inscription: 'Sep. 28
1821 Noon – looking North West windy from
the S.W. large bright clouds flying rather fast
very stormy night followed'
PROV: . . .; private collection, Paris; . . .; Mr
and Mrs Paul Mellon 1965 and given by
them to the Yale Center 1981 (B1981.25.155)
LIT: Thornes 1978, p.21, no.9; Hoozee 1979,
no.309, repr.; Reynolds 1984, no.21.57,
pl.262

*Yale Center for British Art, Paul Mellon
Collection*

Since it includes a strip of land at the bottom and
birds in the sky, this is not strictly a pure cloud
study. Slight though they are, these additional
elements have a major effect on our sense of the
scale and perspective of the clouds. Constable
introduces birds, which regularly appear in his
other works, in very few of his cloud studies,
perhaps not wishing to destroy the illusion of being
close to the sky that the pure cloud studies create.

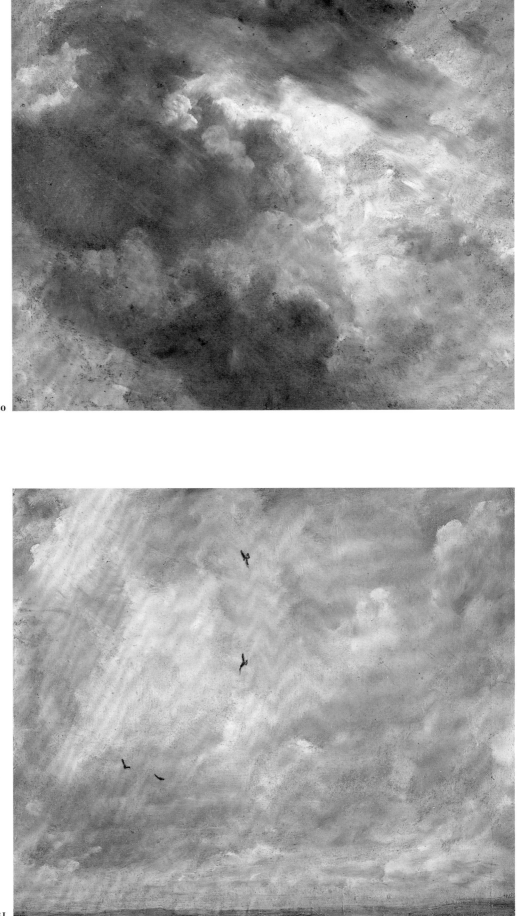

120

121

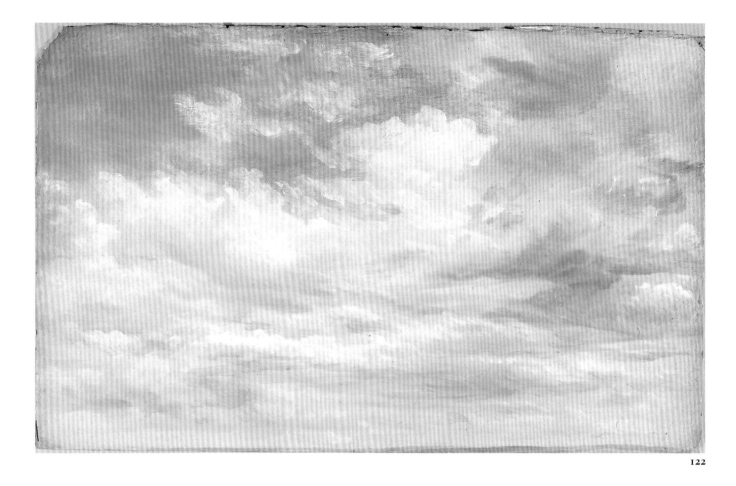

122

122 Cloud Study 5 September 1822

Oil on paper 370 × 490 (14½ × 19¼)
Inscribed on the back '5 Sep.ʳ 1822 10 o clock
Morng. looking South-East. very brisk wind
at West. very bright & fresh Grey Clouds
running very fast over a yellow bed. about
half way in the Sky very appropriate for the
Coast at Osmington.'
PROV: . . .; C.R. Leslie by 1843 and
presumably sold Foster 25 April 1860 (in 86,
'Seventeen Studies of Skies') buyer
unknown; . . .; Sir Michael Sadler; . . .; Spink,
from whom bt for the Felton Bequest,
National Gallery of Victoria 1938
EXH: Tate Gallery 1976 (207, repr.)
LIT: Thornes 1978, p.24, no.22; Hoozee
1979, no.342, repr.; Reynolds 1984, no.22.23,
pl.352 (col.);

*National Gallery of Victoria, Melbourne,
Felton Bequest, 1938*

Constable made another cloud study about two
hours later, when the wind was still 'very brisk' and
the clouds 'moving very fast. with occasional very
bright openings to the blue' (Victoria and Albert
Museum, Reynolds 1984, no.22.24). As suggested
under no.82 above, Constable appears to have been
thinking in 1822 of making a painting based on one
of his Osmington oil sketches. The Hampstead
skies of 5 September struck him as 'Very appropri-
ate' in this connection, though no.122 was not in
fact used when he finally painted the Osmington
picture in 1824.

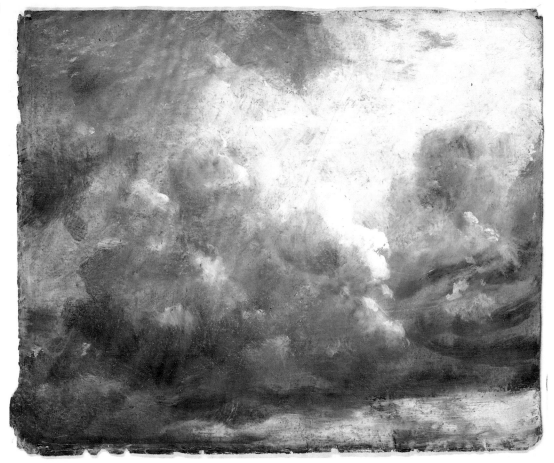

123

123 **Cloud Study** 6 September 1822

Oil on paper 244 × 307 ($9\frac{5}{8}$ × $12\frac{1}{8}$)
Inscribed on the back 'Sepr. 6. 1822 | noon. | Gentle wind at west. | hot & fine'
PROV: By descent to Isabel Constable, who died 1888; sold anonymously, presumably on behalf of her heirs, by Ernest Alfred Colquhoun, Christie's 28 May 1891 as one of the works 'Exhibited at the Grosvenor Gallery, 1889 [314], as the Property of Miss Isabel Constable, deceased' (122) bt in by Bourne; by descent in the Colquhoun family until sold, Sotheby's 10 July 1985 (83, repr. in col.); present owners
EXH: New York 1989 (22, repr. in col.)
LIT: Thornes 1978, p.24, no.24; Hoozee 1979, no.345; Reynolds 1984, no.22.26, pl.356

Mr and Mrs David Thomson

Constable appears to have made two cloud studies in rapid succession on 6 September 1822: this one inscribed 'noon' and another said to be inscribed 'Sept. 6th, 1822, looking S.E. – 12 to 1 oclock, fresh and bright, between showers – much the look of rain all the morning, but very fine and grand all the afternoon and evening' (private collection, Reynolds 1984, no.22.25).

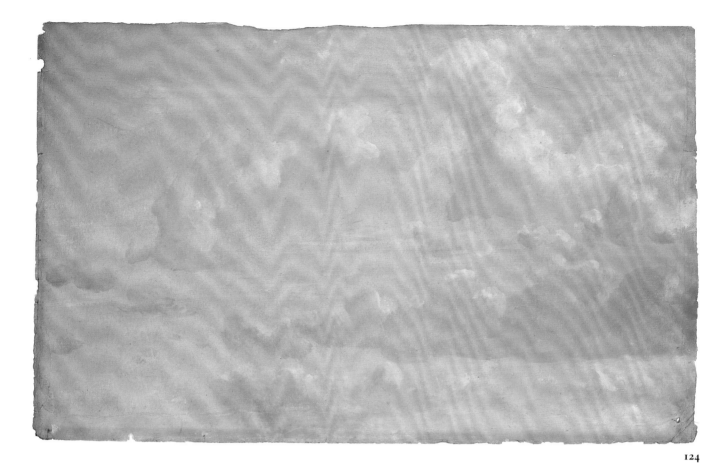

124

124 Cloud Study 21 September 1822

Oil on paper laid on board 305 × 492
(12 × 19¼)
Inscribed on the back 'Sepr 21 1822. looking
South brisk Wind at East Warm & fresh. 3
oclo afternoon'
PROV: . . .; Paterson Gallery 1928; . . .; Sir
Farquhar Buzzard 1937; . . .; Sir Robert Witt,
by whom bequeathed to Courtauld Institute
1952 with a life interest to Miss T. Creke-
Clark, who died 1974
EXH: New York 1983 (44, repr. in col.)
LIT: Thornes 1978, pp.24–5, no.27; Hoozee
1979, no.348, repr.; Reynolds 1984, no.22.28,
pl.354 (col.)

Courtauld Institute Galleries, Witt Collection

This study is also one of a pair painted in quick
succession, the other work in this case being made
around 1.30 p.m. (Yale Center for British Art,
B1981.25.116, Reynolds 1984, no.22.27). Thornes
notes that the two studies are unusual in depicting
'an easterly airstream producing streets of "fair
weather" cumulus'.

Later Hampstead Works

125 Branch Hill Pond, Hampstead 1824–5, exh.1825

Oil on canvas 622 × 781 (24½ × 30¾)
PROV: Bt from the artist by Francis Darby 1825; his son Alfred Darby, from whom bt by Agnew (?1908) and sold to Sir Joseph Beecham, sold Christie's 3 May 1917 (8, repr.) bt Agnew and sold to Knoedler 1918; . . .; Chester Johnson; . . .; Mrs F. Weyerhaeuser; . . .; Newhouse & Co., New York, from whom bt by A.D. Williams; given by Mrs A.D. Williams to Virginia Museum of Fine Arts, Richmond, Virginia 1949
EXH: RA 1825 (115, 'Landscape'); Tate Gallery 1976 (239, repr.); New York 1983 (45, repr. in col.); Japan 1986 (54, repr. in col.); New York 1988 (22, repr. in col.)

LIT: Hoozee 1979, no.441, repr.; Parris 1981, pp.117–18, fig.1; Rosenthal 1983, pp.2, 162, fig.204; Reynolds 1984, no. 25.5, pl.576 (col.); Cormack 1986, pp.169–72, pl.167; Rosenthal 1987, pp.148–9, ill.139

Virginia Museum of Fine Arts, The Williams Collection

Nos.125 and 126 were painted as pendants and are re-united here for the first time since about 1918.

Unlike the 1819 Branch Hill Pond sketch (no.106), the Richmond painting presents a view over Branch Hill Pond high enough for the house called The Salt Box (seen from a different angle in no.107) to be visible above the foreground bank. The panorama – including Harrow Hill at the right – which opens up behind it appealed to at least one

125

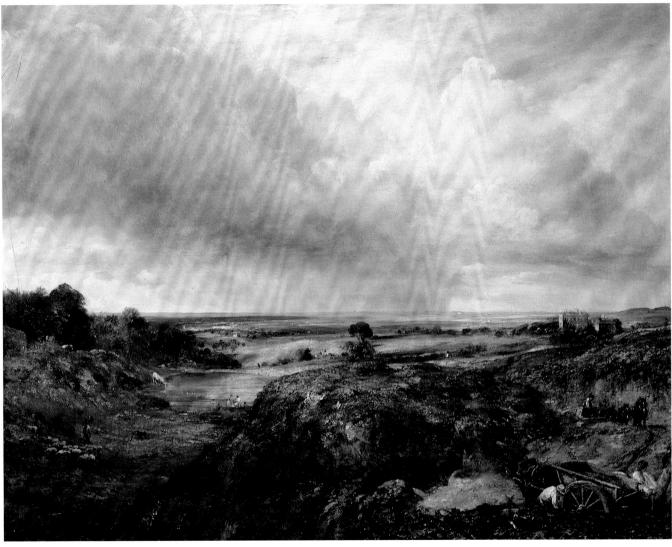

prospective buyer, Francis Darby, son of the man who built the Iron Bridge at Coalbrookdale. Having admired the picture and its companion at the 1825 Academy Darby wrote for more information about the subjects and price of the pictures. In reply Constable described no.125 as 'a Scene on Hampstead Heath with broken foreground. and sand carts – Windsor Castle in the extreme distance on the right of the Shower. the fresh greens in the distance (which You are pleased to admire) are the feilds about Harrow and ye villages of Hendon – Kilburn, &c.' (Beckett IV 1966, p.97). Darby soon after bought no.125 and its companion for 130 guineas, Constable agreeing to a reduction of twenty guineas because he 'felt flatterd that an application should be made to me from an entire stranger, without interest or affection or favor, but I am led to hope for the pictures' sake alone' (ibid., p.98).

There had in fact been some competition for the two works. Henry Hebbert, apparently a textile exporter, had already paid a deposit on them when Darby made his enquiry but had been forced to stand down by 'some serious losses in India', while a dealer called Smart had offered seventy guineas for one of the pictures (ibid., pp.97–8, 100). In addition, Constable had already sold another pair of the same compositions to the Parisian dealer Claude Schroth, who had commissioned two Hampstead views in May 1824 (Beckett II 1964, p.314). These were finished by December 1824 when Constable told Fisher that he had 'copied them, so it is immaterial which are sent away' (Beckett VI 1968, p.187). Schroth's version of no.125 is now in the Oskar Reinhart Collection, Winterthur (Reynolds 1984, no.25.7). Bearing in mind Constable's remarks, it is uncertain whether the Richmond or the Winterthur version was

126

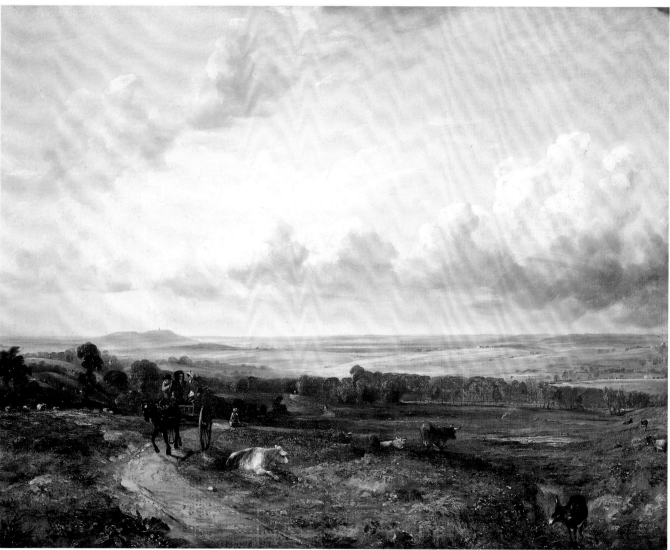

painted first. The role of John Dunthorne Jnr, who became Constable's studio assistant in 1824, is also uncertain. A tracing of the carts and men who appear at the bottom right of no.125 appeared recently (Christie's 12 July 1988, lot 31, repr.) but no other direct preliminary material for the picture seems to be known.

126 Child's Hill 1824–5, exh.1825

Oil on canvas 607 × 775 (23$\frac{15}{16}$ × 30$\frac{1}{2}$)
Inscribed on a damaged label on the stretcher '[. . .]nstable | 35 Upper Charlotte Street | Fitzroy Square' (label applied for 1825 RA)
PROV: Bought from Constable by Francis Darby 1825; his son Alfred Darby, from whom bt by Agnew (?1908) and sold to Sir Joseph Beecham, sold Christie's 3 May 1917 (9, repr.) bt Agnew and sold to Knoedler 1918; . . .; Richard Beatty Mellon; by descent until given to Westmoreland County Museum of Art, Greensburg, Pennsylvania 1966, sold Sotheby's 15 Nov. 1989 (73, repr. in col. with col. detail); present owner
EXH: RA 1825 (186, 'Landscape')
LIT: Paul A. Chew (ed.), *The Permanent Collection*, Westmoreland County Museum of Art, Greensburg 1978, pp.156–8, no.289; Hoozee 1979, no.440 (whereabouts unknown, repr. from 1917 sale cat.); Reynolds 1984, no.25.6, pl.580 (whereabouts unknown, repr. from 1917 sale cat.)

Private Collection

This is the companion to 'Branch Hill Pond' (no.125), presenting a view from some distance further west. Harrow again appears in the distance, this time towards the left. While no oil sketch corresponding to the other painting has come to light, 'Child's Hill' is clearly based on one now in the Victoria and Albert Museum (fig.70, Reynolds 1984, no.25.12) and follows it closely in many respects including the sky. A major change of scale in the foreground, however, brings the track, travellers and cows close to the eye: in the sketch a flock of sheep is seen in the foreground but from a more distant and higher viewpoint.

As described under no.125, this picture and the companion 'Branch Hill Pond' were bought in 1825 by Francis Darby. Constable's description of the painting in his letter of 1 August 1825 to Darby runs as follows: 'Companion to the above [no.125]. Likewise a scene on Hampstead Heath, called Child's Hill. Harrow with its spire in the distance. Serene afternoon, with sunshine after rain, and heavy clouds passing off. Harvest time, the foreground filled with cattle & figures, and an Essex market cart' (Beckett IV 1966, p.97). The version of the composition bought by Schroth (see under no.125) is now in a private collection, on loan to the Whitworth Art Gallery, Manchester (Reynolds 1984, no.25.8). As Reynolds suggests, Schroth probably chose the subject after seeing the small oil sketch in the artist's studio in May 1824. It seems very likely that a comparable sketch used for the Branch Hill Pond composition existed and was shown to the French dealer at the same time.

No.126 was lost sight of by Constable specialists for most of the present century and only became generally known when it appeared at auction in 1989.

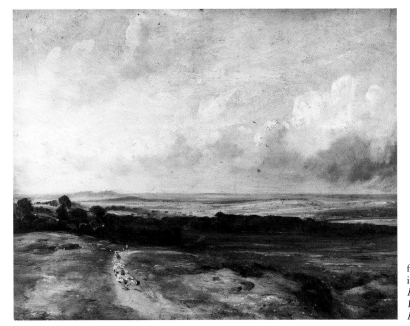

fig.70 'Child's Hill: Harrow in the Distance', *c*.1820–4, *Board of Trustees of the Victoria and Albert Museum, London*

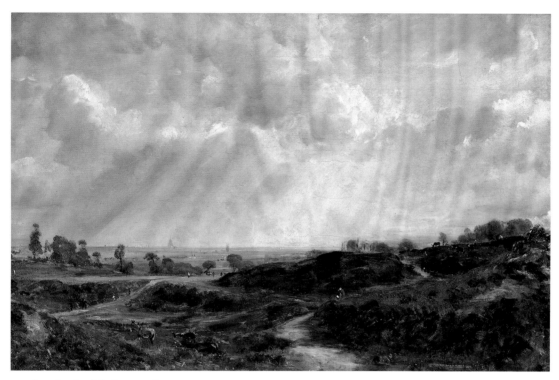

127 (see also detail facing p.193)

127 Hampstead Heath with London in the Distance *c.*1827

Oil on canvas 323 × 503 (12¾ × 19¹³⁄₁₆)
Inscribed 'Lionel. 1848.' in a later hand on a
label on the stretcher, i.e. Lionel Constable's
property in 1848
PROV: By descent to Lionel and thence to
Isabel Constable, who died 1888; her heirs,
sold Christie's 17 June 1892 (262) bt
Boussod; . . .; P.A. Chéramy, Paris, sold
Georges Petit, Paris 5 May 1908 (12, repr.) bt
for Otto Gerstenberg, Berlin; his grandson,
Dieter Scharf, Hamburg; Wolfgang
Wittrock, Düsseldorf, from whom bt by
present owners 1985
LIT: Hoozee 1979, no.531, repr.; Reynolds
1984, no.30.21, pl.788

Mr and Mrs David Thomson

See no.129

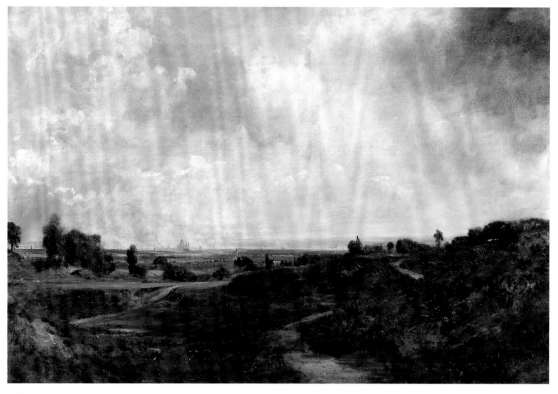

128

128 **Hampstead Heath with London in the Distance** *c.*1827–30

Oil on canvas 641 × 946 ($25\frac{1}{4} \times 37\frac{1}{4}$)
PROV: . . .; private collector, Pennsylvania, sold American Art Association, Anderson Galleries, New York, 8 April 1937 (48, repr.) bt Braus Galleries Inc.; John Phelan, Snr, Texas; Margaret Phelan Reed; Peggy Reed and sisters; Salander-O'Reilly Galleries, New York, from whom bt by present owners 1988
EXH: *Master Paintings*, Agnew, June–July 1989 (9, repr. in col.)

Mr and Mrs David Thomson

129 Hampstead Heath with London in the Distance exh.1830

Oil on canvas 650 × 975 ($25\frac{5}{8}$ × $38\frac{3}{8}$)
PROV: By descent to Charles Golding Constable and sold by court order after his death, Christie's 11 July 1887 (68) bt Stewart;...; J. Stewart Hodgson, sold Christie's 3 June 1893 (27) by Wallis;...; James Reid, by whose sons given to Glasgow Art Gallery 1896
EXH: RA 1830 (248, 'A heath')
LIT: Hoozee 1979, no.532, repr,; Reynolds 1984, no.30.4, pl.776 (col.)

Glasgow Art Gallery and Museum

Nos.127–9 are distant views of London looking south-east from Hampstead Heath, with St Paul's towards the left and Westminster Abbey (except in no.127) towards the right. The viewpoint is somewhere in the vicinity of Well Walk, where the Constable family settled in 1827. Watercolours made from upper windows at the back of their house there show similar views, views reckoned by Constable to be 'unequalled in Europe' (see nos.325–6). While Constable's Branch Hill Pond paintings, for example no.125, are well known, these later pictures made on the other side of Hampstead have only recently begun to receive much notice. The Glasgow painting, no.129, was convincingly identified by Reynolds in his 1984 catalogue as Constable's 1830 exhibit 'A heath', described in the *Morning Post* as showing London in the distance. When sold from C.G. Constable's collection, the picture itself was said to be dated 1830. The other two works shown here, nos.127–8, are comparatively recent rediscoveries, one emerging too late for inclusion in the 1984 catalogue. A further painting of the subject is known to Reynolds and the present authors only from photographs (Reynolds 1984, no.30.22).

Of the three exhibited here, the smallest work, no.127, appears to be an outdoor study preceding the other two. It could have been made before the move to Well Walk but Constable did not take much notice of the east side of Hampstead before then and it may be reasonable to associate it with his first months at Well Walk in the summer of 1827. In what is taken here to be the first of the two larger canvases, no.128, Constable adds more information, particularly about the distant view: St Paul's, for example, is more completely described and Westminster Abbey introduced. The group of trees in the left middle-distance is now seen differently, the gap between the tallest tree and its neighbours being closed up and the composition extended to the left to include a new tree on a bank at the very edge of the picture. Between this tree and the others a neat little vignette of fields and a church spire is introduced. Infra-red reflectography, Sarah Cove reports (thesis), reveals a considerable amount of under-drawing in graphite in this and other parts of the work. There is also a vertical line drawn down the left-hand side, just to the right of the new tree, which may be connected with the extension of the design on this side.

While it contains a degree of freshly observed material not present in the smaller sketch, no.128 lacks the figures seen in that work and in the Glasgow picture, no.129, though it does include the two foreground donkeys. It is very thinly painted in many areas and some of the forms – the banks at the right for example – are not fully defined. It is debatable whether it should be regarded as a sketch for the Glasgow painting or as an unfinished version of the subject.

With the exception of the very late and somewhat fanciful 'Hampstead Heath with a Rainbow' (no.219), the Glasgow picture is Constable's last finished painting of the heath. With its donkeys in the foreground and view of London in the distance (St Paul's now occupying the place once taken by Dedham church) it epitomises the combination of 'town & country life' that Hampstead made possible for Constable.

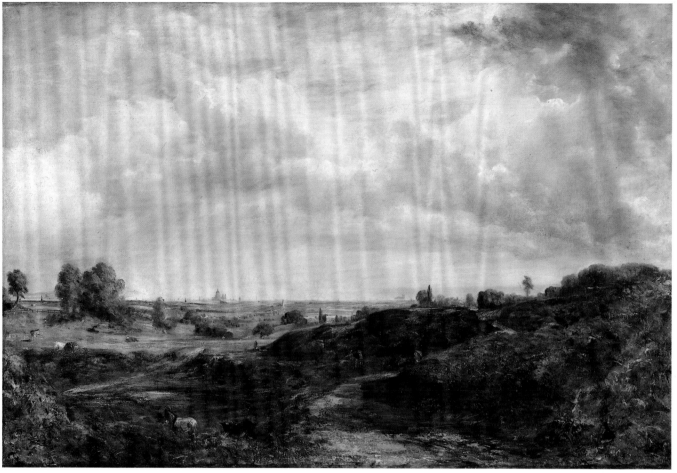

129

130

130 A Romantic House at Hampstead (The Grove) ?exh.1832

Oil on canvas 596 × 502 (23½ × 19¾)
PROV: . . .; given by Consul-General Paul Freiherr von Merling to the Nationalgalerie, Berlin 1905
EXH: ? RA 1832 (152, 'A romantic house at Hampstead')
LIT: Hoozee 1979, no.391, repr. (as no.397); Parris 1981, pp. 99–100, fig.2; Reynolds 1984, no.32.4, pl.825 (col.); Parris and Fleming-Williams 1985, p.169, under no.32.3

Staatliche Museen Preussischer Kulturbesitz, Nationalgalerie, Berlin

The house called 'The Grove' was occupied in the late eighteenth and early nineteenth centuries by a former lieutenant in the navy, Fountain North (1749–1811), who made alterations to the building so that its flat roof resembled the quarter-deck of a man-of-war; from here he is said to have fired cannon on special occasions. George Frere was the occupant in Constable's day, by which time the main relics of this eccentric arrangement appear to

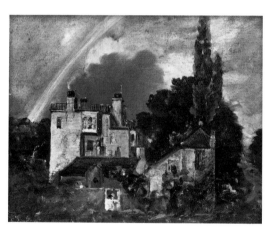

fig.71 'The Grove, Hampstead', c.1821–2, *Board of Trustees of the Victoria and Albert Museum, London*

have been the railings round the edges of the roof. In 1917 the house was renamed Admiral's House in the mistaken belief that Admiral Matthew Barton had lived there. Felicity Marpole revealed the true history of the house in 1981 ('A Romantic House at Hampstead', *Camden History Review*, vol.9, 1981, pp.2–3).

Constable made several oil sketches and paintings in which The Grove appears, including one in the Tate Gallery (Parris 1981, no.23, Reynolds 1984, no.21.108). The Berlin picture, no.130, was based on an oil sketch now in the Victoria and Albert Museum, made when Constable was staying at Lower Terrace in 1821 or 1822 (fig.71, ibid., no.21.107). To this a deep foreground has been added, changing the format of the design and making the house look more imposing. The rainbow in the sketch is omitted and the direction of the light changed so that the surfaces facing us are now in shadow. In his careful drawing of the rooflines Constable has added (from memory ?) a weather vane behind the chimney stack on the left.

The Berlin picture may be the work exhibited in 1832 as 'A romantic house at Hampstead'. It belongs stylistically to that period and the title is certainly appropriate. It is possible, however, that the Tate Gallery painting mentioned above was the 1832 exhibit. This picture was actually known as the 'Romantic House' by Constable's children (Frederick Wedmore, 'Constable 1776–1837', *L'Art*, vol.2, Paris 1878, pp.169–79, where an etching of it is published) and, while undoubtedly a work of Constable's early Hampstead years, could have been brought out for exhibition later. It is also considerably smaller than the Berlin picture: the *Morning Post* described three of Constable's 1832 exhibits, including the 'Romantic House', as small oils of Hampstead. One of them was the 'Sir Richard Steele's Cottage, Hampstead' in the Paul Mellon Collection, which measures only 8¼ × 11¼ inches (Reynolds 1984, no.32.6).

Romantic buildings are very much a feature of Constable's later work, whether houses such as this or Willy Lott's (no.216) or grander structures like Hadleigh Castle (no.170) and Salisbury Cathedral (no.210).

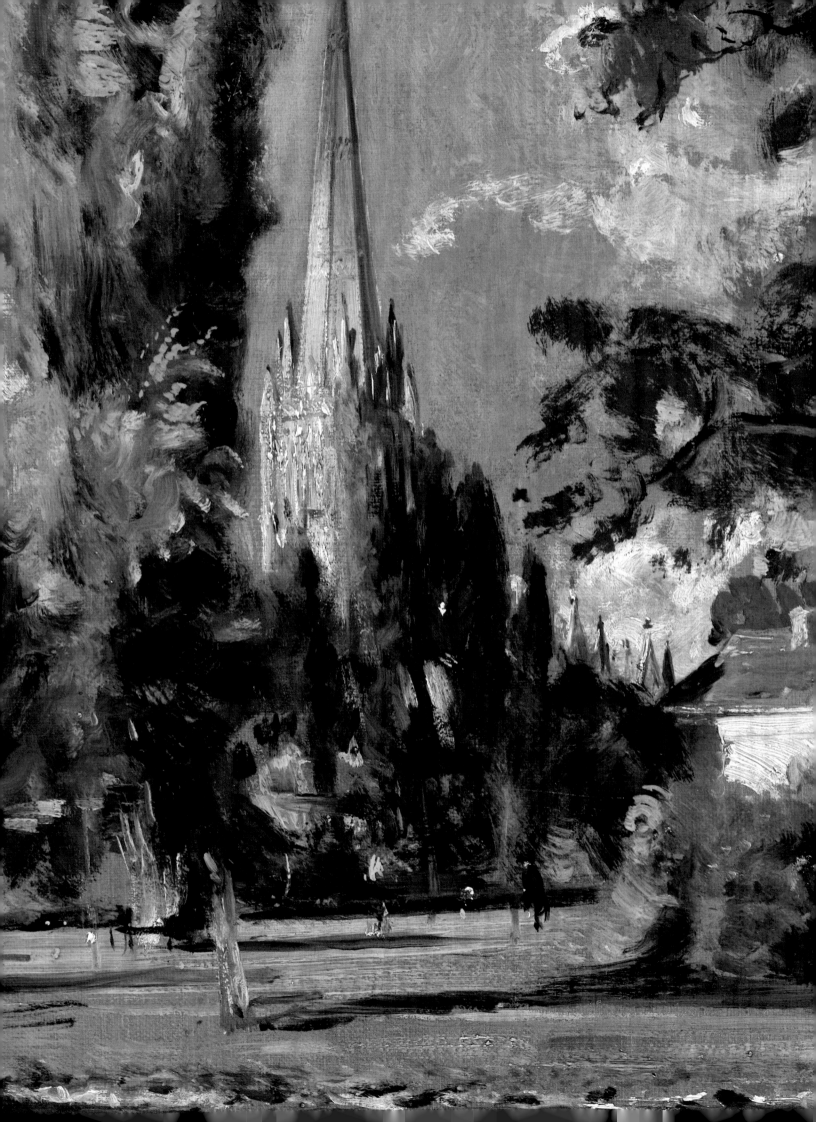

Salisbury

In his *Life* of the artist, C.R. Leslie calls attention to a striking feature of Constable's art, the fact that the subjects he painted form 'a history of his affections. – Bergholt and its neighbourhood – Salisbury – Osmington – Hampstead – Gillingham – Brighton – Folkestone, (where his boys were at school,) – and scenes in Berkshire visited by him with Mr. Fisher. With the exception of his excursion in Derbyshire [1801], and afterwards to the English Lakes [1806], he never travelled expressly for subjects' (Leslie 1845, pp.316–17, 1951, p.288). It is a measure of the strength of Constable's affection for the Fishers, for the Bishop of Salisbury and his wife and for the Bishop's nephew, John Fisher and *his* wife, Mary, that half of the names in Leslie's list were places Constable visited because of his friendship with that family.

Dr Fisher was on one of his annual visits to Langham (probably in 1798) when Constable was first introduced to him. A keen watercolourist himself, Fisher took an active interest in the young artist's career from his very first years as a student in London. It may have been at one of the Bishop's dinner parties in London that Constable first met John Fisher, the nephew, but it was in 1811, on his first visit to Salisbury, while staying at the Palace, that, in Constable's own words, their friendship 'first took so deep a root' (Beckett VI 1968, p.207).

This friendship was of the very greatest importance to Constable, for though younger by some twelve years, Fisher was able to play a number of supportive roles. He officiated at Constable's wedding; hosted him on his honeymoon and subsequently had him to stay on a number of occasions. He shared with Constable a love of landscape and because he too painted in oils, was always able to supply his friend with canvases and paint when he came to stay. He bought Constable's work (including the first two six-footers, 'The White Horse' and 'Stratford Mill', no.100, as well as no.140, 'Salisbury Cathedral from the Bishop's Grounds') and, better equipped academically, was able to provide Constable with an intellectual stimulus that his limited circle of artist friends was less able to supply. Their correspondence is a delight. Containing some of Constable's profoundest thoughts and feelings about his art as well as perceptive analyses by Fisher of his friend's character, it also ranges widely among a host of topics and includes little morsels of local gossip like the following hitherto unpublished postscript from Fisher. 'I found old Majendie at the Palace talking broad smut to his married daughter who is most monstrously big with child for the first time, & thinks nobody knows it. My relative [the Bishop] has just patronised & put into a school a clergyman who is lately released from jail for a conspiracy to father his daughters bastard child on a nobleman: he being suspected of being both father and grandfather. The B[ishop]. is as usual much surprised. Bless me. then brushes his apron' (postscript to letter of 5 July 1823, Beckett VI 1968, pp.122–3).

It is to this friendship that we owe much, even the very existence of some of Constable's finest paintings. He acknowledged his debt in a letter written when he was at work on 'The Hay-Wain'. His painting, he said, 'was getting on . . . Believe – my very dear Fisher – I should almost faint by the way when I am standing before my large

Detail from 'Salisbury Cathedral and Leadenhall from the River Avon', no.137

canvasses was I not cheered and encouraged by your friendship and approbation' (Beckett VI 1968, p.63). It is also undoubtedly to Fisher's credit that when Constable was staying with him he was able to paint some of his best oil sketches and pictures from nature. Possibly because he was using canvases supplied by Fisher, several of these were on a rather larger scale than usual – for example, the Weymouth pair (nos.83 and 85) and the three Salisbury views (nos.136, 137, 139).

Constable stayed with Fisher at Leadenhall, his house in the Close, on five occasions, but only in 1820 and 1829 for any length of time. The 1820 visit of about six weeks was a particularly happy and productive one. A newly elected Associate of the Royal Academy (a position for which he had been competing for ten years), he was beginning to receive more favourable notices in the press. In C.R. Leslie's opinion his art 'was never more perfect, perhaps never so perfect, as at this period of his life' (1845, p.78, 1951, p.72). Fisher had bought his first six-foot painting, 'The White Horse' (fig.65 on p.194) and it was already hanging in the house, where Mary Fisher said she could carry her eye from the picture to the garden and back and observe the same sort of look in both (Beckett VI 1968, p.53). Furthermore, on this, Constable's first visit to Leadenhall, Maria and their children were with him. In 1829 the situation was very different. He had recently lost his wife and, with seven children under the age of twelve, the face of the world had totally changed for him. His election as Academician less than three months after Maria's death brought little more than bitter reflections. His visits this year were also productive, but compared with that of 1820, there is a marked change in the character of much of his work.

131

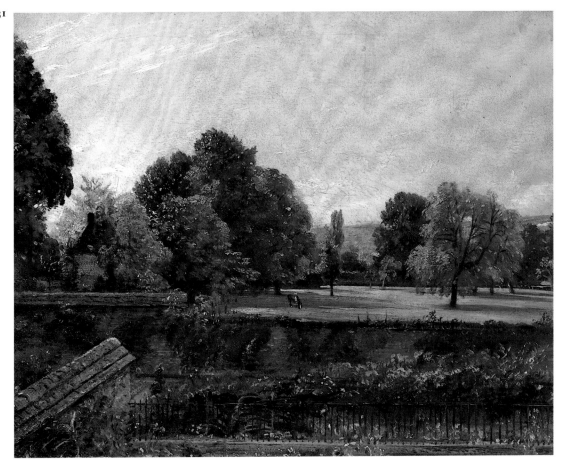

131 A View from Fisher's House ?1820

Oil on canvas 200 × 251 ($7\frac{7}{8}$ × $9\frac{7}{8}$)
Inscribed in a later hand in pencil on the
stretcher 'borrowed by C.R. Leslie May
20th. 1841'; also inscribed 'Lionel 1848 Jany'
on a label on the stretcher, i.e. Lionel
Constable's property then
PROV: As for no.2
EXH: Tate Gallery 1976 (267, repr.); New
York 1983 (35, repr. in col.)
LIT: Reynolds 1973, no.320, pl.229; Hoozee
no.515, repr.; Reynolds 1984, no.29.40,
pl.742 (col.)

*Board of Trustees of the Victoria and Albert
Museum, London*

No.131 has hitherto been regarded as a work of
1829. This dating does not seem to have taken
sufficiently into account the very different circum-
stances prevailing in 1820 and 1829, to which
former year the present authors feel the painting
must surely belong. Here is a work serene in mood,
much of it executed with a richly loaded brush. In
the trees we see a number of those tell-tale,
deliberately placed, pinhead-sized touches of white
that Constable would have seen when copying
Beaumont's Claude 'Hagar and the Angel' (fig.19
on p.60), the touches of sparkle that he began to
emulate in paintings such as the 'Boat-Building' of
1814 (no.72) – further evidence in favour of the
earlier dating. Painted in the early morning,
possibly – judging by the sky – on the same day as
the small view of the garden with the giant alder
(no.133), this could well have been one of the first
subjects Constable chose to paint after his arrival at
Leadenhall in July. It is certainly a work redolent of
contentment and quiet enjoyment.

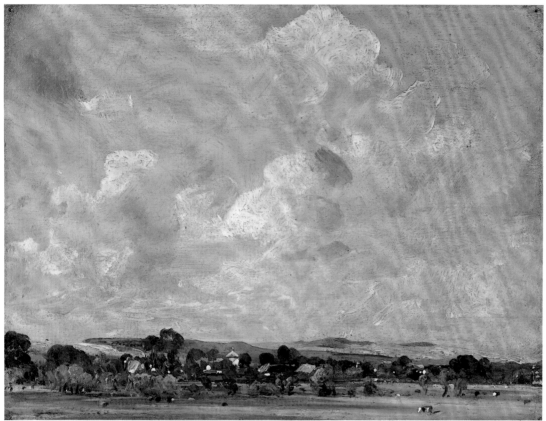

132

132 West Harnham and Harnham Ridge 1820

Oil on paper 175 × 235 (6⅞ × 9¼)
Inscribed in pencil on the back 'Village of
Harnham | 2ᵈ Augᵗ 1820 – | 9 o clock morning
looking | West', repeated with minor
variations in a later hand in ink
PROV: By descent to Isabel Constable, who
died 1888; her heirs, sold Christie's 17 June
1892 (243) bt Dowdeswell; . . .; E.W. Hooper;
his daughter Mrs R.C. Warner; her son
Roger S. Warner Jr, who died 1976; his
executors, sold C.G. Sloan & Co. Inc.,
Washington, 23 Sept. 1979 (2155, repr.) bt
Morton Morris & Co. and the Brod
Gallery; . . .; Richard Thune, New York,
from whom bt by the present owners 1985
LIT: Hoozee 1979, no.277, repr.; Parris 1981,
p.136, fig.1; Reynolds 1984, no.20.37, pl.161

Mr and Mrs David Thomson

See no.133

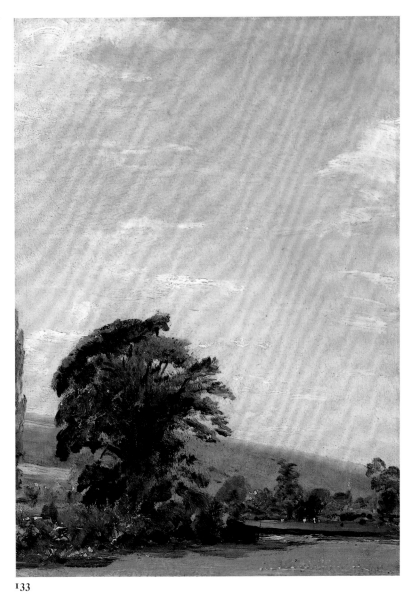

133

133 Harnham Ridge from Leadenhall Garden 1820

Oil on paper 203 × 143 (8 × 5⅜)
PROV:...; J. Johnston, sold Christie's 20
June 1975 (129, repr.) bt Leggatt; present
owners
LIT: Hoozee 1979, no.508, repr.; Parris 1981,
p.136; Reynolds 1984, no.29.33, pl.733

Mr and Mrs David Thomson

Leadenhall faces westwards and from the garden down by the river there were fine views to be obtained across open watermeadows towards the village of West Harnham, with its low-capped church tower, and beyond to the distant, low-lying hills. On either side the lawns were framed by trees: on the left by the giant alder (to be seen in nos.133 and 137) and a tall poplar that in no.133 only just manages to make its appearance.

Constable fully dated only three of the oil sketches he made at Salisbury during his visits of 1820 and 1829: no.132 (2 August 1820); no.141 (15 July 1829); and a third view, this time from 'Fisher's – Library' at Leadenhall (12 July 1829, fig.73 on p.261). No.132 and the 1829 pair are readily distinguishable stylistically and no.133, the other view of the Leadenhall garden shown here, seems to pair off more convincingly with no.132 of 1820 than with the other two. In the work of 1820, the colour and tonal range are more closely knit, Constable adopts a rich impasto and when he is painting freely (as in no.132), the brushwork is entirely lacking in the sharp, nervous touches to be seen in no.141, the 1829 sketch of the trees in Fisher's garden, and in other sketches of that year.

134 Salisbury from Harnham Hill ?1820

Oil on canvas 355 × 511 (14 × 20⅛)
PROV: ...; Gooden & Fox, from whom bt by
Percy Moore Turner 1927; bequeathed by
him to the Louvre 1952 (RF 1952.25)
LIT: Hoozee 1979, no.148, repr.; Reynolds
1984, no.20.24, pl.151 (col.)

Musée du Louvre, Paris

From his visit to Salisbury in the autumn of 1811,
Constable returned with a number of drawings (see
no.242). 'Salisbury', he told Maria on 11
November, 'has offered some sketches – Mr
Stothard admired them [Thomas Stothard RA]
and one in particular – (a general view of Sarum) he
recomends me to paint – & of a respectable size'
(Beckett II 1964, p.54). In March 1812 he sought
Farington's advice on the work and showed it to the
Academician again on 7 April before sending it in
to the Academy. 'I found that by lightening &
clearing His picture [the diarist recorded], "A view
of Salisbury", He had much improved it' (Far-
ington XI, p.4105). Before sending in the Salisbury
with three other works (including nos.33 and 54)
for 'their audit', Constable's 'good friends the
Bishop (of Sarum) and Mrs. Fisher called to see
them' (Beckett II 1964, p.63). John Fisher too had
seen the painting, to which he referred in a letter of
8 May. 'I often walk up to Harnham Hill to look at

your view – I was right about St Martins – it is
connected to the town by a street & is not a *detached*
building. – How have you finished – when I left,
you was in jeopardy?' (Beckett VI 1968, p.15).
Titled 'Salisbury: Morning', the painting was
no.372 in that year's Academy. Neither the draw-
ing from which he worked, nor the painting of
Salisbury from Harnham Hill has so far come to
light. At one time it was thought that no.134 might
be the work exhibited in 1812, but the afternoon
light it portrays and the unfinished state of the
foreground rule this out. Although it is likely to
have been painted in 1820 (the sky in particular
could hardly be of 1811–12), until this can be
convincingly established there must always remain
the possibility that no.134 is a work of an earlier
date. It is of course closely related to the drawing
dated 23 July 1820 (no.293), which was taken from
a nearby viewpoint, off the crest of the hill and a
little to the left. But the drawing shows a familiarity
with some of the ground in the middle distance that
is lacking in the painting. For example, in the
drawing Constable notes carefully the willow
leaning over the bend of the river that is such a
feature in his 'Watermeadows at Salisbury'
(no.135). In no.134, the tree is scarcely discernible.
If of 1820 it is therefore possible that it was painted
quite soon after Constable's arrival in July, before
the 'Watermeadows' and before he made the
drawing.

134

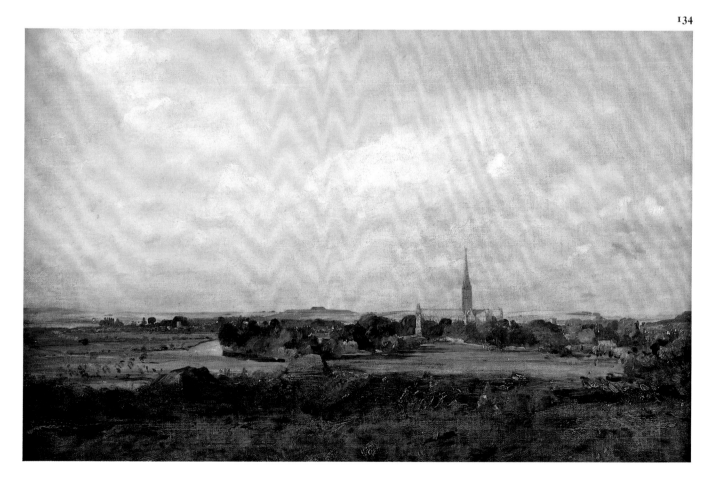

A copy of no.134, oil on canvas 327 × 515 (12⅞ × 20¼), by Dorothea Fisher (with, it was claimed, 'the more brilliant passages' touched in by Constable) was sold at Christie's on 15 April 1988 (70, repr. in col.).

col.); Madrid 1988–9 (57, repr. in col.)
LIT: Reynolds 1973, no.321, pl.232; Hoozee 1979, no.517, pl.LIX (col.); Reynolds 1984, no.29.41, pl.742 (col.); Parris and Fleming-Williams 1985, p.166

Board of Trustees of the Victoria and Albert Museum, London

135 Watermeadows at Salisbury ?1820

Oil on canvas 457 × 553 (18 × 21¾)
PROV: Artist's administrators, sold Foster 16 May 1838 (50, 'Salisbury Meadows; painted from nature') bt Revd J.H. Smith for John Sheepshanks, by whom presented to the South Kensington (later Victoria and Albert) Museum 1857
EXH: Tate Gallery 1976 (269, repr.); Japan 1986 (60, repr. in col.); New York, Bloomington, Chicago 1987–8 (166, repr. in

This view of the Salisbury watermeadows was painted in the grounds of Leadenhall from a spot on the river bank that may be visualised as having been to the right along the path in the sketch of Fisher's house from across the river, no.137. The view is still obtainable from there and is not greatly altered, although only a massive stump remains of the pollarded willow that in the picture leans over the reeds at the water's edge.

The painting has a curious history. In 1830, as a recently elected Academician and a member of the Council of the Royal Academy, Constable served

135

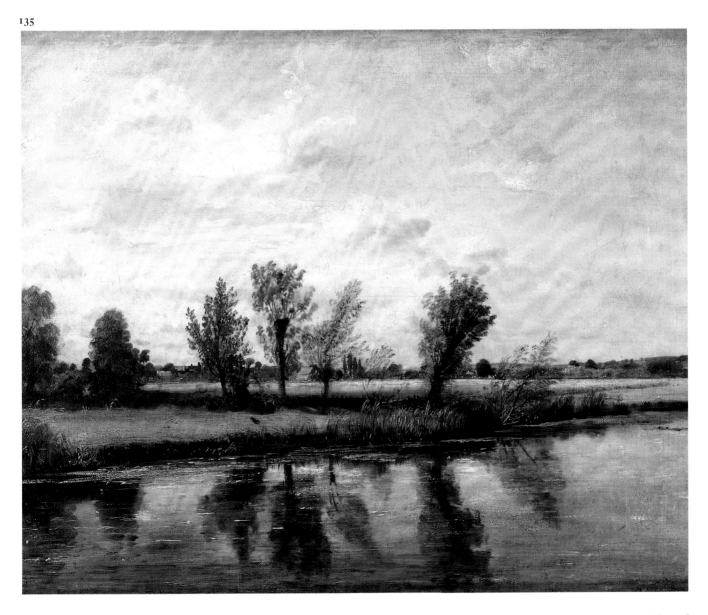

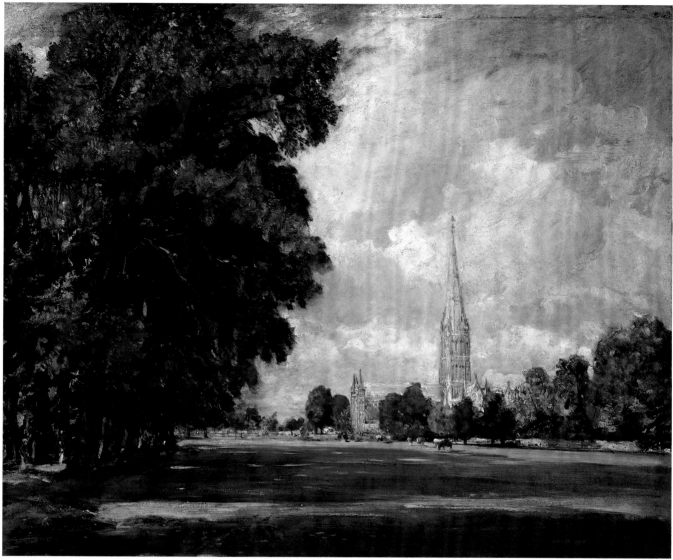

136

on the committee responsible for selecting works from among the many hundreds submitted by non-members for the forthcoming summer exhibition. Academicians and Associates were themselves entitled to exhibit up to eight works without question. Constable sent in four paintings that year. Three were duly hung, but the fourth, the 'Watermeadows at Salisbury' (titled by the artist 'Landscape – a Study'), somehow became separated from the others and was presented for judgement like a work by a non-member. Constable remained silent while his colleagues discussed and condemned his painting as a 'poor thing' and 'very green', and would not allow the verdict to be rescinded when they found out it was his. 'It has been properly condemned as a daub', he is said to have remarked, 'Send it out'. (For the several accounts of the incident in full, see Tate Gallery 1976, under no.269.)

Because Constable had intended that the work should be in the 1830 exhibition, it has been assumed that no.135 was painted during his July visit to Salisbury of the year before, 1829. This is a perfectly logical dating in the circumstances, but stylistically there is little agreement between no.135 and the oil paintings Constable is known to have done on that visit, and the study, as he called it, seems more likely to have been a work of an earlier period when his mind was more at rest, i.e. the summer of 1820 when he painted nos.132, 137 and 138, all scenes on the banks of the Avon. Although in general appearance 'Watermeadows at Salisbury' is a 'one-off', a work not quite like any other painting by Constable, some of the detailing bears a close resemblance to passages in the 'Hampstead Heath' (no.108), a highly finished painting of about the same period.

A puzzling addition to the already unusual history of the painting was provided by the appearance at Christie's (12 July 1988, lot 30, repr.), among a group of Constable's tracings, of a $9 \times 11\frac{7}{8}$ inch pen and ink outline drawing of the subject. On paper watermarked '[F]incher & Sons 1823', that had been carefully squared up in pencil, the drawing had also been prepared on the back with grey chalk for transfer. There is no known engraving or further version of no.135.

136 Salisbury Cathedral from the South-West 1820

Oil on canvas 730×910 ($28\frac{3}{4} \times 36$)
PROV: Artist's administrators, sold Foster 16 May 1838 (in 13, 'Two – Salisbury Cathedral and the Glebe Farm') bt William Hookham Carpenter, sold Christie's 16 Feb. 1867 (77) bt Halstead;...; Sir John Kelk, sold

Christie's 11 March 1899 (6) bt Agnew; Laurie & Co. 1899;...; W.K. Bixby, St Louis 1911;...; Knoedler 1918;...; Andrew Mellon, by whom given to the National Gallery of Art 1937
LIT: Hoozee 1979, no.281, pl.XL (col.); Reynolds 1984, no.20.53, pl.177 (col.)

National Gallery of Art, Washington, Andrew W. Mellon Collection

Painted on one of the larger canvases Constable used during his stay with the Fishers in 1820, this, one of the freshest and most effervescent of his open-air oil sketches, is a view of the cathedral and its Close from just outside the Leadenhall entrance gateway. This was a less frequented part of the Close and Constable would have been able to set up his easel here and work without attracting too much attention. It would have been very different, as we can see, if he had attempted to paint the cathedral from the north-west. Cattle also browsed in the Bishop's grounds. Presumably neither Dr Fisher nor his Chapter were lacking in supplies of fresh milk.

137 Salisbury Cathedral and Leadenhall from the River Avon 1820

Oil on canvas extended to 525×770 ($20\frac{3}{4} \times 30\frac{1}{4}$) by strips 525×27 at the right, 25×743 at the top, 500×34 at the left
PROV: By descent to Isabel Constable, who died 1888;...; George Salting 1891 and bequeathed by him to the National Gallery 1910 (2651)
LIT: Reynolds 1977, pp.12–14, fig.7; Hoozee 1979, no.280, pl.XLI (col.); Reynolds 1981, pp.136–7, 141, fig.36; Reynolds 1984, no.20.51, pl.173 (col.); Cormack 1986, pp.119–20, pl.115 (col.)

Trustees of the National Gallery, London

Leadenhall (spelt 'Leydenhall' in most recent publications), a handsome dwelling in the south-west corner of the Close, became John Fisher's residence when he was admitted Canon Residentiary in 1819. Recorded in a lease of 1305 as 'the house of residence call Aula Plumbia', i.e. Lead Hall, presumably from its lead roof (Salisbury Chapter Muniments, Press IV, Box M), the house appears as 'Leadenhall' in a document of 20 April 1313 (ibid., Box M4). Fisher, writing to his wife in July 1819 after having spent his first few nights in their new house in the Close, spells the name 'Ledyn Hall' (unpublished, private collection) and shortly after, on 11 August, heads a letter to Constable 'Leyden Hall', which Beckett trans-

cribed as 'Leydon Hall' (Beckett VI 1968, p.46). Now a school, it is known as 'Leadenhall' to both the occupants and the Chapter. It seems more logical and less confusing to adopt the original and present day spelling.

Constable lists no.137, 'your house from the meadows', among the sketches that, on his return to London, he told Fisher had been 'much liked' (ibid., p.56). One of the most scintillating of his 1820 oils, when Johnny Dunthorne copied no.137 in 1827, Constable described the copy as 'a very pretty picture of Your Lawn & prebendal House, with the great Alder & Cathedral' (ibid., p.232). From an examination of the paintwork on the strips attached to the three sides of the canvas, it appears that the composition was enlarged after the original sketch was painted. There are many instances of this need of Constable's to increase the size of a painting or drawing at some stage.

When faced with oil sketches by Constable such as no.137, with its confident play along the tonal scale, one wonders to what extent he owed his mastery of tonal intervals to the way he organised the mixes on his palette. Not a lot seems to be known about artists' management of their palettes, but the degree of spontaneity evident in this work renders it improbable that, like some painters, he pre-mixed a range of colours with his knife before commencing. Rather, one imagines, he was a painter who mixed each tone and colour on the palette as it was required. Most of no.137 is in either a high or low key, with the warm brown of the canvas priming playing a medial part – middle C, as it were. It will be noted that many of the accents and details – the little anchor on the bank by the boat, for example – were touched in with a rich black, and indeed the greater part is dark in tone. Yet one of the most striking features of the work is the brilliance of the light that illuminates the scene.

As so often with Constable's sketches from nature, the figures arouse one's curiosity. Particularly so in this case as only members of Fisher's household or his circle and Constable's own family – Maria and her two children, John and Minna, aged two-and-a-half and one – would have had the use of the Leadenhall garden. Is that Fisher, in black, nearest the house? Or is he the figure on the bank just above the stern of the little boat? And was that Maria on the seat under the great alder, waiting for her husband to finish his sketch and be ferried back across the river?

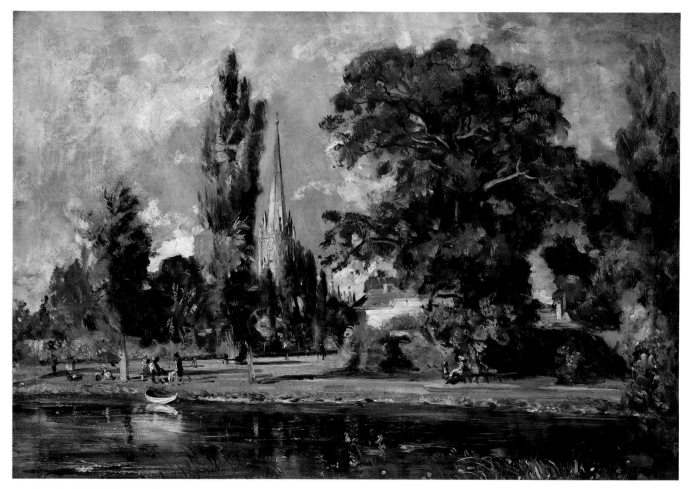

137 (see also detail facing p.245)

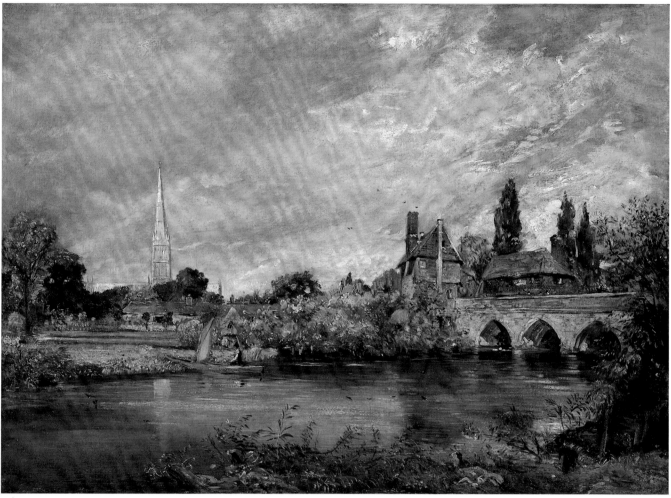

138

138 Harnham Bridge 1820

Oil on canvas 560 × 775 (22 × 30½)
PROV: . . .; E.M. Denny 1904, sold Christie's
31 March 1906 (5) bt Knoedler; private
collection, USA until 1936 when bt by
Knoedler and from them by Leggatt, who
sold it to Sir Julius Wernher (died 1973); by
descent to present owner
LIT: Hoozee 1979, no.283, repr.; Reynolds
1984, no.20.54, pl.175

Private Collection

Hitherto thought to be painted on paper, no.138
was examined in the Tate Gallery Conservation
Department in April 1991 and found to be on can-
vas. It is very close to a drawing of the subject in the
British Museum (no.297) – closer than the view of
Salisbury (no.134) is to its companion pencil study
(no.293) – and this naturally raises the question as
to whether it was painted in front of the motif,
partly so, or entirely in the studio. The work is
unusual also because Constable has chosen to paint
the scene in the middle of the day with the sun high
and behind his back. Noon was a time he liked to
depict ('The Hay-Wain' it will be recalled, was

titled 'Landscape: Noon' when it was first exhi-
bited), but he normally painted into the sun, or
with the source of illumination to one side, so that
there were strong shadows into which he could
paint his lights. In 'Harnham Bridge', with the sun
behind him, many of the forms were only rimmed
with shadow and in appearance the work is
consequently somewhat flattened, like an interior
photographed by flashlight. It was probably this
unusual character that in the past led to the
authenticity of the work being questioned. In the
view of the present authors the quality of the
painting speaks for itself. Only Constable, for
example, could have painted that foreground at the
water's edge.

Although much of no.138 could have been taken
from the drawing (no.297), there is enough infor-
mation in it that the pencil sketch could not have
supplied to suggest that for some of the time at least
Constable worked on the canvas in front of the
motif. The boat and its occupant could have been
painted from memory, but the man at work on the
roof of the cottage, the woman on the bank by the
bridge and the figures on the bridge look much
more like the spontaneous snapshots of the living
world Constable was so adept at taking. It is

possible that the entire work was painted on the river bank; also that it was one of the sketches of bridges that Constable had taken back to London where they had been 'much liked' (Beckett VI 1968, p.56).

Harnham Bridge, or Ayleswade Bridge, as it was originally called (and is being called again, now that there is a modern bridge over the river down-stream), was built by Bishop Bingham, *c.*1240, to span the river Avon south of the city. Built at a point where the river is divided by an eyot into two channels, the bridge spans the northern channel with three arches and the southern, wider channel with a span of six, two-centred arches. Originally some seventeen feet in width, in 1774 it was widened over the existing cut-waters by a further six feet. In Constable's painting we see part of the bridge over the wider, southern channel. The other bridge features in some of his drawings – e.g. Reynolds 1984, nos.27.45, 29.29, and 29.30.

An interesting painting of Harnham Bridge from downstream on a canvas of almost exactly the same dimensions (546×775 mm) was included in the Salander-O'Reilly Galleries Constable exhibition in 1988 (New York 1988, no.26, repr. in col.). This was attributed to Constable himself. He may have lent a hand with parts of the bridge and cottage, but the remainder, the greater part, is unlikely to have been painted by him. John Fisher always had canvas and paints ready for Constable's use when he came to stay, but so far none of his own oil paintings has been indentified. This could be one of his.

139 Salisbury Cathedral from the Bishop's Grounds 1820

Oil on canvas 743×924 ($29\frac{1}{4} \times 36\frac{3}{8}$)
PROV: ?Artist's administrators, sold Foster 16 May 1838 (in 12, 'Two – Salisbury Cathedral, *study for the finished picture*, and Helmington [Helmingham] Park') bt John Allnutt, who died 1863; . . .; Louis Huth by 1884, sold Christie's 20 May 1905 (38) bt Colnaghi; . . .; Col. O.H. Payne, New York, by whom given to L.C.Ledyard; . . .; Agnew 1976, from whom bt the same year by the National Gallery of Canada
EXH: New York 1983 (31, repr. in col.)
LIT: Reynolds 1977, repr. in col. with col. detail on cover and composite x-radiograph, fig.10; Hoozee 1979, no.367, repr.; Reynolds 1981, pp.133, 137–8, 140–2, figs.30 (col.), 37 (composite x-radiograph); Reynolds 1984, no.20.50, pl.172 (col.); Boulton 1984, pp.33, 35–6, ill.9; Cormack 1986, pp.120, 124, pl.117

National Gallery of Canada, Ottawa/ Musée des beaux-arts du Canada, Ottawa

Although John Fisher had become Constable's most valued friend, the artist had known Dr Fisher – 'the Good Bishop', as he so often called him – much longer. In their exchanges by letter, Constable and John Fisher found much in the Bishop's habits and conversation with which to amuse themselves and their patron could at times be downright tiresome. Particularly burdensome for Constable were the Bishop's demands on behalf of his daughter, Dorothea, whom Constable had taken on as a pupil. But over the years, Dr Fisher had proved a loyal and steadfast friend and among Constable's very few patrons, none had taken a livelier interest in his work. After his stay at the palace in 1811 he was able to tell Maria of the great kindness, 'I may almost say affection', that the Bishop and his wife showed and for so long had showed him (Beckett II 1964, p.50). It should perhaps also be remembered that if the Bishop had not commissioned the view of 'our Cathedral [as he called it] from my Garden near the Canal' (Beckett VI 1968, p.101), it is unlikely that the picture, no.140, one of the artist's best-known images, would ever have been painted.

The preceding sketch for this work was an oil painted direct from nature – no.139. During his stay at Salisbury in 1820 it is unlikely that Constable would have been allowed to spend all his time with the Leadenhall Fishers. There would have been dinner invitations from the Bishop's wife, requests for painting lessons from Dorothea and a certain amount of general to-ing and fro-ing among the Fisher families and their guests. Constable painted a small oil of the cathedral from the palace front drive (Reynolds 1973, no.196). He was still in the Bishop's garden when he chose to begin a much larger upright of the cathedral. This was taken from the same angle that he chose for no.139, but it is not possible to judge whether it was from the same spot as the work is now only visible by x-radiography. For, some little time later during that visit, when the paint had dried sufficiently, Constable turned the painting the other way up and with the canvas as a 'landscape' (i.e. with the greater dimension horizontal), over his initial attempt at the cathedral from this view he painted another, the present work, no.139.

One of the three black and white chalk drawings on grey paper that Constable is known to have done on his first visit to Salisbury in 1811 is a view of the cathedral from almost the same spot. In this drawing (fig.72, Victoria and Albert Museum, Reynolds 1973, no.105), Constable included the same tree hanging over the water on the left and the lower part of the elm beside it, but there is otherwise no hint of the inspired, primary theme of the painting, the great church in dazzling light seen through the over-arching trees. When he made his drawing, somewhat inconveniently for a satis-factory view of the cathedral, close by the building there stood a broad-spreading tree, which, in 1811, Constable faithfully recorded. This is not to be seen in the painting, no.139; or is it not? Sue Boulton (1984) has pointed out that the outline of

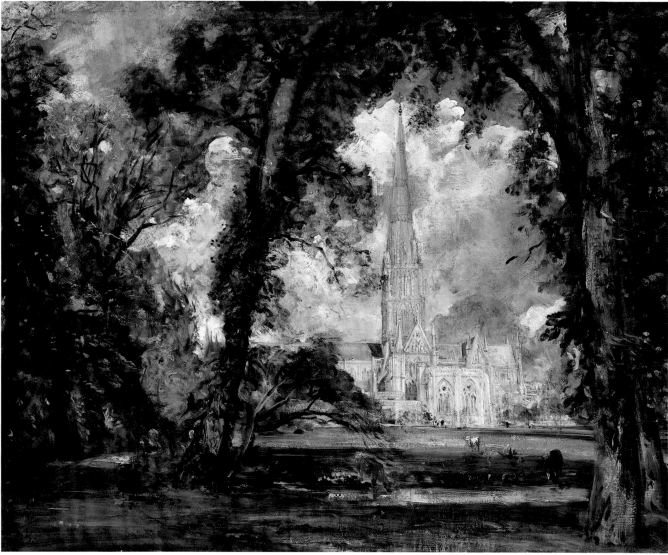

139

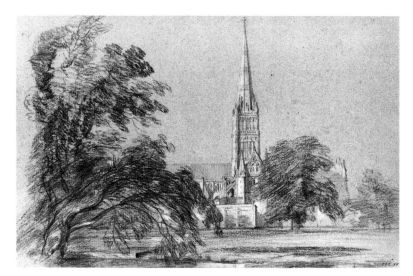

fig.72 'Salisbury Cathedral
from the South-West', 1811,
*Board of Trustees of the Victoria
and Albert Museum, London*

the dark cloud immediately above the chancel roof
follows suspiciously closely the shape of the top of
the tree in the drawing. Was not the tree, she asks,
originally painted in and, maybe at some later date,
overpainted, replaced with what lay behind, the
chapter house and the rest of the main building?
This, to the present authors, seems highly likely
and the results will be discussed in the entry for
no.140, the exhibited version of the subject.

This sketch of the cathedral from the Bishop's
garden (no.139) is clearly a work painted in front of
the motif. The drawing of 1811 (fig.72) could have
brought him again to the same spot, but what, one
wonders, was at the back of his mind that caused
him to look up high above and decide to bring the
great arboreal archway overhead into his compo-
sition. Had he in mind the shafted and ribbed
interior of the cathedral itself? Or could the
response have stemmed from Watteau, from a
painting such as 'The Ball' at Dulwich with its
baroque arcading framing a vista of tall trees
around a fountain, a painting, he said, that looked

'as if painted in honey – so mellow – so tender – so soft & so delicious' (Beckett III 1965, p.41)?

Fisher forwarded a letter on 3 August, shortly after Constable's departure, and in an accompanying note told him that he had left 'a very fine impression on the Salisbury world'. Constable replied by return. 'We had', he said, 'a pleasant journey to London – in truth we were all made far more fit for such an exertion by the unbounded kindness and hospitality of yourself and Mrs. Fisher – & our good friends at the palace – indeed my dear Fisher my wife & myself feel quite at a loss how to speak to you of those things'. 'My Salisbury sketches', he went on, 'are much liked – that in the palace grounds [no.139] – the bridges [no.138] – & your house from the meadows [no.137] – the moat – &c.' (Beckett VI 1968, pp.55–6).

140 Salisbury Cathedral from the Bishop's Grounds 1822–3, exh.1823

Oil on canvas 876 × 1118 (34½ × 44)
Inscribed indistinctly 'John Constable [? ARA London 1823]' b.l. (see Reynolds 1984 for alternative readings) and 'Salisbury Cathedral – from the Bishop's Grounds, John Constable. 35 Upper Charlotte Street Fitzroy Square' on a label on the stretcher
PROV: Painted for Dr John Fisher, Bishop of Salisbury; John Fisher, Archdeacon of Berkshire; bt back by Constable 1829; artist's administrators, sold Foster 16 May 1838 (72, 'Salisbury Cathedral, *from the Bishop's Garden Exhibited* 1823') bt Tiffin, presumably for John Sheepshanks, by whom presented to the South Kensington (later Victoria and Albert) Museum 1857
EXH: RA 1823 (59, 'Salisbury Cathedral, from the Bishop's grounds'); BI 1824 (46, same title, frame size incorrectly given as 36 × 57 in); Worcester Institution 1834 (26, same title); Tate Gallery 1976 (216, repr.)
LIT: Reynolds 1973, no.254, pl.192; Reynolds 1977, pp.22–3, 28, fig.11; Hoozee 1979, no.366, repr.; Reynolds 1981, pp.140–2, fig.33; Rosenthal 1983, pp.143–6, fig.183; Reynolds 1984, no.23.1, pl.393 (col.); Boulton 1984, pp.34–6, ill.10; Cormack 1986, pp.120–4, pl.119

Board of Trustees of the Victoria and Albert Museum, London

Although on a smaller scale than big set-pieces such as 'The Hay-Wain' or 'Stratford Mill', no.140, 'Salisbury Cathedral from the Bishop's Grounds', Constable's main exhibit in 1823, must surely rank as one of his major works. We know that in cash terms the artist himself valued it on an equal footing with a much larger painting, 'The White Horse'.

It has been suggested (Beckett VI 1968, p.57) that Dr Fisher, the Bishop, had commissioned the work before Constable returned to London in August 1820. But there is no suggestion that he had in a note written by the Bishop's daughter, Dorothea, franked 8 October 1820: 'Papa desires me to say', she wrote, 'he hopes you will finish for the Exhibition the view you took from our Garden of the Cathedral by the water-side, as well as Waterloo Bridge' (ibid., p.58). While this is the first mention as such of the 'Waterloo Bridge', the painting Constable was to struggle with for the next eleven years, from the note we learn only that the Bishop regarded Constable's view from the palace grounds (no.139) merely as the start of a painting that he would like to see eventually hanging in the annual exhibition at Somerset House. It may have been after a visit in May 1822 to Constable's studio in the artist's absence, when, as Maria told her husband, the Bishop 'rummaged out the Salisbury & wanted to know what you had done ' (Beckett II 1964, p.276), that Dr Fisher made up his mind and gave Constable a firm order for a finished painting of the subject. By November it appears that Constable had agreed to paint a picture of this view. He had planned a second visit to Osmington in the autumn and may have intended to break his journey at Salisbury, but pressure of work had prevented him from leaving London. 'We are all disappointed at not seeing you here at this time', the Bishop wrote on 4 November, 'I am particularly so, because I was in hopes you would have taken another *peep* or *two* at the view of our Cathedral from my Garden near the Canal ⟨...⟩ But perhaps you retain enough of it in your memory to finish the Picture which I shall hope will be ready to grace my Drawing Room in London' (Beckett VI 1968, pp.101–2). In his reply Constable must have said that he was at work on the picture. 'I received yours this morning', the Bishop wrote, 'I am glad that you are about your View of Sarum for me' (ibid.). On 12 November, as an earnest, the Bishop sent Constable a draft with a note: 'Lawyers frequently receive retaining fees, why should not painters do the same?' (Leslie 1843, p.33, 1951, p.95). Fisher wrote that same day, recommending Constable 'to get on with the Bishops picture. He is quite eager about it. He asked me last night whether I thought he should affront you by sending you part of your price. I replied that I was of the opinion he would *not* offend you: as Sir T. Lawrence himself took earnest money' (Beckett VI 1968, p.103). A few days later he wrote to say that 'the palace party do nothing but talk of your picture that is coming. Put in some niggle to please the good people' (ibid., p.105).

The completion of the painting was delayed by illness – 'they took a good deal of blood away from me which I could ill spare' (ibid., p.112) – and when Constable wrote to Fisher on 1 February

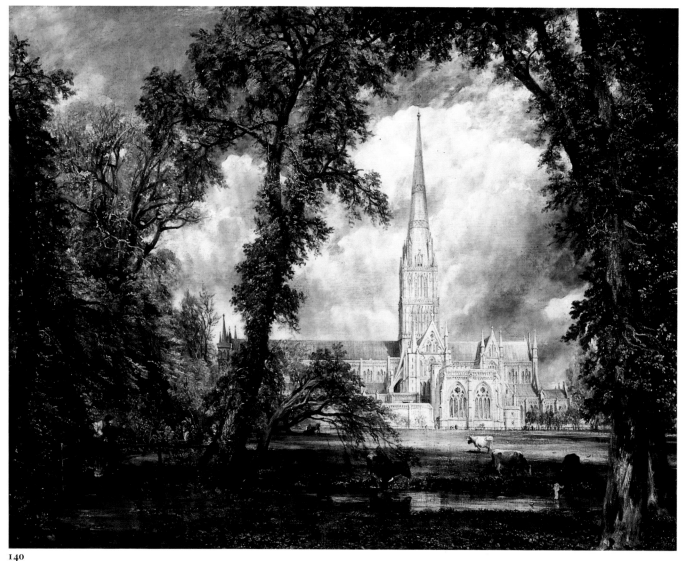

140

1823 he said he had not seen the face of his easel since Christmas. 'It is not the least of my anxiety that the good Bishop's picture is not fit to be seen. Pray my dear Fisher prepare his Lordship for this' (ibid., p.109). Constable had planned to have a large upright landscape for the Academy, but in the event the cathedral from the Bishop's grounds was his main work in the exhibition that year. From the following, in a letter to Fisher of 9 May, one gathers that he was not displeased with the picture when he saw it at Somerset House. 'My Cathedral looks very well. indeed I got through that job uncommonly well considering how much I dreaded it. it is much approved by the Academy and moreover in Seymour St. [the Bishop's London residence] though I was at one time fearfull it would not be a favorite there owing to a *dark cloud* ... It was the most difficult subject in Landscape I ever had upon my Easil. I have not flinched at the work. of the windows, buttresses, &c – &c – but I have as usual made my escape in the Evanescence of the Chiaro-

Oscuro'. Callcott admired the painting; Fuseli, too: 'I like de Landscape of Constable – but he makes me call for my great coat' (ibid., pp.115–16). 'Constable has put the Bishop & Mrs F as figures in his ⟨...⟩ view very like & characteristic', Fisher told his wife after a visit to the exhibition (ibid., p.120). The painting received a mixed reception in the press. The *Examiner* (25 June) considered the Salisbury to be so pre-eminent in 'that "prime cheerer, light" that were many of the other landscapes similar, the mind would not be so conscious of the real over the mimic light on entering into the open air from an Exhibition room'. The *London Magazine* for June thought the cathedral of insufficient magnitude, found 'great merit in the picture', but could not refrain from a sly comment: 'The landscape and cows are extremely well managed; and speak of that rich fat country ever to be found about the church'. With reference to the cattle, Leslie (1843, p.33, 1951, p.96) has a revealing but frequently ignored

observation to make, pointing out that in the foreground Constable has introduced 'a circumstance familiar to all who are in the habit of noticing cattle. With cows there is generally, if not always, one which is called, not very accurately, *the master cow*, and there is scarcely anything the rest of the herd will venture to do until the *master* has taken the lead. On the left of the picture this individual is drinking, and turns with surprise and jealousy to another cow approaching the canal lower down for the same purpose'. He also makes the point that Constable almost always depicts the Suffolk breed, without horns.

While retaining and only slightly refining the composition of the smaller, original sketch (no.139) – basically an inversion of the Claudean balance of unequal masses – in the exhibited work (no.140) Constable made a number of alterations and additions. In the sketch, both cows at the water's edge are drinking; for the painting, according to Leslie, he concocted the little incident of bovine jealousy – compositionally an improvement. He introduced figures and the fence and gate on the left: the Bishop pausing just inside his grounds to draw his wife's attention (and ours, too) to the sunlit building, and coming to meet them, presumably, their daughter Dorothea, Constable's pupil. For the finished painting, a commissioned work, one should perhaps remember, for the proprietorially-minded Bishop, it was necessary that Constable should render a detailed account of the cathedral and, indeed, he has not flinched 'at the work. of the windows, buttresses, &c'. As was his wont, he has slightly increased the ratio of height to width of the tower and spire and by introducing the shadow of a passing cloud over the spire has drawn it upwards still further. Constable had drawings to refer to for most of the building, but (as has been explained in the entry for no.139) nothing to help him with the chapter house. Here, as Sue Boulton has pointed out (1984, p.35), he was less successful, failing altogether to appreciate its true form, a three-dimensional octagon in perspective.

In August, after the exhibition, the Bishop commissioned a repeat on a smaller scale of no.140, to be a wedding present for his other daughter, Elizabeth. In this, he said, he wished to have 'a more serene sky' (Beckett VI 1968, p.125), for he was not happy about the sky in his own picture. If Constable, he told his nephew, 'would but leave out his black clouds! Clouds are only black when it is going to rain. In fine weather the sky is blue' (16 Oct. 1823, ibid., p.138).

Constable was aware of the Bishop's dissatisfaction with his picture. When he told Fisher that he had hung up the 'bridal Picture' in Seymour Street to greet the bride, he said 'It will be better liked than the larger one, because it is "not too good"'.

In January 1824 he sent the painting for exhibition to the British Institution, where it received a few favourable notices, though the *European Magazine* (March, p.271) wished it looked like ivory among emeralds and 'a little less like *porcelain*'. Shortly after it was returned to its owner, on 25 June, Constable called on the Bishop 'by his wish. He had to tell me that he thought of my improving the picture of the Cathedral, and mentioned many things. – "He hoped I would not take his observations amiss". I said, "quite the contrary, as his lordship had been my kind monitor for twenty-five years". I am to have it home tomorrow' (Beckett II 1964, p.344). Rather than meet his patron's criticisms by repainting the sky in no.140, Constable decided to paint another replica (much as he did for Allnutt with 'Ploughing Scene in Suffolk', no.71). 'Johnny' [Dunthorne], he told Maria on 12 July 'has done a delightfull outline of my Cathedral same size for me to copy' (ibid., p.360). Besides a sunnier sky, in this version (Frick Collection, New York, Reynolds 1984, no.26.18, pl.628), instead of forming an over-arching canopy, the trees were moved apart at the top into two entirely separate groups and thinned out – not a compositional improvement. If these changes were designed to meet the Bishop's wishes, it is unlikely that his patron saw the results as Dr Fisher died on 8 May 1825 and it was to his widow that the picture was finally sent. It was probably yet another version of no.140 (Metropolitan Museum, New York, Reynolds 1984, no.26.19, pl.629) that Constable offered to Fisher in a letter of 12 November 1825: 'I have nearly compleated a second Cathedral which I think you will (perhaps) prefer to the first but I will send them both to Salisbury for your inspection if you like' (Beckett VI 1968, pp.206–7). Fisher apparently decided to buy no.140 and on 1 July 1826 reported its arrival. 'The two pictures arrived safe on Friday, & within an hour were up in their places; the white horse [that had been on exhibition in Lille] looking very placid & not as if just returned from the continent. It is wonderfully improved by Dunthorne's coat of varnish. The Cathedral looks splendidly over the chimney peice. The picture requires a room full of light. Its internal splendour comes out in all its power, & the spire sails away with the thunder-clouds. The only criticism I pass on it, is, that ⟨...⟩ it does not go *out* well with the day. The light is of an unpleasant shape by dusk. I am aware how severe a remark I have made' (ibid., pp.221–2). Severe, perhaps, but a very perceptive one.

Fisher was only able to keep the 'Cathedral' and 'The White Horse' for some three years. With six children he found he could not 'afford to retain such valuable luxuries' (29 Dec. 1829, ibid., p.255). Constable bought the pair back for £200 and they remained under his roof until they left for the sale at Foster's in 1838.

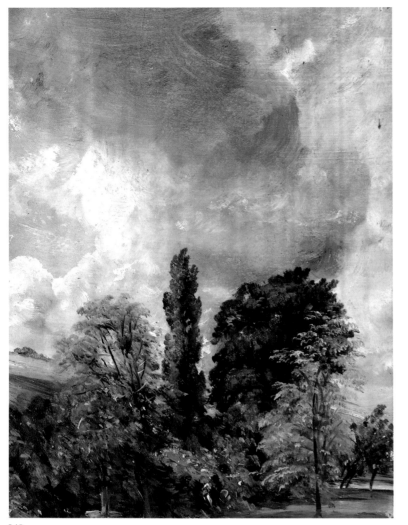

141

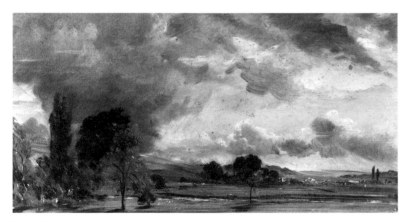

fig.73 'View at Salisbury
from Fisher's Library',
1829, *Board of Trustees of
the Victoria and Albert
Museum, London*

141 Harnham Ridge from Leadenhall 1829

Oil on paper 264 × 203 ($10\frac{3}{8}$ × 8)
Inscribed in pencil on the back 'Close|– 15
July – 1829|11 0 clock noon –|Wind S.W. –
very fine', repeated in ink
PROV: As for no.2
LIT: Reynolds 1973, no.312, pl.231; Hoozee
1979, no.506, pl.LX (col.).; Parris 1981,
p.138; Reynolds 1984, no.29.15, pl.715 (col.)

*Board of Trustees of the Victoria and Albert
Museum, London*

See no.142

142 Harnham Ridge ?1829

Oil on paper laid on canvas 196 × 250
($7\frac{3}{4}$ × $9\frac{7}{8}$)
PROV:...; Leggatt, from whom bt by present
owner 1958
EXH: New York 1988 (18, repr. in col.)
LIT: Reynolds 1984, no.29.39, pl.739

Private Collection, New York

Constable stayed with John Fisher at Salisbury
twice in 1829, in July for about three weeks and in
the autumn, possibly for rather longer (see the
entries for nos.207, 209). Apart from his work for
the Academy, about which he had felt 'greviously
nervous', as, he told Leslie, he was still smarting
under his election (Beckett III 1965, p.20),
Constable is only recorded as having made one
drawing (or painting) that year, a copy of an etching
by Swanevelt of nymphs and satyrs, before the first
of his Salisbury visits. Maria's death and the
ensuing cares had taken their toll and, seemingly, it
required John and Mary Fisher's warmth and
affection, as well as the sight of the familiar scenes
around Leadenhall, to awake in him a real desire to
draw and paint again.

No.141 and another sketch taken from Fisher's
house (fig.73, Victoria and Albert Museum, Rey-
nolds 1984, no.29.14) are the only two dated oils
that Constable is known to have made on this first
trip in 1829. He painted others, but sometimes it is
not easy to decide which of the several Harnham
views were painted in 1820 and which belong to
1829. No.142 is a likelier candidate for the second,
rather than for the first of the two visits. The
brushwork in the sky is closer to the handling in the
two dated works than to any that he appears to have
done in 1820. The flicks of near white and the
brittle look are also more characteristic of the later
date.

The poplar and the great alder seen in no.141

[261]

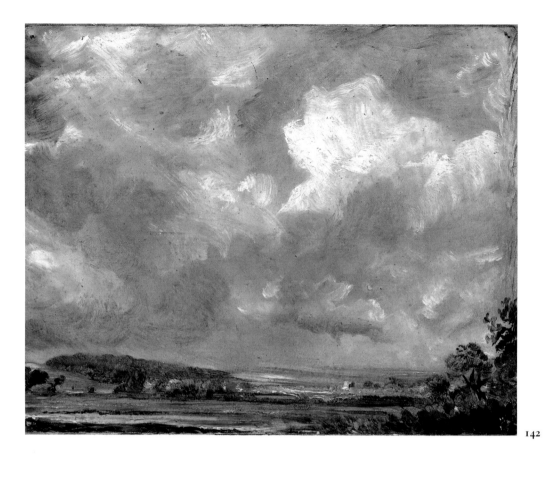

142

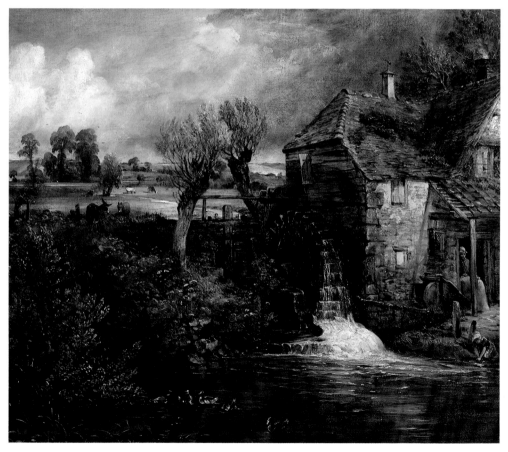

143

near the river-path in the Leadenhall garden appear to have had a special appeal for Constable. By the taller of the two, was he reminded of another poplar, a tree he knew so well and had often drawn and painted, that had risen like a steeple from beside the family home at East Bergholt?

143 Gillingham Mill 1826, exh.1826

Oil on canvas 500 × 605 (19¾ × 23¾)
PROV: Painted for Mrs Hand 1826, sold Christie's 12 June 1847 (54) bt Vokins; . . .; Lewis Fry, Bristol by 1882 and until at least 1889; . . .; C.A. Barton, sold Christie's 3 May 1902 (5) bt Falke; . . .; S.B. Joel, sold Knight, Frank & Rutley 8 Dec. 1931 (268) bt Vicars for Sir Bernard Eckstein, sold Christie's 8 Dec. 1948 (65) bt Vicars; . . .; W.L. Lewis, New York; . . .; J.S. Maas, from whom bt by Mr and Mrs Paul Mellon 1962 and given to the Yale Center 1981 (B1981.25.133)
EXH: RA 1826 (122, 'A mill at Gillingham, in Dorsetshire'); BI 1827 (321, 'A Mill at Gillingham, Dorset', frame 30 × 34 in); Tate Gallery 1976 (243, repr.); New Haven 1982–3 (v.13, repr.); Bloomington and Chicago 1988 (219, repr, in col.)
LIT: Hoozee 1979, no.465, repr.; Reynolds 1984, no.26.4, pl.620 (col.); Cormack 1986, pp.148, 179, pl.148 (col.)

Yale Center for British Art, Paul Mellon Collection

Constable had paid a short visit with Fisher to Gillingham in 1820 (see no.298). His second visit, of 1823, had been planned for some time. In February of that year Fisher had written from Osmington to say that when he was settled at Gillingham there would be 'always a bed & painting room for you there' (Beckett VI 1968, p.110) and on 9 May Constable had expressed a wish to see him at Gillingham: 'I want to do something at that famous Mill. a mile or two off' (ibid., p.116). Constable and the Archdeacon finally met at Salisbury on 19 August and travelled together to Gillingham on the 22nd (see no.306). He returned to London two and a half weeks later. He was able to do little outside for the first few days. 'We are sadly off for weather', he told Maria on the 24th, 'I can do nothing hardly – the Mills are pretty. and one of them wonderfully old and romantic'. In the same letter Constable told his wife that he had received a commission for two upright landscapes from Fisher's solicitor friend, J.P. Tinney, 'a nice winter employment' (Beckett II 1964, pp.282–3). The weather continued troublesome and he was unable to do much 'in the sketching way', but the skies cleared by 5 Sep-

tember and he was then able to report to Maria that he had 'done something from one of the Old Mills which you will like'. This, in all likelihood, was the small, 10 by 12 inch painting (Reynolds 1984, no.23.22, pl.411) only known from photographs since its theft from Lord Binning's collection. From this sketch, in 1824, Constable painted a slightly larger picture of the mill for Fisher. With the introduction of a rainbow, perhaps a reminder of the fine weather at Gillingham that followed the foul, this painting, now in the Fitzwilliam Museum (ibid., no.24.4, pl.481), is an almost exact copy of the original.

No.143 was another commissioned work, this time for a Mrs Hand of whom little is known though she seems to have been a near resident. She is mentioned in passing a couple of times in the journal Constable kept in 1824 while his wife was in Brighton. Mrs Hand tells him that 'Owen [William, RA] always speaks so very highly of me, in every way, that it is quite delightfull' (Beckett II 1964, p.344); he sends her some of their yeast, that 'turned out beautifull' (ibid., p.346); and then on 15 July Mrs Hand calls to say that 'she is anxious about a small picture of mine of the Gillingham Mill' (ibid., p.362). Presumably she had seen one of the first two versions and had asked him for one for herself. Constable was unable to oblige for some eighteen months, but eventually managed to execute the commission during one of his stays at Brighton. This he reported to Fisher (14 Jan. 1825, Beckett VI 1968, p.212). 'I staid a fortnight with them [i.e. his family] & did there one of my best pictures – the subject was the Mill (Perne's) at Gillingham – it is about 2 feet, and is so very rich & pleasing that if you are at Salisbury and would like to see it, I will beg the proprietor Mrs Hand (a friend of the Chancellor's) to let me send it to you – *Mere* church is in the distance.' (Beckett has suggested that by 'the Chancellor' Constable meant the Revd Matthew Marsh, Chancellor of the Diocese of Salisbury, but there is no reason for supposing Mrs Hand had any Salisbury connections.)

Constable made a number of improvements and additions when he painted the picture for Mrs Hand. The canvas was nearly twice the size of the other two. Besides Mere church in the distance near the left-hand edge, he added a young willow in the bottom left-hand corner, two donkeys and the ducks. He redesigned the roof of the mill, putting in a new gable and window and a smoking chimney. Besides these additions he rendered the whole building and the structures around it, with the figures, more credible, explaining in full the structure of the masonry, the tiling and timber-work. With 'The Cornfield' and titled 'A mill at Gillingham, in Dorsetshire', Constable sent no.143 as his only other exhibit to the Academy of 1826. The former received several notices; the latter only the following in the *Gentleman's Magazine* for May (vol.96, pt.1, p.443): 'Amongst the landscapes is a Well [!] at Gillingham, by Constable, of good execution, but wanting effect.'

144

144 Gillingham Mill ?1823–7, exh.1827

Oil on canvas 630 × 520 ($24\frac{3}{4}$ × $20\frac{1}{2}$)
A label formerly on the back is inscribed, possibly in the artist's hand, '[?105] The Water Mill John Constable R.A.'; another, in a different hand, reads 'An undershot water-mill at Gillingham – worked by a branch of the stream from Stourhead'
PROV: Artist's administrators, sold Foster 16 May 1838 (57, 'Gillingham Mill, Dorsetshire') bt in by C.R. Leslie; by descent to Isabel Constable and bequeathed by her to the South Kensington (later Victoria and Albert) Museum 1888 as the gift of Maria Louisa, Isabel and Lionel Bicknell Constable
EXH: RA 1827 (48, 'Mill, Gillingham, Dorset'); probably Birmingham Institution 1828 (31, 'Mill at Gillingham, Dorset'); Worcester Institution 1835 (68, 'A Water Mill'); Tate Gallery 1976 (246, repr.)
LIT: Reynolds 1973, no.288, pl.219; Hoozee 1979, no.479, repr.; Reynolds 1984, no.27.5, pl.645 (col.)

Board of Trustees of the Victoria and Albert Museum, London

All three of the paintings discussed in the entry for no.143 were of the mill at Gillingham owned by Matthew Parham (but known at Perne's Mill) as seen from the same viewpoint. No.144 presents the mill from a new angle, close to the waterside and nearer to the wheel. One of the finest of Constable's landscape 'still lives', it is a work very different in character from the other three and one wonders whether a painting so full of information about natural forms could have been painted anywhere but directly from the motif.

In the letter to Fisher at Gillingham dated 30 September 1823, written after his return to London from Dorset, Constable reported on the reception his work received. 'My Gillingham studies', he wrote, 'give great satisfaction. Old Bigg [William Redmore, RA] likes them better than any I have yet done' (Beckett VI 1968, p.133). The only two works he is known to have done on this trip are the little Binning oil sketch of the mill and the Tate Gallery's 'Gillingham Bridge' (Parris 1981, no.25, repr. in col., Reynolds 1984, no.23.20, pl.408). It would seem reasonable to suppose that Bigg's enthusiasm was aroused by the sight of more than just these two, and that no.144, not necessary in a finished state, was one of the studies that had pleased the old Academician.

There would have been a reason for making a detailed study such as this of the mill and the luxuriant growth on the bank on an upright canvas. While breaking his journey to Gillingham at Salisbury in 1823, Constable had had a talk with Fisher's friend, the lawyer John Pern Tinney, to whom, in gratitude for his professional services, the Archdeacon had presented Constable's 'Stratford Mill' (no.100). 'Tinny is most kind and friendly', Constable had told his wife in his letter of 20 August, 'and wants 2 Landscapes the size of the Cathedral – upright – at 50 Gns Each' (Beckett II 1964, pp.281–2). This news he repeated in his next letter, written on the 24th from Gillingham. 'I am to paint two upright landscapes for tinney – the size of the Cathedral – at 50 gs each' (ibid., p.283). Tinney had a special interest in the mill as it had at one time belonged to an ancestor, presumably the Perne after whom the lawyer had been named. At Gillingham, Fisher would as usual have been able to provide Constable with the painting materials he needed, but it is doubtful whether he would have had a canvas the size of 'the Cathedral', i.e. the 'Salisbury Cathedral from the Bishop's Grounds' that had been shown at that year's Academy (no.140). In lieu of a 44-inch canvas, Constable may therefore have painted no.144, on a smaller canvas, much as he had the oil sketches of 1817, summarily brushing in the whole and studying closely only parts of it, the purpose being to collect the information he required for a larger canvas. There may, of course, have been another sketch made on the spot from which this was painted, as Reynolds suggests (1984), but while there are parts in the painting that could well have been executed in the studio, in few of Constable's reconstructed scenes do we find grass and leaf forms rendered with such a high degree of fidelity, and so much else of the work seems to bear the hallmark of direct observation.

Constable's eventual inability to comply with Tinney's well-meaning request for the two uprights, one of his ancestor's mill, the other of Salisbury (Beckett VI 1968, p.160), is one of the more puzzling episodes in the career of this sometimes so unexpectedly quixotic artist. A passage in a letter to Fisher of 17 November 1824 brings the story to a close. 'I am now free & independent of Tinney's kind & friendly commissions – these things only harrass me – You know my disposition, is this – in my seeming meakness – if I was bound with chains I would break them – and – if I felt a single hair round me I should feel uncomfortable' (ibid., p.182). Earlier in 1824, when at work on 'The Lock' (no.158) for the Academy, Constable had told Fisher that he was hoping 'for one of Tinney's new ones' (ibid., p.150), that is, for one of the uprights the lawyer had asked for. But this idea, with the commission, fell through and we have no inkling as to how it came about that Constable finally had two such highly finished works ready for the Academy in 1827 – no.144 and 'Chain Pier, Brighton', no.156.

Brighton

By the spring of 1824 it had become apparent that Maria Constable needed more than Hampstead air to restore her health: 'this warm weather has hurt her a good deal,' Constable wrote to Fisher on 8 May, 'and we are told we must try the sea – on Thursday I shall send them to Brighton' (Beckett VI 1968, p.157). As Beckett suggested (II 1964, p.309), Brighton was probably chosen because Maria already knew the place a little and because there was now a good coach service between London and the resort, enabling Constable to join his family there whenever his work permitted. Having settled Maria, their four children and their maid and nurse in a house at the west end of the town (near the present Sillwood Street and close to the beach), Constable returned to London on 19 May. He went back to Brighton in June (see nos.145–6) and July, remaining then until October (see no.147). Maria was again at Brighton from the end of August 1825 to January 1826, at a house in Russell Square, and again in June and July 1828. As before, Constable joined her whenever he could.

The Constables were in Brighton during some of the busiest years of its development as a fashionable seaside resort. John Nash had recently finished remodelling the Royal Pavilion for George IV. The Chain Pier, built partly to provide a berth for the Dieppe ferries, opened in November 1823, the first of the big hotels, the York, in 1819, the second, the Albion, in 1826. Work on the fashionable residential estate, Kemp Town, also began in 1823. At the same time Brighton remained a fishing town, its beach a work place and market for the fishermen but also used by the coal industry (see no.147). This was all a far cry from peaceful Osmington, where the Constables had spent their honeymoon and where John had started painting beach scenes (see nos.81–2, 84–5). He poured out his feelings about Brighton in a now celebrated letter to Fisher in August 1824:

> Brighton is the receptacle of the fashion and offscouring of London. The magnificence of the sea, and its (to use your own beautifull expression) everlasting voice. is drowned in the din & lost in the tumult of stage coaches – gigs – 'flys' &c. – and the beach is only piccadilly . . . by the sea-side – Ladies dressed & *undressed* – Gentlemen in morning gowns & slippers on or without them altogether about *knee deep* in the breakers – footmen – children – nursery maids. dogs. boys. fishermen – *preventive service men* (with hangers & pistols). rotten fish & those hideous amphibious animals the old bathing women, whose language both in oaths & voice resembles men – all are mixed up together in endless & indecent confusion – the genteeler part the marine parade is still more unnatural – with its trimed and neat appearance & the dandy jetty or chain pier – with its long & elegant strids into the sea a full $\frac{1}{4}$ of a mile in short there is nothing here for a painter but the breakers – & the sky – which have been lovely indeed and always [?various].
>
> (Beckett VI 1968, p.171)

The oil sketches (see the following examples) and drawings (e.g. nos.309–12, 318–22)

that Constable made at Brighton suggest that his account was not intended to be entirely serious. His fascination with the bustling life of the beach, and not least with the fishermen and their boats, is obvious enough. His one major painting of a Brighton subject (no.156) combines the activities of the beach with a distant view of Marine Parade and the 'dandy jetty'.

145

145 **Brighton Beach with a Fishing Boat** 1824

Oil on paper 244 × 298 ($9\frac{5}{8}$ × $11\frac{3}{4}$)
Inscribed in pencil on the back 'Brighton June 10 1824', repeated in ink in a later hand; also inscribed in a later hand 'M.L.', i.e. the property of Maria Louisa Constable
PROV: As for no.2
LIT: Reynolds 1973, no.263, pl.199; Hoozee 1979, no.409, repr.; Reynolds 1984, no.24.8, pl.482 (col.); Fleming-Williams 1990, p.12, fig.3

Board of Trustees of the Victoria and Albert Museum, London

See no.146

[268]

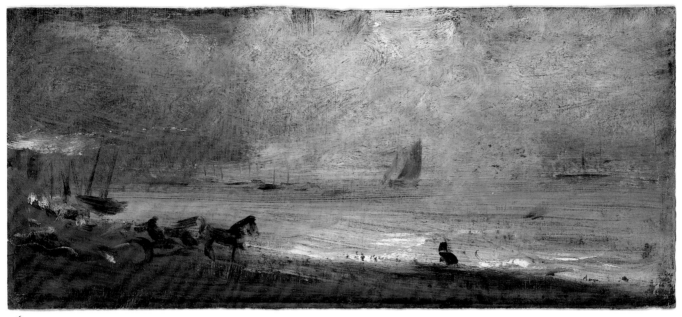

146

146 Brighton Beach with a Gig 1824

Oil on paper laid on board 124 × 286
(4⅞ × 11¼)
Inscribed faintly in pencil 'June 10 182[. . .]'
on the back, transcribed below in ink by
Lionel Constable as 'June 10. 1825.'; also
inscribed in ink on the back 'LC.'
PROV: . . .; according to Sotheby's 1988
catalogue, Sedelmeyer, Paris and
subsequently anon. sale, Christie's 23 April
1910 (117, as 'Yarmouth Beach') bt
Kuhlmann; . . .; anon. sale, Sotheby's 9
March 1988 (75, repr. in col.); present
owners
EXH: New York 1989 (24, repr. in col.)

Mr and Mrs David Thomson

Nos.145 and 146 are the earliest of Constable's
dated Brighton oil sketches, made on the second of
his 1824 visits, which lasted from 8 to 14 June. He
does not appear to have used oils on his equally
brief first visit in May. The two sketches were
painted on the same, rather overcast, day, 10 June.
Lionel Constable read the last digit of the year in
the inscription on no.146 as '5' but his father
appears to have been in Brighton on 10 June only in
1824.

At Brighton Constable was quick to respond to
the pictorial possibilities of beached fishing boats,
using their vertical accents as a counterfoil to the
horizontals of the sea and beach. Like no.153
below, which appears to be very close in date,
no.145 is painted on a piece of paper glued to a
slightly smaller and less regular sheet of thicker
paper, creating ridges along the top and right edges
of the top sheet (examination by Rica Jones, Tate
Gallery, 1986). The reasons for this practice are not
yet clear.

From no.146, a sketch not generally known until
1988, we can see that the gigs mentioned by
Constable in his letter of August 1824 (see p.267)
were sometimes risked on the beach. As Con-
stable's oil sketches show, however, Brighton
beach was then rather sandier than it is today. John
and Jill Ford point out that large quantities of sand
were removed during the Brighton building boom,
12,000 loads being removed in 1823 alone (*Images
of Brighton*, 1981, p.60). Constable's gig is sketched
with an economy remarkable even for him.

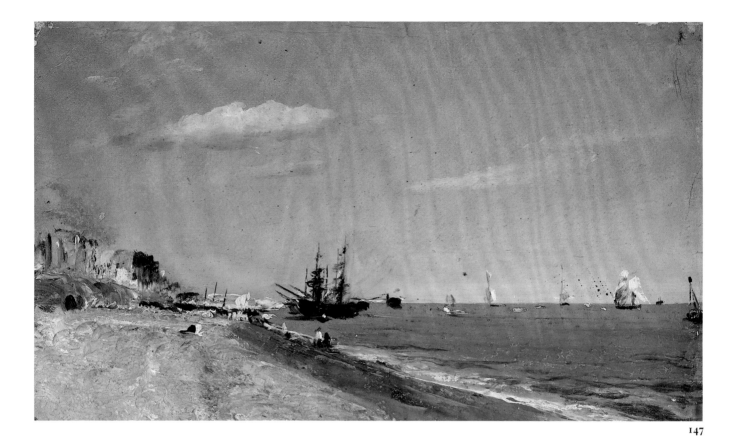

147

147 Brighton Beach with Colliers 1824

Oil on paper 149 × 248 ($5\frac{7}{8} \times 9\frac{3}{4}$)
Inscribed in pencil on the back, partly
reinforced in ink, '3d tide receeding left the
beach wet – Head of the Chain Pier Beach
Brighton July 19 Evg., 1824 My dear Maria's
Birthday Your Goddaughter – Very lovely
Evening – looking Eastward – cliffs & light
off a dark [? grey] effect – background – very
white and golden light'; also inscribed 'JC' in
monogram and 'Colliers on the beach'
PROV: As for no.2
EXH: Tate Gallery 1976 (228, repr.); Paris
1976 (43, repr.)
LIT: Reynolds 1973, no.266, pl.202; Hoozee
1979, no.412, repr.; Rosenthal 1983, p.158,
fig.194 (col.); Reynolds 1984, no.24.11,
pl.487 (col.); Cormack 1986, p.159, pl.156;
Fleming-Williams 1990, pp.205, 212, fig.192

*Board of Trustees of the Victoria and Albert
Museum, London*

This, one of the most celebrated of his Brighton
sketches, dates from the third and longest of
Constable's visits to the resort in 1824. He arrived

on 17 July, two days before the sketch was painted,
and remained until October. While reminiscent of
the annotations on his Hampstead sky studies, the
inscription on the back was clearly also intended to
be read by John Fisher, godfather of the Con-
stables' daughter Maria Louisa. Presumably the
work was included in the batch Constable sent to
him in January 1825. Constable's letter detailing
the arrangements for sending them tells us a good
deal about his methods and the value he placed on
his oil sketches: 'I have enclosed in the box a
portfolio of a Dozen of my brighton oil sketches –
perhaps the sight of the sea may cheer Mrs F – they
were done in the lid of my box on my knees as usual.
Will you be so good as to take care of them I put
them in a book on purpose – as I find dirt destroys
them a great deal Will you repack the box as you
find it. return them to me here at your leisure but
the sooner the better' (Beckett VI 1968, p.189).

The head of the Chain Pier is visible beyond and
to the right of the colliers. The latter, seen
appropriately as black silhouettes, brought coal to
within yards of the town centre; the mechanics of
this operation are discussed under no.312 below.
Pentimenti to the right of the colliers suggest that
they may originally have been shown still partly
under sail.

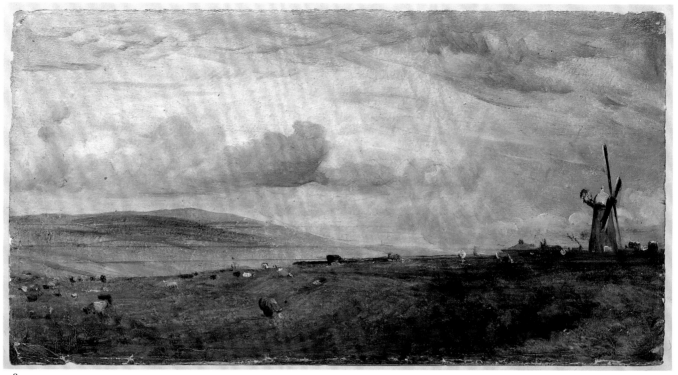

148

148 A Windmill near Brighton 1824

Oil on paper 162 × 308 (6⅜ × 12⅜)
Inscribed in pencil on the back 'Brighton
Augst. 3d 1824 Smock or Tower Mill west
end of Brighton the neighbourhood of
Brighton – consists of London cow fields –
and Hideous masses of unfledged earth called
the country' and repeated in another hand in
ink
PROV: As for no.2
LIT: Reynolds 1973, no.268, pl.204; Hoozee
1979, no.417, repr.; Reynolds 1984, no.24.17,
pl.491

*Board of Trustees of the Victoria and Albert
Museum, London*

As well as working on the beach, Constable made a
number of oil sketches and drawings on the downs
above Brighton, often taking, as here, a windmill
for his focal point. The unflattering inscription on
the back was clearly written in the same mood as his
general account of Brighton quoted on p.267. No
doubt the Sussex downland struck Constable as
raw and 'unfledged' by comparison with the
intensively cultivated landscape of East Anglia but
such thoughts seem to have fled as soon as he
started painting.

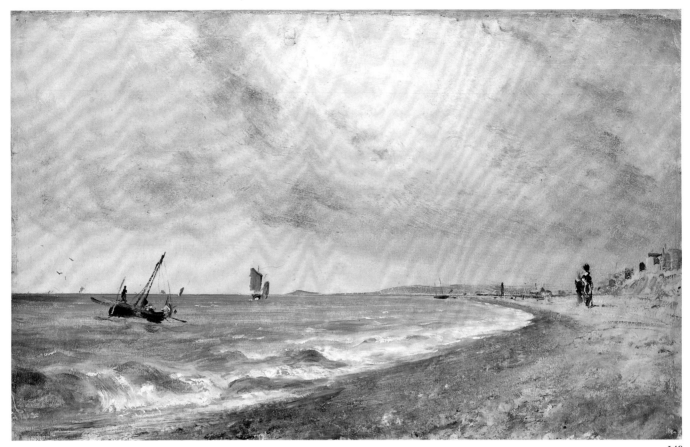

149

149 Hove Beach *c.*1824–8

Oil on paper laid on canvas 298 × 492
($11\frac{3}{4} \times 19\frac{3}{8}$)
PROV: As for no.2
LIT: Reynolds 1973, no.270, pl.206; Hoozee
1979, no.423, repr.; Reynolds 1984, no.24.59,
pl.526 (col.)

*Board of Trustees of the Victoria and Albert
Museum, London*

The view here is westwards towards Worthing. In
this and other sketches of the same view Constable
uses figures standing on the beach as a counter-
weight to the restless sea. Closer to Brighton, as in
nos.145 and 147, he was able to make more use of
buildings and beached boats to achieve a visual
balance.

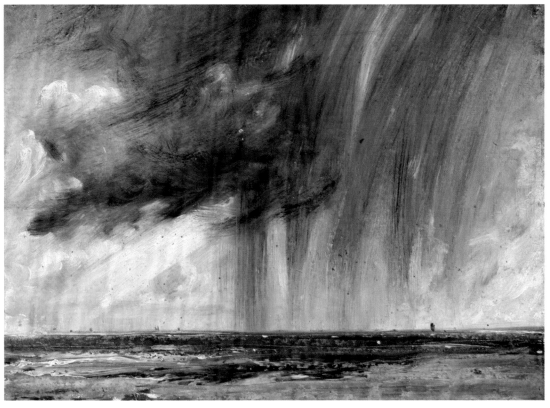

150

150 Rainstorm over the Sea *c.*1824–8

Oil on paper laid on canvas 222 × 310
(8¾ × 12¼)
PROV: By descent to Isabel Constable, by
whom presented to the Royal Academy 1888
EXH: Tate Gallery 1976 (233, repr.); New
York 1983 (50, repr. in col.); Japan 1986 (53,
repr. in col.)
LIT: Hoozee 1979, no.496, repr.; Reynolds
1984, no.24.67, pl.539 (col.); Cormack 1986,
p.159, pl.159 (col.)

Royal Academy of Arts, London

In comparatively few of his Brighton oil sketches
does Constable look so directly out to sea as here.
Faced with such a dramatic sky, he had no need for
the figures and boats that usually make up his
Brighton foregrounds.

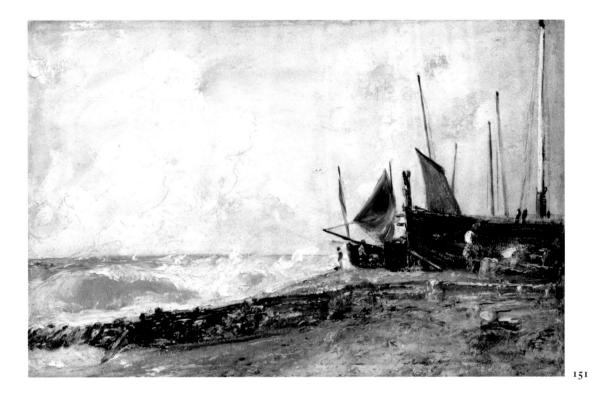

151

151 Brighton Beach ('A Seabeach') *c.*1824–8

Oil on paper laid on canvas 321 × 502
(12⅝ × 19¾)
PROV: By descent to Charles Golding
Constable and sold by court order after his
death, Christie's 11 July 1887 (71) bt Noseda,
probably for J.P. Heseltine (certainly his by
1914); . . .; Langton Douglas 1932; . . .; Mr
and Mrs Edgar B. Whitcomb, by whom
bequeathed to the Detroit Institute of Arts
1953
EXH: Milwaukee 1976 (2, repr.); New York
1983 (52, repr. in col.)
LIT: Hoozee 1979, no.483, repr.; Reynolds
1984, no.24.79, pl. 550 (col.); Hill 1985,
p.103, pl.10 (col.)

*Detroit Institute of Arts, Bequest of Mr and
Mrs Edgar B. Whitcomb*

This is the oil sketch engraved in 1830 for *English
Landscape* as 'A Seabeach' (fig.97 on p.321), the
only Brighton subject included in the original
series. In the text he later wrote to accompany it,
Constable presented a very different image of
Brighton to the one given in his 1824 letter to
Fisher, quoted in the introduction to this section.
There is, he says, 'perhaps no spot in Europe where
so many circumstances conducive to health and
enjoyment are to be found combined'. As well as
enthusing about the climate and vegetation of the
place, giving an account of its rise and a brief
discourse on the structure and value of groynes, he
writes more specifically of the subject of the print,
which is intended to convey 'one of those animated
days when the masses of cloud, agitated and torn,
are passing rapidly' and the wind 'meeting with a
certain set of the tide, causes the sea to rise and
swell with great animation'. The 'solitary sea-fowl',
shown in the print and the painting, 'may be
observed beating his steady course for miles along
the beach just above the breakers . . . These birds,
whether solitary or in flocks, add to the wildness
and to the sentiment of melancholy always atten-
dant on the ocean' (Shirley 1930, pp.259–60,
Beckett 1970, pp.19–21).
 No.151 is one of the few Brighton oil sketches in
which pencil under-drawing is visible.

Chain Pier, Brighton

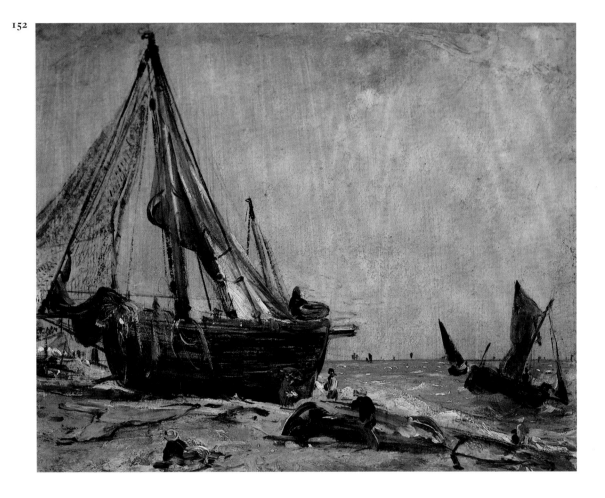

152

152 Brighton Beach 1824

Oil on paper laid on canvas 238 × 293
($9\frac{3}{8} \times 11\frac{1}{2}$)
PROV: By descent to Isabel Constable, who
died 1888; her heirs, sold Christie's 17 June
1892 (255) bt Dowdeswell; . . .; P.L. Halsted
by 1933 and bequeathed by him to Dunedin
Public Art Gallery 1943
EXH: Tate Gallery 1976 (232, repr.)
LIT: Hoozee 1979, no.425, repr.; Parris 1981,
p.124, fig.4; Reynolds 1984, no.24.63, pl.535

Dunedin Public Art Gallery, New Zealand

See no.153

153 Beaching a Boat, Brighton 1824

Oil on paper laid on canvas 248 × 294
($9\frac{3}{4} \times 11\frac{9}{16}$)
PROV: By descent to Isabel Constable, who
died 1888; her heirs, sold Christie's 17 June
1892 (254) bt Dowdeswell; . . .; P.A.
Chéramy, Paris by 1902 and sold Georges
Petit, Paris 5–7 May 1908 (19); . . .; 'Mr
Meyer', from whom bt by Leger 1962 and
sold the same year to Broadway Art Gallery,
Broadway, Worcs.; bt there the same year by
Mrs P.M. Rainsford, by whom presented to
the Tate Gallery 1986 (T 04135)
LIT: Parris, Fleming-Williams, Shields 1976,
pp.139 under no. 232, 149, 204 under 1824
n.1; Hoozee 1979, no.426, repr.; Parris 1981,
p.124, fig.5; Reynolds 1984, no.24.64, pl.536;
*The Tate Gallery 1984–86: Illustrated
Catalogue of Acquisitions*, 1988, pp.21–3,
repr.

Tate Gallery

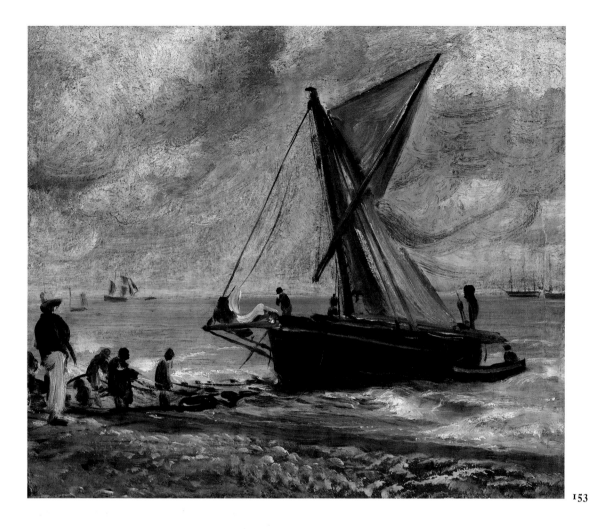

153

Nos.152 and 153 are very similar in character to no.145 above, dated 10 June 1824, and were probably painted about the same time. They have the added interest of having been used by Constable when preparing his large 'Chain Pier, Brighton' (no.156). The figure leaning against the boat in the Dunedin sketch, no.152, reappears in the two compositional sketches in Philadelphia (nos.154–5) and in the final picture. The larger of the two Philadelphia sketches (no.155) copies the boat-beaching scene and watching man from the Tate Gallery sketch, no.153. A different source was used for the boat in the smaller compositional sketch, no.154, which does, however, copy the watching figure from the Tate sketch, this time placing him further along the beach.

The Tate Gallery sketch, no.153, is painted over two priming layers, the lower one pale blue, the upper purple-brown. A Brighton beach sketch in the Victoria and Albert Museum, dated 12 June 1824, is painted over layers of the same colours (Reynolds 1984, no.24.9, examined by Rica Jones, Tate Gallery, 1986). Sarah Cove suggests that Constable may have been using up paper initially primed blue for painting evening sky studies at Hampstead (see p.498). Like the 10 June sketch,

no.145 above, and the 12 June sketch just mentioned, no.153 is also painted on a sheet of paper which had first been stuck down over a smaller and coarser sheet, creating a ridge at the right side. It is not clear why Constable prepared his paper in this way.

154 Sketch for 'Chain Pier, Brighton' c.1826

Oil on paper laid on canvas 330 × 610 (13 × 24)
PROV: Probably by descent to Isabel Constable and probably lent by her heirs to Grosvenor Gallery 1889 (279, 'Brighton Beach', 12½ × 24 in); . . .; French Gallery, from whom bt by John G. Johnson 1893; bequeathed by him to the city of Philadelphia 1917 and later housed in the John G. Johnson Collection at the Philadelphia Museum of Art (869)
LIT: Hoozee 1979, no.693, repr., as after

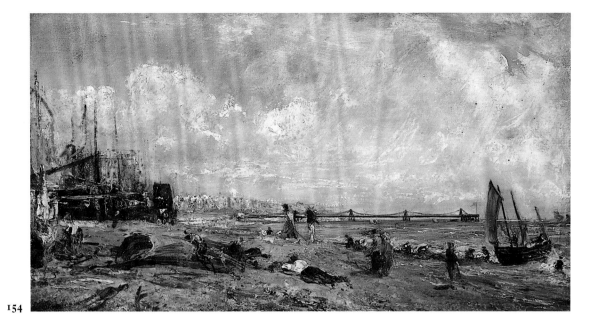

154

Constable; Parris 1981, pp.124, 127 n.8, fig.7, as doubtful; Reynolds 1984, no. 27.3, pl.634 (col.); Parris and Fleming-Williams 1985, p.168, under no.27.3

John G. Johnson Collection, Philadelphia Museum of Art

This is one of two studio sketches made in preparation for 'Chain Pier, Brighton', no.156. Odd features which led to its being doubted in the past (see Parris 1981) appear acceptable today in the light of our greater knowledge of the latitude Constable allowed himself in his rough working sketches (see the comments on no.99, 'Sketch for "Stratford Mill"'). The recent appearance of a drawing closely connected with the boat and figures at the bottom right has also helped clear away doubts (fig.74, Sotheby's 16 Nov. 1989, lot 25, 100 × 135 mm). On paper watermarked 1821, this appears to be a trimmed page from a sketchbook Constable used at Brighton in 1825 and 1828 and was presumably made in the former year.

fig.74 'Two Women near a Fishing Boat', 1825, *Courtesy of Sotheby's Ltd*

When painting no.154 Constable used this drawing in preference to the Tate Gallery oil sketch (no.153), which gives a different account of the boat and does not include the women sheltering under an umbrella. The man watching the boat being beached in the Tate sketch is, however, introduced further along the beach, in the position he occupies in the final picture.

Among the unhappy features about this sketch noted earlier (Parris 1981, p.127 n.8) were the construction of the pier and the positioning of the Albion Hotel, the large building at the left. Examination of the work in 1989 by infra-red reflectography, conducted by the Conservation Department of the Philadelphia Museum of Art, revealed changes in both areas. The two central towers of the pier were originally painted further to the right of their present position. The original position of the last tower and the pier-head is less easy to make out but it does look as though Constable decided to shorten the whole pier, perhaps to make room for the boat at the right. He did not bother to tidy up his sketch by aligning the final tower correctly over the substructure of the pier-head. As we will see, the length of the pier caused problems in the final picture as well.

Although the 1989 examination showed that Constable also slightly changed the position of the Albion Hotel, it appears always to have been depicted flat-on to the spectator rather than at an angle as in the larger Philadelphia sketch, no.155, and the final painting, no.156. Reynolds, however, has pointed out that the viewpoint here is different, being to the left of that adopted for the other canvases. Constable may therefore have intended to show the side of the hotel rather than its main, seaward facade. The point no longer seems very material, since this area of the sketch is clearly unresolved in any case.

155 Sketch for 'Chain Pier, Brighton' *c.*1826

Oil on canvas 606 × 988 (23¾ × 38⅞)
PROV: Artist's administrators, sold Foster 16
May 1838 (in 43, probably with no.20 above,
q.v.) bt James Stewart and sold Christie's 20
April 1839 (in 3, probably with no.20 above)
bt Reeve, presumably Henry Reeve (1813–
95), by whom lent to *Old Masters*, RA 1890
(55); . . .; purchased for the W.P. Wilstach
Collection, Philadelphia 1896, later part of
the Philadelphia Museum of Art
LIT: Hoozee 1979, no.476, repr.; Parris 1981,
p.124, fig.6; Reynolds 1984, no.27.4, pl.636;
Richard Dorment, *British Painting in the
Philadelphia Museum of Art*, Philadelphia
1986, no.12, repr. in col.

*Philadelphia Museum of Art, William P.
Wilstach Collection*

[Not exhibited]

In this larger studio sketch of the 'Chain Pier,
Brighton' composition, approximately half the size
of the final picture, Constable has adjusted the
perspective of the left side so that the pump-house
(the upright timber building), boats and Albion
Hotel are seen more from the right than in the
smaller Philadelphia sketch, no.154. The boat-
beaching scene at the right is now taken from the
small Tate Gallery sketch (no.153) rather than
from the drawing shown in fig.74. For the perspec-
tive and detail of the buildings on Marine Parade,
in the distance towards the left, Constable appears
to have turned for the first time to a panoramic
drawing made a year or two earlier (see fig.78).
Although he was to follow this drawing more
faithfully in the finished picture, he has bothered to
note here even the tiny detail of Rottingdean
windmill, which appears in the far distance
between the first and second towers of the pier.

The work is thinly painted (though with some
impasto highlights) over drawn outlines, which are
especially prominent at the left side. The technique
is similar to that used for the La Chaux-de-Fonds
'Dedham from Langham' (no.20), which appears
to have spent much of its life in company with this
Brighton sketch.

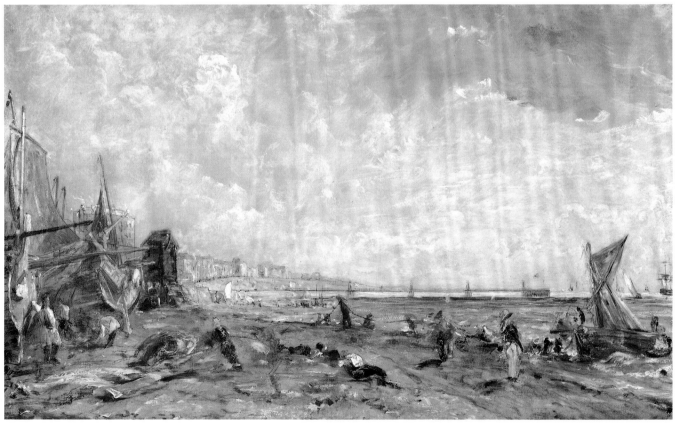

155

156 Chain Pier, Brighton 1826–7, exh.1827

Oil on canvas 1270 × 1830 (50 × 72)
PROV: Artist's administrators, sold Foster 16
May 1838 (68, 'Brighton and the Chain Pier
Exhibited 1827') bt Tiffin; said to have been
bt by the Revd Thomas Sheepshanks the
same year; by descent to Lt-Col. A.C.
Sheepshanks, from whom bt by Agnew 1948
and sold the same year to Dr H.A.C.
Gregory; his sale, Sotheby's 20 July 1949
(136) bt in by Lambert; purchased by the
Tate Gallery through Agnew 1950 (N 05957)
EXH: RA 1827 (186, 'Chain Pier, Brighton');
BI 1828 (64, 'The Beach at Brighton, the
Chain Pier in the distance', frame 68 × 99 in);
Tate Gallery 1976 (247, repr.; also col. detail
opp. p.160)
LIT: Hoozee 1979, no.477, repr.; Parris 1981,
no.32, repr. in col.; Rosenthal 1983, pp.180–
3, 186, fig.220; Reynolds 1984, no.27.1,
pl.633 (col.); Parris and Fleming-Williams
1985, p.168, under nos.27.1, 27.2; Cormack
1986, pp.179–83, pl.172 (col.); Rosenthal
1987, p.166, pl.154 (col.)

Tate Gallery

fig.75 'A Brighton Lugger',
1824, *Courtesy of Sotheby's
Ltd*

below
fig.76 Frederick Smith after
Constable, 'View of
Brighton with the Chain
Pier', 1829, *Trustees of the
British Museum, London*

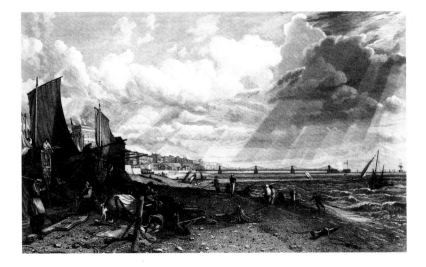

In deciding to paint this, his only six-foot Brighton canvas, Constable must have overcome the aversion expressed (though probably not with entire seriousness) in his August 1824 letter to the 'endless & indecent confusion' of Brighton beach and the pretensions of Marine Parade 'with its trimed and neat appearance & the dandy jetty or chain pier' (see p.267). Beach, buildings and pier act as a foil to 'the magnificence of the sea' and sky in the painting but Constable no longer seems to be forcing an antithesis between the resort and its natural setting. Equally, he must have overcome his reluctance, voiced in the same letter, to compete with the established painters of beach scenes: 'these subjects are so hackneyed in the Exhibition and one in fact so little capable of that beautifull sentiment that Landscape is capable of'. As Reynolds points out, Constable had in fact already painted this sort of subject in his 1822 'Yarmouth Jetty' (1984, no.22.36) and had been working for some years on a composition that closely parallels the design of the Brighton picture – 'The Opening of Waterloo Bridge' (see nos.102–3, 212–13). The Brighton and London works are also linked at another level, both depicting bustling humanity in the context of the grandeur of nature.

Most of the preliminary material used in the painting of 'Chain Pier, Brighton' has been discussed above (nos.152–5), though a number of drawings have still to be mentioned. The principal compositional differences between the half-size sketch, no.155, and the final picture lie in the treatment of the left side and the bottom right corner. The Albion Hotel and the pump-house are now seen further apart with the sail of a fishing boat masking the interval between them. This boat, which appears at the extreme left of the half-size sketch, was based on the drawing shown in fig.75 (Reynolds 1984, no.24.39). Much more of the vessel, including its mainmast and sail, was originally visible in the painting but was lost, together with another boat and several figures, when the canvas was cut down. This occurred at some time between 1829, when Frederick Smith's engraving of the whole picture was published (fig.76, taken from British Museum impression, 1841–11–13–203), and 1888, when the present measurements of the canvas are first recorded. The canvas was reduced by about one eighth of its original width in this process and would have measured about 82 inches initially. As Smith's print (in particular) suggests, the main reason for making changes at the left side of the composition was to build up a stronger 'repoussoir' which would heighten the perspective of the rest of the scene. Looking from the small Philadelphia sketch, no.154, to the larger one, no.155, and then to the final picture, we can see Constable gradually increasing the apparent depth of his composition, a process paralleled (again) in his Waterloo Bridge paintings. Foreground details introduced at the left of no.156 have the same function. For the mooring post with anchors roped to it, which helps push the upturned boat further into the composition, Constable

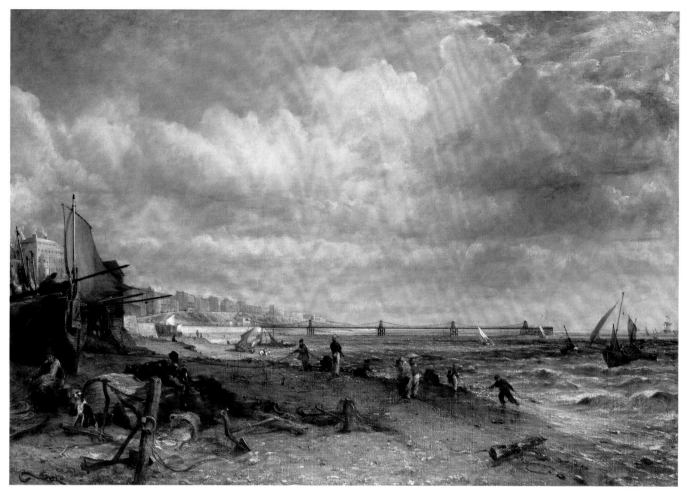

156 (see also detail facing p.267)

referred to two drawings, one now in the Victoria and Albert Museum (Reynolds 1984, no.24.36) and the other a recently discovered double study of the post and a fisherman leaning against a wall (fig.77; with Stephen Somerville Ltd 1988). As we can also see from Smith's print, the dog who now – very untypically for Constable – stares vacantly out of the painting was originally watching a fisherman smoking a pipe at the extreme left.

At the right of the painting Constable has finally given up the boat-beaching episode seen in different versions in the foreground of the two studio sketches, nos.154–5, but has introduced a boat approaching the beach in the middle distance. The watching man, at one time thought to be a customs officer (see *The Tate Gallery 1984–86*, cited under no.153), nevertheless remains, stationed along the beach as in the smaller of the two Philadelphia sketches, no.153.

For the details of Marine Parade and of the pier itself Constable relied on the panoramic drawing seen in fig.78 (Victoria and Albert Museum, Reynolds 1984, no.27.2). This is likely to have been made in 1824, the year after the opening of the pier, because it includes the buoys linked by chains to the pier-head that were set up to protect the pier from boats being swept against it but which were themselves destroyed in a storm in November 1824 and never replaced (see John and Jill Ford, *Images of Brighton*, 1981, p.66). Details of the bathing machines, boats and figures on the beach between the pump-house (the tall timber structure at the left) and the pier were also taken, sometimes very exactly, from this drawing. In transferring the details of the 'dandy jetty' to his canvas Constable first repeated the decreasing intervals between the towers noted in this drawing. He then equalised the intervals, that is, discounted the perspective of the drawing, and lengthened the pier. The sail of a boat had then to be painted out to stop it obscuring the pier-head. These changes can be observed with the naked eye.

Although Fisher admired the painting and thought it 'a usefull change of subject', predicting that 'Turner, Calcott and Collins [leading artists in the field] will not like it' (Beckett IV 1966, p.155, VI 1968, p.230), 'Chain Pier, Brighton' had a poor reception when exhibited at the Royal Academy in 1827 and Constable never found a buyer for it. A few months after reshowing it at the 1828 British Institution he took Maria back to Hampstead after her final visit to Brighton. She died that November and his connection with the place effectively ceased.

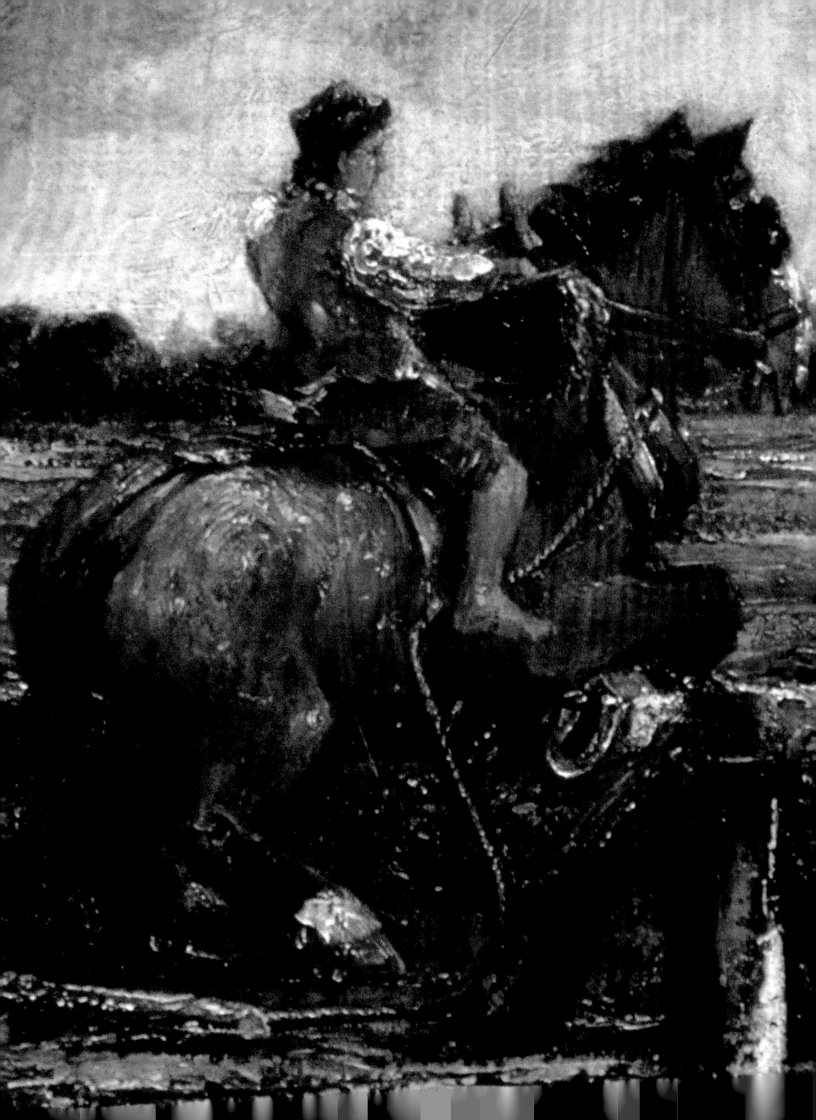

Later Set-Pieces

Having shown a six-foot Stour painting at the Academy each year from 1819 to 1822, Constable's work was severely interrupted by illness in the winter of 1822–3 and he had nothing on this scale ready for the 1823 Academy. His main exhibit that year was 'Salisbury Cathedral from the Bishop's Grounds' (no.140), just as much a 'set-piece' but of a more modest size. The large Stour exhibits continued with 'The Lock' in 1824 (no.158) and 'The Leaping Horse' (no.162) the following year. The central figurative element developed in 'The Hay-Wain' (no.101) and 'View on the Stour' (fig.66 on p.195) assumed even greater importance in these works, the man opening the lock and the boy jumping his horse being given almost heroic roles to play in the landscape. The latter Constable now showed increasing willingness to mould to his own ends, moving or inventing trees, shifting churches, and so on. Taken with their respective full-size sketches (nos.157, 161), 'The Lock' and especially 'The Leaping Horse' reveal the tremendous problems Constable faced in organising his material, part observed, part invented, on these large canvases.

After 'The Leaping Horse' Constable turned to what he called 'inland' scenery in 'The Cornfield' of 1826 (no.165) and then to Brighton for his main exhibit the following year. The set-pieces of these and later years make up no sort of series such as the earlier Stour pictures can be said to do. With the exception of 'Chain Pier, Brighton' (no.156) and 'Salisbury Cathedral from the Meadows' (no.210), for his larger works Constable turned back to a variety of subjects he had first studied many years before.

Detail from 'The Leaping Horse', no.162

The Lock

157 Sketch for 'The Lock' ?1823

Oil on canvas 1417 × 1220 ($55\frac{13}{16}$ × $48\frac{1}{16}$)
Verso: a study of a girl's head with part of her figure outlined (Reynolds 1984, no.24.3, pl.477)
PROV: . . .; Ernest Gambart, sold Christie's 4 May 1861 (294) bt E.A. Leatham, sold Christie's 18 May 1901 (121) bt Vicars; Agnew 1901; John H. McFadden 1901; acquired with his collection by the Philadelphia Museum of Art 1928
EXH: New York 1983 (21, repr. in col.); New York 1987–8 (274, repr. in col.)
LIT: Hoozee 1979, no. 404, repr.; Rosenthal 1983, p.155, fig. 189 (col.); Reynolds 1984, no.24.2, pl.476 (col.); Cormack 1986, p.156, pl.155 (col.); Richard Dorment, *British Painting in the Philadelphia Museum of Art*, Philadelphia 1986, no.11, repr. in col.; Rosenthal 1987, p.140, pl.131; Rhyne 1990b, pp.72–3, 82–3 n.10; Fleming-Williams 1990, pp.196, 198, fig.184

Philadelphia Museum of Art, John Howard McFadden Collection

Constable mentions a 'Lock' specifically for the first time in a letter to Fisher (12 December 1823) in which he discusses his future plans. 'I am settled, for the Exhibition', he writes: 'my Waterloo must be done and one other perhaps one of Tinney's [see under no.144] Dedham but more probably my Lock' (Beckett VI 1968, p.146). If this had been the first allusion to the lock at Flatford as again a possible subject for a major painting, Constable would surely have felt it necessary to say more about what he had in mind. There do not seem to be any letters missing in their exchanges after Constable's visit to Dorset that summer, nor do the two friends appear to have met since then, so it looks as though the idea of a 'Lock' had been in his mind for some time and that he had discussed it with Fisher when they were together in Gillingham. This lends a degree of support to the assumption made by most Constable scholars that the artist may have been referring to no.157 when, on 21 February 1823, he informed Fisher: 'I have put a large upright Landscape in hand, and I hope I shall hold up to get it ready for the Academy' (ibid., p.112). Beckett suggested (ibid., p.101) that Constable was referring to a view of Flatford in an earlier letter. Dated 31 October 1822, and again to

Fisher, in this letter (ibid., p.100) Constable says he has 'an excellent subject for a six foot canvas' that he would certainly paint for next year were it not for a large picture he had been commissioned to paint for a cousin, Albany Savile (a commission that subsequently fell through, leaving Constable to 'finish the picture unshakled': ibid., p.161).

If the 'large upright' Constable said he had put in hand on 21 February was no.157, this was not the beginning of the painting, for the canvas as we see it now is an extension upwards from the original by some $11\frac{1}{4}$ inches; there has been a loss along the right edge (although a faint sign of cusping visible in an x-radiograph suggests that this could not have been more than 6 inches at most – see Cove, thesis); and x-radiography shows that a great deal of the architecture of the lock – the posts and lintels – has been painted over. In short, at some time before 21 February it seems that the canvas, a curiously proportioned horizontal (appproximately 46 by 50 inches), was supporting a rather different image.

The germ of the idea for the picture undoubtedly developed from a detail in an earlier painting, the 'Dedham Lock and Mill' of 1818 (no.94). There in the middle distance, is to be seen a lock-keeper in the same attitude as the figure in no.157, similarly working at the windlass of a lock-gate (frontispiece). Only at the entrance of Dedham lock does there appear to have been a lintel supported by posts. Flatford lock, it seems, was differently constructed. This, too, had an over-reaching lintel earlier on at the downstream entrance (see the painting by Dunthorne, Tate Gallery 1976, no.339). But the lock itself was of a box construction and the framework of posts and lintels (nine sets in all) ran the entire length. In the drawing Constable made in April 1823 (no.305) of the lock from the same viewpoint as the paintings (nos.158–60), we see the posts and lintels that he decided to paint out in the Philadelphia sketch (no.157) and subsequently to leave out altogether in the later paintings.

No.157 is painted on the back of an abandoned work, a somewhat crudely painted head of a girl gazing upwards with her figure, in a reclining position, sketched only in outline, clearly a very early work (Reynolds 1984, no.24.3, pl.477). The fact that he began to rough out the composition in this way, on the back of a rejected canvas, suggests possibly a rather casual approach at the start. This might account for the remarkably uninhibited manner with which he wielded brush and knife when attempting to establish the design.

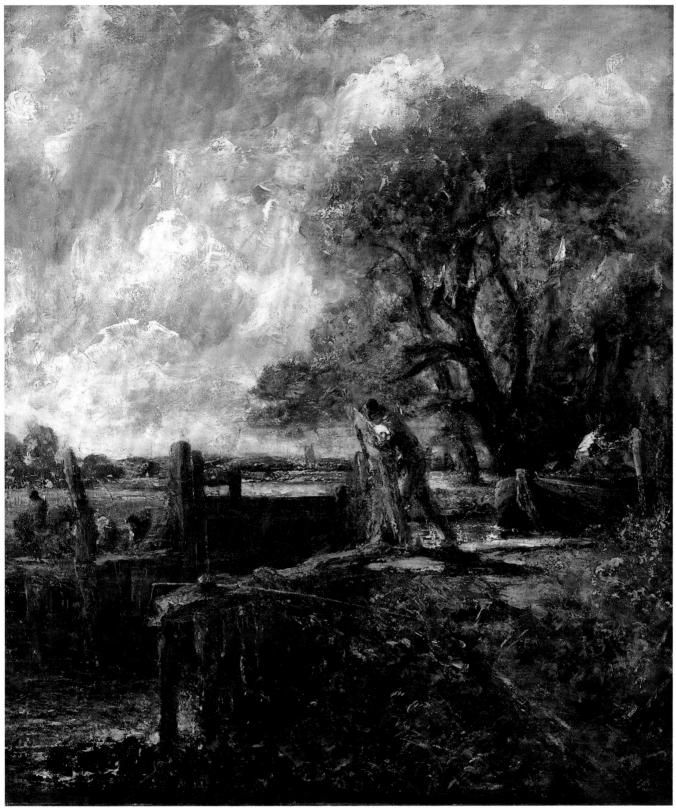

157

158 The Lock 1824, exh.1824

Oil on canvas 1422 × 1207 (56 × 47½)
PROV: Bt at the 1824 RA by James Morrison;
by descent to the Trustees of the Walter
Morrison Picture Settlement, sold Sotheby's
14 Nov. 1990 (128, repr. in col.; also separate
cat., repr. in col. with col. details) bt Baron
Thyssen-Bornemisza
EXH: RA 1824 (180, 'A boat passing a lock');
Living Artists of the English School, BI 1825
(129, 'The Lock'); Tate Gallery 1976 (227,
repr.)
LIT: Smart and Brooks 1976, pp.98–102,
138–9; Hoozee 1979, no.405, pl.XLIV (col.);
Walker 1979, p.114, col. pl.31; Rosenthal
1983, pp.154–6, fig.190 (col.); Reynolds
1984, no.24.1, pl.475 (col.); Cormack 1986,
pp.156–7, pl.154 (col.); Rosenthal 1987,
p.138, pl.132; Rhyne 1988, p.14; Fleming-
Williams 1990, pp.192, 195–9, fig.180

*Thyssen-Bornemisza Collection, Lugano,
Switzerland*

No.158 is a view of Flatford lock from across the
mill-pool on the right bank near the mill-house. A
barge has just entered the channel (or basin)
between the two pairs of gates, and, because it is
still moving ahead, a member of the crew – watched
from astern by a woman in a mob-cap – has taken a
turn with a rope round a post to bring the vessel to a
standstill. On the left, the tow-horse, attended by a
boy and a panting dog, is resting from its labours.
Meanwhile, the lock-keeper (or is it the barge's
skipper?) is at work at the lock-gate. While
preventing the capstan from moving with one knee,
he is inserting his crowbar prior to giving it another
turn. On the other gate we have a better view of a
capstan – lovingly rendered in every detail by
Constable – and can see the chain that, with the
turning of the capstan, raises the 'paddle' and
releases the water held back by the gates. Across the
meadows cattle graze and beyond (very near the
centre of the picture), the tower of Dedham church
breaks the skyline.

As was stated in the previous entry, Constable
may have made a start on an upright of the subject
in February 1823. That December he was certainly
considering a 'Lock' as a possible exhibit for the
next Academy. But he does not appear to have
started work on the painting until January 1824. 'I
should like your advice on the large Waterloo', he
told Fisher on the 17th, 'it is a work that should not
be hurried – I am about my upright lock & I hope
for one of Tinney's new ones' (Beckett VI 1968,
p.150). By 15 April it was finished and had been
sent in to Somerset House – his sole exhibit that
year. On that day he wrote to Fisher: 'I was never
more fully bent on any picture than on that which
you left me engaged upon – It is gone to its audit
with all its deficiences in hand – my *friends* ⟨...⟩ all
tell me it is my best. be that as it may I have done
my best. it is a good subject and an admirable
instance of the picturesque' (ibid., p.155).

From the posture of the man in the Philadelphia
sketch (no.157), it is fairly certain that Constable
obtained the initial idea for a close-up of a lock-
keeper or boatman working at a lock-gate, from the
little figure in 'Dedham Lock and Mill' (no.94,
frontispiece). This was important and central, but
where did he obtain the material he required for the
rest of the composition? As so often was the case, he
seems to have found what he needed among his
early studies. The attitude of the man in the sketch
(no.157) was apparently insufficiently heroic.
Charles Rhyne (1988) has pointed out a correspon-
dence between the action of the man in the red
waistcoat in 'The Lock' and the pose of the model
in one of Constable's studies in the life-class at the
Royal Academy Schools, c.1808 (fig.79). Though
in reverse, the resemblance may be more than
coincidental. What could be more suitable for a sole
exhibit at Somerset House than a landscape built
around an academic study painted beneath its roof?

In all Constable's big canal scenes he felt the
need in the composition for large tree masses,
presumably to balance the areas of open sky. In two
of his pictures there were no such groups where he
wanted them, so, in one, the 1822 'View on the
Stour' (fig.66 on p.195), he resorted to invention
(possibly with the help of earlier studies), and in the
other, 'The Lock', he invented some of the trees in
the group and adapted an early study for the rest.
In 'Flatford Mill' (no.89) and in numerous
sketches of that stretch of the Stour, we have a
reasonably accurate record of the trees that grew
along the bank between the footbridge at Flatford
and the lock, and at no time were there trees
growing beside the tow-path to compare with the
group he placed on the right bank in the Philadel-
phia sketch. The general effect of this group was
repeated in the final painting, but while retaining

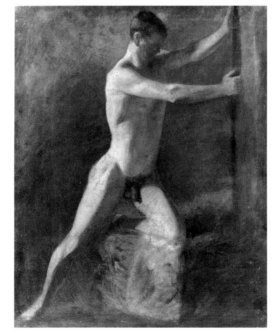

fig.79 'Academy Study',
c.1808, *Private Collection*

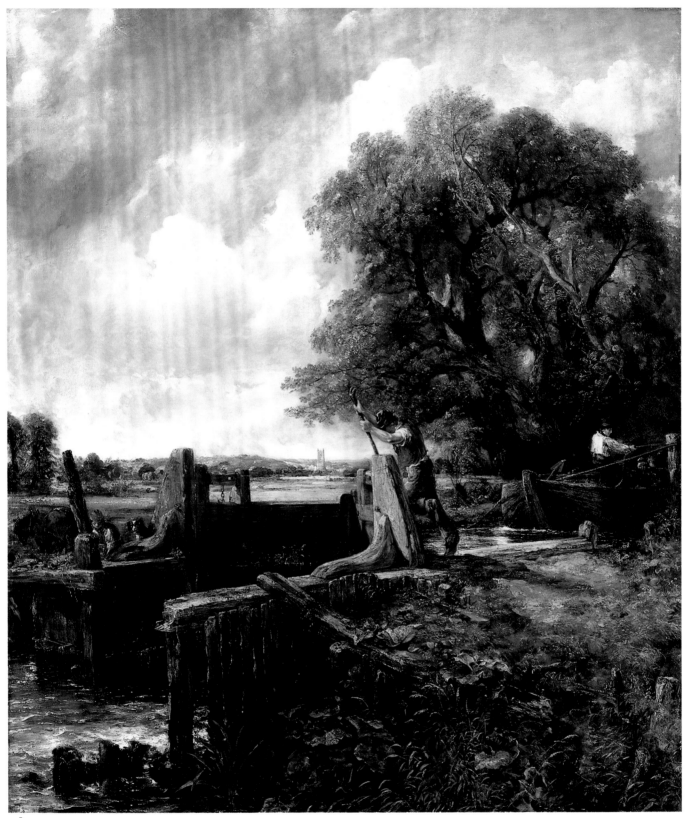

158

the massive trunks and branches, most of the individual limbs were taken from a pencil study of *c*.1812 (fig.36 on p.130), a study that he had faithfully reproduced in his exhibit of 1813, 'Boys Fishing' (no.57). For the lock in the 1813 picture he also had a pencil study (fig.37 on p.131) that showed every detail of the construction of the upper end of the lock, down to the jointing of the somewhat ramshackle timbers and the nuts, bolts and iron straps that held them together.

There are four paintings of Flatford lock from the northern viewpoint: no.158; another upright, a copy of no.158, apparently a joint effort by Constable and his young assistant, Johnny Dunthorne (Reynolds 1984, no.25.33, pl.603); and the two horizontal canvases, the unfinished Melbourne painting, no.159, and the Diploma work, no.160. In all four paintings, one part, the area around the lock (comprising part of the entrance, the gates and the bank with its wealth of plant-growth) is almost identical, down to the smallest detail. To be able to repeat so consistently, Constable must have had a study of some sort to work from. For the trees in no.158 he used a drawing of *c*.1812 (fig.36 on p.130) and it seems probable that he made use of a similar study, perhaps of the same date, for the lock and the area around it, a study such as the one (fig.37) from which he painted the upper lock in 'Boys Fishing', a drawing also probably of *c*.1812. This supposition is reinforced by the appearance of the lock in his drawing of April 1823 (no.305) and by some entries in the Stour Commissioner's Minute Book (ESRO EI1.394/1).

The viewpoint is almost the same in both the drawing, no.305, and the four paintings, but the lock and the area around it differ considerably. When the drawing was made the entrance had been entirely rebuilt; the further gate had been rehung on a less massive stanchion, a second brace had been added to strengthen the nearer stanchion and a lot of work had been done to the bank in the foreground – the heavy, abutting beam, with its iron strap, removed, the ground reshaped. The Minutes of the Stour Commissioners' meetings record numerous complaints about the state of repair of the Stour locks, gates, banks, etc. Abram Constable, the artist's brother, is minuted as having registered strongly worded protests about the state of Flatford lock and the banks around it in 1815, 1820 and 1827. He complained in 1815 that the lock 'is in a very ruinous State' and 'that the upper Gates thereof cannot be opened without the assistance of a Horse'. In 1820 he reported the condition of the lock as still being 'ruinous' and the bank of the river in a very dangerous state. In 1815,

it was ordered that repairs should be completed after nine months' time; in 1820, after one month. Repeated complaints in the Minutes indicate that such orders were not always carried out within the time specified.

From the very start, in his first oil sketch (the Philadelphia painting, no.157), Constable had visualised the lock as it must have been before the repairs following upon Abram's complaints of 1820 – possibly, even, as it was before his brother's protests of 1815. The drawing of the trees (fig.36 on p.130) is badly stained, seemingly with linseed oil, or oil of some sort. Perhaps the study from which he painted the sketch of the lock and the four paintings was also badly stained, but in this case in too poor a condition by the time he had finished with it to be worth keeping.

No.180 in the Royal Academy catalogue for 1824 and titled 'A boat passing a lock', 'The Lock', as it is now best known, was an immediate and, for Constable, an unprecedented success. For it was bought on the opening day by a wealthy businessman, James Morrison, then of Balham Hill, someone quite unknown to Constable. John Jackson, the portrait painter, later told Constable that Lord Fitzwilliam would certainly have bought his picture if it had not been sold to Mr Morrison (Beckett II 1964, p.330). John Fisher was told of the success of the painting in a letter of 8 May. 'My picture', Constable wrote, 'is liked at the Academy indeed it forms a decided feature and its light cannot be put out. because it is the light of nature – the Mother of all that is valuable in poetry – painting or anything else ... My execution annoys most of them and all the scholastic ones – perhaps the sacrifices I make for *lightness* and *brightness* is too much but these things are the essence of Landscape Any extreem is better than white lead and *dado* painting ... I do hope that my exertions may at last turn towards popularity – 'tis you that have to long held my hand above watter. although I have a good deal of the devil in me I think I should have been broken hearted before this time but for you indeed it is worth while to have gone through all I have to have had the hours and thoughts which we have had together and in common'. 'I am not surprised that "The Navigator" sold on a first inspection', Fisher replied, 'for it was one of your best pictures. The purchase of your two great landscapes for Paris ['The Hay-Wain' and 'View on the Stour'] is surely a stride up three or four of the steps of the ladder of popularity. English boobies, who dare not trust their own eyes, will discover your merits when they find you admired at Paris' (Beckett VI 1968, pp.157–8).

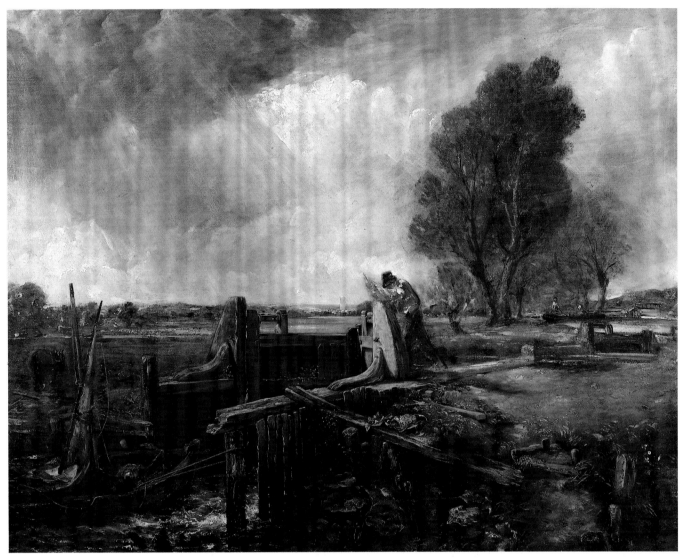

159

159 A Boat Passing a Lock ?1823–6

Oil on canvas 1035 × 1299 (40½ × 51⅛)
PROV: . . .; private collection, Exeter; Arthur
Tooth & Sons 1950, from whom bt for the
Felton Bequest, National Gallery of Victoria
1951
LIT: Hoozee 1979, no.473, repr.; Reynolds
1984, no.26.16, pl.627 (col.); Fleming-
Williams 1990, pp.198–200, fig.189

*National Gallery of Victoria, Melbourne,
Felton Bequest, 1951*

No.159 was discovered in a private collection in
1950. Nothing is known of its previous history. It is
a puzzling work and opinions have differed about
it. In 1976 it was suggested that the painting was an
unfinished replica of Constable's Diploma picture,
no.160 (Parris, Fleming-Williams, Shields 1976,
p.155). In 1984 Graham Reynolds expressed the
view that it might have been a preliminary sketch
made when Constable was 'undertaking a major
change in an existing composition, as he did for the
variant versions of *Salisbury Cathedral from the
Bishop's Grounds*'. There is a further possibility,
that the Melbourne painting is an abandoned
attempt at a picture, an attempt preceding the
Diploma work (no.160), or even the upright 'Lock'
(no.158) of 1824.

The Philadelphia sketch (no.157) was originally a
horizontal composition. Could no.159 have been a
first-stage development of the subject after the
experimental no.157? In December 1823 Constable
talks of 'my Lock' as a possible subject for the next
Academy. A few weeks later, in January 1824, he
says he is at work on his 'upright lock'. Could the
qualifying adjective mean that he had also been at
work on a horizontal canvas as well, on no.159?

With all four paintings of the lock at Flatford on
view together for the first time it may be possible to
find a place for no.159 with more certainty in the
series and to have some answers to the many
questions it raises.

160 A Boat Passing a Lock 1826, exh.1829

Oil on canvas 1016 × 1270 (40 × 50)
Inscribed 'John Constable. f. 1826' on the
horizontal beam below the lock-gate on the
left
PROV: Painted for James Carpenter 1826;
taken back by the artist and given to the
Royal Academy as his Diploma work in 1829
EXH: BI 1829 (38, 'Landscape and Lock',
frame 58 × 67 in); Tate Gallery 1976 (262,
repr.); *La Peinture britannique de
Gainsborough à Bacon*, Galerie de beaux-arts,
Bordeaux 1977 (94, repr.); *European
Landscape Painting*, National Museum of
Western Art, Tokyo 1978 (53, repr.in col.);
Royal Academy Retrospective, RA 1982 (8);
New York 1983 (24, repr. in col.); *J.M.W.
Turner*, Nationalmuseum, Stockholm 1984
(not in cat.); *Fine Art: A Selection of
Paintings, Sculptures and Drawings by Royal
Academicians 1770–1980*, Glynn Vivian Art
Gallery and Museum, Swansea 1985 (8, repr.
in col.); Japan 1986 (51, repr. in col.); Madrid
1988–9 (56, repr. in col.)
LIT: Smart and Brooks 1976, pp.98–102,
138–9, pl.58; Hoozee 1979, no.472, repr.;
Walker 1979, p.126, col. pl.38; Reynolds
1984, no.26.15, pl.626 (col.); Fleming-
Williams 1990, pp.198–200, fig.181

Royal Academy of Arts, London

'Boat Passing a Lock', an horizontal composition,
differs in a number of ways from the upright 'Lock'
(no.158) of 1824. Instead of a barge in the channel
of the lock going downstream, in no.160 we have a
boat on its way upriver being made fast to one of the
timbers at the entrance so that it will not be carried
away when the water above is released. This vessel
is smaller than the barge (or lighter) in no.158 and it
has a mast and sail that has just been lowered. In
'The Lock', the man at the gate appears to be the
lock-keeper who would have been responsible for
taking the tolls (in the Philadelphia sketch, no.157,
he has laid down his fishing rod to attend to his
duties). A different character is working the
capstan in the present work. As he is bare-footed,
presumably he is a boatman, like the man poling
the barge in the Tate Gallery's 'Flatford Mill'
(no.89), and not the lock-keeper. The trees on the
far bank are also notably different. The often drawn
and painted group (adapted from the Fondazione
Horne study, fig.36 on p.130), that Constable
turned into a great mass of boughs, trunks and
foliage in 'The Lock' of 1824, in no.160 is situated
correctly upstream in the middle distance, and in
its place we have two willows with some of their
leaves turning light in the wind. As we can see in a
drawing of 1827 (no.315), taken from beside the
upper lock gates, this is a truer picture of the trees
that grew along the river bank there. It is possible
that a lock composition with the two willows and
the group beyond was tried out initially in a pen-
and-ink drawing now in the Fitzwilliam Museum

(fig.80, Reynolds 1984, no.26.17), a drawing that
could well represent Constable's first thoughts on
the subject. In this unusual compositional study he
has removed all but the first of the lintels that
spanned the lock and has drawn this one at an
unnatural angle, presumably in an endeavour to
avoid having the lintel merging in with the horizon-
line. A similarly-angled lintel at the lock entrance
revealed by x-radiography under the surface paint
of the Philadelphia sketch (no.157), suggests that
this, the first of the 'Lock' paintings, may postdate
the Fitzwilliam drawing. The reverse seems
improbable; that Constable drew the lintel at such
an angle again, having rejected the idea in the
painting. It is interesting to note that the man at the
lock-gate in the drawing has one knee braced
against the capstan, as in the upright 'Lock' of
1824, yet is barefoot as is the figure in no.160 –
further evidence, perhaps, that the drawing was a
source work for both paintings.

The history of 'Boat Passing a Lock' is a little
unusual. It was commissioned by a friend, James
Carpenter, a Bond Street bookseller, who – then
unknown to Constable – had bought a lock scene,
'Boys Fishing' (no.57), after its showing at the BI in
1814. It has been assumed that Constable was
referring to no.160 when he listed 'Mr Carpenter's
picture' among five works he had in hand, his 'dead
horses' as he called them, in an entry for 1 October
1825 in the journal he kept for his wife when she
was in Brighton. 'All of these are paid for', he went
on, 'and one more fortnight will clear them off'
(Beckett II 1964, p.397). If he was referring to
'Boat Passing a Lock', then the painting was not
completed within two weeks as planned, for in an
undated letter written the following year, 1826,
Constable tells Carpenter that he has been at the
picture and that it 'is now all over wet – I was at
work on it at 7 o clock this morning – and I should
have been at it still', adding a postscript, 'I wish
your picture was as good as Claude Lorraine – for I

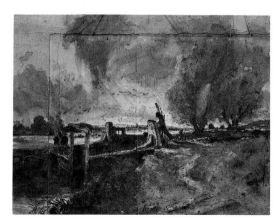

fig.80 'Flatford Lock',
c.1824, *Syndics of the
Fitzwilliam Museum,
Cambridge*

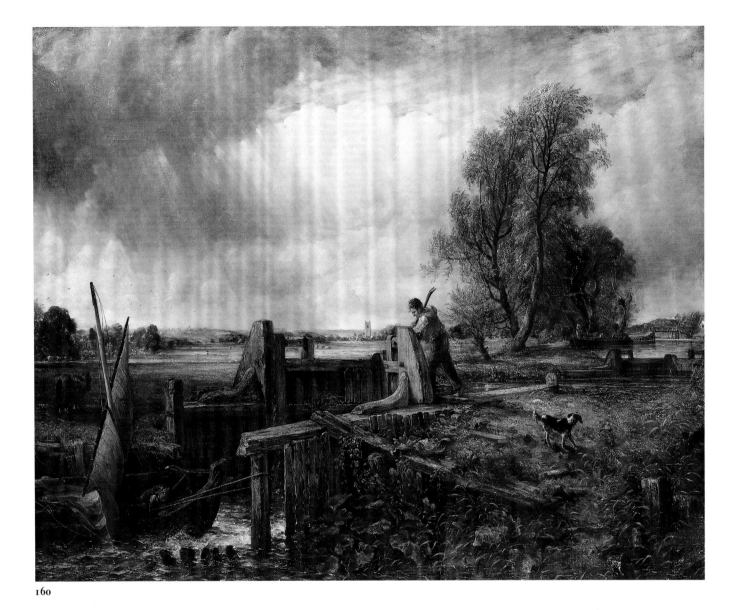

160

beg to assure you that your conduct to me about it, has been most liberal and kind' (Beckett IV 1966, p.138).

Constable liked to rework a painting and he evidently came to feel that he could improve Carpenter's picture. From a letter of 23 July 1828 we learn that he had borrowed it back from Carpenter to make some alterations and had arranged for it to be returned. Constable was writing from Brighton, where, he said, he was attending a very sick wife. 'I hope', he wrote, 'you like the *"new Edition of your picture"* and that you do not think it the worse for the retouch – it is always my endeavour however in making a picture that it should be without a companion in the world. at least such should be ⟨the⟩ a painters ambition, but it shows how worthless has been my boast in this instance when you tell me you have already found one fitting for it. Good heavens! *how* one's dreams of Glory vanish – & so quickly ... Accept

my dear Sir my best thanks for the loan of the picture. You are aware I hope that I have no further claim upon you for any thing that I have now done to your picture – it is sufficient reward that you afforded me an opportunity of making it better' (ibid., p.139). Carpenter's repossession of the picture was short-lived. On 10 February 1829 Constable was elected an Academician – by one vote. Before he could receive his Diploma he had to present a work to the Academy of sufficient merit to gain the approval of the Council. Although he had at least three major works on his hands, unsold (nos.162, 165, 169), for some reason Constable wanted 'Boat Passing a Lock' to be his Diploma picture. Carpenter allowed the painting to go after Constable had signed an agreement that on depositing one hundred guineas as guarantee he would paint 'a picture of the same size with in June 1830; and if he paints a Heath the same size as that of Mr Chantry (I [Carpenter] shall be grateful)' (Beckett

Papers, box-file 'Dealers', Tate Gallery). Chantrey's 'Hampstead Heath' is now in the Victoria and Albert Museum (Reynolds 1984, no.28.2, pl.678). No.160 was accepted at a meeting of the RA Council, with the President (Lawrence) in the chair, on 22 October 1829.

Constable chose to paint Carpenter's new picture, 'Helmingham Dell', on a slightly larger canvas and reported on its progress in a letter of 15 February 1830: 'If *"your Wood"* is not finished by the Exhibition – I will hang my-self on one of the trees!!! Your Heath is likewise began' (Beckett IV 1966, p.141). Carpenter received a second report in a letter of 18 March: 'Will you soon call again – Your picture ⟨wood⟩ is getting on nicely – but I will not *"halloo 'til I am out of the Wood"*. I cannot get out by daylight' (ibid., p.142).

Then, quite suddenly, just before sending the 'Helmingham' to the Academy, Constable changed his mind. After the two previous progress reports,

it must have come as something of a shock to Carpenter when he received the following, dated 2 April. 'I hope you will not be disturbed if I request you to decline the picture I am now about – and allow me to forfeit the 100 guineas now in the hands of Sir C. Scott's banking house. I beg you to beleive that I have no offer for the picture – nor have I any other feeling towards you of the smallest disrespect, on the contrary am truly sensible of your continual friendship for me. I have no motive whatever in asking this favor of you than that the picture be my own property and that I do it and send it to the Academy independently of all other considerations. I shall consider still (& of course) myself indebted to you a picture of a Heath . . ., or of any other subject you may like to prefer' (ibid., p.142). This, with a resultant squabble over the frame, just about terminated the friendship. The 'Helmingham', no.172 in the present exhibition, remained with Constable until his death.

The Leaping Horse

161 Sketch for 'The Leaping Horse' 1824–5

Oil on canvas 1294 × 1880 (51 × 74),
including extensions at top and right where
the original tacking edges were incorporated
in the picture surface
PROV: Artist's administrators, sold Foster 16
May 1838 (in 30, 'Two – Sketches of
Landscapes, *the pictures now in France*') bt in
by William Purton for the Constable family;
in C.R. Leslie's care until acquired, by 1853,
by D.T. White, from whom bt by Henry
Vaughan by 1862 and bequeathed to the
South Kensington (later Victoria and Albert)
Museum 1900
EXH: Tate Gallery 1976 (236, repr., with col.
detail opp. p.129)
LIT: Reynolds 1973, no.286, pl.216; Smart
and Brooks 1976, pp. 102–7, 139, pl.62;
Fleming-Williams 1976, p.86, fig.59; Hoozee
1979, no.451, pls.XLVIII (col.), L (col.
detail); Walker 1979, p.118, col. pl.33
(detail); Paulson 1982, p.123, fig.58;
Rosenthal 1983, pp.162–6, figs.195 (col.
detail), 201 (col.); Fleming-Williams and
Parris 1984, pp.23, 44–5, 47, 53–4;
Heffernan 1984, p.75, pl.7; Reynolds 1984,
no.25.2, pl.573 (col.); Cormack 1986,
pp.167–9, pl.164 (col.); Rosenthal 1987,
pp.144–6, pl.135 (col.); Rhyne 1990b, p.72

*Board of Trustees of the Victoria and Albert
Museum, London*

See no.162

162 The Leaping Horse 1825, exh.1825

Oil on canvas 1422 × 1873 (56 × 73¾),
including extensions made by incorporating
the original tacking edges in the picture
surface and by adding a separate 64 mm (2½
in) strip at the top
PROV: ? Artist's administrators, sold Foster
16 May 1838 (35, 'River Scene and Horse
Jumping') bt Samuel Archbutt, ? sold
Christie's 13 April 1839 (97) bt in; . . .;
William Taunton, sold Christie's 16 May
1846 (42) bt in, sold Christie's 27 May 1849
(111) bt in; . . .; Charles Birch, sold Christie's
7 July 1853 (41) bt Gambart; . . .; Charles
Pemberton 1863; . . .; Charles Sartorious,
whose wife (later Mrs Dawkins) presented it
to the Royal Academy 1889

EXH: RA 1825 (224, 'Landscape'); Tate
Gallery 1976 (238, repr.); *Zwei Jahrhunderte
Englische Malerei*, Haus der Kunst, Munich
1979 (353, repr. in col.); *Royal Academy
Retrospective*, RA 1982 (7); *Paintings from the
Royal Academy: Two Centuries of British Art*,
USA touring exh. (International Exhibitions
Foundation, Washington) 1983 (32, repr. in
col.); Madrid 1988–9 (55, repr. in col.)
LIT: Smart and Brooks 1976, pp.102–7, 139,
pl.60; Fleming-Williams 1976, p.86, fig.60;
Hoozee 1979, no.452, pls.IL [XLIX] (col.), LI
(col. detail); Walker 1979, pp.116–8, col.
pls.32, 34 (detail); Paulson 1982, pp.122–4,
132, 133, fig.57; Rosenthal 1983, pp.162–70,
245 n.71, figs.202 (col.), 203 (col. detail), 205
(col. detail); Heffernan 1984, p.75; Reynolds
1984, no.25.1, pl.572 (col.); Cormack 1986,
pp.167–9, pl.165 (col.); Rhyne 1987, pp.56–
8, figs.3–4; Rosenthal 1987, pp.144–7,
pls.136, 137 (col. detail); Rhyne 1990b,
pp.72, 79; Fleming-Williams 1990, pp.198,
295, figs.188, 270 (detail)

Royal Academy of Arts, London

The sixth and last of Constable's big Stour scenes,
'The Leaping Horse' (no.162) is one of the most
powerful of his set-pieces. Yet with only one other
large picture, his 'Waterloo Bridge', does he appear
to have experienced greater difficulty: 'no one
picture ever departed from my Easil with more
anxiety on my part with it', he told Fisher just after
he had sent the painting to the Academy (8 April
1825, Beckett VI 1968, p.198).

The subject he chose, yet again the traffic on the
Stour, was this time sited some distance upstream
from Flatford. The scene was the Float Jump, so
frequently referred to in the Stour Commissioners'
Minutes as in need of repair (see p.118). From here
the course of the old river left the navigable Stour
(to rejoin it further down), while continuing to
serve as the boundary between Essex and Suffolk.
It was Attfield Brooks who first realised that the
horse and rider in the picture were jumping from
the one county into the other, from Essex into
Suffolk (Smart and Brooks 1976, p.105). The jump
itself was a wooden barrier built across the tow-
path at a height – three feet – sufficient to prevent
cattle from straying, but low enough to allow a
barge-horse to leap over it.

In his imagination, Constable viewed the scene
from the south, the Essex bank, looking north-
eastwards, across a bend in the river towards
Flatford. It is necessary to bear this orientation in
mind, for in the final painting (no.162), on the
extreme right, Constable painted the tower of
Dedham church, which from this viewpoint would
have been behind the spectator. This topographical

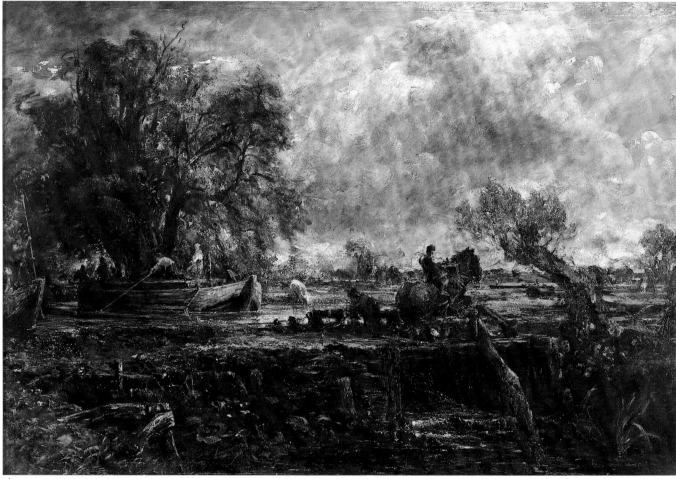

161

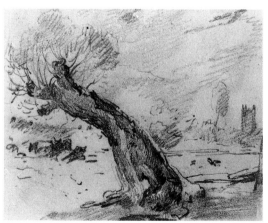

fig.81 'A Willow Stump', ?1821, *Courtauld Institute Galleries*

misplacement, like one or two other things in the final painting, is a survival from the original source-work, a small undated pencil sketch taken from a spot on the north bank of the river (fig.81, Courtauld Institute Galleries, Reynolds 1984, no.21.14). This drawing is essentially a study of an old pollarded willow, a tree so old that the end of a rail low down on the right can be seen protruding through into its hollow interior. The rest has been lightly sketched in: cattle on the opposite bank; the tower of Dedham church; and a bird, almost certainly a moorhen, flying away low over the water. The willow is a prominent feature in what is considered to be the first of the two pen and wash compositional studies (no.313). The tree appears again in the full-size oil sketch (no.161) and it was similarly placed in the final painting when that was shown at the Academy in 1825. Constable recorded its removal in his journal for 7 September: 'Got up early – set to work on my large picture took out the old willow stump – by my horse which has improved the picture much – almost finished made – one or two other alterations' (Beckett 11 1964, p.385). However, he could not bring himself to take the willow out altogether, so left the trunk as if cut across horizontally a foot or so above ground with the rail still visibly piercing its side.

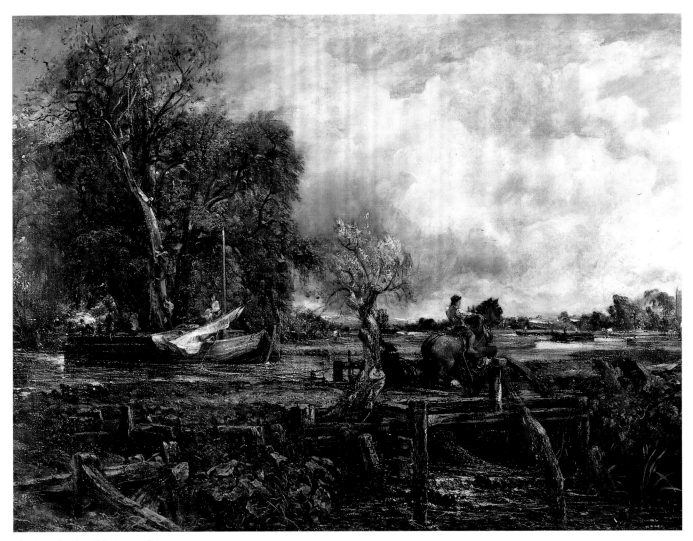

162 (see also detail facing p.283)

When Constable made the first of his two pen and wash preparatory compositions (no.313), the scene as he conceived it was to consist of two barges manoeuvring past the Float Jump, the first getting under way with its horse and rider moving on down the tow-path after negotiating the jump, and with the other barge (just coming into the picture) waiting for its horse to be ridden over the barrier. Though vigorously executed, the work portrays movement in suspension or in balance. Drawn almost entirely with the brush and powered by an even fiercer creative drive, the next composition (no.314) contains a number of changes. The second barge (now with a mast) is downstream; the sky is wild; the horizon broken; the willow, now upright, is more to one side to make way for the horse, now an heroic, prancing steed. At the next stage, in the full-size oil sketch (no.161), the horse is no longer riderless; now, with its 'leader' urging it over the jump, we have an image of a monumental character. Kenneth Clark called this introduction a stroke of genius. Constable, he wrote, 'must have recognised unconsciously that the horse on its high,

architectural base was like an equestrian monument; and so in the final version this rustic episode takes its place at the end of that long line of heroic commanders on prancing horses which began with Leonardo da Vinci's monument to Francesco Sforza' (*Looking at Pictures*, 1960, p.120). In the final painting, no.162, the horse reminds one of one of the greatest equestrian portraits, Velasquez's 'Count-Duke Olivares on Horseback' (Prado, Madrid), in which the Duke's mount is also leaping away at an angle from the viewer. This has been compared with an earlier engraving by Antonio Tempesta of Julius Caesar on horseback (J. Brown, *Velasquez*, 1950, p.127, pls.146–7). In one of his earliest surviving letters Constable tells his friend J.T. Smith that he had 'lately copied Tempesta's large Battle' (16 Jan. 1797, Beckett II 1964, p.8). Was it a memory of this copy that gave Constable the idea for his leaping horse? A cavalryman on a prancing steed was almost de rigueur in such battle scenes.

Constable had told Fisher that he was planning a large picture on 17 November 1824. The Arch-

deacon had suggested that he might diversify the subject of his next big picture 'as to *time of day*. Thompson [sic] you know wrote, not four Summers but *four Seasons*. People are tired of Mutton on top Mutton at bottom & mutton at the side dishes, though of the best flavour & smallest size' (Beckett VI 1968, p.180). 'I regard all you say', Constable had replied, 'but I do not enter into the notion of variing ones plans to keep the Publick in good humour – subject and change of weather & effect will afford variety in Landscape ... I imagine myself driving a nail. I have driven it some way – by persevering with this nail I may drive it home – by quitting to attack others – ⟨it⟩ though I amuse myself. I do not ⟨get⟩ advance them beyond the first – but that particular nail stands still the while' (ibid., p.181). His next reference to the work (in a letter to Fisher of 17 December) is brief – 'I am putting a 6 foot canvas in hand' (ibid., p.187) – but he does not seem to have really started work on the painting until after Christmas. In a letter of 5 January 1825 he says he is writing in the dark 'before a six foot canvas – which I have just launched with all my usual anxieties it is a canal scene – my next shall contain a scratch with my pen of the subject' (ibid., p.190). His next letter contains a description of the subject, perhaps in lieu of the promised 'scratch': 'the large subject now on my Easil is most promising and if time allows ⟨it⟩ I shall far excell most of my other large pictures in it. it is Canal. and full of the Bustle incident to such a scene where four or five boats are passing in Company with dogs. Horses boys & Men & Women & Children. and best of all old timber-props, Water plants. Willow stumps. sedges old nets &c &c &c' (ibid., p.191).

Constable made a number of alterations while working on both no.161 and no.162. Some pentimenti are visible to the naked eye; others are revealed by x-radiography. In the centre of the sketch, for example, at one stage there appears to have been a willow leaning slightly to the right, like the one in the final painting. At one time several features, now only seen in the sketch, were duplicated on the other canvas: the barge appearing on the left, the port bow of the other barge; the sloping pole (for which Constable substituted the gaff of the sail); the cow at the water's edge, etc. X-radiography in addition reveals in no.162 the figure of a man standing in the middle of the barge and a sail, the height of the church tower, to the right of the now vanished willow-stump. In the first edition of the *Life*, Leslie says that Constable made two large sketches of the subject, each on a six-foot canvas, one of which, he believed, was intended to be the picture 'but was afterwards turned into a sketch' (1843, p.51, but omitted from the 1845 edition). There is a confusing duality in these two works and one possible source of Constable's anxiety about the outcome may have been the difficulty he had in deciding on which horse, as it were, he should place his money. In the

end he was not satisfied when he sent no.162 to the Academy: 'it is a lovely subject', he told Fisher, 'of the Canal kind ⟨but⟩ lively – & soothing – calm and exhilarating. fresh – & blowing. but it should have been on my easil a few weeks longer' (Beckett VI 1968, p.198).

Another source of the trouble Constable had with 'The Leaping Horse' appears to have been a lack of material from which to work. Usually, for these reconstructed scenes on the Stour he was able to refer to the mass of drawings and oil sketches he had made during his Suffolk years. The Float Jump and the bridge over the sluice were familiar enough ground, for this stretch of the tow-path had been part of his daily walk to school as a boy. But as far as we know he had never sketched the place and was therefore relying entirely on his powers of recall and invention when, fired by the little sketch of the willow (fig.81 on p.294), he began to compose the reciprocal views, the pen and wash drawings, nos.313–14. The barges presented no difficulty. He had drawn and painted these vessels from every angle often enough. For part of the timber-work in the foreground he was able to turn to a page in his little sketchbook of 1813 (p.76 of no.247). But in the two wash compositions and the full-size oil sketch he had again roughed out a group of massive trees in the background, apparently with no working drawings in view, and when it came to the final painting, no.162, as Michael Rosenthal has pointed out (1983, p.245 n.71), to achieve the desired degree of credibility, he had to resort to the study he had made in 1817 (no.281) for the reworking of his 'Flatford Mill' (no.89), thus transplanting a tree from its rightful position a mile or two downstream.

Constable's description of the painting in a letter in August 1825 to Francis Darby, a potential buyer, may serve as a reminder that some of the clues to an understanding of a work such as this may have to be sought out with care. 'Scene in Suffolk – banks of a Navigable River – barge Horse leaping on an old Bridge. under which is a ⟨sluice⟩ flood Gate and an Eli bray. river plants and weeds – a more-Hen frighten from her [? nest] – near by in the meadows is the fine Gothic tower of Dedham.' (Beckett IV 1966, p.97.) 'Eli bray' or elibray is probably local vernacular for an eel-trap (OED: 'Eelery ... A place where eels are caught'). Trailing in the sluice, under the bridge, can be seen a net (see above, the letter of 5 Jan. 1825), almost certainly set to trap eels. (On the near bank of 'View on the Stour', fig.66, Constable painted an eel-spear, sometimes mistaken for a hay-rake.) In the British Museum and the family collection there are four oil studies of a moorhen, comprising six views of the bird in the same attitude, running with its wings outstretched (Reynolds 1984, nos.24.84–24.87). From one of these Constable painted the moorhen in the bottom right-hand corner of no.162; the bird startled from its nest, Constable seems to be telling us, by the thunder of hoofs on the wooden bridge

overhead. Freshwater fishermen and anyone who has walked beside inland waters in this country will be familiar with the alarm cry, a startling sound, of the disturbed moorhen as it flies away from the intruder. This Constable probably heard when he made his pencil study of the hollow willow stump (fig.81 on p.294) and perhaps wished to recapture by painting the bird in 'The Leaping Horse'. When telling Fisher of the things he loved, with willows and old rotten banks, Constable listed the 'sound' of water escaping from mill dams and 'slimy' posts and brickwork (Beckett VI 1968, pp.77–8). For him landscape was a total experience – aural and tactile as well as visual – and if we are to read him aright, and fully, we should be on the lookout for evocations of sound. In another letter to Fisher he breaks off to write: 'I at this moment – hear a rook fly over my painting room in which I am now writing – his ⟨voice⟩ call – transports me to Osmington and makes me think for a minute that I am speaking and not writing to you – it reminds me of our happy walks in the feilds – so powerful is the voice of Nature – yet it was only a smal still voice – and that for once' (ibid., p.217). In his next he returns to this. 'Were you at all struck by my sobbing rook? His caw – (happening at the moment of writing to you) made me start: it was a voice which instantaneously placed my youth before me' (ibid., p.219).

Here, in 'The Leaping Horse', with its squawking moorhen bringing to our notice the cause of its flight, the thundering hoofs, Constable is endeavouring to extend our experience of landscape. There are similar evocations in other paintings: in 'The Hay-Wain' (no.101) the boy in the cart calling out to the dog, and in 'The Cornfield' (no.165) the sheepdog glancing up at the sound of clapping wings. Michael Rosenthal writes about the totality of experience to be gained from Constable, who, he feels, in 'The Leaping Horse' is attempting 'to transmit pictorially the sensations, the flux of shifting lights, the feel of the wind, the shifts in perception caused by actual bodily movement, of being outdoors' (1983, p.166).

The Cornfield

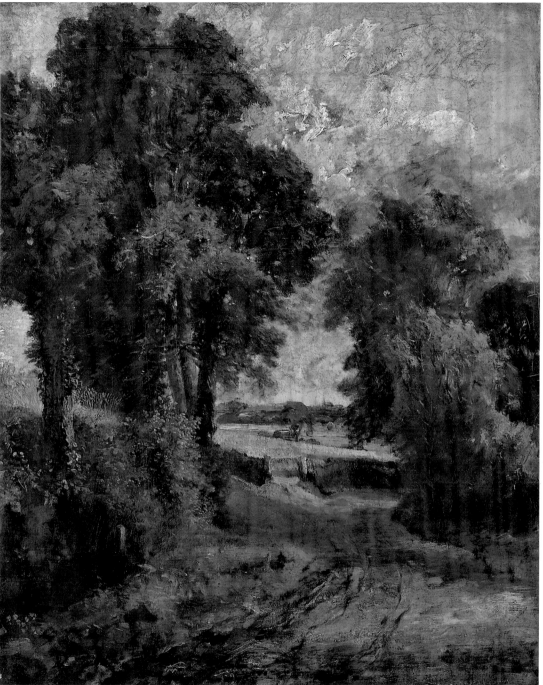

163

163 A Cornfield ?1817

> Oil on canvas 597 × 492 (23½ × 19⅜)
> PROV: By descent to Isabel Constable, who
> died 1888; her heirs, sold Christie's 17 June
> 1892 (244) bt Gooden; . . .; James Orrock; . . .;
> T.W. Bacon 1895; by descent to present
> owner
> EXH: New York 1983 (22, repr. in col.)
> LIT: Smart and Brooks 1976, pp.108, 112,
> pl.67; Hoozee 1979, no.466, repr.; Reynolds
> 1984, no.26.2, pl.612 (col.); Cormack 1986,
> p.176, pl.171
>
> *Private Collection (on loan to Birmingham
> Museums and Art Gallery)*

Hitherto it has been the accepted opinion that
no.163 is a preparatory study for 'The Cornfield'
(no.165), Constable's main exhibit in the Academy
of 1826. The probable dating given here, 1817, and
the consequent reassessment of the relationship of
the painting with the final work is based on two
lines of reasoning.

Firstly, on content. To bring to life on a large
canvas recollections of his native Suffolk, Con-
stable always needed some remembered or re-
corded incident, a simple, everyday occurrence
involving figures: the loosening of a tow-rope as
barges were poled under a bridge (no.89), children
intent on their fishing (no.57), a hay-cart at a ford
(no.101), or, in the case of 'The Cornfield', a
shepherd boy with a flock of sheep, drinking at a
spring, while beyond preparations are being made
for harvesting a field of wheat. Sometimes
Constable seems to have worked out the compo-
sition for one of his big set-pieces for the first time
on a full-sized, six-foot canvas (e.g. the Royal
Holloway College sketch for 'View on the Stour'),
at other times to have composed initially on a much
smaller scale (e.g. fig.67 on p.203), but in every
instance, from the very beginning, the occurrence,

whatever it was, formed an integral part of the
composing process. It therefore seems unlikely that
no.163, a landscape altogether devoid of incident,
could have been intended as a preparatory study
specifically for 'The Cornfield', although at the
time Constable doubtless hoped to find a good use
for it.

The second line of reasoning that leads us to
revise the date of no.163 concerns the nature of the
work. It shares many of the characteristics of 'East
Bergholt Church from the South-West' (no.90),
'Fen Lane, East Bergholt' (no.91) and 'Dedham
Lock and Mill' (no.93), works proposed earlier in
this catalogue as examples of the 'painted sketches'
Constable showed Farington after his ten weeks in
Suffolk in 1817. As in these, parts of no.163 are
rendered in great detail while the rest is summarily
brushed in. As we can see in the Melbourne 'Boat
Passing a Lock' (no.159), it appears to have been
Constable's practice to bring a painting to a finish
piecemeal, after having worked broadly over the
whole canvas; that is, to create levels of credibility
at two distinct stages. During his stay with Maria at
Bergholt in the summer of 1817, with the sale of the
family home planned for the following year,
Constable would have been fully aware that this
might be his last long look at his native scenes. The
character of the three works mentioned above and
of no.163 suggests that it became his policy that
summer to collect as much material as possible for
future use rather than try to complete pictures on
the spot.

Some of the changes visible in the composition
of no.163 may have been made in 1826, when
Constable decided to use it as the basis for a new
large painting – 'The Cornfield'. Originally some-
what larger, the trees on the right appear to have
been overpainted with sky to reduce their bulk and
render them as a more obviously subordinate
group, so as to achieve a finer balance with the
larger mass at the left.

164 Sketch for 'The Cornfield' *c.*1826

Oil on canvas 330 × 208 (13 × 8³⁄₁₆)
PROV: ? Artist's administrators, sold Foster
16 May 1838 (in 14, 'Two – The Cornfield; *a
study from nature, for the picture in the
National Gallery*, and Salisbury from the
Meadows') bt Radford; . . .; private
collection, London; . . .; George Eames,
Boston, Mass.; . . .; Dr G.H.A. Clowes,
Indianapolis
EXII: New York 1988 (25, repr. in col.)
LIT: Hoozee 1979, no.692 (rejected work),
repr.

*Indianapolis Museum of Art, The Clowes Fund
Collection*

Originally rejected by some scholars, in his cata-
logue of the 1988 New York exhibition Rhyne
convincingly argues the case for no.164 being an
autograph work by Constable and probably the
painting described above as part of lot 14 in
Foster's 1838 sale. Although some of the handling
is unusual – the swirl of knife-work in the sky and
some of the wriggled impasto – there seems to be a
reasonable enough case for accepting this as a
preliminary sketch by Constable for the painting he
exhibited in 1826, no.165.

A great many copies exist of the National
Gallery picture, which was available for students to
work from at the Gallery. During the 1870s and
1880s up to ten copies are recorded as being made
annually (see Fleming-Williams and Parris 1984,
p.87). But, as Rhyne points out, correspondences
between no.164 and the larger sketch, no.163 – the
vigorous tree at the left, for example, and the
sunlight crossing the lane from the right, neither of
which feature in the final painting – obviate any
possibility that no.164 derives from the National
Gallery picture. The turning up of all the tacking
edges of the canvas to expand the surface available
for painting no.164 is also, as he says, typical of
Constable.

In Rhyne's opinion no.164 is a sketch made on
the spot, direct from nature. This is not a view
shared by the present authors, whose reasons for
dating the work later, *c.*1826, and seeing it as a
studio work, a compositional study, are bound up
with the revised dating and reassessment of the
larger sketch, no.163, hitherto regarded as a studio
composition.

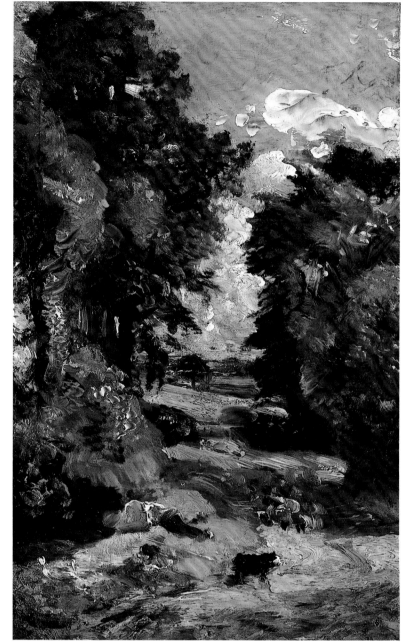

164

165 The Cornfield 1826, exh.1826

Oil on canvas 1430 × 1220 (56¼ × 48)
Inscribed 'John Constable. f. London. 1826.'
b.r.
PROV: Artist's administrators, from whom bt
by a body of subscribers for presentation to
the National Gallery 1837 (130)
EXH: RA 1826 (225, 'Landscape'); BI 1827
(101, 'Landscape; Noon', frame size 70 × 63
in); Salon, Paris 1827–8 (219, 'Paysage avec
figures et animaux'); Birmingham Society of
Arts 1829 (122, 'Noon'); Worcester
Institution 1835 (50, 'Harvest – Noon; a
Lane Scene'); Tate Gallery 1976 (242, repr);
New York 1983 (23, repr. in col.)
LIT: Smart and Brooks 1976, pp.107–19,
pl.IV (col.), fig.64 (detail); Hoozee 1979,
no.467, pls.LIII (col.), LIV (col. detail);
Paulson 1982, pp.109–10, fig.48; Rosenthal
1983, pp.174–9, figs.206 (col.), 208 (col.
detail); Fleming-Williams and Parris 1984,
pp.9–10; Heffernan 1984, pp.98–101, pl.20;
Reynolds 1984, no.26.1, pl.611 (col.);
Cormack 1986, pp.176–8, pls 169 (col.), 170
(col. detail); Rosenthal 1987, pp.156–7,
pl.142 (col.)

Trustees of the National Gallery, London

Constable had intended the 'Waterloo' (see
nos.212–13) to be his main exhibit at the Academy
of 1826 and – most unusually for him – by October
of the previous year he was already at work,
outlining the subject on the canvas. But progress
was slow. There were commissions to attend to,
and a week after assuring Fisher that the Waterloo
'shall be done for the next exhibition' (12 Nov.
1825, Beckett VI 1968, p.206), he confessed that he
was 'so hard run in every way' that he knew not
'which canvas to go to first', and the Waterloo 'like
a blister' began to stick closer and closer and to
disturb his nights (ibid., p.207). Eventually, the
necessity to complete his commissions proved too
great and on 14 January 1826 he told Fisher that his
'large picture was at a stand' (ibid., p.212). This left
him with only two-and-a-half months in which to
paint a successor to 'The Leaping Horse', his main
exhibit of the previous year (no.162). After a letter
to Fisher in which he said he was greatly distressed
for a sketchbook or two he had lent him, all
outgoing correspondence apparently ceased. 'My
picture occupied me wholly', Constable later said
of this period, 'I could think of and speak to no one.
I was like a friend of mine in the battle of Waterloo
– he said he dared not turn his head to the right or
left – but always kept it straight forward – thinking
of himself alone' (ibid., p.217).

The scene Constable chose to depict was again a
familiar one, a bend in Fen Lane, the path he had
walked as a boy so often on his way across the valley
from East Bergholt to his school in Dedham. This
was an inland view, a break in the succession of big
canal scenes. The subject he chose was also new, a
small flock of sheep being driven down the lane by a
shepherd boy and his dog. The time of year was
July or August, when the wheat was being prepared
for harvesting; the hour, noon; the moment, a halt
in the drive while the boy slaked his thirst at a
spring. Constable titled the work just 'Landscape'
when it was shown at the Academy; he later
referred to it as the 'Drinking Boy' (Beckett IV
1966, p.404).

For each of his big canal pictures, as we have
seen, Constable had rehearsed the composition on a
full-size canvas. In the case of 'The Leaping Horse'
(no.162), his exhibit of the previous year (1825),
this had led to difficulties for the concept had
twinned at the outset (see nos.313–14) and conse-
quently the process of resolution was unusually
prolonged. He was still working on the canvas in
October, when he had already started on the
'Waterloo'. It was probably to avoid a repeat of
such a struggle that, for his main 1826 exhibit, he
finally chose a more conventional composition and
provided himself with a richer store of reference
material to work from, thus removing the necessity
for a full-size sketch. In the oil sketch of Fen Lane,
no.163, he had a composition almost ready-made, a
vista framed by a Claudean balance of unequal
masses, a design he had used in one of his 1802
studies (no.2) and to which, much later – in 1816 –
nature herself had responded (no.47). The subject,
the drinking boy, he found in one of his earlier oil
sketches from nature, no.46, a view of the same
lane, it has been suggested (Smart and Brooks
1976, pp.107–8), but further down, where the
ground levels off (Parris 1981, p.58). The boy
figures large in the little compositional sketch,
no.164, larger in proportion to the whole than in
the final work, which suggests that in introducing
him there Constable was reliving old memories. On
his own, however, the boy would not have been
enough. Graham Reynolds has pointed out that in
the BI exhibition of Old Masters in 1822 Constable
would have seen Gaspard Poussin's 'Landscape
near Albano' (National Gallery), in which a
shepherd is seen leading sheep out into sunlight
from a shady lane, and that the idea of putting his
boy in charge of a similar flock stems from that
painting. This is quite possible. Constable cer-
tainly noted one of the Gaspards in the exhibition
as he wrote scathingly of a copy by Thomas
Hofland as being 'nothing more like Gaspard than
the shadow of the man like himself on a muddy
road' (Beckett VI 1968, p.101).

An important departure in the final painting
from both the 1817 study (no.163) and the little
compositional sketch (no.164) was the substitution
of a very different tree for the one on the left in the
two previous paintings. In the 1817 study he had
detailed part of the tree trunk and the headland of
wheat beyond, but the study provided insufficient
information about the rest of the tree and here a
strong, convincing image was required. He there-
fore turned to a surprisingly early work, another
upright, the Toronto 'Edge of a Wood' (no.1), in
which he had painted a tree of a singular character,
an oak that had been pollarded some years before

and from the swollen head of which stout new branches had grown. This tree, with a few changes, he reproduced on the big canvas in great detail, in places branch for branch. A major change was the removal of the limbs that in the Toronto painting grew from the right of the tree out into the picture. One detail, however, remained, the pigeon that in no.1 is to be seen flying up almost among the leaves (fig.17 on p.57). In the final painting, no. 165, the bird is similarly placed but this time it is flying with a purpose, to join its mate, hardly visible among the shadows of the elms (fig.82). His stock of earlier studies was raided for additional material: an early study in oil of two ploughs (Victoria and Albert Museum, Reynolds 1973, no.136, pl.96) for the one just under the hedge by the bend in the lane, and another oil sketch, difficult to date, of a donkey and her foal (Victoria and Albert Museum, Reynolds 1984, no.26.3, pl.613) for the pair in the shadows by the spring. For the rest – the dog glancing up in the direction of the pigeon (perhaps at the sudden sound of clapping wings), the sheep, the gate, etc. – there are no known studies.

The painting was completed in good time and on 8 April 1826 Constable was able to write to Fisher to tell him about it, first apologising for having 'remained so long silent'. 'I have dispatched', he wrote, 'a large landscape to the Academy – upright the size of my lock [no.158] – but a subject of a very different nature – inland – cornfields – a close lane – kind of thing – but it is not neglected in any part the trees are more than usually studied and the extremities well defined – as well as their species [?stems] – they are shaken by a pleasant and healthful breeze – "*at Noon*" – "while now a fresher gale, *sweeping with shadowy gust the feilds of corn*" &c &c ... I am much worn, having worked very hard – & have now the consolation of knowing I must work a great deal harder. or go to the workhouse. I have however work to do – & I do hope to sell this present picture – as it has certainly got a little more eye-salve than I usually condesend to give to them' (Beckett VI 1968, pp.216–17).

When he wrote to Fisher next, on 26 April (ibid., pp.220–1), Constable was busy at the Academy as it was one of the Varnishing Days. He thought it a delightful show. 'Turner never gave me so much pleasure – and so much pain – before.' In this letter he talks of Chantrey, the sculptor, coming upstairs making jokes, painting on his, Constable's, pictures and ending up by throwing a dirty palette rag in his face. Lucas retells Constable's account of the incident in his annotated first edition of Leslie's *Life*: 'When the picture of the Corn field was at Somerset house previous to the opening of the exhibition Chantry came up and noticing the dark shadows under the tails of the sheep. suddenly said why Constable all your sheep have got the rot give me the pallet I must cure them his efforts made all worse when he threw the pallet [rag] at Constable and ran off' (Parris, Shields, Fleming-Williams 1975, p.59).

The most favourable review of the painting appeared in the *Examiner* for 2 July over the initials 'R.H.' – i.e. Robert Hunt, elder brother of the editor, Leigh Hunt. There it was commended for its 'saphire sky and silver clouds, its emerald trees and golden grain, its glittering reflexes of sun-light among the vegetation; in fine, its clear, healthful, and true complexion, neither pale, nor flushed, nor artificial'. But it did not sell. So, as was his custom, Constable sent it to the British Institution the following January, renamed it 'Landscape; Noon' and in the catalogue quoted Thomson's lines from *Summer* (1654–6) that he had misremembered in his letter to Fisher of 8 April:

> A fresher gale
> Begins to wave the woods and stir the stream,
> *Sweeping with shadowy gust the fields of corn*

disregarding the fact that they were part of Thomson's description of 'sober Evening'.

Still hopeful of a sale, Constable exhibited the painting three more times: as 'Paysage avec figures et animaux' at the Paris Salon in 1827; at the Birmingham Society of Arts in 1829 as 'Noon'; and, repenting perhaps the brevity of the last title, as 'Harvest – Noon; a Lane Scene' at the Worcester Institution in 1835. The painting remained unsold until 1837, when, some months after the artist's death, it was bought for £315 by a body of well over a hundred subscribers, admirers of his work (among them Wordsworth and Faraday), for the National Gallery. It was formally accepted as a gift by the Trustees on 9 December – the first Constable to enter the national collection.

Second only to 'The Hay-Wain' in popularity, no.165 has suffered somewhat from its status as a national icon. Because it has been reproduced endlessly – on paperweights, biscuit-tins and even on thimbles – when confronted by the original it is sometimes difficult to allow the painting to speak for itself and to see it for what it is, partly a display of remarkable power and technical skill, but essentially a work of considerable beauty. Charles

fig.82 Detail from no.165

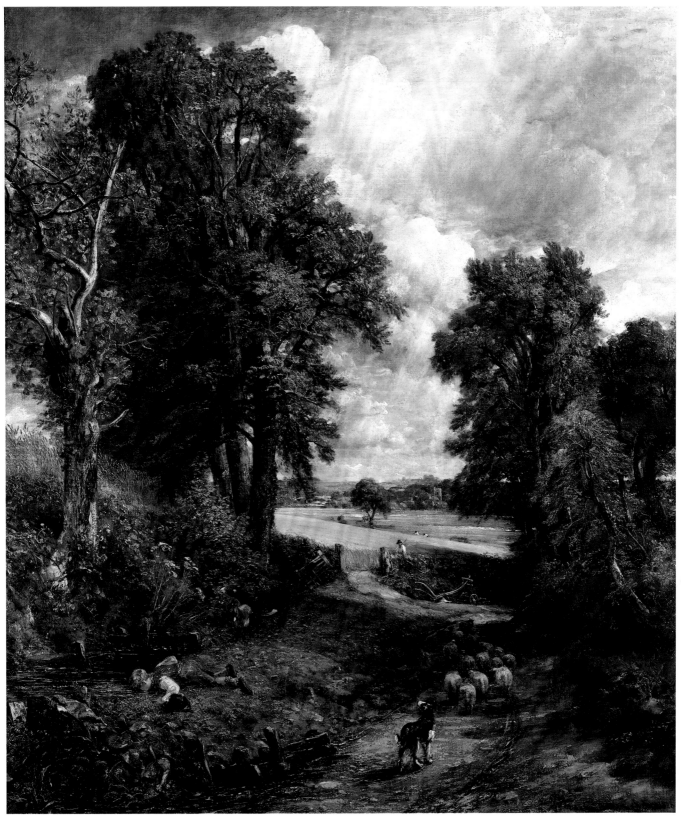

165

Holmes was one of the first to appreciate its importance in the artist's oeuvre and, as a painter himself, singled out for comment its 'technical orchestration'. 'The picture', he wrote, 'is in itself practically an epitome of Constable's practice at its very best, where every device of solid and transparent painting, of scumbling and glazing, of pats with a palette-knife and delicate touches with a fine sable, are perfectly blended and harmonised' (*Constable and his Influence on Landscape Painting*, 1902, p.94). For many years after this, although remaining a popular favourite, little more than lip service was paid to the painting. This may have been partly due to to the difficulty writers experienced in finding anything to say about it. Since 1975, however, there have been a number of interpretive attempts by authors who were convinced that there were hidden meanings to be discovered in the picture.

Karl Kroeber, in his *Romantic Landscape Vision: Constable and Wordsworth* (1975, pp.31–4), recognised the difficulty, but reasoned that this arose in part from Constable's 'diffusion of focus: no one element dominates others'. However, in the progression from foreground to background, from the boy to the man at the gate, the labourers and on to the distant church – 'the foreground-to-background line of humanity' – Kroeber saw the 'diagonal progression from youth to the hope of life beyond death within the context of nature' as 'almost too contrived', overlooked by critics 'only because Constable complicates and enriches its stark directionality'. In *Literary Landscape: Turner and Constable* (1982), Ronald Paulson accepted the notion of the 'unbroken progression from foreground to distance' and that the signposts, boy, farmer and distant church signified 'some such topos as the "Ages of Man"', but maintained that because of these metaphors the painting was an exception to the non-literary run of six-footers of Suffolk. James Heffernan in his book on Wordsworth, Coleridge, Constable and Turner, *The Re-Creation of Landscape* (1985), asks 'Just what is this carefully assembled configuration of elements meant to signify?' and in his answers suggests that the farmer at the gate is the mature Constable contemplating his own past – the boy drinking, the sheep and the dog, etc. – the picture being a Wordsworthian spot of time 'in which Constable represents himself in the very act of seeing again the boy he once was'.

These ingenious readings seem curiously at odds with Constable's own thoughts on a supposed allegory of The Life of Man, Ruisdael's 'Jewish Cemetery', which in his view was a failure 'because he attempted to tell that which is outside the reach of the art ... there are ruins to indicate old age, a stream to signify the course of life, and rocks and precipices to shadow forth its dangers. But how are we to discover all this?' (Beckett 1970, p.64).

Quite a new line was opened up on 'The Cornfield' with the publication of Michael Rosenthal's *Constable: The Painter and his Landscape* (1983), a line subsequently adopted by Malcolm Cormack in his *Constable* (1986) and propounded again by Rosenthal in his shorter *Constable* of 1987. Rosenthal has much to offer in his two books, not least because he was himself brought up in the area. He quite rightly stresses Constable's debt in the painting to Gaspard, Gainsborough and Claude (even by seeing in the drinking boy a possible oblique reference to the 'Narcissus' in the National Gallery). But his main purpose in writing about 'The Cornfield' is to point to evidence he finds in the work that in effect the artist has turned his back on reality, to create an 'illusory countryside'. He presents his evidence as a series of wilful improbabilities, starting with the drinking boy, 'a figure not only improbable, but potentially disastrous. Constable', he says, 'knew enough about border collies to know that this one would not continue driving its flock towards a cornfield.' 'Were this illusory countryside real,' he continues, 'that dead tree would be down; wheat would not grow to the edge of the field as the crop to the left does; the donkeys would be tied up; neither, at harvest-time, would the sheep look unshorn, nor be heading towards a field where the gate is not just open, but off its hinges'. Rosenthal concludes with the observation that one departing figure with a stick, not a sickle, leaving two men at work, represents a totally inadequate workforce to cut the corn. Cormack, assuming the validity of the evidence, takes much the same line in his book: the sheep 'who would surely have been shorn by July, are disastrously close to wandering in the cornfield, if the dog and the boy do not soon remember their duties. The field itself is without a proper hinged gate', and so on. 'Constable seems to have forgotten his earlier beliefs in convincing realistic figures.' In his second book, Rosenthal pursues much the same line: 'A shepherd would not abandon a flock, which looks unshorn at harvest, which is carried out by only two, not the usual crowds of figures', etc.

Before this somewhat debatable interpretation becomes established as the norm, perhaps one or two questions should be asked and some of the evidence re-examined. *Has* the boy abandoned his flock and is the situation so potentially disastrous? The heads of the sheep are down, so they are untroubled and moving slowly. Is the dog still driving them? If he was, *his* head would be down. Has he not paused, ears half-cocked, perhaps to call our attention to the pigeon? Might not the gate have been taken off its hinges to facilitate an easy passage for the wagons when they start to arrive? According to Mr William James, a sheep-breeder in Suffolk for many years, the unshorn state of the animals in the flock and their undersize indicate that they are lambs. They could have been recently weaned ready for sale at the annual Ipswich Lamb Fair held in August (see Arthur Young, *Agriculture of the County of Suffolk*, 1813, p.213), or they could be on their way down to the water-meadows which would have been let out to share for grazing. There would be little danger of their wanting to enter the cornfield (sheep know well enough where to find grazing) and the leading animal anyway is already

heading round the bend to the right. As has already been pointed out, the 'dead' tree on the left is a pollarded oak and surely not yet ready for the axe. When Constable painted no.163, the crop in the field on the left was growing very near to the edge, though not quite so well. Donkeys feature in many of Constable's paintings; in none are they depicted tethered. Lastly, the men at work on the far side of the field of wheat are what is known as 'flashing the brew', i.e. clearing around the headlands in preparation for the arrival of the full gang of harvesters.

The facts do not seem to be in agreement with the notion that in painting 'The Cornfield' Constable was turning his back on reality, on things as he knew them to be; quite the reverse, and if we were better acquainted with life on the land as it was lived in Suffolk in the early years of the nineteenth century, we would probably be able to appreciate still further the extent of the knowledge that went into the making of the picture. There is evidence on the surface of the canvas, moreover, that Constable went to extraordinary lengths to reach the level of realism he wished to achieve. Heavy impasto and a rough surface texture are characteristics of his late work. But hitherto in no picture had he gone to greater lengths with paint as a substance to achieve verisimilitude. In places, from close to, the results are quite startling. The handles and the beam of the plough, for example, are modelled rather than painted, shaped three-dimensionally almost like high relief in lacquer-work. Other parts, such as the stems and heads of wheat in the field on the left, are similarly treated – each stem a filament of stiff paint laid along the surface of the canvas. Were this an illusory country-side, while at work on the picture Constable would have had little need of the help he had plainly sought from his friend, the botanist, Henry Phillips, help with the correct plants to put in the foreground for the time of year he was depicting. Phillips sent him the following in a letter of 1 March: 'I think it is July in your green lane. At this season all the tall grasses are in flower, bogrush, bullrush, teasel. The white bindweed now hangs its flowers over the branches of the hedge; the wild carrot and hemlock flower in banks of hedges, cow parsley, water plantain, &c.; the heath hills are purple at this season; the rose-coloured persicaria in wet ditches is now very pretty; the catchfly graces the hedge-row, as also the ragged robin;

bramble is now in flower, poppy, mallow, thistle, hop, &c.' (Beckett v 1967, p.80). Bramble, poppy and cow-parsley, oak, elm and ash may be readily recognised in the painting; what else, one wonders, could the trained eye name?

It was Constable's son Charles Golding in a letter to the *Art Journal* in 1869 (p.118), who first published the location of 'The Cornfield' viewpoint. 'It was taken', he wrote, 'in the lane leading from East Bergholt (my father's native village) to the pathway to Dedham across the meadows, a quarter of a mile from East Bergholt Church, and one mile from Dedham Church, as the crow flies. The little church in the distance', he continued, 'never existed; it is one of the rare instances where my father availed himself of the painter's licence to improve the composition'. Attfield Brooks in the valuable book he wrote with Alastair Smart, suggested that the tower in the distance might be that of Higham church, a short distance upstream from Stratford St Mary. This is a possibility, though Higham lacks a stair-turret. The significance of this deliberate topographical misplacement by Constable (in fact a valuable visual stabilising element in the composition) has often been commented upon, sometimes detrimentally. Likewise, in an endeavour to find a key to a work that otherwise seems to evade explanatory analysis, some writers have seized upon part of a sentence in Constable's letter to Fisher of 8 April, from which a passage has already been quoted. He was troubled about his prospects, as he had recently lost his chances of selling on the French market. 'I am much worn,' he wrote, 'having worked very hard – & have now the consolation of knowing I must work a great deal harder. or go to the workhouse. I have however work to do – & I do hope to sell this present picture [no.165] – as it has certainly got a little more eye-salve than I usually condesend to give to them' (Beckett VI 1968, p.217). It is this talk of providing the public with 'a little more eye-salve' than he usually condescends to give that has raised a few eyebrows. Perhaps he felt he was addressing the public as his preferred poet, Cowper, in *The Task* (Book II, lines 203–5), bade those who doubted the power of God:

Go, dress thine eyes with eye-salve, ask of him,
Or ask of whomsoever he has taught,
And learn, though late, the genuine cause of all.

The Glebe Farm

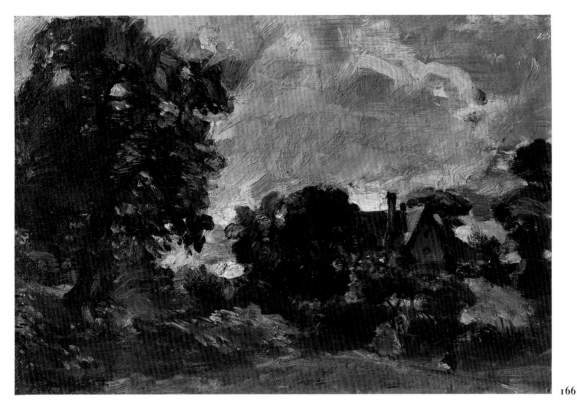

166

166 Church Farm, Langham (The Glebe Farm) *c*.1811–15

Oil on canvas 197 × 280 (7¾ × 11)
Inscribed 'JC' in monogram on the back
PROV: As for no.2
LIT: Reynolds 1973, no.111, pl.66; Hoozee 1979, no.141, repr.; Parris 1981, p.145, fig.1; Rosenthal 1983, p.180, fig.216; Cormack 1986, p.208, pl.194

Board of Trustees of the Victoria and Albert Museum, London

This oil sketch of Church Farm, Langham was the basis of the 'Glebe Farm' that Constable exhibited in 1827 (no.167) and subsequently repeated with variations (see no.168). Unlike the later paintings, the sketch is faithful to the topography of the place in not including Langham church, which is out of sight behind the farmhouse from this angle. The figure with a basket at the bottom right probably suggested the similar figure seen further along the path in the 1827 picture. See no.259, a drawing of Church Farm dated 1815, for comment on the date of no.166.

From close to the spot depicted here Constable painted many of his early views of Dedham Vale (see nos.17–19).

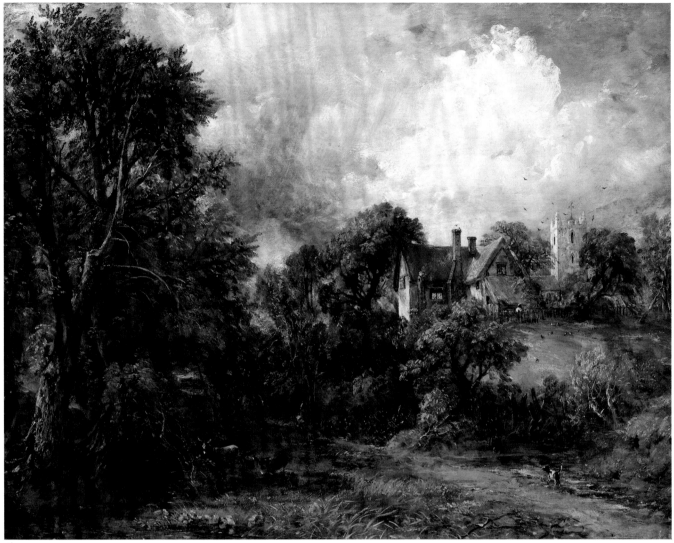

167

167 The Glebe Farm 1826–7, exh.1827

Oil on canvas 465 × 596 (18¼ × 23½)
PROV: Bt by George Morant at the 1827 BI
and sold Phillips 21 May 1832 (44) bt Wynn
Ellis, by whom sold Christie's 6 May 1876
(36) bt Agnew; . . .; Armstrong Heirlooms,
sold Christie's 24 June 1910 (47) bt
Tooth; . . .; Henry Reinhardt, Chicago, from
whom bt by Mrs Joseph B. Schlotman 1913
and given by her to the Detroit Institute of
Arts 1964
EXH: BI 1827 (314, 'The Glebe Farm', frame
31 × 37 in); New York, Bloomington,
Chicago 1987–8 (215, repr. in col.)
LIT: Hoozee 1979, no.478, repr.; Parris 1981,
pp.145–6, fig. 2; Rosenthal 1983, p.180,
fig.215; Reynolds 1984, no.27.7, pl. 637;
Parris and Fleming-Williams 1985, p.168,
under no.27.7; Rosenthal 1987, pp.163–6,
pl.153

*Detroit Institute of Arts, Gift of Mrs Joseph B.
Schlotman*

Constable decided to work up his Langham oil
sketch, no.166, into a picture after the death in 1825
of his old friend and patron Dr Fisher, Bishop of
Salisbury. Fisher had been appointed Rector of
Langham in 1790 while a Canon of Windsor and
continued to enjoy the living during his years as
Bishop of Exeter from 1803 to 1807. It was on one
of Fisher's visits to Langham, in 1798, that his
curate there, the Revd Brooke Hurlock, introduced
Constable to him. In his text to accompany the
'Frontispiece' to *English Landscape* (see nos.173–
80) Constable later described the meeting as one of
the events that 'entirely influenced his future life',
leading as it did not only to the Bishop's patronage
but also to Constable's great friendship with his
nephew Archdeacon John Fisher. It was to the
latter, in September 1826, that Constable first
wrote of his 'Glebe Farm' composition: 'My last
landscape [is] a cottage scene – with the Church of
Langham – the poor bishops first living – & which
he held while at Exeter in commendamus. It is one
of my best – very rich in color – & fresh and bright –
and I have "pacified it" – so that it gains much by

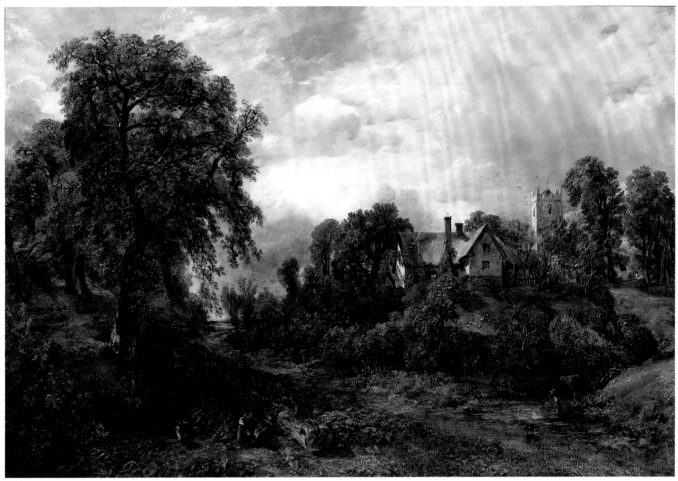

168

that in tone & solemnity' (Beckett VI 1968, pp.223–4).

Constable's description of the work as 'a cottage scene – with the Church of Langham' is apt since the two buildings were not visible together in the way he depicted them – as we have seen, the church does not appear in the original oil sketch, no.166. Constable had recently moved another church for pictorial effect in 'The Cornfield' (no.165). The height of the bank on which the farmhouse stands was also increased, creating a valley for the path to run through and making this another 'lane' picture: Constable was later to refer to the subject as the 'Glebe farm – or Green Lane' (Beckett III 1965, p.144). Again like 'The Cornfield', donkeys are shown browsing at the left of the lane, while a black and white dog enters towards the right. But the scale of the picture is, of course, very different from that of the great 1826 canvas. This, the first 'Glebe Farm', is a cabinet picture, intimate in character, picturesque in several senses of the word (as Rosenthal has suggested) and very pleasant on the eye. Constable had no difficulty in selling it on its first appearance at the British Institution in January 1827 and went on to paint other versions, including no.168 below.

Although in a public collection since 1964, no.167 has only been seriously noted in the Constable literature in the last ten or so years; its identification as the 1827 exhibit now seems beyond doubt.

fig.83 'The Glebe Farm', c.1830, *Tate Gallery*

168 The Glebe Farm *c.*1830

Oil on canvas 648 × 956 ($25\frac{1}{2}$ × $37\frac{5}{8}$)
PROV: Artist's administrators, sold Foster 16 May 1838 (70, 'The Glebe Farm *Exhibited* 1835') bt in by C.R. Leslie for John Charles Constable; by descent to Isabel Constable, by whom bequeathed to the National Gallery 1888 as the gift of Maria Louisa, Isabel and Lionel Bicknell Constable; transferred to the Tate Gallery 1919 (N 01274)
EXH: Worcester Institution 1835 (171, 'The Glebe Farm'); Tate Gallery 1976 (321, repr.)
LIT: Hoozee 1979, no.536, repr.; Parris 1981, no.37, repr. in col.; Rosenthal 1983, p.180, fig.218; Reynolds 1984, no.27.8, pl.639 (col.); Cormack 1986, p.208; Rosenthal 1987, p.163, pls. 155 (col.), 156 (col. detail)

Tate Gallery

This larger version of the 1826–7 'Glebe Farm' (no.167) widens the format, allowing the bank at the left to be more fully described and further trees to be included. The central valley is opened up and with it the distant glimpse of fields. Another small vista is opened up between the trees to the right of the church. In place of the donkeys Constable shows a girl with a pitcher resting beside the trunk of a cut-down tree. A cow now appears towards the bottom right in place of the dog. There are numerous other small changes.

The date of no.168 is not precisely known but it was this version that was published in *English Landscape* in July 1832 (fig.102 on p.321, Shirley 1930, no.29) and Lucas appears to have been asked to begin the plate the previous December (Beckett IV 1966, p.361). At that time an earlier plate, based on an unidentified sketch, was abandoned, subsequently to be changed into 'Castle Acre Priory' (Shirley 1930, no.22). The first plate had given trouble as early as August 1831 and Constable had then considered having it re-engraved using as the basis an unfinished painting of the subject which he had given to C.R. Leslie (ibid., p.351). Leslie's version, now also in the Tate Gallery (fig.83, Parris 1981, no.38, Reynolds 1984, no.27.9), appears to have been in existence by February 1830.

Because he had already exhibited a version of the subject (no.167) at the British Institution Constable would not have been allowed to show no.168 at the Royal Academy. He did, however, exhibit it at Worcester in 1835. Both George Constable of Arundel and John Sheepshanks tried to buy a 'Glebe Farm' from him, probably no.168 in both cases, but Constable seems to have hung on to the work. It was, he said, 'one of the pictures on which I rest my little pretensions to futurity' (Beckett III 1965, p.144).

Dedham Vale

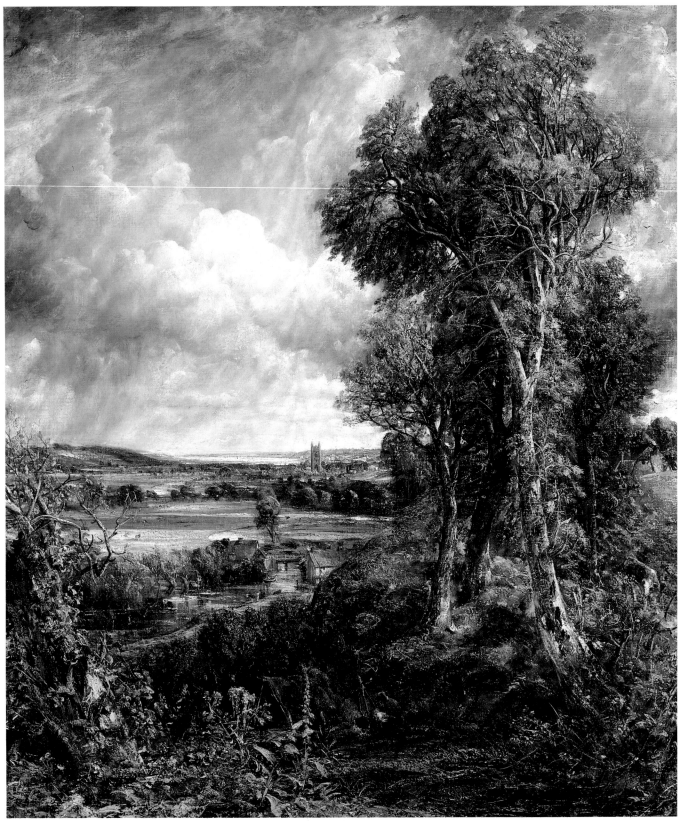

169

169 Dedham Vale ?1827–8, exh.1828

Oil on canvas 1450 × 1220 (57⅛ × 48)
Inscribed on a label on the stretcher 'No.1
Landscape John Constable 35 Charlotte
Street Fitzroy Square' (applied for 1828 RA)
PROV: Artist's administrators, sold Foster 16
May 1838 (75, 'View of Dedham, Suffolk;
Gipsies in the fore-ground Exhibited 1828') bt
Bone (? H.G. Bohn); ...; Sir John Neeld by
1877; by descent to L.W. Neeld, from whom
bt by the National Gallery of Scotland 1944
EXH: RA 1828 (7 or 232, both entitled
'Landscape'); BI 1834 (329, 'The Stour
Valley, which divides the Counties of Suffolk
and Essex; Dedham and Harwich Water in
the distance', frame 72 × 63 in); Royal
Hibernian Academy, Dublin 1834 (46, Land-
scape, morning, valley of the Stour, which
divides the county of Suffolk and Essex,
Dedham and Harwich, water in the
distance'); Worcester Institution 1835 (185,
'Valley of the Stour – Morning'); Tate
Gallery 1976 (253, repr., col. detail opp. p.161)
LIT: Smart and Brooks 1976, pp.119–24,
139–40, pls.74 (detail), 75; Hoozee 1979,
no.480, pl.LV (col.); Barrell 1980, pp.136–7,
repr.; Paulson 1982, pp.133, 155, 167, fig.69;
Rosenthal 1983, pp.186–90, 213, figs.213–14
(col. details), 219 (col.); Heffernan 1984,
pp.25, 27–9, pl.5; Reynolds 1984, no.28.1,
pl.677 (col.); Cormack 1986, p.186, pl.176
(col.); Bermingham 1987, pp.150–1, pl.6
(col.); Rosenthal 1987, pp.166–7, pls.157
(col. detail), 158 (col.); Rhyne 1990a, pp.116,
123, 129 n.64, fig.12

National Galleries of Scotland, Edinburgh

When Constable first painted this subject in one of
his 1802 studies, Claude's small upright landscape
'Hagar and the Angel' (fig.19 on p.60) helped him
visualise Dedham Vale as seen framed by trees on
the hills near Langham (no.2). Later he tried the
subject in horizontal formats (nos.7–9) but aban-
doned an attempt to paint a six-foot canvas of the
scene. Taking up the subject again, probably in
1827, he reverted in no.169 to his original vertical
format, basing the composition largely on the 1802
study but taking into account lessons learned in
other versions. A dramatic increase in scale,
however, and the expansion of Constable's own
ideas and powers of 'natural painting', made this
later picture a very different sort of work to the
tentative study of 1802. A quarter of a century on,
Constable was able to offer, in Alastair Smart's
words, 'a magisterial evocation of windblown skies
and quivering trees, whose leaves sparkle in the
changing light'.

As suggested in the 1976 exhibition catalogue,
Constable may have been inspired to return to this
subject by the death in 1827 of his old friend, and
the owner of Claude's 'Hagar', Sir George Beau-
mont. Constable was later to commemorate Beau-
mont in 'The Cenotaph' (fig.13 on p.37, National
Gallery, Reynolds 1984, no.36.1), a painting of
Beaumont's own memorial to Sir Joshua Reynolds.
The large 'Dedham Vale' may have been conceived
as a more private celebration of both Beaumont's
and his own love of Claude. Whether it was also, as
Rosenthal suggests (1983 and 1987), a deliberate
reference to Turner's 'Crossing the Brook' seems
less certain. If Constable had any recollection of the
picture, exhibited in 1815 and not engraved until
after his death, he would probably also have
remembered Beaumont's horror of it. The connec-
tion between the two works perhaps lies more
simply in the homage both pay to Claude.

We have seen the problems Constable encoun-
tered in dealing with the bottom left corner of the
composition in his earlier treatments, in the area
occupied in Claude's painting by the figures of
Hagar and the angel. This corner is spatially
ambiguous in the 1802 study, no.2, but more
clearly defined in nos.6 and 9, where a light-
coloured bank and sandy outcrop in front of the
tree at the left edge give a new perspective to the
whole foreground. In the abandoned six-foot
painting, known only through x-radiography of the
Washington 'White Horse' sketch (fig.22 on p.68),
Constable appears to have felt the need for an even
stronger accent in the corner and a large sloping
tree trunk is placed firmly across it. He elaborates
this solution in the big Edinburgh painting, where
an ancient stump that has sprouted new branches
and leaves (a favourite device with him as he grew
older) blocks the corner and directs attention to the
distant landscape, almost as if gesturing towards it.
'Like Hagar stirred by the touch of the angel,'
writes James Heffernan, 'the old stump is stirred to
a life of sharp and vivid particularity by the com-
plexity of forms that are made to emanate from it'.

The centre foreground is treated much as in the
Tochigi painting, no.6, but a gipsy mother and
child with their fire and bivouac are now intro-
duced on the slope of the hill (though even these
may first have appeared in no.6, as Sarah Cove has
suggested). Reynolds and Rhyne point to the
likelihood of gipsies being found in a place like this,
while Rosenthal (1987) suggests a borrowing from
Gainsborough as well as a reference to either the
Nativity or the Rest on the Flight to Egypt. Again
like the Tochigi picture, and unlike the 1802 study,
Stratford bridge and its flanking buildings are
included in the middle distance but Constable also
shows, just beyond the bridge, the tree seen at the
bend of the river in the 1802 study and which is
excluded from no.6. As Rhyne has noticed, the
conspicuous cow on the Essex bank of the river
appears also in the six-foot horizontal version.

The distant view of Dedham and the Stour
estuary contains more topographical detail than
any of the other versions of the subject except the
work on paper of *c*.1805–9, no.7, which was
presumably brought out again when Constable was
painting this part of the new picture. To the right of
the magnificent foreground tree group a new
subsidiary view of a field with a cow at its edge and a
cottage beyond is added.

Hadleigh Castle

170 Sketch for 'Hadleigh Castle' *c.*1828–9

Oil on canvas 1225 × 1674 (48¼ × 65⅞)
including strips added at left and bottom
PROV: Artist's administrators, sold Foster 16
May 1838 (31, 'Sketch of Hadleigh Castle')
bt Revd J.H. Smith; by descent to Mrs Violet
Becket Williams 1918; sold by her to Leggatt
1930 and by them to Percy Moore Turner,
from whom bt by the National Gallery 1935;
transferred to the Tate Gallery 1956
(N 04810)
EXH: Tate Gallery 1976 (261, repr., with col.
detail opp. p.176)
LIT: Hoozee 1979, no.501, pl.LVI (col.);
Parris 1981, no.33, repr. in col.; Paulson
1982, pp.124, 167; Louis Hawes, 'Constable's
Hadleigh Castle and British Romantic Ruin
Painting', *Art Bulletin*, vol.65, Sept. 1983,
pp.455–70, fig.6; Rosenthal 1983, pp.214–18,
fig.243 (col.); Fleming-Williams and Parris
1984, pp.124–5; Heffernan 1984, pp.77–8,
116–17, 209, pl.11; Reynolds 1984, no.29.2,
pl.705 (col.); Parris and Fleming-Williams
1985, p.169, under no.29.2; Cormack 1986,
pp. 187–91, pl.178 (col.); Rosenthal 1987,
pp.176–80, pl.170; Jonathan Wordsworth,
Michael C. Jaye, Robert Woof, *William
Wordsworth and the Age of English
Romanticism*, 1987, pp.179–81; Fleming-
Williams 1990, pp.220–9

Tate Gallery

While he painted a few late canvases of, or based
on, Flatford, the 1828 'Dedham Vale' (no.169) was
Constable's last depiction of the Stour valley. At
the following year's Academy he exhibited a
subject of a very different kind, 'Hadleigh Castle.
The mouth of the Thames – morning, after a
stormy night' (fig.84, Yale Center for British Art,
Reynolds 1984, no.29.1). Like the 'Dedham Vale',
this had its origin in a much earlier work but in this
case a very much slighter one, a tiny pencil sketch
(fig.85, Victoria and Albert Museum, Reynolds
1973, no.127) made in 1814 during a short tour of
south Essex with an old friend, the Revd W.W.
Driffield, vicar of Feering near Colchester, with
whom he was staying at the time (see nos.250–1).
At Hadleigh, Constable wrote to Maria, 'there is a
ruin of a castle which from its situation is really a
fine place – it commands a view of the Kent hills,
the nore and north foreland & looking many miles
to sea' (Beckett II 1964, p.127). Constable does not
appear to have gone back to Hadleigh. We do not
know why he thought of it again when choosing a
subject for his major exhibit of 1829 but it is
reasonable to assume, as most commentators have,
that Maria's death the previous November had
some connection with his turning to this image of

fig.84 'Hadleigh Castle',
1829, *Yale Center for British
Art, Paul Mellon Collection*

fig.85 'Hadleigh Castle',
1814, *Board of Trustees of
the Victoria and Albert
Museum, London*

fig.86 'Sketch for
"Hadleigh Castle"', ?1828,
*Paul Mellon Collection,
Upperville, Virginia*

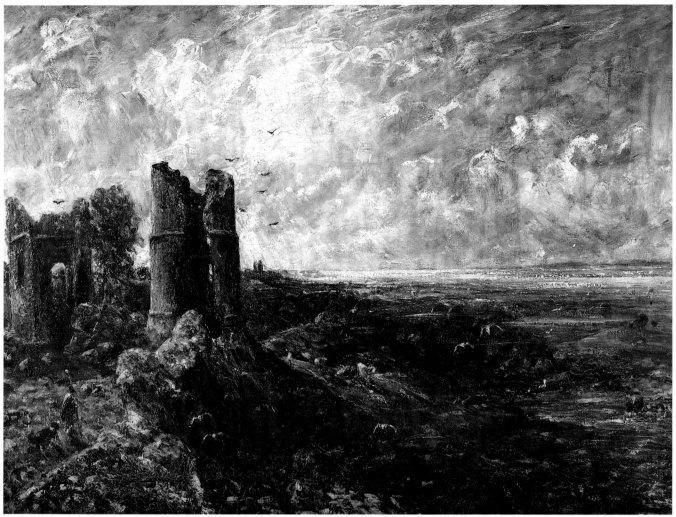

170

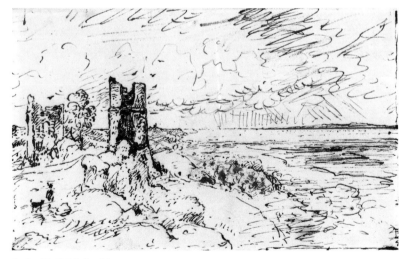

fig.87 'Hadleigh Castle',
?1828, *Mr and Mrs David
Thomson*

loneliness and decay, a few pencil lines that were to
become six-feet of richly expressive canvas and for
later generations the very epitome of Romantic
landscape painting.

Information about when Constable began his
first sketch for 'Hadleigh' might help us under-
stand his choice of subject but there are no firm
dates before February 1829. The sequence of
preparatory material seems clear enough, however:
a small oil sketch based on the 1814 drawing but
adding a shepherd and his flock at the bottom left
(fig.86, Paul Mellon Collection, Reynolds 1984,
no.29.3); a pen and ink drawing in which the
composition is for the first time made emphatically
horizontal by being extended on the right to
include the distant Kent shore, and in which a tree
is added beside the left-hand tower of the castle, the
shepherd altered, given a dog but deprived of his
flock (fig.87, Mr and Mrs David Thomson, ibid.,
no.29.4; see Fleming-Williams 1990 for full discus-
sion); the present sketch, no.170, which establishes
the scale and chiaroscuro of the final picture and
introduces cows in the middle-distance and gulls
flying in from (or out to?) sea, the latter shown at or

below the spectator's eye-level to create an impression of height; finally, the Yale Center painting (fig.84), which, while generally following the design of the Tate sketch, warms its cool tonality, defines its often ambiguous forms, especially the amorphous right foreground, and tames its savage handling.

At least two other drawings were consulted. One, taken from the same 1814 sketchbook as the original drawing of the castle, shows shipping in the Thames and the distant Kent shore at Sheerness (Victoria and Albert Museum, Reynolds 1973, top of no.126, pl.100). As Fleming-Williams has shown (1990), this detail was incorporated in both the pen drawing and the final picture. He also suggests that in extending the composition to include more of the Thames and the Kent coastline Constable would have recalled his voyage down the river in 1803, when he spent nearly a month aboard an Indiaman, the *Coutts*, and also explored parts of north Kent on foot. The other drawing is of a shepherd, more or less corresponding to those in the two large paintings (Reynolds 1984, no.29.5, pl.708). The dog who accompanies him in the finished picture first appears in 'The Cornfield' (no.165) and turns up again in 'Salisbury Cathedral from the Meadows' (no.210). In the latter and in 'Hadleigh Castle' he takes over from a differently posed dog who has stood in, as it were, for the rehearsal in the full-size sketch. Unusually, Constable gives the 'Hadleigh Castle' animal nothing to look at, or at least, nothing within our view.

In his wide-ranging survey of the subject Louis Hawes discusses Constable's awareness of earlier 'ruin' subjects, one of the more relevant being Beaumont's painting 'Peele Castle in a Storm' (Wordsworth, Jaye, Woof 1978, fig.164 in col.), known to Constable also through its literary apotheosis, Wordsworth's 'Elegiac Stanzas ...' (see no.86, and, for a searching comparison of the poem and 'Hadleigh Castle', Karl Kroeber, *Romantic Landscape*, 1975, pp.44–60). With their stoic conclusion – 'Not without hope we suffer and mourn' – Wordsworth's lines seem particularly appropriate to the circumstances surrounding 'Hadleigh Castle', though it was with a more conventional hymn to sunrise from Thomson's 'Summer' that Constable accompanied the painting on its appearance at the Academy.

Although ruined buildings do not figure significantly in Constable's work before 1829, the pattern for the telling juxtaposition of solid and void that we see in 'Hadleigh Castle' was already part of his pictorial vocabulary, employed to a degree in 'Chain Pier, Brighton' (no.156) but more strikingly in 'The Opening of Waterloo Bridge' (see nos.102–3, 212–13), the composition he worked on intermittently throughout the 1820s and finally completed in 1832. By the time he painted 'Hadleigh Castle' the first large version of the 'Waterloo', now at Anglesey Abbey (fig.108 on p.371), was in existence. Despite their different moods, there are obvious similarities between these two Thames subjects with their weight of buildings at the left, where a rounded wall surface and a curving tree are used in conjunction, balancing an expanse of water and sky at the right. Most remarkably, perhaps, in neither work can the spectator easily imagine what his own viewpoint might be. Both are bird's-eye views that leave him suspended in the void, part of the aerial expanse that Constable has created.

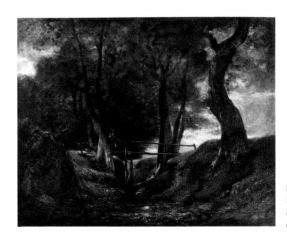

fig.88 'Helmingham Dell', ?1823, *Private Collection (on loan to Birmingham Museums and Art Gallery)*

Helmingham Dell

171 Helmingham Dell *c.*1830

Oil on canvas 1030 × 1290 (40½ × 50¾)
PROV: . . .; Percy Moore Turner by 1935;
acquired from him by the Louvre 1948
LIT: Hoozee 1979, no.474, repr.; Reynolds
1984, no.30.3, pl. 775 (col.); Hill 1985, p.102,
pl.8 (col.)

Museé du Louvre, Paris

See no.172

172 Helmingham Dell 1830, exh.1830

Oil on canvas 1135 × 1308 (44⅝ × 51½)
PROV: Painted for James Carpenter to
replace no.160 but retained by Constable, by
whose administrators sold Foster 16 May
1838 (73, 'View in Helmington Park, Suffolk
Exhibited 1830') bt John Allnutt; F.T.
Rufford by 1857; Henry McConnell by 1862
and sold Christie's 27 March 1886 (66) bt S.
White; J.M. Keiller by 1887; . . .; Knoedler
1928; . . .; James J. Hill, New York; . . .; W.
Butterworth; his widow, Katharine D.
Butterworth 1946, sold Parke-Bernet, New
York 20 Oct. 1954 (33) bt Knoedler; bt by
Nelson-Atkins Museum of Art 1955
EXH: RA 1830 (19, 'Dell scene, in the park of
the Right Hon. the Countess of Dysart, at
Hatmingham, Suffolk'); New York 1983 (62,
repr.); New York 1988 (28, repr. in col.)
LIT: Hoozee 1979, no.530, repr.; Paulson
1982, pp.162–3, fig. 82; Reynolds 1984,
no.30.1, pl.770 (col.); Cormack 1986, pp. 196,
208–10, pl.196; Rhyne 1990b, pp.80, 83 n.53

*Nelson-Atkins Museum of Art, Kansas City,
Missouri (Nelson Fund)*

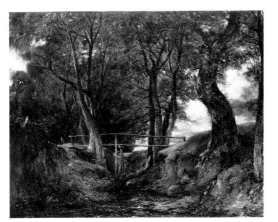

fig.89 'Helmingham Dell',
1825–6, *John G. Johnson
Collection, Philadelphia
Museum of Art*

Staying in an empty parsonage on a visit to the
Dysarts' Suffolk estate in 1800, Constable wrote to
tell John Dunthorne that he was 'quite alone
amongst the Oaks and solitudes of Helmingham
Park . . . There are abundance of fine trees of all
sort; though the place upon the whole affords good
objects [rather] than fine scenery . . . I have made
one or two ⟨. . .⟩ drawing that may be usefull'
(Beckett II 1964, p.25). One drawing he made on
this visit, no.224 in the present exhibition, did
indeed prove useful but possibly not for twenty or
so years. The unidentified 1816 exhibit 'A wood:
Autumn' may have been of Helmingham Dell but
only in 1823 do we hear of a painting that definitely
was of that subject. In July that year Constable told
Fisher that Sir George Beaumont was 'pleased with
a large wood I have just toned. He said "well done"'
(Beckett IV 1966, p.125). According to Leslie, this
was a 'large sketch of the dell in Helmingham Park'
(1843, p.38, 1951, p.104). It may be the work now
on loan from a private collection to Birmingham
City Art Gallery (fig.88, Reynolds 1984, no.30.2).
This follows the 1800 drawing quite closely but,
like all the other versions, removes the large tree
seen at its left, which is shown now as a decayed
stump (in no.172 part of the fallen trunk is also
shown below) – rather than simply omit the tree,
Constable explains its disappearance to himself in
natural terms. Unlike the other three painted
versions, however, the Birmingham canvas also
omits the tree at the extreme right of the drawing; it
appears to have been there once but to have been
painted out. In place of the woman at the right of
the bridge in the drawing, a man with a gun and a
dog appear at the left-hand side.

A second and more finished version of about the
same size – approximately 28 × 36 inches – was
painted in 1825–6 for Constable's Woodbridge
patron James Pulham. This was reacquired by the
artist after Pulham's death and exhibited at the
British Institution in 1833; it is now in the J.G.
Johnson Collection at the Philadelphia Museum of
Art (fig.89, ibid., no.26.21). In this painting a heron
is shown in the water at the bottom left and a small
figure in red appears beyond the left-hand end of
the bridge.

The two later versions shown here, nos.171–2,
are similar in size to one another and considerably
larger as well as squarer in format than the other
two. Again, they follow the original 1800 design
fairly closely but vary the figurative details. The
Louvre canvas (no.171), which has the appearance
of being a sketch, includes two figures only, a
mother and child at the left of the bridge. In the
Kansas City picture (no.172) we see a smaller red
figure at this point (as in the Philadelphia version),
a cow in the water at the bottom left, a stag on the
bank at the right and further deer in the centre

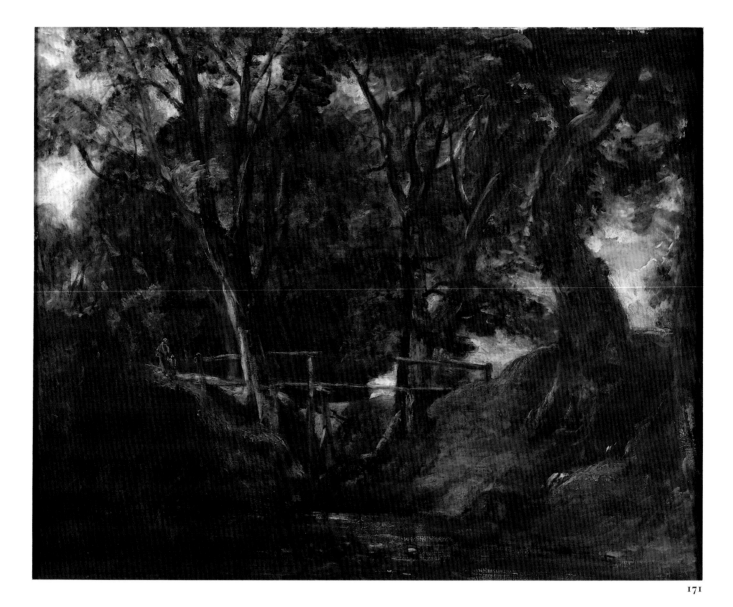

171

beyond the bridge. Charles Rhyne has recently reported (1990b) the results of technical examinations showing that Constable first painted a deer where the cow now is. The Kansas City version is the one painted in 1830 for James Carpenter to re-place 'Boat Passing a Lock' (no.160). As explained in the entry on that work, Constable decided at the last minute not to hand over the new 'Dell' but to exhibit it at the 1830 RA as his own property.

Reynolds has made out a case for pairing off the four versions of 'Helmingham Dell' in the order indicated above, seeing the work on loan to Birmingham as a preliminary for the Philadelphia picture and the Louvre canvas as a sketch for the Kansas City one. Only the two finished versions can be firmly dated but the 'Birmingham' canvas, with its uncertainty about the extreme right-hand tree and its larger than usual figure (making the dell seem smaller), looks as though it precedes all the others. It is also worth adding that the Louvre and Kansas City pictures are further linked by being

the only two in which the handrail of the bridge is partly obscured by foliage in the centre. The foliage at this point in the original drawing seems to lie behind the bridge, but Constable was evidently still referring to the drawing in 1830: only the Kansas City picture shows the bridge passing between rather than behind the two trees at the left, as he observed it doing in 1800. A close connection between the Louvre and Kansas City works is also suggested by the history of the mezzotint Lucas made of the subject for *English Landscape* (fig.94 on p.320). This includes the woman and child from the Louvre canvas and the stag and cow from the Kansas City painting (in progress proofs the cow is shown at the same angle as in the painting); the position of the bridge relative to the two trees is also as in the latter work. From Constable's request to Lucas in December 1829 'for the Wood which will now be usefull to me' (Beckett IV 1966, p.322) it would appear that he was asking for the return of the Louvre canvas, from which the plate had been

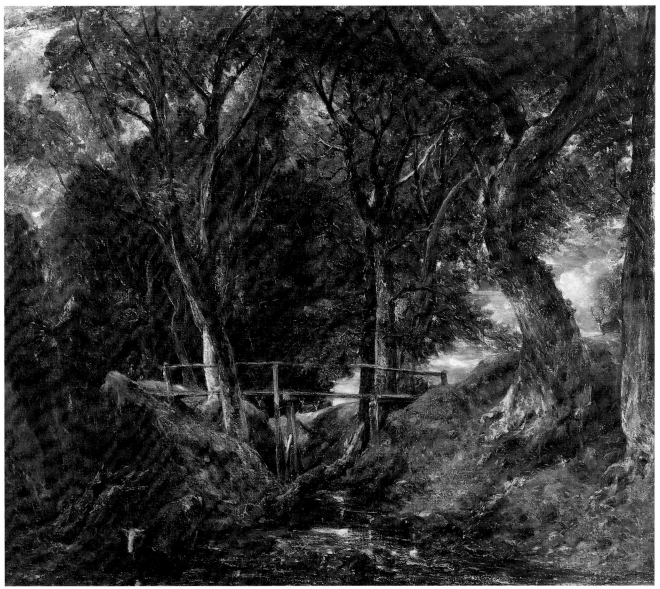

172

begun, in order to proceed with the new painting for Carpenter, the Kansas City one, from which Lucas then took the additional details of the cow and stag.

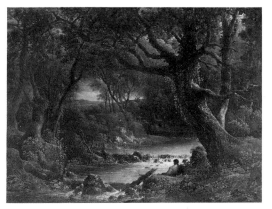

fig.90 Sir George Beaumont, 'Jaques and the Wounded Stag', 1819, *Tate Gallery*

We do not know why Constable took up his 1800 drawing in the early 1820s and reworked the composition on canvas. He may simply have been looking through an old portfolio and been struck by the potential of this fine drawing, or there may have been some external stimulus, perhaps a sight of Sir George Beaumont's dell picture 'Jaques and the Wounded Stag' (fig.90, Tate Gallery), painted in 1819 and given by his widow to the National Gallery in 1828. By (and possibly in) the latter year Constable had made the first of his own illustrations to this scene from *As You Like It* (see Fleming-Williams 1990, p.300 n.46). There are clear links between his surviving Jaques drawings and the Helmingham Dell subject but, despite the presence of deer in the final version (no.172), Constable does not force the connection. The 'Oaks and solitudes' that had so impressed him in 1800 remain his subject.

The 'English Landscape' Mezzotints

From 1829 until his death Constable devoted considerable time, energy and money to the business of print-making and publishing, activities that had concerned him only marginally before. The principal outcome was a series of twenty-two mezzotints engraved under his close supervision by the young David Lucas (1802–81) and entitled *Various Subjects of Landscape, Characteristic of English Scenery, from Pictures Painted by John Constable, R.A.*, generally known today simply as *English Landscape*. Based on a wide range of oil sketches, finished paintings and perhaps one or two drawings made by Constable at various periods of his life, the series was first issued in parts between June 1830 and July 1832. A supplementary series was begun but not published in Constable's lifetime. Lucas also engraved several larger plates on his own initiative and, after Constable's death, some further small ones.

English Landscape was conceived in the months following Maria's death and Constable's long-delayed election, begrudged by some (including its President), to the Royal Academy. It was a time of retrospection and stocktaking for an artist who had yet to make a mark with the public (at least in England) and who still had much to say. By publishing a pictorial review of his work Constable hoped to increase his audience and to justify his labours of the previous thirty years. The texts he wrote to accompany the series made clear its function as an apologia. There were two kinds of artist, he wrote: the imitator or eclectic who gains ready acceptance by retailing the familiar, and the innovator who adds to art 'qualities of Nature unknown to it before'. Because 'so few appreciate any deviation from a beaten track', the rise of an original artist 'must almost certainly be delayed', as Constable had good reason to feel his own had been. But in offering the public a survey of his past work, Constable was again deviating from the beaten track, for his print series was unlike any other.

As the new subtitle added in 1833 explained, the work was *Principally Intended to Mark the Phenomena of the Chiar'Oscuro of Nature*. Constable now saw chiaroscuro not only as the artist's means of defining space and articulating a picture surface but as a principle of nature itself, the 'medium by which the grand and varied aspects of Landscape are displayed, both in the fields and on canvass'. By finding equivalents in his own chiaroscuro the artist could represent the changing effects of light and shade that more than anything else, Constable now thought, gave natural landscape its character. With Lucas working in mezzotint (the most chiaroscuratic of print techniques, in which a newly prepared plate prints black and lights have to be created by scraping and burnishing), Constable could focus more directly on the interaction of light and dark and explore the nuances of the tonal range. The works chosen for inclusion were not so much reproduced as translated into a new language, a language that fully revealed their latent chiaroscuro but one that had to a large extent to be invented as Lucas went along – there was little precedent in mezzotint for the combination of dramatic contrasts and subtle tonal gradations demanded by Constable.

In revising his painted images in mezzotint, Constable and Lucas were following a

Detail from 'Hadleigh Castle (Large Plate)', no.203

fig.91 Lucas and Constable,
'Spring', 1830, *Tate Gallery*

fig.92 Lucas and Constable,
'Noon', 1831, *Tate Gallery*

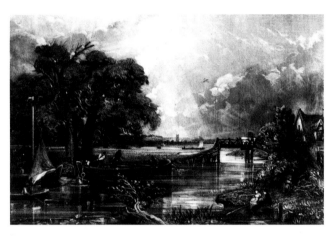

fig.93 Lucas and Constable,
'River Stour, Suffolk', 1831,
Tate Gallery

fig.94 Lucas and Constable,
'A Dell, Helmingham Park,
Suffolk', 1830, *Tate Gallery*

fig.95 Lucas and Constable,
'A Heath', 1831, *Tate
Gallery*

fig.96 Lucas and Constable,
'Yarmouth, Norfolk', 1832,
Tate Gallery

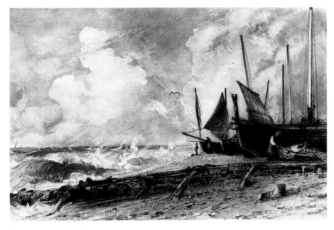

fig.97 Lucas and Constable,
'A Seabeach', 1830, *Tate
Gallery*

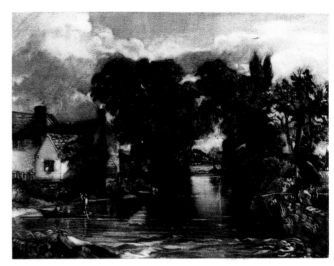

fig.98 Lucas and Constable,
'Mill Stream', 1831, *Tate
Gallery*

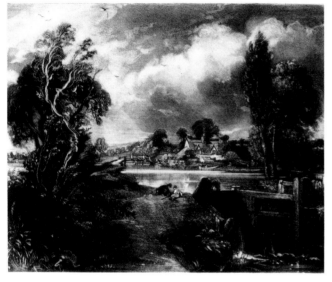

fig.99 Lucas and Constable,
'A Lock on the Stour,
Suffolk', 1831, *Tate Gallery*

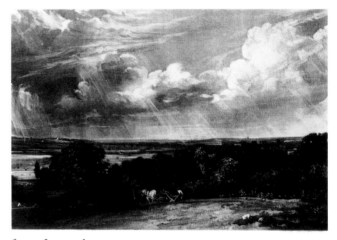

fig.100 Lucas and
Constable, 'A Summerland',
1831, *Tate Gallery*

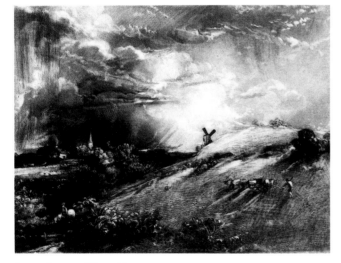

fig.101 Lucas and Constable,
'Summer, Afternoon – After a
Shower', 1831, *Tate Gallery*

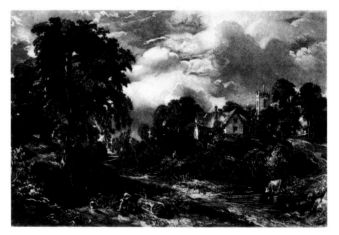

fig.102 Lucas and
Constable, 'The Glebe
Farm', 1832, *Tate Gallery*

procedure similar to one that had become a standard part of Constable's painting practice during the 1820s. In such pictures as 'The Glebe Farm' (no.167) and 'Dedham Vale' (no.169) he returned to paintings and sketches made many years before, to ideas that had not yet been worked through to his satisfaction and which he could now recast in new and bolder forms. Similarly, the mezzotints gave Constable the opportunity not only to bring out more forcibly the tonality of completed paintings but also to use material that had not yet been developed in his painting. Several of his small oil sketches, known only to his closest friends, were worked up in mezzotint into more complete images that seemed to some to presuppose the existence of finished originals. Constable had a request in 1835 from Edward Carey of Philadelphia for 'a picture which I have not got nor ever had . . . he has seen the book [*English Landscape*] and has taken a liking to the "Sea Beach" – thinking, no doubt, that it was done from something more than the sketch [no.151]' (Beckett III 1965, p.133). One of the most striking examples is 'Summer Morning' (nos.186–90), based in the first place on the wonderfully placid 'Dedham from Langham' oil sketch of *c*.1812 (no.17) and gradually elaborated on the plate with the sort of 'business' that Constable might have introduced when painting a larger version. In this case, as we have recently learned, he did begin a larger canvas (no.20) but whether this preceded or was contemporary with the print is difficult to establish. The extent to which Constable's print-making and painting overlapped in the 1830s has still to be investigated. What we wish to suggest here is that his collaboration with Lucas was not the peripheral activity it has sometimes seemed but an essential part of his continued growth as an artist.

The Constable-Lucas mezzotints require an exhibition to themselves. The present sampling of original oils, progress proofs and finished prints is intended to suggest how the printed images of *English Landscape* were developed rather than to represent the complete series (figs.91–102 illustrate subjects not exhibited here). A number of touched proofs are included. These were a vital means of communication between the two artists, Constable marking Lucas's proofs in a variety of media to show how he thought the plate should be developed, Lucas then sending further proofs, and so on. One of Lucas's larger prints, not part of *English Landscape*, is also shown here (no.203); another appears later in the exhibition (no.211).

Note. In the following entries different image and plate sizes are sometimes given for impressions from the same plates. These discrepancies can be attributed in the main to variations in the rate of contraction of the papers on drying. Although all the prints are described simply as mezzotints, drypoint is frequently used in addition. For recent publications covering aspects not dealt with here, see the Tate Gallery 1986 catalogue and *The Tate Gallery: Illustrated Catalogue of Acquisitions 1984–86*, 1988, pp.23–61.

Frontispiece: East Bergholt House

The 'Frontispiece' to *English Landscape* depicts a summer evening in the grounds of East Bergholt House, the artist's birthplace. An oil sketch giving a more distant view of the house is shown as no.22 above. The original upon which the print was based has not been identified but, as suggested under no.173, it may have been a drawing rather than a painting.

As well as writing an Introduction to the whole work Constable had texts printed to accompany six of the individual plates. The 'Frontispiece' received a substantial commentary in which he developed the sentiments expressed in the Latin verses engraved below the image (see no.178). Although to others, Constable wrote, East Bergholt might be a place 'void of interest or any associations', to him it was 'fraught with every endearing recollection'. He had endeavoured to make the subject more generally accessible by investing it with a 'richness of Light and Shadow', with the chiaroscuro which is the underlying artistic principle of *English Landscape*: 'The broad still lights of a Summer evening, with the solemn and far-extended shadows cast around by the intervening objects, small portions of them only and of the Landscape gilded by the setting sun, cannot fail to give an interest to the most simple or barren subject, and even to mark it with pathos and effect.'

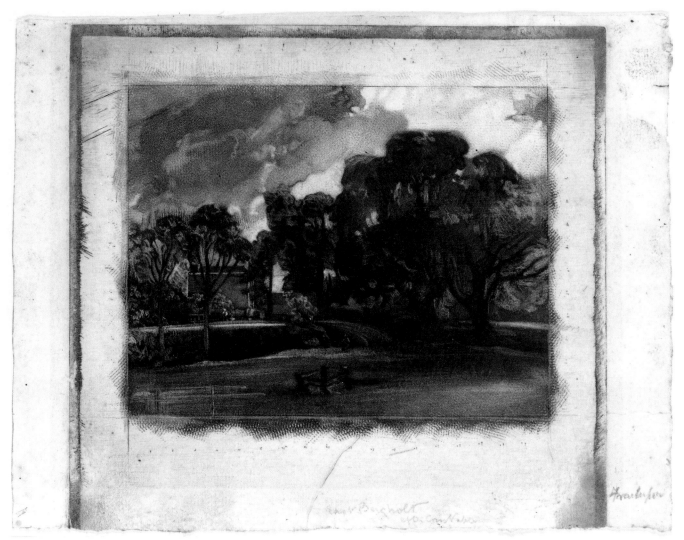

173

173 Frontispiece: East Bergholt, Suffolk
(Progress Proof, before 'a')

Mezzotint 140 × 186 (5½ × 7⁵⁄₁₆), excluding the
uncleared margins of the image, on wove
paper 220 × 292 (8¹¹⁄₁₆ × 11½); plate mark 238
(9⅜) wide (cut within bottom edge)
Inscribed in pencil in later hands 'East
Bergholt|after Constable' bottom centre of
sheet and 'Frontispiece' b.r.
PROV: . . .; anon. sale, Sotheby's 27 June 1986
(in 741); present owners
LIT: Fleming-Williams 1990, pp.298–9,
fig.275

Mr and Mrs David Thomson

This is the earliest known proof of the 'Frontis-
piece', preceding the first ('a') described in Shir-
ley's 1930 catalogue of the prints. The subject is
boldly blocked in with as yet few details made out;
the margins have still to be cleared. A series of
marks at three-eighths of an inch intervals in each
margin shows that Lucas squared up the original
and his plate in order to transfer the design as
accurately as possible.

Work on the plate began some time after 12
March 1831 when Constable reminded Lucas 'we
must begin the frontispeice' (Beckett IV 1966,
p.344). Two parts – eight prints – of the series had
already been published but Constable had now
decided to issue both the 'Frontispiece' and the
concluding 'Vignette' (see nos.204–5) as a sort of
bonus.with the final four prints in the fifth part; this
appeared in July 1832.

By 23 March 1831 Constable had made 'a
drawing of the Title' to show to Lucas (ibid.,
p.346). As suggested in the 1976 Tate Gallery
catalogue (no.273), this may have been a small pen
drawing now in a private collection which shows a
different view of the house enclosed in a frame
across the top of which Constable wrote 'FRONT-
ISPICE', with the date '1831' given below the
frame (Reynolds 1984, no.31.17, pl.805). He seems
to have been remembering the framed painting on
the title-page of Turner's equally didactic print
series, *Liber Studiorum*, a work that has several
features in common with *English Landscape*. This
idea was given up, however, and a different view of
the birthplace used. Its identity has not been
established but some plausible suggestions about it
have been made recently. Reynolds (1984, under
nos.17.8, 31.18) points out that the verses engraved
on the 'Frontispiece' appear in various forms on
two detached pages from a sketchbook Constable
used in 1817 and 1820, suggesting that the sketch-
book may have contained a drawing, now missing,
of East Bergholt House corresponding with the
view seen in the mezzotint. More recently, Flem-
ing-Williams (1990) has suggested that the present
proof impression, no.173, 'looks very like an

attempt by Lucas to interpret the liquid washes of a
blottesque drawing' of the kind that Constable had
adopted after studying Alexander Cozens's meth-
ods. As he says, support for this idea is given by the
existence of a different view of the house drawn in
the same style and technique (Reynolds 1984,
no.36.30, pl.1079). Until the original is found we
can only speculate. Possibly Constable based a
blottesque drawing on the earlier one hypothesised
by Reynolds? It seems very likely, in any case, that
Cozens, as well as Turner, was in Constable's mind
when he conceived *English Landscape*. In his vari-
ous systems of classifying skies, types of landscape
composition and natural phenomena ('circum-
stances' as he called them), Cozens provided
models for Constable's own survey of the charac-
teristics of English scenery.

After the March 1831 letter referring to the
'drawing of the Title' nothing is heard about
progress on the plate in Constable's correspon-
dence with Lucas until 3 October that year, when
Constable was expecting a visit from the engraver
at about 3 pm the following day: 'we shall then have
light enough to touch the "*Title*"' (Beckett IV
1966, p.356). Ten days later Constable was asking
for changes in the lettering of the verses beneath
the image (ibid., p.357), so the proofs shown here,
nos.173–9, had already been taken by then.

174 Frontispiece: East Bergholt, Suffolk
(Progress Proof 'a')

Mezzotint 140 × 185 (5½ × 7¼) on laid paper
260 × 363 (10¼ × 14⁵⁄₁₆); plate-mark 233 × 238
(9³⁄₁₆ × 9⅜)
Inscribed in pencil by Lucas '151' below
plate-mark at centre
PROV: . . .; Sir Henry S. Theobald, from
whom bt by John Charrington and presented
to the Fitzwilliam Museum 1910
LIT: Shirley 1930, no.27, progress proof 'a',
pl.XXVIIA

*Syndics of the Fitzwilliam Museum,
Cambridge*

Cows have now been added in the centre above the
small figure, further lights have been scraped on
the trees and other minor changes made. Shirley
records an impression of this state in which
Constable has already touched in birds in the sky
and the seated man and his dog at the bottom right,
changes not made on the plate until his state 'c'
(no.176). These figurative elements would almost
certainly have been invented as the plate pro-
gressed, especially if the original was a broad ink-
wash drawing as suggested above under no.173.

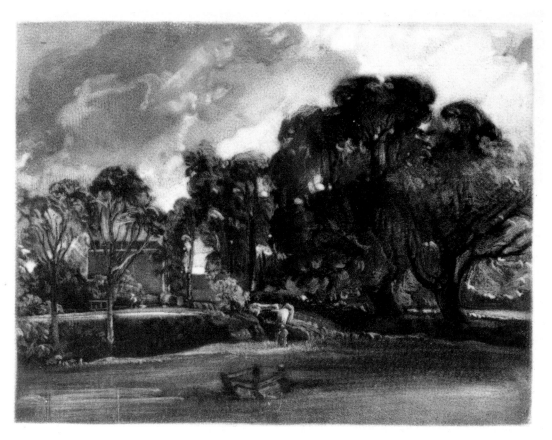

174

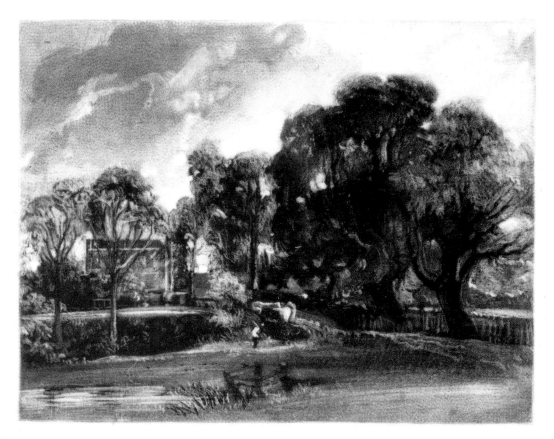

175

175 Frontispiece: East Bergholt, Suffolk
(Progress Proof 'b')

Mezzotint 140 × 186 (5½ × 7⁵⁄₁₆) on laid paper
268 × 362 (10⁹⁄₁₆ × 14¼); plate-mark 233 × 238
(9³⁄₁₆ × 9³⁄₈)
Inscribed in pencil by Lucas '152' below
plate-mark at centre
PROV: As for no.174
LIT: Shirley 1930, no.27, progress proof 'b'

*Syndics of the Fitzwilliam Museum,
Cambridge*

Constable has now changed his mind about the small figure in the centre and has substituted a different one facing right and carrying a stick or some sort of implement. Traces of the first figure remain right through to the published states, however. Reeds and grasses have been added at the bottom left and the fence made out at the right. Windows have been lightly indicated on the facade of the house.

The numbers pencilled by Lucas on many of the progress proofs, sometimes with the addition of his initials, may represent a later ordering or indexing of his own copies. Additional annotations on proofs in the Fitzwilliam Museum show that separate drawings by Constable were also part of this enumeration: on a proof 'c' of 'The Glebe Farm', Lucas's no.261, we read 'No 260 a pen & ink drawing of the tree[?s] & figure in this plate D.L.'; similarly a proof ('a', Lucas's no.13) of 'Spring' is inscribed 'Nos. 11 & 12. drawings relating to this plate'. (See also the inscription on no.199). In the short time the present authors have had to investigate this issue, it does not appear certain that Lucas's numbering system reflects the order in which the plates were engraved. Although one of the proofs of the 'Vignette' (no.204) is Lucas's no.3 and Lucas elsewhere records that this was the first subject to be engraved, some of the higher numbers in his sequence do not so easily tally with what is known from other sources of the progress of the whole work. Proofs of individual subjects do, however, appear to be consecutively numbered. Curiously, Andrew Shirley does not mention Lucas's numbering system in his pioneer catalogue. Clearly it needs to be thoroughly examined to see what light it throws on the sequence of proofs from individual plates as well as on the overall chronology of *English Landscape*.

176 Frontispiece: East Bergholt, Suffolk
(Progress Proof 'c', touched)

Mezzotint 140 × 185 (5½ × 7¼) on laid paper
265 × 310 (10⁷⁄₁₆ × 12³⁄₁₆); plate-mark
233 × 238 (9³⁄₁₆ × 9³⁄₈); touched with white
body-colour and grey wash
PROV: . . .; James Brook Pulham, from whom
bt by the British Museum 1842 (1842–12–
10–67)

LIT: Shirley 1930, no.27, progress proof 'c'

Trustees of the British Museum, London

The figures of a seated man and a dog have now been added at the bottom right. In a later note to Lucas about this part of the print (see under no.180) Constable refers to 'the man drawing'. Appropriately, then, the 'Frontispiece' includes an artist (of some sort) at work. He can perhaps be seen as Constable himself, whose 'boyish fancy' was 'first tinged . . . with a love of the art' at East Bergholt, according to the lines later engraved on the plate (see nos.178, 180), or even as a member of Constable's wished-for audience, come to sketch East Bergholt House in the knowledge that 'This place was the origin of my Fame'.

Constable's touchings on this impression include the addition of further birds in the sky, changes to the trees at the right and the lighting of a window on the house. No.176 is one of 155 Lucas mezzotints acquired by the British Museum in 1842 from Constable's friend James Brook Pulham, son of his Woodbridge patron James Pulham.

177 Frontispiece: East Bergholt, Suffolk
(Progress Proof 'd', touched)

Mezzotint 140 × 186 (5½ × 7⁵⁄₁₆) on laid paper
210 × 280 (8¼ × 11); plate-mark 238 (9³⁄₈) wide
(cut within top and bottom edges); touched
with white bodycolour, black ink wash, pen
and pencil and with a pencil drawing in the
right margin of the seated man and two
pencil drawings and one ink drawing in the
bottom margin of the dog; at the bottom left
of the sheet a slighter pencil sketch of an
arched shape
Inscribed in pencil by Lucas '185│DL' at
bottom centre of sheet, '185' perhaps in error
for '155'
PROV: As for no.174
LIT: Shirley 1930, no.27, progress proof 'd'

*Syndics of the Fitzwilliam Museum,
Cambridge*

As his marginal pencil sketch indicates, Constable now wanted to show the seated figure more in profile. The printed image has also been touched to make the same change. Only in the published state, however (see no.180), does the figure closely approximate to Constable's drawing. The dog has almost disappeared under Constable's touchings of white gouache and pencil but his ink dog in the margin below shows what he is after. The slight sketch at the bottom left of the sheet seems to relate to the rectangular shape (a window? a fence?) seen in the print at the base of the house just to the left of the second main tree from the left. The vertical pencil stroke indicates the trunk of this tree. Constable shows that he now requires a curved top to this puzzling shape.

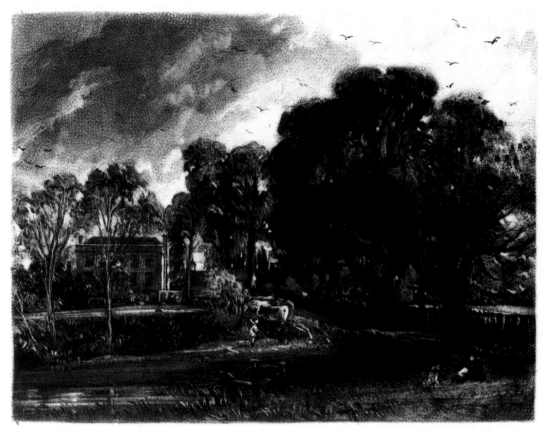

176

177

178

178 Frontispiece: East Bergholt, Suffolk
(Progress Proof 'e', touched)

Mezzotint 140 × 185 (5½ × 7¼) on laid paper
270 × 316 (10⅝ × 12⁷⁄₁₆); plate-mark 233 × 238
(9³⁄₁₆ × 9⅜); touched in ink and pencil and with
scratching; the image has been cut along all
sides except the top, thus forming a hinged
flap
Inscribed in pencil 'FRONTISPEICE|
DOMUS. PATRIS. NATUS JUNIUS II
MDCC.LXXVI.' above image, 'JOHN
CONSTABLE RA. PINX' below image at left,
'DAVID LUCAS SCUL' below image at right,
and 'EAST BERGHOLT. SUFFOLK.|"HIC
LOCUS ETATIS NOSTRA PRIMORDIA
NOVIT.|ANNOS FELICES, LÆTITIÆQUE
DIES|HIC LOCUS INGENIUS PUERILES
IMBUIT ANNOS|ARTIBUS, ET NOSTRÆ
LAUDIS ORIGO FUIT."|NATUS JUNISS
MDCCLXXVII.' below image at centre,
followed by a scribbled indication of further
lines; extensively but more or less illegibly
inscribed in pencil on the back of the margins
of the sheet; inscribed in pencil by Lucas
'164|164|DL' on back of image
PROV: As for no.174
LIT: Shirley 1930, no.27, progress proof 'e'

*Syndics of the Fitzwilliam Museum,
Cambridge*

Lucas has made further small changes on the plate,
including the addition of a seventh bird and the
lighting of one of the windows of the house. The
dog now follows Constable's drawing on no.177
above more closely but the seated man is not yet
properly in profile. Constable's touchings include
the addition of many more birds in the sky. The
plate is now sufficiently advanced for him to sketch
out the lettering. The author of the Latin verses has
not been identified. As mentioned under no.173,
they are first found on two detached pages from a
sketchbook used in 1817 and 1820. One of these
pages (Reynolds 1984, no.20.43) also includes
translations of the verses made in 1820 by C.
Cookson and by John Fisher, the latter a free
rendering:

> This spot saw the day spring of my Life,
> Hours of Joy, and years of Happiness,
> This place first tinged my boyish fancy with a
> love of the art,
> This place was the origin of my Fame.

Constable retained Latin for the verses on the
published print (no.180) but did away with the
references in Latin to his father's house and his
own birth date (represented here as June '11' – or
just possibly '11' – instead of 'XI'). The 'Frontis-
piece' nevertheless remained an extraordinarily
personal, even egotistical document.

In a letter to Lucas on 13 October 1831
Constable requested the first 'Hic locus' in the
verses to be changed to 'Haec domus' (Beckett IV
1966, p.357). The change was never made but it
would seem that the verses had by then been
engraved in some form, which would date the
present proof to before 13 October. Shirley's
progress proof 'j', in which the lettering is engraved
in trial form, follows the pencilled inscriptions on
no.178 but corrects Constable's 'Frontispeice'
while introducing new errors, including the advan-
cement of the artist's birthday to 'Julius'.

Constable may have cut round the image in the
way described at the head of this entry so that he
could fold it back and try out the effect of the pencil
lettering over subsequent proofs.

179 Frontispiece: East Bergholt, Suffolk
(Progress Proof, ? 'h', touched)

Mezzotint on wove paper 139 × 185
($5\frac{1}{2}$ × $7\frac{5}{16}$), cut to image; with extensive
scratching
Inscribed in pencil by Lucas on the back
'Touched with his Penknife | at Padington'
PROV: As for no.174
EXH: Tate Gallery 1976 (274, repr.)
LIT: Shirley 1930, no.27, progress
proof 'h' (?)

*Syndics of the Fitzwilliam Museum,
Cambridge*

David Lucas lived at 57 Harrow Road, Padding-
ton, where, the inscription indicates, Constable
touched this proof. The vigorous scratching out of
highlights parallels his practice in later years of
adding white highlights to his paintings – the
'snow' his critics loved to hate. Few if any of the
marks made here appear to have been intended as
instructions to Lucas and the plate never achieved
the degree of sparkle Constable created with his
penknife. Flickering lights would, however, have
been inappropriate when he was trying to suggest
the 'broad still lights of a Summer evening' (see
p.323). In his touching of this impression
Constable was creating an independent work of art
that stands at a tangent to the mezzotint. The
removal of the margins, presumably by Constable
himself, lends it the appearance of a drawing.

180 Frontispiece: East Bergholt, Suffolk
(First Published State)

Mezzotint 139 × 187 ($5\frac{1}{2}$ × $7\frac{3}{8}$) on india paper
laid on wove paper 266 × 362 ($10\frac{1}{2}$ × $14\frac{1}{4}$);
plate-mark 232 × 239 ($9\frac{1}{8}$ × $9\frac{7}{16}$)
Inscribed in pencil by Lucas '160' below
plate-mark at centre. Engraved inscriptions:
'FRONTISPIECE, | To M.͡ Constable's
English Landscape.' above image, 'Painted
by John Constable. R.A.' below image at left,
'Engraved by David Lucas.' below image at
right, 'EAST BERGHOLT, SUFFOLK. | "*Hic
locus ætatis nostræ primordia novit | Annos*

*felices lætitiæque dies: | Hic locus ingenuis
pueriles imbuit annos | Artibus, et nostræ laudis
origo fuit.*" | London, Published by M.͡
Constable 35, Charlotte St.͡ Fitzroy Square,
1831.' below image at centre
PROV: As for no.174
LIT: Shirley 1930, no.27, state I; Barnard
1984, no.I, state I

*Syndics of the Fitzwilliam Museum,
Cambridge*

This is the 'Frontispiece' as first published with the
fifth and final part of *English Landscape* in July
1832, still carrying Constable's optimistic publica-
tion date of the previous year. Between the first
appearance in engraved form of the inscriptions in
Shirley's progress proof 'j' (see under no.178) and
the publication of the print, two more proof states
are known in which the inscriptions are variously
re-engraved. Such details mattered surprisingly
much to Constable, who went on fiddling with the
lettering of the plates long after they were first
published. Some of the classical aspirations of his
original version of the lettering of the 'Frontis-
piece' have now been abandoned and the Latin
verses are more discreetly couched in italic.
Constable later added the English line 'Fond
recollections round thy memory twine' between
the title of the print and the verses.

At a late stage, between the last known progress
proof and the published state, Constable changed
his mind about the dog, now wanting it to look not
at the man but at the scene he is sketching. Lucas
made the change but was unable to remove all
traces of the original animal. Instructions given to
him in February 1832 relate to this part of the print,
though it is not clear whether they precede or
follow the alteration to the dog. Like the touched
proofs, they show how closely Constable sought to
direct the engraver's hand:

> Before you print the frontispeice, pray drypoint
> down the light on the bank on which the man
> sits – it is too bare, from the man to the right
> hand edge of the picture. Also a line or two on
> the water over the lightest part, as it is too bare
> – a very little will do it . . . The dog's snout
> must be tipped with a light touch . . . The light
> by the man drawing to which I object is the
> sunshine over the pales – it is a grand thing.
> (Beckett IV 1966, p.366)

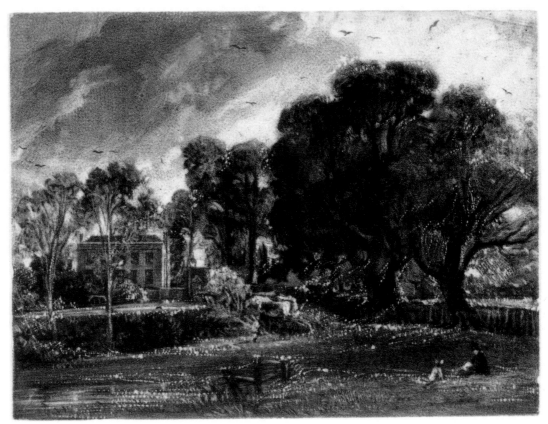

179

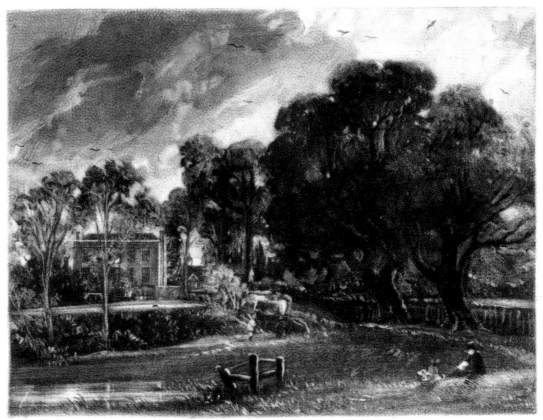

180 Painted by John Constable, R.A. Engraved by David Lucas

Autumnal Sunset

Published in the final part of *English Landscape* in July 1832, 'Autumnal Sunset' (or 'Autumnal Sun Set' as it was lettered) was based on the early oil sketch shown here as no.181, an evening view over the fields on the west side of East Bergholt. Labourers are shown returning home along a path between Bergholt and Stratford St Mary, whose church is seen in the centre distance. Langham church appears on the hills at the left and Stoke-by-Nayland church in the distance towards the right. Vale Farm, East Bergholt, lies in the dip in the right middle-ground.

Constable decided to include the subject after talking to C.R. Leslie on 14 September 1829. Next day he wrote to Lucas: 'Leslie dined with me yesterday – we have agreed on a long landscape (Evening with a flight of rookes), as a companion to the "Spring"' (Beckett IV 1966, p.322) but work on the plate was slow and intermittent. In March 1830 Constable was anxious to see a first proof of what was apparently this subject (ibid., p.326) but in March 1832 complained 'we have not advanced one step since November 1831 ... The Autumnal Evening was then as it is now' (ibid., p.369). Thereafter progress seems to have been more rapid and the proof shown here as no.184 is likely to have been made by the start of June 1832. The 'flight of rookes', a key feature of the oil sketch, created problems in the final stages of the engraving.

181 Autumnal Sunset 1812

Oil on canvas 171 × 336 ($6\frac{3}{4}$ × $13\frac{1}{4}$)
PROV: As for no.2
LIT: Reynolds 1973, no.120, pl.71; Smart and Brooks 1976, p.27, pls.16, 17 (modern photo of view); Hoozee 1979, no.161, repr.; Hill 1985, pp.41, 100, 123, pl.3 (col.); Cormack 1986, p.80, pl.74 (col.); Fleming-Williams 1990, p.115

Board of Trustees of the Victoria and Albert Museum, London

This oil sketch is close in subject and handling to those Constable painted in 1812 in the fields behind Mrs Roberts's house, West Lodge, East Bergholt (nos.34–5). Sarah Cove has noticed that it and no.35 are in fact painted on two adjoining pieces cut from the same larger stretched canvas, the upturned tacking edge of which can be seen at the bottom of this sketch (see p.495).

182 Autumnal Sunset (Progress Proof 'a')

Mezzotint 130 × 242 ($5\frac{1}{8}$ × $9\frac{9}{16}$) on wove paper 269 × 370 ($10\frac{5}{8}$ × $14\frac{9}{16}$); plate-mark 176 × 252 ($6\frac{15}{16}$ × $9\frac{15}{16}$)
Inscribed in pencil by Lucas '133' below plate-mark at centre; mezzotinted inscription 'I.C D L' b.r. of image
PROV: As for no.174
LIT: Shirley 1930, no.14, progress proof 'a'

Syndics of the Fitzwilliam Museum, Cambridge

Lucas begins by faithfully representing features of the oil sketch, no.181, which are later altered on the plate. The triangular patch of light in the foreground, for example, with shadow to its right and less deep shade to its left, eventually grows as Constable lets more light flood the foreground (see no.184). The diffused light of the left-hand side of the sky is also matched in this proof: in the next, no.183, Constable trails clouds across the base of the sky. Some things are done differently from the start, however. Lucas may have found difficulty in translating the effect in the oil sketch of the descending sun tipping the foliage of the tree at the right. He pierces the tree with rays of sunlight to compensate. Perhaps on Constable's suggestion, the building in the valley towards the right – Vale Farm – is made lighter and more conspicuous than in the sketch.

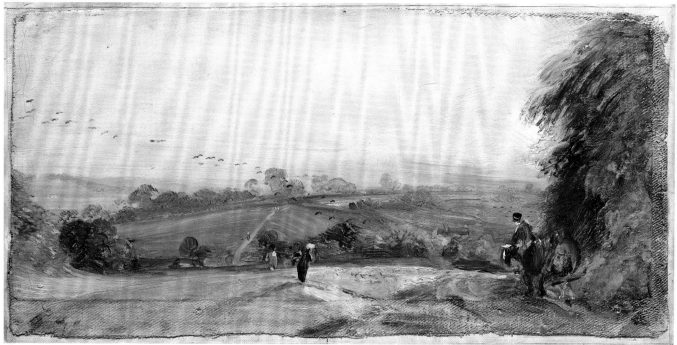

181

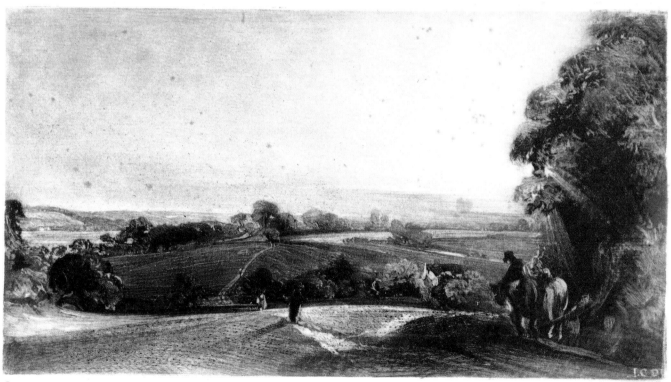

182

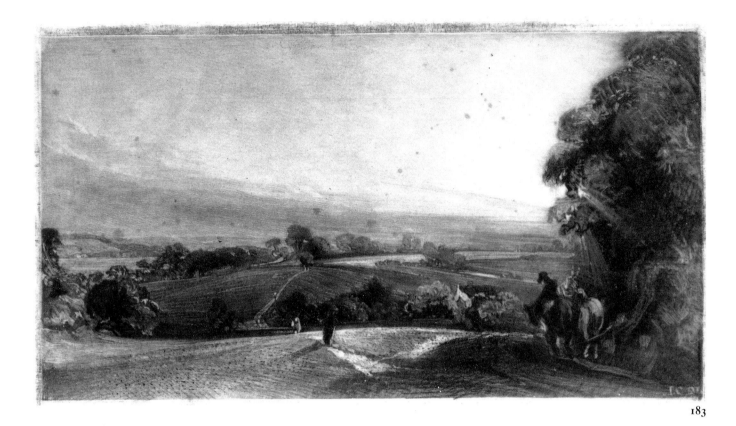

183

183 Autumnal Sunset (Progress Proof 'b')

Mezzotint 130 × 242 ($5\frac{1}{8}$ × $9\frac{9}{16}$), excluding
uncleared margins, on laid paper 215 × 292
($8\frac{1}{2}$ × $11\frac{1}{2}$); plate-mark 175 × 252 ($6\frac{7}{8}$ × $9\frac{15}{16}$)
Mezzotinted inscription as on no.182
PROV: As for no.174
LIT: Shirley 1930, no.14, progress proof 'b'

*Syndics of the Fitzwilliam Museum,
Cambridge*

The sky has been regrounded so that Lucas can
scrape a long line of low-lying clouds, more or less
on the flight-line of the rooks in the oil sketch. The
new ground has gone over the margins of the image
and these will have to be cleared again at a later
stage.

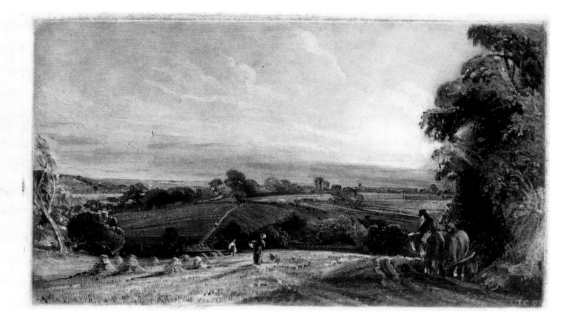

184

184 Autumnal Sunset (Progress Proof 'c', touched)

Mezzotint 130 × 242 ($5\frac{1}{8}$ × $9\frac{9}{16}$), excluding uncleared margins, on wove paper 260 × 385 ($10\frac{1}{4}$ × $15\frac{3}{16}$); plate-mark 175 × 252 ($6\frac{7}{8}$ × $9\frac{15}{16}$); touched with white body-colour and black and grey wash and with numerous birds drawn in pencil in the left margin
Mezzotinted inscription as on no.182; inscribed by H.S. Theobald in pencil b.r. of sheet: 'from Miss Isabel Constable│Sale│touched by Constable│H.S T'
PROV: By descent to Isabel Constable, who died 1888; her heirs, sold ?Christie's 17 June 1892 (in 62, 'Autumnal Sunset ... engraver's proof, touched by Constable; and a print') bt Young; Sir Henry S. Theobald; then as for no.174
LIT: Shirley 1930, no.14, progress proof 'c'

Syndics of the Fitzwilliam Museum, Cambridge

Substantial changes have now been made to the plate. A new tree has been introduced at the left edge and corn stooks and stubble added in the foreground field, which is now more broadly lit than before. Fleming-Williams (1990, p.115) suggests that when Constable added the corn stooks he may have been recalling two small compositional sketches of the scene, in which stooks seem to be indicated, that he had made in 1814 on the back of a drawing of a 'Farmhouse at East Bergholt' (no.253, fig.133 on p.417). In addition, highlights have been added on the central figures and on the head and nose of the left-hand horse and its rider's face. Langham and Stoke-by-Nayland churches appear for the first time. The flight of rooks is tentatively indicated. Constable's additional touches in his own hand include the extension leftwards of the very top of the tree at the right and the addition of two small black shapes (? birds, ? animals) to the right of the central woman. In the margin he has drawn numerous birds to show Lucas how to proceed with the rooks. Constable's letter to him of 2 June 1832 presumably refers to the engraver's first attempt at the rooks, the hesitant scrapings seen on this proof: 'The Evening, is spoiled owing to your having fooled with the rooks – they were the cheif feature, which caused me to adopt the subject. Nobody knew what they are – but took them only for blemishes on the plate' (Beckett IV 1966, p.376).

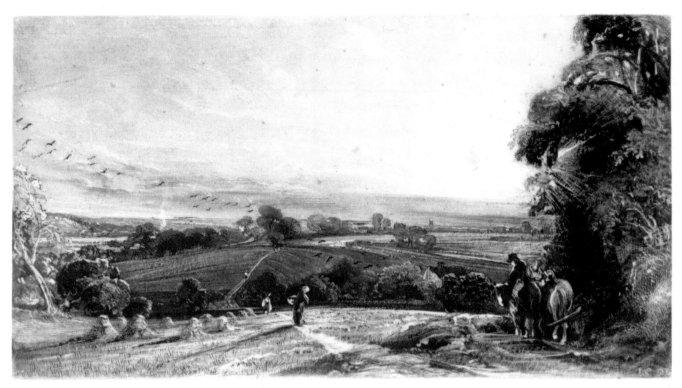

185

185 Autumnal Sunset (Progress Proof 'd' or 'e')

Mezzotint 129 × 241 (5$\frac{1}{16}$ × 9$\frac{1}{2}$) on laid paper 260 × 295 (10$\frac{1}{4}$ × 11$\frac{5}{8}$); plate-mark 175 × 251 (6$\frac{7}{8}$ × 9$\frac{7}{8}$)
Inscribed in pencil by Lucas '135│DL' below plate mark; mezzotinted inscription as on no.182
PROV: As for no.174
LIT: Shirley 1930, no.14, progress proof 'd' or 'e'

Syndics of the Fitzwilliam Museum, Cambridge

Constable at last has his flight of rooks, though, as with the dog in the 'Frontispiece', their prototypes remain visible: like his paintings, Constable's prints contain pentimenti. While stocks of the mezzotints remained in his studio (very few found buyers), Constable made further alterations, touching passages that continued to worry or intrigue him. Impressions of 'Autumnal Sunset' in its published form, which differs only in a few details from no.185, are sometimes found with alterations to the shadows of the central woman and the tree group at the right, as well as the lighting of the central figures (see, for example, Tate Gallery T 03991 and T 03992, described in *The Tate Gallery 1984–86: Illustrated Catalogue of Acquisitions*, 1988, p.29–30).

Constable said that it was the rooks that made him include this subject in *English Landscape*. In a moment of frustration with Lucas's first attempt at them he may have exaggerated, but remarks made to Fisher in 1826 show what powerful associations these birds held for Constable: 'I at this moment – hear a rook fly over my painting room in which I am now writing – his ⟨voice⟩ call – transports me to Osmington and makes me think for a minute that I am speaking and not writing to you – it reminds me of our happy walks in the feilds – so powerful is the voice of Nature – yet it was only a smal still voice '; 'Were you at all struck by my sobbing rook? His caw – (happening at the moment of writing to you) made me start: it was a voice which instantaneously placed my youth before' (Beckett VI 1968, pp.217, 219).

Summer Morning

Published in the third part of *English Landscape* in September 1831, 'Summer Morning' is unusual in being derived from possibly three paintings by Constable. It was begun from the 'Dedham from Langham' oil sketch of *c*.1812, no.17 in this exhibition, but may have been finished from the larger La Chaux-de-Fonds canvas, no.20, though it is possible that this was worked on at the same time as the print. The Ashmolean Museum oil sketch of the subject, no.18, provided the detail of the man leading horses down the hill.

Work had begun on the plate by 19 February 1831, when Constable advised Lucas 'Go on with what you like, of the 3rd number – the "Morning" or the "Evening"' (Beckett IV 1966, p.342). The artist was 'sanguine' with proofs he saw in June and was asking for more in July (ibid., pp.348–50). After publication further changes were made to the image (see no.190). The sequence of proofs and published states shows Constable elaborating the composition by gradually building up the staffage and foreground details. The substitution of a milkmaid for the boy seen in the original oil sketch led to problems, Constable being indecisive about which way she should face. Turned left, then right, then left again, she finally, if a little wearily, studied the distant landscape.

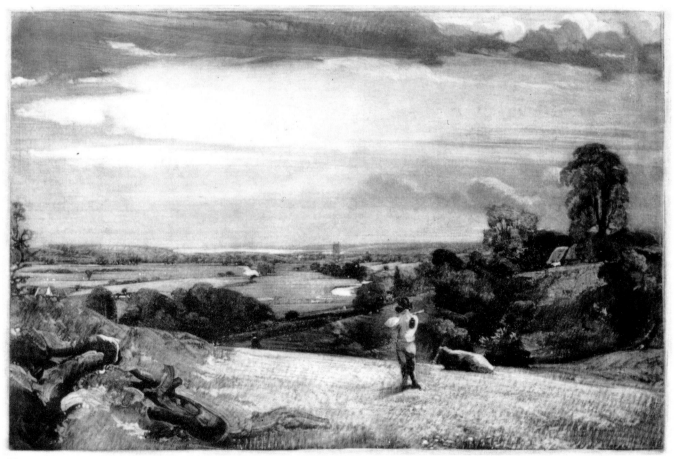

186

186 Summer Morning (Progress Proof 'b')

Mezzotint 140 × 215 (5½ × 8½) on wove paper
210 × 289 (8¼ × 11⅜); plate-mark 173 × 250
(6¹³⁄₁₆ × 9⅞)
PROV:...;? H.P. Horne;...; presented
anonymously to the Fitzwilliam Museum
through the National Art-Collections Fund
1954 (P.101–1954)
LIT: Shirley 1930, no.26, progress proof 'b',
pl.XXVIB (different impression)

*Syndics of the Fitzwilliam Museum,
Cambridge*

Proofs such as this show Lucas's remarkable ability
to translate the subtle paint surfaces of Constable's
early oil sketches. It would be interesting to know
what sort of briefing the artist gave him before he
started work on each subject and how Lucas
responded with advice on what would be possible,
what problematic. A note to 'Make the butterfly'
(Beckett IV 1966, p.454) refers to later work on this
plate but Constable must surely have had to tell
Lucas in the first place that the tiny winged shape
on the timber at the bottom left of the painting,
no.17, was indeed intended for a butterfly. Just to
the right of the timber in the sketch is a darker
patch of earth which Lucas seems to have inter-
preted, or have been prompted to interpret, as
another piece of wood. This shape soon becomes
the blade of the plough that Constable introduces
in the touched proof no.187 below. (After writing
this we noticed that Charles Rhyne had made the
same observation: Rhyne 1981, under no.38, a
drawing that may have been made while Constable
was working on the print.) Marks just to the left of
the boy suggest that Lucas, perhaps unguided here
by Constable, reproduced a pentimento in the oil
sketch, where the artist first painted the figure
further to the left (see fig.28 on p.78).

Shirley records an earlier progress proof, his 'a',
which lacks the figure of the boy and the distant
tower of Dedham church.

187 Summer Morning (Progress Proof 'b',
touched)

Mezzotint 140 × 218 (5½ × 8⁹⁄₁₆) on laid paper
162 × 225 (6⅜ × 8⅞); cut within plate-mark;
touched with white body-colour, ? white
chalk, black wash and pencil
PROV: As for no.186 (P.102–1954)
LIT: Shirley 1930, no.26, progress proof 'b'

*Syndics of the Fitzwilliam Museum,
Cambridge*

This impression appears to represent the same
state as no.186 but has been extensively reworked
by Constable in a variety of media. The boy has
been more or less obliterated and a second cow
indicated with white body-colour behind the first
one, the head of the new animal masking the boy's
waist. In the foreground a plough has been drawn
or painted in with black ink in different positions.
White lines on the dark slope in the middle distance
and around the tops of the trees behind show
additional lights required by Constable. Part of the
sky at the top right has been lightened with what
appears to be chalk.

The drawing of the ploughs in this impression is
very similar in character to the way the plough is
painted on the La Chaux-de-Fonds canvas (no.20;
detail, fig.103). If, as suggested under no.186
above, Lucas's interpretation of the dark patch of
earth in the small oil sketch was what eventually
suggested the inclusion of a plough in the print, this
part, at least, of the La Chaux-de-Fonds painting
may follow or be contemporary with work on the
mezzotint. This is very speculative, of course, and a
more thorough examination of the sequence of
events would be desirable. It is always possible that
Constable was reminded at this stage – perhaps by
Lucas's marks – of the La Chaux-de-Fonds canvas
with its plough in the foreground (and its two cows
attended by a milkmaid). That painting may in any
case already have entered his deliberations: on
1 January 1831 Constable told Lucas 'Perhaps it

fig.103 Detail from no.20,
'Dedham from Langham'

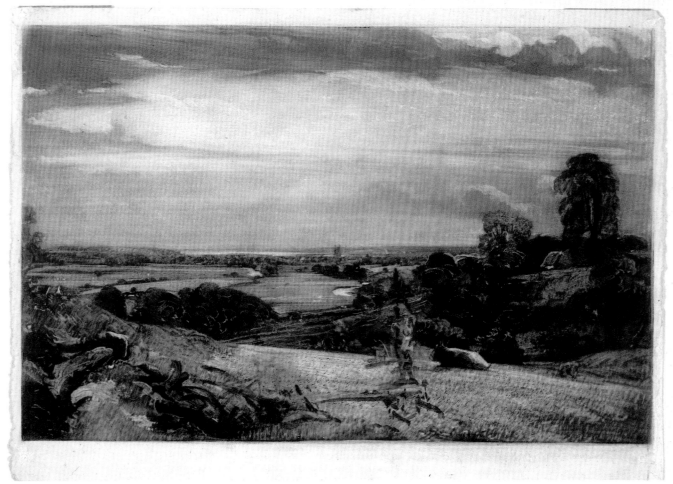

187

fig.104 'Dedham from Langham', 1830, *Mr and Mrs David Thomson*

will be as well to send [i.e. send back] the long landscape of the "Vale" as we shall not use it' (Beckett IV 1966, p.338). A pen sketch of the subject made about a week earlier, on 23 December 1830 (fig.104, coll. Mr and Mrs David Thomson, Fleming-Williams 1990, pp.292–5) corresponds more closely with the Ashmolean Museum oil sketch than with any of the other paintings. It looks as though Constable may have considered all his options before settling for the simplest version of all, the Victoria and Albert Museum oil sketch, no.17.

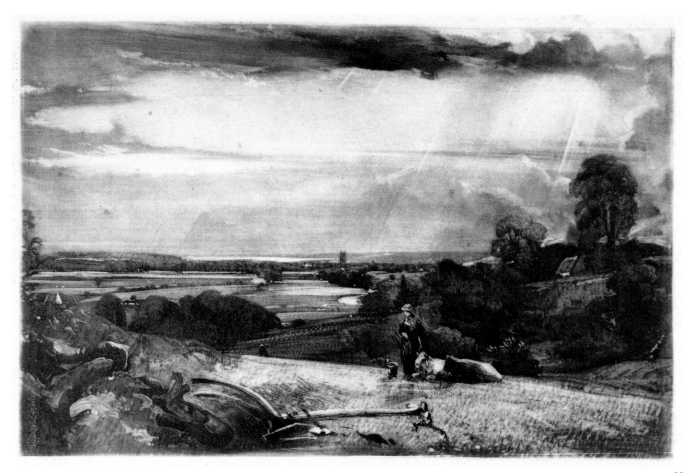

188

188 Summer Morning (Progress Proof 'e')

> Mezzotint 140 × 217 (5$\frac{1}{2}$ × 8$\frac{9}{16}$) on laid paper
> 273 × 365 (10$\frac{3}{4}$ × 14$\frac{3}{8}$); plate-mark 175 × 252
> (6$\frac{7}{8}$ × 9$\frac{15}{16}$)
> Inscribed in pencil by Lucas '97.|DL' below
> plate-mark at centre
> PROV: As for no.174
> LIT: Shirley 1930, no.26, progress proof 'e'
>
> *Syndics of the Fitzwilliam Museum,*
> *Cambridge*

Constable and Lucas have now (or rather in
Shirley's intervening state 'd') transformed the boy
into a milkmaid facing left and the second cow
indicated on the touched proof no.187 has also been
engraved on the plate. The plough drawn on the
same proof appears for the first time in the present
state 'e', scraped in and drawn with drypoint, as
does the milkmaid's pail.

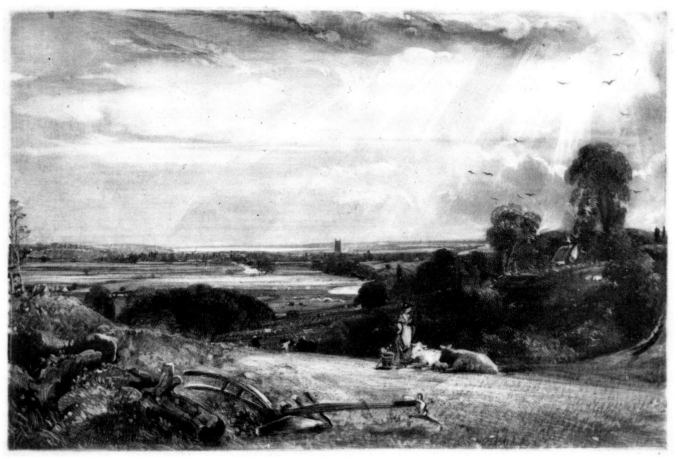

189

189 **Summer Morning** (Progress Proof 'h' or 'i')

Mezzotint 140 × 215 ($5\frac{1}{2}$ × $8\frac{1}{2}$) on india paper laid on thin card 268 × 366 ($10\frac{9}{16}$ × $14\frac{7}{16}$); plate-mark (possibly false, after transfer of india paper to new support) 180 × 255 ($7\frac{1}{8}$ × $10\frac{1}{16}$)
PROV: As for no.174
LIT: Shirley 1930, no.26, progress proof 'h' or 'i'

Syndics of the Fitzwilliam Museum, Cambridge

The milkmaid has now been turned to face right, as marked on a touched proof (? between 'e' and 'f') in the Metropolitan Museum of Art, New York (22.67.12), which also shows the man leading horses down the hill. The latter detail was derived from the Ashmolean Museum oil sketch of 1812, no.18 above, and first appears on the plate in Shirley's state 'g'. On the La Chaux-de-Fonds canvas (no.20) Constable uses a similar white-shirted figure with his arms outstretched but there the man is a reaper, accompanied by two others.

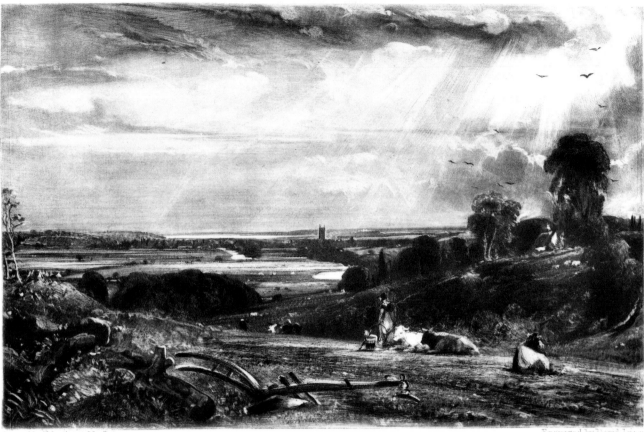

190

190 Summer Morning (Fourth Published State)

Mezzotint 140 × 219 ($5\frac{1}{2}$ × $8\frac{5}{8}$) on ? wove paper (laid down on mount when examined) 248 × 325 ($9\frac{3}{4}$ × $12\frac{13}{16}$); plate-mark 174 × 253 ($6\frac{7}{8}$ × 10)
Engraved inscriptions: 'Painted by John Constable R.A.' below image at left, 'Engraved by David Lucas.' below image at right, 'SUMMER MORNING. | London Pubd by Mr Constable 35. Charlotte St Fitzroy Square 1831.' below image at centre
PROV: . . .; James Brook Pulham, from whom bt by the British Museum 1842 (1842–12–10–122)
LIT: Shirley 1930, no.26, state V; Barnard 1984, no.6, state IV

Trustees of the British Museum, London

Comparatively minor alterations were made between the state represented by no.189 above and the first publication of the print in September 1831. In 1833, however, more substantial changes were made for the re-issue of the whole series that May. On 20 April Constable told Lucas 'Alfred [Lucas, David's brother] says he wants a proof of the Morning as we wished it to be. This I send – but a little cow I will send you an outline of, on Monday' (Beckett IV 1966, p.396). With a subsequent note Constable enclosed 'a few cows for the Summer Morning. Put which you please – if you would rather I put them into the "proof" you can only let Alfred come with it' (ibid.). A touched proof showing the alterations in hand – the turning of the milkmaid yet again, to face left, and the addition of a third cow – is in the Metropolitan Museum of Art, New York (22.67.11). The changes are seen in no.190, an impression of the print as republished in 1833 but still bearing the original publication date.

The cows Constable sent Lucas may have been copied or traced from page 56 of the 1813 sketchbook (fig.126 on p.410), which includes one that resembles the cow added to the print. This page of his sketchbook was probably already associated for Constable with the 'Summer Morning' subject: twenty years earlier, he appears to have chosen another cow from it to add to the Tate Gallery oil sketch of the scene, no.20.

Other Subjects

The 'Frontispiece', 'Autumnal Sunset' and 'Summer Morning' have been examined in some detail above, though without attempting to represent every stage of work. The subjects that follow are treated more briefly, with one or two impressions only from each plate.

191

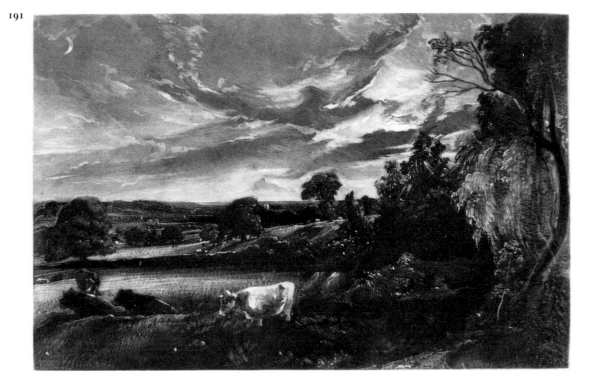

191 Summer Evening (Progress Proof, ? before 'a')

Mezzotint 140 × 217 ($5\frac{1}{2}$ × $8\frac{9}{16}$) on wove paper 265 × 356 ($10\frac{7}{16}$ × 14); plate-mark 175 × 252 ($6\frac{7}{8}$ × $9\frac{15}{16}$)
Inscribed in pencil by Lucas '297' below plate-mark at centre
PROV: As for no.174
LIT: Shirley 1930, no.6, progress proof 'a' or earlier

Syndics of the Fitzwilliam Museum, Cambridge

'Summer Evening' was based on the painting Constable exhibited in 1812 as 'Landscape: Evening', no.33 above, which is a view from behind Mrs Roberts's house at East Bergholt. The plate was begun before 15 September 1829, when Constable told Lucas that it was a 'pity the "Evening" prints so very bad' (Beckett IV 1966, p.322) but it was probably laid aside the following year. In February 1831 Constable gave Lucas the choice of continuing with either 'Summer Morning' (see nos.186–90) or 'the "Evening" of which I send a touched proof' (ibid., p.342). Both subjects appeared in the third part of *English Landscape* that September and were intended as a pair. In a draft of the letterpress to accompany 'Summer Morning' Constable set out what he saw as 'the different appearances which characterize the morning and evening effects' (see Shirley 1930, pp.260–1, Beckett 1970, p.17).

No.191 is an early progress proof showing areas of solid black where the plate has yet to receive any work with the scraper.

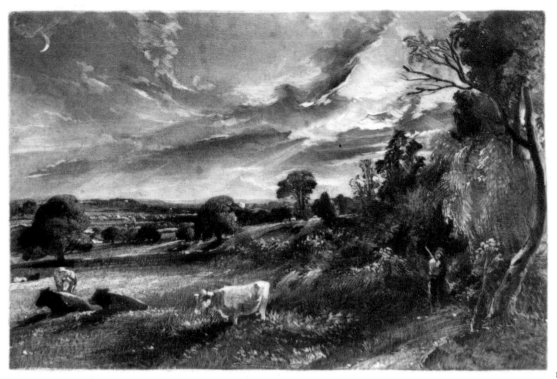

192

192 Summer Evening (Progress Proof 'd')

Mezzotint 142 × 218 ($5\frac{5}{8}$ × $8\frac{9}{16}$) on laid paper
270 × 361 ($10\frac{5}{8}$ × $14\frac{1}{4}$); plate-mark 176 × 252
($6\frac{15}{16}$ × $9\frac{15}{16}$)
Inscribed in pencil by Lucas '301' below
plate-mark at centre
PROV: As for no.174
LIT: Shirley 1930, no.6, progress proof 'd'

*Syndics of the Fitzwilliam Museum,
Cambridge*

The chiaroscuro is now more fully developed but
the plate will receive a good deal of further work
before publication. Clearly visible in this state is
the figure of a man at the right, carrying a stick or an
implement on his shoulder. This figure is not in the
original painting and was deleted from the print
after the state shown here. Presumably Constable
felt, if only briefly, that some human element was
required. In the event, 'Summer Evening' was the
only print in the original series in which no human
figure was included.

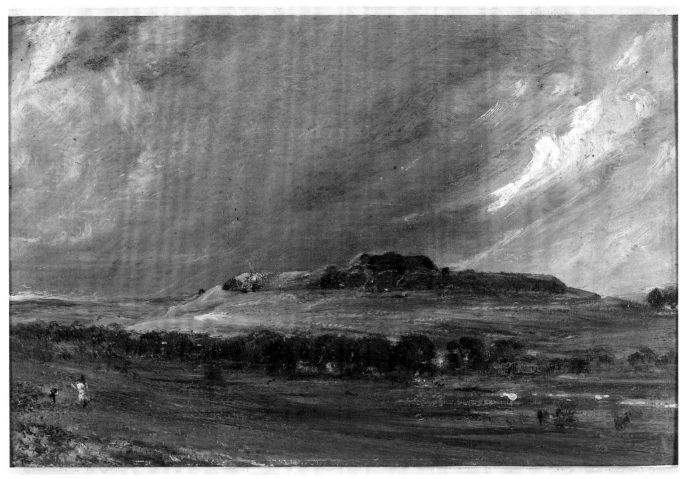

193

193 Old Sarum 1829

Oil on card 143 × 210 ($5\frac{5}{8}$ × $8\frac{1}{4}$)
Inscribed in the back 'ML', i.e. Maria Louisa
Constable's property
PROV: As for no.2
EXH: New York 1983 (36, repr. in col.)
LIT: Reynolds 1973, no.322, pl.233; Hoozee
1979, no.516, repr.; Reynolds 1984, no.29.65,
pl.763 (col.); Hill 1985, p.105, pl.14 (col.);
Cormack 1986, p.204; Rosenthal 1987, p.184,
pl.177 (col.); Fleming-Williams 1990, p.177

*Board of Trustees of the Victoria and Albert
Museum, London*

Constable made many drawings of Old Sarum on
his various visits to Salisbury. The present oil
sketch is related to one drawn there on 20 July 1829
(Reynolds 1984, no.29.17, pl.717), a more panora-
mic view than the oil gives but, like it, including a
shepherd at the bottom left. Reynolds suggests that
Constable may have based his oil sketch on this
drawing but it seems as likely that no.193 was
painted from nature, with only the figure added in
the studio: the drawing is a peaceful noon scene,
not a tempestuous evening one. At this stage in
Constable's life, however, one must be less sure
than ever. As the 'Hadleigh Castle' he exhibited
earlier in 1829 shows, transposing 'direct' exper-
ience into a more emotionally charged key was not
only possible but necessary. In his commentary on
the print (see no.195) Constable suggests that Old
Sarum is a subject particularly suited to such
transpositions.

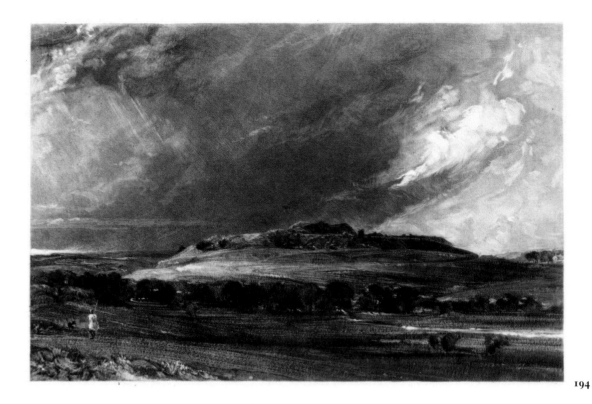

194

195

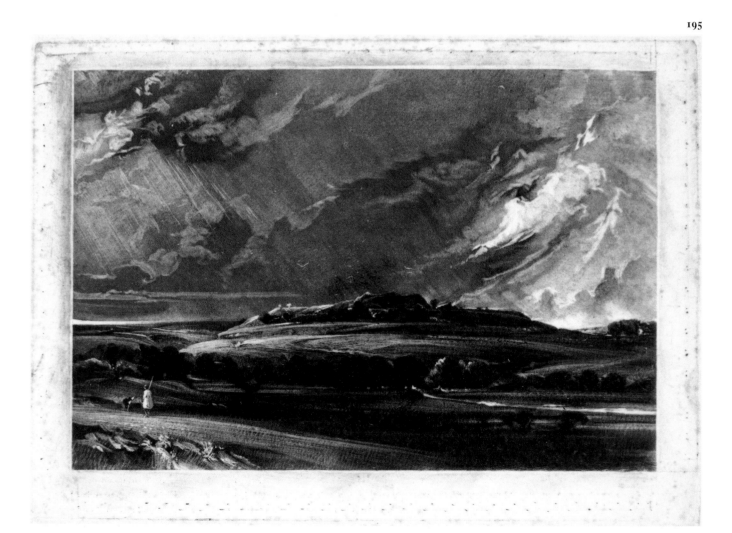

194 Old Sarum (First Plate, Progress Proof 'f')

Mezzotint 140 × 215 ($5\frac{1}{2}$ × $8\frac{1}{2}$) on laid paper
262 × 359 ($10\frac{5}{16}$ × $14\frac{1}{8}$); plate-mark 185 × 253
($7\frac{5}{16}$ × 10)
PROV: As for no.174
LIT: Shirley 1930, no.8, progress proof 'f'

Syndics of the Fitzwilliam Museum,
Cambridge

Lucas engraved two plates from the Old Sarum oil
sketch, no.193. This is a late proof from the first
plate, with the image in its final form and only the
lettering to be added before publication. The date
scratched on an earlier proof, '1829', indicates that
this was one of the first subjects to be engraved. By
19 January 1830 it was 'perfect & might be printing
to save time' (Beckett IV 1966, p.324). Constable
had already sent an impression to the President of
the Royal Academy, Sir Thomas Lawrence, who
wrote to thank him on 27 October 1829, finding the
print 'exceedingly well executed' and adding, 'I
suppose you mean to dedicate it to The House of
Commons?' (Parris, Shields, Fleming-Williams
1975, p.234). This may have been a reference to the
fact that the first Parliament was held at Old Sarum
or, ironically, to its notoriety as a 'rotten borough'.
The print was published in the second part of
English Landscape in January 1831 but Constable
later became dissatisfied with it and had a second
plate engraved (see no.195).

195 Old Sarum (Second Plate, Progress Proof
'b')

Mezzotint 149 × 223 ($5\frac{7}{8}$ × $8\frac{3}{4}$) on wove paper
204 × 283 ($8\frac{1}{16}$ × $11\frac{1}{8}$); plate-mark 179 × 254
($7\frac{1}{16}$ × 10)
PROV: As for no.174
LIT: Shirley 1930, no.32, progress proof 'b'

Syndics of the Fitzwilliam Museum,
Cambridge

According to C.R. Leslie, Constable asked Lucas
to re-engrave 'Old Sarum' because he thought the
'mounds and terraces were not marked with
sufficient precision' in the first plate (Leslie 1843,
p.76, 1951, p.196), though Lucas had in fact been
remarkably faithful to the original oil sketch in this
respect. In having a new plate engraved Constable
took the opportunity also to heighten the chiaros-
curo and drama of the subject. The text he wrote to
accompany the print (Shirley 1930, pp.258–9,
Beckett 1970, pp.24–5) explores the idea of
chiaroscuro at several levels. The former greatness
of the city of Old Sarum is contrasted with its
present 'wild, desolate, and dreary' appearance,
while the scenes of violence that Constable
imagines the place to have witnessed are set against
its later pastoral innocence, typified by the shep-
herd and his flock. These contrasting historical

and moral associations find their equivalent in
Constable's own chiaroscuro. The place is 'so
grand in itself, and interesting in its associations . . .
that no kind of effect could be introduced too
striking, or impressive to portray it'. 'Sudden and
abrupt appearances of light, thunder clouds . . .
conflicts of the elements' accord best with its
character. While claiming in the 'Introduction' to
English Landscape that the effects of light and shade
in the plates were 'transcripts' from nature,
Constable here advises the artist to choose his
chiaroscuro according to the 'sentiment' he wishes
to convey: chiaroscuro is 'entirely at his command'
and to be used 'with the most perfect freedom'.

Although the second 'Old Sarum' may have
been begun in the autumn of 1831 (Beckett IV
1966, p.358), little can have been done by 20
November 1832, when Constable asked Lucas to
make the image six by ten inches in size (ibid.,
p.388). Lucas was sent a touched proof on 28
February 1833 (ibid., p.393) and the print was
issued with the new edition of the whole work that
May. Shirley records only two progress states.
No.195 is an example of the second, with the image
complete but the margins still to be cleared. There
are squaring-up marks at $\frac{5}{16}$ inch intervals in all
margins.

196 Stoke-by-Nayland, Suffolk (Progress
Proof 'e', touched)

Mezzotint 144 × 219 ($5\frac{11}{16}$ × $8\frac{5}{8}$) on laid paper
280 × 405 ($11\frac{1}{16}$ × 16); plate-mark 178 × 251
(7 × $9\frac{7}{8}$); touched with ink and pencil and
with pencil drawings of the church in the left
margin
Inscribed in pencil 'Sepr 20. 1830 | J C.' b.l. of
sheet and 'little shadow in | the Cloud over
the Rainbow' towards top of left margin
PROV: As for no.174
EXH: *John Constable R.A. 1776–1837*,
Fitzwilliam Museum, Cambridge and Arts
Council tour 1976–7 (C, repr. but without
marginal drawings)
LIT: Shirley 1930, no.9, progress proof 'e'

Syndics of the Fitzwilliam Museum,
Cambridge

The first surviving progress proofs of 'Stoke-by-
Nayland' (e.g. Shirley 1930, pl.IX) show the
church in a different position from the one we see
here, an image that cannot be matched in any of the
known oil sketches or drawings of the subject.
Commenced in 1829, the plate underwent numer-
ous changes (detailed in Shirley 1930 and discussed
in Fleming-Williams 1990, pp.297–30) before
publication in the second part of *English Landscape*
in January 1831. No.196 is included here partly to
show the lengths to which Constable went in
marking proofs. The changes to the church tower
he asks for here include the thinning down of the

pinnacles and the insertion of crenellations. These are indicated by ink touches on the print and further demonstrated in a detailed pencil drawing of the whole tower in the margin. In his catalogue of the 1976 Cambridge exhibition Reg Gadney suggested that Constable had drawn the church in reverse, with the nave to the left, because Lucas would have to engrave it thus, but there appear to be two separate though adjoining drawings, one of the tower and the other, to its left, of the east end of the nave and the lower chancel. The shadow in the cloud above the rainbow asked for in Constable's marginal note is also indicated with pencil on the proof, as are changes on the tree above the girl.

This was one of the prints for which Constable wrote an accompanying text (Shirley 1930, pp.255–7, Beckett 1970, pp.21–4). 'The solemn stillness of Nature in a Summer's Noon, when attended by thunder-clouds,' he explained, 'is the sentiment attempted in this print'. As with 'Old Sarum', his weather is chosen to reflect the character of the place: the great mediaeval churches of Suffolk 'seen as they now are standing in solitary and imposing grandeur in neglected and almost deserted spots' give 'a solemn air to even the country itself'.

For the large painting Constable made of this subject in his last years, perhaps prompted by the mezzotint, see no.218 below.

197 Weymouth Bay (Progress Proof 'a')

Mezzotint 144×183 ($5\frac{11}{16} \times 7\frac{3}{16}$) on laid paper 295×365 ($11\frac{5}{8} \times 14\frac{3}{8}$); plate-mark 178×228 (7×9)

Inscribed in pencil below plate-mark '"There is a rapture in the lonely sounding shore" | "Silent he wandered by the sounding main" –' (the first 'sounding' is above the rest of the line and there is a faint indication of a line erased between the two quoted here) and with barely legible inscriptions at the b.l. of the sheet (including a date of 'Jany 30. [. . . ?o]') and b.r. (possibly a reference to this being the first proof from the plate)

PROV: . . .; presented anonymously to the Fitzwilliam Museum through the National Art-Collections Fund 1954 (P.147–1954)
LIT: Shirley 1930, no.13, progress proof 'a'

Syndics of the Fitzwilliam Museum, Cambridge

'Weymouth Bay' was based on the Louvre painting, no.86 in this exhibition. As mentioned in the entry on that work, Constable associated the subject with the death of Captain John Wordsworth, who drowned off Portland Bill in 1805, as well as with the poetry of his brother William, a line from whose 'Elegiac Stanzas, suggested by a

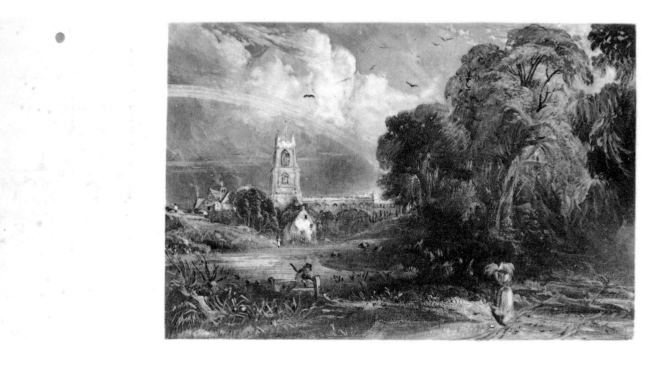

picture of Peele Castle in a storm' he quoted when sending Mrs Leslie an impression of the print. The first line inscribed by Constable on the present early proof is adapted from Byron's 'There is a rapture on the lonely shore' (*Childe Harold*, canto IV, stanza clxxviii) and confirms the familiarity with his verse suggested in Constable's letter to Maria of 13 May 1813: 'Lord Byron was pointed out to me – I was anxious for the sight of him – his poetry is of the most melancholy stamp – but there is great ability' (Beckett II 1964, p.106). The second line has not been identified. There are

frequent quotations from the poets – from Milton, Thomson, Gray, Cowper, Goldsmith, Akenside, Crabbe and others – in Constable's texts for *English Landscape*. They tell us as much about the way poetry had formed or confirmed his own attitudes to nature as about the cultural background he looked for in his audience.

Although an example of the earliest known progress proof, no.197 shows the subject well advanced. The print was issued in the first part of the work in June 1830. The date faintly inscribed on this impression is likely to be 30 January 1830.

197

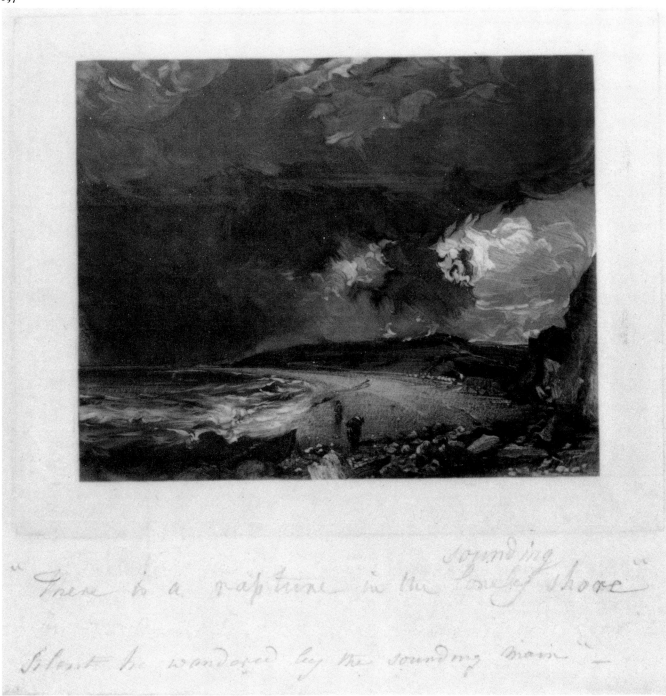

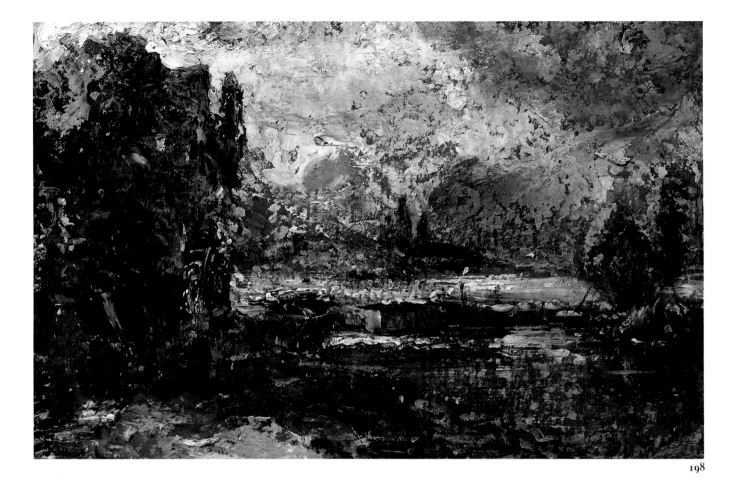

198

198 Dedham Mill 1829

Oil on paper laid on canvas 180 × 300
(7 × 11¾)
PROV: Isabel Constable (according to an old
label on the stretcher); . . .; Hon.Ralph
Bathurst 1948; . . .; anon. sale, Sotheby's 30
Nov. 1960 (121) bt Leggatt; . . .; anon. sale,
Christie's 24 April 1987 (47, repr. in col.);
present owner
EXH: New York 1988 (30, repr. in col.); New
York 1989 (26, repr. in col. in reverse)
LIT: Hoozee 1979, no.518, repr.; Reynolds
1984, no.29.59, pl.759; Hill 1985, p.107, pl.17

Private Collection, New York

Constable may have painted this studio sketch after
leafing through his 1814 sketchbook, no.248, and
finding on p.37 an upright, but in many other ways
comparable, drawing of a building standing beside
water with trees on the other side. Whether the
drawing represents Dedham mill is not clear but

the addition of a waterwheel at least clarifies the
function of the building as it appears in this oil
sketch. The print based on it, no.199, is referred to
in the correspondence simply as the 'Water Mill'
before its publication (as 'A Mill') in the first part of
English Landscape in June 1830. 'Dedham' only
appears in the correspondence in 1833, around the
time that Constable added the tower of Dedham
church to the print.

It seems likely that the oil sketch was made in
1829 when Constable decided that he wanted to
include a watermill in the series and that his
original, rather Cozensish, intention was to demon-
strate an 'effect' as much as to describe a place.
Even after adding the church tower Constable
wrote that 'The subject of this print is little more
than an assemblage of material calculated to
produce a rich Chiar Oscuro, and is noticed solely
with that view' (Shirley 1930, p.248, Beckett 1970,
p.26). According to C.R. Leslie, the print was
engraved 'from a very slight sketch' and 'Constable
did not again place anything so unfinished in the
hands of Mr. Lucas' (1843, p.67, 1951, p.180).

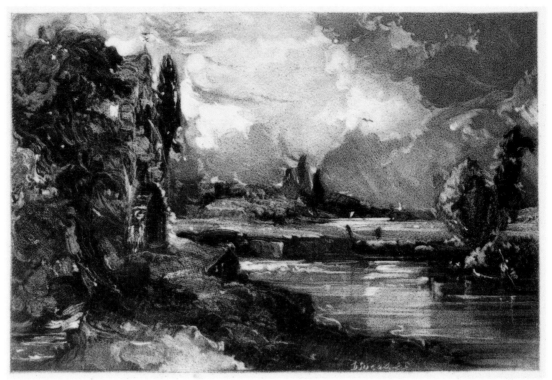

199

199 A Mill (Progress Proof 'a')

Mezzotint 141 × 214 ($5\frac{9}{16}$ × $8\frac{7}{16}$) on laid paper
267 × 368 ($10\frac{1}{2}$ × $14\frac{1}{2}$); plate-mark 184 × 251
($7\frac{1}{4}$ × $9\frac{7}{8}$)
Inscribed in pencil by Lucas 'N° 34 a pen &
ink Drawing | 35. a letter & Drawing | relating
to this | plate' b.l. of plate-mark, '36 | D.L.'
below plate-mark at centre and, in ink, '12 in
this state N.2' b.l. of sheet; mezzotinted
inscription 'DLucas.29' at bottom of image
towards right
PROV: as for no.174
LIT: Shirley 1930, no.5, progress proof 'a'

*Syndics of the Fitzwilliam Museum,
Cambridge*

In translating the oil sketch, no.198, into mezzotint
Lucas has had to use his imagination to complete
Constable's hastily formed clouds. Whether or not
guided by the artist, he has also transformed the
blue sky at the top right and in the centre into
darker cloud. Shirley noted what looked to him like
water pouring from high up on the wall of the mill.
If this is what was intended by Lucas, it may have
been a misreading of the slighter and more casual
mark that appears at this point in the oil. The detail
is omitted in later states.

No.199 is an impression of the first recorded
progress state, one of twelve such impressions
according to Lucas's annotation. It must date from
some time before 26 December 1829, when
Constable asked for 'the next (and I hope the last)
proof of the Water Mill' (Beckett IV 1966, p.323).

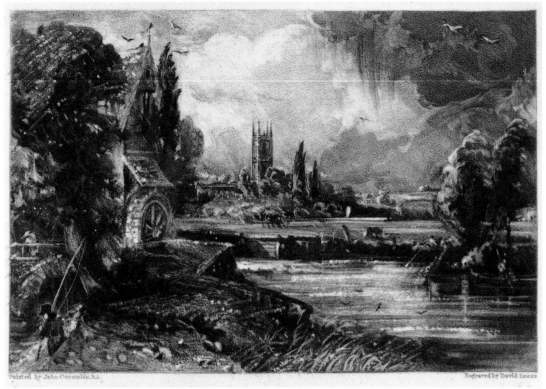

Painted by John Constable,R.A. Engraved by David Lucas

200

200 A Mill (Fifth Published State, touched)

Mezzotint 142 × 214 ($5\frac{5}{8}$ × $8\frac{7}{16}$) on wove paper 217 × 290 ($8\frac{9}{16}$ × $11\frac{7}{16}$); plate-mark 184 × 251 ($7\frac{1}{4}$ × $9\frac{7}{8}$); touched in grey wash and scratched
Engraved inscriptions: 'Painted by John Constable, R.A.' below image at left, 'Engraved by David Lucas' below image at right, 'A MILL.│London. Published by Mr Constable. 35. Charlotte St Fitzroy Square. 1832.' below image at centre
PROV: As for no.174
LIT: Shirley 1930, no.5, state IV; Barnard 1984, no.17, state V

Syndics of the Fitzwilliam Museum, Cambridge

Although many alterations were made to 'A Mill' between the state seen above, no.199, and its publication in the first part of *English Landscape* in June 1830, more substantial changes were put in hand for its reissue in the new edition of the work in May 1833, the most obvious being the anomalous introduction of Dedham church (see the 'Dedham Lock and Mill' paintings, nos.93–6 for the actual topography) and the addition of a fisherman and a woman at the bottom left. The number of birds was increased, rain shown falling from the dark cloud, the tops of the poplars bent and other small changes made. (At an earlier stage the bird in the sky to the right of centre had been turned into a heron, like the one Constable noted in his Flatford lock drawing of 1827, no.315 below.) The new alterations appear to have been underway in February 1833 (Beckett IV 1966, p.393). On this impression Constable has scratched further lights in the river, on the water falling from the wheel, on the roof over the wheel and in the water by the fisherman.

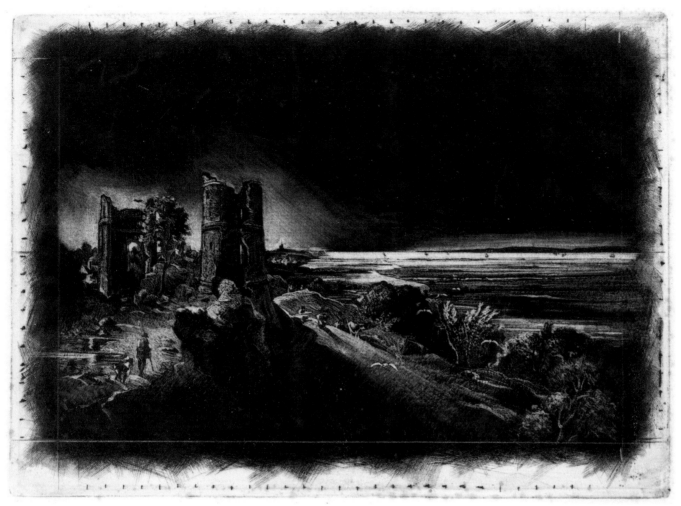

201

201 **Hadleigh Castle near the Nore** (Progress Proof 'a')

Mezzotint, image size indicated by ruled lines 143 × 216 ($5\frac{5}{8}$ × $8\frac{1}{2}$) but work extends irregularly beyond, on wove paper 257 × 356 ($10\frac{1}{8}$ × $14\frac{1}{16}$); plate-mark 180 × 252 ($7\frac{1}{8}$ × $9\frac{15}{16}$) Inscribed in pencil by Lucas '226' below plate-mark at centre
PROV: As for no.174
EXH: *John Constable R.A. 1776–1837*, Fitzwilliam Museum, Cambridge and Arts Council tour 1976–7 (E, repr.)
LIT: Shirley 1930, no.34, progress proof 'a'

Syndics of the Fitzwilliam Museum, Cambridge

See no.202

202 **Hadleigh Castle near the Nore** (Progress Proof 'b')

Mezzotint, image size indicated by ruled lines 143 × 216 ($5\frac{5}{8}$ × $8\frac{1}{2}$) but work extends beyond to approx. 170 × 240, on laid paper 260 × 355 ($10\frac{1}{4}$ × 14); plate-mark 180 × 252 ($7\frac{1}{8}$ × $9\frac{15}{16}$)
Inscribed in pencil by Lucas '227' below plate-mark at centre
PROV: As for no.174
EXH: As for no.201 (F, repr.)
LIT: Shirley 1930, no.34, progress proof 'b'

Syndics of the Fitzwilliam Museum, Cambridge

Both of Lucas's 'Hadleigh Castle' mezzotints, this small one for *English Landscape* and the larger, separately published one (no.203), appear to have been based on the painting of the subject that Constable exhibited in 1829 (fig.84 on p.312, Yale Center for British Art). The smaller print extends the composition to include additional landscape on the left side.

While some of the *English Landscape* plates are not much smaller than the originals they were

derived from, 'Hadleigh Castle' is only about one eighth of the size of the painting. This is no doubt why Constable asked Lucas, on 26 December 1831, 'to bring me a slight outline of the "Nore" and you must divide it thus', showing him with a diagram that he wanted it divided into sixteen rectangles crossed by diagonals (Beckett IV 1966, p.363, repr. Cormack 1986, pl.180). Constable would want to check Lucas's 'slight outline' when such a massive reduction was involved. The first progress proof (no.201), however, carries squaring-up marks at much closer intervals – $\frac{1}{4}$ inch apart – than Constable's diagram. Little is so far known about Lucas's procedure for transferring the compositions to his plates, though a letter to him from Constable in 1836 indicates that the larger canvases, at least, were crossed with threads to form a network of squares (Beckett IV 1966, p.429; see also Cove on pp.508–9).

Nos.201–2 represent the earliest stages of Lucas's work on the small 'Hadleigh', with the sky still to be scraped in no.201 but substantially formed in no.202. The area of the image has not yet been settled; it was later extended beyond the ruled lines at the left and bottom, which are still visible on the print as published in the fifth part of the work in July 1832.

203 Hadleigh Castle (Large Plate, Progress Proof 'b')

Mezzotint 267 × 363 ($10\frac{1}{2}$ × $14\frac{5}{16}$) on wove paper 362 × 510 ($14\frac{1}{4}$ × $20\frac{1}{16}$); plate-mark 276 × 373 ($10\frac{7}{8}$ × $14\frac{11}{16}$)
Mezzotinted inscriptions: 'J Constable. RA' b.l. of image, '1829' on rock, left of centre at bottom of image, and 'D Lucas' b.r. of image; collector's mark of F. Reiss on back
PROV: . . . ; Fritz Reiss (but not in his sale, Christie's 18–19 Dec. 1923); . . . ; presented anonymously to the Fitzwilliam Museum through the National Art-Collections Fund 1954 (P.223–1954)
LIT: Shirley 1930, no.11, progress proof 'b'

Syndics of the Fitzwilliam Museum, Cambridge

This 'Hadleigh Castle' was the first of several large plates after Constable that Lucas engraved on his own account but with the artist's co-operation. Constable told him on 26 February 1830: 'I have not the wish to become the owner of the large plate of the Castle, but I am anxious that it should be fine, & will take all pains with it. It will not fail of being so, if I may now judge', adding later in the

202

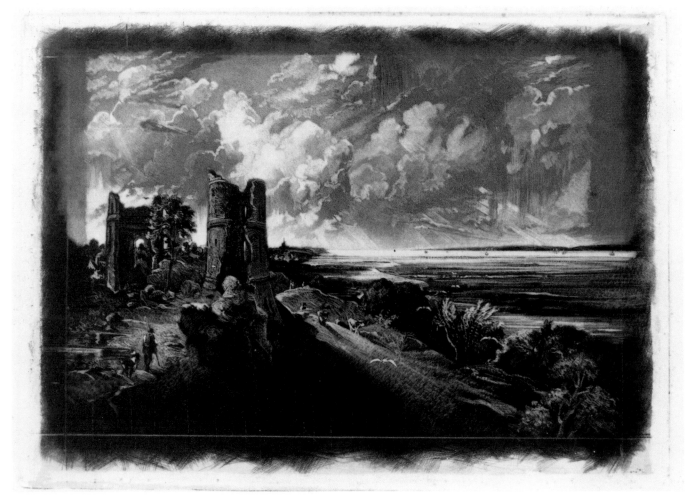

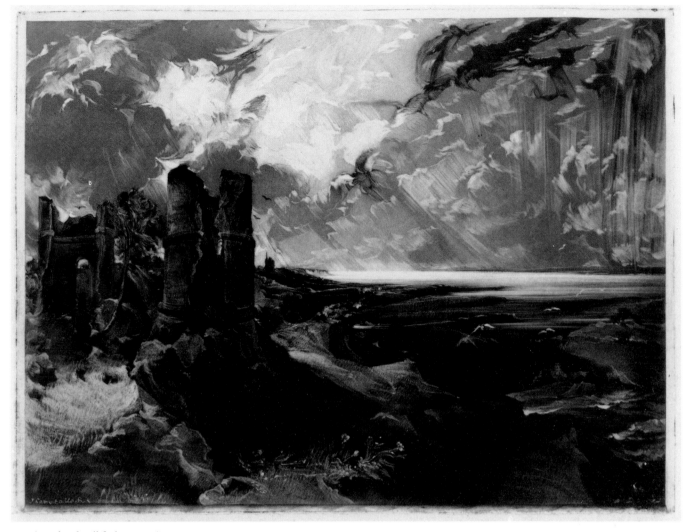

203 (see also detail facing p.319)

same letter, 'Bring me another large Castle or two or three, for it is mighty fine – though it looks as if all the chimney sweepers in Christendom had been at work on it, & thrown their soot bags up in the air. Yet every body likes it' (Beckett IV 1966, p.325). Constable's own admiration for the print in its early stages, no doubt in some such state as we see in no.203, sanctions (if sanction is necessary) modern acclaim of the unfinished plate. In this condition R.B. Beckett thought it 'perhaps the most inspired of all' Lucas's works.

No.203 shows both sides of the main tower more or less equal in height. In the finished print the right-hand side is raised higher than the left, oddly reversing the order seen in all Constable's paintings and drawings of the subject. After the splendid beginning in 1829–30, work on the plate lapsed at least until 1832, when Constable lent Lucas 'the sketch of the Castle that it may help you when you resume the large plate of it' (ibid., p.377). The 'sketch' has not been identified but might possibly be no.170 above. It may have been some time before Lucas returned to the large plate, which Shirley records as being rusty by the time of his progress proof 'd', the state in which the height of the main tower was altered. The print was not published until 1849.

204 Vignette: Hampstead Heath, Middlesex (Progress Proof 'a')

Mezzotint 81 × 153 ($3\frac{3}{16}$ × 6) on laid paper
260 × 360 ($10\frac{1}{4}$ × $14\frac{3}{16}$); plate-mark 165 × 227
($6\frac{1}{2}$ × $8\frac{15}{16}$)
Inscribed in pencil by Lucas '3│D.L.' below
plate-mark at centre and 'in this State n 2.'
b.l. of sheet
PROV: As for no.174
EXH: Tate Gallery 1976 (281, repr.)
LIT: Shirley 1930, no.3, progress proof 'a',
pl.IIIA (? different impression)

*Syndics of the Fitzwilliam Museum,
Cambridge*

See no.205

205 Vignette: Hampstead Heath, Middlesex (First Published State)

Mezzotint 91 × 153 ($3\frac{9}{16}$ × 6) on laid paper
262 × 368 ($10\frac{5}{16}$ × $14\frac{1}{2}$); plate-mark 165 × 227
($6\frac{1}{2}$ × $8\frac{15}{16}$)
Engraved inscriptions: 'VIGNETTE.│To M^r
Constable's English Landscape.' above image
at centre, 'Painted by John Constable, R.A.'
below image at left, 'Engraved by David
Lucas.' below image at right, 'HAMPSTEAD
HEATH, MIDDLESEX.│*"Ut Umbra sic Vita."*
│London, Published by John Constable, 35,
Charlotte S^t Fitzroy Square, 1831.' below
image at centre
PROV: . . .; Deighton, from whom bt by
Craddock & Barnard 1951; bt from the firm
by Osbert Barnard for his private collection
1952, sold Sotheby's 7 March 1985 (in 237)
bt Christopher Mendez for the Tate Gallery
(T 04062)
EXH: Tate Gallery 1986 (34)

LIT: Shirley 1930, no.3, published state II;
Barnard 1984, no. 22, published state I; *The
Tate Gallery 1984–86: Illustrated Catalogue
of Acquisitions*, 1988, p.49

Tate Gallery

The 'Vignette', published in the fifth and final part
of *English Landscape* in July 1832, shows a bank on
Hampstead Heath with, in the later states, St Paul's
in the distance on the left. The original painting or
drawing is not known today.

Correcting Leslie's statement that the first plate
to be engraved for *English Landscape* was 'A Mill'
(no.199), Lucas wrote in his copy of the *Life* (the
eccentric punctuation is his): 'no. this is a mistake
the first engraving was the small Hampstead Heath
called the Vignette. the figure on the brow of the
bank. was. Collins the painter who happened to be
sketching on the heath at the time.' (Parris, Shields,
Fleming-Williams 1975, p.60). By the end of the
1820s Constable and William Collins, who lived at
Hampstead (see p.213), had more or less broken off
relations. Lucas's identification, if correct, may
point to the original of the 'Vignette' being a work
made earlier in the decade.

After the first state, no.204, which can be dated
to before 6 October 1829, Constable gradually
transformed the figure of the man in the print,
placing a pick-axe over his shoulder and then
bending his head forward. It seems unlikely that
these changes had anything to do with his view of
Collins. When it was begun the print was probably
intended to open the whole series and an image of
an artist surveying the landscape would have been
entirely appropriate. Instead, the 'Vignette'
became the concluding print and an artist was
meanwhile introduced in the new 'Frontispiece'
(nos.173–80). In his final form, as we see him in
no.205, the man – now a bent labourer – accords
better with the sentiment expressed in the motto
engraved beneath the title, 'Ut Umbra sic Vita'
('even as a shadow is our life' or 'life is like a
shadow'). This, the inscription on the sundial of
East Bergholt church, forms an apt colophon to a
work of art which conveys the chiaroscuro of
human life as well as that of nature.

204

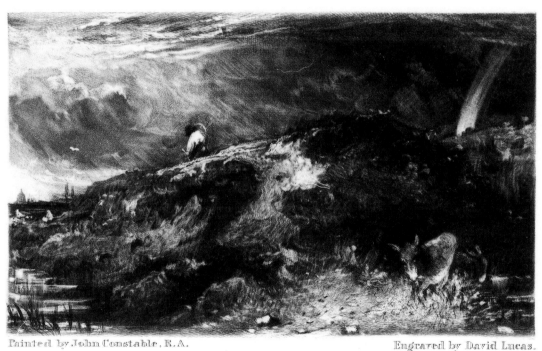

Painted by John Constable, R.A. Engraved by David Lucas.

205

The 1830s

Although his work with David Lucas on the *English Landscape* prints (see nos.173–205) took up much of Constable's time in the early 1830s, he nevertheless managed during the same period to paint two of the most ambitious and impressive canvases of his whole career: 'Salisbury Cathedral from the Meadows' (no.210), exhibited in 1831, and 'The Opening of Waterloo Bridge' (no.213), shown the following year. Thereafter he showed only two large paintings, 'The Valley Farm' (no.216) in 1835 and 'The Cenotaph' (fig.13 on p.37) in 1836. Smaller pictures, drawings and watercolours, most notably the 'Old Sarum' and 'Stonehenge' (no.345) watercolours, made up the bulk of his final exhibits. A few oil sketches of the middle-1830s, however, suggest that he was planning new large compositions on Suffolk themes (see nos.214–15, 217–18). The colourful, unrestrained character of these works, painted in the studio (there appear to be no outdoor oil sketches after 1829), contrasts strikingly with the last exhibited canvases but is paralleled in the wild pencil sketches in his 1835 sketchbook (no.340) and in his bold ink 'blots' (for example, no.343). The artist's final works present a wide range of ways of dealing with landscape and argue against a neat definition of 'Late Constable'.

Detail from 'A Farmhouse near the Water's Edge (On the Stour)', no.215

Salisbury Cathedral from the Meadows

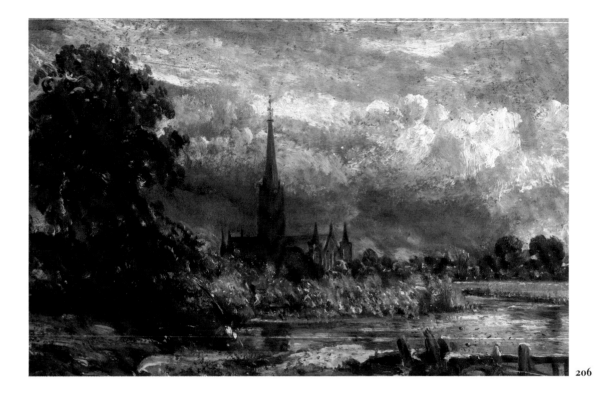

206

206 **Salisbury Cathedral from Long Bridge** *c*.1829

Oil on paper laid on card 184 × 279 (7¼ × 11)
Inscribed in a later hand on the back
'Salisbury | painted by John Constable RA. | given to Alice Fenwick | by Isabel Constable.'
PROV: By descent to Isabel Constable who gave it to Alice Fenwick, née Ashby, probably in the 1880s; by descent to Major C.W. Maffett; Trustees of the Mrs D.H. Maffett Will Trust, sold Christie's 19 Nov. 1982 (45, repr. in col.) bt Adams for present owners
LIT: Fleming-Williams 1983b, pp.34–8, repr. in col.; Parris 1983, p.223; Reynolds 1984, no.31.4, pl.795; Fleming-Williams 1990, pp.232–43, fig.214

The Hart Collection

See no.207

207 **Salisbury Cathedral from the River Nadder** *c*.1829

Oil on paper laid on card 197 × 278 (7¹³⁄₁₆ × 11)
Inscribed in a later hand on a fragment of paper pasted on the back 'Salisbury | J. Constable R.A..'
PROV: By descent to Isabel Constable who gave it to Alice Fenwick, née Ashby, probably in the 1880s; by descent to Major C.W. Maffett; Trustees of the Mrs D.H. Maffett Will Trust, sold Christie's 19 Nov. 1982 (44, repr. in col.) bt Oscar and Peter Johnson Ltd for present owner
LIT: Fleming-Williams 1983, pp.34–8, repr. in col.; Parris 1983, p.223, fig.37; Reynolds 1984, no.31.3, pl.794; Cormack 1986, p.204, pl.189 (col.); Fleming-Williams 1990, pp.237–8, fig.221

Private Collection, New York

Constable's two visits to Salisbury in 1829 were the last he was to spend with the Fishers. In June Fisher had left a note for Constable with an invitation to come and stay at Leadenhall, ending: 'You know Dr Sam Johnsons sentiment: make new friendships continually & do not let your old ones die a preturnatural death' (Beckett VI 1968, p.248). Mary Fisher extended the invitation to include the two elder children and on 4 July Constable wrote to

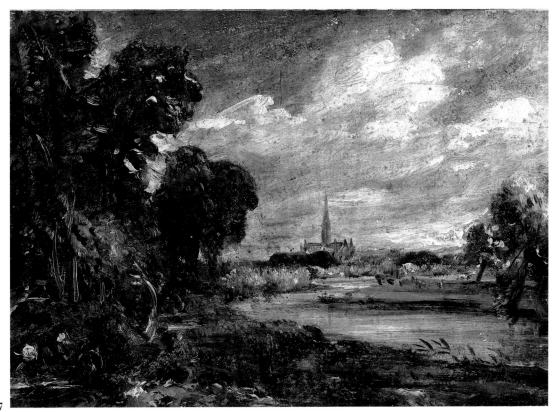

207

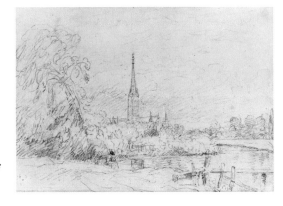

fig.105 'Salisbury Cathedral from Long Bridge', 1829, *Syndics of the Fitzwilliam Museum, Cambridge*

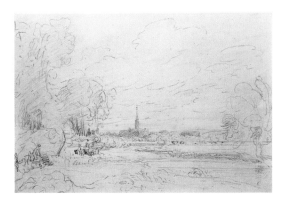

fig.106 'Salisbury Cathedral from the Meadows', 1829, *Paul Mellon Collection, Upperville, Virginia*

say that he had booked places in the Salisbury coach for the 7th. On this trip he made a number of drawings, the last of which, 'A Cottage and Trees near Salisbury' in the Victoria and Albert Museum (Reynolds 1984, no.29.22, pl.729 in col.) is dated 28 July. Constable must have left for London that day or the next, for Fisher wrote on the 31st to say that they suddenly had a house full and could not keep the children. John Charles was fetched home, but Minna was able to stay. It is evident from Fisher's next letter, of 9 August, that during Constable's stay they had discussed a view of Salisbury Cathedral as a possible subject for his next picture and that on his next visit Constable intended to make a start on a large canvas. 'Roberts [the Constable children's nurse] was come & gone like a flash of lightning [to fetch John Charles]. The great Easil has arrived & waits his office. Pray do not let it be long before you come & begin your work. I am quite sure the "Church under a cloud" is the best subject you can take. It will be an amazing advantage to go every day & look afresh at your materials drawn from nature herself. You may come as soon as you will' (Beckett VI 1968, pp.250–1).

Constable had already drawn the cathedral many times, from near to and from afar. During this July visit, however, he seems to have made an unusual number of drawings of the great church from across the meadows or from a similar distance – no.323, for example. Two are of special interest in

the present context. The first, in the Fitzwilliam Museum, is of a view from Long Bridge on the northern branch of the river Nadder (fig.105, Reynolds 1984, no.29.43); the second, in the Paul Mellon Collection, also a pencil study, was taken from a spot further up the river (fig.106, Reynolds 1984, no.29.42). Nos.206 and 207 were painted from these two drawings, presumably as trial compositions for the set-piece that Constable and Fisher had been discussing.

The subsequent development of the composition was based more on no.206 than on no.207, but the Long Bridge view was lacking in one essential, an occurrence or incident that would set the scene in motion, what in art-teaching at one time used to be called 'the centre of interest'. In the Fitzwilliam drawing (fig.105), Constable sketched a fisherman seated on the river bank; this figure, with a touch of the artist's beloved red, was repeated in no.206. But something more would be required for a six-foot canvas. In the bottom left-hand corner of no.207 Constable has retained the idea of a horse and cart with a driver that he had noted in the Mellon drawing (fig.106). At the next stage (see no.208), this became a central feature.

208 Compositional Sketch for 'Salisbury Cathedral from the Meadows' ?1829

Oil on canvas 365 × 511 ($14\frac{3}{8}$ × $20\frac{1}{8}$)
PROV:...; Henry Vaughan by 1862; bequeathed by him to the National Gallery 1900; transferred to the Tate Gallery 1951 (N 01814)
LIT: Hoozee 1979, no.543, repr.; Parris 1981, no.36, repr. in col.; Fleming-Williams 1983, p.36, repr.; Reynolds 1984, no.31.5, pl.799 (col.); Rosenthal 1987, p.190, ill. 181; Fleming-Williams 1990, pp.237–8, fig.222

Tate Gallery

See no.209

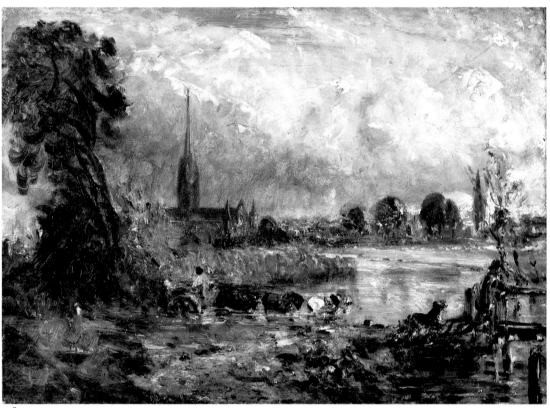

208

209 Sketch for 'Salisbury Cathedral from the Meadows' *c*.1829–31

Oil on canvas 1358 × 1880 (53½ × 74) including an extension of 38 mm (1½ in) at the left

PROV: ?Artist's administrators, sold Foster 16 May 1838 (37, 'Sketch of Salisbury Cathedral, from the Meadows') bt Williams; . . .; James Price, Barcombe, Devon, from whose executors bt by Agnew 1895; Sedelmeyer, Paris 1895; . . .; Charles Gassiot 1897 and bequeathed by him to the Guildhall Art Gallery 1902
EXH: *The City's Pictures*, Barbican Art Gallery, Nov.1982–Jan.1983 (98); *The City's Pictures*, Barbican Art Gallery 1984 (16, repr. in col., but no.23 in checklist); *London's Pictures*, Victoria Art Gallery, Bath, May–June 1985 (7); Japan 1986 (65, repr. in col., with col. detail); Madrid 1988–9 (58, repr. in col.)
LIT: Hoozee 1979, no.662, repr.; Parris 1981, pp.143, 144 n.7, fig.6; Fleming-Williams 1983, p.38; Reynolds 1984, no.31.2, pl.793 (col.); Cormack 1986, p.205, pl.191 (col.); Rosenthal 1987, p.190, ill.182; Fleming-Williams 1990, p.237, fig.220

Guildhall Art Gallery, City of London

Most of the drawings Constable had made at Salisbury in July 1829 were done in a large, nine by thirteen inch sketchbook. He took this book with him again on his second visit in the autumn. The development of the cathedral subject was brought a stage further in a compositional drawing from the book, now in the Lady Lever Art Gallery, Port Sunlight (fig.107, Reynolds 1984, no.29.13). Inscribed with a truncated date, '11 1829', this is of the Long Bridge view but with the scene extended to the right

to reveal part of the footbridge with a man and a dog about to cross it. The horse and cart and driver from no.207 are now depicted crossing the ford. The first fully dated drawing of the autumn trip is a pen and watercolour sketch of some pollarded willows inscribed on the back '13. & 14. of Novr. 1829 done in the Evng – at Salisbury – from the sketch made at the bottom of the Garden' (Reynolds 1984, no.29.25, pl.724); the last drawing of the stay is dated 26 November (ibid., no.29.31, pl.731).

The Port Sunlight drawing must have been done on either 11 July or 11 November. The former seems unlikely, as it would mean that the decision to embark on the cathedral subject, the two pencil drawings (figs.105–6 on p.361) and the pair of oil sketches (nos.206–7) were all made in the first three days of the summer visit. No.208, a larger compositional sketch, follows logically upon the Port Sunlight drawing. Twice the size of the earlier pair of oils, it is also very different stylistically. This suggests a lapse of time between nos.206–7 and no.208, the Tate composition – i.e. that the smaller oils were done either in July or shortly after Constable had returned to London. During the latter part of August he embarked on the great *English Landscape* project with the young engraver David Lucas.

It is not known exactly when Constable joined the Fishers in the autumn. Beckett assumed that the purpose of the visit was just to fetch Minna home (see under nos.206–7). But from Fisher's announcement in his letter of 9 August that the 'great Easil has arrived & waits his office' and his expectation that Constable would be coming to begin his work with the 'amazing advantage' of being able to go every day to look afresh at the material (presumably he means the Long Bridge view), from all this we may assume that it was Constable's intention to make his autumn visit a working holiday. If, as we suspect, the Port Sunlight drawing (fig.107) was done on 11 November and he stayed for a few days after his last dated sketch, made on the 26th (Reynolds 1984, no.29.31, pl.731), he would have had plenty of time in which to make a start on the great easel, that is, on the full-size Guildhall sketch, no.209.

Having established the main proportions of his design in the pencil composition (fig.107), in the Tate oil sketch (no.208) Constable begins to develop some of the component parts. A willow, similar to the one in the Mellon drawing (fig.106 on p.361) is sketched in on the right-hand side behind the man on the bridge. The tower of St Thomas's, one of the Salisbury parish churches, is drawn near the left-hand edge and then painted in still lower down, strangely out of alignment with the eye-level established for the rest of the work. The cart, becoming of increasing importance, is now drawn by a team of three horses led by a grey. Among the reeds, beyond the cart, a red roof has appeared. In the Fitzwilliam drawing (fig.105 on p.361), on the extreme right-hand edge, Constable noted the position of one of the poplars in the Leadenhall garden. With the extension of the composition to

fig.107 'Salisbury Cathedral from Long Bridge', 1829, *National Museums and Galleries on Merseyside (Lady Lever Art Gallery)*

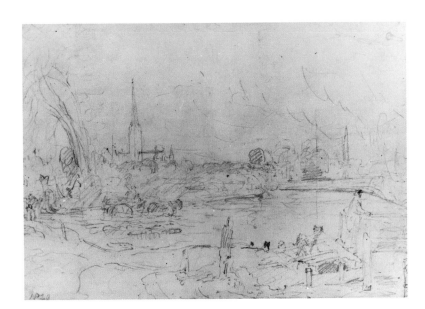

the right, this tree figures prominently as a topographical marker in both the Port Sunlight composition (fig.107) and no.208, as well as in no.209 and the final painting.

The presence of the big easel at Leadenhall and the length of Constable's stay there in November renders a start on the full-size sketch for 'Salisbury Cathedral from the Meadows' both feasible and likely during those weeks. A radical alteration in the character of the vehicle in the ford provides additional support for the notion. Hitherto, the horses had been depicted pulling a cart no different from those he had drawn and painted in Suffolk and at Hampstead. In no.209 the cart has become a wagon and of a type, a bow-wagon, only built and used in the southern and south-western counties of England. In no.209, though plainly of the right type, the wagon is poorly realised. This is not the case in the final painting (no.210). For this rendering Constable must have had a drawing to work from. Perhaps, after painting the bow-wagon

from memory in no.209 he was able to make a drawing of one before leaving Salisbury for London.

For some years no.209 had suffered the indignity of carrying areas of overpainting by another hand, the cathedral having been replaced by a castle! These were removed in 1951 but doubts, shared by the present authors, still remained as to the authenticity of the work. For some of the more awkward passages – the poorly managed perspective of the cathedral, for example – it is still difficult to find a satisfactory explanation. One or two similarly ungainly passages in a work of undoubted authenticity, the 'Stratford Mill' sketch (no.99), have made it easier to accept such lapses in a preparatory sketch, however, and no.209 is now accepted as entirely authentic. In many parts of the sketch there are to be seen flashes of his customary brilliant handling, samples of his flickering shorthand and boldly spread impasto.

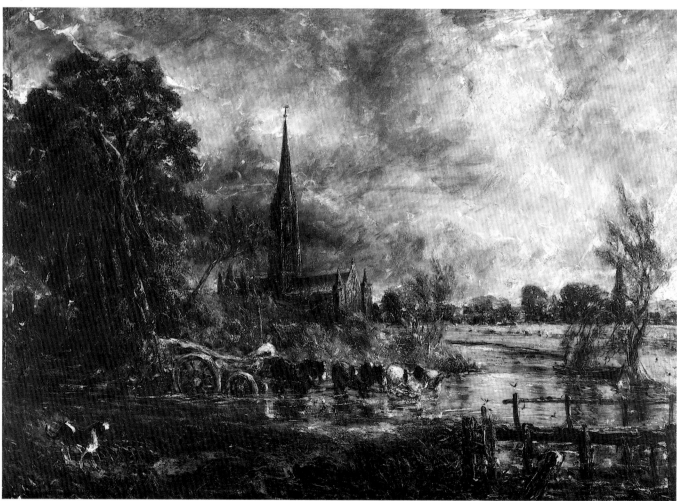

209

210 **Salisbury Cathedral from the Meadows** exh.1831

Oil on canvas 1518 × 1899 (59¾ × 74¾)
PROV: Artist's administrators, sold Foster 16
May 1838 (79, 'Salisbury Cathedral, from the
Meadows *Exhibited* 1831') bt Ellis; . . .;
William Taunton, Worcester, by 1843, sold
Christie's 16 May 1846 (41) bt in, sold
Christie's 27 May 1849 (110) bt Rought;
Agnew from whom bt by Samuel Ashton
1850; by descent to present owner
EXH: RA 1831 (169, 'Salisbury cathedral,
from the meadows'); BI 1833 (155, 'Salisbury
from the meadows', frame 72 × 82 in);
Birmingham Society of Arts 1834 (317,
'Salisbury Cathedral, from the Meadows,
Summer Afternoon, A retiring Storm');
Worcester Institution 1836 (2, 'Salisbury
Cathedral from the Meadows – Summer
Afternoon – A retiring Tempest'); Tate
Gallery 1976 (282, repr.)
LIT: Hoozee 1979, no.544, repr.; Parris 1981,
pp.140–3, fig.1; Schweizer 1982, pp.425–7,
figs.1–2; Fleming-Williams 1983, pp.34–8,
repr.; Rosenthal 1983, pp.227–34, figs.241
(col. detail), 255 (col.); Reynolds 1984
no.31.1, pl.792 (col.); Boulton 1984, pp.39–
42, ill.1; Edward S. Harwood, 'Constable's
"Church under a cloud": Some Further
Observations', *Turner Studies*, vol.5, no.1,
Summer 1985, pp.27–9; Cormack 1986,
pp.204–7, pl.188 (col.); Fleming-Williams
1990, pp.232–42, fig.215

*The Dowager Lady Ashton (on loan to the
National Gallery, London)*

With 'Salisbury Cathedral from the Meadows'
(no.210) we come to arguably the greatest of
Constable's major set-pieces; a work that in its final
form presents familiar ground in an heroic guise;
that, in a survey of the full cycle of his big
landscapes, may be seen as the climax, a thundering
reply to those critics who had denied him the
recognition he felt he deserved.

Although an unusually complete run of the
preparatory work for no.210 has survived, it is not
mentioned again in the remaining exchanges
between Constable and Fisher (see under nos.206–
7), so for the next reference to the painting we have
to turn to a letter Constable wrote to David Lucas
on 23 March 1831, not long before the picture
would have been sent in to the Academy. 'I have
made a great impression to my large canvas.
Beechey was here yesterday, and said, "Why *damn*
it Constable, what a *damned* fine picture you are
making, but you look *damned* ill – and you have got
a *damned* bad cold". So that you have evidence on
oath of my being about a fine picture & that I am
looking ill' (Beckett IV 1966, p.346). The painting
is mentioned only once more before sending-in
day, in a letter of 28 March from Constable's ten-
year-old son Charles to his sister Minna: 'Papa is

painting a beautiful Picture of Salisbury Cathedral'
(Beckett V 1967, p.130).

That year, 1831, with Charles Eastlake and
Henry Bone, Constable was again responsible for
the hanging of the pictures at Somerset House. He
must therefore have agreed or even chosen to have
his 'Salisbury' (no.169 that year) hanging near
enough to Turner's main exhibit, no.162, 'Caligu-
la's Palace and Bridge' (an even larger canvas) to
invite comparisons. The 'Salisbury' received a
mixed reception in the press but the colouring of
the sky and particularly Constable's scattered
touches of white (the freshness he so prized) were
universally condemned. The critic of *The Times* for
6 May voiced the general opinion. 'A very vigorous
and masterly landscape, which somebody has
spoiled since it was painted, by putting in such
clouds as no human being ever saw, and by spotting
the foreground all over with whitewash. It is quite
impossible that this offence can have been commit-
ted with the consent of the artist.' The juxtaposi-
tion with Turner's fiery 'Caligula' did not pass
notice either, in the case of the *Literary Gazette* (14
May) to the artists' mutual advantage. 'Fire and
water. If Mr. Turner and Mr. Constable were
professors of geology, instead of painting, the first
would certainly be a Plutonist, the second a
Neptunist. Exaggerated, however, as both these
works are. – the one all heat, the other all humidity,
– who will deny that they both exhibit, each in its
own way, some of the highest qualities of art? None
but the envious or ignorant.'

The painting was taken up again in January 1833
to prepare it for another showing, this time at the
British Institution. 'I have much to do with the
great Salisbury', he told Leslie on the 11th, 'and am
hard run for it' (Beckett III 1965, p.88). Much of
the painting had been executed with a palette knife
but from amused comments about his friends John
and Alfred Chalon in two letters to Leslie, it seems
that Constable had been using only brushes when
reworking the picture. On 7 January: 'I called on
the Chalons. Johns landscape is very promising . . .
They are both of them adopting the palette knife
just as I have laid it down – but which I did not do
'till I had cut my throat with it' (ibid., p.87). On 11
January: 'John Chalon has spread a report respect-
ing myself that has reached me from two or three
quarters, much to my advantage – namely that he
actually saw four small sable pencils [i.e. brushes]
in my hand & that I was bona fide using them – in
the art of painting' (ibid., p.88). His next report on
the 'Salisbury' is in an undated letter, but of around
this time. 'My dear Leslie . . . It is not fair to
request to see you again by day light (if this may be
so called). I have got the Great Salisbury into the
state I always wished to see it – and yet have done
little or nothing – "it is a rich and most impressive
canvas" if I see it free from self-love. I long for you
to see it' (ibid., p.89). We learn of a final reworking
of the 'Salisbury' in a note of 1834, again to Leslie,
written just before the picture was sent to Birm-
ingham for an exhibition that was due to open in
September. 'I have never left my large Salisbury

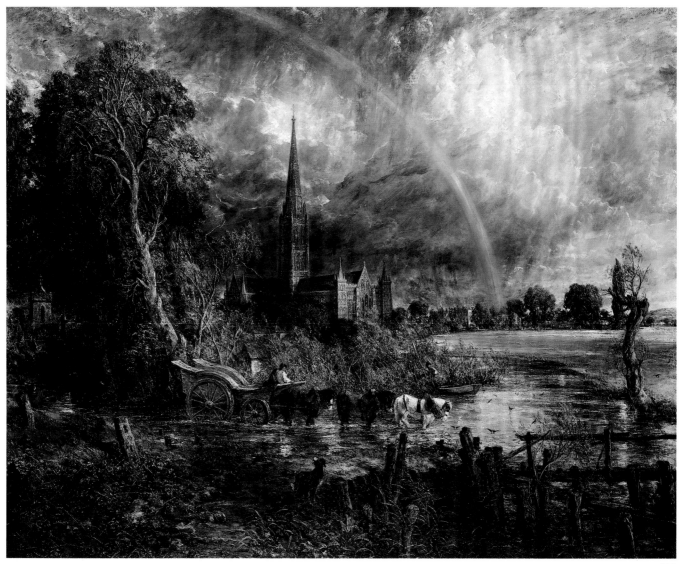

210

since I saw you. It would much – very much – delight me, if, in the course of today (as it goes tomorrow), you could see it for a moment. I cannot help trying to make myself beleive that there may be something in it, that, in some measure at least, warrants your (too high) opinion of my landscape in general' (ibid., pp.112–13). In his *Life*, Leslie said that the 'Salisbury' was a picture that Constable felt, in the future, would be considered to be his greatest, 'for if among his smaller works there were many of more perfection of finish, this he considered as conveying the fullest impression of the compass of his art' (Leslie 1843, p.97, 1951, p.237).

If Constable had been using sable brushes to re-work the picture in 1833, it looks as if this did not entail any major changes. He made a number of alterations and additions, however, on the final canvas when working from the full-size sketch (no.209), the most important of which – both for the character of the work and the message it would

seem to be carrying – was the introduction of the rainbow.

A fundamental change, made right at the start, was the selection of a canvas taller by some nine inches than the one he had used for no.209. This enabled him to construct a complex foreground of timber-work, etc., of a strength capable of support-ing, as it were, the weight of the rest of the composition, a foreground over which the eye could also move more readily into the scene beyond. As had happened before in some of the canal pictures (e.g. 'The Lock' and 'The Leaping Horse') he was faced with the problem of rational-ising and depicting convincingly the tree-mass, a compositional necessity, that he had roughed out in no.209 – in this case a veritable palisade of massive trunks. This he again solved by anatomising in some detail the foremost tree in the group. Graham Reynolds has pointed out (1984) that this tree is in almost all respects the same as that in a large watercolour in the Victoria and Albert Museum of

a single ash (on paper watermarked 1833) that Constable is believed to have used to illustrate a lecture at Hampstead in 1836 (Reynolds 1984, no.35.5, pl.991). Presumably both were derived from a common source, a study now missing.

Constable's reasons for the inclusion of a dog in the foreground of one of his set-pieces are nearly always worth speculating about. In the Port Sunlight and Tate compositions (fig.107 on p.363 and no.208) the animal was playing only a bit-part at the heels of the figure (Fisher?) about to cross the footbridge. In no.209, the full-size sketch, he is on his own in the left-hand corner, presumably to enliven that rather dull area, but also, perhaps, to act like a trained pointer, and draw our attention across to the other side of the canvas where the sky is getting lighter. In no.210, Constable's final choice was to have him more centrally placed and pausing, as the sheepdog in 'The Cornfield' (no.165) had paused at the sound of the pigeon's flapping, but this time maybe to draw our attention to the thunder and lightning over the cathedral.

Constable said he felt that 'Salisbury Cathedral from the Meadows' conveyed the fullest impression of the compass of his art. Certainly, in no painting does he explore and exploit more fully the physical properties of his medium. Some of the handling is reminiscent of parts of 'The Cornfield': stems of bramble and grass and small branches of the trees and bushes are likewise modelled three-dimensionally in thick paint carefully laid over the surface of the canvas. In parts the relatively stiff paint is knifed on with sharp, swift movements, elsewhere the rich impasto is more sensuously applied. At the opposite extreme the medium has been used almost like watercolour, in the sky for example, where there are to be seen thin veils of colour and thinned paint softly applied – notably in the rainbow. It is possible to see the work of the sable in much of the detailing: in some of the glistening thorns among the brambles in the foreground and in the two figures deftly touched in across the meadows in the Leadenhall garden. Were these figures there, one wonders, when the painting was first exhibited in 1831, or were they added later, after Fisher's untimely death in 1832?

Leadenhall itself, the home of John Fisher and his family, is not distinguishable in the full-size sketch, but the house is quite easy to recognise in the final painting, and if there were any doubts as to its whereabouts, Constable has provided us with the finest of visual aids to bring it to our attention – the rainbow, a glorious arc ending immediately above the Archdeacon's residence in the Close. There is no record of Fisher having seen the 'Salisbury' at the Academy, but it is unlikely that he would not have done so, having had so much to do with the work in its early stages. Would he have known about the introduction of the rainbow and of its significance? Was it intended as a playful reminder of the time when he alone was the purchaser of Constable's most ambitious canvases and in an almost literal sense the artist's pot of gold? Or was the rainbow, this 'arch of promise' (Beckett 1970, p.22), thus placed, a more heartfelt expression of gratitude, Constable's recognition of support received and hope renewed after the terrible months of black despair following the death of his wife?

'Salisbury Cathedral from the Meadows' has invited a motley collection of interpretations. More than one writer has taken Fisher's reference to the 'Church under a cloud' as a text and seen the picture as a covert political statement. In the view of the present authors, however, much the most convincing interpretation is the one proposed by Edward Harwood in his 1985 article. Harwood feels that a politically orientated interpretation appears to fly in the face of the overwhelmingly personal nature of Constable's art and draws our attention to the lines (and their context) from Thomson's *Summer* that Constable chose for the catalogue entry for the 'Salisbury' when it was shown at the Academy in 1831. The lines (1223–32) describe the passing of a storm and, in a tale of the young lovers Celadon and Amelia, follow immediately upon the account of Amelia's death in Celadon's arms, killed by a bolt of lightning. The tale continues: 'But who can paint the lover, as he stood | Pierced by severe amazement, hating life, | Speechless, and fixed in all the death of woe?' In his concluding paragraph, after discussing the relevance of this sad tale to Constable's own condition, Harwood summarises most admirably, thus: 'The central meaning of this painting is surely to be found in Constable's awareness of his own state of mind. Emotional turmoil and despair are passing, driven away by a renewed sense of life and creativity arising from religious faith and hope, as well as personal certainty.'

DAVID LUCAS AFTER JOHN CONSTABLE

211 Salisbury Cathedral from the Meadows: The Rainbow c.1835

Mezzotint 551 × 692 ($21\frac{11}{16} \times 27\frac{1}{4}$) touched with pencil, chalk, and grey wash; white paper collage on post at lower left
PROV: By descent from the artist to the present owner
EXH: New York 1988 (129, repr.)
LIT: Shirley 1930, no.39, progress proof e (?)

Richard Constable

When his work for Constable had begun to slacken off, unwilling, perhaps, to lose the momentum of the previous three years, in the autumn of 1832 David Lucas decided to branch out on his own and – with the consent of the artist – to engrave a larger, 22 by 19 inch, mezzotint of 'The Lock', the work his one-time master, S.W. Reynolds, had also engraved but never published. With an equally large print of 'The Cornfield', this was published in

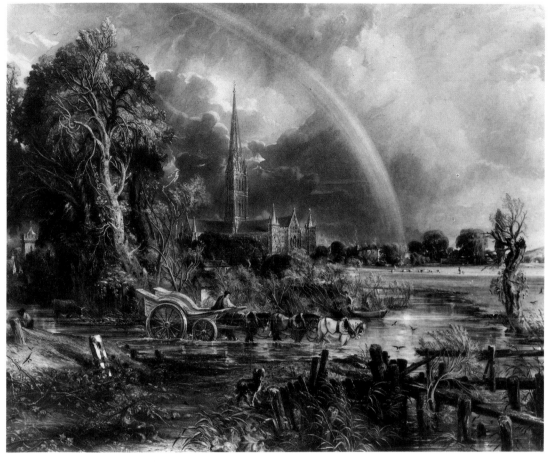

211

1834, with some success, by F.G. Moon. A 'Stratford Mill' (subsequently titled by Lucas 'The Young Waltonians') was next attempted but was laid aside unfinished until after Constable's death. Work began on the largest of all the plates, the great 'Salisbury', soon after 27 December 1834, when the big canvas was sent round to Lucas with 'every good wish for its success' (Beckett IV 1966, p.419). Progress was slow; proofs do not appear to have begun to circulate until the following June. The first impressions greatly pleased Constable. 'Leslie', he wrote on the 30th, 'is so much *impressed* with the proof, that he would give any thing to possess *one* – so am I, and would give anything to possess *two* at least . . . it never can or will be grander than it is now' (ibid., p.420). But customary anxiety was emerging by September, when Constable was working on his big watercolour of Stonehenge with its double rainbow (no.345). 'I am most anxious to see you on all accounts – but I wish to talk to you about our Rainbow in the large ⟨picture⟩ print – if it is not exquisitely done – if it is not tender – and elegant – evanescent and lovely – in the highest degree – we are both ruined' (ibid., p.421). Further proofs and further anxieties and instructions followed. 19 January 1837: 'We must keep this proof as a *criterion* and get as much of it as we can –

the *Bow* is grand whole – provided it is clean & ⟨. . .⟩ tender . . . How I wish I could scratch and tear away at it with your tools on the steel ! (ibid., p.434). Publication had been planned for 20 March. On the 18th Constable was still not content with the 'bow'. 'I have had much anxiety about the bow – it has never been quite satisfactory in its *drawing* to my eye. John [his eldest son] and I have now clearly and directly set it out – and in the most accurate manner possible, which must obviate all cavillings, & carping, from the *learned ignorant*' (ibid., p.436). His last instructions are dated 29 March, a Wednesday: 'The proof is about what I want – I mean that you took hence. I took the centre from the elder bush – a blossom to the left – you will do possibly the same. Go on as you think proper' (ibid., p.438). He died on the Friday night.

No.211 is a fine example of a touched progress proof. A number of the reworkings in this proof were executed by Lucas on the plate – the lights on the river seen through the willows, for instance. This was not always so. Constable often seems to have touched a proof just for his own amusement. It will be noticed that to obtain whites striking enough on the post in the foreground to the left, Constable has carefully stuck down five small pieces of paper.

The Opening of Waterloo Bridge

212 Sketch for 'The Opening of Waterloo Bridge' *c*.1826–9

Oil on canvas 620 × 990 (24⅜ × 39)
PROV: . . .; Camille Groult; Pierre Bordeaux-Groult; . . .; Agnew 1960; . . .; Mr and Mrs Paul Mellon 1970 and given by them to the Yale Center 1977 (B1977.14.44)
EXH: New York 1983 (56, repr. in col.); Japan 1986 (62, repr. in col.)
LIT: Hoozee 1979, no.546, repr.; Reynolds 1984, no.29.63, pl. 762 (col.); Cormack 1986, p.216, pl.205

Yale Center for British Art, Paul Mellon Collection

See no.213

213 The Opening of Waterloo Bridge ('Whitehall Stairs, June 18th, 1817') exh.1832

Oil on canvas 1308 × 2180 (51½ × 85⅞)
PROV: Artist's administrators, sold Foster 16 May 1838 (74, 'The Opening of Waterloo Bridge *Exhibited* 1832') bt Moseley; . . .; Charles Birch, Birmingham by 1839, sold Christie's 7 July 1853 (42) bt in, sold Foster 27 Feb. 1857 (LXVI) bt Henry Wallis; sold by him, Foster 3 Feb. 1858 (104) bt in, sold Foster 6 Feb. 1861 (86) bt Davenport; . . .; Kirkman D. Hodgson; . . .; Sir Charles Tennant Bt by 1892; by descent to his grandson, 2nd Baron Glenconner; . . .; Leggatt, from whom bt by Harry Ferguson 1955; by descent to anonymous vendor from whom bt through Agnew by the Tate Gallery 1987 with assistance from the National Heritage Memorial Fund, the Clore Foundation, the National Art-Collections Fund, the Friends of the Tate Gallery and many others (T 04904)
EXH: RA 1832 (279, 'Whitehall stairs, June 18th, 1817'); Tate Gallery 1976 (286, repr.); New York 1983 (57, repr. in col.); Japan 1986 (66, repr. in col.); *Treasures for the Nation: Conserving our Heritage*, British Museum, Oct.1988–Feb.1989 (31, repr.)
LIT: Hoozee 1979, no.545, repr.; Reynolds 1984, no.32.1, pl. 819 (col.); Cormack 1986, pp.213–16, pl.203 (col.); *The Tate Gallery 1986–88: Illustrated Biennial Report*, 1988, pp.55–6, repr. in col.

Tate Gallery

The beginnings of the 'Waterloo' project are discussed in the entries on nos.102–3, the two small oil sketches of about 1819, where the events depicted are also described. Constable worked towards a large exhibition picture of the subject at intervals during the 1820s, several times hoping to finish and submit a canvas to the Academy but not in fact doing so until 1832, when no.213 was shown, nearly fifteen years after the event that originally inspired it. The other painting shown here, no.212, is a half-size preliminary sketch for the 1832 exhibit.

The first reference to Constable's work on 'a large canvas' of the Waterloo subject comes in a letter to Fisher of 1 September 1820 (Beckett VI 1968, p.56). This canvas was presumably the 'new begun picture; "A view on the Thames on the day of opening Waterloo Bridge"' that he took (no doubt with some help) to show Farington on 21 November 1820 and was advised by him to lay aside in favour of another Suffolk scene (Farington XVI, p.5582). Although Constable followed the advice and went ahead with 'The Hay-Wain', the *Monthly Magazine* reported the subject of his forthcoming exhibit as 'the opening of Waterloo Bridge' (vol.51, 1 April 1821, p.276), as did the *Gazette of Fashion* the following year (30 March 1822, p.149; both references kindly communicated by Judy Ivy). But in May 1822 the picture was still a 'sketch' according to Bishop Fisher, who sat on the floor at Keppel Street to admire it, calling it the equal of Canaletto (Beckett II 1964, p.276, VI 1968, p.94). We do not know whether this version was ever completed. When Robert Balmanno (Secretary of the Artists' Benevolent Fund) called on Constable on 28 November 1825 he saw both a 'sketch' and an 'outline' of the Waterloo, the former perhaps the work of 1820–2 just referred to, the latter a new canvas which will be discussed shortly. If Constable did at some point finish the 1820–2 work, it might be the very large (1536 × 2438 mm, 60½ × 96 in) canvas at Anglesey Abbey, Cambridgeshire (fig.108; Reynolds 1984, no.32.2). Of the surviving works, this certainly represents the next stage in the development of the composition after the 1819 sketches, nos.102–3. In it Constable has introduced at the left the bow-fronted house, 5 Whitehall Yard, with its river balcony, but the viewpoint is lower than that adopted for the later sketch and painting, nos.212–13, and the composition is generally less sophisticated. The absence of the Shot Tower at the right-hand side, included in nos.212–13, points to a date before 1826, the year of the tower's construction.

In 1825 we hear of a new version being prepared. The canvas had been ordered the previous year (Beckett VI 1968, p.161) but it was not until September or October 1825 that, with John Dunthorne Jnr's help, Constable set about 'getting

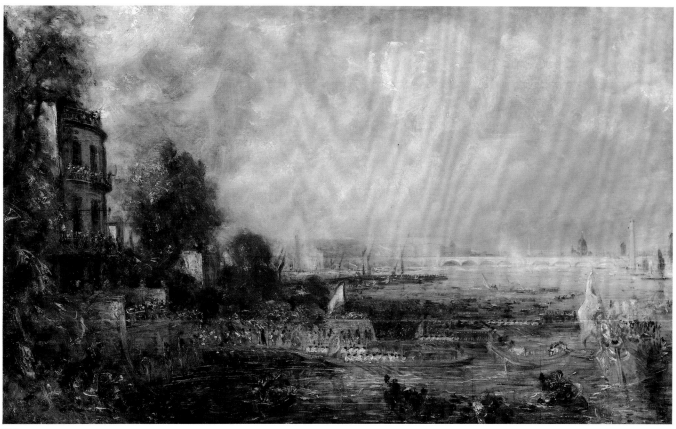

212

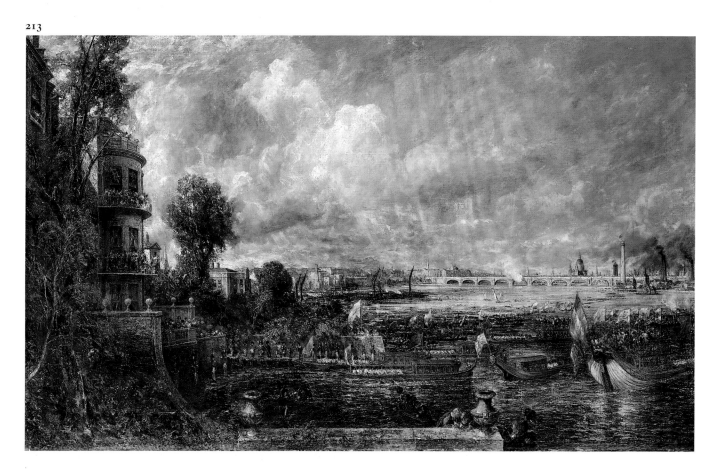

213

fig.108 'The Opening of
Waterloo Bridge', *c.*1820–5,
*Fairhaven Collection,
Anglesey Abbey* (*The
National Trust*)

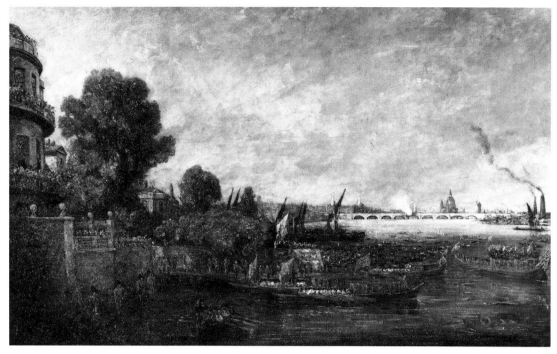

the outline on the Waterloo' (Beckett II 1964, p.397). On 4 October Constable's old friend the Academician Thomas Stothard suggested 'a very capital alteration' that would increase the 'consequence' of the picture (ibid., p.398) though we can only guess what this might have been. On 12 December Constable and Dunthorne were still 'on the intricate outline of the Waterloo' (ibid., p.421). Sir Thomas Lawrence came to see the work in January 1826, saying it was 'admirable especially to the left – not but the line of the bridge was grand' (ibid., p.424). Then, on 7 July 1826, Constable reported to Fisher: 'I have made several visits to the terrace at Lord Pembroke's; it was the spot of all others to which I wanted to have access. I have added two feet to my canvas' (Beckett VI 1968, p.223). It is this letter that tells us that Constable had now discovered the higher viewpoint that we see employed in no.212 and the final picture, no.213. The change of height is most easily gauged by comparing the perspective of the side walls of the garden of the bow-fronted house in the Anglesey Abbey picture and in nos.212–13. Since the terrace of Pembroke House was further away as well as higher than his earlier viewpoint, Constable was now able to see another building to the left of the bow-fronted house. This building, just visible in no.212 and more clearly so in no.213, is either Pembroke House itself or the adjoining house, Michael Angelo Taylor's, which lay between the former and the bow-fronted building. Constable presumably made fresh drawings from the new viewpoint but they are not known today; he would have taken the opportunity to sketch the new Shot Tower on this occasion.

The identity of this second large canvas is no more certain than that of the first, the one begun in 1820. Constable clearly intended it to be a work he would exhibit, referring to it in October 1825 as 'the large picture of the Waterloo, on the real canvas' (Beckett II 1964, p.407), that is, we are not dealing with a half-size sketch such as no.212. At present only two large versions are known, the Anglesey Abbey and Tate Gallery pictures. The former, as suggested above, may be the work begun in 1820. If it is not, it seems unlikely to be the second large canvas mentioned in the correspondence, since Constable apparently intended to incorporate in that the improvements suggested by his visit to Pembroke House terrace, and the Anglesey Abbey work uses the earlier, lower viewpoint adopted before his visit. We cannot, however, conclude that the Tate Gallery painting, the work exhibited in 1832, was necessarily the canvas that Constable and Dunthorne began in 1825. Constable said he had added two feet to this picture after his visit to Pembroke House but the Tate canvas (*pace* Reynolds) shows no sign of such an addition. (In case it helps further research into the problem, it should be pointed out that the two feet need not have been added at the left side, as is usually assumed: Constable may, for example, have extended his canvas by a foot there and a foot at the top or bottom. The possibility that his statement expressed an intention – an extension of the canvas so far made only in his imagination – rather than a *fait accompli* should also be considered.)

After Constable's report of his visit to the terrace at Pembroke House in 1826, work on the subject appears to have come to a standstill again. In view of the fresh impetus the visit gave him, this is surprising, but we hear nothing more until 1829.

From a letter of 15 September that year to David Lucas it seems that the half-size sketch, no.212, may by then have been in existence. Constable had decided to include the Waterloo subject and 'Autumnal Sunset' (no.181) in *English Landscape* and asked Lucas to come that evening '& take the things away, lest I *change* again' (Beckett IV 1966, p.322). Because the print Lucas started engraving in 1831 was clearly based on the half-size sketch, no.212 (early proofs contain details only found in that work), it has been assumed that the latter was the painting Constable asked him to take away in 1829. This may well be the case but we cannot be absolutely certain because there exists another half-size sketch, similar to, though less colourful than, no.212 (private collection, New York; Reynolds 1984, no.29.64, pl.765: his entry erroneously states that the Shot Tower is not included in this sketch). The two could have been exchanged before Lucas started work two years later. The reason for the existence of two half-size sketches has not yet been satisfactorily explained. Since both include the Shot Tower, they presumably date from 1826 or later. If – leaving aside the problem of the added two feet – the final canvas, no.213, was in fact the one begun in 1825, the half-size sketches would have been made as an aid to advancing it rather than as preliminary studies.

The remaining references to the 'Waterloo' in Constable's correspondence are refreshingly un-ambiguous. On 21 February 1832 he asked Lucas to return 'all the *sketches and drawings* &c &c &c which relate to the *Waterloo*, which I am now about' (Beckett IV 1966, p.366). No.212 would have been among them. A week later he was 'dashing away at the great London' and feeling sufficiently buoyed up by it to add, ' – and why not? I may as well produce this abortion as another' (ibid., p.368). The lively surface of the final picture, no.213, bears out Constable's description of himself at work. While the 'intricate outline' is still visible in places, for example in the drawn outlines of the buildings to the left of the bridge, the foreground is vigorously brushed and knifed with bold touches and stabs of red, green and white. Leslie called on 28 February and 2 March and suggested 'a bit more on the right', to which Constable apparently agreed (ibid., and Beckett III 1965, p.62). The Lord Mayor's barge was in place at the right, in a different perspective to that used in the sketch (no.212), by 8 April, when Mrs Pulham confessed herself 'quite in love with the Lord Mayor's bottom' (Beckett III 1965, p.66).

A few weeks later the picture went to the Academy, where, during the 'varnishing days' allowed to Academicians, Turner felt put out by its high colour key and added an intense red buoy to his own otherwise cool seapiece 'Hevoetsluys' (C.R. Leslie, *Autobiographical Recollections*, ed. Tom Taylor, 1860, I, pp.202–3). 'Whitehall Stairs, June 18th, 1817', as Constable titled his picture,

fig.109 Detail from no.213

received more abuse than praise from the critics, some of whom, reasonably enough, could not recall what happened at Whitehall Stairs fifteen years earlier. One or two confused the event depicted with the subject of works by Stanfield and George Jones shown in the same exhibition – the opening of London Bridge in 1831 by William IV. This more recent royal bridge-opening may in fact have spurred Constable to complete his own work, especially if he had heard that fellow artists were planning to depict it.

Looking back to the early studies, no.102–3, on to the Anglesey Abbey work (fig.108 on p.371) and then to the half-size sketch and final picture, nos.212–13, we can see Constable gradually shifting the scene of royal embarkation further into his composition by adding to the foreground at the left and bottom. As he does so, the sky and river and the line at which they meet, the bridge itself, assume greater importance. The tree that closes the left side of the Victoria and Albert Museum oil sketch (no.103) ends up a quarter of the way across the final canvas. In the latter the spectator is removed further from the ceremonial happenings by the addition of a feature not shown in the half-size sketch, no.212, a parapet surmounted by urns that runs along the bottom edge. By the right-hand urn two boys lean against the parapet with their backs turned on the day's events, engrossed in some activity of their own, apparently writing or drawing. Directly above them, beyond the bridge, lies Somerset House, then home to the Royal Academy, thrown into chiaroscuro by shafts of sunlight. Whether or not Constable seeks to remind us in this way of the power of art as distinct from the power of princes, it is a thought that comes readily to mind as our eyes move from the boys up the richly encrusted surface of the canvas.

The Last Works

The opening works in this final section introduce us to what may appear to be two conflicting aspects of Constable's painting in the mid-1830s. In nos.214–15 he seems to be casting off many of his earlier concerns, freely re-interpreting old material just as he had in the *English Landscape* prints (see particularly nos.198–200) and especially in no.215 treating it, to many twentieth-century eyes, with refreshing abandon, as though only the paint surface really mattered. By contrast, in 'The Valley Farm' (no. 216) we may feel that he is almost desperately adhering to earlier values, trying to preserve a basically naturalistic image in which he no longer has much faith, obsessively polishing the life out of it. By contrast again, the final painting in the exhibition, 'Arundel Mill and Castle' (no.220), shows us a third aspect of 'late Constable', his continued ability and desire to paint fresh images based closely on direct observation. How Constable's last works should be interpreted is a relatively new question and one which their present gathering together may help to answer.

214

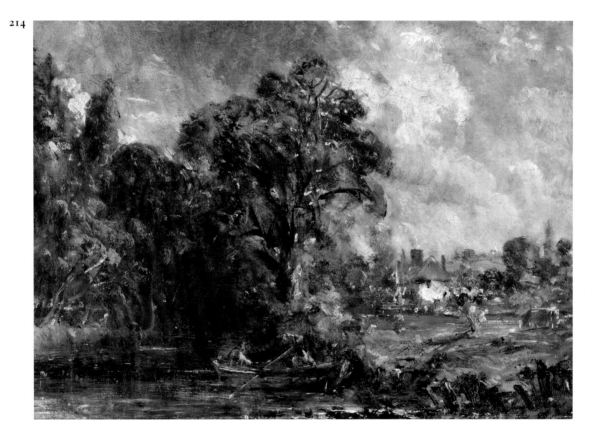

214 A Farmhouse near the Water's Edge
*?c.*1834

Oil on canvas 254 × 349 (10 × 13¾)
Inscribed in a later hand (? Isabel Constable's) 'J. Constable Valley Farm' over a half erased inscription, 'M[inna] Dec 27 4[?7]', i.e. Maria Louisa Constable's property 184[?7]
PROV: As for no.2
EXH: Tate Gallery 1976 (328, repr.); Japan 1986 (72, repr. in col.); New York, Bloomington, Chicago 1987–8 (158, repr. in col.)
LIT: Reynolds 1973, no.403, pl.304; Hoozee 1979, no.561, pl.LXI (col.); Rosenthal 1983, p.235, fig.259 (col.); Reynolds 1984, no.34.75, pl.982 (col.); Cormack 1986, p.224, pl.208 (col.)

Board of Trustees of the Victoria and Albert Museum, London

See no.215

215 A Farmhouse near the Water's Edge ('On the Stour') ?c.1834

Oil on canvas 620 × 790 (24⅜ × 31⅛)
PROV:...; ? Alicia Whalley, later Webb, who
died c.1880;...; Sir Joseph Beecham, sold
Christie's 3 May 1917 (7, repr.) bt in by
Freeman, sold anonymously, Christie's 10
May 1918 (89) bt Knoedler;...; Scott &
Fowles, New York, from whom bt by
Duncan Phillips 1925
EXH: Milwaukee 1976 (10, repr.); *Master
Paintings from the Phillips Collection*, Fine
Arts Museums, San Francisco, July–Nov.
1981 and tour to Dallas, Minneapolis and
Atlanta 1981–2 (10, repr. in col.); New York
1983 (26, repr. in col.); *Impressionism and the
Modern Vision: Master Paintings from the
Phillips Collection*, Nihonbashi Takashimaya
Art Galleries, Tokyo, Aug.–Oct., Nara
Prefectural Museum of Art, Oct.–Nov. 1983
(5, repr. in col.); Japan 1986 (73, repr. in
col.); *Old Masters – New Visions: El Greco to
Rothko*, Australian National Gallery,
Canberra, Oct.–Dec. 1987, Art Gallery of
Western Australia, Perth, Dec. 1987–Feb.
1988, Art Gallery of South Australia,
Adelaide, March–May 1988 (7, repr. in col.);
*Master Paintings from the Phillips Collection,
Washington*, Hayward Gallery, May–Aug.
1988 (not in cat.); *The Pastoral Landscape:
The Legacy of Venice and the Modern Vision*,
National Gallery of Art and the Phillips
Collection, Washington, Nov.1988–Jan.1989
(87, repr. in col.)
LIT: Hoozee 1979, no.562, repr.; Rosenthal
1983, p.235, fig. 258 (col.); Reynolds 1984,
no.34.76, pl.983 (col.); Cormack 1986, p.224,
pl.212; Rosenthal 1987, p.199, ills.185 (col.
detail), 190; Rhyne 1990a, p.127 n.2

The Phillips Collection, Washington DC

fig.110 'The Farmhouse by the River', 1829, *Trustees of the British Museum, London*

fig.111 'A Farmhouse near the Water's Edge', ?exh.1832 or 1833, *Trustees of the British Museum, London*

Reynolds has established a likely sequence of
events in the development of the 'Farmhouse near
the Water's Edge' subject seen in nos.214–15.
After agreeing in December 1829 to buy back 'The
White Horse' (fig.65 on p.194) from John Fisher,
Constable made a pen drawing (fig.110, Reynolds
1984, no.29.55) very loosely based on the left-hand
side of that picture, that is, on the principal tree
group and Willy Lott's house. The barge and white
horse were omitted and the figurative element
supplied instead by a ferryman in his boat, drawn
up to a bank introduced at the right-hand side.
Dated the evening of 25 December 1829, the
drawing appears to have been made before
Constable received back the great 1819 canvas. It
would be understandable had he spent part of
Christmas evening, pen in hand, musing on the
theme of the awaited picture, but the drawing, with
its fully-formed composition and pen-line border,
looks more like the record of an idea already worked
out elsewhere: perhaps a sketchier version remains
to be found. A highly finished watercolour in the
British Museum (fig.111, Reynolds 1984, no.32.17)
corresponds closely with this pen composition; as
suggested in the 1976 Tate Gallery exhibition
catalogue (no.294), it may have been one of
Constable's RA exhibits of 1832 or 1833. The oil
sketch shown here as no.214 is related to the
watercolour but the right-hand side of the compo-
sition has now been opened up to show a meadow
with hills beyond, thus radically transforming the
earlier enclosed design. A house or cottage, no
longer bearing any particular resemblance to Willy
Lott's, appears on the far side of the meadow. With
its bright colour, flickering highlights and dis-
regard for topography, this sketch seems to herald
new developments. For Reynolds it is 'a necessary
touchstone for establishing the changes which took
place in his style in the last four or five years of his
life'.

The larger and even more brilliant Phillips
Collection sketch, no.215, may represent a further
development of the composition, with a fisherman
substituted for the ferry (though a boat now

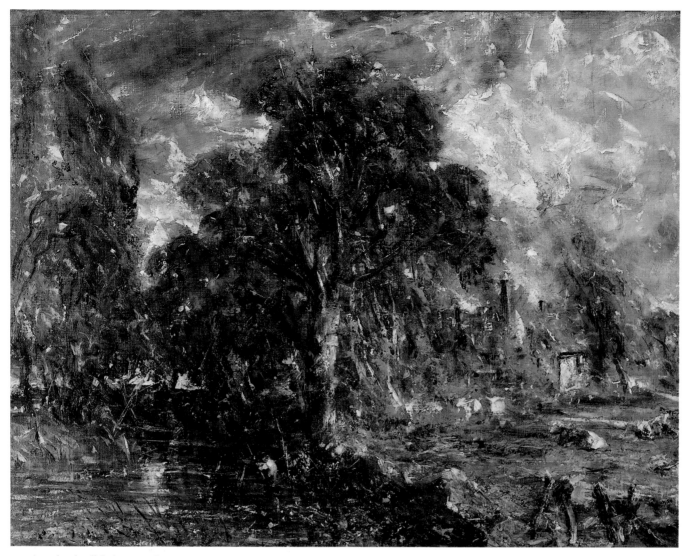

215 (see also detail facing p.359)

appears further down the river), the house moved closer to the spectator and more light admitted at the left. Variations on the theme are found in two further canvases, one in California, the other in Stockholm (Reynolds 1984, nos.34.77–34.78, pls.984–5 in col.; neither known at first hand to the present authors).

In nos.214–15 Constable appears to have been working towards a new large river picture which in the event was never realised. The Phillips canvas may have been seen as a half-size sketch for a six-foot painting of the subject. Whether the project was abandoned in favour of the related 'Valley Farm' of 1835 (no.216), as Reynolds suggests, is less certain since neither no.214 nor no.215 is precisely datable. A reference cited by him in Constable's letter to C.R. Leslie of 8 September 1834 – 'I have almost determined to attack another canal [i.e. a Stour subject] for my large frame' (Beckett III 1965, p.119) – seems more likely to

refer to 'The Valley Farm' than to the alternative composition seen in no.215. A letter of the same year which is not usually quoted in this context, one to George Constable of 2 July, at least suggests why Constable may have felt it necessary to invent subjects of the kind represented by 'A Farmhouse near the Water's Edge': 'The difficulty is to find a subject fit for the largest of my sizes. I will talk to you about one, either a canal or a rural affair, or a wood, or a harvest scene – which, I know not' (Beckett V 1967, p.17).

We can only speculate on the reasons for Constable abandoning what appears to have been a promising new subject. Having let his imagination run more freely than usual, did he find after all that he needed a more factual basis to produce a credible image for a large finished picture? On the Phillips canvas did he, as it were, lose rather than find himself in paint?

216 The Valley Farm exh.1835

Oil on canvas 1473 × 1251 (58 × 49¼)
Inscribed 'John Constable R.A.|[? fecit]
1835' b.r.
PROV: Bt from the artist by Robert Vernon
1835 and given by him to the National
Gallery 1847; transferred to the Tate Gallery
1919 (N 00327)
EXH: RA 1835 (145, 'The valley farm'); BI
1836 (43, 'The Valley Farm', frame 73 × 65
in); Tate Gallery 1976 (320, repr.)
LIT: Smart and Brooks 1976, pp.126–32,
pl.76; Hoozee 1979, no. 551, pl.LXII (col.);
Barrell 1980, pp.159–61, repr. with detail;
Parris 1981, no.41, repr. in col.; Rosenthal
1983, pp. 235–6, fig.262 (col.); Reynolds
1984, no.35.1, pl.987 (col.); Cormack 1986,
pp.229–36, pl.217 (col.); Rosenthal 1987,
pp.198–9, ill.189; Rhyne 1990b, pp.78, 83
n.40

Tate Gallery

As we have seen, Constable exhibited a painting of
this subject in 1814 as 'The Ferry' (no.65),
following it up later with a smaller, unexhibited
version (no.66). The composition, with Willy
Lott's house seen through the cutting that led from
the Stour to the mill stream of Flatford mill, had
been in his mind for a few years before that, having
been worked out in detail in a drawing of c.1812–13
(fig.40 on p.141). In no.216 he returned to the
subject for the last time, now designating Willy
Lott's house as 'The Valley Farm'.

Constable's letter of July 1834 confessing his
difficulty in finding subjects for large canvases has
been quoted under no.215. By September he had
'almost determined' on one of the options men-
tioned in that letter, another 'canal', i.e. a river
Stour scene, and this was probably the large canvas
he told William Purton in December that he was
'foolishly bent on' (Beckett V 1967, p.43). Both
references seem likely to be to the picture that must
have been underway soon afterwards, 'The Valley
Farm'. Robert Vernon, who had made a fortune
hiring horses to the Army and was now forming a
major collection of contemporary British painting,
saw the picture in Constable's studio in March
1835 before it went to the Academy and bought it
on the spot. The price afterwards agreed on, £300,
was the largest Constable ever received. Vernon
allowed him to continue working on it after it
returned from the exhibition and did not take
delivery until December 1835.

In general no.216 follows the composition
worked out in the early treatments of the subject
(see nos.63–6), with a number of details taken
specifically from the latest in that group, no.66: the
timberwork in the left foreground, the bird skim-
ming the water, the figures on the far bank and the
boat near them, the man at the gate. A major
change was made to the trees at the right, Constable
evidently now feeling that a more impressive
specimen was needed to front the group, just as he

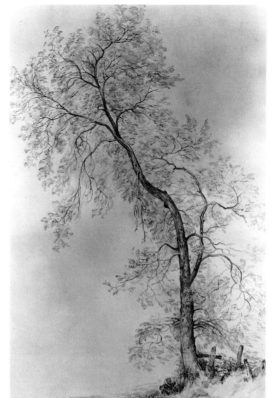

fig.112 'An Ash Tree',
1835, *Board of Trustees of
the Victoria and Albert
Museum, London*

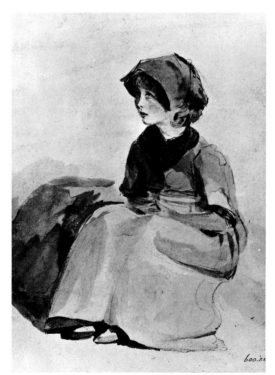

fig.113 'A Suffolk Child',
*Board of Trustees of the
Victoria and Albert Museum,
London*

had in 'Salisbury Cathedral from the Meadows'
(no.210). In fact he used a sister drawing to the one
related to that picture. The 'Valley Farm' tree
began life as a Hampstead ash, carefully studied in

216

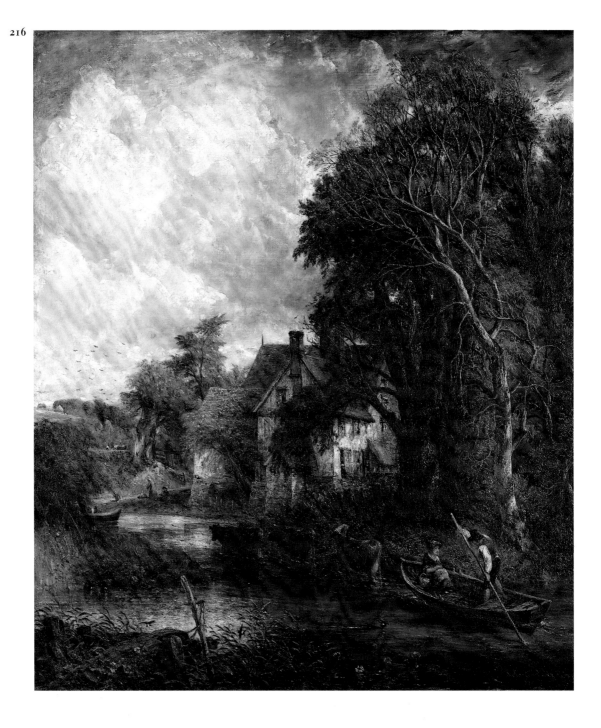

the drawing shown here as no.301. This was enlarged to the scale of the 1835 painting in a huge pencil and watercolour drawing now in the Victoria and Albert Museum (fig.112, Reynolds 1984, no.35.4). A few variations on the drawing were introduced in the painting, including the addition of another large branch on the right of the trunk.

As well as referring to the last in his early sequence of 'Valley Farm' treatments, no.66, Constable made use in the 1835 picture of his earliest version of the subject, the Courtauld Institute drawing (fig.40 on p.141), which records the large roof seen behind the others in no.216 but which is omitted in the other painted versions. From the same drawing Constable painted the

south-east elevation of the house, obscured in the early paintings. These modifications, together with the addition of some further windows and the suggestion of half-timbering on one of the elevations, created a more impressive image of Willy Lott's house, now aggrandised just as the trees had been. The figuration was also enlarged, Constable now giving the ferryman a passenger, based in reverse on a watercolour known as 'A Suffolk Child' (fig.113, Reynolds 1984, no.35.6). Preceding them in their passage through the cutting, three cows were also added to the composition, one (in the manner of Constable's dogs) turning its head to look up at something.

'The Valley Farm' has not received a good press,

either in the artist's own day or recently. Seen by some reviewers in 1835 as a perverse work ('through whim he is voluntarily unnatural', 'He ought to be whipped for thus maiming a real genius for Landscape', etc.: see Parris 1981, pp.162–3), in the 1960s it struck Graham Reynolds as a painting in which 'the artist has for once lost his normal feeling of immediate contact with his subject' (*Constable: The Natural Painter*, 1965), while others went so far as to suggest that it was 'a sinister object', its figures 'creatures in a bad, bad dream' (Conal Shields and Leslie Parris, *John Constable 1776–1837*, 1969). By the 1980s that bad dream could seem more like a horror movie: 'The Stour has become the Styx, and the girl in the boat is being taken to a rambling house where a dark figure waits at the gate', wrote David Hill, and, perhaps more to the point, 'If Constable discovered anything about his relationship to the past in painting this picture, it must have been that it was long dead' (*Constable's English Landscape Scenery*, 1985).

The time Constable spent reworking the picture, 'Oiling out, making out, polishing, scraping', is well documented by the artist himself and his words have been taken to support the view that no.216 was an act of desperation, a misconceived attempt to revive old images, past emotions. At the same time it has long been known that Constable himself saw this process of reworking as improving the painting. Before it went to the Academy he thought he had got his picture 'into a very beautifull state. I have kept my brightness without my spottiness, and I have preserved God Almighty's daylight' (Beckett v 1967, p.20), but after months of further work subsequent to the exhibition he was telling Leslie, 'I don't wonder at your working so much on the same picture … now that I see what can be done by it. I want you of all things to see my picture now, for it has proved to me what *my* art is capable of when time can be given sufficient to carry it home' (Beckett III 1965, p.132). Charles Rhyne (1990b) has recently focused on the discrepancy between the present appearance of 'The Valley Farm' and Constable's enthusiastic accounts of it, a discrepancy he attributes to the deterioration of the bitumen Constable used to glaze the work: 'As far as I can tell, no one had considered the possibility that Constable and modern critics were looking at two quite different paintings, one glowing with the brilliant, translucent effects of fresh bitumen, the other depressed with the dark, dull, wrinkled effects of deteriorated bitumen. Exactly those areas which Constable most wanted to bring to life are now deeply depressed'. There is clearly much truth in this, yet in acknowledging Constable's need to 'bring to life' certain areas, Rhyne returns us to the basic question: how much life was there in the picture in the first place? Perhaps in the present exhibition we may be able to answer this question with more certainty. Hung, as it probably never has been, near the Phillips Collection sketch (no.215), we should be able to measure more finely the distance or affinity between the currently projected extremes of Constable's late work.

217 A Cottage at East Bergholt 1830s

Oil on canvas 876 × 1118 (34½ × 44), extended from 800 × 800 (31½ × 31½)
PROV: …; acquired by Henry Engleheart after 1834; sold by Sir J.C.D. Engleheart c.1893 through Sir J.C. Robinson to James Orrock, sold Christie's 4 June 1904 (64) bt Agnew for W.H. Lever, later Lord Leverhulme, by whom presented to the Lady Lever Art Gallery 1922
EXH: Tate Gallery 1976 (329, repr.)
LIT: Hoozee 1979, no.563, repr.; Rosenthal 1983, pp.235–6, fig.257 (col.); Fleming-Williams and Parris 1984, pp.103–4, pl.48; Reynolds 1984, no.36.20, pl.1072 (col.); Rosenthal 1987, p.196, ill.188

National Museums and Galleries on Merseyside (Lady Lever Art Gallery)

Like the 'Farmhouse near the Water's Edge' sketches (nos.214–15), the Lady Lever Art Gallery canvas is thought to depict an imaginary scene, this time based on memories of East Bergholt rather than Flatford. Rhyne (as reported in Rosenthal 1983 and Reynolds 1984) has suggested that the rainbow was derived from Constable's sketch 'Landscape and Double Rainbow' of 28 July 1812 (fig.114, Victoria and Albert Museum, Reynolds 1973, no.117), which also includes a windmill, though not in the same place and under a very different sky. As mentioned in the 1976 Tate Gallery catalogue, the donkey is taken from the version of 'A Cottage in the Cornfield' that Constable finished for the RA exhibition of 1833 (no.77 above). The cottage itself is not exactly comparable to any other drawn or painted by Constable, or, at least, to any surviving drawing or painting of one by him.

The rainbow is largely painted on the 12½ inch strip of canvas added on the right, suggesting that it was a late addition like the rainbow in the 'Salisbury Cathedral from the Meadows' composition (see nos.209–10). Rainbows figure prominently in

fig.114 'Landscape and Double Rainbow', 1812, *Board of Trustees of the Victoria and Albert Museum, London*

Constable's final works: in the great 'Salisbury' just mentioned; in the 'Stoke-by-Nayland' mezzotint (no.196), the accompanying text for which contains a long passage on their visual qualities, physical properties and literary associations; in the last Hampstead painting (no.219) and in the 'Stonehenge' watercolour, no.345.

Reynolds discusses the early history of no.217 in some detail, citing documents suggesting that it was acquired by Henry Engleheart soon after 1834. It seems unlikely, however, that Constable would have parted with a sketch of this kind except possibly to a close friend and Engleheart does not appear to have been even an acquaintance. More likely he acquired the work in the 1838 studio sale. Leslie's son G.D. Leslie rashly denounced the picture as a fake when it was shown at the Royal Academy in 1893. Recalling the 'storm of dis-cusion' this created, Charles Holmes commented: 'No one . . . who understands Constable's spirit and method can, I think, have a doubt as to the authenticity of this powerful and brilliant study. The purity of its colour, and the transparency of its shadows, distinguish it at once from the muddy, heavy work of the average forger. A still more convincing proof of its genuineness may be found in the amazing power of drawing with the palette-knife which its maker must have possessed. Look, for instance, at the donkey in front, and note with what certainty, and accuracy, and force the blots of black and white that make the beast are applied. The variety, beauty, and freedom of the cloud-forms also are qualities which only Constable's knowledge, daring, and skill could attain so simply and so forcibly' (*Constable and his Influence on Landscape Painting*, 1902, p.236).

217

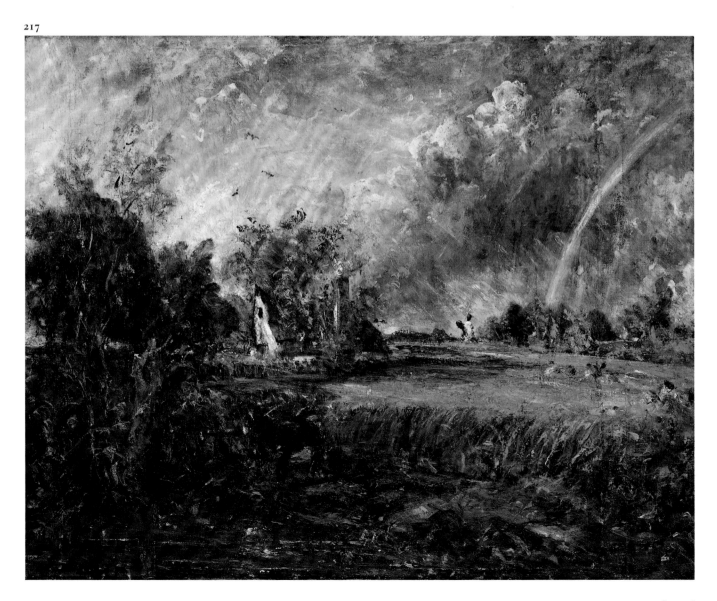

218 Stoke-by-Nayland *c*.1835–7

Oil on canvas 1258 × 1685 (49½ × 66⅜)
PROV: ? Artist's administrators, sold Foster
16 May 1838 (in 40, 'Two – Sketch of the
Opening of Waterloo Bridge, and Stoke
Church', the first deleted from some copies of
cat.) bt Ivy; . . .; ? Miss Morris, sold 1860, bt
Cox; . . .; ? Jonathan Nield, sold Christie's 3
May 1879 (13) bt Permain; . . .; Sir Frederick
Mappin, sold Christie's 17 June 1910 (14) bt
Sulley; . . .; Mrs W.W. Kimball, by whom
bequeathed to the Art Institute of Chicago
1922
EXH: New York 1983 (60, repr. in col.)
LIT: Hoozee 1979, no.564, repr.; Parris 1981,
pp.63–4, fig.7; Rosenthal 1983, p.236, fig.263
(col.); Reynolds 1984, no. 36.19, pl.1070
(col.); Cormack 1986, pp.225–8, pl.213;
Charles Rhyne, 'Constable's Last Major Oil
Sketch: The Chicago *Stoke-by-Nayland*',
unpublished article on file in the Dept. of
European Painting, Art Institute of Chicago,
1987; Fleming-Williams 1990, p.300, fig.277;
Rhyne 1990a, pp.119, 125 n.3, 128 n.45;
Rhyne 1990b, p.77

Art Institute of Chicago, Mr and Mrs W.W.
Kimball Collection

Charles Rhyne made a major contribution to our
understanding of this painting in the 1987 article
cited above, which has unfortunately not yet been
published. Previously the work had generally been
considered an unfinished canvas which Constable
intended to complete for exhibition. Certain odd
features – the foreground figures especially – were
regarded by some writers as a ham-fisted attempt
by a later hand to do just that, to complete the
picture (see, for example, Parris 1981). Rhyne
convincingly proposed that no.218 is in fact a
sketch for a painting that Constable never executed
and that it must therefore be assessed by different
criteria: 'The reclining figure is unresolved, com-
bining one posture for the lower body and an
impossible turn for the upper body. The plough
and fence, though not irrational, are not repre-
sented with the structural clarity so persuasive in
Constable's large finished paintings. On the other
hand, they are in keeping with the character of
comparable objects in other large sketches'. As
noted in the entries on the large sketches for
'Stratford Mill' (no.99) and 'Salisbury Cathedral
from the Meadows' (no.209), Constable appears to
have been willing to sacrifice many of his usual
skills when trying to pull together the sketch for a
large composition, though, curiously, most of the
big sketches do not suffer from the wild distortions
of anatomy that we see in no.218 or the alarming
perspective given to the cathedral in no.209.

The Chicago sketch is referred to in a letter from
Constable to his Hampstead friend William Pur-
ton, published by Leslie under the date 6 February
1836 but now thought to be of 1835:

I am glad you encourage me with the 'Stoke'.
What say you to a summer morning? July or
August, at eight or nine o'oclock, after a slight
shower during the night, to enhance the dews in
the shadowed part of the picture, under
 'Hedge row elms and hillocks green.'
Then the plough, cart, horse, gate, cows,
donkey, &c. are all good paintable material for
the foreground, and the size of the canvas
sufficient to try one's strength, and keep one at
full collar.

(Leslie 1843, p.104, 1951, p.250,
Beckett V 1967, p.44)

Leslie adds that the 'large picture of "Stoke" was
never painted' but, as Rhyne suggests, this state-
ment need no longer puzzle us if we accept that the
Chicago canvas is a sketch rather than an un-
finished picture.

All the ingredients mentioned by Constable are
included in no.218. The way he offers up the
treatment of the subject for Purton's approval and
suggests suitable foreground material – appropri-
ate garnishing, as it were, for the dish he is
recommending – implies that 'Stoke' could be
presented in other ways. In his text for the 'Old
Sarum' print in *English Landscape* (see nos.193–5)
Constable wrote about the latitude the artist should
allow himself in this respect: he ought to have
'these powerful organs of expression' – colour and
chiaroscuro – 'entirely at his command, that he
may use them in every possible form, as well as that
he may do [so] with the most perfect freedom;
therefore, whether he wishes to make the subject of
a joyous, solemn, or meditative character, by
flinging over it the cheerful aspect which the sun
bestows, by a proper disposition of shade, or by the
appearances that beautify its rising or its setting,
a true "General Effect" should never be lost sight
of' (Shirley 1930, p.258). In *English Landscape*
Constable decided that he wanted to use the 'Stoke'
subject to convey the 'solemn stillness of Nature in
a Summer's Noon' (see no.196). The Chicago
sketch, a morning scene, aims at a more cheerful
general effect. Constable's wilful use of his material
to convey particular effects and 'sentiments' is a
distinctive feature of his late work.

Constable's earlier drawings and paintings of
Stoke-by-Nayland church, including the Victoria
and Albert Museum oil sketch, fig.115 (Reynolds
1973, no.330), are discussed at length in the
literature (see especially Parris 1981 and Rhyne
1987). When he returned to the subject in the
English Landscape print, begun in 1829, Constable
worked towards an image not dissimilar to these
early versions but he added a figure at a gate in the
foreground and moved the whitewashed cottage
below the church tower to the right. The revival of
the subject in printed form may well have sug-
gested the idea of treating it on a large canvas. The
Chicago painting follows the print in including a
figure at a gate and also in the repositioning of the
cottage, though the latter is no longer highlighted.

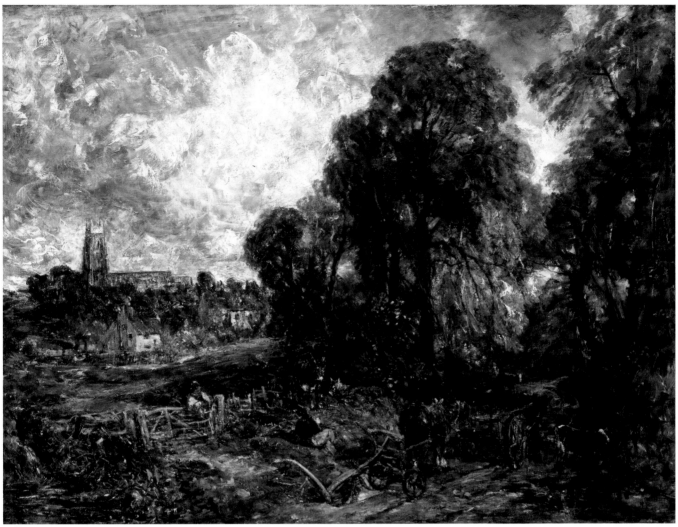

218

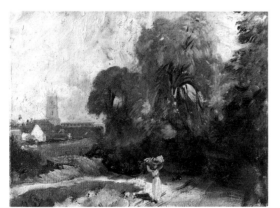

A 'blottesque' drawing of the subject made around the time of Constable's work on the mezzotint is shown as no.324 in this exhibition. In many ways this is closer still to the large oil sketch: the church is moved more to the left of the composition, vague animal forms can be made out in the lane on the right, and the man at the gate is already growing monstrous.

The plough in no.218 is derived from an oil sketch (Reynolds 1973, no.136) made in 1814 and used also in the 1826 'Cornfield' (no.165). Among other relevant material discussed by Rhyne in his 1987 article is a watercolour of Stoke-by-Nayland in the British Museum, which Constable probably exhibited in 1832 (Reynolds 1984, no.32.14).

219 Hampstead Heath with a Rainbow 1836

Oil on canvas 508 × 762 (20 × 30)
Possibly inscribed 'J C [. . .]' b.l.; inscribed
by W.G. Jennings on the back of the original
canvas (photographed before relining in
1964) 'Painted by John Constable RA | for me
W: Geo Jennings | 1836'
PROV: Painted for William George Jennings
1836; acquired by the Constable family at an
unknown date and bequeathed by Isabel
Constable to the National Gallery as the gift
of Maria Louisa, Isabel and Lionel Bicknell
Constable 1888; transferred to the Tate
Gallery 1954 (N 01275)
EXH: Tate Gallery 1976 (334, repr.)
LIT: Hoozee 1979, no.558, pl.LXIV (col.);
Parris 1981, no.42, repr. in col.; Fleming-
Williams and Parris 1984, p.212; Reynolds
1984, no.36.7, pl.1057 (col.); Cormack 1986,
p.240, pl.228; Bermingham 1987, p.149,
fig.66

Tate Gallery

This is Constable's final treatment of one of his
favourite Hampstead subjects, the view westward
over Branch Hill Pond. He had earlier worked out
two principal ways of dealing with the subject, one
from a higher viewpoint than the other. The
Virginia Museum picture, no.125 above, repre-
sents the former type, with the house known as the
Salt Box clearly in view. This last Hampstead
picture, no.219, returns to the lower viewpoint first
adopted in the 1819 sketch, no.106, and seen again,
for example, in a painting exhibited in 1828
(Victoria and Albert Museum, Reynolds 1984,
no.28.2). In these the distant view is partly
obstructed on the right by a large bank. Against the
bank in no.219 Constable now places two donkeys
instead of the cart, horse or horses, and shovelling
labourers seen in most other versions of both types
of the composition. The windmill and rainbow are
more important variations. There was no mill in
the spot shown by Constable and both Reynolds
and Bermingham have reasonably suggested that
Constable turned to one of his Brighton oil
sketches, 'A Windmill on the Downs near Brigh-
ton' (fig.116, Victoria and Albert Museum, Rey-
nolds 1984, no.24.73) not only for this feature but
also for the adjacent cottage and the rainbow.

Constable painted no.219 for his friend William
George Jennings (1763–1854), a gentleman ama-
teur whom he had known since at least 1826 and
who in his later work absorbed something of
Constable's style. Jennings's letters (see Parris

1981) record his delight with the work and his
gratitude for acquiring it at the special price of £50.
Constable was equally pleased with the outcome,
telling his Arundel namesake, George Constable,
on 16 September 1836, 'I have lately turned out one
of my best bits of Heath so fresh – so bright –
[?dewy] & sunshiney' (Beckett V 1967, p.35). A few
months before, while he was still working on
Jennings's picture, Constable used similar terms to
express his enthusiasm for Rubens's rainbows. 'By
the Rainbow of Rubens, I do not allude to a
particular picture,' he said in his third lecture to the
Royal Institution, 'for Rubens often introduced it;
I mean, indeed, more than the rainbow itself, I
mean dewy light and freshness, the departing
shower, with the exhilaration of the returning sun'
(Leslie 1843, p.143, 1951, p.315). It may have been
while collecting his thoughts for this lecture that
Constable decided to introduce a rainbow in
no.219.

The windmill was surely a more personal
addition. Bermingham, who sees the painting as 'an
example of decorative picture making . . . a collage
of motifs and effects', rejects the idea that
Constable may have introduced it in allusion to his
Suffolk childhood (as suggested in the 1976 Tate
Gallery catalogue), but his method of constructing
the work can hardly exclude this as a possible
dimension of the picture's meaning. It is reason-
able, in any case, to suppose that it was Constable's
early knowledge and love of the Suffolk mills that
attracted him to those he found at Brighton. We
may indeed have in this painting a unique 'collage',
or rather fusion, of motifs and associations: Hamp-
stead, Brighton, East Bergholt. Although set about
in a different way and worked to a high finish,
no.219 is another example of that freeing of the
imagination which we have seen in the 'Farm-
house' sketches, nos.214–15, and the 'Cottage at
East Bergholt', no.217.

fig.116 'A Windmill on the
Downs near Brighton',
?1824, *Board of Trustees of
the Victoria and Albert
Museum, London*

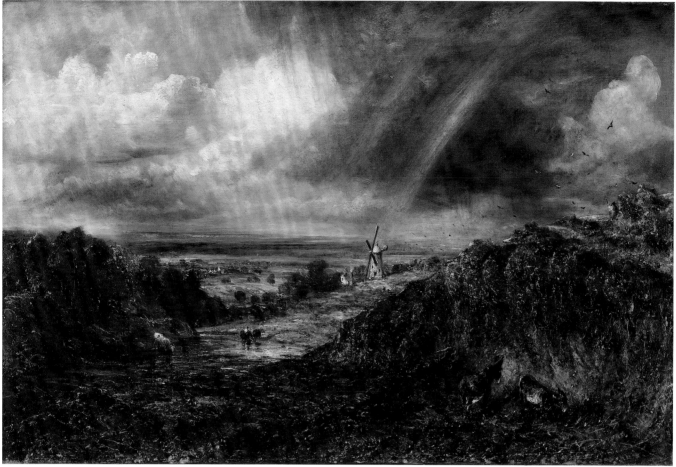

219

220 Arundel Mill and Castle 1836–7,
exh.1837

Oil on canvas 724 × 1003 (28½ × 39½)
PROV: Artist's administrators, sold Foster 16
May 1838 (81, 'Arundel Mill and Castle; *the
last picture Mr. Constable painted Exhibited*
1837') bt in by John Charles Constable, who
died 1841; his brother Charles Golding
Constable, by whom sold to Holbrook
Gaskell 1878; his sale, Christie's 24 June
1909 (8) bt Knoedler; Edward Drummond
Libbey, Toledo, 1909 and presented by him
to the Toledo Museum of Art, Toledo, Ohio
1925
EXH: RA 1827 (193, 'Arundel mill and
castle'); Tate Gallery 1976 (335, repr.); New
York 1983 (64, repr. in col.)
LIT: Hoozee 1979, no.565, repr.; Reynolds
1984, no.37.1, pl. 1086 (col.); Cormack 1986,
pp.240–2, pl.227 (col.); Rosenthal 1987,
pp.195, 199, ill.187; Fleming-Williams 1990,
p.273, fig. 244

*Toledo Museum of Art, Gift of Edward
Drummond Libbey*

C.R. Leslie's observation about Constable's sub-
jects forming 'a history of his affections' has already
been quoted in the Salisbury section of the
catalogue. Characteristically, the artist owed his
introduction to West Sussex, the final addition to
the map of 'Constable's England', to an important
new friendship made late in life, that with George
Constable (1792–1878), Arundel brewer, maltster,
collector and amateur painter. Constable's unre-
lated namesake had written in December 1832 to
congratulate him on *English Landscape* and to
enquire its price. A friendly correspondence
ensued, followed by two visits to Arundel, in July
1834, when Constable took his eldest son, John
Charles, and July 1835, when Minna also accompa-
nied them. Some of the drawings made on these
visits are shown as nos.333–5 and 338–40, no.340
being the sketchbook Constable used in Sussex in
1835.

The first mention of a painting of Arundel mill
and castle comes in a letter of 16 December 1835, in
which Constable asked George Constable to bring
with him to London 'the sketch I made of your mill
– John wants me to make a picture of it' (Beckett v
1967, p.28). The planned visit had to be postponed,
so Constable repeated his request in January 1836:
'When you come will you bring the little sketch of
the Arundel Mill, as I should like to contemplate a
picture of it, of a pretty good size' (ibid., p.30).
Evidently George Constable did manage to bring
the sketch up, since he was under the impression in
April that Constable had by then painted the
contemplated picture, which he trusted was 'now
hanging on the Academy walls' (ibid., p.31). On 12
May the artist explained that he had decided to
send 'The Cenotaph' to the Academy, 'not the
Mill, which I had hoped to do, and which was
prettily laid in so far as chiaroscuro, but I found I

could not do both' (ibid., p.32). Only in February
1837 is the picture mentioned again. 'I am at work
on a beautifull subject,' Constable told his name-
sake, 'Arundel Mill, for which I am indebted to
your friendship. It is, and shall be my best picture –
the size, three or four feet. It is safe for the
Exhibition, as we have as much as six weeks good'
(ibid., p.37).

The identity of the 'little sketch' has been
debated. Reynolds is confident that it is the oil
study belonging to the Fine Arts Museums of San
Francisco (1984, no.37.2, pl.1087 in col.), a work
George Constable's son said was painted on the
spot and given to his father (Rhyne 1990a, p.126
n.11). The present authors have expressed reserva-
tions about this identification (Parris and Fleming-
Williams 1985, p.169 under no.37.2). What is not
in question is the use Constable made when
painting the Toledo picture of two drawings:
no.338, which provided the composition and most
of the detail (and which could have been the sketch
lent to George Constable), and p.33 (fig.117) in the
1835 sketchbook (no.340), from which the detail of
the castle on its wooded promontory was more
specifically taken. The two young anglers in the
painting echo those in Constable's earlier Suffolk
pictures, especially 'Boys Fishing' (no.57), while
the cows closely follow two of the three seen in the
Tate Gallery canvas 'Trees at Hampstead' (Parris
1981, no.34; Reynolds 1984, no.29.67).

Although 'Arundel Mill and Castle' is unusual
among Constable's late paintings in being based on
fresh visual material, its subject matter clearly
belongs to his favourite repertoire. Arundel mill
provided him with a very acceptable equivalent to
Willy Lott's house, one that was already suffi-
ciently massive and romantic not to need the boost
given to the Flatford cottage in his 1835 'Valley
Farm' (no.216) – indeed, Lott's house may have
grown in his imagination after his first sight of
Arundel mill in 1834. Nor did he need to import a
more impressive tree to set off the building, as he
had in 'The Valley Farm': 'all here sinks to
insignificance in comparison with the woods, and

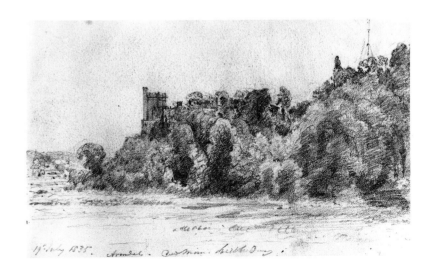

fig.117 1835 sketchbook
(no.340), p.33, *Board of
Trustees of the Victoria and
Albert Museum, London*

hills . . . the trees are beyond everything beautifull', he wrote to Leslie from Arundel (Beckett III 1965, p.111). At the beginning of his career, we have suggested, Constable was redoing Gainsborough from nature: here, on his final canvas, after flights of imagination (see nos.214–15, 217) and more prosaic studio ramblings (no.216), we may feel that he is redoing Constable from nature. But, of course, this is too neat a conclusion to his life's work. When he told George Constable on 17 February 1837 that he had as much as 'six weeks good' to complete 'Arundel Mill and Castle' for the Academy, Constable looked to the future and to other works, not knowing that he would die just so, six weeks later, during the night of 31 March–1 April. While dressing on the morning of 1 April 1837 C.R. Leslie looked out of his window and saw Constable's messenger Pitt:

> I ran down expecting one of Constable's amusing notes, or a message from him; but the message was from one of his children, and to tell me that he had died suddenly the night before. My wife and I were in Charlotte Street as soon as possible. I went up to his bedroom, where he lay, looking as if in tranquil sleep; his watch, which his hand had so lately wound up, ticking on a table by his side, on which also lay a book [a volume of Southey's edition of Cowper] he had been reading scarcely an hour before his death. He had died as he lived, surrounded by art, for the walls of the little attic were covered with engravings, and his feet nearly touched a print of the beautiful moonlight by Rubens, belonging to Mr. Rogers.
>
> (C.R. Leslie, ed. Tom Taylor, *Autobiographical Recollections*, 1860, 1, p.158)

One of the first of the many services Leslie performed for his departed friend was to arrange for him to be posthumously represented at the Academy, under a rule allowing a deceased artist's work to be shown in the first exhibition following his death. The almost complete 'Arundel' was submitted, and duly appeared, but 'two smaller pictures' that accompanied it were judged 'not forward enough to be admitted even as sketches' (Leslie 1843, p.115, 1951, p.267). Tantalisingly, they have never been identified.

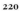

220

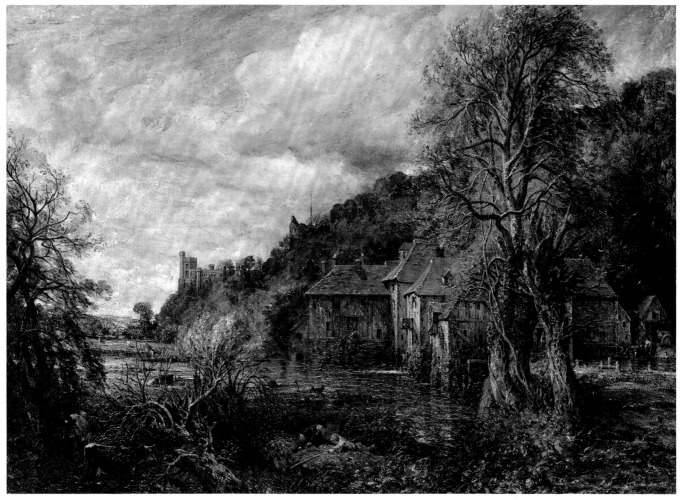

DRAWINGS

While Constable has been acclaimed as a painter, so far he has not received full recognition as one of the greatest of landscape draughtsmen. This may be accounted for partly by the nature of the medium – his works on paper (other than oils) present problems of conservation, stricter control of lighting, etc., and are to be seen less often on public display – but also by the fact that for the majority of his finest drawings he used that commonplace tool, the graphite pencil. Colour has an immediate appeal and after the paintings a certain mental readjustment has to be made if the monochromatic drawings are to be fully appreciated. Scale also partly accounts for his relative neglect as a draughtsman. Large-scale works such as the study of elms (no.282) and the late study of firs (no.332) are exceptional. Most of his drawings were made in sketchbooks and he was as happy to work in a small pocket-sized one as he was in one of the larger books. Some of his most memorable images are to be found on 3 by 4 inch pages – in the 1813 and 1814 books (nos.247–8), often two or three to a page.

Drawing played a vital part in Constable's development as a landscape painter and drawings subsequently played an equally important part as a source of material for his paintings. For a time his advance was a sort of leap-frog process, drawing and painting each in turn providing him with the means to master the complexity of the subject: 1797–9, 1805–6 and 1813–14 being the years when drawing led the way. Watercolour played an important role only twice in his career, in 1805–6 and in the 1830s, towards the end of his life, when he exhibited quite a number of works in that medium. Although tinted pen and ink drawings occasionally served as gifts, in his early years drawing was primarily a means of study, part of the learning process, and the contents of his sketchbooks were of interest and value only to himself. Gradually, however, as his sketches became more pictorial in character, they began to interest others in his small circle of intimates. In a letter to Maria Bicknell of 1814, he talked of his sketchbook of the previous year (no.247) as a journal that ought to amuse her. Later sketchbooks were borrowed and passed around among his friends, their contents admired and copied. 'Your pencil sketches', Fisher told him, 'always take people: both learned and unlearned' (Parris, Shields, Fleming-Williams 1975, p.118). In 1815 and 1818, he felt sufficiently confident in his powers as a draughtsman to exhibit examples of his work with the pencil at the Academy (see nos.254, 282).

In his early years Constable was influenced strongly by the work of others – by J.T. Smith, R.R. Reinagle, Sir George Beaumont, George Frost, Gainsborough, Dr Crotch and Girtin. But by 1812 he had extracted all he needed from these mentors and models and had become his own man. His work continued to develop and change throughout his life, however, and, when needs be, he was quite capable of adopting a completely new approach – as he did in 1824, for example, with pen and wash for the studies of life on the foreshore at Brighton (see nos.309–10). In the end he arrived at a highly personal kind of shorthand – to be seen at its best in two of the last drawings of 1835, 'Arundel Mill and Castle' (no.338) and 'Dowles Brook' (no.342).

Detail from 'Elm Trees in Old Hall Park, East Bergholt', no.282

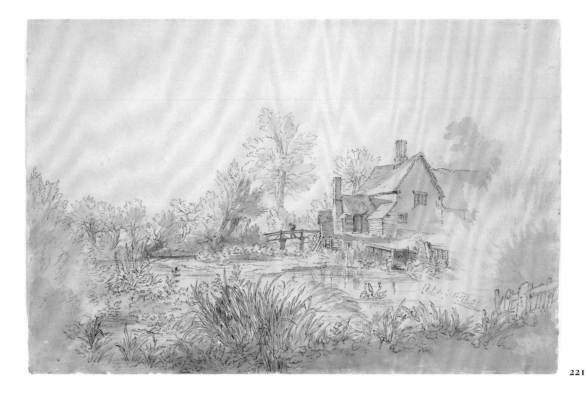

221

221 A Farmhouse by a River 1798

Pencil, pen and brown ink with green wash
on a half sheet of deckle-edged wove paper
295 × 449 (11⅝ × 17¹¹⁄₁₆); watermark: fleur-de-
lys in shield, crown above
Inscribed '1798' in pencil t.r. and 'Hadley |
1798' in ink on the back
PROV: ...; private collector, New York, from
whom acquired by Colnaghi 1984; present
owners
LIT: Fleming-Williams and Parris 1984,
p.149, pl.74; Fleming-Williams 1990, pp.30–
47, pl.1 (col.)

Mr and Mrs David Thomson

fig.118 'The Deserted
Cottage', 1797, *Board of
Trustees of the Victoria and
Albert Museum, London*

Constable's first meeting with anyone from the
world of art took place in 1795, when his mother
obtained for him an introduction to the renowned
amateur and collector Sir George Beaumont, then
staying with his mother, the Dowager Lady
Beaumont, a resident in Dedham. Constable was
visiting relations in Edmonton the following year
when he first came into contact with professional
artists: J.T. Smith – topographer, engraver and
part-time drawing master – and with the eccentric
John Cranch, painter of quaint scenes of low life.

Smith became an apparently unpaid but not
unwilling tutor to the twenty-year-old Constable
and over the next two years, while remaining in the
family business, Smith's young pupil attempted
little more than to model his style of drawing on his
tutor's and his manner of painting on that of
Cranch. Smith lent him prints to copy, plaster casts
to draw and taught him the art of etching. The
earliest known etching by Constable (fig.118) was

an attempt to emulate Smith's illustrations to a
theoretical work he published in 1798: *Remarks on
Rural Scenery; with Twenty Etchings of Cottages,
from Nature; and Some Observations and Precepts
Relative to the Pictoresque.*

No.221 is one of a small group of drawings
Constable made in 1798, when his adoption of
Smith's way of drawing was beginning to awaken in
him a more personal view of landscape. The sharp
delineation of detail with pen and ink in no.221
differs little from Smith's own somewhat finicky
manner, but the freer use of the wash to suggest a
radiant flood of light and the more openly disposed
elements in the composition represent an early
stage in the emergence of a new breadth of vision.

222 The Valley of the Stour with Stratford St Mary *c*.1800

Pen, wash and watercolour on trimmed wove paper 340 × 517 ($13\frac{3}{8}$ × $20\frac{3}{8}$)
PROV:...; Professor Francis Pierrepont Barnard, by whom bequeathed to the Ashmolean Museum 1934
LIT: David Brown, 'A New Drawing by John Constable', *Master Drawings*, vol.17, no.3, Autumn 1979, pp.278–9, pl.43; Fleming-Williams and Parris 1984, p.5

Visitors of the Ashmolean Museum, Oxford

On 22 November 1800 Lucy Hurlock, daughter of the Revd Brooke Hurlock, was married in Dedham Church to Thomas Blackburn of King's Lynn. The bride's father was rector of Lamarsh and for some time, to oblige his friend Dr John Fisher, later Bishop of Salisbury, he also acted as curate of Langham (it was through this connection that Constable met the future bishop). From a letter Lucy Hurlock wrote to Constable in April 1800 we gather that they were well acquainted: she was looking forward, she said, to his annual visit to East Bergholt, 'when I shall again obtain a sight of the production of gradual progress of an early genius' (Beckett II 1964, p.19). When she was married, Constable evidently felt that their friendship

warranted a handsome gift and he presented her with a set of four large watercolours, views of the Stour valley from the Essex side that together formed a panorama from Langham round to Harwich and the estuary in the east. Three are now in the Victoria and Albert Museum (Reynolds 1973, nos.16A–C, pls.6a-b); the fourth is at the Whitworth Art Gallery, Manchester. All four were seen together in 1988 at the Barbican Art Gallery exhibition *Panoramania!* (no.38).

No.222 is an almost exact replica of the second of the series, of the view looking northwards from Gun Hill, with the toll-gate in the middle distance, and further off on the left the village of Stratford St Mary with the church in the far distance to the right. It was some years before the group of four and the replica were correctly attributed. No.222 originally entered the Ashmolean as a work by Pieter Tillemans; later, John Webber (1752–93) was suggested as the author. It was correctly attributed only in 1979, when David Brown published his article in *Master Drawings*, naming Constable as the artist.

Despite its somewhat archaic character, there are discernible signs in no.222 of the Constable to come: in the sense of movement conveyed by the cloud shadow passing over the fields to the left and the wagon – of which only the hood is seen – descending the hill towards the bridge.

222

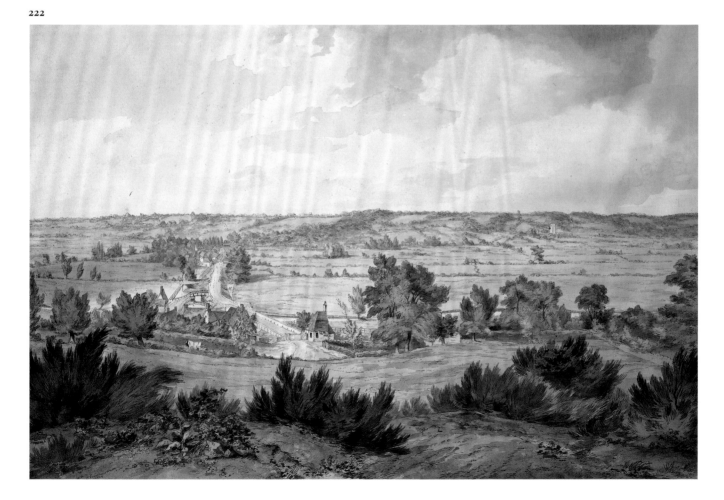

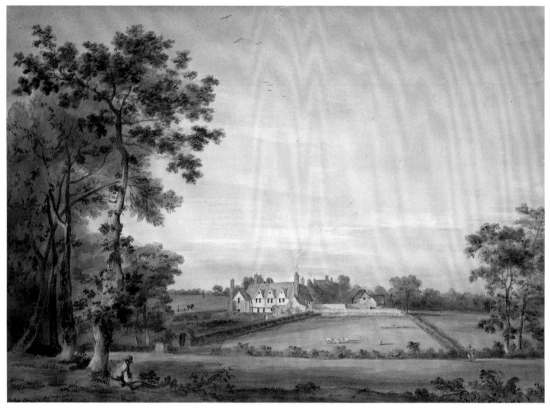

223

223 The Old Lecture House, Dedham, Seen across Long Meadow from Black Brook 1800

Pen and brown ink and watercolour with white heightening on wove paper 328 × 458 (12$\frac{15}{16}$ × 18$\frac{1}{16}$)
Inscribed 'John Constable. f: 1800.' b.l.; inscribed by E.T. Master on a label on the back of the frame with details of provenance
PROV: Given by the artist to Maria Sophia Newman 1800; by descent to her great-great-grand-daughters, sold Christie's 29 March 1983 (126, repr. in col.); present owner
LIT: C. Attfield Brooks, *The Dedham Lectureship*, Dedham 1983, unnumbered preliminary pages, repr. as col. frontispiece

Private Collection

No.222 is said to have been a gift from the artist to Maria Newman, daughter of the Revd Samuel Newman, Rector and Lecturer of Dedham, on the occasion of her marriage to Lt.-Col. Harcourt Master on 6 March 1800. Constable's inscription gives only the year so we are unable to estimate more exactly when the drawing was done. If it was completed in time for the wedding, Constable must have sketched the subject the year before, as he had been in London all winter and in March was only hoping to see Suffolk 'in the spring, when the cuckoos have picked up all the dirt' (Beckett II 1964, p.24). But there may have been no need for the gift to be ready for the wedding and he could have sketched the scene and then completed the drawing when he was in Suffolk in the summer.

No traces of pencilling are to be discerned in no.222 but it is probable that it was originally drawn in with a graphite pencil. The formal character of the composition, with the centre bracketed by a Claudean repoussoir of trees, bears a close resemblance to that of another house portrait, also believed to be a wedding present, 'Lamarsh House', painted a little earlier (Tate Gallery 1976, no.20, repr.). Technically, no.223 shows little signs of originality. Much of the brush and pen work derives directly from J.T. Smith's handling, but the suggestion of soft, low slanting sunlight on the house and the long shadows on the fields herald a life-long devotion to the movement of light in space.

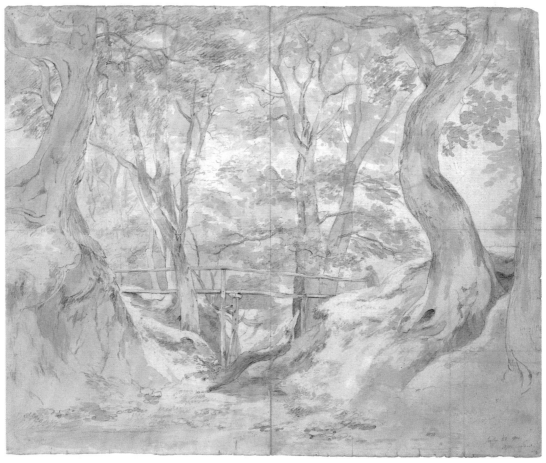

224

224 Helmingham Dell 1800

Pencil and grey wash on untrimmed wove
paper 533 × 664 (21 × 26⅛)
Inscribed 'July 23 1800. | Afternoon' b.r.
PROV: . . .; anon. sale, Christie's 9 June 1964
(229) bt Spink & Son Ltd for present owner
EXH: Tate Gallery 1976 (21, repr.)
LIT: Fleming-Williams 1976, p.18, pl.1;
Cormack 1986, p.28, pl.19

Private Collection

In the chapter on 'Study' in his *Remarks on Rural
Scenery* of 1798 (a work for which Constable
obtained a number of subscribers), J.T. Smith
advises the student to retire 'into the inmost
recesses of forests, and most obscure and unfre-
quented villages' when selecting subjects from
nature to be depicted. 'On the remote wild
common,' he continues, 'on the straggling undeter-
mined borders of the forest – or in the silent
sequestered dell, you shall find, unguarded, the
richest treasures of picturesque Nature'. The
Toronto painting, no.1, and the present drawing
show how closely Constable paid attention to those
passages in the *Remarks*.

It is not known why, at this juncture, Constable
chose to sketch in the park at Helmingham, the seat
of the Earl of Dysart, unless it was only here, in his
part of Suffolk, that he could find a suitable
'sequestered dell'. Nor is it known how he obtained
permission to work there. Later, in 1807, Constable
obtained an introduction to Lord Dysart, and the
connection proved fruitful, but in 1800 it must
have been someone on the estate, possibly a friend
of his father's, who made the necessary arrange-
ments. Strangers in those days were not freely
given the run of a walled deer park. Two days after
making this drawing of the dell, Constable wrote
the following to his friend Dunthorne at East
Bergholt, a letter from which passages have already
been quoted in the entry for nos.171–2:

Here I am quite alone amongst the Oaks and
solitudes of Helmingham Park. I have taken
quiet possession of the parsonage finding it
quite emty. A woman comes up from the farm
house (where I eat) and makes the bed; and I
am left at liberty to wander were I please during
the day. There are abundance of fine trees of all
sort; though the place upon the whole affords
good objects [rather] than fine scenery. but I
can badly judge yet what I may have to shew
You. I have made one or two ⟨. . .⟩ drawing
that may be usefull. I shall not come home yet.
(Beckett II 1964, p.25)

Nos.222 and 223, contemporary works, were executed in a formal manner. In no.224 we have Constable working for himself alone, oblivious of others and absorbed in his own responses to nature. Now a student in his second year at the Royal Academy Schools, with experience of some of the rigours of academic training, it is possible that he was drawn to this particular subject because he could see the great tree forms in terms of the drawings he had been making of the human figure in the life-classes. Leslie owned two drawings of Helmingham dated 23 and 24 July – the first of which may well be no.224 – and praised them for their 'true sense of the beautiful in composition' (Leslie 1843, p.6, 1951, p.11). He would of course have been writing with full knowledge of the pictures Constable painted of the dell from no.224 (see nos.171–2).

A Gothic stone bridge now spans the watercourse and most of the trees have been replaced by others. The serpentine oak on the right of the drawing, however, remains much the same, though grown a little stouter in the intervening years.

225 The Windmill at Brantham 1802

Black chalk, ? charcoal and red chalk on trimmed wove paper, edged all round with ruled chalk lines, 240 × 298 ($9\frac{1}{2}$ × $11\frac{3}{4}$); four pinholes t.l., three t.r.
Inscribed in pencil on the back '3 Octr Noon | 1802', repeated in ink in a later hand
PROV: As for no.2
LIT: Reynolds 1973, no.38, pl.17; Rosenthal 1983, p.38, fig.35; Fleming-Williams and Parris 1984, pp.163, 170, 172, 176, pl.83; Cormack 1986, pp.44–9, pl.36; Rosenthal 1987, p.47, ill.25

Board of Trustees of the Victoria and Albert Museum, London

George Frost (1745–1812) figures prominently among those by whose work Constable was influenced in these, his early experimental years. A clerk in the Blue Coach Office in Ipswich and part-time drawing-master, Frost was a prolific autodidact who had modelled his style very largely on that

225

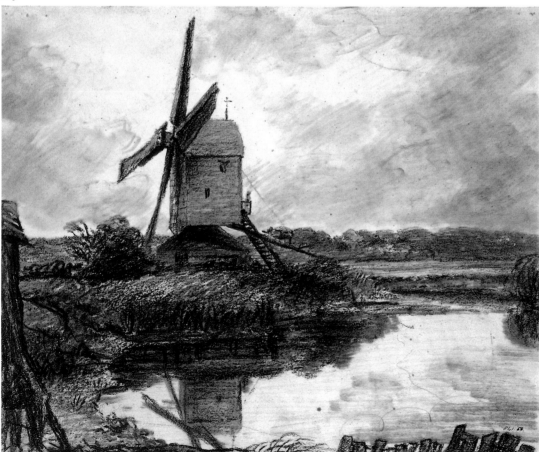

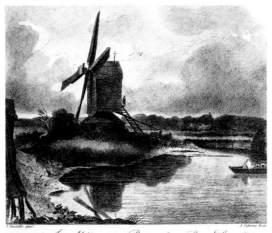

fig.119 J. Ogbourne after Constable, 'A Mill on the Banks of the River Stour', 1810, *Board of Trustees of the Victoria and Albert Museum, London*

226

of Gainsborough, of whose graphic work he possessed a number of examples. It was from Frost that Constable appears to have learnt to draw with black chalk in a bold, free manner and through use of the medium to begin to register landscape in broad, tonal terms, as in no.225.

A noticeable feature of no.225 is Constable's use of the stump. This tool, much used by pastellists and by draughtsmen wishing to soften the otherwise gritty texture of chalk or charcoal, consisted of a tight roll of chamois leather, blotting paper or amadou (a prepared fungus), tapered to a rounded point at either end. In a manner he would have learnt from a study of Gainsborough's later drawings, Constable has used the stump here (coated with powdered chalk or charcoal) to obtain the soft tones in the sky and for much of his tonal under-drawing. In some parts – for example, the sky – he seems to have drawn with the stump on paper previously wetted.

Two mills stood at the mouth of the canalised Stour at Brantham, a tidal watermill, and, close by, the windmill depicted in no.225, a mill that Constable's father, Golding, appears to have owned for some years. The mills at Brantham are to be seen in a small drawing of 1814, no.252.

An engraving of this composition (with one or two features added or dispensed with) is lettered, 'A Mill on the Banks of the River Stour. J. Constable pinxt. J. Ogborne Fecit. Published by Thos. Thane 1810' (fig.119). Commenting on the use of the word 'pinxt', Reynolds (1973) suggests that Constable may have made an oil painting or watercolour from the drawing.

226 Washbrook 1803

> Black chalk on wove paper 333 × 243 (13⅛ × 19⁹⁄₁₆); watermark '17[?9]4 | J WHATMAN'; pinholes in all four corners; paper at some time folded across middle
> Inscribed on the back '5 Octr 1803 | noon. Wash brook' b.l.
> PROV:...; anon. sale, Christie's 12 July 1988 (170, repr.); present owners
> LIT: Fleming-Williams 1990, p.19, fig.11

Mr and Mrs David Thomson

Constable spent part of 5 October 1803 in the company of George Frost, drawing the quays and shipping in Ipswich. Washbrook is some four miles short of Ipswich on the route Constable would have taken that day to join his friend. In the past many of Frost's drawings have been misattributed to Constable, especially those that show most clearly evidence of Frost's admiration for Gainsborough – of whose drawings he is known to have possessed quite a number. Constable too became an admirer of Gainsborough's early drawings, but his indebtedness to the older artist's graphic work is most

often to be found in drawings such as no.226, which in so far as it is stylistically not entirely his own, most strongly resembles Gainsborough interpreted by Frost.

Frost also used the stump (see no.225) to soften the gritty texture of chalk on paper, but here Constable has employed it to blur and lighten the tones in the distance and achieve an effect of aerial perspective.

227 A Dell *c.*1805

Black chalk on buff laid paper 335 × 492 (13$\frac{1}{8}$ × 19$\frac{3}{8}$), sight size; unequally divided by three vertical pencil lines
PROV:...; John Dunthorne (according to Gerald S. Davies);...; H.W. Underdown 1921;...; Gerald S. Davies;...; present owner
LIT: Fleming-Williams 1990, pp.56, 60, 61, fig.53

Private Collection

See no.229

228 The Stour Valley 1805

Pencil and watercolour on untrimmed, deckle-edged wove paper 173 × 274 (6$\frac{13}{16}$ × 10$\frac{13}{16}$); pinholes t.l.,t.r. and b.l.
Inscribed on the back in pencil 'Novr 4. 1805 – Noon very | fine day the Stour'
PROV:...; Mrs M.H. Percy, from whom bt by Leger Galleries and sold to L.G. Duke 1950; sold by him to Mrs Dorothy Moir 1951; by descent to Mrs F.R. Harris, sold Christie's 9 Nov. 1976 (82, repr. in col.); present owners
EXH: Tate Gallery 1976 (76, repr. in col.)
LIT: Fleming-Williams 1976, p.26, pl.5 (col.); Fleming-Williams 1990, pp.48–63, pl.2 (col.)

Mr and Mrs David Thomson

See no.229

227

228

229

229 Dedham Vale *c.*1805

Pencil and watercolour on trimmed wove
paper 155 × 226 (6⅛ × 8⅞)
PROV: . . .; Mrs Suzanne Beadle; her
executors, sold Christie's 15 June 1982 (100,
repr. in col.) bt John Phillips, from whom bt
by Andrew Wyld and sold 1985 to Spink &
Son Ltd, from whom bt by present owner
1986
EXH: *English Watercolours, Drawings and Oil
Paintings from Gainsborough to Turner*,
Andrew Wyld, May 1985 (30, repr. in col.);
English Watercolour Drawings, Spink & Son
Ltd, April–May 1986 (4, repr)
LIT: Fleming-Williams 1990, pp.51, 61, 62,
63, fig.42

Private Collection, New York

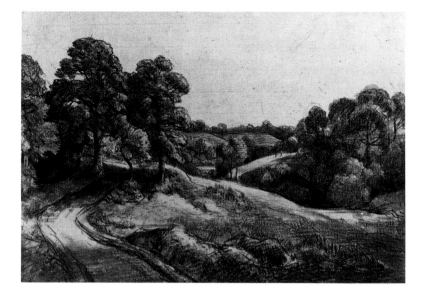

Dated watercolours and a group of chalk drawings and watercolours with certain shared characteristics mark the beginning, in 1805, of a new phase in the development of Constable's understanding and mastery of the art of landscape. Two stimuli appear to have initiated this advance: a friendship and an exhibition of watercolours, the first of its kind.

The new friend was Dr William Crotch (1775–1847), a remarkable polymath who, in addition to fulfilling his duties as Professor of Music at Oxford, had a flourishing practice as a drawing-master – one of five thus employed there at the time. Crotch applied simple geometric principles to basic drawing, teaching his pupils to analyse landscape in terms of related angles and measurements, and to see an individual tree as a conglomerate of overlapping, ovoidal forms contained within a rounded whole. This schematic approach seems to have had an immediate appeal for Constable, who, in its application to landscape, found answers to problems the existence of which few artists had hitherto been aware – namely, how to represent the insubstantial forms of trees three-dimensionally, as volumes, and to convey concommitant sensations of enveloping space. Constable's initial attempts to address these problems found expression in drawings such as no.227 and the two watercolours, nos.228–9. In the first of the three, 'A Dell' (no.227), and in an equally powerful chalk drawing of the same size at the Yale Center (fig.120, 'Wooded Slopes with a Road Receding at the Left', Rhyne 1981, no.8), the landscape is presented sculpturally with the trees firmly rounded, almost as if modelled out of lumps of clay.

The years 1805 and 1806 were exceptional in Constable's working life for the number of watercolours produced. It seems probable that his sudden interest in the medium and its potential was triggered off by the success of an exhibition held in galleries just off Bond Street in April 1805 by the Society of Painters in Water-Colours, a body newly formed by artists disenchanted with the showing of their work at the Academy. Hitherto, as we have seen in nos.221–2, Constable's use of colour in his drawings had been restricted, sometimes to merely

tinting a pen and ink study. In the autumn of 1805 he begins – if at times somewhat haltingly – to *paint* with watercolour.

'The Stour Valley' and 'Dedham Vale' are both views from the northern, Suffolk side of the Stour; no.228 apparently from the fields near the eastern approach to Flatford; no.229 from the fields below East Bergholt – a prospect Constable drew and painted many times from various viewpoints.

fig.120 'Wooded Slopes with a Road Receding at the Left', *c.*1805, *Yale Center for British Art, Paul Mellon Collection*

230 Epsom Common 1806

Pencil and watercolour on wove paper, left
edge trimmed, 107 × 177 (4¼ × 7)
Inscribed in pencil on the back 'Epsom Book
1806 Aug│Constable'
PROV: By descent to Charles Golding
Constable's children, by whom given to a Mr
West 1888; . . .; Dr Andrew Scott Myrtle; by
descent to vendor, Sotheby's 13 Nov. 1980
(98, repr. in col.); present owners
LIT: Fleming-Williams 1981, pp.58–60. fig.1
(col.); Fleming-Williams 1990, p.91, pl.3
(col.)

Mr and Mrs David Thomson

See no.231

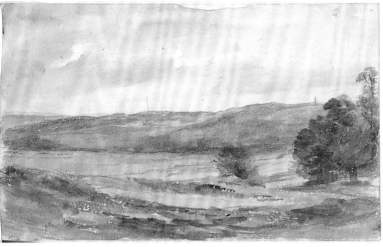

230

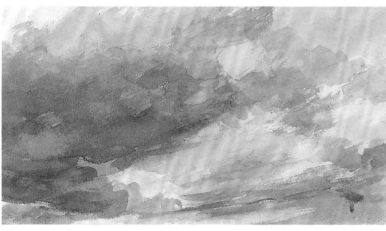

231

231 Sky Study 1806

Pencil and watercolour on trimmed wove
paper 86 × 157 ($3\frac{3}{8} × 6\frac{3}{16}$)
PROV:...; Cooling Galleries;...; acquired
1937 by mother of Mrs H. Brown, by whom
sold Christie's 20 March 1984 (115, repr.);
present owners

Mr and Mrs David Thomson

Pencil drawings and watercolours from a sketch-
book Constable used when staying with relations at
Epsom in August 1806 are now widely scattered.
Others, previously unrecorded, have recently been
coming to light. Many of the watercolours done
later in the year have faded badly. Four known to
be from the 'Epsom book' (i.e. 'Epsom Common',
Rhyne 1981, no.10, pl.4a; 'Epsom Downs', Soth-
eby's 14 July 1988, lot 85, repr. in col.; and
nos.230–1) have been preserved in a relatively
unfaded state. No.230 and Rhyne's no.10 are
almost a pair – both painted boldly with liquid
washes of colour. These Epsom watercolours were
not the first of this unusually productive year. Two,
of East Bergholt church and the thatched cottage at
Flatford, are dated respectively 9 and 13 June.

It is in some of the work of this period, when
Constable was discovering the nature of his own
personal vision, that the influence of Thomas
Girtin (1775–1802) is sometimes to be seen most
clearly. Two larger views of Epsom are plainly
experiments in Girtin's distinctive manner and
some of Girtin's 'realisations' of sketches by Sir
George Beaumont were an undoubted influence
later in the year when Constable was in the Lake
District (see Fleming-Williams 1990, figs.81–7).

The earliest known sky study by Constable is a
slight pastel drawing on brown paper in a sketch-
book of 1806 in the Louvre (RF 08700). There may
have been others. While not a 'pure' sky study,
no.231 is further evidence that he was aware of the
importance of skies for a landscape painter long
before he began his serious 'skying' in the 1820s.

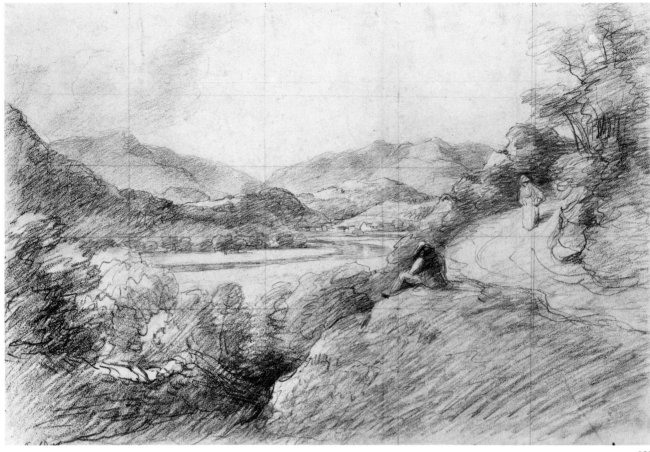

232

232 The River Brathay and the Village of Skelwith Bridge 1806

Pencil on wove paper 247 × 373 (9¾ × 14¹¹⁄₁₆); watermark 'E & P | 1804'; squared for transfer Inscribed in pencil '[?7] Sepʳ. 1806' b.l.
PROV: By descent to Charles Golding Constable; . . .; anon. sale, Christie's 11 March 1960 (15) bt Spink & Son Ltd; . . .; the Clonterbrook Trust; . . .; John Richards, sold Christie's 20 March 1984 (88, repr.); present owners
LIT: Rhyne 1986, pp.63–4, 69 n.19, pl.54; Fleming-Williams 1990, pp.76, 86–90, pl.4 (col.)

Mr and Mrs David Thomson

C.R. Leslie (1843, p.8, 1951, p.18) begins his short account of Constable's tour of the Lakes in 1806, thus: 'In this year his maternal uncle, David Pike Watts, recommended to him a tour in Westmoreland and Cumberland in search of subjects for his pencil, and paid his expenses.' Dated drawings made on this tour span a seven-week period, from 1 September to 19 October. Many are inscribed, often with detailed written descriptions of the weather and the effects he witnessed. It is thus possible to follow his trail for much of the time. The first couple of weeks were spent on Winder-

mere's eastern shore, with his uncle's agent at Storrs, and then at Brathay, at the head of the lake, with new friends, the Hardens. He then set out, with George Gardner (son of a friend, the painter Daniel Gardner) to explore the vales, lakes and fells to the north. They ended up in Borrowdale where Constable spent three weeks, most of the time without his companion, who had tired of 'looking on' and returned to Brathay.

While staying at Brathay he painted portraits in oils of his host and hostess, John and Jessy Harden, but with one possible exception, a small oil of Langdale Pikes, he does not appear to have painted landscape in oils during the tour. His output of drawings, however, was remarkable. Rhyne (1986) says he has catalogued eighty-nine drawings and watercolours done during those seven weeks – in a season when rain would often have rendered it impossible to work out-of-doors.

No.232 is a view of a bend on the road to Langdale, about a mile from Brathay Hall, a view now obscured by trees, although the wall beside the descending track on the left is still recognisable. A gentler scene than many he was shortly to encounter, Constable is nevertheless already working with a new breadth and freedom, responding, as the pencil point moves swiftly over the paper, to the rhythms of this (for him) entirely strange mountain scenery.

233 Derwentwater 1806

Pencil and watercolour on wove paper, left
edge irregular, 208 × 345 ($8\frac{3}{16}$ × $13\frac{5}{8}$);
pinholes t.r. and t.l; faintly squared for
transfer
Inscribed on the back in pencil 'Sep.ʳ Noon
1806 about 2 o clock the clouds had moved
off [? to] the left and left a very beautiful clear
effect on all the Distances – very much like
that in Sir G B picture of the Lake of Albano
– the heavy clouds remained edged with
light'
PROV: . . .; Camille Charles Groult (1830–
1907); his grandson, Pierre Bordeaux-
Groult, from whom acquired by Agnew,
from whom bt by present owners 1982
LIT: Fleming-Williams 1983a, p.219, fig.32;
Rhyne 1986, p.68, pl.63; Fleming-Williams
1990, pp.76, 80–1, 90, pl.5 (col.)

Mr and Mrs David Thomson

A dozen or so of the thirty Girtin watercolours
Beaumont is known to have shown Constable as
examples of 'great breadth and truth' (Leslie 1843,
p.4, 1951, p.5) were the 'realisations' already
referred to after pencil and wash drawings by
Beaumont. These (preserved intact in the original
sketchbooks of 1798, Wordsworth Trust, Dove
Cottage, Grasmere) Constable would also undoub-
tedly have seen; indeed, the earlier part of his
itinerary after leaving Brathay for the fells seems to
have been based on views Beaumont had sketched.

As Constable noted on the back of no.233, the
clear effect in the distances reminded him of
Beaumont's 'Lake of Albano', a painting exhibited
in that year's Academy. But the view itself was also
a subject Beaumont had drawn, from a viewpoint at
no distance from the one chosen by Constable
(fig.121). Sir George is mentioned again in an
inscription on the back of another drawing, a view
looking down into Borrowdale made on 25 Sep-
tember: '. . . fine clouday day tone very mellow like
– the mildest of Gaspar Poussin and Sir G B & on
the whole deeper toned than this drawing' (Rey-
nolds 1973, no.74, pl.42). Constable had Gaspard
Dughet in mind again later on: 'Borrowdale 4 Oct
1806 – Dark Autumnal day at noon – tone more
blooming ⟨that⟩ ⟨?than⟩ this . . . the effect
exceeding ⟨terrific⟩ terrific – and much like the
beautiful Gaspar I saw in Margaret St.' (Reynolds
1973, no.80, pl.43).

Constable's earliest comment on the weather,
the terse 'Noon very fine day' in his inscription on
the back of the 1805 'Stour Valley' (no.228), was
perhaps a response to the titling of many of the
exhibits in the Society of Painters in Water-
Colours show earlier in the year, for example
'Sunshine and distant rain', 'Still, warm evening'.
But it was not until this Lakeland tour that he
began to record regularly such detailed obser-
vations on the weather.

233

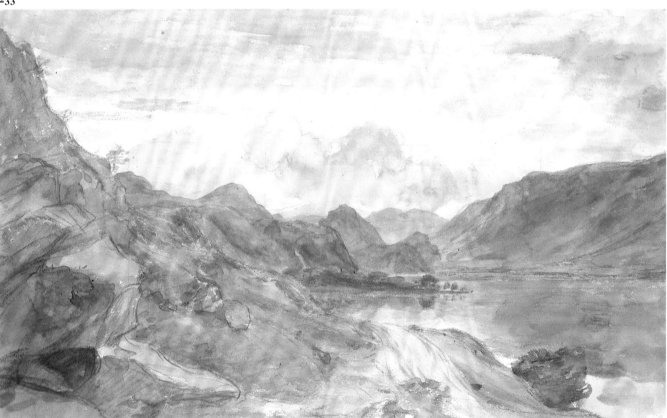

Two-thirds of the drawings done on this tour were watercolours, but very few have retained their original colour. From two shown here – 'Derwentwater' (no.233) and 'Borrowdale by Moonlight' (no.237) – we can obtain some idea of how the remainder must have looked in their pristine state.

Squaring-up a study for transfer is normally done at some stage after the completion of a drawing. A curious feature of no.233 is that the ruled pencil grid was drawn *before* Constable began colouring it. In some of his pencil studies the squaring-up also seems to be under the drawn image. It would be interesting to know whether Constable used a visual aid such as the perspective frame employed by Van Gogh, a device the latter portrayed himself using on the dunes at Scheveningen in a letter (222) to his brother Theo (J. van der Wolk, R. Pickvance, E.B.F. Pey, *Vincent van Gogh: Drawings*, 1990, p.17, fig.1). If he had such an apparatus with him, perhaps it was more like the one described by the poet John Clare (1793–1864) in one of his autobigraphical fragments. He was reminiscing about a boyhood friend, John Turnill, a farmer's son, who 'was always anxious after knowledge . . . somtimes he would be after drawing by perspective and he made an instrument from a shilling art of painting which he had purchased that was to take landscapes almost by itself it was of a long square shape with a hole at one end to look thro and a number of diferent colord threads crossed into little squares at the other from each of these squares different portions of the Landscape was to be taken one after the other and put down in a facsimile of these squares done with a pencil on the paper' (E. Robinson, ed., *John Clare's Autobiographical Writings*, 1986, pp.40–1).

234 Taylor Gill Force, Borrowdale 1806

Pencil and wash (? two shades of grey) on untrimmed wove paper 482 × 344 (19 × 13$\frac{9}{16}$); several pinholes t.r. and t.l. Inscribed on the back in pencil '26 Sepr. 1806 – Sty Head fall – or the Taylor's Ghill – Head of Borrowdale'
PROV: As for no.2
LIT: Reynolds 1973, no.75, pl.52; Rhyne 1986, pp.64–7, pl.57

Board of Trustees of the Victoria and Albert Museum, London

See no.235

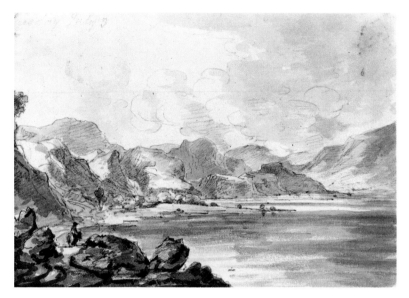

fig.121 Sir George Beaumont, 'Derwentwater', 1798, *Wordsworth Trust, Dove Cottage, Grasmere*

234

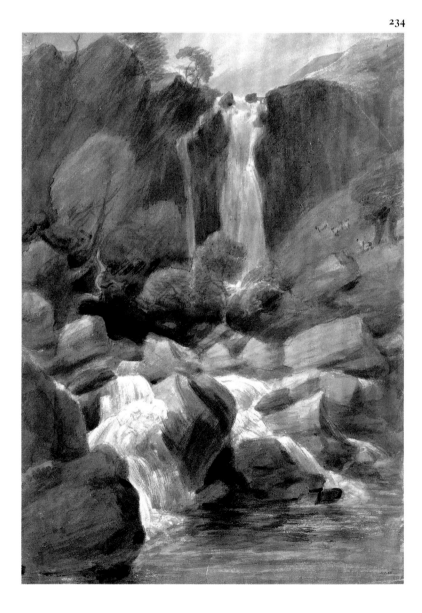

235

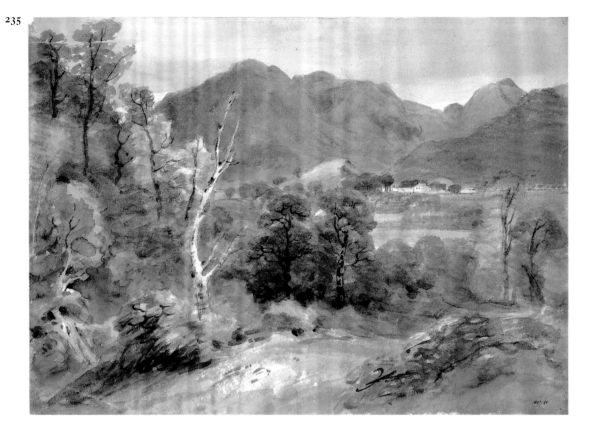

235 Borrowdale, Looking towards Glaramara 1806

Pencil and grey wash on untrimmed wove paper 347 × 486 ($13\frac{11}{16}$ × $19\frac{1}{8}$); pinhole t.r. (none t.l.: corner missing)
Inscribed in pencil on the back in another hand 'J. Constable'
PROV: As for no.2
LIT: Reynolds 1973, no.90, pl.49

Board of Trustees of the Victoria and Albert Museum, London

A few of the Lakeland pencil and wash drawings and watercolours appear to have been pencil sketches done on the spot that Constable subsequently worked up – perhaps in his lodgings on rainy days. This is unlikely to have been the case with no.234, a work undoubtedly done before the motif. The groups of pinholes in the top corners indicate that this complex study had demanded especially intensive application, requiring several visits to the scene.

Taylor Gill Force is a waterfall at 1,200 feet situated in a remote spot about three miles from Rosthwaite, the village on the Borrowdale valley floor. To reach it Constable would have had to walk up past the famed plumbago mines above Southwaite, at that time still the sole European source of graphite (the very substance with which Constable made his pencil drawings). Even today it is quite a scramble to reach Taylor Gill and it is surely indicative of the profound impression the Lakeland experience was having upon Constable that so soon after entering Borrowdale he should be exploring its furthermost reaches and choosing to work there, far from the nearest habitation.

Constable's sculptural treatment of landscape in some of his drawings the year before was noted in the entry for no.229. Several of the Lake District watercolours (no.239 for example) are studies of atmospheric effect, of cloud, mist and the occasional flash of sunlight on bare hillsides. He has created a subtle effect of light (and of recession) in no.234 by leaving the paper white only for the small waterfalls in the foreground, but in the main the stress is on form – the weighty forms of the rocks and boulders and the simplified, again rounded forms of the trees.

No.235 is a view of Borrowdale from the path that leads to Watendlath, a remote hamlet in a hanging valley where Constable made several sketches. Beyond Glaramara, in the far distance, may be seen the pyramidal peak of Great Gable. The single pinhole in the top corner of no.235 and the summary treatment of the trees and foreground on the left suggest that Constable was only able to complete the other parts of the drawing on the spot – the hills, valley and the trees further down the track. These, however, again reveal his deep concern with the rendering of forms in space – the rounded forms of the trees and the contrasting land masses beyond. Gestural, curving brush-strokes show him tentatively feeling his way in space, as it were, around the tree on the right.

236 Glaramara from Borrowdale 1806

Pencil on untrimmed wove paper 409 × 343
(16⅛ × 13½); squared for transfer; a small
triangular area of fixative missing in the tree
to the left
Inscribed faintly on the back in pencil 'Will
you Sup with me at 9 o clock|to[?night] [. . .]|
[. . .]|Wed morn^g'
PROV: . . .; Sir John and Lady Witt, sold
Sotheby's 19 Feb. 1987 (110, repr.); present
owners
LIT: Fleming-Williams 1976, p.32, fig.22;
Fleming-Williams 1990, pp.86, 89–91, pl.6
(col.)

Mr and Mrs David Thomson

So far, Constable's viewpoint for this powerful
drawing has not been identified, although the
Glaramara profile seems familiar enough. In
several of his Borrowdale studies Constable picks
out certain diminutive features to emphasise by
contrast the awesome scale of the scenery in which
he finds himself. In no.234 it is the group of sheep
on the slope to the right that conveys the idea of the
height of the waterfall. Here, in no.236, he has used
the two small groups of trees for this purpose – one
on a level with the eaves of the house in the
foreground, the other just above the eaves; the first,
lit against shadow, the second seen dark on light.

236

237 Borrowdale by Moonlight 1806

Pencil and watercolour on wove paper
trimmed at left and right 107 × 241 (4¼ × 9½);
pinholes t.l. and t.r.; on the back a pencil and
grey wash drawing of Watendlath (fig.122)
PROV: By descent to Charles Golding
Constable's children, by whom given to a Mr
West 1888; . . .; Dr Andrew Scott Myrtle; by
descent to vendor, Sotheby's 13 Nov. 1980
(99, repr. in col.) bt Spink & Son Ltd;
present owner
LIT: Fleming-Williams 1981, p.61, fig.4 (col.)

Private Collection

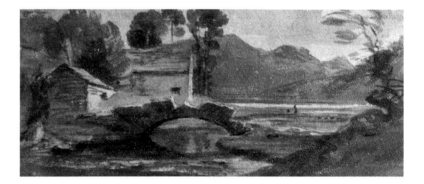

A clear sky appears to have been a rare event during
Constable's stay in Borrowdale and it is therefore
not surprising to find him out-of-doors enjoying
the evening and a sight of the rising moon.

From these fields, no distance from Rosthwaite
village, views of both branches of the vale may be
obtained. Stonethwaite is on the left and the moon
has been rising over Eagle Crag, the awkward profile
of which Constable has managed to minimise. In the
centre we have the quaintly named Bessy Boot, a
subsidiary peak on the Glaramara Range. It is on the
westward-facing side of this fell (the first slopes of

the other, right-hand branch of the vale) that we see
the last of the fading light.

In his perceptive article 'The Drawing of
Mountains' (1986), Charles Rhyne quotes a pas-
sage from Andrew Shirley's short biography of the
artist, *The Rainbow* (1949, p.72). It was Shirley's
belief that during this tour of the Lakes 'Constable
developed a natural perception of the structure of
the earth, and, with a foretaste of his later passion
for geology, began to anatomize landscape much as
he was studying the science of the skies. In fact, he
had built up a much larger store of knowledge in

fig.122 'Watendlath' (verso
of no.237)

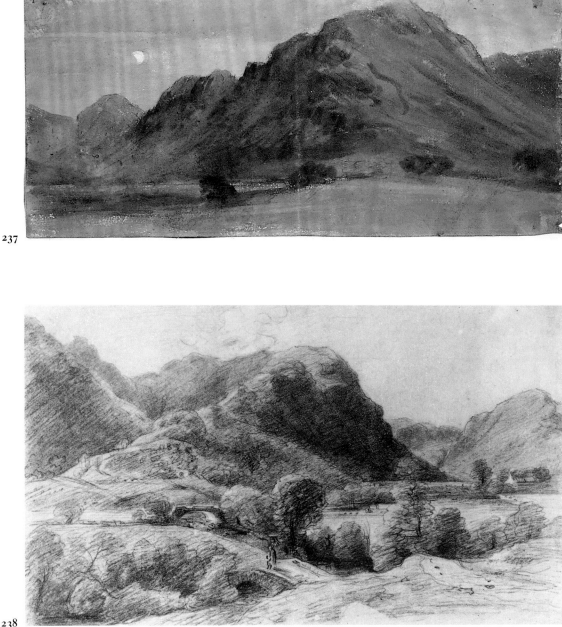

237

238

that wet autumn than he knew'. Constable had an intuitive feel for structure, but it was only in these last weeks in Borrowdale, in works such as 'Folly Bridge', no.238, and the present watercolour, no.237, that he was able entirely successfully to apply this innate sense to the 'geological structure underlying the perceived surface of the earth' (Rhyne 1986, p.64).

238 Folly Bridge, Borrowdale 1806

Pencil on wove paper 280 × 480 (11 × $18\frac{15}{16}$)
PROV: . . .; William Edward, 1st Baron Rootes; by descent to W.B. Rootes, sold Sotheby's 13 Nov. 1980 (151, repr.); present owner
LIT: Fleming-Williams 1981, p.61, fig.3

Private Collection

One of the finest of the Lakeland pencil studies, no.238 well illustrates Constable's ability to handle work on this scale in the open, as well as his remarkable breadth of vision, and the level of understanding of land structure and hill forms that he achieved during his stay in Borrowdale. The view

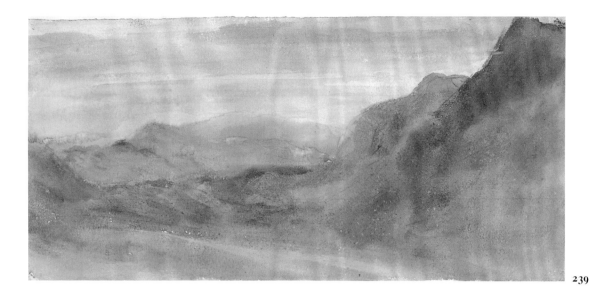

239

was taken from a hillside to the north of the River Derwent. The nearer bridge, Folly Bridge, takes its name from the inscription carved on a memorial stone placed alongside it that reads: 'This Bridge was built | at the Expense of John | Braithwaits of Seatoller | in the Year of our Lord | 1781 | By Thomas Hayton and | Richard Bowness. | I count this folly you have done | As you have neither Wife nor Son | Daughter I have God give her grace | And Heaven for her Resting place'. Beyond is Strand Bridge, that carries the road up the valley towards Seatoller, just out of sight to the right.

239 **Esk Hause** 1806

Pencil and watercolour on wove paper, right edge irregular, 127 × 274 (5 × 10$\frac{13}{16}$); pinholes t.l. and b.l.
Inscribed in another hand on a slip of card, probably from the old mount, 'Ashcourse – Sunday Oct. 12 1806 the finest senry that ever was'
PROV: . . .; Sir Thomas Gibson Carmichael Bt, Castle Craig, sold Christie's 10 May 1902

(?8) bt Philpot; . . .; Agnew; . . .; Norman Lupton, by whom bequeathed to Leeds City Art Galleries 1952
LIT: Rhyne 1986, p.68, pl.64

Leeds City Art Galleries

'In my view,' writes Charles Rhyne, 'Constable's most original and moving Lake District image is the watercolour done towards the end of his Borrowdale excursion, *Esk Hause, Scawfell*. 'Is there, in fact,' he continues, 'any watercolour by any other European artist by this date that captures with equal specificity such a fluid mountainscape?' Certainly, none of Constable's Lakeland drawings carry a more enthusiastic inscription than his 'the finest senry that ever was', and in none of his many watercolours of this trip did he work more boldly, painting into wetted paper over only the most cursory pencilling.

To envisage no.239 in its original state requires a little imagination, for this is not a work that has retained its original colour intact. Some of the colour that appears to have survived in the lower part of the sky suggests sunrise or sunset. This is puzzling for according to Herbert Bell of Ambleside who identified the topography in 1937 (as recorded on the mount), in no.239 we are looking south towards Harter and Birker Fells with the end of the Scawfell range on the right.

240

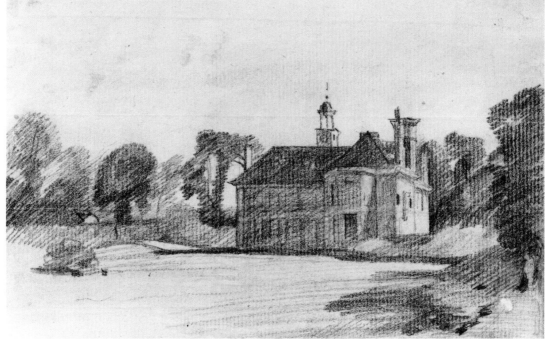

240 Twyford 1809

Black chalk on trimmed laid paper 95 × 155
($3\frac{3}{4}$ × $6\frac{1}{8}$); fragment of illegible watermark
PROV:...; Sir J.C. Robinson, sold Christie's
21 April 1902 (in 83) bt Reynolds;...; anon.
sale, Christie's 12 July 1988 (9, repr.) bt
present owners

Salander-O'Reilly Galleries Inc., New York

See no.241

**241 Malvern Hall and the Conservatory,
from the South-West** 1809

Black chalk on trimmed laid paper 96 × 154
($3\frac{3}{4}$ × $6\frac{1}{4}$); fragment of illegible watermark
Inscribed on the back in pencil '2 | August the
first made the | picture of the House from the |
great pool'
PROV:...; Sir J.C. Robinson, sold Christie's
21 April 1902 (in 82) bt Reynolds;...; anon.
sale, Christie's 12 July 1988 (13, repr.);
present owners

Mr and Mrs David Thomson

Until comparatively recently only a handful of
drawings (mainly of Warwickshire subjects) were
known from the sketchbook Constable used in
1809. Our knowledge of his sketching practice at
this time was increased considerably when sixteen
sheets, comprising twenty-one drawings, came on
the market in 1987 (Sotheby's 16 July, lots 38–40

and 19 November, lots 23–4, 26–7) and 1988
(Christie's 12 July, lots 8–15). The greater number
were of Malvern Hall and its environs, but three
were of the house at Twyford seen in no.240. One
of the three (Christie's 12 July 1988, lot 8), showing
a mill adjacent to the house, is inscribed 'Twyford
June 25. 1809'. Constable is not known to have
visited any of the seven Twyfords listed in the
directories. However, the similarity of grouping of
house, mill and unusually straight mill stream in
the inscribed drawing to a mill site, stream and
house at Twyford, Berkshire, encourages the belief
that it was here – for some reason – that Constable
was to be found in June of that year. There is no
reference to any such visit in a letter his mother
wrote to him on 26 June (Beckett I 1962, p.33),
although in her next, of 17 July (ibid., p.34), she
expresses the hope that he will be going to 'Mr
Lewis's' – i.e. Malvern Hall.

A drawing of the same mill at Twyford, hitherto
unidentified, is reproduced in Day 1976, pl.27.

No.241 is one of three 'new' drawings from the
1809 sketchbook of Malvern Hall, the seat of
Constable's patron H.G. Lewis. A fourth, of the
entrance front (Fondazione Horne, Florence; Tate
Gallery 1976, no.89, repr.) is inscribed on the back
'Left Town for Malvern – Saturday July 15 1809'.
A rapid pencil sketch of Warwick from the main
London road at Hatton Hill (Sotheby's 16 July
1987, lot 38, repr.), dated 7 August, may have been
done when Constable was on his way back home.
John Soane's 'Doric Barn', Solihull church and
Temple Balsall were among other subjects that
Constable drew in the vicinity of Malvern Hall
during that visit.

By comparison with the powerful Lakeland

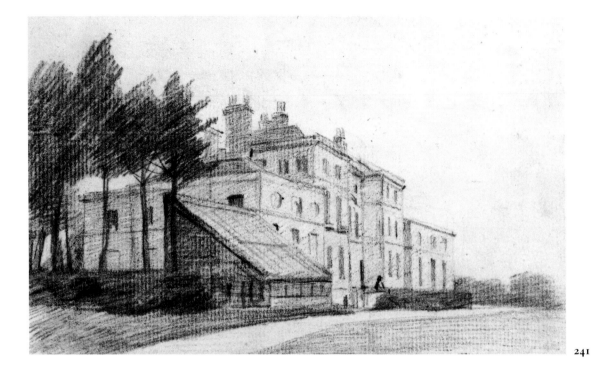

241

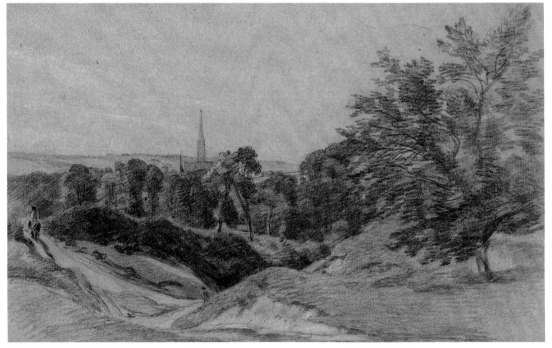

242

pencil studies, the drawings of 1809 may seem to be lacking in creative drive, to be the work of a spirit, as it were, chastened. The fact of the matter is that Constable was otherwise actively engaged, that painting had taken over (requiring an entirely new set of mental responses to direct experience) and that he was now beginning to make his historic breakthrough with his oil studies from nature.

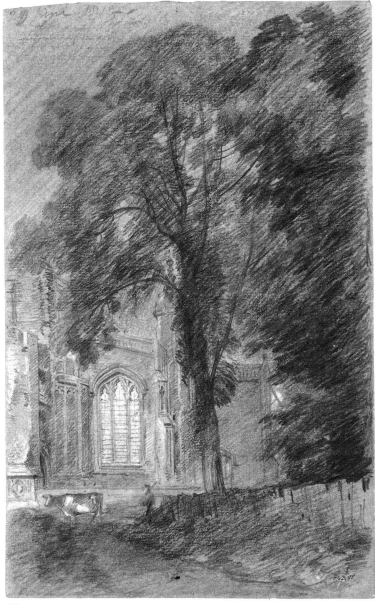

243

242 Salisbury from Old Sarum 1811

Black and white chalk on blue-grey paper
196 × 307 (7¾ × 12 1/8)
Inscribed on the back in pencil, reinforced in ink, 'N E Salisbury Sep. 18 1811'
PROV: By descent to Charles Golding Constable, sold Christie's 11 July 1887 (41 or 42) bt Shepherd; . . .; given by Charles E. Lees to Oldham Art Gallery 1888
EXH: Tate Gallery 1976 (106, repr.)
LIT: Fleming-Williams 1976, p.38, pl.11

Oldham Art Gallery

Most of Constable's life studies at the Royal Academy Schools were drawn with black and white chalk on grey paper, but it was not until 1810 that he began to use toned paper at all regularly when working out-of-doors. Figs.25–7 on p.75 are from a sketchbook (Louvre, Paris, RF 11615) with leaves of grey paper that he used that year. A few of its nineteen leaves are blank but the remainder provide a valuable if fleeting glimpse of what was attracting his notice as he roamed the countryside around Bergholt that summer. He continued to use the three-tone medium – black, white and grey – over the next two years, that is, until 1813, when he discovered he could make an adequate tonal response to landscape with the graphite pencil.

No.242, the first of many drawings of Old Sarum, was made when Constable was staying at Salisbury at the Bishop's Palace with Dr Fisher and his wife. It was during this visit that Constable met the Bishop's nephew, the Revd John Fisher, destined to become his closest friend. On this trip Constable made a number of pencil drawings of the cathedral from close to in a 5 by 3 inch sketchbook as well as a few of Stourhead during a short stay there with the Fishers.

243 East Bergholt Church 1812

Black and white chalk on grey wove paper
310 × 198 (12¼ × 7¹³⁄₁₆)
Inscribed in pencil '29 June 1812 | E Bergholt' t.l.; this is repeated on the back in another hand
PROV: As for no.2
LIT: Reynolds 1973, no.114, pl.72

Board of Trustees of the Victoria and Albert Museum, London

See no.244

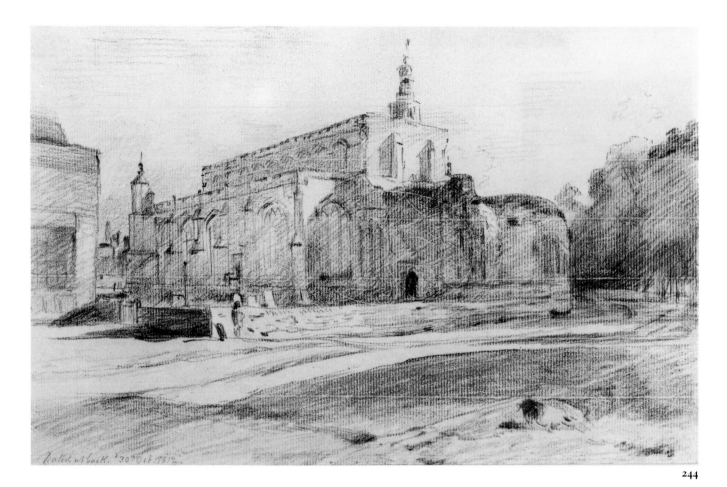

244

244 East Bergholt Church from the North-West 1812

Black chalk on laid paper 190 × 300
($7\frac{1}{2}$ × $11\frac{13}{16}$); watermark: Britannia within
upright ovals surmounted by a jewelled
crown; on the back a small pencil study of
two figures
Inscribed on the back in ink '30 Octr 1812'
PROV: ...; Hugh Frederick Hornby, who
died 1899; by descent to the vendor,
Lawrence Fine Art, Crewkerne, 19 April
1979 (HAI, repr.) bt Somerville; present
owner

Private Collection

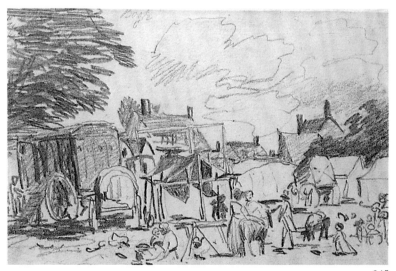

245

Both of these chalk studies of St Mary's seem to
have been inspired by an effect of light: no.243,
taken from a viewpoint at the junction of Church
Street and the lane from Flatford, by a complex
play of light and shadow (note the moon behind the
sundial on the south porch); no.245, an unusual
view from the green almost opposite Constable's
home, by the broad stream of afternoon sunlight.
On 31 October, the day after he drew no.244,
Constable sketched a sunset over the Stour valley
in oils with similar, wide sweeping movements of
the hand (no.36).

245 East Bergholt Fair ?1812

Pencil on trimmed wove paper 110 × 164
($4\frac{5}{16}$ × $6\frac{7}{16}$)
Inscribed in pencil 'Book|c' at top
PROV: . . .; E. Cowles Voysey, by whom
bequeathed to present owner
LIT: Paul Goldman, 'Newly Discovered John
Constable Drawing', *Antique Collector*, Oct.
1982, p.86, repr.; Fleming-Williams 1990,
pp.100, fig.97

Private Collection

See no.246

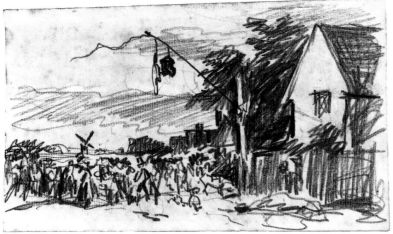

246

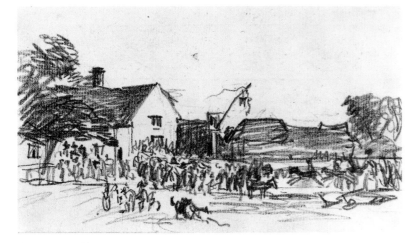

fig.123 'The White Horse
Inn', 1812, *Henry E.
Huntington Library and Art
Gallery, San Marino*

246 The White Horse Inn ?1812

Pencil on laid paper, trimmed with scissors at
left, 109 × 186 ($4\frac{1}{4}$ × $7\frac{5}{16}$); watermark: part of
a crown; on the back, a rapid pencil sketch of
trees and undergrowth with a distant cottage
PROV: . . .; anon. sale, Sotheby's 21 Nov.
1984 (84, repr.); present owners
LIT: Fleming-Williams 1990, pp.100–105,
pl.7 (col.)

Mr and Mrs David Thomson

Constable made a number of sketches of the 'toy'
fair at East Bergholt that was held annually on the
green in front of the family home on the last
Wednesday and Thursday of July. Two of the
sketches are in oils: one, of the fair in 1811, by day
(Reynolds 1973, no.101, pl.60), the other of the
scene by night (private collection). Two of the
drawings in his 1813 sketchbook (pp.85, 87 of
no.247) are of the fair held that year. (A further
drawing in the 1814 sketchbook, p.13 of no.248, of
festivities on the green at East Bergholt depicts a
feast given to nearly 800 of 'the Poor of its men,
women and children' on 9 July to celebrate 'the
blessings of a general Peace'.)

Nos.245–6 belong to a group of five drawings
that, by a process of elimination, are reckoned to be
of the fair held on 29 and 30 July 1812. No.245 and
two of the other drawings show the stalls and
sideshows that were erected in the centre of the
village, from where there arose 'a tumult of drums
and trumpets & buffoonery of all sorts' (Constable,
writing to Maria Bicknell, 1 August 1816, Beckett
II 1964, p.191). Constable seems to have chosen to
make no.245 at a quiet moment, either before the
crowds had begun to arrive or perhaps on the 31st,
when the stallholders had started to take their
booths down.

The remaining two sketches of the 1812 fair,
no.246 and a drawing in the Huntington Library
and Art Gallery (fig.123) are of crowds outside a
pub, The White Horse, that stood at a road
junction at the edge of the Heath, half a mile or so
from the main part of the village. In the Hunt-
ington drawing the crowds have gathered around
the finish of a race – seemingly for donkeys and
their riders. In no.246 a rather more disorderly
crowd has assembled. What are they so eager to
see? It has been suggested by Norman Scarfe, an
authority on Suffolk matters, that the crowds
outside the inn in no.246 are celebrating after a
ploughing match and that one of the objects
hanging from the pole would have been the prize
for the winner, a pair of breeches. Scarfe remem-
bers one of his grandfather's men winning so many
pairs of breeches that the organisers of such events
were reduced to making him a judge! Arthur
Young, when writing in 1813 about the skill of the
Suffolk ploughmen in laying straight furrows, adds
that 'a favourite amusement is ploughing such
furrows, as candidates for a hat, or pair of breeches'
(*General View of the Agriculture of the County of
Suffolk*, 1813, p.46).

fig.124 No.247, p.11

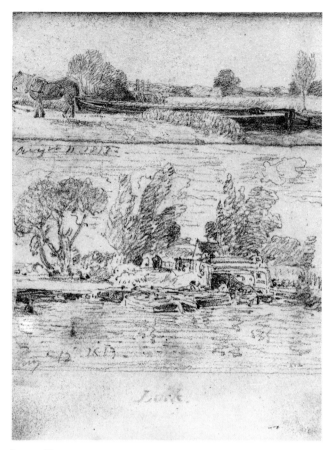

fig.125 No.247, p.54

fig.126 No.247, p.56

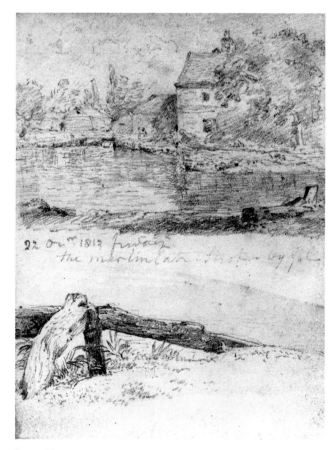

fig.127 No.247, p.77

247 Sketchbook 1813

Containing 90 pages (with intercalated leaf, pp.91–2, from a sketchbook of 1815) of wove paper 89 × 120 (3½ × 4¾); watermark 'J. WHATMAN 1810'; half-bound in black leather and marbled boards; drawings in pencil on 72 of the pages
Inscribed in pencil inside front cover 'Essex From 1ˢᵗ July. 1813 –'; many individual drawings inscribed
PROV: As for no.2
EXH: Tate Gallery 1976 (119, 3 pp. repr.)
LIT: Reynolds 1973, no.121, pls.76–118; Graham Reynolds, *Victoria & Albert Museum: John Constable's Sketch-Books of 1813 and 1814 Reproduced in Facsimile*, 1973; Fleming-Williams 1976, p.46, pls.15a–e, figs.31–2, 89, 91; Smart and Brooks 1976, pp.55–6, 68, 2 pp. repr. on title-page and p.134; Rosenthal 1983, pp.64–5, figs.68–9, 71–6, 85–6, 150, 238; Cormack 1986, p.80, pls.72–3, 76; Rosenthal 1987, p.76, ills.58–60; Fleming-Williams 1990, pp.108–11, 115, figs.103–5

Board of Trustees of the Victoria and Albert Museum, London

See no.248

248 Sketchbook 1814

Containing 84 pages of wove paper 80 × 108 (3⅛ × 4¼); fully bound in brown leather, with a broken metal clasp; drawings in pencil on 58 of the pages, many inscribed
PROV: As for no.2
EXH: Tate Gallery 1976 (126, 3 pp. repr.)
LIT: Reynolds 1973, no.132, pls.102–16; Graham Reynolds, *Victoria & Albert Museum: John Constable's Sketchbooks of 1813 and 1814 Reproduced in Facsimile*, 1973; Fleming-Williams 1976, pp.50, 52, pls.17a–d, figs.35–7, 88; Smart and Brooks 1976, pp.55–6, 68, pls.34, 37, 53–5; Rosenthal 1983, p.82, figs.96–9, 101–2, 108–10, 122, 133, 149, 179–80; Cormack 1986 p.86, pl.81; Rosenthal 1987, p.76, ills.67–8, 71, 96, 120; Fleming-Williams 1990, pp.108–11, 115, figs.106–7

Board of Trustees of the Victoria and Albert Museum, London

The majority of Constable's drawings and watercolours were originally pages in a sketchbook. Eight of these books have survived virtually intact. The remainder, some twenty or so, were dismembered over the years and their contents widely dispersed. Attempts have been made to reconstruct the contents of some of these; a worthwhile endeavour, as sometimes this will enable the dating of uninscribed drawings to be estimated. Four of the intact books are exhibited here: those of 1813 (no.247), 1814 (no.248), 1819 (no.287) and 1835 (no.340). The remaining four – three of 1806 and one of 1810 – are in the Louvre.

Constable's earliest group of drawings were originally pages (fourteen in number) in a sketchbook that he used in 1796 (Victoria and Albert Museum, Reynolds 1973, nos.1–13, pls.1–6). After this, for some years, it seems to have been chiefly when he was away from home – Derbyshire in 1801, Tottenham, Epsom and the Lakes in 1806, Berkshire and Warwickshire in 1809, Salisbury, Stourhead and Worcester in 1811 – that he made his studies in a sketchbook. From 1813 onwards, however, there was hardly a year in which a sketchbook was not currently in use. Each book had its special character. Those of 1806 are full of sketches of nubile young women; the 1801 book contained views of places visited; in the 1810 sketchbook he sketched some local views but also odds and ends – cattle, country folk, isolated trees, effects of light. This more haphazard noting was continued in the pocket books of 1813 and 1814 (nos.247–8). Several pages in the 1810 book provided material for paintings; the contents of nos.247–8 subsequently became a prime source of such material.

Many of the pages in these two books are minutely inscribed and the dating gives us some idea of the period when they were in use: no.247 between 1 July and 22 October 1813; no.248 between the end of July and 23 October 1814.

Other than within the covers of the 1813 sketchbook, only two other dated drawings of that year are known – a pair of outline pencil tracings of the view from below Flatford lock, one inscribed 14 and 24 November, the other 6 November (Christie's 12 July 1988, lots 26–7: see under no.49). It seems unlikely that the contents of no.247 represent Constable's total output that summer, but it contains well over a hundred drawings (a third of which are dated) and the innovatory character of many of these suggests that it was in this sketchbook that he first began to articulate some of his newer ideas about landscape. Figs.44, 124 and 127 are of drawings on three of the pages which subsequently provided him with material for his paintings. From p.11 (fig.124) in 1822 he obtained the idea for the main subject of 'View on the Stour' (fig.66 on p.195), the manhandling of barges on the river; from p.12 (fig.44 on p.151) he painted much of the landscape in 'Ploughing Scene in Suffolk' (no.71), the work he exhibited in 1814; and from p.77 (fig.127) in 1820 he painted part of the foreground of 'Stratford Mill' (no.100).

The following March, in a letter to Maria Bicknell, Constable mentions this sketchbook of 1813: 'You once talked to me about a journal – I have a little one that I ⟨kept⟩ made last summer that might amuse you could you see it – you will then see how I amused my leisure walks – picking up little scraps of trees – plants – ferns – distances &c &c' (Beckett II 1964, p.120). After a visit to

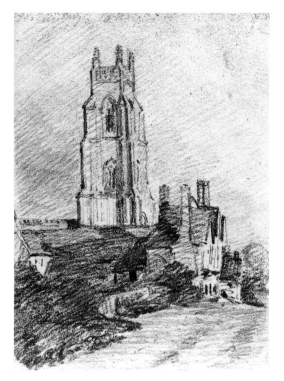

fig.128 No.248, p.21

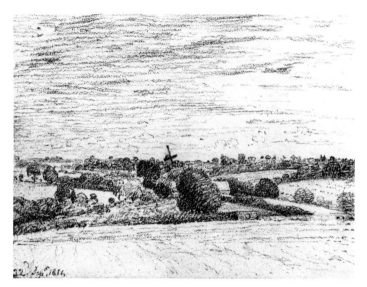

fig.129 No.248, p.38

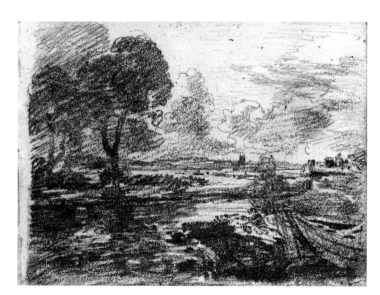

fig.130 No.248, p.59

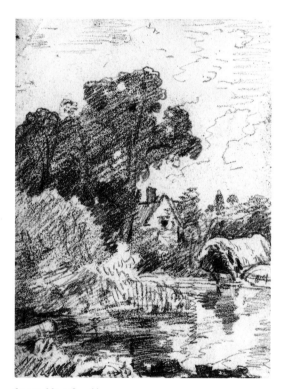

fig.131 No.248, p.66

Essex he refers to another sketchbook in a letter to Maria of 3 July: 'I have filled as usual a little book of hasty memorandums of the places which I saw which You will see' (ibid., p.127). The book he refers to here, the first of the two he used in 1814, is now broken up (see nos.252–3). The second, no.248, an even smaller sketchbook, differs in character quite markedly from no.247. There are fewer drawings (mostly one to a page) and the majority are drawn in a much bolder style, possibly because he was currently working on two pictures and was viewing things rather differently – with a painter's eye. Containing fewer of the very small experimental compositions, in this second 1814 sketchbook Constable seems to have had a clearer idea of the sort of motifs he wanted to paint and to be rather more aware of the part studies such as these could play in choosing a subject and in the preparatory stages of composition. He seems to have toyed with the idea of a view of Flatford lock from downstream (see no.49 and fig.35 on p.122). Three of the drawings (pp.27, 52, 59, see fig.130 for the last) were of seminal importance in the development of his large painting 'View on the Stour' (fig.66 on p.195), now in the Huntington. From motifs in two other drawings, major paintings developed: 'Flatford Mill' (no.89) from the view sketched on p.61 (fig.58 on p.179); from the scene on p.66 (fig.131) his first six-footer, 'The White Horse' (fig.65 on p.194). Several drawings relate directly to the paintings on which he was actively engaged that season – 'Boat-building' (no.72, see fig.46 on p.153) and 'The Stour Valley and Dedham Village' (no.73, figs.48–9 on p.159).

249 Dedham from Langham ?1813

Pencil with white heightening on untrimmed wove paper 321 × 667 ($12\frac{5}{8} \times 26\frac{1}{4}$)
PROV: . . .; Royal Museum of Fine Arts, Copenhagen by 1887
EXH: Tate Gallery 1976 (114, repr.)
LIT: Fleming-Williams 1976, p.44, pl.14; Rosenthal 1983, p.60, fig.61; Rosenthal 1987, p.74, ill.54

Department of Prints and Drawings, The Royal Museum of Fine Arts, Copenhagen

The subject of this fine drawing, Dedham from the fields near Langham church, has been discussed in the introduction to nos.17–21 and it was there suggested that Constable may have been planning a panoramic view of the valley from the Essex side – a companion to a reciprocal view, his 'Dedham Vale: Morning' of 1811 (no.14).

Hitherto, *c*.1812 has been the accepted date for no.249, but after a reconsideration of the evidence 1813 now seems to be the likelier date. Stylistically, no.249 is undoubtedly closer to the drawings in the sketchbook of 1813 (no.247) than to the work of 1812 as previously suggested (Fleming-Williams 1976). Furthermore, after an initial reconnaissance of the view in 1812 (see nos.17–18), the drawings he made in his 1813 sketchbook (no.247, pp.39, 51–2, see fig.29 on p.81 for p.39) and a third oil sketch believed to be of this year (no.19) suggest an intensification of interest that would logically conclude with a study such as the Copenhagen drawing.

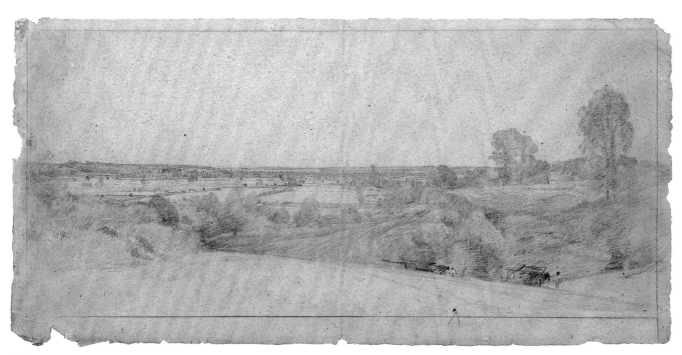

249

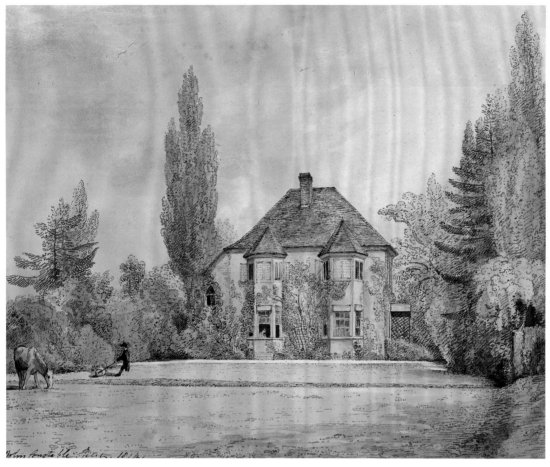

250

250 Feering Parsonage 1814

Pen and watercolour on wove paper
305 × 381 (12 × 15)
Inscribed 'John Constable fecit. 1814.' b.l.
PROV: Given by the artist to the Revd Walter
Wren Driffield; by descent to present owner
EXH: Tate Gallery 1976 (125a, repr.)
LIT: Fleming-Williams 1990 p.123, fig.119

Private Collection

See no.251

251 Feering Church and Parsonage ?1814

Pencil and watercolour on laid paper
267 × 362 (10½ × 14¼)
PROV: By descent to Charles Golding
Constable; . . .; J.E. Taylor, by whom
presented to Whitworth Art Gallery 1892
EXH: Tate Gallery 1976 (125, repr.)
LIT: Fleming-Williams 1976, p.48, pl.16

*Whitworth Art Gallery, University of
Manchester*

In a letter to Maria Bicknell of 22 September 1812,

Constable tells her about an old friend of his
father's whom he met when staying with the Slater-
Rebows at Wivenhoe (see no.79): 'the Revd. Mr
Driffield who once lived in this village [East
Bergholt] – he always remembers me as he had to
go in the night over the Heath to make a christian of
me at a cottage where I was dying – when I was an
infant' (Beckett II 1964, p.85). Driffield was vicar
of Feering, a parish just off the Colchester–London
road. In a letter to Maria of 3 July (ibid., p.127),
Constable gives as his reason for staying with
Driffield in 1814 the promise of a drawing of the
vicarage and the church. He and the old vicar spent
nearly a fortnight together, during part of which
time they made a short tour of south Essex (see
no.170).

A recently discovered drawing of the vicarage,
dated 25 June, shows that they were back from this
trip for Driffield to take the services in his church
the following day, Sunday. This small drawing
(fig.132) is the first of three that Constable made of
the vicarage from that viewpoint. The second
(Sotheby's 20 July 1949, lot 85; Parris, Fleming-
Williams, Shields 1976, p.13, repr.) is a 7⅛ by 9½
inch pencil drawing inscribed '30 June 1814
morning Feering Essex'. It must have been about
this drawing that David Lucas wrote (with his
usual neglect of punctuation) when annotating his
copy of Leslie's *Life*:

fig.132 'Feering Parsonage', 1814, *Mr and Mrs David Thomson*

Here he was drawing late in the evening/ Mʳ Driffield/ retired early to rest looking out of the casement wishing him good night Constable proceeded with his drawing as long as a ray of light permitted him at the dawn of day (being an early riser) he was again occupied at the same spot when his host rose in the morning early he was astonished to find his visitor. where he had left him the previous night and acosted him thinking he had been on the same place the whole of the night

(Parris, Shields, Fleming-Williams 1975, p.55)

It was some time before Driffield received his drawing – the third (no.250). In this, Constable depicted the vicar rolling his lawn, with Ball, the horse Constable had apparently ridden during their short tour, grazing nearby. The vicar had the drawing framed and hung in his drawing room, and wrote to thank the artist for it in October 1815. He had two criticisms to make: 'you have not done *Ball* justice, after the excursions he took you, and *I* never roll my garden in *black* breeches' (Beckett 1 1962, p.129).

Watercolours by Constable of this period – 1814–17 – are comparatively rare and there is very little work with which his view of the vicarage and the church from across the fields (no.251) may be compared. The generally accepted date for this work is 1814, and stylistically, with its gently touched-in pencilling and multiple washes of colour, it would seem more likely to have been done that year than in either 1816 or 1817, when Constable is also known to have visited Feering.

251

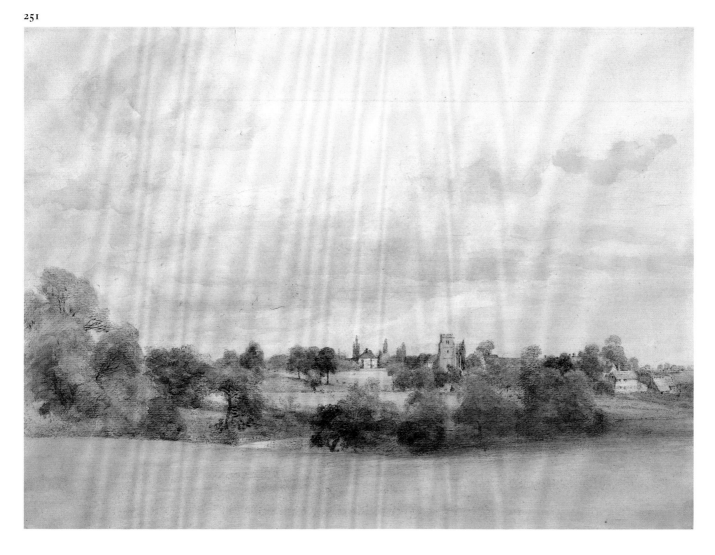

252 Brantham Mills 1814

Pencil on untrimmed wove paper 81 × 108
($3\frac{3}{16}$ × $4\frac{1}{4}$)
Inscribed in pencil 'Brantham. Mills – ' t.l.
PROV: By descent to Hugh Constable; . . .;
Guy Bellingham-Smith; . . .; anon. sale,
Sotheby's 17 Nov. 1983 (77, repr.); present
owners
LIT: Fleming-Williams 1990, pp.111–13,
pl.9 (col.)

Mr and Mrs David Thomson

See no.253

253 A Farmhouse at East Bergholt 1814

Pencil on untrimmed wove paper 81 × 108
($3\frac{3}{16}$ × $4\frac{1}{2}$)
Inscribed in pencil '[. . .] House – E.Bergholt'
t.l. On the back (fig.133) two pencil
compositions, one above the other, of the
valley to the west of East Bergholt, the
subject depicted in 'Autumnal Sunset'
(no.181 and see no.184)
PROV: . . .; J.P. Heseltine, sold Sotheby's 25
March 1920 (122B, mounted with no.260) bt
Meatyard; . . .; Guy Bellingham-Smith; . . .;
Sir Robert Witt; . . .; anon. sale, Christie's
17 Nov. 1981 (26, repr.); present owners
LIT: Fleming-Williams 1983a, p.219, fig.34;
Fleming-Williams 1990, pp.110–11, 115,
pls.8 (col.), 10 (col.)

Mr and Mrs David Thomson

As has been stated in the entry for no.248,
Constable used two sketchbooks in the summer of
1814, the second of which (no.248) has survived
intact. This, a book of eighty-four pages, contains
drawings dated from 1 August to 23 October. The
first of the two books, originally filled with
drawings of 'hasty memorandums' (Constable to
Maria Bicknell, 3 July, Beckett II 1964, p.127), has
been dismembered and, like so many of his other
sketchbooks, its contents dispersed. So far, the
whereabouts of only twelve folios from it are
known. Five are in the Victoria and Albert
Museum (Reynolds 1973, nos.124–5a, 126–8,
pls.100–1); two are in the Fitzwilliam Museum
(Gadney 1976, nos.11–12, repr.); one in the
Minories, Colchester; one in the Courtauld Insti-
tute Galleries; and three in the collection of Mr and
Mrs David Thomson (nos.252–3 and fig.132). The
sketch of Feering Vicarage (anon. sale, Sotheby's
10 March 1988, lot 8), having surfaced so recently,
encourages the belief that there may be others
awaiting discovery.

Small pencil drawings such as nos.252–3 can be
easily overlooked, but they are in fact full of
information and, despite the limitations of the
medium, are often as capable of rewarding appreci-
ative study as some of the oil sketches. 'Brantham

252

253

Mills' (no.252) is remarkable for its seemingly
effortless descriptive power; we can but admire
how completely, with the placing of a few well-
judged accents of varying strengths, Constable has
captured the radiant light of a summer's day.

The two mills at Brantham, one driven by wind,
the other by the fall of tidal water, were close by the
first of the fifteen locks that the boats and barges
had to negotiate between Manningtree on the
Stour estuary and Sudbury, twenty-five miles
upstream. For a time, Golding Constable, the
artist's father, appears to have owned the windmill.
The working of the tidal mill at Brantham was
accountable for the varying heights of the water at

fig.133 Verso of no.253

Flatford that Constable noted, for example, in no.58 and the sketch on its back (fig.38 on p.133). Only above Flatford lock was the Stour constantly sweet – or relatively so.

The first word of the inscription on the drawing of the farmhouse (no.253) is only just illegible, tantalisingly so, as it appears to be a name and might enable the location to be identified. It was to this drawing that Constable turned many years later when he needed a subject for a watercolour, the 'Farmhouse' now in the High Museum of Art, Atlanta (no.328).

254 View over the Gardens from East Bergholt House 1814, ?exh.1815

Pencil on trimmed wove paper 302 × 449 ($11\frac{7}{8}$ × $17\frac{11}{16}$); watermark 'J.WHATMAN| 1811'; mounted within pencil-lined borders on two sheets of paper, each watermarked 'J.RUSE 1804'.
Inscribed in pencil in a later hand on the back of the mount 'From the Garden', apparently written over an inscription by the artist, 'The Garden belonging to G. Constable Esq.'
PROV: As for no.2
EXH: ? RA 1815 (415, 446 or 510, each titled 'A drawing'); Tate Gallery 1976 (128, repr.); Japan 1986 (14, repr.)
LIT: Reynolds 1973, no.176, pl.140; Fleming-Williams 1976, p.52, pl.18; Rosenthal 1983, p.93, fig.121; Cormack 1986, pp.89, 92, pl.86; Rosenthal 1987, p.85, ill.70; Fleming-Williams 1990, pp.126–7, fig.121

Board of Trustees of the Victoria and Albert Museum, London

From this viewpoint on the first floor of the family home, or from one of the other windows at the back of the house, Constable had made a number of oil sketches (see nos.23–4) and from here and the floor above he painted the remarkable pair now at Ipswich, nos.25–6. The present study is one of two carefully detailed drawings, similarly mounted within lined borders, that he is believed to have exhibited at the Royal Academy in 1815; see fig.134 for the other, a study of the south archway of the remains of the tower of East Bergholt church. (The subject of the third exhibited drawing is discussed in Fleming-Williams 1990, pp.126–7.)

In the two Ipswich paintings, nos.25–6, more of the view is to be seen on either side – both barns to the left and some of the neighbours' gardens to the right. Here, in no.254, on the far horizon may be discerned the sails of the windmill owned by Golding, Constable's father (for the other windmill, see no.252); across the fields on the right is the rectory, the residence of the much-feared Dr Rhudde, Maria Bicknell's grandfather; and on the left, the new barn with a threshing-floor, built by

fig.134 'East Bergholt Church: South Archway of the Tower', ?exh. 1815, *Board of Trustees of the Victoria and Albert Museum, London*

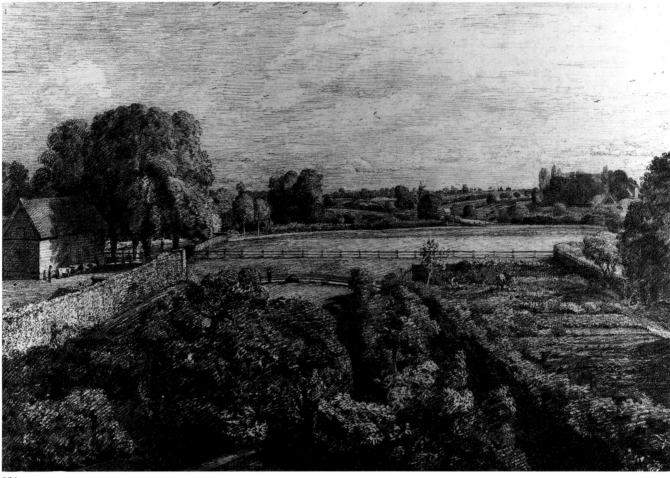

254

Golding some time after 1797 since it does not appear in the 'View from my Window' Constable sketched in a letter to J.T. Smith that year (Tate Gallery 1976, no.9, repr.). Below us we have the two gardens: the flower garden, with a central circular bed filled with shrubs (?lilac) and by the further bed a solitary figure; and the kitchen garden, with two men at work among its orderly rows of vegetables. In the painting of the flower garden of the following year (no.25), we see that the character of the circular bed has been radically changed, that the shrubs have been removed (perhaps because they were obscuring the view from downstairs) and that it is now filled with herbaceous plants, many in full flower. Recalling to mind the period 1805–6, when Constable was tending to reduce the shapes of his trees down to globular and ovoidal forms, it is interesting to note that here, in this comparatively mature work, many of the more distant trees and bushes are similarly shaped – as rounded sculptural forms – perhaps in an endeavour to render more keenly his intimate knowledge of this tract of land, of the relative sizes and distances he was portraying.

255 East Bergholt House, Two Views 1814

> Pencil on untrimmed wove paper 108 × 81 ($4\frac{1}{4} \times 3\frac{3}{16}$); possibly a page from the 1814 sketchbook, no.248
> Inscribed in pencil below the upper, moonlight view 'Oct 2d 1814'; on the lower sketch in pencil '3d Oct', b.l.; on the back in pencil 'The House in which J.C. was born'
> PROV: As for no.2
> LIT: Reynolds 1973, no.133, pl.116; Fleming-Williams 1990, pp.125, 126, fig.118
>
> *Board of Trustees of the Victoria and Albert Museum, London*

Constable drew and painted a number of views of the back of his home (see nos.22, 286). He also made several oil sketches from the front of the house (of the fair in 1811 for instance – see under no.246), but the appearance of the front is only known from no.255 and from an outline drawing (a tracing, Fleming-Williams 1990, pl.11) done on 5 October, two days after he made the lower of the two in no.255. In the 1813 sketchbook (no.247) there are three of the front of the house, but from further away, from a little lane and from the fields opposite. One of these, in which the house is

255

marked with a cross (the upper drawing in fig.135) is inscribed '19 July 1813 House in which I was born X'. Constable we know was an early riser and liked to take the dogs for a walk at the start of the day (Beckett 11 1964, pp.78 and 89). The pair lurking nearby with a certain air of expectancy, in the drawing of the house by daylight, were perhaps two of those he was accustomed to take with him, with his favourite, the pug, Yorick.

There are several moonlight scenes in Constable's listed oeuvre. He exhibited 'A Landscape: Moon-light' at the Academy of 1805 and in 1832 another 'Moonlight', both of which were presumably oils. Two early oil sketches, of almost identical subjects, landscapes with a rising moon, were on the market not long ago within a few months of each other (Sotheby's 16 Nov. 1983, lot 70, repr. in col.; Christie's 16 March 1984, lot 44, repr. in col.). In the 1813 and 1814 sketchbooks there are four local views by moonlight (no.247, pp.8, 44, no.248, pp.67, 72). Page 72 in the 1814 book, inscribed at the bottom, '28 Sept ½ [?past] 8 o clock', depicts a figure near the church silhouetted against a flood of moonlight, with its foreshortened shadow cast on the road before it (fig.136). This, with hindsight, becomes a haunting image as the figure is almost certainly that of his cousin James Gubbins, who was killed the following year at the battle of Waterloo (the inscription is repeated on the otherwise blank previous page, with the addition of 'James' and an illegible surname).

fig.135 1813 sketchbook (no.247), p.34, *Board of Trustees of the Victoria and Albert Museum, London*

fig.136 1814 sketchbook (no.248), p.72, *Board of Trustees of the Victoria and Albert Museum, London*

256 Wimbledon Park 1815

Pencil on the back of a visiting card 38 × 76
($1\frac{1}{2}$ × 3)
Inscribed 'Wimbledon Park | July 3ᵈ 1815.' in
pencil on the front of the card, on which is
engraved 'Mʳ I. CONSTABLE. | 63,
Charlotte Street, Fitzroy Square'
PROV: As for no.2
LIT: Reynolds 1973, no.138, pl.101; Reg
Gadney, *Constable and his World*, 1976, repr.
pp.44–5 (both sides)

*Board of Trustees of the Victoria and Albert
Museum, London*

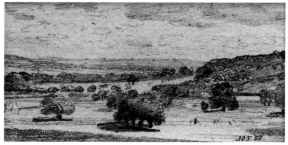

256

Constable had been in London since January and
when he wrote to Maria Bicknell on 30 June, at the
house her father had taken in Putney, to arrange a
rendezvous the following Monday, 3 July, he was
making preparations to leave for Suffolk. He and
Maria were seeing each other now with the full
knowledge of her family, but the rendezvous was
'on Putney Bridge at a little before eleven' on the
3rd (Beckett II 1964, p.145) presumably because it
was still wiser for them not to be seen together by
Mr Bicknell. In Wimbledon Park they could have
walked without fear of disapproval.

257 Cottage in a Cornfield 1815

Pencil on untrimmed laid paper 102 × 79
($4\frac{1}{16}$ × $3\frac{1}{8}$)
PROV: As for no.2
EXH: Tate Gallery 1976 (136, repr.)
LIT: Reynolds 1973, no.145, pl.117;
Fleming-Williams 1976, p.54, pl.19b; Ian
Fleming-Williams, 'A Rediscovered
Constable: The Venables *Cottage in a
Cornfield*', *Connoisseur*, vol.198, June 1978,
pp.135–7, fig.2

*Board of Trustees of the Victoria and Albert
Museum, London*

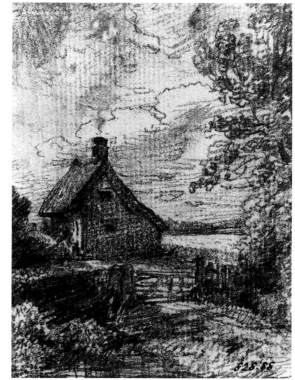

257

In the entry for no.136 in the Tate Gallery
catalogue of 1976, it was stated that Constable used
this drawing for his painting of the same title
exhibited in 1833 (no.77 above) and possibly for an
hitherto untraced work shown at the RA in 1817.
That painting, a work Constable exhibited as 'A
cottage', has now been traced and is no.78 in the
present exhibition. However, the whereabouts of
the cottage in its field of corn, of which Constable
appears to have made several other drawings (e.g.
no.247, pp.25, 59), has not as yet been convincingly
located, though it was certainly somewhere in the
East Bergholt area. In both paintings the young
tree on the right-hand side of the drawing caused
problems. Constable left that part of the canvas
untouched when painting no.77 on the spot, and in

no.78, the work exhibited in 1817, he replaced the tree with one taken from an engraving after Titian's 'St Peter Martyr'.

It is said that 1815 was a year of abundant corn harvests (J.M. Stratton, *Agricultural Records, A.D.220–1968*, 1970). The fine weather that held from March until the autumn is reflected in many of the skies that Constable drew and painted that year: in the Tate 'Dedham from Gun Hill' (no.8), the Victoria and Albert Museum 'Cottage in a Cornfield' (no.77), and in drawings such as no.257, the original pencil study for the latter.

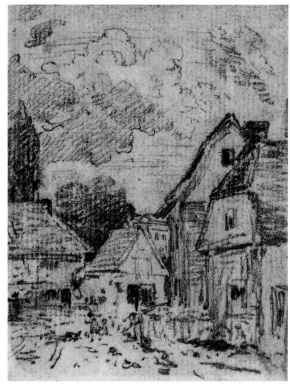

258

258 John Dunthorne's House and Workshop, East Bergholt *c.*1815

Pencil on trimmed laid paper 100 × 76 ($3\frac{15}{16}$ × 3); on the back a pencil sketch of a man, woman and child with what appears to be a chair

PROV:...; Ronald Shaw Kennedy; by descent until bt by Hazlitt, Gooden & Fox, from whom bt by Davis & Langdale, New York, who sold it to the present owner

LIT: Fleming-Williams 1983, p.219, fig.31

Mr Julian W. Glass, Jr, USA

John Dunthorne (*c.*1790–1844), village constable, plumber and glazier, was Constable's earliest tutor in the elements of the craft of painting. 'Mr. Dunthorne', said Leslie, 'possessed more intelligence than is often found in the class of life to which he belonged; at that time he devoted all the leisure his business allowed him, to painting landscapes from nature, and Constable became the constant companion of his studies. Golding Constable did not frown on this intimacy' (Leslie 1845, p.4, 1951, p.3) but, added David Lucas, 'he often passed ludicrious jokes upon them when returning together he would say here comes Don Quixote and his man Friday' (Parris, Shields, Fleming-Williams 1975, p.54).

In no.258, on the left we have Dunthorne's house with his workshop (centre) presenting a large opening onto the main street of the village. Between the workshop's gable-end and the house nearer to us on the right we are given just a glimpse of the two upper storeys of East Bergholt House, Constable's home. An early pen and wash drawing in the Victoria and Albert Museum, 'East Bergholt Street' (fig.137; Reynolds 1973, no.14), is an almost reciprocal view.

Though undated, no.258 is a classic example of Constable's pencil-work in 1815, with its firm, confident manner and with greater stress laid on simple linear statements than in the comparable work of 1813 and 1814. This was a painting year and his pencil drawings had become more like written notes.

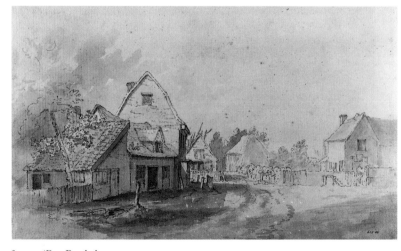

fig.137 'East Bergholt Street', late 1790s, *Board of Trustees of the Victoria and Albert Museum, London*

259 Church Farm, Langham (The Glebe Farm) 1815

Pencil, within ruled pencil border, 150 × 91
($5\frac{7}{8}$ × $3\frac{9}{16}$) on trimmed laid paper 154 × 94
($6\frac{1}{16}$ × $3\frac{11}{16}$)
Inscribed in pencil '10 July 1815' b.l.
PROV: By descent from the artist to the
present owner
EXH: *Constable: Six Generations*, Salander-
O'Reilly Galleries, New York, March 1989
(2)
LIT: Parris 1981, p.148

Richard Constable

The earliest known dated work made in Suffolk in
the summer of 1815, this drawing has hitherto
hardly been noticed in the literature on the 'Glebe
Farm' paintings (see nos.166–8). Taken from a
spot somewhat to the left of the viewpoint from
which Constable painted no.166, the drawing
shares with the oil sketch a keen appreciation of the
downward fall of light. They are also not dissimilar
in treatment. The drawings Constable made in his
little 3 by 4 inch sketchbook are stylistically pretty
consistent (see nos.257–8, 260–1). The remaining
dated drawings of that year from a larger sketch-
book or on sheets of odd sizes do not conform to
such a coherent stylistic group. None of these
larger sketches is drawn so freely, in such a
painterly manner as no.259 and when the drawing
is compared with the Glebe Farm oil sketch,
no.166, one wonders whether a later dating for the
latter should not now be preferred – perhaps 1815 –
instead of the hitherto accepted *c*.1810.

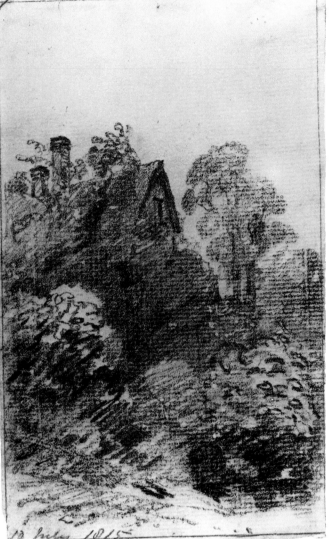

259

260 East Bergholt: Looking towards Stoke-by-Nayland 1815

Pencil on untrimmed wove paper 79 × 102
($3\frac{1}{8}$ × 4)
Inscribed in pencil on the mount in a later
hand, presumably copying Constable's
original inscription, 'East Bergholt looking
towards stoke.|Aug. 23. 1815'
PROV: . . .; J.P. Heseltine, sold Sotheby's 25
March 1920 (122A, mounted with no.253) bt
Meatyard; . . .; Guy Bellingham-Smith; . . .;
Sir John and Lady Witt, sold Sotheby's 19
Feb. 1987 (116, repr.); present owners
LIT: Fleming-Williams 1976, p.54, fig.38

Mr and Mrs David Thomson

Stoke-by-Nayland church tower, so often depicted
by Constable in his westward-looking views of the
Stour valley, is visible as a mere stump on the
horizon in no.260. The same pair of trees on the
near slope to the right of the tower are to be seen
similarly positioned in relation to the tower in
no.71, a view from the top of Fen Lane. Though
severely mauled by the 'hurricane' of October

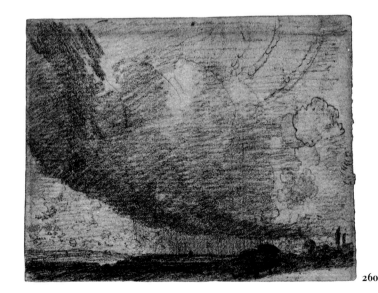

260

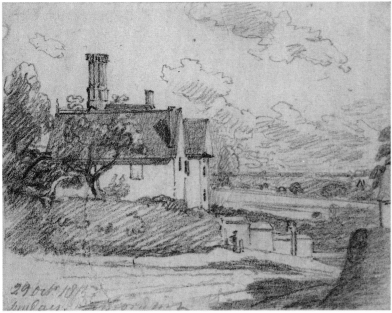

261

1987, the trees, a pair of oaks, are nevertheless still standing and may be viewed through an occasional gap in the hedge bordering the Bergholt to Flatford road.

A cloud formation such as this, curving round towards the viewer in a great floating mass, features prominently in the two Branch Hill Pond paintings of 1825 (see no.125).

261 A Manor House 1815

> Pencil on untrimmed wove paper 78 × 102 (3⅛ × 4)
> Inscribed '29 Oct.ʳ 1815 | Sunday morning' b.l.
> PROV: . . .; J.P. Heseltine, sold Sotheby's 19 May 1935 (in 300) bt Percy Moore Turner; by descent to present owner
>
> *Private Collection*

See no.262

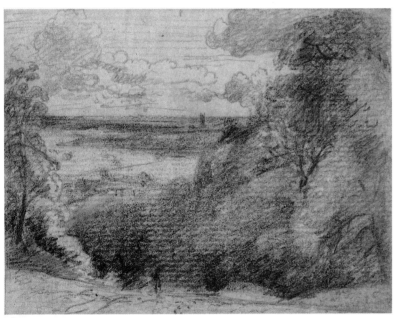

262

262 Dedham from near Gun Hill, Langham *c.*1815

> Pencil on untrimmed laid paper 79 × 100 (3⅛ × 3¹⁵⁄₁₆)
> PROV: As for no.261
> LIT: Parris 1981, p.53
>
> *Private Collection*

About a dozen drawings are known from the 3 by 4 inch pocket sketchbook Constable used in 1815 (see nos.257–60). This was a book containing sheets of laid paper. From no.261 and from a drawing in the Fondazione Horne, Florence (L.R. Collobi, *Disegni inglesi della Fondazione Horne in Firenze*, 1966, no.48, pls.37–8) it appears that he also used another sketchbook that summer, a book of similar size but in this case of wove paper.

The subject of no.261 has not at present been identified but it is possible that it is a house on the outskirts of Dedham village. For Constable, Sunday seems to have been a day to spend away from his easel. A pencil sketch on laid paper of a barn was also drawn on a Sabbath that year; it is inscribed '3 o clock | 1ˢᵗ Octᵗ 1815 Sunday aftn' (Christie's 21 March 1989, lot 48, repr.).

Oil paintings of the view of Dedham from Gun Hill corresponding to no.262 are shown above as nos.8–9. In all there are four pencil sketches of the subject. The earliest is in the sketchbook used in 1810 (Louvre, Paris, RF 11615, fol.17v.). The remaining three – no.262, a drawing in the Fitzwilliam Museum (fig.21 on p.67) and the one in the Fondazione Horne mentioned above – all appear to have been drawn at around the same time in 1815.

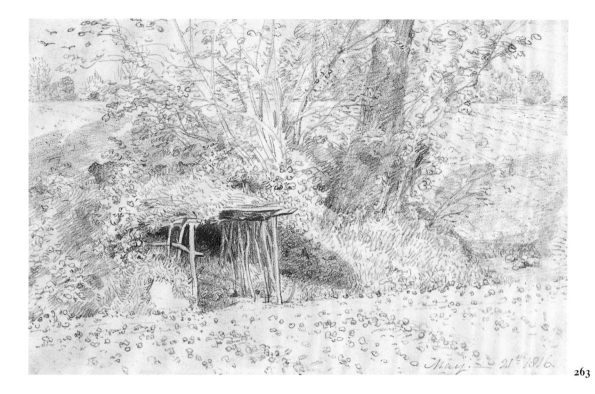

263

263 The Gamekeeper's Hut 1816

Pencil on trimmed wove paper 115 × 179
(4½ × 7)
Inscribed 'May _ 21ˢᵗ 1816.' b.r.
PROV: ...; Alfred de Pass, by whom given to
the Royal Institution of Cornwall 1925
EXH: Tate Gallery 1976 (142, repr.)

*Royal Institution of Cornwall, County
Museum and Art Gallery, Truro*

Constable was present at neither the death of his
mother in 1815, nor at that of his father on 14 May
1816 – the latter event, a turning-point in the
artist's life. For his father's funeral on the 20th, he
left London the previous day and on arrival sent
Maria Bicknell an account of his father's last
moments: 'he died while sitting in his chair as usual
– without a sigh or a pang – and without the
smallest alteration in his position or features –
except a gentle inclination of his head forwards'
(Beckett II 1964, p.189).

No.263 was drawn the day after the funeral. The
title by which it has hitherto been known – 'The
Gamekeeper's Hut' – is only doubtfully a correct
description of the picturesque little shelter
depicted in the drawing. Topographically, it is
most likely that the hut was situated among the
fields behind the family home – one of Constable's
most frequented haunts. His father had held a
game licence for many years (see *Ipswich Journal*,
11 Feb. 1786) and his son, Golding, aged eighteen,
is listed among 'gamekeepers' entitled to hold a
licence in 1792 (ibid., 29 Oct. 1792). The
Constable's thirty-two acres at East Bergholt
would hardly have justified the employment of a

gamekeeper, and, if the younger Golding was not
known jokingly by the family as 'the gamekeeper',
the probability is that the hut was a shelter available
for the men who worked for the Constables, one of
whom is to be seen hoeing in one of those fields in
no.37.

264 Dedham Lock and Mill 1816

Pencil on trimmed wove paper 86 × 114
(3⅜ × 4½)
Inscribed indistinctly with a hard pencil '22
July 1816' bottom centre
PROV: ...; J.P. Heseltine, sold Sotheby's 25
March 1920 (123A) bt Corder; W.S. Corder,
sold Neal's, Nottingham, Sept. 1984 bt
Anthony Reed; present owners
EXH: *British Watercolours and Drawings*,
Anthony Reed, Jan. 1986 (27, repr.)
LIT: Fleming-Williams 1990, pp.131–4,
pl.12 (col.)

Mr and Mrs David Thomson

It is possible that when he made this drawing
Constable was already contemplating a painting of
the subject. He had returned to Suffolk from
London on 16 July and it had poured all the way
down. 'I did not get at all wet', he told Maria in a
letter of the 17th, 'for in addition to my own great
coat. Samuel. Taylor the coachman lent a large
wrapping one – which kept me so warm &
comfortable that I was often sound asleep on his

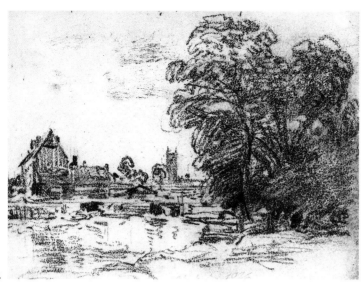

264

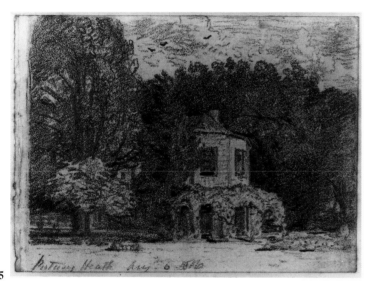

265

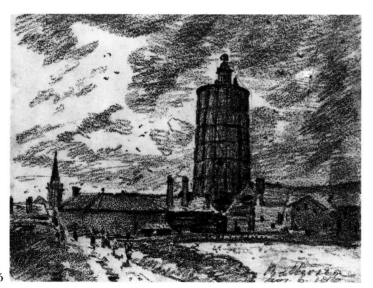

266

coach-box' (Beckett II 1964, p.187). It is from Maria's reply, of the 20th, that we gather he had plans for a painting of the mill: 'you must lament this rain very much, there can be no going on with Dedham' (ibid., p.188). It seems there *was* 'going on' with Dedham, though, for the present drawing of the lock and mill is dated 22 July, almost immediately after he would have received Maria's letter – perhaps the weather had improved.

265 The Octagonal House (? Bowling Green House), Putney 1816

Pencil 88 × 117 ($3\frac{1}{2}$ × $4\frac{5}{8}$) on untrimmed wove paper 88 × 121 ($3\frac{1}{2}$ × $4\frac{3}{4}$), including fragment of adjoining sketchbook page
Inscribed 'Putney Heath Aug. 6. 1816' b.l.
PROV: . . .; Arthur Hawley, by whom bequeathed to Uppingham School, Leicestershire, from whose Trustees bt by present owner through Oscar and Peter Johnson Ltd 1980
LIT: Reynolds 1973, p.111, under no.147; Fleming-Williams 1986, p.19 no.9, fig.6; Fleming-Williams 1990, p.134, fig.130

Private Collection, New York

One of the pages from the now dismembered 'Honeymoon' sketchbook, no.265 was drawn on the same day as 'The Horizontal Mill', no.266. During the months before their marriage, Maria Bicknell spent most of her time with her sister Louisa at their father's country 'cottage' in Bristol House Terrace, one of a little cluster of houses on Putney Heath (see Reynolds 1984, nos.18.15–18). From a contemporary map of the area, the 'Octagonal House' would appear to have been Bowling Green House (only a short distance from Bristol House Terrace), known as such after a resort popular in the seventeenth century. Until his death in 1806, Bowling Green House was the country residence of the Prime Minister, William Pitt. It was on the heath nearby that Pitt is said to have fought his duel with George Tierney in 1798. This aspect of the house faced eastwards, so Constable must have made his drawing fairly early in the morning, perhaps before visiting Maria that day.

266 The Horizontal Mill, Battersea 1816

Pencil on wove paper, left and bottom edges trimmed, 86 × 116 ($3\frac{3}{8}$ × $4\frac{9}{16}$)
Inscribed in pencil 'Battersea | Aug.6.1816' b.r.
PROV: . . .; Hugh Frederick Hornby, who died 1899; by descent to the vendor, Lawrence Fine Art, Crewkerne 19 April 1979

(HA5, repr.) bt Wyld; . . .; anon. sale,
Sotheby's 19 March 1981 (162, repr.) bt in;
present owners
LIT: Fleming-Williams 1986, p.18 no.8;
Fleming-Williams 1990, p.134, pl.13 (col.)

Mr and Mrs David Thomson

Built by Thomas Fowler from designs by Capt.
Stephen Hooper, the horizontal windmill close by
Battersea Bridge was intended as a mill for grinding
linseed, but subsequently was put to work for the
nearby distilleries (R. Wailes, *The English Wind-
mill*, 1954, p.85, pl.VI). The mill is also to be seen in
one of the most famous of all English watercolours,
Thomas Girtin's 'The White House' (Tate Gal-
lery), midway between the white house and the
windmill on the left.

 Constable was in London on a short visit from
the country in the first week of August to present
Maria Bicknell and her sister, Louisa, with a young
spaniel pup, Dash. In a letter to her of 1 August he
said he planned to be in town on Saturday (3
August) and asked her to send him a note saying
when he could see her and what he should do with
Dash: 'I doubt I cannot see you on sunday if your
father should be with you' (Beckett II 1964, p.191).
No.266 was drawn on the Tuesday – maybe on his
way back from Putney, after delivering Dash to his
new home.

**267 Salisbury Cathedral, the South
Transepts** 1816

 Pencil on trimmed wove paper 114 × 87
($4\frac{1}{2}$ × $3\frac{7}{16}$)
Inscribed in pencil '4 Octr 1816' at bottom
PROV: . . .; Hugh Frederick Hornby, who
died 1899; by descent to the vendor,
Lawrence Fine Art, Crewkerne 19 April 1979
(HA7, repr.) bt Spink & Son Ltd; given to
Stanford University Museum of Art in
honour of Robert E. and Mary B.P. Gross
LIT: Fleming-Williams 1986, p.20 no.12,
fig.8; Fleming-Williams 1990, p.139, fig.132

*Stanford University Museum of Art, Given in
Honour of Robert E. and Mary B.P. Gross*

See no.268

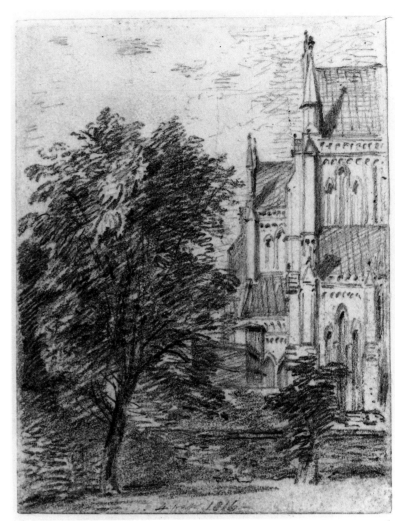

267

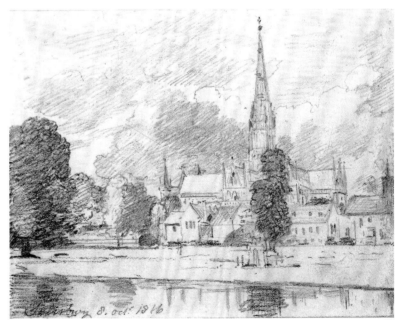

268

268 Salisbury Cathedral and the Bishop's Palace 1816

Pencil on wove paper, trimmed at left and
bottom, 86 × 113 (3⅜ × 4⁷⁄₁₆)
Inscribed in pencil 'Salisbury 8.Octʳ 1816'
b.l.
PROV: . . .; Hugh Frederick Hornby, who
died 1899; bt from his descendant by present
owners 1982
LIT: *John Constable, R.A: Fifteen Drawings
from the Hornby Album*, sale cat., Lawrence
Fine Art, Crewkerne 19 April 1979,
Appendix A, repr.; Fleming-Williams 1986,
p.20 no.13; Fleming-Williams 1990, pp.139–
40, pl.14 (col.)

Mr and Mrs David Thomson

After a difficult and prolonged courtship,
Constable and Maria Bicknell were married on 2
October 1816 by John Fisher in St Martin's-in-
the-Fields, the church nearest to Maria's London
home. In Farington's diary (XIV, p.4940) we have
the only documentary account of the honeymoon:

Constable called, having returned to London
yesterday with His wife after passing six weeks
with the Revd. John Fisher, in Dorsetshire,
some days at Salisbury, with the Bishop and his
family, and a few days with the Revd. Dr.
Cookson at Binfield, Berks.

It was from the dates on nos.267–8 that we first
learned that Constable and his wife spent the first
few days of their honeymoon with his old friends
the Bishop of Salisbury and Mrs Fisher at the
Palace.

No.267 was drawn from quite near the main
entrance to the Palace. The time of day when the
drawing was made – mid-morning – may be
deduced from the angle of the shadows cast on the
transepts' lead roofs by the pinnacles. No.268 and a
similar undated pencil sketch from the same book
of the Palace and Cathedral (Lawrence Fine Art,
Crewkerne, 19 April 1979, HA6, repr.) are the only
known views by Constable of this aspect, showing
the southern, rather more domestic elevation of the
Bishop's residence.

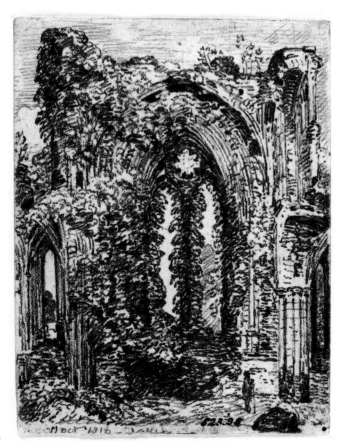

269

269 Netley Abbey, the East Window 1816

Pencil on trimmed wove paper 113 × 88
(4⁷⁄₁₆ × 3½)
Inscribed '11 Oct 1816 – Netley' at bottom
PROV: As for no.2
LIT: Reynolds 1973, no.147, pl.117;
Fleming-Williams 1986, p.20 no.14

*Board of Trustees of the Victoria and Albert
Museum, London*

Before Constable received an invitation from
Fisher on 27 August 1816 to come and spend part
of his honeymoon at Osmington, Dorset, it seems
that he and Maria had been planning to stay for a
month or so with an aunt, Mary Gubbins, and her
family, who had moved from Epsom to Southamp-
ton after the death of her husband in 1814. The
greater part of the honeymoon, some six weeks, was
spent at Osmington but two dated drawings,
no.269 and a view of Weston Shore (Southampton
Art Gallery), done on successive days, 11 and 12
October, indicate that the newly married couple
certainly spent a few days with Mary Gubbins and
her family.

Besides no.269, Constable made several larger
drawings of the ruins of the thirteenth-century
Cistercian monastery at Netley. One of these
(Reynolds 1973, no.148, pl.121) became the subject
of an etching, of a late painting and also of a
watercolour of *c*.1833, a work nostalgic in mood, in
which the scene is depicted drenched in moonlight
(Parris 1981, no.40, repr. in col.).

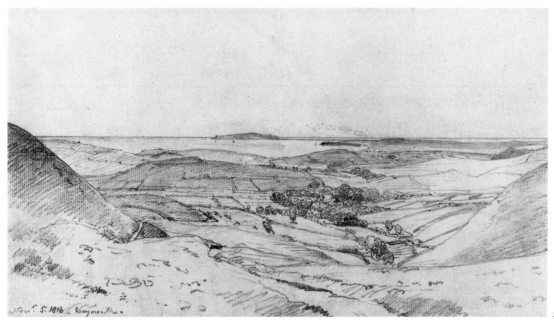

270

270 Weymouth Bay from the Downs 1816

Pencil on trimmed laid paper 175 × 311
(6⅞ × 12¼); watermark: Britannia within an
oval
Inscribed in pencil 'Nov.ʳ 5. 1816.
Weymouth' b.l.
PROV: . . .; Dr H.A.C. Gregory, sold
Sotheby's 20 July 1949 (91) bt Agnew;
presented to the Whitworth Art Gallery by
the National Art-Collections Fund 1949
EXH: Tate Gallery 1976 (148, repr.)
LIT: Fleming-Williams 1976, p.56, pl.20;
Rosenthal 1987, p.98, ill.84

*Whitworth Art Gallery, University of
Manchester*

The six weeks spent at Osmington with the Fishers
was a productive period. Suitable subjects for
Constable's brush and pencil abounded in the area
round the village and he had little need to go far in
search of material. Portland Bill (on 20 November)
seems to have been the furthest he, and presumably
Maria and the Fishers, ventured. In the time he
was at Osmington, besides oil paintings and
sketches (see nos.80–5), Constable made twenty or
so drawings and watercolours.

All but two of the drawings were done in the 3 by
4 inch sketchbook from which we have already seen
several examples, and in a larger, 4 by 7 inch one.
The exceptions are no.270 and a strangely formal
pencil study of Osmington church in its rural
setting, said at one time to have belonged to the
Fisher family (Sotheby's 17 November 1981, lot
80). No.270 is a view from the Downs inland, with
the village of Sutton Poyntz below among the trees
in the middle distance, Weymouth to the right and
in the distance across the bay, Portland Bill.

Osmington is out of sight behind the steep slope on
the left. In the Ashmolean Museum there is a
similar view from higher up on the Downs (Day
1975, pl.147) and at Ipswich, a drawing in the same
linear manner as no.270, also from the Downs but
looking eastwards towards Osmington and Ring-
stead (Rosenthal 1983, fig.140). Both of these are
from the larger of the sketchbooks.

Most, if not all, of the drawings made on this
honeymoon trip would have been drawn with the
certain knowledge that on completion they would
be examined and commented on by John Fisher
and his wife – the latter a one-time pupil of William
Sawrey Gilpin (Farington IX, p.3200, 16 January
1808). In kind, they vary. Some, like the drawings
of Redcliff Point (no.271) and Osmington village
(no.272) are pictorial in character. Others are less
complete, brief snapshots taken, as it were, on the
wing (e.g. no.273). No.270 and the other views
from the heights inland are essentially descriptions
of the lie of the land, with every hedgerow and field
clearly marked out. If the two wives had not seen fit
to walk so far, with the help of no.270 they would
still have been able to identify each natural feature
in the panorama. No officer cadet, trained for
reconnaissance, could have made a plainer and
clearer statement about the character of the terrain.
The prospect has changed remarkably little; so
little, in fact, that when shown a photograph of the
drawing a farmer who worked much of the land was
able to recognise and name many of the fields
Constable had drawn.

John Fisher, when writing from Osmington on
22 April 1826, seems to have forgotten this
drawing: 'I had rather see you here than in London.
This is a country that the more you live in it, the
more you discover its beauties. Did you ever look
down the little wooded valley of Sutton and

Preston from the spring-heads in the little amphitheatre formed by the hills [the very subject of no.270] ? It has a peep of the blue bay in the distance with Portland: and two old forlorn ash trees in the foreground [here, a sketch of the trees]. The place is very sequestered & is frequented by kingfishers & woodcocks. But fellows from Weymouth with padded chests & vacant faces come there, & let off guns' (Beckett VI 1968, pp.218–19).

271

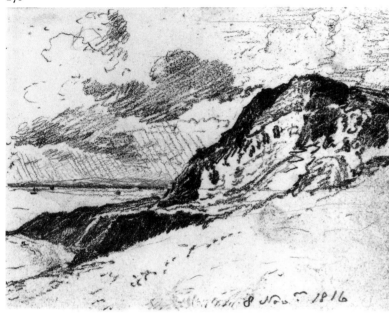

272

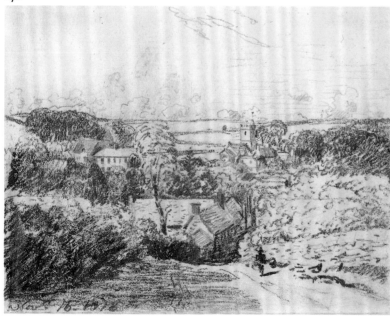

271 Redcliff Point 1816

Pencil on wove paper 87 × 114 ($3\frac{7}{16}$ × $4\frac{1}{2}$), trimmed at left and bottom
Inscribed in pencil '8 Nov.ʳ 1816' b.r.
PROV: . . .; Hugh Frederick Hornby, who died 1899; by descent to the vendor, Lawrence Fine Art, Crewkerne, 19 April 1979 (HA9, repr.) bt Leggatt; present owners
LIT: Fleming-Williams 1986, p.20 no.16; Fleming-Williams 1990, pp.140, 143–4, pl.16 (col.)

Mr and Mrs David Thomson

Redcliff Point is a headland about a mile and a half to the west of Osmington Mills, the nearest beach to Osmington village (see no.81). In the Boston 'Osmington and Weymouth Bays' (no.83) the headland is to be seen clearly in the middle distance, pointing out to sea. Bowleaze Cove, the subject of the National Gallery's 'Weymouth Bay' (no.85), is just round the corner, beyond the Point. Constable was attracted by structures of many kinds and here, at Redcliff Point, he was plainly struck by the dramatically exposed stratifications, noting the essential character of the two main deposits, crumbling rock on heavy, more resistant clay.

272 Osmington Church and Village 1816

Pencil on wove paper trimmed at bottom, top and left, 88 × 110 ($3\frac{1}{2}$ × $4\frac{3}{8}$)
Inscribed 'Nov.ʳ 16. 1816' b.l.
PROV: . . .; ?Thomas Hastings; . . .; Louise Burke Wrenn, Aiken, South Carolina, from whose estate bt 1978 by Dr Robert Lipe, sold Christie's 29 March 1983 (11, repr.) bt Leggatt; present owners
LIT: Fleming-Williams 1986, p.20 no.17; Fleming-Williams 1990, pp.140, 141–3, pl.15 (col.)

Mr and Mrs David Thomson

No.272 was drawn from a spot on what is known locally as the Roman Road, now a rough track that runs up a hill eastwards out of Osmington village towards Poxwell. Today, trees and shrubbery obscure the view. To the left of the church, St Osmond's, Fisher's vicarage is to be seen (with the smoke rising from the chimney), where Constable and Maria spent most of their honeymoon.

Fisher had made a generous offer of hospitality in the letter of 27 August 1816 in which he had urged Constable 'to get to his lady' and agree on a date for their wedding, 'instead of blundering out long sentences ⟨. . .⟩ about yᵉ hymeneal altar'. 'And now my dear fellow', he had continued, 'I shall reckon it a great pleasure if you & your bride will come & stay some time with me & my wife. That lady joins with me in my request. The country here is wonderfully wild & sublime & well

worth a painters visit. My house commands a singularly beautiful view: & you may study from my very windows. You shall [have] a plate of meat set by the side of your easel without your sitting down to dinner: we never see company: & I have brushes paints & canvas in abundance' (Beckett VI 1968, p.29).

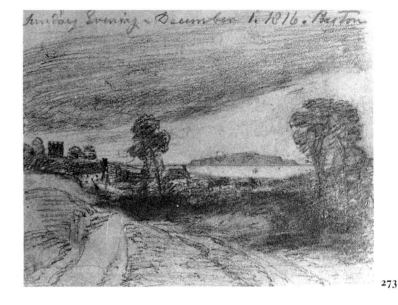

273

273 Preston Village 1816

Pencil on wove paper 90 × 115 ($3\frac{9}{16}$ × $4\frac{1}{2}$)
Inscribed in pencil 'Sunday Evening – December 1. 1816. Preston' at top; on the back, drawings of two dogs
PROV:...; Musée Grobet-Labadié, Marseille
LIT: Fleming-Williams 1986, p.21 no.19, fig.11

Musée Grobet-Labadié, Marseille

No.273 was drawn on the last Sunday of Constable and Maria's long stay at Osmington. On the same day, on the back of a drawing of Preston church (dated 21 Nov., Reynolds 1973, no.153, pl.125), from a seat in the south choir-stall, he made a sketch of the interior of the church with Fisher in the pulpit. Preston was a parish adjoining Fisher's own Osmington and in the absence of an incumbent he had for a time undertaken the duties of a vicar.

A view of the church and village looking south (with Portland Bill across the bay), no.273 was taken from the road that leads into the village from Sutton Poyntz. Though rather more hurriedly drawn than most of the sketches in the small sketchbook, no.273 was nevertheless just as consciously composed.

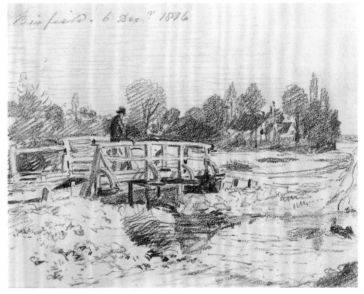

274

274 A Footbridge and Watersplash at Binfield, Berkshire 1816

Pencil on wove paper 86 × 111 ($3\frac{3}{8}$ × $4\frac{3}{8}$), right edge trimmed
Inscribed in pencil 'Binfield. 6 Dec.ʳ 1816' at top
PROV:...; Hugh Frederick Hornby, who died 1899; by descent to the vendor, Lawrence Fine Art, Crewkerne 25 Sept. 1980 (5, repr.); present owners
LIT: *John Constable, R.A: Fifteen Drawings from the Hornby Album*, sale cat., Lawrence Fine Art, Crewkerne 19 April 1979, Appendix C, repr.; Fleming-Williams 1986, p.21 no.21; Fleming-Williams 1990, pp.144–6, pl.17 (col.)

Mr and Mrs David Thomson

See no.275

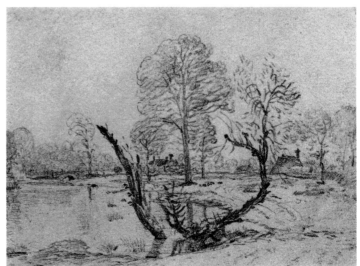

275

276

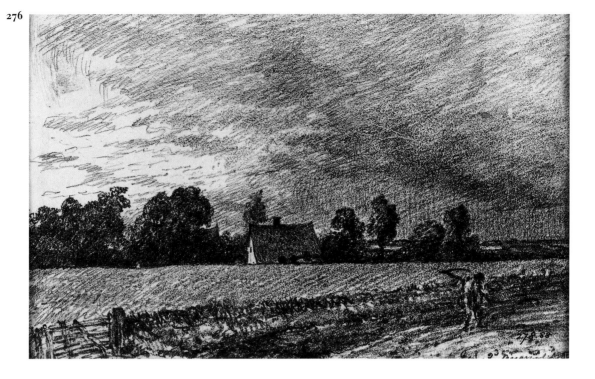

275 Trees by a River, Binfield 1816

> Pencil on trimmed wove paper 83 × 106
> ($3\frac{1}{4}$ × $4\frac{3}{16}$)
> Inscribed in pencil 'Binfield Berks Dec 7
> 1816' t.l.
> PROV: . . .; Dr H.A.C. Gregory, sold
> Sotheby's 20 July 1949 (94) bt Tooth; . . .;
> Agnew 1979; present owner
> LIT: Fleming-Williams 1986, p.21 no.23,
> fig.13

Private Collection

Constable and his wife spent four or five nights on their way back to London from Osmington with Mary Fisher's parents, the Cooksons, at Binfield, where Canon Cookson was the incumbent. During their short stay Constable made eight drawings in the smaller sketchbook (two during a visit to a nearby seat, Shottisbrooke) and one in the larger book of Binfield church from the south with the vicarage in the background (Christie's 18 June 1980, lot 41, repr.).

So far, the subjects of neither no.274 nor no.275 have been located. It is not known, either, whether the Fishers accompanied Constable and Maria on their homeward journey as far as Binfield. But the Fishers were married in July of that year, and it would have been very natural for Mary Fisher to wish to see her parents again. If this was the case, then the figure in the top hat on the footbridge in no.274 would almost certainly have been John Fisher, of whom, with two dogs in company, Constable made a pen and ink and watercolour sketch at Salisbury in 1829 (Reynolds 1973, no.313, pl.234).

276 A Reaper, East Bergholt ?1817

> Pencil on untrimmed wove paper, left edge
> irregular, 115 × 186 ($4\frac{9}{16}$ × $7\frac{5}{16}$); faint
> evidence of squaring-up
> Inscribed 'E B $3^{\underline{d}}$ August 1[. . .]' b.r., the
> remaining digits missing owing to a tear.
> PROV: As for no.2
> EXH: Japan 1986 (21, repr.)
> LIT: Reynolds 1973, no.157, pl.128;
> Rosenthal 1983, p.115, fig.144; Reynolds
> 1984, no.17.9, pl.9; Rosenthal 1987, p.101,
> ill.88

Board of Trustees of the Victoria and Albert Museum, London

Described by Graham Reynolds (1984) as 'one of the most haunting images by Constable of the solitary nature of Suffolk farm-work', no.276 well illustrates Constable's feel for the land and for those who worked it. It is evident from the pencil-work around the figure that from an early stage in the making of the drawing it was the intention to include the reaper – his presence may even have been the raison d'être for the work. This does not seem to have been an instance of the inclusion of a passing figure in a drawing already begun.

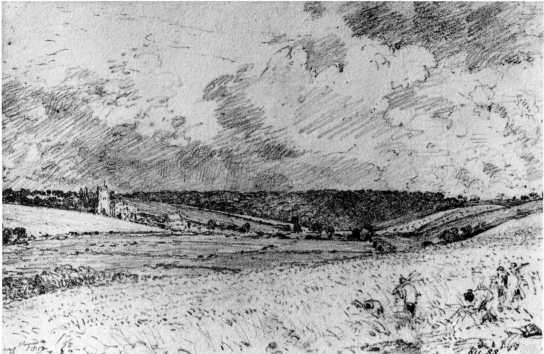

277

277 Churn Wood and Greenstead Church 1817

Pencil on untrimmed wove paper with stitch-marks down the left edge 115 × 186 (4½ × 7⁵⁄₁₆); watermark 'JOHN DICK[INSON]| 18[. . .]' Inscribed '29 Aug. 1817|Wivenhoe Park – churn Wood' b.l.
PROV: As for no.2
LIT: Reynolds 1973, no.160, pl.129; Rosenthal 1983, p.115, fig.143; Reynolds 1984, no.17.19, pl.21

Board of Trustees of the Victoria and Albert Museum, London

On finding that they were spending the summer at East Bergholt, Constable's old friend W.W. Driffield (see no.251) wrote to ask whether he and Maria would favour him with their company for a few days. They obliged, and during their stay Constable made two drawings, 'Markshall House' and 'View at Feering' (Reynolds 1984, nos.17.22–3, pls.22–3). Feering is not far from Wivenhoe and no.277 could have been drawn on a day trip to see the Slater-Rebows. On the other hand, Constable also received an open invitation to come and stay at Wivenhoe with his wife and to paint the young daughter of the house, so the present drawing and two others (a sketch of cattle in the park, Reynolds 1984, no.17.18, pl.18 – also dated 29 August – and an undated drawing of the lake, fig.55 on p.166) may have been done while he and Maria were guests of the Slater-Rebows.

No.277 was drawn from outside the gates of Wivenhoe Park. Greenstead church (not to be confused with the better-known Saxon log-church at Greensted) is to be seen across the little valley – through which runs Salary Brook – with Churn Wood in the distance. In contrast to the solitary reaper in no.276, here we have agricultural workers in concert – farmhands or a hired gang starting to harvest a field of corn. Notable in this drawing is Constable's handling of the pencil to suggest colour and movement.

278 East Bergholt Church Tower, from the South-East 1817

Pencil on wove paper 317 × 238 (12½ × 9⅜)
PROV: By descent to Charles Golding Constable and sold by court order after his death, Christie's 11 July 1887 (23) bt Agnew for Sir Cuthbert Quilter; . . .; P.M. Turner; . . .; Gilbert Davis; Mr and Mrs W.W. Spooner by 1963; bequeathed by W.W. Spooner to Courtauld Institute Galleries 1967
EXH: Tate Gallery 1976 (155, repr.)
LIT: Fleming-Williams 1976, p.58, pl.21; Reynolds 1984, no. 17.32, pl.32

Courtauld Institute Galleries (Spooner Collection)

It would seem to have been the original intention of the builders of St Mary's, East Bergholt to rival the tower of Dedham church, with a similar plan, a plan that would provide a way through on a north–south axis so that the structure would serve as both

[432]

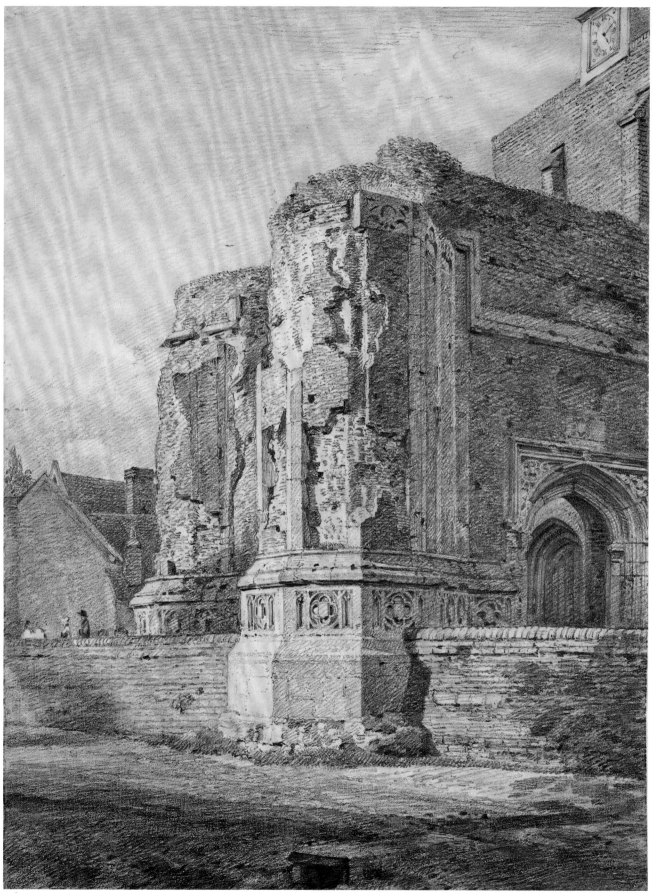

278

tower and porch for the west door. Work probably began soon after Dedham was completed (1520), but ceased after the ambitious first stage had been built. The resultant effect is that of a ruined tower, for which it is frequently mistaken.

The picturesque stump features in many of Constable's watercolours and pencil sketches. In no.278 Constable gives a detailed account of the crumbling structure, the rubble core with its facing of flint and stone as it catches the afternoon light. That summer he made an equally elaborate study of the south porch with the same sharp clarity of detail (Huntington Library and Art Gallery, Reynolds 1984, no.17.31). This he chose as one of his exhibits at the Academy the following year, in preference to no.278, probably because he had already shown another view of the tower in 1815 (Victoria and Albert Museum, Reynolds 1984, no.17.33; see Fleming-Williams 1990, p.127).

fig.138 'East Bergholt Church', late 1790s, *Board of Trustees of the Victoria and Albert Museum, London*

279 East Bergholt Church, from the South-West 1817

Pencil on slightly trimmed wove paper
181 × 115 (7⅛ × 4½)
Inscribed in pencil '12' b.l. and on the back in another hand 'E.B. Church 12 M.L.C' (i.e. Maria Louisa Constable)
PROV: By descent to Col. J.H. Constable, who died 1974; . . .; present owner
EXH: New York 1988 (66, repr.)
LIT: Reynolds 1984, no.17.29, pl.29

Mrs J. Katz

Constable's earliest known drawing of East Bergholt church (fig.138), a pen and ink study on a 10 by 15 inch sheet (Reynolds 1973, no.15), was taken from the same viewpoint as no.279. Holmes (*Constable and his Influence on Landscape Painting*, 1902, p.238) dated this drawing *c.*1798 and reckoned that it was a study for an oil, 'East Bergholt Church', no.55 in Leggatt's 1899 exhibition, a painting now lost to view. More an exercise in two-point perspective than a study taken on the spot, this wide-angled, early drawing included the whole church as well as a foreshortened vista of the houses in the main street. For Constable, the subject had a strong appeal. Of the church from this spot, the beginning of the lane leading to Flatford, he made two oil sketches (Hoozee 1979, nos.134–5, repr.; dated by Hoozee *c.*1811), as well as the fine Durban oil, no.90. Equally fine, within the limits of the medium, no.279 could have been a preliminary study for no.90, or intended as a notation of the changing effects of sunlight and shadow. It is interesting to note the different eye-levels in the two works, probably to be accounted for by the fact that the artist was seated when he drew no.279 and standing at his easel when he painted no.90.

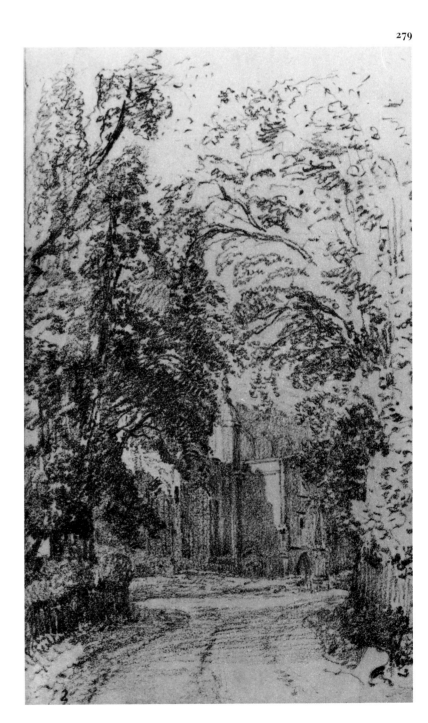

279

280

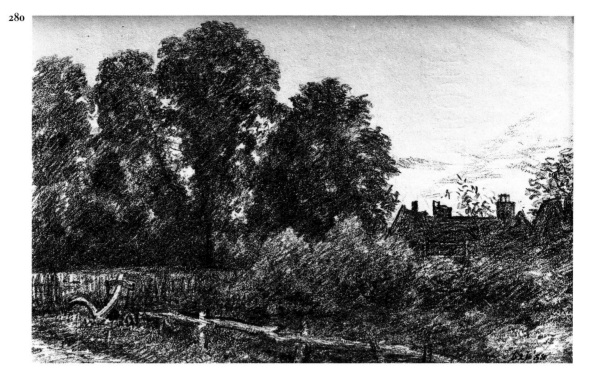

280 A Farmhouse Seen from the Edge of a Field 1817

Pencil on untrimmed wove paper with stitch-marks down the left edge 115 × 187 (4½ × 7⅜); watermark 'JOHN DICK[INSON]│18[...]'
PROV: As for no.2
LIT: Reynolds 1973, no.202, pl.152; Reynolds 1984, no.17.27, pl.26

Board of Trustees of the Victoria and Albert Museum, London

Although the scene has not yet been identified, on the evidence of the Suffolk type of plough to be seen in the left-hand corner, Reynolds has given this drawing (hitherto thought to be of 1820) to the group done at Bergholt in 1817.

No.280 seems to have been drawn in two stages, initially with a harder, light-toned pencil and then with a softer, darker one. Traces of the under-drawing may be seen down the left-hand edge. Presumably a depiction of fading light – in which details are less obtrusive – no.280 is one of several pencil studies where the aim appears to have been to achieve a greater than usual tonal verisimilitude by brushing over every part but the sky with varying pressures of the soft graphite point.

281 Trees on the Tow-Path at Flatford 1817

Pencil on deckle-edged wove paper 550 × 387 (21⅝ × 15¼); watermark 'E & [?O]│180[?7]'; pairs of pinholes top centre, b.l. and b.r. Inscribed 'Oct.ʳ 17ᵗʰ 1817 – E. Bergholt' b.l.
PROV: As for no.2
EXH: Tate Gallery 1976 (154, repr.)
LIT: Reynolds 1973, no.161, pl.130; Smart and Brooks 1976, pp.69–72, 134 n.3, pl.38; Parris 1981, p.75, fig.9; Rosenthal 1983, p.106, fig.137; Reynolds 1984, no.17.20, pl.19

Board of Trustees of the Victoria and Albert Museum, London

Displeased with the nearest group of trees in his main exhibit of 1817, 'Flatford Mill' (no.89), Constable made this remarkable study, from which he would be able to repaint the offending area when he returned to London. For the subsequent repainting of the picture, see no.89.

It is doubtful if any pair of trees received more attention from Constable than these that stood on the right bank of the Stour between the footbridge and the lock at Flatford. They feature in a drawing in the Fondazione Horne (fig.36 on p.130) from which he painted them into his 'Boys Fishing' (no.57); he sketched them in oils from upstream; and he painted them from across the river in 'Boat-Building' (no.72). A main limb on the nearer tree, lost when Constable made the present study, may be seen in a page of the intact 1814 sketchbook (fig.58 on p.179).

The lightly touched-in outlines of the trees in the middle distance on the left and around the bush

in the foreground show how Constable began to realise the scene on this large sheet of paper, a necessary initial stage before starting on the 'serious' drawing.

Two small circular stains (probably linseed oil) on the right-hand side are plainly visible on the back of the drawing.

It is odd that such a painstaking and seemingly accurate drawing has not rendered the identification of the tree species an easier task. Willow and alder both grow along the banks of the Stour, but these do not look like willows, nor do they have the more obvious characteristics of the alder.

282 Elm Trees in Old Hall Park, East Bergholt 1817, exh.1818

Pencil, grey wash and white heightening on trimmed wove paper 592 × 494 ($23\frac{5}{16}$ × $19\frac{7}{16}$) Inscribed in pencil 'John Constable | Octr 22d | 1817 | East Bergholt | 1817' b.l., the first and last lines with a different pencil from the middle three. On the back, in pencil: 'This Noble Elm – stood in the Park of Peter Godfrey Eqr – called "Old Hall" Park | at East Bergholt – Suffolk | it was blown down April 1835. | it broke even with ground – it measured standing [?upright] 10 × d[?iameters] | | knew [. . .] lost the large Arm on the Right | J.C.' and 'This drawing was made 1816. an the Autumn'; below, in pencil in another hand : 'The above in the Handwriting of John Constable R.A. (who made | the Drawing) | – Purchased at the Sale of his Pictures and Drawings at Fosters in | Pall Mall. 16 May 1838 – | A. James'
PROV: Artist's adminstrators, sold Foster's 16 May 1838 (63) bt White Jr for A. James; Miss James, sold Christie's 22 June 1891 (168) bt for the South Kensington (later Victoria and Albert) Museum
EXH: RA 1818 (483, 'Elms'); W.B. Cooke's Gallery 1822 (296, 'Study of a Group of Elms'); Tate Gallery 1976 (156, repr., with detail as frontispiece); Paris 1976 (24); Japan 1986 (22, repr.)
LIT: Reynolds 1973, no.162, pl.131; Fleming-Williams 1976, p.60, fig.43, pl.22 (detail); Reynolds 1984, no.17.21, pl.20; Rosenthal 1987, p.101, ill.89

Board of Trustees of the Victoria and Albert Museum, London

Old Hall was adjacent to the church, and the palings along the southern edge of the park lined the first part of the lane down to Flatford. One of Constable's earliest commissions, in 1801, was a painting of Old Hall, then owned by John Reade (Tate Gallery 1976, no.27, repr.). Peter Godfrey was the next owner (Lord of the Manor 1811) and he and his wife became good friends to Constable,

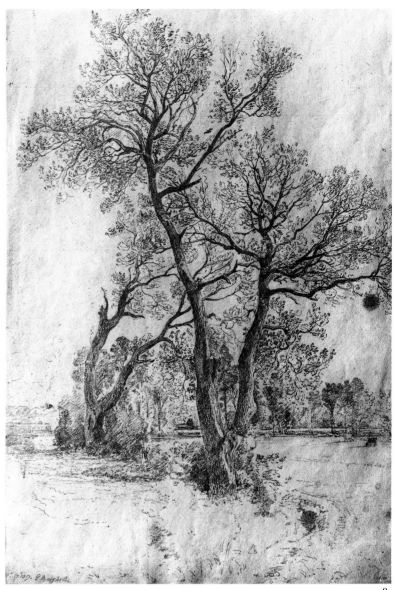

281

who painted a portrait of their son and a view of the Stour Valley (no.74) for their daughter. Mrs Godfrey was eager to see his portrait of Maria when he brought it down with him in 1816 and would certainly have wished to see the original when Constable and his wife came to Suffolk in 1817. Maria was seven months pregnant when this drawing was made – possibly within sight of the house – and the time her husband spent on it may have been a measure of her success with the Godfreys.

Constable's confusion over dates – '1817' on the front and '1816' written on the back – may be accounted for by the later date having been hidden by the mount or frame when he wrote the later inscription.

He made a number of elaborate studies of trees – nos.281 and 301 for instance – but none illustrate better his powers of sustained endeavour while

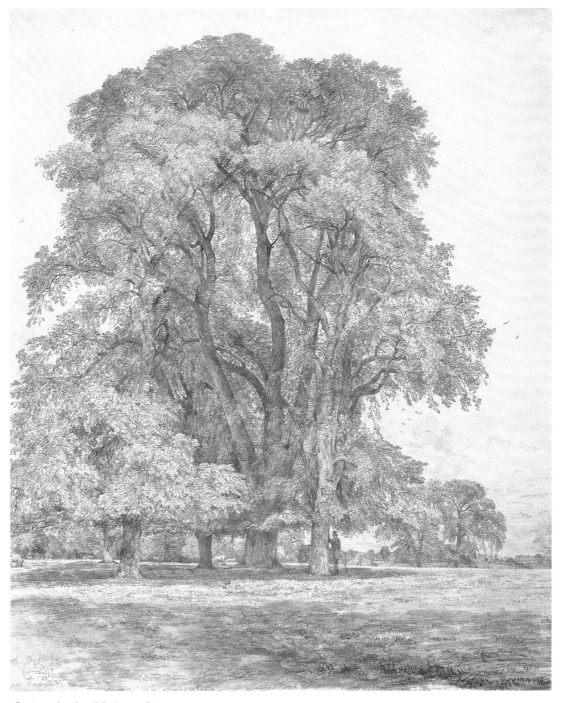

282 (see also detail facing p.387)

retaining a resourceful spontaneity of touch. In technique, this is one of the more complex of his drawings. For the trees he used two pencils: a relatively hard one (perhaps HB in the modern grading) which produced a silvery grey tone, and a much softer one (2 B or an equivalent) which looks slightly browner by comparison. It appears to be by an interplay between the two that Constable obtained the drawing's scintillating luminosity; in some of the lighter areas of foliage he used the '2 B' to produce a grittiness on the surface of the paper

that one could liken to a negative of the scattering of 'whitewash' that so irritated the critics in his later paintings.

The foreground is enlivened with touches of grey wash and white, reminiscent of Constable's touching of the proofs of Lucas's mezzotints for *English Landscape*. The inscription on the back postdates 1835. Could this work with the brush be contemporary with the inscription? Constable's inability to 'leave well alone' is a familiar characteristic.

283 Scene on the Thames 1818

Pencil on trimmed wove paper 98 × 129
($3\frac{7}{8}$ × $5\frac{1}{16}$)
Inscribed '8 Sepr' b.l.; on the back a
watercolour of a rainbow (Reynolds 1984,
no.18.23, pl.48 in col.)
PROV: As for no.2
LIT: Reynolds 1973, no.183, pl.144;
Reynolds 1984, no. 18.22, pl.56

Board of Trustees of the Victoria and Albert
Museum, London

On 8 September 1818 Constable also made a large
pencil drawing of Fulham church from across the
river (Yale Center for British Art, Reynolds 1984,
no.18.21) and, in the same sketchbook as no.283, a
drawing of a flagstaff on Putney Heath (Fitzwilliam
Museum, ibid., no.18.19) and another of a wind-
mill on Barnes Common (private collection, ibid.,
no.18.20). At the time Maria was staying with her
sisters at her father's house on Putney Heath.

Beckett (typescript catalogue, Tate Gallery)
identified the scene as the Thames at Shepperton
on the basis of an oil sketch, said to be of
Shepperton, but now no longer attributed to
Constable. R.A. Shaw, Local Studies Librarian,
Battersea District Library, considers it most likely
that the view is of the river at Mortlake or Chiswick
(looking upstream), the buildings on the left being
too tall and too close to the river bank for it to be of
the bend in the Thames at Putney.

284 Richmond Bridge 1818

Pencil on untrimmed wove paper with stitch-
marks down the left side 99 × 134 ($3\frac{7}{8}$ × $5\frac{1}{4}$)
Inscribed 'Richmond Sep. 9. 1818' b.l.; on
the back 'JC'
PROV: As for no.2
LIT: Reynolds 1973, no.166, pl.134;
Reynolds 1984, no.18.24, pl.51; Rosenthal
1987, p.103, ill.90

Board of Trustees of the Victoria and Albert
Museum, London

See no.285

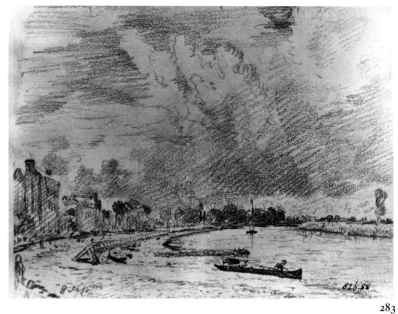

283

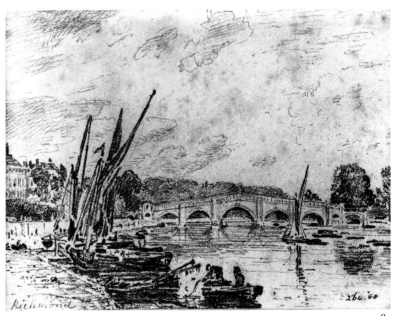

284

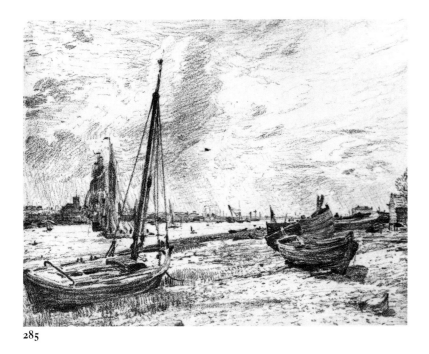

285

285 Shipping on the Thames 1818

Pencil on wove paper, slightly trimmed,
98 × 130 ($3\frac{7}{8}$ × $5\frac{1}{8}$)
PROV: . . .; Gooden & Fox, from whom bt by
Paul Mellon 1966; given by Mr and Mrs Paul
Mellon to the Yale Center 1975 (B1975.4.162)
EXH: *English Landscape 1630–1850*, Yale
Center for British Art, New Haven, April–
July 1977 (157, repr.)
LIT: Rhyne 1981, no.29; Reynolds 1984,
no.18.25, pl.52

*Yale Center for British Art, Paul Mellon
Collection*

Constable was roving the banks of the river that
summer as far upstream as Windsor, but it seems
unlikely that nos.284 and 285 were done on the
same day, though stylistically so very similar. It is
improbable that a square-rigged vessel like the one
in no.285 would have been capable of negotiating
the bridges spanning the Thames and so no.285
must be a view of one of the lower reaches of the
river, beyond any of the now recognisable features
on either bank.

These two examples well illustrate the degree of
confidence Constable had now attained in his
powers as a draughtsman. His mastery of the
conventions necessarily inherent in the effective
use of the medium is to be seen in his avoidance of
confusion by the use in places of a simple device,
the white 'halo' he leaves around certain objects –
around some of the rigging and spars of the barges
on the left of the Richmond drawing, for instance.

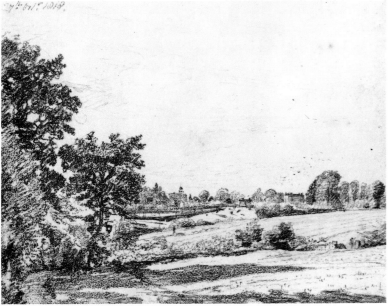

286

286 East Bergholt House and St Mary's Church 1818

Pencil on trimmed wove paper 102 × 127
(4 × 5)
Inscribed '27ᵗʰ Octʳ 1818.' t.r.
PROV: By descent from the artist to the
present owner
EXH: Tate Gallery 1976 (161, repr.)
LIT: Fleming-Williams 1976, p.62, fig.44;
Reynolds 1984, no.18.29, pl.56

Private Collection

This is a view of the house (with the church on the
left) from a field near the rectory, one of the fields
where Constable and Maria used to walk together
during the early days of their courtship.

After the death of Golding Constable in 1816,
his unmarried sons and daughters rearranged their
lives: Ann and Golding took separate houses in the
village. Abram, who ran the business, and the
youngest, Mary, went down to Flatford to live at
the Mill House. Constable's presence was required
several times at Bergholt subsequently while the

[439]

house was being sold and its contents being disposed of. In October 1818 he was there to agree about the acceptance of an offer for the property. No.286 was to be the last of his many sketches of that familiar area at the back of the house.

fig.139 No.287, p.5

287 Sketchbook 1819

Containing 54 pages of wove paper 67 × 93 (2⅝ × 3¹¹⁄₁₆); bound in red morocco with a metal clasp and empty pencil holder; drawings in pencil, pen and ink and watercolour on 24 of the pages and inscriptions only on a further four; several pages scribbled over by childish hands
Inscribed in pencil inside front cover 'Hampstead – Sepr 9th 1819.' and 'George Smith|Boat Builder|No 108 – [?Globe/ ?Glebe] Stairs|Redriff'; inscribed in another hand 'Early Sketch Book|of R.P. Bonington'
PROV: . . .; J.O.K. Denny, Tasmania 1960; C. Keith Denny, by whom given to the British Museum 1972 (1972–6–17–15)
EXH: Tate Gallery 1976 (168, 3 pp. repr.)
LIT: Fleming-Williams 1976, p.66, pls. 25a–d, fig.45; Reynolds 1984, no.19.28, pls.91–118; Rosenthal 1987, p.108, ill.99

Trustees of the British Museum, London

This, the smallest of Constable's sketchbooks, was probably bought on 9 September (the inside of the back cover also records this date – and the price, 2s.). Three of the drawings are dated: the view looking towards Harrow he later so frequently painted (p.13, 10 October, fig.141); a view of East Bergholt church with the parents' tomb (p.23, 28 October, fig.142; see also no.289); and a sketch of a cedar tree (p.27, Putney, 10 November). These dates, however, can only be a rough guide as to the period the sketchbook was in use, though there is no indication it was used after 1819. The majority of the drawings are of Hampstead and it is significant that six of the first seven used pages were filled with 'snapshots' of men at work, presumably on the Heath, with attendant carts and horses. For this exhibition the book is open to show page 5 (fig.139), Constable's sketch of the church of St John at Hampstead, where he was to bury his wife in 1828 and where he too found his last resting-place. Two of the drawings, on pages 11 (fig.140) and 45 (fig.143, the Lower Pond on the Heath, related to an undated watercolour in the British Museum, Reynolds 1984, no.23.13, pl.402) are

fig.140 No.287, p.11

complete little compositions. Animals – donkeys, sheep, cats – figure on several of the pages. A slight sketch of a soldier (?presenting arms) on p.26 may have been one of the preparatory studies for 'The Opening of Waterloo Bridge' (see nos.102–3).

The inscription about George Smith the boat-builder on the inside of the front cover may relate to a request Constable received from John Fisher in a letter of 19 July 1821: 'The immediate object of this letter is to ask you in your visit to the Thames to purchase me a cheap wherry for the river here . . . You as a millwright of course are a judge of the state of repair of a boat' (Beckett VI 1968, p.70).

fig.141 No.287, p.13

fig.142 No.287, p.23

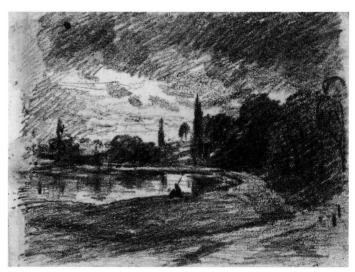

fig.143 No.287, p.45

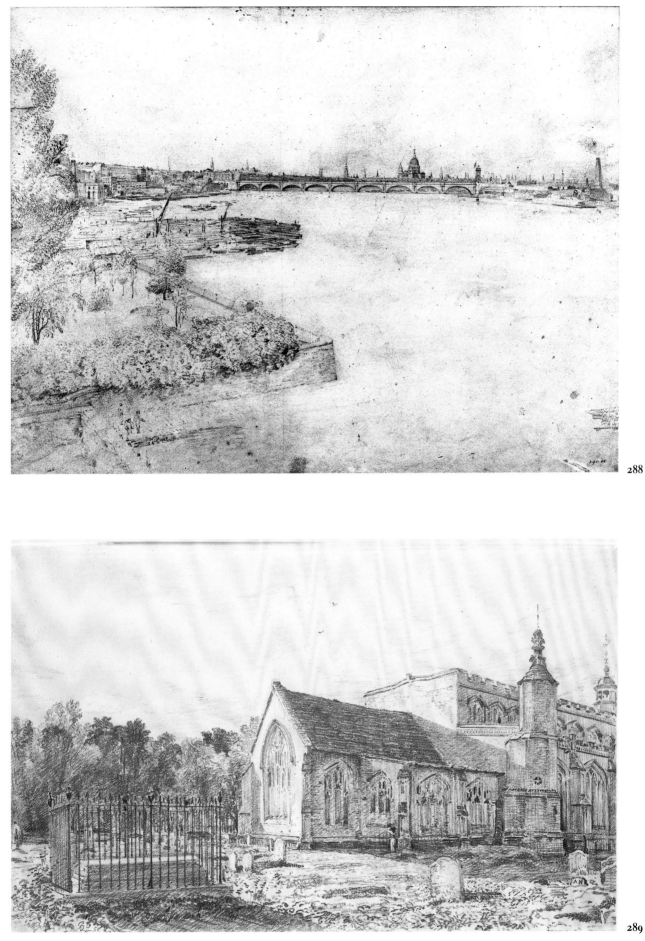

288

289

288 Waterloo Bridge from above Whitehall Stairs *c*.1819

Pencil on trimmed wove paper 306 × 410 (12$\frac{1}{16}$ × 16$\frac{1}{8}$); watermark 'J WHATMAN 1811'; pinholes t.l., t.r., and right of top centre
PROV: As for no.2
EXH: Tate Gallery 1976 (174, repr.)
LIT: Reynolds 1973, no.173, pl.139; Fleming-Williams 1976, p.68, pl.26 (detail); Reynolds 1984, no.19.24, pl.85; Cormack 1986, p.215, pl.204; Fleming-Williams 1990, p.168, fig.162

Board of Trustees of the Victoria and Albert Museum, London

A preparatory study for the large picture of the ceremonial opening of Waterloo Bridge that Constable was intending to paint, no.288 was probably drawn from one of the second-floor windows of the bow-fronted house, 5 Whitehall Yard, to be seen on the left of the exhibited picture of 1832, no.213. Constable had already made two pencil drawings of the view from lower down in 1817 (Reynolds 1984, nos.17.5, 17.7, pls.3, 7). Faced with the problem of choosing the best level from which to depict the event, Constable was at first inclined to present it from relatively high up, as here in no.288.

In the first of his surviving letters to Fisher (17 July 1819, Beckett VI 1968, p.45) Constable says 'I have made a sketch of my scene on the Thames ⟨embankment⟩ – which is very promising'. This may refer to no.288 or to an oil sketch (either no.102 or no.103) which he later showed to Farington, who thought it too much of a bird's eye view (see under no.103). There are other extensive panoramas in Constable's oeuvre, no.222 for instance and the fine Copenhagen drawing (no.249), but none can rival this study for sheer skill of execution and a rendering of space. Nothing is to be seen on the river, apart from the barges in the basin, but the plane of water receding into the distance is nevertheless almost tangibly there. So sharp has his eye become in his accurate depiction of detail – the 'glissando' of railings, for instance – that Constable almost seems to have been at a loss when it came to drawing the foliage on the left.

The garden belonged to Fife House, the residence of Lord Liverpool, the Prime Minister. Beyond the basin, the Adelphi may be seen; and on the other side of the bridge, still on the left bank, Somerset House. The Shot Tower which features in the final painting on the other bank, at this time had not been built.

289 East Bergholt Church, with the Tomb of the Artist's Parents 1819

Pencil on trimmed wove paper 196 × 320 (7$\frac{3}{4}$ × 12$\frac{5}{8}$)
The following inscription in another hand is said to have been on the back of an earlier mount: 'East Bergholt Church. With the Tomb of Golding and Ann Constable, parents of J. Constable, by whom this was drawn Oct 28, 1818. Golding died 1816 aged 78. Ann died 1815 aged 67. By the side of their tomb are the tombs of Jas. Revans, his wife, and son and daughter. Revans was Golding Constable's faithful servant.' (This inscription could not have been completed before 1841, when Mrs Revans died.)
PROV: By descent to Charles Golding Constable and sold by court order after his death, Christie's 11 July 1887 (22) bt Noseda for J.P. Heseltine, sold Sotheby's 25 March 1920 (112) bt Agnew; . . .; Sir Robert and Lady Witt, by whom given to their son John 1929; Sir John and Lady Witt, sold Sotheby's 19 Feb. 1987 (111, repr. in col.); present owners
EXH: Tate Gallery 1976 (162, repr.)
LIT: Reg Gadney, *Constable and his World*, 1976, repr. p.51 with a 1975 photograph of the scene; Reynolds 1984, no.18.30, pl.57; Fleming-Williams 1990, pp.158–61, pl.19 (col.)

Mr and Mrs David Thomson

If this drawing was done on 28 October 1818 (as is maintained by the inscription at one time on the back of the mount), it is curious that a year later to the day Constable should have been back again in the churchyard making a drawing of the same subject from only a slightly different angle (fig.142 on p.441). The information on the mount about the date must itself have been transcribed. Could a slight error have been made in reading the date? It is easy to mistake a handwritten '9' for an '8'.

Constable was down in Suffolk this time for the sharing out with his brothers and sisters of the family plate, linen, etc. The only evidence against the re-dating of no.289 is his report in a letter to Maria of 24 October 1819 (Beckett II 1964, p.254) that there had been a heavy fall of snow, although no further reference to this is made in his letters of 26 and 28 October (ibid., pp.255–7).

James Revans (d.1823) was Golding Constable's steward, his 'valuable & confidential servant' (ibid., p.114). In a letter to Abram after this visit of 1819, Constable asked his brother to thank the Revans 'for my very pleasant visit under their Roof' (Parris, Shields, Fleming-Williams 1975, p.74).

290 A House Seen amidst Trees 1819

Pencil on trimmed wove paper 67 × 88
($2\frac{5}{8}$ × $3\frac{1}{2}$)
Inscribed 'Octr [. . .] 1819' b.r.
PROV: . . .; Hugh Frederick Hornby, who
died 1899; by descent to vendor, Lawrence
Fine Art, Crewkerne 19 April 1979 (HAII) bt
Leggatt; present owners
LIT: Reynolds 1984, no.19.30, pl.120;
Fleming-Williams 1990, p.22, fig.15

Mr and Mrs David Thomson

Probably a Hampstead subject, no.290 is one of two
pages extracted from the 1819 sketchbook, no.287.
The other (Reynolds 1984, no.19.29, pl.119),
possibly a view of Whitestone Pond, Hampstead, is
somewhat slighter. There is a noticeable resemb-
lance between the tall tree or trees on the right of
no.290 and those in a tree study also of 1819
(Reynolds 1984, no.19.31, pl.121).

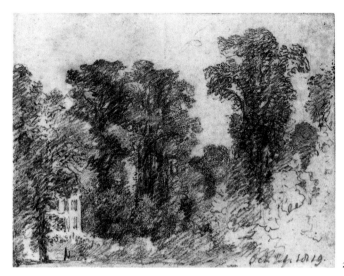

290

291 Stonehenge 1820

Pencil on untrimmed wove paper 115 × 187
($4\frac{1}{2}$ × $7\frac{3}{8}$)
Inscribed '15 July 1820' b.l.
PROV: As for no.2
EXH: Tate Gallery 1976 (181, repr.); Japan
1986 (29, repr.)
LIT: Reynolds 1973, no.186, pl.146;
Fleming-Williams 1976, p.70, pl.27;
Reynolds 1984, no.20.17, pl.144; Cormack
1986, pp.119, 236, pl.225; Fleming-Williams
1990, pp.17, 173, fig.10

*Board of Trustees of the Victoria and Albert
Museum, London*

The initial study on which Constable based his
great watercolour of 1836, no.345, was drawn
towards the end of the day with the shadows
lengthening. The precise hour could probably be
determined if the site was visited on a future 15
July, from the shadow cast on the leaning stone by
the seated figure, for the drawing is remarkaby
accurate and the positions of few of the stones have
been altered since 1820, when Constable sat down
to sketch the scene.

The theme of a contemplative rustic in a
churchyard casting his shadow before him on to a
grave and its tombstone was a motif artists had
toyed with since it first appeared in the illustration
for the *Elegy* in *Designs by Mr R. Bentley for Six
Poems by Mr. T. Gray*, 1753 (see no.30 and Leslie
Parris, *Landscape in Britain c.1750–1850*, exh. cat.,
Tate Gallery 1973, nos.61, 155). Presumably it was
that same day Constable also drew Stonehenge
from a more distant viewpoint beside the Ames-
bury road to the east (Reynolds 1984, no.20.18,
pl.145).

**292 Salisbury Cathedral from beside the
River Nadder** 1820

Pencil on wove paper, left edge slightly
trimmed, 114 × 184 ($4\frac{1}{2}$ × $7\frac{1}{4}$)
Inscribed in pencil '18 July 1820' b.l.; on the
back in a another hand 'M.L.C. 41', i.e.
Maria Louisa Constable's property 1841
PROV: By descent to Maria Louisa and
presumably Isabel Constable, who died
1888; . . .; L.G. Duke; . . .; Edward Seago; his
executors, sold Christie's 1 March 1977 (55,
repr.); . . .; anon. sale, Sotheby's 12 July 1984
(83) bt Leggatt; present owners
LIT: Reynolds 1984, no.20.20, pl.147;
Fleming-Williams 1990, p.176, pl.22 (col.)

Mr and Mrs David Thomson

This view of the cathedral from the north-west
records an early reconnoitre of the north bank of
the Nadder (the main tributary of the Avon) where,
in 1829, Constable found material for his great six-
footer, 'Salisbury Cathedral from the Meadows',
no.210. Very different in mood from the other
drawings made on this trip, no.292, with its
merging forms and soft outlines, appears to have
been drawn soon after first light. Constable was an
early riser and liked to take a stroll before breakfast.

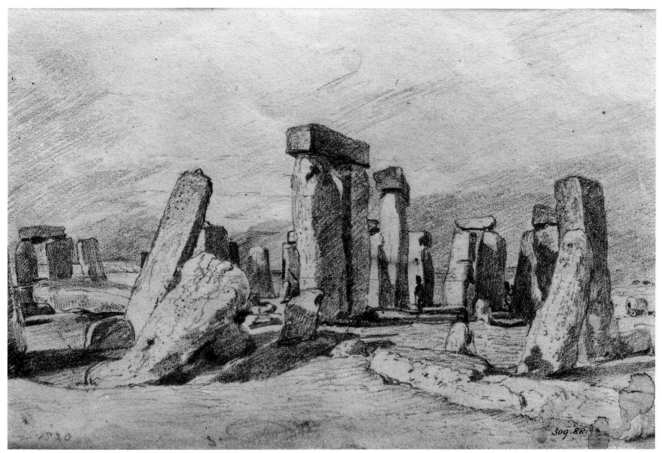

291

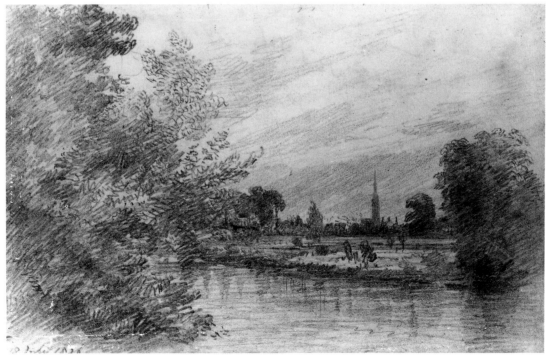

292

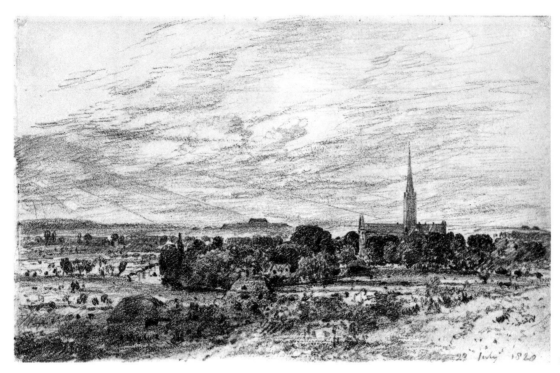

293

293 Salisbury from the South 1820

Pencil on untrimmed wove paper 115 × 185
($4\frac{9}{16}$ × $7\frac{5}{16}$)
Inscribed in pencil '23 July 1820' b.r.; on the
back in another hand 'M.L.C. 41', i.e. Maria
Louisa Constable's property 1841
PROV: By descent to Isabel Constable, by
whom given c.1888 to R.A. Thomson; by
descent to Mrs Bell Duckett, sold Morrison
McChlery & Co., Glasgow 18 March 1890
(101, repr.) bt Aitken & Dott; . . .; Sir
William Younger Bt, by whom bequeathed to
the Victoria and Albert Museum 1973
(P.6–1973)
LIT: Reynolds 1984, no.20.23, pl.152

*Board of Trustees of the Victoria and Albert
Museum, London*

See no.294

294 Salisbury from Old Sarum 1820

Pencil on trimmed wove paper 161 × 233
($6\frac{3}{8}$ × $9\frac{3}{16}$)
PROV: . . .; anon. sale, Sotheby's 15 March
1984 (91, repr.); . . .; present owners
LIT: Fleming-Williams 1976, p.70, fig.49;
Reynolds 1984, no.20.58, pl.180; Fleming-
Williams 1990, p.26, fig.23

Mr and Mrs David Thomson

Drawn in sketchbooks of different sizes, nos.293–4
are nevertheless very close in treatment. Trees and
scrub on the ramparts of Old Sarum now make it
difficult to reach Constable's viewpoint in no.294;
housing on the hill to the south of the city limits an
appreciation of the prospect from that side. But
otherwise neither view has been radically altered by
subsequent developments.

Topographically, no.293 is the more interesting
in the present context as one can identify features in
it that are to be found in other works by Constable.
For instance, the leaning willow, a prominent
feature in the well-known 'Watermeadows at
Salisbury' (no.135), is to be seen on the outside
bank of the bend in the river, and just opposite one
can make out the giant alder and the poplar that he
painted in the oil sketch of Leadenhall garden from
just across the river at that point (no.137).

The relationship of no.293 to the oil painting of
the same subject (no.134) is by no means clear.
Both appear to have been done direct from the
motif, the oil from a viewpoint a little to the right of
the spot from which Constable made the drawing.
During the first weeks of his stay at Salisbury that
summer Constable seems to have made more
drawings than oils and no.293 may have been done
during a preparatory reconnoitre of the ground.

Constable was a remarkably accurate topogra-
pher (when he was not deliberately changing things
round, as in 'The Leaping Horse', no.162, or 'The
Cornfield', no.165) but in the vertical dimension he
often allowed himself a certain degree of latitude.
In the drawing of the city from the south (no.293)
he has exaggerated the height of Old Sarum, and in
both the painting (no.134) and the pencil sketch he

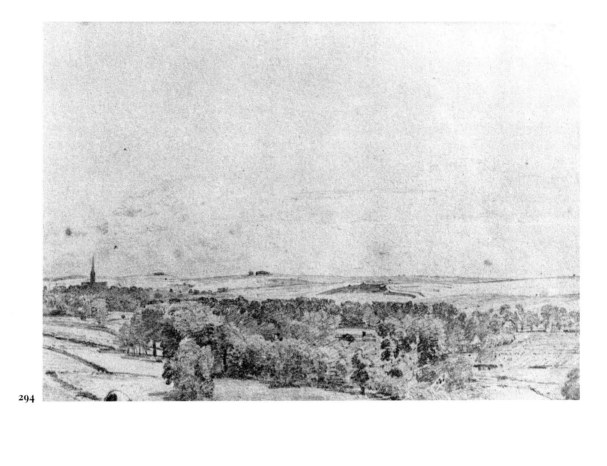

294

295

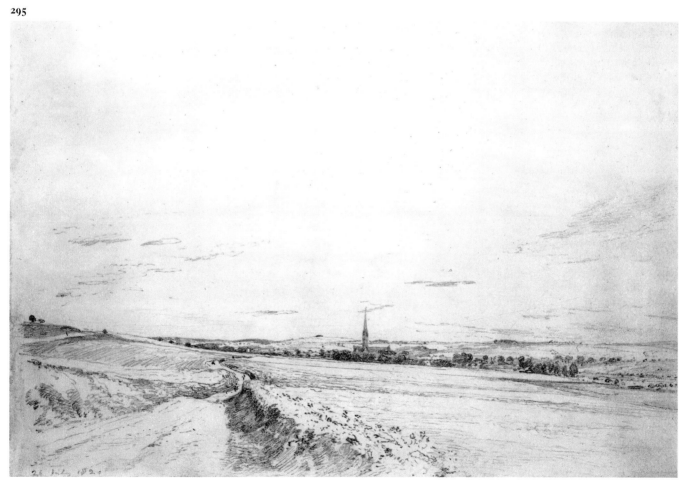

has narrowed the tower and spire of the cathedral to increase the sensation of its soaring height. A similar increase in the ratio of height to width is to be found in many of his drawings and paintings of Dedham church tower.

295 The Road from Old Sarum 1820

Pencil on untrimmed wove paper with stitch-marks down the left side 157 × 235 ($6\frac{3}{16}$ × $9\frac{1}{4}$) Inscribed in pencil '26 July 1820' b.l.
PROV: By descent to Isabel Constable, by whom given to Dr G.D. D'Arcy Adams; his daughter, Miss A.M. Austin; . . .; acquired through Sotheby's by present owners 1984
LIT: Fleming-Williams 1983a, p.219n; Reynolds 1984, no.20.30 pl.155; Fleming-Williams 1990, pp.176–9, pl.23 (col.)

Mr and Mrs David Thomson

This view of Salisbury looking south towards the city was taken from beside the road just before the last, steeper part of the ascent up to Old Sarum. The line of the road has remained much the same, but though fields to the right are still open, housing now obscures the view to the left.

With his eye both for detail and the wide panoramic sweep, Constable has made full use of the road's twisting perspective to create a sense of space and depth. In one of his lectures he defined chiaroscuro ('by no means confined to dark pictures') as 'that power which creates space; we find it everywhere, and at all times in nature; opposition, union, light, shade, reflection, and refraction, all contribute to it' (Beckett 1970, p.62). No.295 would seem to exemplify the working of chiaroscuro interpreted thus.

296 The Mound of Old Sarum from the East 1820

Pencil on untrimmed wove paper 154 × 230 ($6\frac{1}{16}$ × $9\frac{1}{16}$)
Inscribed in pencil 'Old Sarum S.E.' t.l.; on the back in a later hand 'E.N. Mackinnon née Constable'
PROV: By descent to Ella Mackinnon, née Constable; . . .; Leggatt 1898; . . .; Alfred A. de Pass, by whom given to the Royal Institution of Cornwall 1925; . . .; Leggatt; present owners 1985
LIT: Reynolds 1984, no.20.28, pl.150; Fleming-Williams 1990, pp.176–9, pl.24 (col.)

Mr and Mrs David Thomson

On 26 July, when he drew no.295, Constable also made a drawing of Old Sarum similar in style but taken from the south, a drawing untraced since 1926 (Leverhulme sale, Anderson Galleries, New York, 2 March, lot 85). Reynolds suggests that no.296 and this drawing may have been done on the same day. If this is the case, then Constable made three drawings on that day – nos.295–6 and the Leverhulme study. The cast of the shadows in the three drawings supports the notion, for the light in the missing drawing (Reynolds 1984, no.20.27, pl.149) is coming from an easterly direction; in no.295 the sun is not long past its zenith; and though still high, in no.296 it has moved round further towards the west.

297 Harnham Bridge 1820

Pencil on trimmed wove paper 155 × 229 ($6\frac{1}{8}$ × 9)
PROV: . . .; George Salting, by whom bequeathed to the British Museum 1910
EXH: Tate Gallery 1976 (183, repr.)
LIT: Fleming-Williams and Parris 1984, p.194, pl.111; Reynolds 1984, no.20.55, pl.176

Trustees of the British Museum, London

It was not unusual for Constable to make a pencil study of a subject that he was painting out-of-doors. There is a corresponding drawing (fig.63 on p.185) to the painting of Fen Lane of 1817 (no.91), and we have a pair of East Bergholt church (nos.90, 279) in the present exhibition. It would be normal practice for a drawing such as no.297 to be a preliminary study for the painting of the subject, no.138. But the drawing could just as well have been done after the artist had begun his oil, so that he could continue to work on the painting indoors if the weather prevented a return to the motif.

When writing of the work of these years – 1819–20 – Leslie said Constable's art was never more perfect, perhaps never so perfect (Leslie 1845, p.78, 1951, p.72). The artist's genius subsequently manifested itself in many forms, frequently more forcefully, but in drawings such as 'The Road from Old Sarum' (no.295) and in this pencil study of Harnham Bridge, there is a clear-sightedness and a certainty of intent only to be found in drawings of this period. In the drawing from Old Sarum Constable achieves his effect with the slightest of means. No.297 is a contrasting work, richly textured, almost a demonstration of the full range the graphite pencil is capable of achieving.

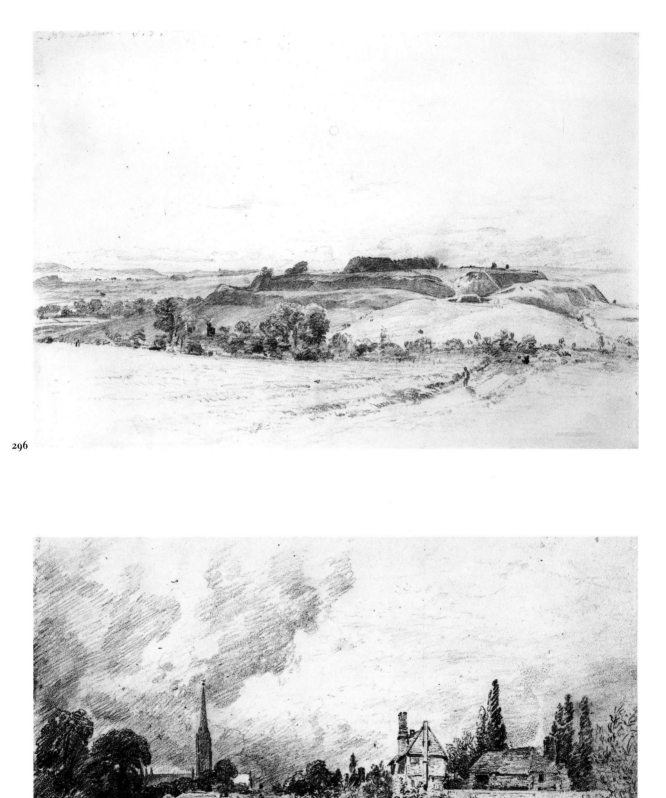

296

297

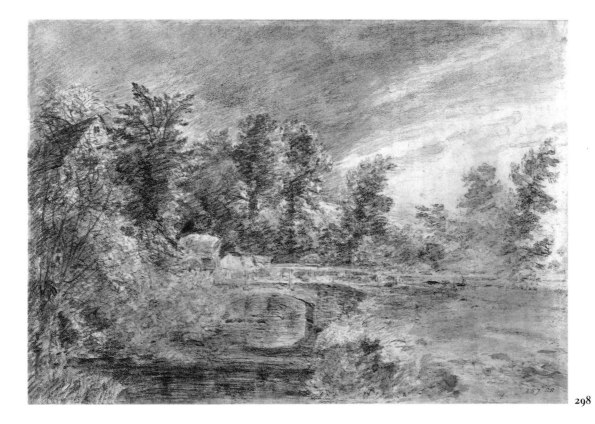

298

298 **The Bridge at Gillingham, with a Cart** 1820

> Pencil and grey wash on untrimmed wove paper with stitch-marks down the left side
> 161 × 236 (6⅜ × 9⁵⁄₁₆)
> Inscribed on the back in a later hand in pencil 'M.L.C.' (Maria Louisa Constable) and in ink '32'.
> PROV: As for no.2
> LIT: Reynolds 1973, no.192, pl.153; Reynolds 1984, no.20.32, pl.157

> *Board of Trustees of the Victoria and Albert Museum, London*

In addition to the living at Osmington, in 1819 John Fisher was given the licence to hold the vicarage of Gillingham, Dorset, by his uncle the Bishop of Salisbury, a gift then worth £1,000 per annum. Dated drawings indicate that Fisher and Constable were away for four or five days in July on this visit to Gillingham. Constable sketched the approach to the village with the church in the middle distance on Sunday the 30th (Reynolds 1984, no.20.33, pl.158). A pencil study in the British Museum (ibid., no.20.31, pl.156) of the bridge from the other side of the river is dated 29 July.

What, one wonders, was the purpose of the grey wash in no.298? It seems only to have had a negative effect. Could it be the work of another hand?

299 **Malvern Hall** 1820

> Pencil on untrimmed wove paper 115 × 185 (4½ × 7⁵⁄₁₆); watermark '[WH]ATMAN | [TURKE]Y MILLS | [18]17'
> Inscribed 'Malverne Hall | Sepr 10. 1820' t.r.
> PROV: By descent from the artist to the present owner
> EXH: Tate Gallery 1976 (184, repr.); New York 1988 (68, repr.)
> LIT: Fleming-Williams 1976, p.72, pl.28; Reynolds 1984, no.20.70, pl.192

> *Richard Constable*

This aspect of Malvern Hall was one of several that Constable had drawn on his first visit in 1809 (see nos.68–70).

In 1819 he had executed an unusual commission for his host, H.G. Lewis, a portrait of an ancestor, Humphri de Greswolde, dressed as a Norman warrior, a painting on panel for a space between windows on the main staircase of the house. The painting had been installed and Lewis now wanted Constable's help with an heraldic companion panel. He had also wanted the artist to come and see the restorations he had been making to the house – bringing it to what it had been before 'that *Modern Goth*, Mr. Soane' spoilt it – and wished for the artist's opinion 'in forming the Landscape of the park by cutting glades' etc. (Beckett IV 1966, p.62).

Constable's drawing of the restored entrance front was probably drawn with a fresh commission in mind; an order for two paintings of her old home

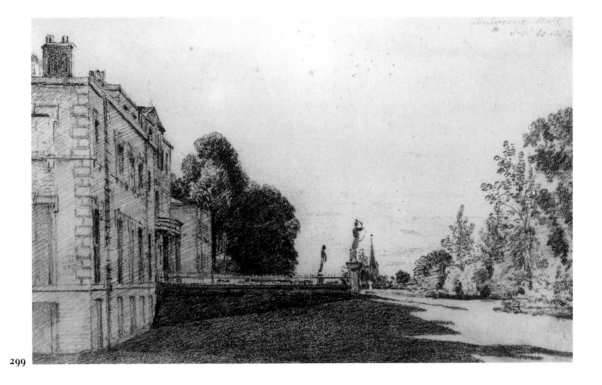

299

from Lewis's sister, the Dowager Countess of Dysart (Reynolds 1984, nos.21.80, 21.82), who appears to have been staying with her brother at the time.

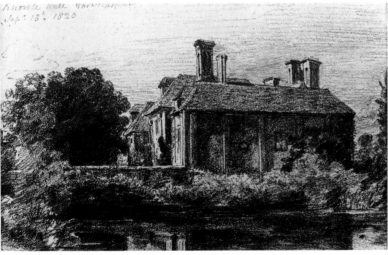

300

300 Knowle Hall 1820

Pencil on untrimmed wove paper with stitch-marks down the left side 115 × 185 (4½ × 7⁵⁄₁₆)
Inscribed in pencil 'Knowle Hall
Warwickshire | Sepʳ 13ᵗʰ 1820' t.l.; and in another hand in ink on the back 'Residence of Lord Brook who was killed at the seige of Lichfield. – Knowle Hall'
PROV: As for no.2
LIT: Reynolds 1973, no.199, pl.151;
Reynolds 1984, no.20.72, pl.193

Board of Trustees of the Victoria and Albert Museum, London

Situated some two miles from Malvern Hall, Knowle was built early in the seventeenth century by the poet Sir Fulke Greville, 1st Baron Brooke, who died a violent death in 1628. It was his son Robert, 2nd Baron, the parliamentary general, who was killed directing an attack on the Minster Close at Lichfield in 1643.

When Constable made his drawing of the Hall it was occupied by Capt. R.W. Wilson, whose wife, a relation of H.G. Lewis's, had inherited the property jointly with Lewis. Knowle was demolished c.1831.

301 Study of Trees *c.*1821

Pencil on trimmed wove paper 328 × 238
(13 × 9⅜); watermark 'J WHATMAN'
PROV: As for no.2
LIT: Reynolds 1973, no.163, pl.132; Smart
and Brooks 1976, pp.127–8, pl.78; Parris
1981, p.158, fig.9; Reynolds 1984, no.20.85,
pl.203; Cormack 1986, pp.229–32, pl.218

*Board of Trustees of the Victoria and Albert
Museum, London*

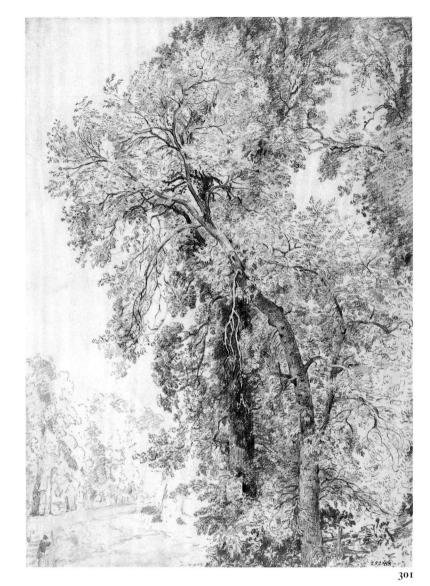

301

While no firm date or location can be given to this
drawing, it seems most likely to have been done at
Hampstead in the early 1820s. In a letter written on
20 September 1821, Constable told Fisher that he
had made some studies 'carried further than I have
yet done any' and then went on to describe one
work in particular, 'a natural (but highly elegant)
group of trees, ashes, elms & oak &c' (Beckett VI
1968, p.73). The painting that matches this
description, no.115, is a highly detailed study in
which the character of each individual species is
closely examined. No.301 – in which the character
of the ash is distinguished with equal clarity from
the other trees – may well be one of the other
studies he mentions.

Constable's feeling for trees was of a remarkable
intensity. 'I have seen him admire a fine tree',
Leslie recalls in his *Life* (1845, p.310, 1951, p.282),
'with an ecstasy of delight like that with which he
would catch up a beautiful child in his arms. The
ash was his favourite, and all who are acquainted
with his pictures cannot fail to have observed how
frequently it is introduced as a near object, and how
beautifully its distinguishing peculiarities are
marked'. In the last of his lectures (given at
Hampstead in July 1836) he illustrated some
practical hints for drawing from nature with a few
of his own tree studies. One was of a 'tall and
elegant ash', of which he said 'many of my
Hampstead friends may remember this *young lady*
at the entrance to the village. Her fate was
distressing, for it is scarcely too much to say that
she died of a broken heart. I made this drawing
when she was in full health and beauty; on passing
some time afterwards, I saw, to my grief, that a
wretched board had been nailed to her side [as one
had to a trunk in no.301], on which was written in
large letters "*All vagrants and beggars will be dealt
with according to law.*" The tree seemed to have felt
the disgrace, for even then some of the top branches
had withered. Two long spike nails had been driven
far into her side. In another year one half became

paralyzed, and not long after the other shared the
same fate, and this beautiful creature [note the
noun] was cut down to a stump, just high enough to
hold the board' (Leslie 1845, p.360, 1951, p.328).
Evidence of a similar anthropomorphic slant is to
be found in the contrast Constable makes between
the living branches of the ash in no.301, drawn with
rhythmic sweeps of the pencil, and the dead one,
hanging down limply from the main trunk.

A squared-up drawing of the ash, mostly in
outline, on paper measuring 416 × 280 mm, was
sold at Christie's on 12 July 1988 (32, repr.)

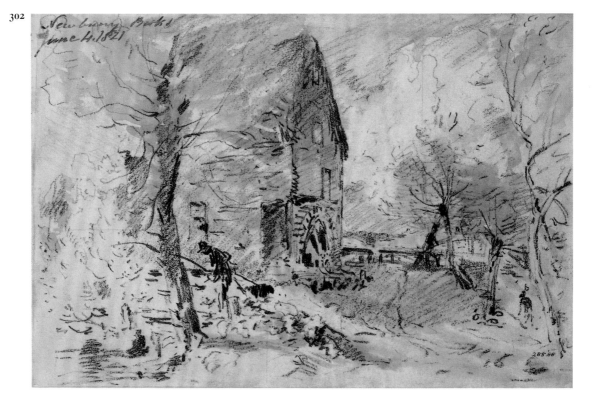

302

302 A Watermill at Newbury 1821

Pencil and grey wash on untrimmed wove
paper 173 × 260 (6¾ × 10¼); watermark
'TURKE[Y MILLS]│J WHA[TMAN]│18[19]'
Inscribed in ink 'Newbury Berks│June 4.
1821'
PROV: As for no.2
EXH: Japan 1986 (33, repr.); *John Constable:
Drawings of Berkshire and Oxfordshire in
1821*, Newbury District Museum, May 1986
(1, repr.)
LIT: Reynolds 1973, no.211, pl.160;
Fleming-Williams 1976 p.74, fig.51;
Reynolds 1984, no.21.17, pl.226

*Board of Trustees of the Victoria and Albert
Museum, London*

See no.303

303 Greenham Lock 1821

Pencil on trimmed wove paper 175 × 248
(6⅞ × 9¾)
Inscribed in ink 'Lock near Newbury│June 5
1821' b.r.; on the back, down the right-hand
edge, a continuation of the left-hand part of a
pencil drawing of the river with a Kennet
barge against the bank, now in the
Huntington Library and Art Gallery
(Reynolds 1984, no.21.21)
PROV: By descent to Charles Golding
Constable and sold by court order after his
death, Christie's 11 July 1887 (9) bt Noseda,
probably for J.P. Heseltine (certainly his by
1902); . . .; Francis L. Bery; . . .; P.M. Turner;
by descent until sold, Sotheby's 15 March
1984 (89, repr.); present owners
EXH: Tate Gallery 1976 (193, repr.); *John
Constable: Drawings of Berkshire and
Oxfordshire in 1821*, Newbury District
Museum, May 1986 (5, repr.)
LIT: Fleming-Williams 1976, p.74, pl.29;
Fleming-Williams 1990, pp.182–7, pl.25
(col.)

Mr and Mrs David Thomson

In the execution of his duties as Archdeacon of
Berkshire, Constable's friend John Fisher was
expected to make an annual tour of inspection of
the four rural deaneries, Newbury, Reading,
Wallingford and Abingdon, during which visi-
tation he would meet representatives of the sur-
rounding parishes. The idea that Constable should

accompany him on the tour of 1821 may have been discussed the previous summer for Fisher had only just returned from a visitation when the Constables were staying at Salisbury with the Archdeacon and his family. The notion is first mentioned in the correspondence when Fisher wrote on 6 March 1821: 'The first week in June I go my Visitation. Will you accompany me free of expence. I shall take Oxford in my way.' (Beckett VI 1968, p.64.)

The two men joined forces in London (Farington XVI, p.5673, 2 June) and probably on the 3rd booked in at the George and Pelican Inn, Newbury. On the 4th Constable made the first drawings of the tour, no.302 and two pencil and wash studies, both canal subjects (Reynolds 1984 nos.21.16, 21.18). The next day he made four more sketches beside the Kennet and Avon canal: no.303; two now in the Victoria and Albert Museum (ibid., nos.21.19, 21.23); and on the page in his sketchbook after no.303, a pencil drawing now in the Huntington Library and Art Gallery (ibid., no.21.21). Eleven further drawings done on the tour are known – views of Reading, Abingdon, Blenheim and Oxford – all from the same 6 by 10 inch sketchbook. From later correspondence with Fisher (Beckett VI 1968, pp.189, 198), it is apparent that he also had with him a smaller sketchbook, on the first page of which he had drawn 'a View of Oxford Bridge', presumably Magdalen Bridge

Nos.302–3 well illustrate Constable's differing working methods when sketching at speed and at a slower pace. In the drawing of the watermill his pencil flies over the page, jumping almost inconsequentially from one rapidly selected accent to another, pressing strongly home when structural detail or chiaroscuro demands it, the general sweep of movement held for an instant by the attitude of the fishermen peering intently down into the millstream. Monochrome wash or watercolour feature in several of the visitation drawings – mostly, as in this case, in the more hastily executed examples.

For no.303 Constable chose a harder graphite and, no longer in such a hurry, built up the scene with the same assurance but with gentler, more deliberate touches, examining the structure and character of each element of the composition with the point of the pencil. The subject was one much after his own heart: a familiar scene – canal, lock, distant church tower – yet strange in every detail, from the water-level of the canal, borne by its banks high above the surrounding fields, down to the smallest working part of the lock gate itself.

303

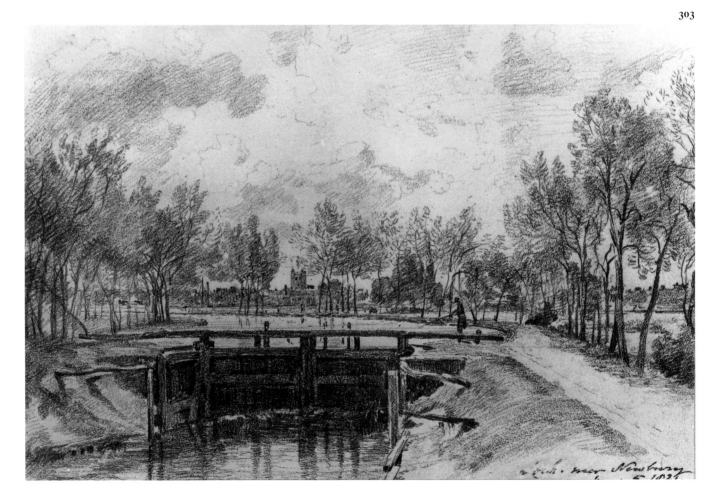

304

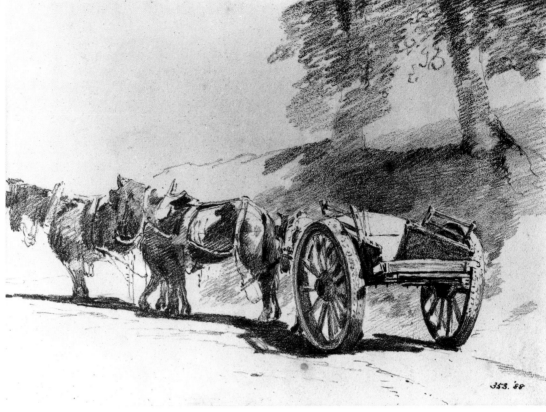

304 A Cart and a Team of Horses at Hampstead 1821

Pencil on untrimmed wove paper with stitch-marks down left side 162 × 236 (6¾ × 9⁵⁄₁₆); watermark '[WH]ATMAN│[1]818'
Inscribed in pencil 'Augst 21ˢ.ᵗ. 1821' b.l.
PROV: As for no.2
LIT: Reynolds 1973, no.220, pl.165; Reynolds 1984, no.21.43, pl.249

Board of Trustees of the Victoria and Albert Museum, London

One of two drawings done on 21 August (see Reynolds 1984, no.21.42, pl.248), no.304 is an unusually detailed study of one of the teams that worked on the Heath, teams that featured so often in his paintings of Hampstead. Constable's interest here was mainly concentrated on the vehicle, with its massive, studded wheels. The team is rendered in a more cursory, painterly fashion. It will be noticed that to avoid confusion, he has ignored the presence of the legs of the nearest horse, leaving the paper white between the spokes of the nearside wheel. A similar team was sketched a few weeks later in a smaller book (ibid., no.21.56, pl.261).

305 Flatford Lock 1823

Pencil and grey wash on two trimmed sheets of wove paper from adjoining pages in a sketchbook 172 × 50 (6¾ × 1¹⁵⁄₁₆) and 172 × 267 (6¾ × 10½); overall size 172 × 317 (6¾ × 12½)
Inscribed in pencil 'Flatford 19 April 1823' b.r. and (in another hand?) in faded ink 'April 19 1823'
PROV: By descent to Charles Golding Constable, by whom given to A.J. Clark; his grandson, sold Sotheby's 21 Nov. 1985 (118, repr.); present owners
LIT: Fleming-Williams 1983a, pp.219–20, fig.33; Reynolds 1984 no.23.8, pl.397; Fleming-Williams 1990, pp.190, 192, 199–200, pl.26 (col.)

Mr and Mrs David Thomson

It has been assumed that when Constable told Fisher on 21 February 1821 that he had 'put a large upright landscape in hand', that he was referring to his preliminary oil sketch for 'The Lock', no.157, or to a start he had made on the final canvas, no.158. Both these and two later paintings of the subject, nos.159–60, depict Flatford lock from the same viewpoint as this drawing. There are, however, differences in the scene as portrayed in the paintings and in the drawing that require explanation. Most noticeable in all the paintings is the absence of the overreaching lintels, so prominent a

feature in the drawing, but of equal importance for a discussion of the place of no.305 in the development of the composition are the differences to be seen in the structure of the lockgates and in the boards on either side of the entrance.

In all but the first oil sketch of the subject Constable gives precisely the same account in the paintings of the construction of the lock, noting clearly details such as the iron strap strengthening the attachment of the two main members at right-angles to each other in the foreground, and the nut around the end of the bolt in the massive post behind which the lock-keeper is working the windlass. No oil sketch or drawing is known from which Constable could have obtained this information, nor is any of it supplied by the drawing of 19 April (no.305). As we have seen, he painted the trees and lock-gates in the 'Boys Fishing' of 1813 (no.57) from two pencil studies (figs.36–7 on pp.130–1 and although this may not be immediately apparent, the trees in 'The Lock' of 1824 are also based on the same c.1812 tree study. If Constable was able to use material such as this, collected at a much earlier date, for his trees, is it not likely that it was from a pencil drawing similar to the study of the upper gates (fig.37), perhaps also of c.1812, that he worked when painting the lower entrance of the lock in 1823–4?

If this was the case, why, we may well ask, when he already had the subject on canvas did he not want to paint the scene as he found it in April? The most probable answer is that it had changed and that he found it less to his liking. In recent years his brother Abram, now running the family business from Flatford, had twice complained to the Commissioners of the Stour Navigation about the condition of the lock and river bank at Flatford. In 1815 his complaint was minuted that the lock 'was in a very ruinous State' and 'that the upper Gates thereof cannot be opened without the assistance of an Horse'. In 1820 his report was noted that the lock 'is become ruinous and in great decay and the bank of the River in a very dangerous state'. After his first complaint an order was minuted that repairs should be completed within nine months; after the second, it was ordered that the lock 'be repaired effectively within one month' (ESRO EI1.394/1). From the drawing we can see that the last order had been executed: a new angle-brace fitted on the side of the nearer post supporting a lintel and a new nut and bolt fixed lower than the previous one; the planks and posts renewed at the entrance; the bank tidied up. Constable, it seems, was unable to resist the temptation to record the new appearance of the lock, but continued to work on the painting from an earlier study that showed the lock, ruinous maybe, but richer in the sort of material he needed for his foreground.

305

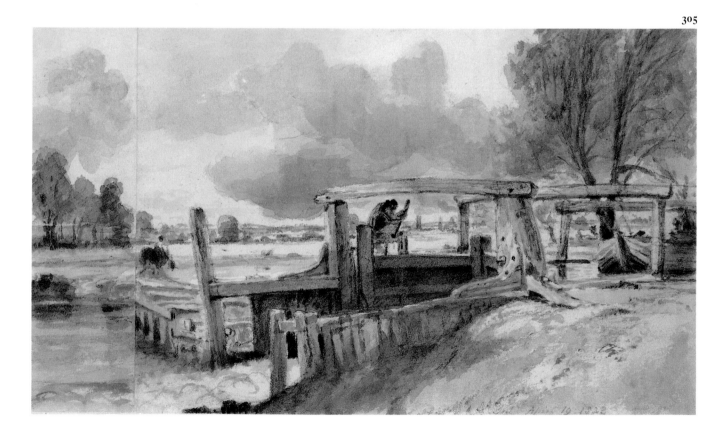

306 *Aug.ᵗ 22. 1823.*

306 Fonthill Abbey from the Road to Gillingham 1823

Pencil on trimmed wove paper 177 × 258 (7 × 10³⁄₁₆)
Inscribed in pencil 'Aug.ᵗ 22. 1823.' t.l. and on the back in pencil 'Sherborne Collegiate church | September 2. 1823
PROV: By descent to Charles Golding Constable, sold Christie's 17 Feb. 1877 (171) bt Ellis; . . .; anon. sale, Sotheby's 30 March 1983 (142, repr.); present owners
LIT: Reynolds 1984, no.23.18, pl.406

Mr and Mrs David Thomson

This unusual view of Fonthill was drawn by Constable when he and Fisher were on their way from Salisbury to Gillingham to join Mary Fisher and the children, having taken the longer, northerly route (now the B3039) through Hinden, possibly in order to pass by William Beckford's famous abbey. Woods now totally cover the low hills to be seen on the right of the drawing and only the pair of hills to the left and the straight stretch of road enable Constable's viewpoint to be identified with any degree of certainty.

There had been plans for a stay with Fisher at Osmington the previous October and a visit to Fonthill had been mooted, but pressure of work rendered it impossible for Constable to get away. 'I do not regret not seeing Fonthill', he told Fisher, 'I never had a desire to see sights – and a gentleman's park – is my aversion. It is not beauty because it is not nature' (Beckett VI 1968, p.98). However, while Constable was at Gillingham Fisher took him to see 'that extraordinary place' (Beckett II 1964, pl.284) on the 28th, as there was a view of a sale there. He appears to have been quite overwhelmed and quite forgot his aversion to gentlemen's parks, describing it to Maria as 'a strange – Ideal romantic place – quite fairyland' (ibid., p.285). From the top of the tower, to which he wandered, he could see the 'wild regions of the downs to the north', the terrain he had drawn in no.306, and from that height, 'Salisbury at 15 miles off darted up into the Sky like a needle'.

The inscription on the back of no.306 refers to a drawing Constable made on the next page of his sketchbook, a careful and detailed study of the abbey church at Sherborne (Reynolds 1984, no.23.19, pl.407).

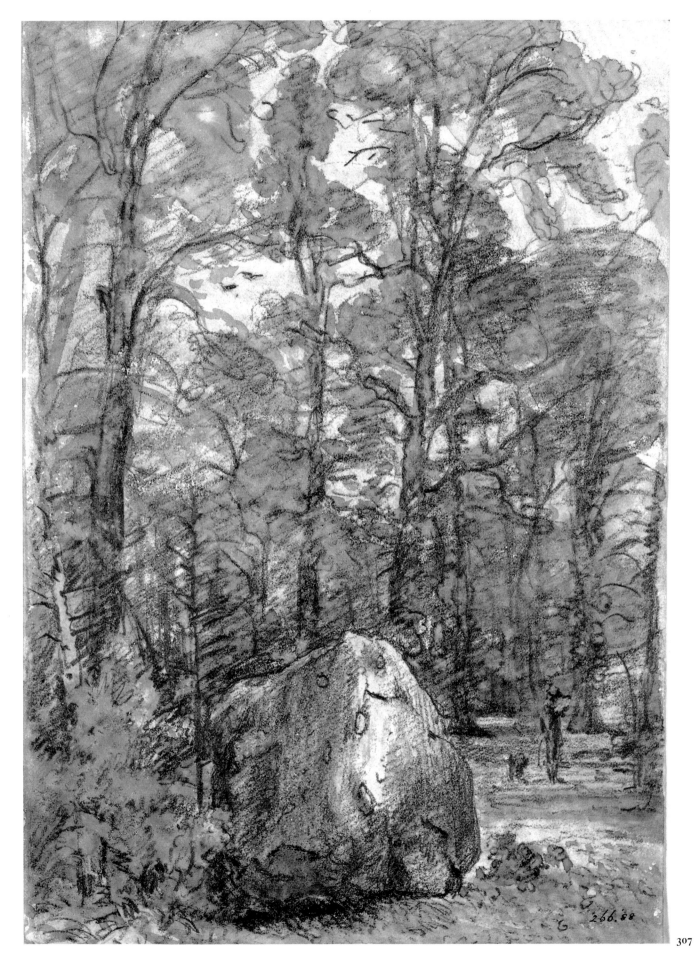

307

fig.144 'Cenotaph to Sir
Joshua Reynolds', 1823,
*Board of Trustees of the
Victoria and Albert Museum,
London*

fig.145 'A Stone Dedicated
to Richard Wilson', 1823,
*Board of Trustees of the
Victoria and Albert Museum,
London*

307 A Stone in the Garden of Coleorton Hall 1823

Pencil and grey wash on trimmed wove paper
254×181 ($10 \times 7\frac{1}{8}$)
Inscribed on the back in ink 'Stone in the
Garden of Coleorton Hall'
PROV: As for no.2
LIT: Reynolds 1973, no.261, pl.197;
Reynolds 1984, no.23.33, pl.421; Felicity
Owen and David Blayney Brown, *Collector of
Genius: A Life of Sir George Beaumont*, New
Haven and London 1988, p.219

*Board of Trustees of the Victoria and Albert
Museum, London*

No.307 is one of three drawings Constable made of
the grounds of Coleorton Hall. The other two, of
the cenotaph erected to the memory of Sir Joshua
Reynolds and of the stone dedicated (according to
the inscription) to the painter Richard Wilson, are
both dated 28 November (see figs.144–5, Reynolds
1984, nos.23.31–2). It does not previously seem to
have been pointed out that no.307 is another view
of the Wilson stone, a view from a spot about ninety
degrees round to the left from the other (fig.145).
The similarity of no.307 to the two dated studies
leads one to suppose that this drawing, too, was
done on the 28th, almost at the end of Constable's
stay at Coleorton.

Beaumont had known Wilson, and one of the
rare likenesses of the artist in his later years is an
etching after a caricature by him of the old man in
near profile with his maulstick and bibulous nose.
By the 1820s, Wilson had become a revered
memory, and a great rock, so often a feature in the
foreground of his landscapes, was evidently con-
sidered a suitable tribute. It apparently took the
combined strength of twenty-three horses to place
it in position (see Owen and Brown 1988). Carved
in half-inch letters, the stone is inscribed
'BROUGHT HERE 6 JAN 1818'. Beyond, in no.307,
there is to be seen a figure in an attitude as if
reading, with a dog. Was this Beaumont obliging
yet again (see no.308)? The stone is now almost
hidden by a large yew tree, growing immediately
against it. This may be the young tree beside the
stone that Constable sketched in no.307.

308 Trees in a Lane at Staunton Harold, Leicestershire 1823

Pencil on untrimmed wove paper with stitch-marks down left side 180 × 262 ($7\frac{1}{8}$ × $10\frac{5}{16}$); a lighter triangle of graphite to be seen near t.l. corner, where fixative was not applied
Inscribed in pencil on the back
'Leicestershire – the lane leading to Ferrars Hall – Ld Ferriers house | I was on horseback with Sr G.B – who kindly held my horse | when I made this sketch | 1823 | I think it was the finest ash I ever saw'
PROV: As for no.2
LIT: Reynolds 1973, no.262, pl.195; Reynolds 1984, 23.26, pl.414

Board of Trustees of the Victoria and Albert Museum, London

Constable's visit to Coleorton was a turning-point in his relationship with Sir George Beaumont. When they first met in 1795, Beaumont was a renowned connoisseur, the most distinguished amateur painter of the day, whilst Constable was a mere youth, untutored in art and socially of an inferior station. Beaumont was very helpful to Constable during the latter's student years, but then, for some time, his interest waned, only to revive when Constable began to exhibit his six-footers and was elected ARA. In 1821, the year of 'The Hay-Wain', Constable was dining once more with the Beaumonts in London. In October 1823 he received an invitation from Lady Beaumont at Coleorton, the Beaumont seat in Leicestershire: 'if you should be disposed to take a little country air for a few days we should be glad to see you' (Parris, Shields, Fleming-Williams 1975, p.146).

During his stay – planned for two weeks, but extended to nearly six – one of Constable's great delights was his acceptance by the Beaumonts as one of themselves. He and his host spent the mornings at work in the painting room at the top of the house, and at two o'clock the horses were brought to the door 'and Lady Beaumont hunts us both out' (Beckett II 1964, p.292). Beaumont always rode out in the afternoon, 'fine or foul' (ibid., p.296), so one fine day, he told Maria, 'I had an opportunity of seeing the Ruins at Ashby – the mountain stream and Rocks (such as Everdingens) at Griesdieu [Grace Dieu] – and an old convent there Lord Ferrer's – a Grand but melancholy spot' (ibid., p.292). Graham Reynolds (1984) explains that 'Ferrars Hall' was identified by Andrew Shirley as Staunton Harold, some two and a half miles from Coleorton. It must have been on this outing that Constable sketched the finest ash he ever saw, while Sir George held his horse. No.308 appears to have been executed in two stages: the ash, the tree on the left, with the cottager and cart, drawn on the spot; the rest, scribbled in with a blunter pencil, probably done some time later.

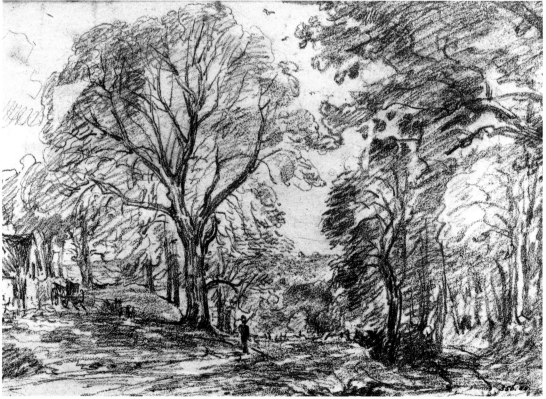

308

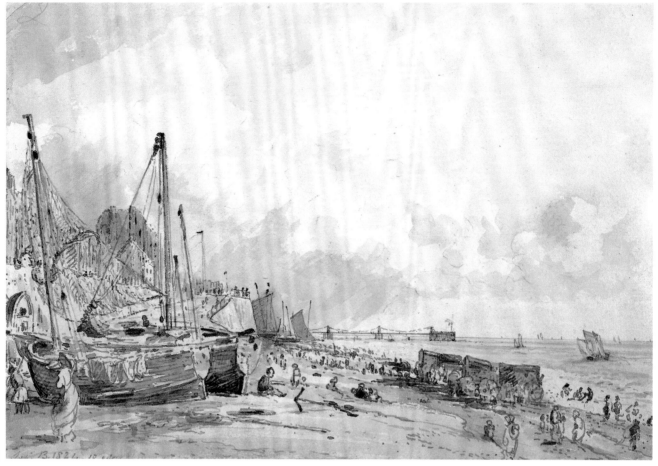

309

309 **Brighton Beach, Looking East** 1824

Pencil, pen and grey wash on trimmed wove
paper 179 × 261 (7$\frac{1}{16}$ × 10$\frac{5}{16}$)
Inscribed in pencil 'Sepr 13. 1824. 10 oclock'
b.l., '2' in pencil t.l.; certified as authentic on
reverse of backing card by Charles Golding
Constable's widow, Mrs A.M. Constable, on
9 June 1879
PROV: By descent to Charles Golding
Constable and sold by court order after his
death, Christie's 11 July 1887 (probably
either 28 or 38) bt Noseda for J.P. Heseltine,
sold Sotheby's 25 March 1926 (120) bt
Agnew, from whom bt by A. Murray-Smith
1933; . . .; anon. sale, Christie's 28 June 1963
(11) bt Oscar Johnson, from whom bt by
present owner the same year
LIT: Reynolds 1984, no.24.30, pl.502;
Fleming-Williams 1990, p.206, fig.194

Private Collection, New York

See no.310

310 **Fishing Boats on Brighton Beach** 1824

Pencil, pen and brown ink and grey wash on
wove paper 178 × 260 (7 × 10$\frac{1}{4}$)
Inscribed in ink '25 Sepr 1824' b.l.
PROV: By descent to Charles Golding
Constable, who died 1879; his widow Mrs
A.M. Constable, by whom given to Frank
Wall 25 June 1879; by descent to the vendor,
Christie's 19 March 1985 (106, repr. in col.);
present owner
LIT: Fleming-Williams 1990, p.206, fig.195

Private Collection

For the first half of Constable's long stay at
Brighton (July to October) with his family in 1824,
he appears to have sketched exclusively in oils.
After the last of his dated oil sketches (20 August,
Reynolds 1984, no.24.20, pl.493) he seems to have
abandoned oils and, out-of-doors, to have devoted
himself to drawing. With a few exceptions all the
drawings are of one subject, the Brighton longshore
fishing fleet, the boats and their crews, and the gear
that littered the beach – the nets, blocks and tackle,
capstans, etc. What, we may well ask, had moti-
vated this radical change in choice of medium?

In a letter to Fisher postmarked 29 August, just
before making the first of the series of drawings of

life on the shore, he had written somewhat scathingly of the subject as material for a painter:

> there is nothing here for a painter but the breakers – & sky – which have been lovely indeed and always [?various]. the fishing boats are picturesque but not so much as the Hastings boats. which are luggers . . . but these subjects are so hackneyed in the Exhibition and one in fact so little capable of that beautiful sentiment that Landscape is capable of or which rather belongs to Landscape that they have done a great deal of harm to the art – they form a class of art much easier than Landscape & have in consequence almost surplanted it'
>
> (Beckett VI 1968, p.171)

Yet three days later, on 1 September, he is to be found making the first of the dated drawings in the series, 'Brighton Beach, with Capstans', a view looking westwards at the end of the day (Reynolds 1984, no.24.26, pl.499).

The only reference to the series is in a letter Constable wrote some time after from London in answer to a plea from Fisher (in Bath) on behalf of his wife who had been ill and needed cheering up. 'Should you be afraid', Fisher had written, 'to send me by the Bath Coach one of your sketch books? We are sadly at a loss for employment: and copying ⟨your⟩ the leaves of your mind is a great source of amusement to my wife' (27 November, Beckett VI 1968, p.184). Constable replied, on 17 December:

> Everything which belongs to me – belongs to you and I should not have hesitated a moment about sending you my brighton book – but I will tell you – just at the time you wrote to me

my frenchman was in London. We were settling about work. and he has engaged me to make twelve drawings (to be engraved here. and published in paris). all from this book . . . I work at these in the evening. This book is larger than the others – and does not contain odds. and ends – I wish it did but all complete compositions – all of boats. or beach scenes'

(ibid.)

The Frenchman was of course the Paris dealer, Arrowsmith, who had recently bought, among other works, 'The Hay-Wain'.

From this letter one gathers that it was only in December that Constable agreed to prepare some Brighton drawings for the engraver, and from this it might be assumed that the idea for the series was Arrowsmith's. This, however, seems unlikely. The drawings are all executed with care in pen and wash over equally deliberate pencilling and in a formal style consistent with studio work, but from the immediacy of much of the subject matter it is clear that they were initially drawn on the spot. This suggests predetermination, that the series was drawn (perhaps just in pencil) in accordance with some sort of plan.

At Brighton, in 1824, Constable formed a new friendship; with Henry Phillips, a banker turned author who had published a number of works on botanical and horticultural subjects (see no.165 for his suggestions about suitable flora for 'The Cornfield'). Phillips appears to have been a man full of plans of one sort or another and it is possible that Constable himself first thought of publishing – in his case a series of Brighton views – during his talks with his friend.

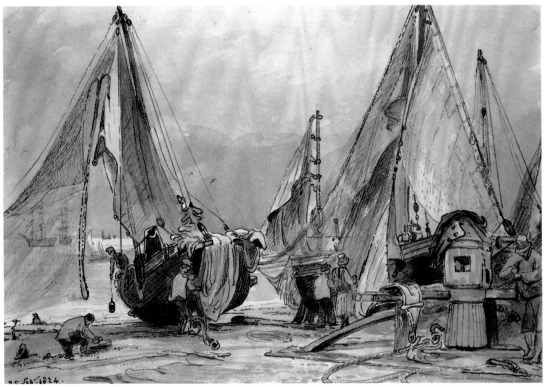

310

311

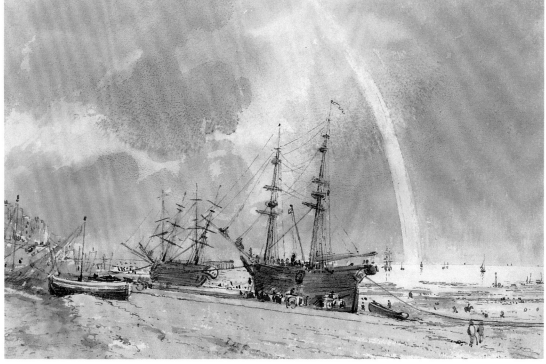

311 Brighton Beach, with a Rainbow: Colliers Unloading 1824

Pen and grey wash on wove paper 176 × 261 (6$\frac{15}{16}$ × 10$\frac{5}{16}$)
PROV: By descent Charles Golding Constable and sold by court order after his death, Christie's 11 July 1887 (32) bt Shepherd; Charles E. Lees, by whom to Oldham Art Gallery 1888
LIT: Reynolds 1984, no.24.34, pl.506; Fleming-Williams 1990, p.212

Oldham Art Gallery

See no.312

312 Colliers on Brighton Beach 1825

Pencil on wove paper trimmed at left
114 × 184 (4$\frac{1}{2}$ × 7$\frac{1}{4}$)
Inscribed in pencil 'Brighton|Oct 14. 1825' b.l.
PROV: ...; anon. sale, Sotheby's 16 July 1987 (132, repr.); present owners
LIT: Fleming-Williams 1990, p.213, fig.197

Mr and Mrs David Thomson

A fast-growing, fashionable resort, Brighton must have depended for coal very largely on supplies delivered by sea. As the nearest harbour, Shoreham, was several miles along the coast and as the beach at Brighton was suitably hard, it was more economical for the masters of the colliers to bring their vessels in at high water there, to beach them not far from the centre of the town, and then to have them unloaded as the tide receded. Constable often sketched the scene – from afar (see no.147), from close to and at varying states of the tide. His interest in colliers was understandable. Trading in coal had been an important part of the family business when he worked in it and his father had owned a brig, the *Telegraph*. In a report of a meeting of Essex and Suffolk dealers assembled to review the price of coal, East Bergholt (i.e. Flatford) was listed as one of thirteen 'ports' in the area (*Ipswich Journal*, 11 July 1789).

At Brighton, the colliers usually arrived at the beach in threes. In no.311 we see two of them (and the masts of a third) at low tide. The nearest is unloading and there are horses and carts alongside under the derrick. Constable's practised eye details the masts and rigging with considerable expertise.

In 1825 he took Maria to Brighton again, this time in August, and could only afford to join them there for short visits – in September, October, November and December. On the October trip he made four drawings: a pencil sketch of the partly ruined church at Hove (Reynolds 1984, no.25.21, pl.592); no.312; another of the colliers from a distance (ibid., no.25.20, pl. 591) – all three dated 14 October; and an undated sketch of the same vessels, this time in pen and wash (private collection). In no.312 the familiar trio of vessels is joined by a fourth, also with her sails furled. Constable has just scrawled the sea in, but note how brilliantly he has captured the movement of the boat with its crew, rowing out from the shore.

Constable, we know, had a healthy respect for Turner and expressed his admiration for his work a number of times, but we appear to have no know-

312

ledge of Turner's opinion of Constable, at least not of him as an artist. There is, however, a record of one of Turner's comments on Constable on another matter, on the latter's knowlege of ships. This is to be found in a letter written by Robert Leslie, the son of Constable's biographer, a letter published by Ruskin in *Dilecta*, a coda to his *Præterita* (ed. K. Clark, 1949, p.536). Leslie was recollecting Petworth in 1834, when he was eight years old. His father had made a model ship for him out of a flat piece of board and Constable (this must have been in September) had stuck a sail on it for him. 'I must have mentioned this to Turner, as I have a recollection of him saying, as he rigged it, "Oh, he don't know anything about ships," or "What does he know about ships? this is how it ought to be," sticking up some sails which looked to my eyes really quite ship-shape'. In a previous letter Leslie describes how Turner (possibly to outdo Constable) had stuck masts into the little ship and torn out some pages from a small sketchbook for the sails.

313 First Study for 'The Leaping Horse' 1824

Pen, brown ink (or wash?), grey and brown wash on trimmed laid paper 202 × 300 (8 × 11$\frac{13}{16}$)
PROV: By descent to Isabel Constable, by whom presented to the British Museum 1888
EXH: Tate Gallery 1976 (234, repr.)
LIT: Fleming-Williams 1976, p.86, pl.35;
Smart and Brooks 1976, pp.103, 139;
Rosenthal 1983, p.164, fig.196 (col.);
Reynolds 1984, no.25.3, pl.574 (col.);
Cormack 1986, pp.167–8, pl.161

Trustees of the British Museum, London

See no.314

314 Second Study for 'The Leaping Horse' 1824

Pencil, pen(?) and grey wash on trimmed laid paper 202 × 301 (8 × 12$\frac{7}{8}$)
PROV: As for no.313
EXH: Tate Gallery 1976 (235, repr.)
LIT: Fleming-Williams 1976, p.86, pl.36;
Smart and Brooks 1976, pp.103, 139, pl.63;
Rosenthal 1983, p.164, fig.197; Reynolds 1984, no.24.4, pl.575 (col.); Cormack 1986, pp.167–8, pl.162

Trustees of the British Museum, London

The position nos.313–14 probably occupied in the preparatory work for Constable's main exhibit in 1825, 'The Leaping Horse', is fully discussed in the entries for nos.161–2. If the two drawings represent Constable's first attempts to realise the composition, they can probably be dated to mid-November of the previous year. On the 17th he told Fisher that he was planning 'a large Picture' (Beckett VI 1968, p.181) and it is evident that he had chosen a Suffolk subject again. 'I imagine myself driving a nail', he told Fisher, 'I have driven

313

314

it some way – by persevering with this nail I may drive it home' (ibid.). By December he was 'putting a 6 foot canvas in hand' (ibid., p.187).

While the two studies, nos.313–14, represent a new approach to the problems of composing a major work, they also appear to be innovatory stylistically. In some of Constable's oil sketches of the early 1820s (particulary some of the sky studies he made from the back garden of 2 Lower Terrace, Hampstead), and increasingly in his full-size sketches for the six-footers, he was seeking to capture the sparkle and freshness he so strongly favoured with a seemingly random scatter of touches of white (or nearly white) paint, applied sometimes with a brush, sometimes with a palette-knife. In both no.313 and no.314, he has resorted to an equivalent, to scraping and scratching at the surface of the paper. This was a method of obtaining highlights for the invention of which George Robertson (1748–88) is credited, used by both Turner and Girtin in the later 1790s, but for which Constable does not hitherto seem to have found a real need, though he had experimented with it in a watercolour of 1806 ('View in Borrowdale', Reynolds 1973, no.80, pl.43).

At about this time – November, December – in the evenings, Constable appears to have been employed on the drawings of Brighton beach for the engraver S.W. Reynolds (see under no.310) and the explosive, rather wild manner of the two 'Leaping Horse' compositions may well have been a joyful reaction from the restrained, highly disciplined work with pen and wash required of him by the engraver.

315 Flatford Lock 1827

Pencil on trimmed wove paper 221 × 321 ($8\frac{3}{4}$ × $12\frac{5}{8}$); watermark 'J WHATMAN TURKEY MILL | 182[. . .]'
PROV: By descent to Isabel Constable, by whom presented to the British Museum 1888
LIT: Fleming-Williams 1976, p.92, fig.64; Reynolds 1984, no.27.30, pl.659

Trustees of the British Museum, London

In October 1827, rather against his brother's wishes, Constable took his two eldest children, John Charles (aged nine) and Minna (aged eight), to Flatford for a fortnight's holiday. One can understand why Abram was against the idea: 'a more dangerous place for children', he wrote, 'could not be found upon earth, it would be impossible to enjoy your company, as your mind would be absorb'd & engrossed with the Children & their safety' (Beckett I 1962, p.233) The visit, however, turned out to be a great success. This was the first real holiday Constable had had in Suffolk since he was there with Maria in 1817. The children loved it. John, he told his wife, 'is crazy about fishing – he caught 6 yesterday and 10 to day' (4 October; Beckett II 1964, pl.439). Minna was also successful. While the children fished, their father sketched. Half of the drawings he made during those two weeks were of scenes along the river bank, done, presumably, while keeping an eye on the children. One is of John, with his sister, fishing from a barge moored against the bank above Flatford lock (Reynolds 1984, no.27.34, pl.662).

315

One of the finest of the drawings Constable made during his stay with his brother and sister at Flatford, no.315 is a view of the river between the upper gates of the lock and the footbridge upstream. Another of the drawings made on this trip, an almost reciprocal view, is of the lower gates. In that drawing (ibid., no.27.17, pl.647), he seems to have completely ignored the presence of the overreaching lintels – so pronounced a feature in his study of 1823 (no.305) – they would have incommoded his view. In no.315, on the other hand, the single lintel and its supporting members are retained, having an important part to play in the composition. The heron, drawn with a few deft touches of the pencil, reappears in the Lucas mezzotint 'River Stour, Suffolk' (fig.93 on p.320), the engraving of the Huntington 'View on the Stour' (fig.66 on p.195).

316 Flatford Old Bridge 1827

Pencil on untrimmed wove paper with stitch-marks at left side 224 × 331 ($8\frac{13}{16}$ × $13\frac{1}{16}$)
PROV: As for no.2
EXH: Tate Gallery 1976 (250, repr.)
LIT: Reynolds 1973, no.297, pl.222; Smart and Brooks 1976, pp. 117, 138, pl.70; Reynolds 1984, no.27.25, pl.654

Board of Trustees of the Victoria and Albert Museum, London

See no.317

317 Flatford Old Bridge *c.*1827–33

Pencil, pen and brown ink and grey wash on trimmed laid paper 179 × 265 ($7\frac{1}{16}$ × $10\frac{7}{16}$); watermark 'J BUDGEN 1820'
PROV: As for no.2
LIT: Reynolds 1973, no.324, pl.246; Reynolds 1984, no.27.41, pl.669

Board of Trustees of the Victoria and Albert Museum, London

The footbridge that crossed the Stour above Flatford lock and the thatched cottage nearby feature in numerous drawings and paintings by Constable, notably in 'View on the Stour' (fig.66 on p.195). In this exhibition they are best seen in 'Boys Fishing' (no.57). 'Flatford Mill' (no.89), depicting the stretch of the river downstream, was taken from a viewpoint on the slope up to the bridge. This holiday at Flatford enabled Constable to obtain a fresh store of material for possible paintings. In the event, for none of the works he subsequently exhibited does he appear to have used any of the drawings he made in the 1827 sketchbook. No.316, however, may have started him off on a train of thought. As Graham Reynolds has pointed out (1984), the stylistic affinity between no.317 and the studies for 'The Leaping Horse' (nos.313–14) and the existence of a pencil and wash composition of the subject in a private collection (Reynolds 1984, no.27.42, pl.670), suggest that at some later date – probably in the early 1830s – he contemplated another 'canal' canvas based on no.317: the subject, a barge shooting the bridge, with a tow-horse and rider, and with the group of trees he had painted so

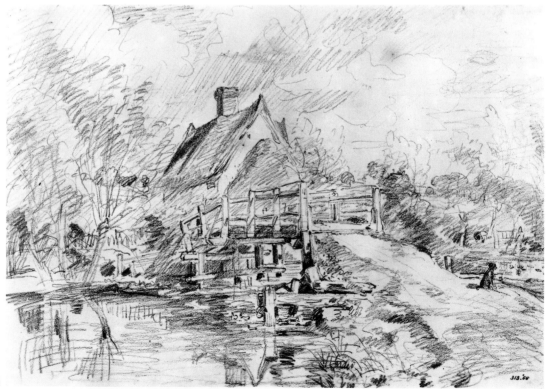

316

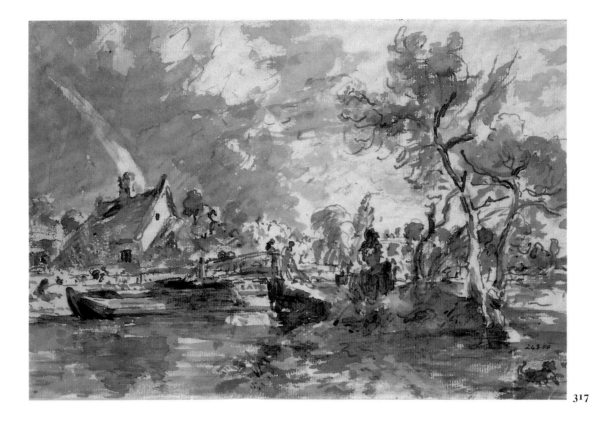

317

318

painstakingly in 'Flatford Mill' (no.89), uprooted and placed on the nearside of the bridge. If this was so, then it is conceivable that no.316 was intended to be a preliminary sketch, a relatively objective study of the structure and the individual timbers of the bridge that would supply him with all the information he might need when he came to reconstruct it on a large canvas.

318 The Schooner *Malta* on Brighton Beach 1828

Pen and ink and grey wash on slightly trimmed wove paper 112 × 180 ($4\frac{7}{16}$ × $7\frac{1}{8}$)
Inscribed in pencil 'May 30. 1828' t.l.; inscribed in ink by Charles Golding Constable t.l. on the back 'Brighton, Wreck of a Schooner lying on the beach. May 30 1828 | J.C. made 4 other sketches of this wreck on the same day. And on | the 29th. (the day previous), he likewise made 4 of her in different vie[ws]'; also inscribed by C.G. Constable's wife in ink in the centre of the back 'I certify this to be the work of my | late Father-in-law | J.Constable R.A. | A M Constable | May 18th 1877'
PROV: By descent to Charles Golding Constable, who died 1879; his widow Mrs A.M. Constable; ...; Berkely Fase; by descent to a grandson, sold Phillips 30 April 1984 (94, repr.); present owners
LIT: Fleming-Williams 1990, pp.210–19, pl.28 (col.)

Mr and Mrs David Thomson

In its issue of 5 June 1828, the *Brighton Gazette* reported that 'a very fine vessel, the Malta, from Sunderland, with coals, has stranded on the beach at the bottom of West-street, but, it is expected she will be got off. The cargo is discharged. Another vessel, *The Shepherd*, coal laden, was also stranded at Hove, but got off to sea on Tuesday [the 3rd] after sustaining considerable damage and is gone to Newhaven to be repaired'. Two days later, the rival paper, the *Brighton Herald*, included a report on the south-west gale that had prevailed 'the greater part of the present week' and gave further news of the stranded *Malta*, which, owing to the 'roughness of the weather' had not 'been got off. As soon as the weather moderates it is intended to launch her, as she now lies too high on the beach to float'. On the 12th, the *Gazette* told its readers that 'The Malta coal brig still lies on the beach, the attempts made to get her off having hitherto proved unsuccesful. A large concourse of spectators assembled on Sunday evening [the 8th] to witness the efforts then made; but owing to a rope breaking, the task was abandoned until the return of the spring tide.' A week later, on the 19th, the *Gazette* had better news of the vessel, which 'after several unsuccessful endeavours was got off to sea last Thursday [12th]'.

Constable brought his wife to Brighton again in May 1828, this time in the vain hope that the sea air would help in her struggle with pulmonary tuberculosis. 'My wife is sadly ill at Brighton', he confessed to Fisher in a letter of 11 June, written after his return to London (Beckett VI 1968, p.237). The last of his dated sketches of the resort, 'Stormy Sea, Brighton' (Reynolds 1984, no.28.13, pl.690) was painted on a visit in July. Maria died at Well Walk, Hampstead, in November.

Nos.318 and 319–22 were made on the second of Constable's trips to Brighton in May. The five sketches of the stranded *Malta* dated 30 May that Charles Golding mentions in his inscription on the back of no.318 are known, but so far only one of those drawn on the 29th has been seen – a faint pencil sketch of a vessel ashore with a wild sea and sky. In no.318 we have the *Malta*, still high and dry, with her companion, the brig, setting her sails, apparently just before she was afloat again and able to depart.

319 Coast Scene with Colliers on the Beach at Brighton 1828

Pencil and grey wash on wove paper trimmed at left 115 × 189 ($4\frac{1}{2}$ × $7\frac{7}{16}$); watermark 'J WH[ATMAN] | TURK[EY MILL]'
Inscribed in ink over pencil 'May 30 1828' t.l.
PROV: As for no.2
LIT: Reynolds 1973, no.304, pl.226; Fleming-Williams 1976, p.96, fig.67; Reynolds 1984, no.28.8, pl.684; Fleming-Williams 1990, p.215 no.I, fig.198

Board of Trustees of the Victoria and Albert Museum, London

See no.322

320 Coast Scene with Vessels on the Beach at Brighton 1828

Pencil, pen and grey wash on untrimmed wove paper, stitch-marks at left side, 115 × 185 ($4\frac{1}{2}$ × $7\frac{5}{16}$)
Inscribed in pencil indistinctly 'May [?30] 1828' t.l.
PROV: As for no.2
LIT: Reynolds 1973, no.305, pl.227; Fleming-Williams 1976, p.96, pl.40; Reynolds 1984, no.28.10, pl.686; Fleming-Williams 1990, p.216 no.III, fig.200

Board of Trustees of the Victoria and Albert Museum, London

See no.322

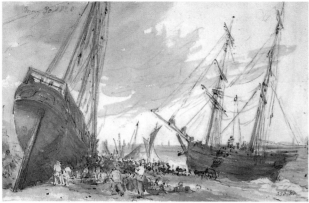

319

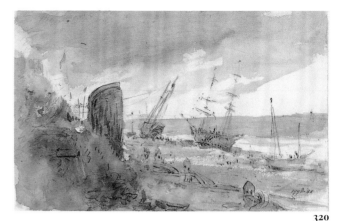

320

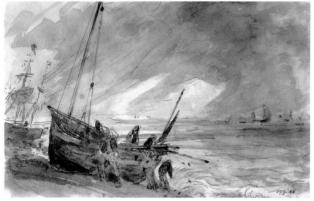

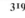

321

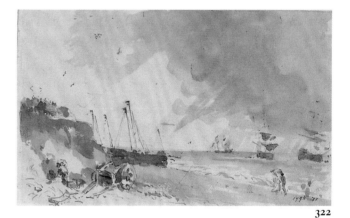

322

321 Coast Scene at Brighton 1828

Pencil, pen and grey wash on untrimmed wove paper, stitch-marks at left side, 115 × 185 (4½ × 7⁵⁄₁₆)
PROV: As for no.2
EXH: Tate Gallery 1976 (255, repr.)
LIT: Reynolds 1973, no.306, pl.226; Reynolds 1984, no.28.11, pl.687; Fleming-Williams 1990, pp.218–19 no.VI, fig.202

Board of Trustees of the Victoria and Albert Museum, London

See no.322

322 Coast Scene at Brighton 1828

Pencil and grey wash on untrimmed wove paper, stitch-marks at left side, 115 × 185 (4½ × 7⁵⁄₁₆); watermark '[TURKE]Y MILL | [18]21'
PROV: As for no.2
EXH: Tate Gallery 1976 (256, repr.)
LIT: Reynolds 1973, no.307, pl.227; Reynolds 1984, no.28.12, pl.688

Board of Trustees of the Victoria and Albert Museum, London

Nos.319–20, with no.318, are all of the *Malta* and the brig from the west. In a pencil drawing also dated 30 May (private collection, Fleming-Williams 1990, fig.201) the two vessels as well as the stranded *Shepherd* in the distance (mentioned in the *Gazette*'s report on 5 June) are viewed from the east. In this drawing Constable shows the *Malta* roped from her masts to the shore to prevent her from listing any further over on to her side. A second pencil drawing of the *Malta* in a private collection (Reynolds 1984, no.28.9, pl.685) with a crowd gathered round her must have been drawn at around the same time as no.319. In this latter drawing, as Graham Reynolds has pointed out (1984), the nearer figures appear to be engaged in lowering 'some bulky object, perhaps a mast or spar'. Others seem to be attempting to 'fill in' under the hull (Michael Robinson has suggested) to prevent the vessel from heeling over any further.

The remaining two drawings, nos.321–2, were probably done before the others. If no.322 depicts the oncoming storm, as seems to be the case, then this sketch may have been done the day before (the 29th) or even earlier; the *Brighton Herald* had reported a gale lasting most of the week. Unlike the others, no.321, with the men struggling to secure their boat, appears to have been done from memory. The *Gazette* for 5 June had said that most of the fishing boats ran to Shoreham for the night to

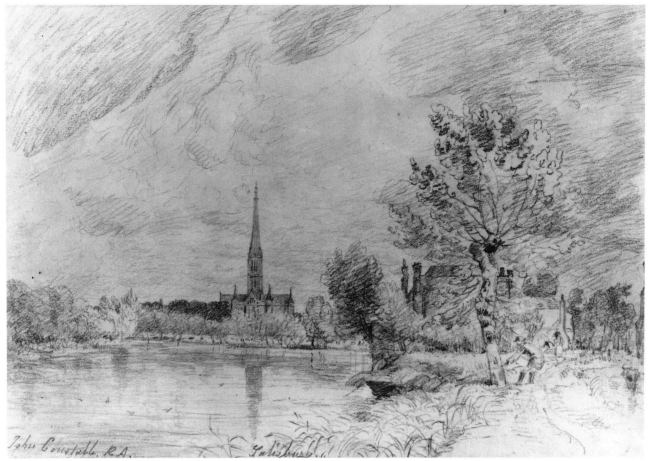

323

escape the gale, but that some had 'put to sea and returned next a.m. with 1000–1500 mackerel'. Are these the boats one can just discern in the distant squall to the right in no.321?

It is unusual to find Constable sketching an event such as this over a period of some days. As far as we know this was quite a short visit to Brighton made, primarily, to be with his ailing wife. We know too little of their life together at this time to even guess as to his reasons for wanting to make a record of the near disaster down on the shore, but following the efforts to save the *Malta* may have afforded him some sort of relief from the fearful inevitability of Maria's terminal condition.

323 Salisbury Cathedral from the West 1829

Pencil on trimmed wove paper 232 × 337 ($9\frac{1}{8}$ × $13\frac{1}{4}$); on the back a reverse image of the foremost figure
Inscribed in pencil 'Salisbury 23 July 1829 noon' b.l.; in a later hand 'John Constable. RA.' b.l. above original inscription and 'Salisbury.' bottom centre
PROV: ...; Mrs Marietta Peabody Tree, sold Sotheby's New York 9 Oct. 1976 (196, repr.) bt present owner

EXH: Milwaukee 1976 (extra no.19, not in cat.); New York 1988 (73, repr.)
LIT: Reynolds 1984, no.29.20, pl.719

Private Collection, New York

Constable stayed with Fisher at Salisbury twice in 1829; for a couple of weeks in July and possibly for rather longer in the autumn. During his first visit he made several oil sketches – all, it seems, from the grounds of Leadenhall, Fisher's house in the Close – and a number of drawings, including a few in watercolour. Three of the pencil drawings were of Old Sarum; six were of the cathedral, taken from some distance away (of which three are discussed in the entries for nos.206–10).

Constable had drawn the cathedral many times before, from close to and from afar, but most of this group of 1829 were of the great church from a variety of new angles. There is no other record of his having explored along this bank of the River Nadder and having drawn the cathedral from almost due west, as in no.323. He and Fisher discussed the subject of his next picture during this visit and a painting of the cathedral was one of the options they had talked about. It is likely that the pencil studies he was making of the cathedral were done while he was scouting along the riverbanks in search of the best views.

324 Stoke-by-Nayland *c.*1829–35

Pencil and iron-gall ink wash with white heightening on irregularly trimmed wove paper 122 × 165 ($4\frac{13}{16}$ × $6\frac{1}{2}$)
Inscribed on the back in ink '[...] I will no longer omit [...] to you – I find [...] | Stoke' and in a later hand in pencil 'R Thompson from Isabel Constable'
PROV: By descent to Isabel Constable, by whom given to R.A. Thompson; ...; Sydney Cowper; by descent to vendor, Sotheby's 16 July 1987 (113, repr. in col.); present owners
LIT: Fleming-Williams 1990, pp.298–300, pl.37 (col.)

Mr and Mrs David Thomson

Stoke-by-Nayland church was the subject of some twenty or so drawings and oil sketches by Constable, mostly depicted on its hill from below as in the Lucas mezzotint (no.196), the late Chicago composition (no.218) and as we see it in the present drawing.

This forceful, 'blottesque' composition, a new variation on a familiar theme, combines elements seen in either the mezzotint or the Chicago 'Stoke' but not in both: the rainbow and sheaf (or bundle) on the woman's head, both prominent in the print (no.196); the sunlight through the branches of the tree on the right and the cattle that he introduced in the painting (no.218). It is unlikely that Constable had visualised the light coming through the leaves of the tree when he was sketching in the branches, as this would have implied a double source of sunlight. But it is possible that no.324 was a preparatory work for a new painting – the Chicago picture – and that the unintended effect of light through the branches in the drawing led him to abandon the rainbows in favour of a light-source similar to the one he had chosen for 'The Hay-Wain', which would enable him to have some of the foliage in the painting translucent.

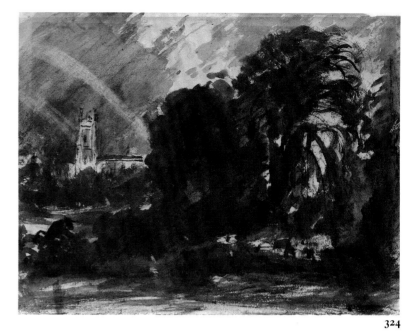

324

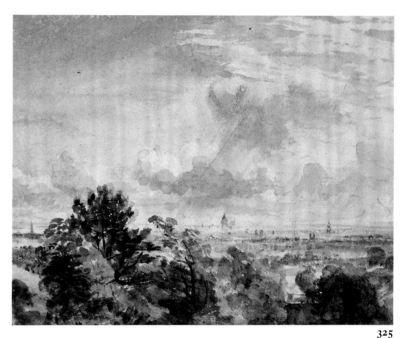

325

325 London from the Drawing-Room, Well Walk 1830

Pencil and watercolour on trimmed wove paper 90 × 115 ($3\frac{9}{16}$ × $4\frac{9}{16}$)
Inscribed in pencil on the back 'Hampstead. drawing Room 12. oclock noon Sep.t 1830'
PROV: By descent to Isabel Constable, by whom presented to the British Museum 1888
EXH: Tate Gallery 1976 (271, repr.)
LIT: Reynolds 1984, no.30.14, pl.781

Trustees of the British Museum, London

See no.326

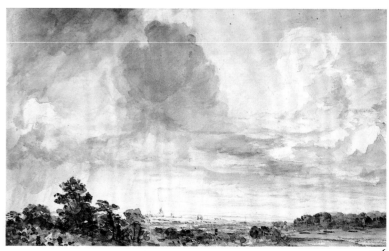

326

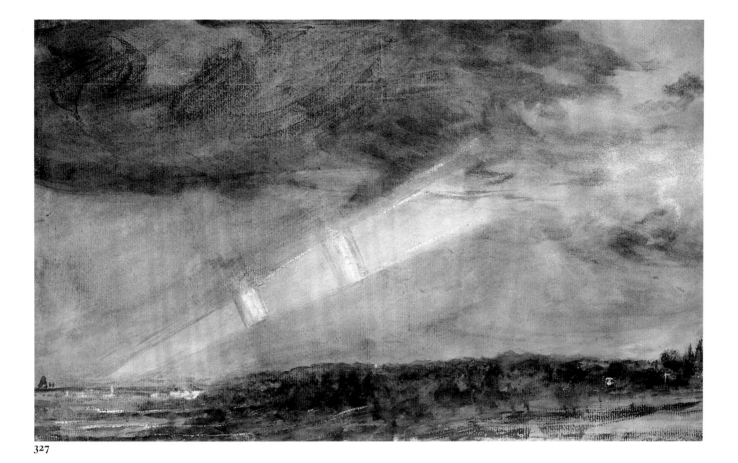

327

326 London from a Window, Hampstead 1832

Pencil and watercolour on trimmed wove
paper 111 × 187 ($4\frac{3}{8}$ × $7\frac{3}{8}$)
Inscribed in pencil on the back '10 to 11
oclock Hamd Window Augt 1832'
PROV: As for no.325
EXH: Tate Gallery 1976 (272, repr.)
LIT: Fleming-Williams 1976, p.100, fig.72;
Reynolds 1984, no.32.30, pl.840

Trustees of the British Museum, London

One imagines that Constable never ceased to
observe the sky, but after the series of cloud studies
in oils of 1821–22 it is not until the early 1830s that
we again find him giving something of the same
attention to the sky.

For the summers of 1819 to 1823 and 1825–6 he
had taken lodgings at Hampstead for his wife and
family. In 1827 they returned there, but this time as
residents, having taken a lease on a house in Well
Walk, No.6. This became his home for the next six
years. (In July 1834 the house was entered 'Empty,
late Constable' in the local rate books.) From the
windows at the back of the house there were
magnificent views to be obtained of London. This
was an attraction from the start: 'our little drawing
Room', he told Fisher in a letter of 26 August 1827,
'commands a view unequalled in Europe – from
Westminster Abbey to Gravesend – the doom [sic]

of St Paul's in the Air – realizes Michael Angelo's
Idea on seeing that of the Pantheon – "I will build
such a thing in the Sky"' (Beckett VI 1968, p.231).
The watercolours he painted from the windows of
No.6 of the skies over London are not to be
compared with the oil studies of the 1820s, either in
number or for intensity of application, but they
make a fascinating group nevertheless.

327 London from Hampstead, with a Double Rainbow 1831

Watercolour on trimmed laid paper
196 × 320 ($7\frac{3}{4}$ × $12\frac{5}{8}$); watermark 'THOMAS
JAMES 1830'; on the back a faint pencil
sketch of St Paul's upon which beams of light
are converging from a cloud
Inscribed on the back in pencil 'between 6.&
7.0'clock Evening June 1831'
PROV: By descent to Isabel Constable, by
whom presented to the British Museum 1888
EXH: Tate Gallery 1976 (283, repr.); New
York 1987–8 (218, repr. in col.)
LIT: Fleming-Williams 1976, p.100, pl.42
(col.); Schweizer 1982, pp.426–7, fig.3;
Reynolds 1984, no.31.7, pl.800 (col.);
Cormack 1986, p.207, pl.197 (col.)

Trustees of the British Museum, London

One of the most dramatic of Constable's water-colours of the view over London from his house in Well Walk, Hampstead, no.327 captures two phenomena that particularly interested him – the rainbow and the shaft of sunlight. Rainbows had a strong appeal for Constable, both for their own sake and, at times for their association value – most noticeably in 'Salisbury Cathedral from the Meadows' (no.210). In his 1982 article Paul Schweizer writes at length on the subject and mentions no.327 specifically for its clarity in differentiating 'between the lower and the narrower primary band of the rainbow and the upper arc, which is always several degrees wider on account of the greater dispersion of prismatic light that takes place in the secondary bow'. Schweizer also points out that Constable had correctly recorded the fact that the colour sequence of the secondary arc is always the reverse of the sequence that appears in the primary one.

The other phenomenon manifest in this view over London is the shaft of light, sometimes (Schweizer tells us) called a 'sun pillar'. Leslie recollected Constable having drawn his attention to the fact that when the sun is behind the spectator 'the rays may be sometimes seen *converging* in perspective towards the opposite horizon' (Leslie 1845, p.310, 1951, p.282). In a picture, he said, he had only seen this effect in Constable's 'Waterloo' (no.213). Having had this pointed out to him, Leslie goes on to say that very early in the morning he had observed the lines of the rays diminish in perspective through a rainbow. Some years after his father's death, Constable's son Alfred wrote to his younger brother Lionel, who, apparently, had also seen the converging rays of the sun: 'only think of you having seen the suns rays going off into Perspective how did it look I believe it is very rare it ⟨it⟩ is painted in the large picture of Waterloo Bidge' (Fleming-Williams and Parris 1984, p.58).

In his article Schweizer points out that in 'Salisbury Cathedral from the Meadows' Constable had violated the laws of optics in depicting a rainbow (which appears only when the sun is behind the viewer) when the sunlight is entering the composition obliquely from the right. The inscription on the back of no.327 – 'between 6.&7.o'clock Evening' – would suggest that Constable observed the effect at that hour, but it fails to explain a similar optical misrepresentation, in this case, the two rainbow arcs revealed by an oblique 'pillar' of sunlight.

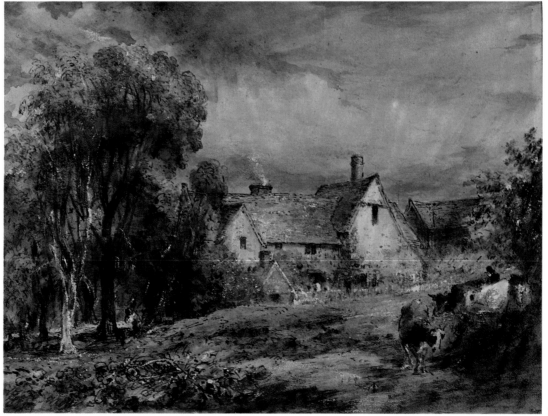

328

328 A Farmhouse 1832, ?exh.1832 or 1833

Pen and ink and watercolour 145 × 190
($5\frac{3}{4}$ × $7\frac{1}{2}$)
Inscribed on the back 'Water Street,
Hampstead. To: Mr. John Allen, East
Bergholt, Suffolk | With the sincere regards of
his friend | John Constable, R.A. | Nov. 22,
1832.'
PROV: Given by the artist to John Allen
1832; . . .; Mr and Mrs Alfred W. Jones, by
whom given to the High Museum of Art,
Atlanta, Georgia 1961
EXH: ? RA 1832 (644, 'Farm-house') or ?1833
(639, 'An old farm-house'); New York 1988
(74, repr.)
LIT: Reynolds 1984, no.32.18, pl.829

*High Museum of Art, Atlanta, Gift of Mr and
Mrs Alfred W. Jones*

In 1806 Constable's sole exhibit at the Royal
Academy was a watercolour – the *Victory* 'in the
memorable battle of Trafalgar' (Reynolds 1973,
no.65, pl.36). He exhibited drawings – pencil
studies – in 1815 and 1819 but after that did not
submit a drawing (or watercolour) again until 1832.
In that year, however, with four oils, including
'Waterloo Bridge' (no.213), he showed an equal
number of drawings. The following year three of
his seven exhibits were drawings and in 1834 he
showed drawings only. In the Academy of 1836 he
was represented by two works, 'The Cenotaph' and
a watercolour, the splendid 'Stonehenge', no.345.
This change of policy is a reflection of his current
practice. After the Salisbury visit of 1829, there is
no record of his ever again having used the oil
medium for sketching out-of-doors.

In all, we have four candidates, all watercolours,
for the six unidentified drawings shown in 1832 and
1833, for those titled 'A church', 'A mill' and
'Farm-house' in the catalogue of 1832, and in 1833
'An old farm-house', 'A miller's house' and 'A
windmill – squally day'. Three of the probable
exhibits are almost exactly the same size; the fourth
(no.328) differs in width only – by some 6 mm.
Two match happily with the titles in the RA
catalogues: the British Museum 'Stoke-by-Nay-
land' with the 'church', and 'Greenstead Mill'
(no.329) with the 'windmill – squally day'. The
dating of the present work, no.328, depends upon
how we match this drawing and 'A Farmhouse near
the Water's Edge' (fig.111 on p.374) with the two
remaining exhibits, the 1832 'Farm-house' and the
1833 'An old farm-house'. The house in fig.111 is
Willy Lott's, an ageless building of no recognisable
date. The farmhouse in no.328 *looks* the older of the
two and could be readily matched with the exhibit
of 1833 were it not for the 1832 inscription. Could
this be yet another case of Constable borrowing
back from its owner a work he wished to exhibit?

As was so often the case in his London years, for
a suitable subject Constable had turned back to a
sketchbook used in Suffolk many years before – to a
page in the earlier of the two he filled in the summer
of 1814, no.253 in the present exhibition. As we can
see, he followed the original pretty closely, only
adding for the sake of interest the figures and the
cattle.

329 Greenstead Mill ?exh.1833

Pencil, pen and watercolour on trimmed
wove paper 146 × 198 ($5\frac{3}{4}$ × $7\frac{13}{16}$)
PROV: . . .; Steinkopff Collection, sold
Christie's 24 May 1935 (8) bt Cooling; . . .;
D.M. Irvine, sold Sotheby's 10 July 1985
(98, repr. in col.); present owners
EXH: ? RA 1833 (647, 'A windmill – squally
day')
LIT: Parris and Fleming-Williams 1985,
p.169, under no.33.35 ('Stanway Mill');
Fleming-Williams 1990, pp.252–61, pl.31
(col.)

Mr and Mrs David Thomson

No.329 is one of three versions of the subject and,
the strongest of the three, the most likely to have
been the exhibit at the Academy in 1833, 'A
windmill – squally day'. Like 'A Farmhouse'
(no.328), 'Greenstead Mill' was also based on a
drawing made some years before, one of two of
windmills drawn on 26 July 1816. Previously titled
'Stanway Mill' from the mill's resemblance to a
windmill Constable drew (and inscribed thus) the
following day, the mill in no.329 may be identified
with some degree of certainty. As Graham Rey-
nolds points out in his entry for the second version
of the subject (1984, no.33.35, pl.891; the third is in
the Edmonton Art Gallery), the church tower to be
seen in the distance is that of St Mary-at-the-
Walls, Colchester. This tower has a stair-turret in
the north-east corner and, as we see it in no.329,
our viewpoint must be to the east of the town.
Hereabouts there stood only two windmills and
only one, Greenstead, was of the correct type, a
post-mill. This mill 'Situated in the Parish of
Greenstead' was described in an advertisement in
the *Ipswich Journal* of 28 July 1798 as being 'well
situated for an extensive retail trade, as well as for
the London Markets, being within half a mile of a
quay, where corn &c, is shipped'.

When Constable made his original drawing of
the mill in 1816 the sailcloths were fully spread,
presumably to catch the light July breeze. In
no.329 he depicts the windmill on a squally day and
has arranged the sailcloths accordingly, partially
reefed at what the millers called at 'sword' or
'dagger point'.

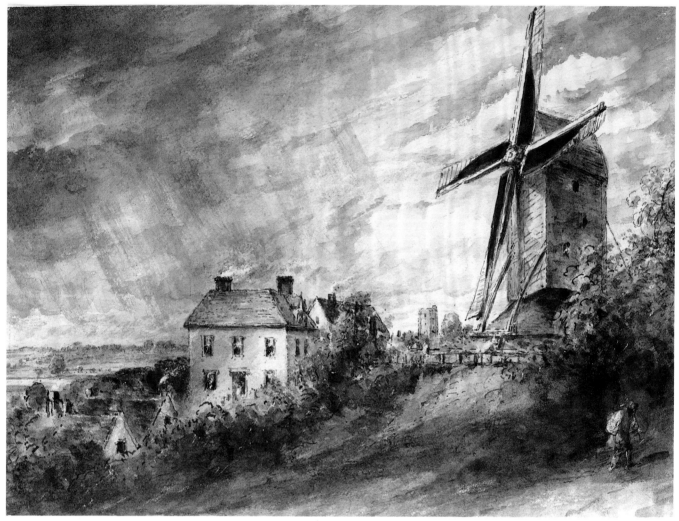

329

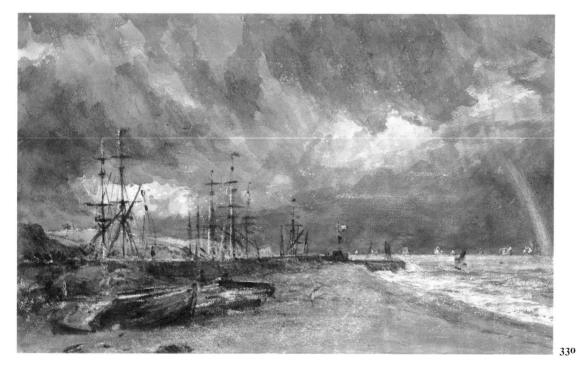

330

330 Folkestone Harbour, with a Rainbow 1833

Pencil and watercolour on trimmed wove paper 128 × 210 ($5\frac{1}{16} \times 8\frac{1}{4}$)
PROV: By descent to Isabel Constable, by whom presented to the British Museum 1888
EXH: Tate Gallery 1976 (325, repr.)
LIT: Reynolds 1984, no.33.24, pl.881

Trustees of the British Museum, London

Having endured brutal treatment himself at a boarding school (Leslie 1843, p.2, 1951, p.2), Constable kept his sons at home and for their education employed a living-in tutor, Charles Boner. In February 1833, however, somewhat reluctantly, he sent his second son, Charles, to a school at Folkestone kept by a Mr Pearce. This proved such a success that in August the eldest boy, John, aged fifteen, was allowed to join his brother there. All was well until John walked in his sleep and suffered an injury that developed into erysipelas. This necessitated leeches and a spell in bed. Constable immediately took coach for Folkestone, arriving there on 10 October; he remained there for nearly two weeks. During this time he made a number of watercolours, mainly of the harbour. No.330, with its threatening sky and delicately tinted rainbow, is the most dramatic of the group.

We have already seen several examples of Constable's use of the knife in his watercolours. Scraping and scratching through colour to the white of the paper features increasingly in his more elaborate, late paintings. Here, in no.330, the raw paper is used to great effect, especially for the scatter of sails catching the sunlight on the horizon.

Like his 'whitewash' that offended the critics so in the 'Waterloo' of 1832, his use of the knife also gave cause for concern. 'We dislike these scraped effects', wrote the critic of the *Reviewer* (20 May 1832, p.82), 'they are unworthy of an artist who is capable of employing the legitimate resources of his art'.

331 East Hill, Hastings 1833

Pencil, pen and watercolour on trimmed wove paper 129 × 209 ($5\frac{1}{16} \times 8\frac{1}{4}$); watermark 'J WHA[TMAN] 182[?8]'
PROV: ...; Fanny, Lady Agnew, wife of Sir George Agnew Bt; her daughter Cicely, who died 1979; Agnew 1980; present owners
EXH: *107th Annual Exhibition of Watercolours and Drawings*, Agnew, Jan.–Feb. 1980 (42)
LIT: Reynolds 1984, no.33.31, pl.888; Fleming-Williams 1990, pp.266–7, pl.32 (col.)

Mr and Mrs David Thomson

Previously thought to be a view of Folkestone, Constable's explicit delineation of the stratification of the cliffs in no.331 has enabled them to be identified as part of the coastline immediately to the east of Hastings. Though a visit by Constable to the latter resort is otherwise unrecorded, the unusual character of the drawing may at least partially explain his reasons for being there.

His son John was a keen collector of fossils and a friend, Robert Bakewell, had presented the boy

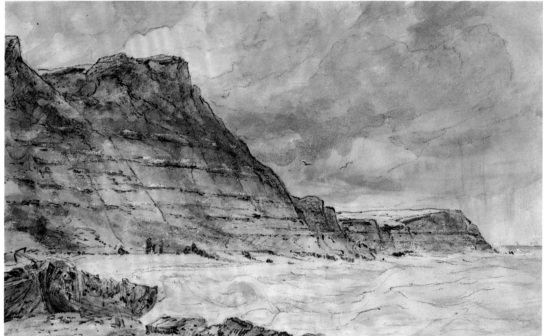

331

with a copy of his *Introduction to Geology* (Parris, Shields, Fleming-Williams 1975, p.50). In John's letters to his brother before joining him at school in Folkestone there are several references to places in the area where Charles should be looking for fossils. In his book Bakewell describes a formation known as the 'Hastings Sands' as being particularly rich in fossils. A likely hunting-ground for specimens from this formation would have been at the foot of the cliffs each side of Hastings itself. It seems probable, therefore, that the purpose of Constable's visit to the resort was to look for fossils for John, his temporarily bedridden son, and that he made this drawing of the cliffs, with its stress on the layering of the strata, a by no means picturesque image, for his son's edification.

332 Study of Trees at Hampstead ?1833, ?exh.1834

Pencil on wove paper 735 × 582 (28$\frac{15}{16}$ × 22$\frac{15}{16}$), including added strips at left and bottom
PROV: ...; Gerald Davies; ...; Colnaghi, from whom bt by Cecil Higgins Art Gallery 1959
EXH: ? RA 1834 (548, 'Study of trees, made in the grounds of Charles Holford, Esq., at Hampstead'); Tate Gallery 1976 (306, repr.)
LIT: Reynolds 1984, no.34.3, pl.914

Trustees of the Cecil Higgins Art Gallery, Bedford

If no.332 was the work exhibited at the Academy of 1834 as 'Study of trees, made in the grounds of Charles Holford, Esq., at Hampstead', it must have been drawn some time the previous year, perhaps in July when Constable made another stylistically similar study of trees in West End Fields (Reynolds 1984, no.33.12, pl.867). Constable had known Charles Holford and his wife since 1824, at least. Stamford Lodge, where Maria and the children spent the summer and autumn of 1823, was very near Holford House. One of the most prominent residents of Hampstead, Charles Holford appears to have been one of the organisers of the lectures Constable gave to the Literary and Scientific Society of Hampstead. He is mentioned as such in a letter Constable wrote to Charles Boner on 26 June 1835: 'I gave another lecture last Monday 22nd at Hampstead at the request of Mr Holford and the committee. It went off immensely well' (Beckett v 1967, p.185).

Exceeded in size only by two tree studies in the Victoria and Albert Museum (Reynolds 1984,

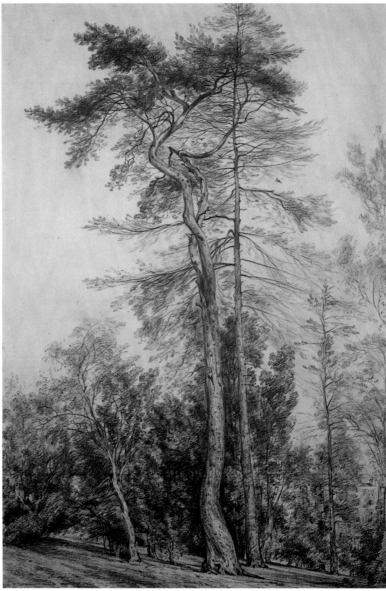

332

nos.35.4–5, pls.990–1), no.332 is probably the finest of Constable's late pencil studies. The five-inch additional strip along the bottom suggests that Constable was initially taken with the upper parts of the two firs, intrigued perhaps by their contrasting characters – the one a single, slender vertical line, the other opening out into a pair of branches that twisted and wove about almost like the arms of a dancer. As was so often the case when he was drawing from nature, Constable was happy to include whatever birds happened to settle or fly about among the trees.

333 North Stoke, Sussex 1834

Pencil on trimmed wove paper 263 × 373
(10⅜ × 14¹¹⁄₁₆); watermark 'J WHATMAN|
183[...]'
Inscribed in pencil 'North Stoke|12 July
Arundel' b.l.
PROV: By descent to Isabel Constable, by
whom presented to the British Museum 1888
LIT: Fleming-Williams 1976, p.112, pl.48;
Reynolds 1984, no.34.16, pl.925

Trustees of the British Museum, London

Sussex, or at least the environs of Brighton, had not
found favour with Constable when he was there
with his wife and family in 1824: 'the neighbour-
hood of Brighton – ', he wrote on the back of an oil
sketch of the fields near his lodgings (no.148),
'consists of London cow fields – and Hideous
masses of unfledged earth called the country'. The
panoramic views inland from the Downs, 'perhaps
the most ⟨natural⟩ grand and affecting natural
landscape in the world', he considered to be 'unfit
for a picture' as it was the business of an artist 'to
make something out of nothing' (Beckett VI 1968,
p.172). However, when he went to stay with a new
friend, George Constable (an unrelated namesake),
a well-to-do brewer and maltster who lived at
Arundel, Constable found West Sussex almost
overwhelmingly beautiful, affording him a release
of feeling he had hardly experienced since the death
of his wife. His eldest son, John, was with him and,

he told Leslie in a letter of 16 July, 'the chalk cliffs
[such as those to be seen in no.333] afford him
many fragments of oyster shells and other matters
that fell from the table of Adam'. The castle, he said
(see no.338), was the chief ornament of the place,
'but all here sinks to insignificance in comparison
with the woods, and hills. The woods hang from
excessive steeps, and precipices, and the trees are
beyond everything beautifull: I never saw such
beauty in *natural landscape* before ... The mea-
dows are lovely, so is the delightfull river, and the
old houses are rich beyond all things of the sort –
but the trees above all, but anything is beautifull'
(Beckett III 1965, pp.111–12).

Generally, Constable was content to work on the
scale determined by the sketchbook or books he
happened to have with him at the time. These, as
we have seen, ranged in scale from small 3 by 4 inch
pocket books to the largest, the 9 by 13 inch one he
took with him to Flatford in 1827 (see nos.315–16).
Occasionally, however, he seems to have felt the
need to work on a larger scale – as was the case with
no.333, a drawing he made soon after his arrival at
Arundel on 9 July. One of his wide-angled studies,
this view looking northwards across the watermea-
dows of the Arun valley is evidently an early
response to the West Sussex scenery, the beauty of
which had made such an impression on Constable.
Technically, with its subtle distribution of accents
and delicate foreground handling, no.333 well
illustrates his remarkably resourceful command of
the medium in these, the years of his later maturity.

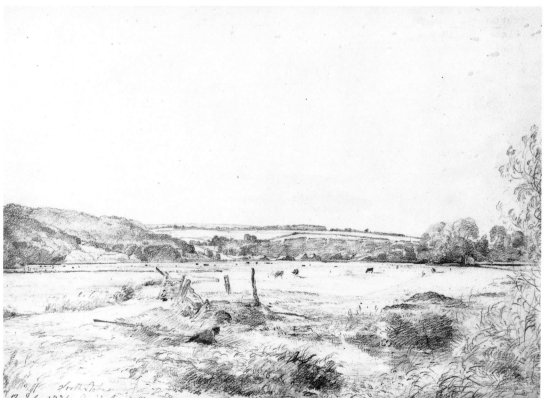

333

334 View on the Arun 1834

Pencil on trimmed wove paper 136 × 230
(5⅜ × 9¹⁄₁₆)
Inscribed in pencil 'July 19 1834' b.l.
PROV: . . .; Hugh Frederick Hornby, who
died 1899; by descent to the vendor,
Lawrence Fine Art, Crewkerne, 19 April
1979 (HA15, repr.) bt Leggatt; present
owners
LIT: Reynolds 1984, no.34.25, pl.934;
Fleming-Williams 1990, pp.268–75, pl.33
(col.)

Mr and Mrs David Thomson

Drawn a week after no.333, 'View on the Arun'
comes from the medium-sized sketchbook, one of
three that Constable used in Sussex that year.

Arundel was a flourishing inland port at this
time. Coastal vessels could sail up the river as far as
the bridge near the centre of the town, and
upstream smaller boats and barges could navigate
their way along a canal system right through to the
River Wey and the Thames. There is a degree of
uncertainty as to the exact whereabouts of the
viewpoint from which Constable made this draw-
ing. But the position of the Portreeves Acre
windmill on the extreme right and the two masts on
the left – on one of which men are furling a sail –
indicates that the creek and the barge in the
foreground must have been below the town bridge.

335 Petworth Park 1834

Pencil and watercolour on trimmed wove
paper 129 × 279 (5⅛ × 11) including a
67 mm-wide strip at left, taken from the
facing sketchbook page
PROV: By descent to Charles Golding
Constable and sold by court order after his
death, Christie's 11 July 1887 (? 52) bt
Colnaghi for the British Museum
LIT: Reynolds 1984, no.34.52, pl.962; Martin
Butlin, Mollie Luther, Ian Warrell, *Turner at
Petworth*, 1989, p.127, fig.121

Trustees of the British Museum, London

Constable told Leslie in his letter from Arundel of
16 July (see no.333): 'we have been to Petworth.
pictures forms [sic] a cheif attraction. I have
thought of nothing else but this vast house & its
contents – the Earl the master of all was there. He
was [pleased] to come out to me, and to Mr. & Mrs.
Constable and their daughter. He wanted me to
stay all day – nay more he wished me to pass a few
days in the house. This I was much pleased at, but I
excused myself for the present, saying I would so
much like to make that visit while you was there –
which he took very agreably, saying let it be so then,
if you cannot leave your friends now. He came out
to us 3 times, & once to the riding house from which
I was sketching' (Beckett III 1965, p.112)

One of the sketches that have survived from that
first visit is a view of Petworth and the church with
a windmill in the foreground (Reynolds 1984,
no.34.19, pl.929). During his subsequent stay at
Petworth in September Constable made good use
of the carriage that Lord Egremont generously
placed at his disposal. Most of the twenty or so
drawings he made while at Petworth were of scenes
in the surrounding country – Cowdray, Cathanger,
Fittleworth, etc. Only two were done within the
grounds of Petworth itself – a rapid sketch of the
house from across the lake and no.335, a view
possibly taken from the top of the Upperton
monument, a Gothic folly within the park, but
almost the furthest point from the house.

Just before his visit, Constable had admitted to
Leslie that he felt awkward with 'the great folks'
(ibid., p.117), and his biographer, a fellow guest,
tells us nothing of Constable in the rather grand
company that frequented the house; only of his
sketching in the park before breakfast and of the
dressing-table in his bedroom, littered with
flowers, feathers and pieces of lichen- and moss-
covered bark that he had collected 'for the sake of
their beautiful tints' (Leslie 1843, p.96, 1951,
p.236). The other view of the house is a slight
pencil and watercolour sketch, probably drawn on
the spot and coloured later (Reynolds 1984,
no.34.50, pl.953 in col.). The panoramic no.335, in
which we see the house to the east with Chancton-
bury escarpment beyond in the far distance, was
drawn across the open sketchbook on to the left-
hand page and may also have been sketched in
pencil on the spot and completed later.

336 A View from Hampstead *c*.1834

Watercolour on trimmed writing-paper
112 × 186 (4⁷⁄₁₆ × 7⅜)
PROV: As for no.2
LIT: Reynolds 1973, no.409, pl.297;
Reynolds 1984, no.33.38, pl.894

*Board of Trustees of the Victoria and Albert
Museum, London*

See no.337

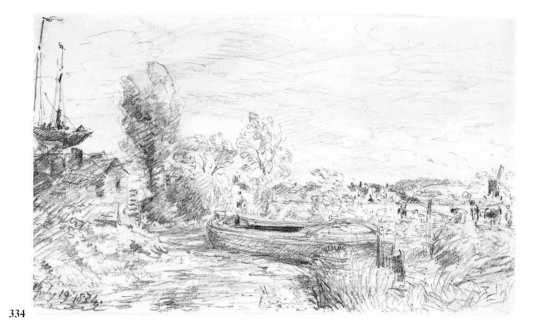

334

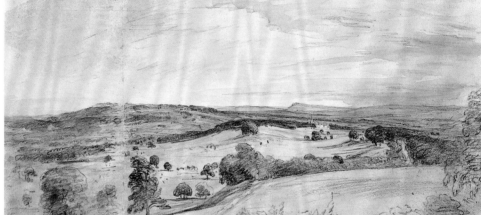
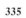

335

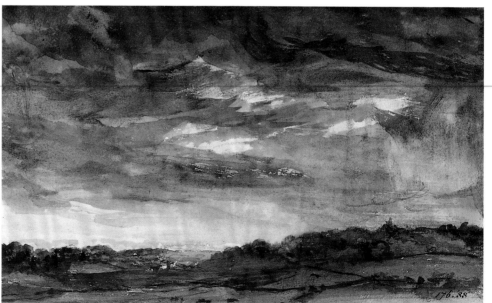

336

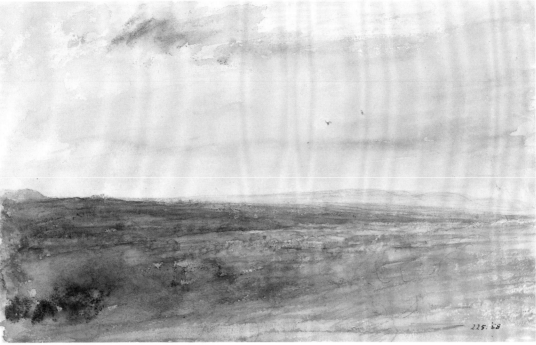

337

337 View of Downland Country *c*.1834

Pencil and watercolour on untrimmed wove
paper with stitch-marks at left side 130 × 211
($5\frac{1}{8}$ × $8\frac{5}{16}$); watermark 'J WHAT[MAN]|
182[...]'; on the back a slight pencil scribble
PROV: As for no.2
LIT: Reynolds 1973, no.393, pl.294;
Reynolds 1984, no.34.65, pl.973

*Board of Trustees of the Victoria and Albert
Museum, London*

Neither of these contrasting watercolours can be
dated with any degree of assurance. Although it
does not include the dome of St Paul's, no.336 is
probably one of the series of paintings Constable
made from one of the windows of his house in Well
Walk, Hampstead, and belongs to the earlier 1830s.
His choice of colour often seems to reflect his health
or state of mind. Black and dark greens inform
many of the paintings of his despairing years,
1811–12; warmer, golden greens appeared increas-
ingly in his work as his long courtship of Maria
Bicknell approached fulfilment. A watercolour
dated 2 April 1834 (Reynolds 1984, no.34.6, pl.918
in col.), the first after a crippling illness, presents a
forbiddingly narrow range of muddy colour.
No.336, with its spiky, nervous brushwork, seems
to suggest that Constable was recording more than
just a rather gloomy day.
 No.337 comes from the sketchbook Constable
used when staying at Folkestone in 1833 (see
nos.330–1) and at Arundel and Petworth in 1834
(see no.335). With good reason, Graham Reynolds
(1984) thinks it to be a view taken in Sussex rather

than in Kent – i.e. in 1834. It was many years since
Constable had selected such a singularly featureless
scene to paint, a prospect reminiscent of some he
had painted at Epsom in 1806.

338 Arundel Mill and Castle 1835

Pencil on trimmed wove paper 219 × 281
($8\frac{5}{8}$ × $11\frac{1}{16}$)
Inscribed in pencil 'Arundel Castle & mill'
t.l., 'Arundel Mill July 9 1835' b.r.
PROV: As for no.2
EXH: Tate Gallery 1976 (326, repr.); Japan
1986 (75, repr.)
LIT: Reynolds 1973, no.379, pl.274;
Fleming-Williams 1976, p.116, pl.50;
Reynolds 1984, no.35.11, pl.997

*Board of Trustees of the Victoria and Albert
Museum, London*

The question of a second holiday with the George
Constables in Sussex was discussed in letters
between Constable and his friend the brewer in the
spring of 1835. Constable finally suggested a date in
a letter of 2 July. 'My poor boy John and myself', he
wrote, 'are panting for a little fresh air ... if it is
quite agreeable to you and Mrs Constable, John, &
myself, will come to Arundel on Tuesday [7th] to
pass a few days with you ... I long to be amongst
your *willows* again, in your walks and hangers,
among your books of antiquities &c, &c, and to

enjoy your society – all as I did before without reserve, restraint, coldness & form, which belongs to "no friendship", and "great houses"' (Beckett v 1967, p.23). In the letter Constable also asked if he could bring his eldest girl, Minna. They travelled down on the 7th, as planned, for on the 8th he was already out with two of his sketchbooks, drawing a picturesque ruin in the town (Reynolds 1984, no.35.10, pl.996) in the larger book and a view of Littlehampton harbour in the smaller one (ibid., no.35.9, pl.995 in col.). On the 9th he walked up the valley and in the larger book made this drawing of the mill owned by the Duke of Norfolk with the castle, the ducal residence, beyond.

One of the finest drawings he made on this trip,

passages of no.338 are unmatched for unabashed bravura and sheer vigour of execution. The main tree on the right in particular appears to have been drawn with a positive whirlwind of pencil strokes of varying intensity, the forms of the branches sensed three-dimensionally in space, as always in the work of his maturity.

The last dated drawing in the small sketchbook is inscribed '19th. July 1835. Arundel. dear Minnas birthday.' (fig.117 on p.384). Of the castle on its tree-clad promontory, it appears to have been drawn from closer to than no.338. In the painting (no.220), it was upon this drawing rather than on no.338 that he relied for some of the details of the castle and the trees.

338

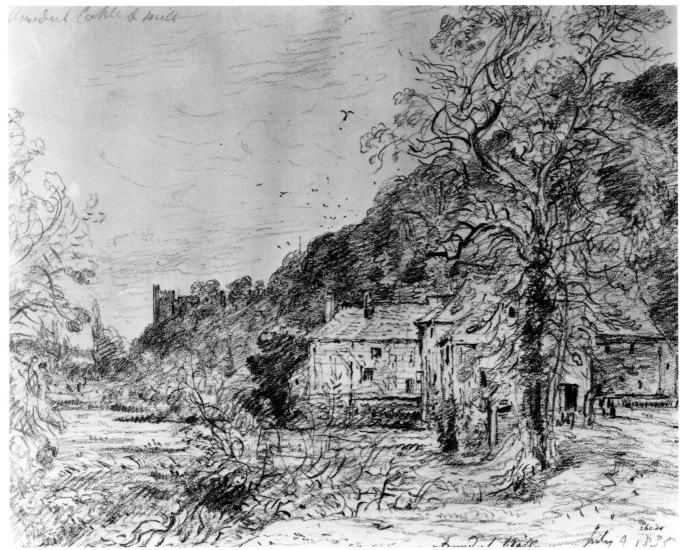

[483]

339 Maudlin, near Chichester 1835

Pencil on untrimmed wove paper 285 × 222
($11\frac{1}{4}$ × $8\frac{3}{4}$); watermark 'J WHATMAN 1833'
Inscribed 'Maudlin ! near Chichester – July
18. 1835.' t.r.
PROV: . . .; Major Leonard Dent; by descent
to present owner

Private Collection

Maudlin, spelt so at the present time and also on
the Ordnance map of 1813, lies at the junction of
the main Arundel to Chichester road (A27) with the
road from Petworth (A265). A village of modest
proportions now, in Constable's day it appears to
have been little more than a hamlet. No.339 was
drawn on a day trip to Chichester, presumably with
the two children and his host, George Constable.
After a storm (or in the afternoon – the inscription
is unclear), Constable made another upright draw-
ing, this time of the west end of Chichester
cathedral (Reynolds 1984, no.35.17, pl.1002), a
work on which he must have spent rather more
time than on his sketch at Maudlin.

No.339, an hitherto unpublished drawing, is a
fine example of his fluent handling in this, his last
season of drawing out-of-doors (see the entry for
no.342). Barely a couple of miles from Chichester,
one would like to know why Constable stopped at
Maudlin to make this drawing. Had they taken
shelter, stopped for refreshment, or, like the great
ash at Staunton Harold that he dismounted to draw
(no.308), was it just the magnificence of those tall
trees, with their flighting rooks, that he wanted to
record?

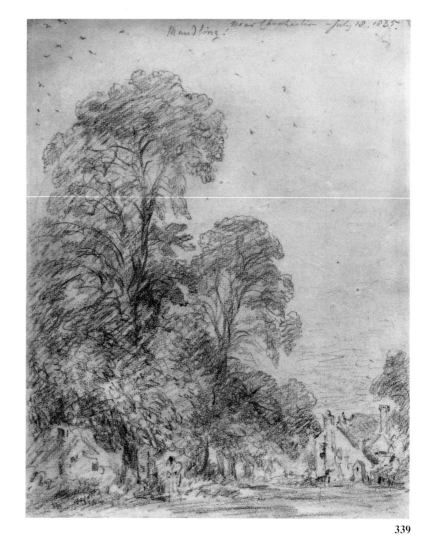

339

340 Sketchbook 1835

Containing 50 pages of wove paper 115 × 188
($4\frac{1}{2}$ × $7\frac{7}{16}$); watermark 'J WHATMAN 1832';
half-bound in green leather, gold tooled, and
marbled boards; label inside front cover of 'S.
& J. Fuller, Temple of Fancy, 34, Rathbone
Place, London'; drawings in pencil, pen and
ink, and watercolour on 25 of the pages,
many inscribed; various inscriptions inside
front and back covers, including some
concerning writers on the antiquities of
Sussex
PROV: As for no.2
EXH: Tate Gallery 1976 (322, 2 pp. repr.)
LIT: Reynolds 1973, no.382, pls.278–89;
Reynolds 1984, no.35.19, pls.1004–9, 1010–
11 (col.), 1012–28; Fleming-Williams 1990,
p.316, figs.287–9

*Board of Trustees of the Victoria and Albert
Museum, London*

This, the last of the intact sketchbooks, was the
smaller of the two Constable used during his visit to
Arundel in July 1835 (see no.338). It was used
again later in the month when he went to fetch
Minna, his eldest daughter, from Kingston-upon-
Thames, where she had been spending a few days
with John Fisher's mother and her family. On his
first day at Arundel Constable made a drawing in
his larger sketchbook of the Maison Dieu, a Gothic
ruin in the town (Reynolds 1984, no.35.10, pl.996),
and in the smaller book, no.340, a watercolour of
Littlehampton harbour – a page later detached and
given by Isabel Constable to the British Museum
(ibid., no.35.9, pl.995 in col.). A second drawing of
Littlehampton harbour mouth, this time in pen and
ink, is on p.1 of the sketchbook.

No.340 is shown open here at pp.10–11. The
inscription on p.10 reads 'Sussex Cottage' (refer-
ring to a drawing on the previous page) and
'Middleton Church | Coast of Sussex – | in part
washed away by the Sea | see Charlotte Smiths

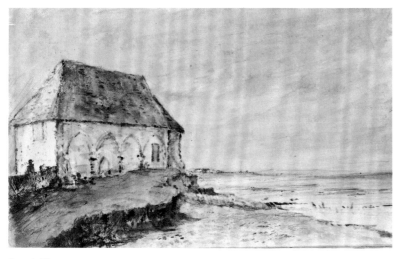

fig.146 No.340, p.11

fig.147 No.340, p.29

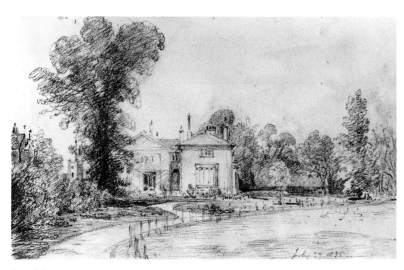

fig.148 No.340, p.37

Sonnet 10 July'. Charlotte Smith's 'Sonnet written in the Church-Yard of Middleton' (given in full by Reynolds) refers to the invasive wind and waves that tear 'from their grassy tomb the village dead' and on p.13 of the sketchbook there is a detailed and charmingly coloured drawing of a skeleton exposed in a chalk bank by the elements. The watercolour of the church on p.11 (fig.146) shows clearly the fate that awaits the little building. On p.14 there is a second, pencil, sketch of the church (of which nothing now remains) from the shore, and on the opposite page the same view, with some ruled perspective lines, seemingly by another hand – possibly by John Charles.

Fittleworth, a village some ten miles or so north of Arundel, with its mill on the river Rother, a tributary of the Arun, had been visited and sketched in 1834. Constable returned there twice on this trip of 1835 with both sketchbooks. No.340 contains three sketches of the village made on 14 July and three rather wild pencil drawings of a sunken lane done on the 16th (see fig.147 for p.29), this last a subject he had already sketched in the larger book two days before (Fleming-Williams 1990, fig.286). On the last of the Arundel pages, pp.32, 33, 35, Constable made three pencil studies of Arundel castle. One of these, the most complete of the three and dated 19 July (fig.117 on p.384), was used rather than the view of the castle in no.338 when he came to paint the picture of the scene, no.220.

Constable kept in touch with John Fisher's family – his parents and his widow and children – until the end of his life. (He had arranged to dine at the Charterhouse, of which Fisher's father was Master, on Saturday 1 April 1837; he died during the night of 31 March.) Mrs Philip Fisher, the Archdeacon's mother, had reminded him in a letter of 9 July 1835 of a promise to visit them at Kingston-upon-Thames: 'Maria [Minna] you remember is to be left to make us the long promised visit' (Beckett VI 1968, p.270). Constable wrote from Arundel to suggest the 20th, evidently intending to leave Minna at Kingston on the return journey from Sussex. His drawing, reproduced here (fig.148), of the Fishers' house at Kingston, described on the opposite page as 'Canbury House | my friends the | Fishers villa', is dated 27 July. He must have made this drawing – of a fairly formal character, it will be noted – when he went there to fetch Minna at the end of her stay. On p.46 of the sketchbook a little watercolour of a gloved hand holding a small parrot is inscribed in pencil 'done for and at the | desire of Minna July 27th 1835'.

[485]

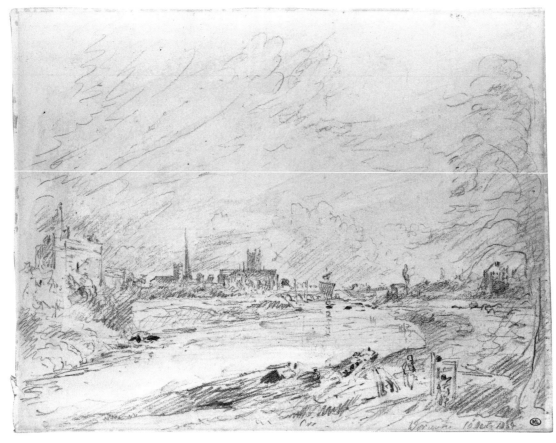

341

341 Worcester 1835

Pencil on wove paper 223 × 292 (8¾ × 11½);
watermark 'J WHATMAN 1833'
Inscribed in pencil 'Worcester 10 Octr. 1834'
b.r.
PROV: By descent to Hugh Constable, from
whom acquired by Leggatt 1899; . . .; Squire,
from whom bt by Percy Moore Turner 1935;
acquired from his family by the Louvre 1951
LIT: Reynolds 1984, no.35.21, pl.1030

Musée du Louvre, Paris

The date in the inscription is incorrect. It should be
1835. The error may have been Constable's but it is
possible that the original has been gone over with a
darker pencil and a faint '5' altered to a '4'.

Constable's visit to Worcestershire in 1835 was
his second to that county. His purpose this time
was to deliver three lectures on landscape at the
Worcester Athenaeum to the Worcestershire Insti-
tution for promoting Literature, Science and the
Fine Arts. He had been somewhat reluctant to
make the long journey but finally agreed. 'I am
writing to Worcester', he told Lucas in an undated
note, 'I must go – they are fully expecting me with
my sermons – but I must take care that while I "am
preaching to others I myself may be a castaway".
Who would ever have thought of my turning
Methodist preacher, that is, a preacher on
"Method" – but I shall do good, to that art for
which I live' (Beckett IV 1966, p.422). He travelled
down on the Sovereign coach on 5 October, gave
his lectures on the 6th, 8th and 9th and then stayed
on for a few days. No.341, the first of two drawings
that he made of the city, is taken from the west bank
of the Severn looking downstream towards the
cathedral. The other view, in the Victoria and
Albert Museum, is of the city from a road to the
north-east with the Malvern Hills in the distance
(Reynolds 1984, no.35.22, pl.1031). These, and the
drawings he did around Bewdley (see no.342), are
the last sketches he made from nature in any
medium.

342 Dowles Brook 1835

Pencil on trimmed wove paper 218 × 278
(8⅝ × 11)
Inscribed in pencil 'Dowlis brook│Oct 15
1835' b.r.
PROV: . . .; C. Bostock, sold Sotheby's 26
June 1946 (in 71, an album) bt Agnew; . . .;
Mrs Young 1947; . . .; anon. sale, Sotheby's
14 March 1985 (87, repr.); present owners
LIT: Reynolds 1984, no.35.26, pl.1035; Parris
and Fleming-Williams 1985, p.169, under
no.35.26; Fleming-Williams 1990, pp.315–
16, 318, pl.22 (col.)

Mr and Mrs David Thomson

Constable's first visit to Worcestershire was in
1811, in the early days of his courtship. Maria had
been sent into the country by her parents for
safekeeping to stay with her half-sister at Bewdley,
some miles north of Worcester on the Severn.
Constable, driven to desperation by the tone of her
letters, had made a dash by coach to Spring Grove,
where she was staying and, during the few days he
was there, entirely won her heart. 'I may now say',
he wrote on his return, 'that some of the happiest
hours of my life were passed at Spring Grove –
mixed as they were with moments of unutterable
sadness nor could it be otherwise when I reflected
that you who might & who deserved to have been
entirely happy – I had taken pains to render not so
– and had implanted in Your excellent mind a
source of sorrow to Your worthy parents' (Beckett
II 1964, p.57).

Although he had almost lost touch with his
wife's Worcestershire connections, in 1835, on this
his second venture into the county, the temptation
to revisit scenes so strongly associated with his
beloved Maria must have been irresistible. In
Worcester his host had been Edward Leader
Williams (father of Benjamin Leader Williams RA,
1831–1923); at Bewdley he stayed at Spring Grove
with his hostess of 1811, his wife's half-sister
Sarah, now married to a younger man, the Revd

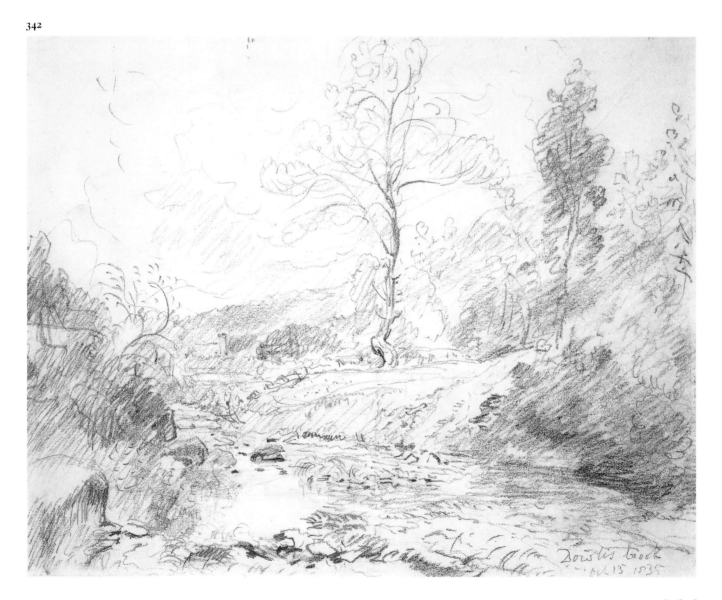

342

Joseph Fletcher, Rector of St Andrew's, Dowles, the church seen in the distance in no.342.

This drawing was taken from the left bank of the brook where the old Bewdley to Bridgenorth road – then, it seems, little more than a track – crossed the stream. Now a stone bridge carrying a metalled road (B4194) spans the brook and Constable's view is no longer obtainable. The last of his known dated sketches from nature, no.342 represents well the stage he had reached as a draughtsman in these last years of his life. By this time he had evolved a kind of shorthand, a system in which the pencil point seems to have skimmed over the paper, leaving here a linear swirl, there a scrap of shading, elsewhere sharply chiselled accents, dots, flicks, commas and an endless variety of other rhythmical touches, all of which acquire meaning only in context and most strongly in a spatial register. It is drawings such as these that come closest to the sometimes rather mystifying late oils.

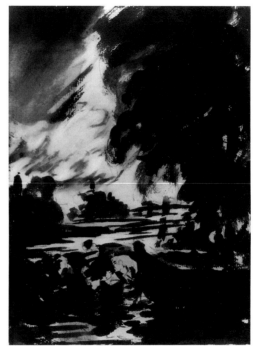

fig.149 'A Barge on the Stour', *c*.1836, *Board of Trustees of the Victoria and Albert Museum, London*

343 View on the Stour: Dedham Church in the Distance *c*.1836

Pencil and iron-gall ink on laid paper, left edge irregular, 205 × 169 ($8\frac{1}{16}$ × $6\frac{11}{16}$); watermark 'GILLING & [ALLFORD 1829]'
PROV: As for no.2
EXH: *Alexander and John Robert Cozens: The Poetry of Nature*, Victoria and Albert Museum, Nov.1986–Jan.1987 (115), Art Gallery of Ontario, Jan.–March 1987 (112)
LIT: Reynolds 1973, no.410, pl.308; Fleming-Williams 1976, p.110, pl.47a; Reynolds 1984, no.36.27, pl.1076; Cormack 1986, p.225, pl.214 (col.); Kim Sloan, *Alexander and John Robert Cozens: The Poetry of Nature*, New Haven and London 1986, pp.85–6, pl.106; Fleming-Williams 1990, p.278, fig.248

Board of Trustees of the Victoria and Albert Museum, London

One of a pair, no.343 is on one half of a sheet of thin paper that has been torn in two; a similar wash drawing, 'A Barge on the Stour' (fig.149, Reynolds 1984, no.36.28), is on the other half. Although one or other of these remarkable images is reproduced in most books on Constable as examples of his late, explosive manner, and although Leonardo's recommendation that old walls should be studied to stimulate the imagination, Claude's wash drawings and Alexander Cozens's 'blots' are cited as exemplars, writers on the subject have found it difficult to know what else there is to be said about them.

This is understandable. They remain enigmatic, as do a number of Constable's late paintings, but recent discoveries (see Fleming-Williams 1990, pls.34, 36–9, 39 and Reynolds 1984, no.36.32, pl.1081) have rendered them less a seemingly isolated feature in his oeuvre, and work on some of

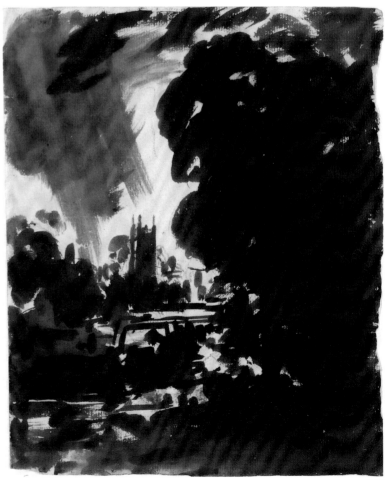

343

the related material has increased our understanding of their origins. The apparently random choice of paper for the Victoria and Albert Museum pair and their mode of execution suggest that they were created on impulse and were not part of a premeditated scheme of work. But their subject matter, the river Stour and yet again the tower of Dedham church (cf. nos.93–6), brings them into line with late works in other media of other such familiar scenes.

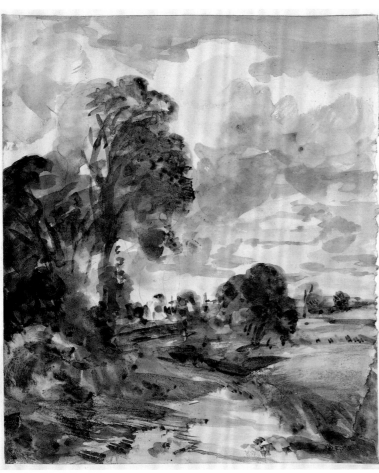

344

344 A Country Lane *c.*1836

Pencil and watercolour on wove paper, right edge irregular, 213 × 183 (8⅜ × 7³⁄₁₆); watermark 'R TASSELL 1833'
PROV: As for no.2
EXH: Tate Gallery 1976 (317, repr.); Paris 1976 (64)
LIT: Reynolds 1973, no.415, pl.310; Parris 1983, pp.220–3; Reynolds 1984, no.36.26, pl.1073 (col.)

Board of Trustees of the Victoria and Albert Museum

A number of doubts about this drawing by Constable were removed when no.47, the so-called 'Stoke-by-Nayland' of 1816, came to light in 1981 among a group of oils then belonging to Major C.W. Maffett, for 'A Country Lane' is a late realisation of the same subject. Previous commentators had seen no.344 as reflecting the composition of 'The Cornfield' (no.165) and no.47 is possibly part of the development of that theme. Unfortunately, the title inscribed in a later hand on the back of no.47 is misleading as local topographers have discounted the possibility of the view being towards Stoke-by-Nayland; we are no nearer an identification of the subject today. It was not until the discovery of the oil sketch, no.47, that it was possible to identify the white shape in the distance of no.344 as a church.

Maybe it was just the different proportions of the paper, but Constable has extended the composition to the right and in general reduced height to width, most noticeably in the path. The resultant spaciousness contributes to the work's somewhat dreamy, wistful mood.

345 Stonehenge 1835, exh.1836

Pencil and watercolour on wove paper,
deckle-edged top and left, 385 × 565
($15\frac{3}{16}$ × $22\frac{1}{4}$) laid down on a larger sheet
387 × 591 ($15\frac{1}{4}$ × $23\frac{5}{16}$); the hare, b.l., is on a
separate piece of paper cut roughly to the
shape of the animal and pasted down
Inscribed in ink on the mount 'Stonehenge
"The mysterious monument of Stonehenge,
standing remote on a bare and boundless
heath, as much unconnected with the events
of past ages as it is with the uses of the
present, carries you back beyond all historical
records into the obscurity of a totally
unknown period."'
PROV: By descent to Isabel Constable, by
whom bequeathed to the South Kensington
(later Victoria and Albert) Museum 1888 as
the gift of Maria Louisa, Isabel and Lionel
Bicknell Constable
EXH: RA 1836 (581, 'Stonehenge'); Tate
Gallery 1976 (331, repr., also col. detail opp.
p.177); New York, Bloomington, Chicago
1987–8 (161, repr. in col.)
LIT: Reynolds 1973, no.395, pl.296;
Fleming-Williams 1976, p.118, pl.51 (col.);
Walker 1979, p.154, pl.55 (col.); Reynolds
1984, no.36.3, pl.1055 (col.); Cormack 1986,
pp.236–8, pl.226 (col.); Rosenthal 1987,
p.195, ill.159

*Board of Trustees of the Victoria and Albert
Museum, London*

Exhibited at Somerset House in 1836 with 'The
Cenotaph' (fig.13 on p.37), from the artist's
correspondence 'Stonehenge' appears to have been
completed the previous autumn. 'I have made a
beautifull drawing of Stone Henge', he told Leslie
on 14 September, 'I venture to use such an
expression to you' (Beckett III 1965, p.131). A few
days before he had written about rainbows to
David Lucas who was then engaged on the large
mezzotint of Salisbury Cathedral (no.211): 'I wish
to talk to you about our Rainbow in the large
⟨picture⟩ print – if it is not exquisitely done – if it
is not tender – and elegant – evanescent and lovely
– in the highest degree – we are both ruined – I am
led to this having been very busy with rainbows –
and very happy in doing them – by the above rules'
(Beckett IV 1966, p.421).

It was unusual for Constable to complete a work
for the Academy as early as this, some seven
months before sending-in day, but when he began
it a public showing was probably not uppermost in
his mind. The period immediately before had been
a fraught and deeply emotional one. Passionately
attached to his children and particularly to the two
eldest boys, in August he lost both: John, the elder,
only temporarily, to the Arundel Constables, who
were in Paris; but the fourteen-year-old Charles
permanently, to the merchant navy. Seeing him off
on his first voyage had been extremely painful. The

boy's last letter in home waters from his Indiaman,
the *Buckinghamshire*, was written 'in a gale of wind,
having just come down from taking in first reef of
the mizzen topsail ... the ship pitching forecastle
under at every wave' (Beckett III 1965, p.130) –
news to stir a father's heart but hardly to set him at
rest. Bereft of his family – the other children were
away at a Hampstead boarding school – and with
Leslie, now his closest friend, out of town,
Constable turned to his painting-room and as was
his habit sought for inspiration in his work of past
years. He found what he was looking for in the
sketchbook he had had with him in 1820 when he
and John Fisher were visiting Stonehenge (see
no.291).

Before embarking on the final watercolour, from
the pencil sketch he had drawn on 15 July 1820
(no.291) Constable made four preliminary com-
positional studies: a watercolour in the Victoria and
Albert Museum (Reynolds 1984, no.36.4, pl.1053);
a pencil outline drawing in the Courtauld Institute
Galleries (ibid., no.36.5, pl.1054); a second water-
colour in the British Museum (ibid., no.36.6,
pl.1056 in col.); and a vigorous pencil drawing, only
recently discovered, in a private collection. All but
the last are squared up; all but the Courtauld study
feature the left-hand arcs of the rainbow. The order
in which they were done is not as yet clear, but it is
possible that the new drawing is the earliest of the
four. (It is hoped to discuss all four in relation to
no.345 in a future article.) One of the most
noticeable differences between the original sketch
and all five subsequent drawings of Stonehenge is
the extension of the scene on either hand, to include
several stones on the left and distant hills on the
right. It is unlikely that the stones were drawn from
memory. Probably the drawing of July 1820
originally continued to the left, over onto the facing
page so as to include the stones. Constable
experimented with the positioning of the rainbow
in the preliminary compositional studies. Only in
the final watercolour did he decide to bring the
inner arc so dramatically down onto the central
trilithons, and only then did he allow himself full
play with the potential of the medium and
orchestrate the awesome sky (perhaps with poor
Charles in mind, up aloft in the storm).

In the 1970s the monumentally conceived 'vast,
mushrooming thunder-cloud' brought to mind 'a
veritable nuclear explosion' (Louis Hawes, *Con-
stable's Stonehenge*, 1975, p.4). In an only marginally
less threatened world, how may we and far *should* we
attempt to interpret this last great watercolour
painting? The inscription on the mount (repeated in
the RA catalogue) invites us to make the attempt and
brings us into line with the artist's own train of
thought. Transience, immutability, and the nature
of existence before recorded time are the themes we
are surely asked to ponder – the circle of stones as a
timeless island, past which the covered wagon in the
distance slowly lumbers, the scuttling hare races,
and on which the image of man is a mere shadow that
passes with the hour.

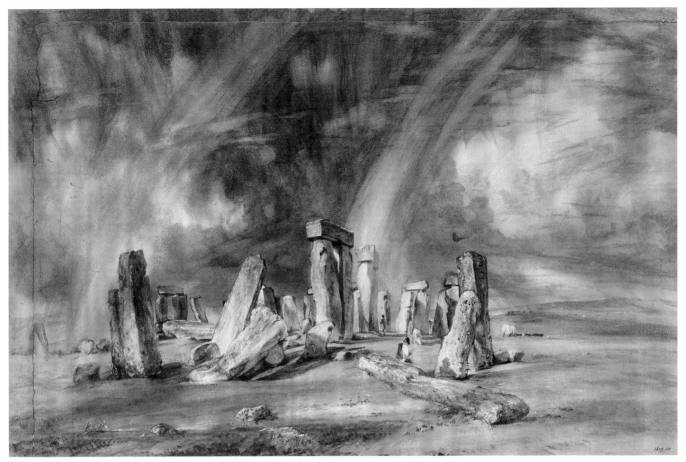

345

Constable's Oil Painting Materials and Techniques

SARAH COVE

Introduction

One of the most striking aspects of Constable's painting is the range and diversity of his work in oil. On a tiny fragment of paper he can suggest a vast area of sky and landscape with supreme economy of brushwork. By contrast, he may labour over minute details of architecture and foliage on a six-foot canvas intended for the Academy. His sketches demonstrate a passionate involvement with painting directly from nature, yet many of his greatest works were painted entirely in the studio. Whatever his approach to a particular subject, the paintings reveal a masterful ability to reproduce glorious effects of light, weather and atmosphere in paint. In addition, his pictures appear to be in very good condition when compared to the works of many of his contemporaries and predecessors.

These observations prompt certain questions. Does the range of materials and techniques used in Constable's sketches differ from those employed in the 'finished' paintings? Do his methods change throughout his career? If so, were new 'effects' a response to the availability of new materials, or did he seek new materials in order to achieve a particular, and elusive, effect? Why have Constable's paintings survived so well? Was he concerned with the preservation of his work for the future? With this in mind did he take care in his choice of materials and pay special attention to technique? These questions assume that his paintings are, in fact, unchanged. Perhaps this is not the case. We may be looking at works that have been significantly altered by natural ageing of the materials or by the intervention of a later hand.

In recent years technical examination and scientific analysis have increasingly been seen as an essential part of art historical study because they help to answer these questions. They aim to identify the materials used by an artist and how these were combined to make a work of art. This information provides an objective basis for the interpretation of an artist's oeuvre through the detailed study of his working practices. It may also give additional insight into more traditional art historical concerns such as attribution, dating and the evolution of certain compositions.

The technical examination of paintings is not new. It has been of interest to both conservators and art historians for many years. More recently, however, exhibitions such as the National Gallery's *Art in the Making* series have brought technical information to a wider public.[1] In such cases an understanding of the way in which a painting is made can significantly increase enjoyment of it, and may also elucidate the artist's intentions in a particular work. However, the systematic examination of a large number of works by a single artist can make a more significant contribution to art historical scholarship than the study of individual paintings in isolation. In order to answer the most pertinent questions concerning Constable's materials and techniques and their contribution to his art, it is necessary to examine as wide a range of his paintings as possible.

This has been the intention of the Constable Research Project.[2] Over fifty paintings, from both public and private collections in Britain and the United States, have been examined.[3] These date from 1802 to c.1834 and represent every type of image Constable created in oil, from small sketches on paper and fragments of canvas to large exhibited works. The examination of carefully selected paintings, spanning the artist's career, together with associated objects such as a sketching box[4] and palette,[5] has provided a huge data bank of technical information. This is then considered in the broader context of studio practices, contemporary artists' handbooks and instruction manuals on oil painting,[6] published information on the materials and techniques used by Constable's contemporaries and mentors, and in the light of his own writings.[7] In this way the technical information, in conjunction with the most up-to-date art historical scholarship, has suggested answers to previously insoluble questions. This essay describes some of the most significant findings to date, particularly in relation to paintings in the current exhibition.

It is useful when considering the materials and techniques used by an artist to do so in relation to the layer structure of a painting. This approach has been adopted here, where the supports, grounds, primings, pigments and media chosen by Constable are discussed in turn. This is followed by a general description of the actual process of painting. Within each section the development of his methods is outlined in roughly chronological sequence, from 1802 to 1837. However, it is worth a brief diversion to consider Constable's technical ability and his preoccupations at the beginning of this period, since by 1802 he had already been painting for some years.

The Years before 1802

I paint by all the daylight we have . . . All the evening I employ in making drawings and reading
(Constable to John Dunthorne Snr, early in 1801)[8]

Constable was a self-taught artist. He began to work in oils in the 1790s, possibly when painting with John Dunthorne Senior in the Suffolk countryside. From Dunthorne, a local plumber, glazier and amateur painter, Constable may have learnt a craftsmanlike approach to the selection and preparation of his materials. In 1799 he entered the Royal Academy Schools. Under the 'wise neglect' of Henry Fuseli (Professor of Painting 1799–1805) Constable, along with fellow students Wilkie and Reinagle, received no formal training in oil painting.[9] However, he would have increased and enriched his knowledge from discussions with students and Academicians. He was also helped and encouraged by both professional and amateur painters – notably Sir George Beaumont and Joseph Farington. From the latter he received kind, but critical, advice: 'Constable called, & brought a small landscape of his painting. I recommended to him to unite firmness with freedom, and avoid flimsiness'.[10]

At that date the accepted way to learn to paint in oils was through copying the work of the Old Masters. Constable had begun this practice as early as 1795 when he copied a Claude in sepia.[11] Copying in oil only began in earnest after his arrival in London. In May 1800 he explained his intentions to Dunthorne: 'I have copied a small landscape of A. Caracci, and two Wilsons . . . a very fine picture by Ruysdael . . . [and] Sir George Beaumont's little Claude . . . Indeed I find it necessary to fag at copying, some time yet, to

acquire execution. The more facility of practice I get, the more pleasure I shall find in my art'.[12]

In addition to copying, an aspiring painter would probably have consulted artists' instruction manuals for information on painting materials and techniques. These were frequently written by professional painters in order 'to short-cut for the student the laborious discovery of practical information which they had experienced in relative isolation'.[13] By the beginning of the nineteenth century a considerable number of such books were available on both the theory and practice of painting. In September 1796 the artist John Cranch gave Constable a list of 'Painter's Reading, and hint or two respecting study' which included Leonardo da Vinci's treatise on painting and Gerard de Lairesse's book on painting.[14] In the latter, Cranch mentioned, there were 'many usefull hints and helps of study, and many ingenious things to facilitate *practice*'.[15] In October 1796 Constable wrote to J.T. Smith that he was particularly enjoying 'Leonardo da Vinci, and Count Algarotti'.[16] This early interest in artists' manuals and theoretical books on art continued for the rest of Constable's life. Among others, Algarotti's *Essay on Painting*,[17] Thomas Bardwell's influential *The Practice of Painting and Perspective Made Easy*[18] and De Massoul's *Treatise on the Art of Painting, and the Composition of Colours*[19] were found in his library after his death. Still collecting late in life, his subscription to the first edition of George Field's *Chromatography*,[20] published in 1835, attests to his positive interest in painting materials and techniques.

Constable's early painting techniques and understanding of materials were learnt through the good oral tradition of English painting, supplemented by copying and by reference to painting manuals. Despite the lack of formal teaching, the excellent condition of his 1802 'studies' demonstrates that by that date he had acquired a fundamental grasp of sound oil painting practice.

Painting Supports and Grounds

Constable painted on a variety of supports including canvas, paper, millboard and occasionally panel. Despite being hidden under layers of ground and paint, the painting support influences the final image. The most important considerations when choosing a support are texture, rigidity, absorbency and size. The texture and absorbency can be modified by the application of a ground or priming.[21] The comparatively rough surfaces of canvas and panel become smoother as more layers of ground and priming are applied. By contrast, paper and millboard are intrinsically smooth. Brushwork is affected by the rigidity of the support and how much 'give' there is when the paint is laid on. Although canvas may be bought in standard sizes, or in large pieces off-the-roll, the size of a support can be altered by cutting it down. This was particularly important for an artist such as Constable who, when painting out-of-doors, had to carry his materials with him. The cost of the support is also important: many painters have to use cheap, poor quality materials when they are students. They may, on occasion, use an unfamiliar support because their usual choice is not available. This can also affect the appearance of a work.

Canvas

Constable's usual painting support is a medium-weight plain weave linen canvas. The weave count is 12–16 threads per centimetre in each direction. It has a characteristic appearance in x-radiographs. Despite irregularities in the weave it has a relatively smooth surface when prepared with a ground and priming. Two of Constable's earliest paintings, 'Dedham Vale' (no.2, fig.150) and 'Dedham Vale, Evening' (no.32) of 1802, are painted on this type of canvas. Constable may have bought it stretched or unstretched from a colourman, ready-prepared with a white ground. In order to apply his own coloured priming on top of the ground, he probably tacked it to a temporary strainer. The canvas could then be stretched directly or cut to a smaller size and then stretched. In the latter case Constable's priming is visible on the tacking edges. In later years, larger exhibition canvases were usually permanently stretched before the coloured priming was applied, leaving the colourman's white ground exposed on the tacking edges.

Constable also used twill weave canvas in 1802, as the support for the studies 'Valley Scene' (no.3), 'Dedham Vale' (no.4) and 'A Lane near Dedham' (no.5). Twill is woven with the weft thread (horizontal) going over two and under one warp thread (vertical) such that a diagonal pattern is created on the surface. This can be seen in x-radiographs (fig.151) and in paintings where the priming is left exposed, as it is in these studies. All three canvases are tacked to small four-membered stretchers, the corners of which have been nailed so that they cannot be expanded. Constable used 'fixed' stretchers of this type for oil sketches throughout his career; 'Branch Hill Pond', 1819 (no.106) and 'A Farmhouse near the Water's Edge', *c.*1834 (no.214) are

fig.150 'Dedham Vale', no.2, detail of x-radiograph showing plain weave canvas

fig.151 'Valley Scene', no.3, detail of x-radiograph showing twill weave canvas

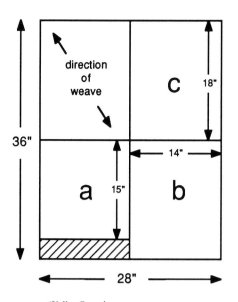

a: 'Valley Scene', no.3
b: 'Dedham Vale', no.4
c: 'A Lane near Dedham', no.5

fig.152 Diagram showing how a 'kit-cat' canvas was cut up to provide the supports for nos.3, 4 and 5. Measurements include present tacking edges. The shaded area is the strip of canvas removed from the right-hand side of no.3 before it was restretched to its present dimensions

painted on canvas stretched onto fixed stretchers identical to those used in 1802. Constable may have made them or bought them from an artists' colourman. For large finished paintings, however, Constable used expandable stretchers, sometimes with corner braces.

In the spring of 1802 Constable wrote to Dunthorne, 'I hope to compleat some little performance for the exhibition . . . it will be a kit-cat size, that is two feet and a half, by three feet'.[22] Constable's dimensions are not strictly accurate since a 'kit-cat' canvas measures 36 × 28 inches. The term 'kit-cat' was taken from a group of portraits by Kneller, depicting members of the 'Kit-cat' Club, which were painted on canvases of this size. Constable used 'kit-cat' canvases as early as 1799 when Farington noted: 'Constable called. Has just finished a Kitcat picture'.[23] Stretched and unstretched canvases in this popular size were readily available from artists' colourmen.[24] 'Edge of a Wood', ?1801 (no.1) is an early example of Constable's use of such a canvas. Turned to a horizontal format, this standard size was convenient for landscape painting, for example 'Dedham Lock and Mill', 1817–18 (no.94).

Examination of the canvas, ground and priming of 'Dedham Vale' (no.4) and 'A Lane near Dedham' (no.5) shows that both supports

were cut from a single primed 'kit-cat' canvas. On the back of 'A Lane near Dedham' is a London colourman's stamp, 'J. Middleton, 81 St. Martins Lane'. He supplied the 'kit-cat' canvas, which may or may not have been stretched when it was bought. Constable subsequently primed the canvas with a dark reddish-brown. It was then cut into quarters (14 × 18 inches). Two of these provided the supports for 'Dedham Vale' (no.4) and 'A Lane near Dedham' (no.5), which were originally joined along the top edge of no.4 and the bottom edge of no.5. 'Valley Scene' (no.3) is another piece of the same canvas (fig.152). It was painted in two distinct stages. In the first attempt Constable included a large leafy tree on the right. In the final image this tree has been painted out but is now visible as a pentiment in the top right corner. The canvas originally measured approximately 14 × 18 inches, the same size as nos.4 and 5. Before painting the final version, however, Constable cut three inches from the right-hand edge of the composition. He then stretched the canvas, turning a further inch onto the right-hand tacking edge and reverse (fig.154) giving the current dimensions of 14 × 13 inches.

Constable may have been influenced by fashion in his early use of twill canvas as it was particularly popular with artists during the last quarter of the eighteenth century.[25] He may have initially chosen twill for its obvious texture, but after 1802 he largely discontinued its use, perhaps because it was unsuitable for the effects he was trying to achieve. There are, however, a few later examples in the exhibition: the small 'Cottage in a Cornfield', 1817 (no.78) and the 1812 sketches 'Fields behind West Lodge, Sunset' (no.35) and 'Autumnal Sunset' (no.181).

Technical examination of these 1812 sketches (nos.35 and 181) has shown that they are painted on adjacent fragments cut from an unidentified painting (probably a 'kit-cat' canvas). It was removed from its stretcher, the tacking edges were roughly flattened, and it was cut into at least three pieces. The sketches were then painted without the application of a preparatory ground or priming over the unidentified painting. As a result the twill weave is very prominent where the unprimed tacking edges have been incorporated into the picture plane. Constable regularly reused discarded paintings in this way, particularly around 1810–12. It would appear that as he developed as a painter he no longer valued some of his early attempts so he cut them up and painted over them. This may partly explain the lack of pictures dating from 1802 to 1808.

Many of Constable's oil sketches are on canvas supports. In 1810–12 he usually cut them from large primed canvases to a size that could conveniently be carried in his sketching

box and pinned to the lid during painting. Constable probably bought and primed a number of large canvases in London, in preparation for his summer painting trips to Suffolk. When he needed sketching supports he took a canvas off its stretcher, crudely flattened the tacking edges and cut it into small pieces. 'View on the Stour', 1810 (no.48) 'West Lodge, East Bergholt', 1811 (no.31) and 'Flatford Mill from the Lock', 1811 (no.52) are supports of this type. In two of these sketches (nos.31 and 52) parallel cracks run horizontally across the sky (fig.204 on p.524). These were formed in the ground when the canvas was initially stretched, before the application of Constable's priming. A flattened tacking edge (with a colourman's white ground) is visible along the top of each painting. 'A Village Fair at East Bergholt', 1811 (not in the exhibition)[26] and 'Flatford Mill from the Lock' (no.52) are adjacent pieces cut from the same canvas, as can be seen in the x-radiograph mosaic (fig.205 on p.524).

Constable often enlarged (and occasionally reduced) canvases that he was working on in the studio. 'Hampstead Heath with the House Called "The Salt Box"', c.1819–20 (no.107) is a 'cabinet' picture, started in front of the motif. After the initial paint layers were dry Constable unfolded the right-hand tacking edge and restretched the painting. He then prepared the flattened edge strip with a different ground and priming to the rest of the painting. He then continued to work-up the landscape, extending it on the right over the flattened tacking edge. These alterations were apparently intended to improve the composition by the addition of a figure in red on the far right, painted partly on the extension and partly in the original picture plane.

Constable also used strips of new canvas glued to unfolded tacking edges as a means of enlargement. The Philadelphia sketch for 'The Lock' (no.157) is an example. It has such a strip, approximately 11½ inches wide, glued to the tacking edge at the top of the painting.[27] At the same time Constable reduced the width of the painting by turning a strip of painted canvas on the right onto the back of the stretcher. As well as gluing extra pieces to the tacking edges, Constable sometimes butt-joined and stitched his additions. 'A Wooded Bank with an Open Book and Distant View of Water', c.1829–36 is made from five differently sized pieces joined in this way.[28]

Constable frequently extended large studio canvases, particularly when working on the full-size sketch for an Academy exhibit. As he was often late starting these works, the last-minute haste probably forced him to make alterations rather than beginning the composition on a new support. In some cases he unfolded the tacking edges and stuck the painting onto a larger canvas, i.e. lined it. The

tack holes from the first stretching are often visible within the picture plane, as can be seen in the sketch for 'The Hay-Wain', c.1820–21 (fig.68 on p.204).[29]

Perhaps the most idiosyncratic construction known to the author is the support of 'The Cenotaph', 1836 (fig.13 on p.37).[30] Constable began with a stretcher which had already been modified by the addition of wooden strips nailed to the edges. The canvas was then stretched with a 'loose' lining, a second canvas stretched on the back of, but not adhered to, the support. During the painting process, in order to enlarge the composition, several strips of wood were nailed through the top, bottom and right-hand tacking edges. Paint was then applied on the wooden strips without a ground or priming. The crude wooden extensions have regularly caused the paint to crack and flake along the joins. There is no easy solution to this conservation problem as the strips cannot be removed without destroying Constable's composition.

In general Constable's preparation of canvas with a ground and priming was careful, but frequently his impetuous temperament took control once the picture was underway. He did not have standard methods for dealing with the problems that arose, but apparently used whatever came to hand with a complete disregard for the permanence of the finished work, as, for example, in 'The Cenotaph'. The use of unstretched canvas fragments shows an obvious lack of concern for the long-term preservation of his early sketches. Where they have not subsequently been stuck onto a secondary support (lining canvas, board, panel) the paint often lifts and sometimes flakes off, particularly along the cracks caused by initial stretching or folding.[31] As the sketches were his personal notations, not intended for public display, the issue of permanence seems not to have been important to him at this date, although it was to become significant in later years. Ironically, due to the correct application of the ground and priming in the first place, coupled with the thin direct paint layers, many of them have survived in almost perfect condition.

Grounds and Coloured Primings on Canvas

Traditionally, a canvas is prepared for painting with a sealing coat of animal glue size, followed by one or more layers of an even-toned 'ground'. This usually consists of pigment bound in glue, egg or oil, or mixtures of these. A ground is usually applied to fill the interstices of the canvas weave, leaving sufficient texture to provide a good 'tooth' for the paint layers. The more layers applied to the

surface, the smoother it becomes. An absorbent ground (chalk and glue) will leach the oil from the first paint layer, causing it to become dry and matt quickly. A non-absorbent ground (lead white in oil) slows down the drying process of the paint, allowing the artist more time to work over the surface. In the nineteenth century the terms 'ground' and 'priming' were used interchangeably. Here, 'priming' specifically refers to a coloured layer applied by the artist on top of the ground, to seal it and provide a suitable background tone for painting.

In Constable's paintings before c.1820 the preparation of canvas followed a reasonably standard pattern (fig.153). In the early 1820s a greater variety of construction is found. This might be explained if, as suggested below (p.508), John Dunthorne Junior had already become Constable's assistant, responsible for much of the preparatory work in the studio. In the mid-1820s Constable developed a new system which he continued to use for the rest of his career.

From 1802 to c.1820 Constable's canvas was generally heavily sized and coated with two layers of lead white and chalk ground bound in linseed oil (fig.153,a,b). The layers are separated by a second size layer which is visible in paint cross-sections (fig.155).[32] 'Dedham Vale', 1802 (no.2) and 'Boat-Building', 1814–15 (no.72) are both painted on plain weave canvas prepared with this type of ground. A survey of British paintings from c.1720 to 1760 at the Tate Gallery revealed that this construction was commonly used during this period.[33] Artists' 'prepared' canvas (with ground applied) was readily available from London colourmen, cut to standard sizes, off-the-roll, unstretched and stretched by the 1740s.[34] Constable's ground is likely to have been such a commercial preparation.

Occasionally Constable's grounds do not have this typical construction. The 1802 studies on twill canvas (nos.3–5) were prepared with only one thick layer of chalk ground which leaves the weave texture very prominent. Media staining tests on cross-sections[35] suggest that in this case the binding medium is animal glue, possibly with the addition of egg white. A chalk/glue/egg ground would be highly absorbent and particularly suitable for painting out-of-doors where the artist wanted the first layers of paint to dry rapidly. We know the canvas was supplied by Middleton (see above, p.495) and this ground could be his commercial preparation. It is more likely, however, to have been applied by Constable using a traditional recipe. The addition of egg white to grounds is recommended in artists' handbooks of the period.[36] Turner is known to have used a similar ground for many of his early works. His consisted of lead white in egg and is

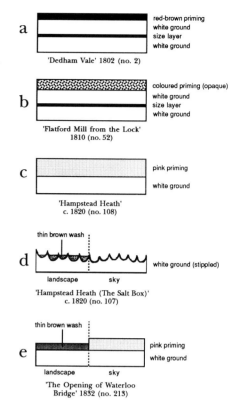

fig.153 Diagram of Constable's typical ground and priming constructions

presumed to have been applied by his father who worked as his studio assistant at that time.[37]

Constable's usual practice before c.1820 was to coat the white ground with an overall layer of coloured priming. This was generally a mid-toned shade of reddish-brown, salmon or 'mushroom' pink. Occasionally he used a very dark brown. In highly 'finished' paintings before c.1818 the coloured priming is entirely covered by the paint layers, but it still imparts a warm tonality to skies and shadowy areas of foregrounds. In the sketches where it was left visible the colour plays an important part in the final image.

In 1802 Constable used a dark reddish-brown translucent priming for 'Dedham Vale' (no.2), 'Valley Scene' (no.3), 'Dedham Vale' (no.4) and 'A Lane near Dedham' (no.5). It consists of a medium-rich mixture of vermilion, red lake, black and umber. It may be the 'sort of tanned leather colour' recommended for landscape painting by Bardwell, and popularised in the late eighteenth century by his book *The Practice of Painting and Perspective Made Easy*.[38] Sir George Beaumont, one of Constable's early mentors, used a similar brown priming for both 'finished' paintings and oil sketches, as can be seen in a small oil sketch on paper (fig.156) in the Tate Gallery and 'Jaques and the Wounded Stag', 1819 (fig.90 on p.317).[39] Constable's priming

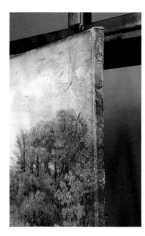

fig.154 'Valley Scene', no.3: a strip of the earlier composition seen turned onto the right-hand tacking edge; the pentimento of a large tree is also visible at top right of sky

fig.155 'Summer Evening', no.33, cross-section from top edge of sky (350 ×). Two layers of lead white and chalk ground are separated by a size layer which appears as a thin horizontal yellow line. The red-brown priming is just visible on top of the uppermost ground layer

fig.156 Sir George Beaumont, 'Landscape' (Tate Gallery T 01148), detail of dark reddish-brown priming

fig.157 'The Rectory from East Bergholt House', no.23, detail of sky showing vertical brushstrokes in the priming

fig.158 'A View at Hampstead Looking Due East' (Victoria and Albert Museum), detail of landscape with pale blue ground visible between brushstrokes

fig.159 'Dedham Lock and Mill', no.94, detail of main tree at right showing pink priming creating a 'simultaneous contrast' with the green leaves

fig.160 'Hampstead Heath with the House Called "The Salt Box"', no.107, raking-light detail from left-hand foreground showing the stippled ground; the thin brown wash has settled into the distinctive texture

was thinly applied, very dilute, by brush. It settled into the interstices of the canvas weave allowing the luminosity of the white ground to show through. Even though the 1802 studies are highly 'finished',[40] Constable deliberately left the priming visible in many areas to create a 'simultaneous contrast' with the greens of the foliage. The skies, which are thinly painted using Prussian blue and lead white and scumbled with natural ultramarine, owe much of their colour to the underlying brown. A similar priming can be seen in the sketches of c.1808–10, for example 'The Rectory from East Bergholt House' (no.23), painted in September 1810. In this painting vertical brushmarks from the application of the priming are visible in the sky (fig.157).

Constable probably began priming his canvases with opaque colours in late 1810. The support of 'Willy Lott's House' (fig.189; on the back of no.42) was first coated with a pink ground. Constable went on to re-prime the canvas four more times before reverting to the translucent brown priming he had used consistently for earlier paintings (figs.193–4).[41] The multiple layers of ground and priming show that Constable was already revising his earliest painting techniques and beginning to reconsider the issue of priming colour. By the summer of 1811 he was preparing canvases in batches of coloured primings, ranging from a light salmon pink to a purplish brown. In general, the opaque pigment lead white was mixed with varying amounts of vermilion, red and brown ochres, black and red lake to make the various shades. One thin application was enough to completely cover the white ground.

It is not clear why Constable decided to vary his priming colours at this time, as no obvious pattern is evident in his use of one colour or another. He may have used a pink ground much earlier, in 'Dedham Vale, Evening', 1802 (no.32), and in this case was perhaps only reverting to a former practice. The choice of a pink ground would not have been surprising in Constable's early paintings, for Gainsborough is known to have used a similar dull pink ground in his Suffolk landscapes.[42] Having developed his handling of paint during the intensive period of oil sketching in 1810, Constable apparently sought a new method that would allow him the greatest range of 'effects' with a minimal palette. The use of coloured primings provided the solution in the most economical manner.

In late 1811 or early 1812 Constable again began to experiment with a wider range of priming colours, including blue, olive green and yellow. In 'Figures and a Donkey on the Lane from East Bergholt to Flatford', c.1811–12 (no.42) Constable applied vertical stripes of colour across the canvas.[43] The effect created by a blue stripe in this 'experimental' painting may have led later in 1812 to two sketches

painted on what *appears* to be a blue priming. 'Fields behind West Lodge, Sunset' (no.35) and 'Autumnal Sunset' (no.181) are painted in thin translucent oil washes over what appears in cross-sections to be the sky of an unknown painting (see above, p.495). Constable painted directly over the pale blue layer as if it were a blue priming, creating a strikingly atmospheric evening effect. No full-size paintings on blue primings have so far been identified by the author, but eleven years later Constable returned to this method in some of his Hampstead sketches. 'A View of Hampstead Heath, Looking Due East', a sketch on paper, is dated by the artist 'Eveg – 6th Augt 1823' on the reverse (fig.158).[44] It is painted on a pale blue ground which Constable apparently found particularly suitable for evening landscapes. The effect is very similar to that created in the 1812 sketches.

By the 1820s Constable was quite specific about the priming he wanted for a certain time of day or place. This is illustrated by a number of Brighton sketches from 1824. These were painted on paper supports initially primed with a blue identical to that used at Hampstead in 1823. A number of supports were apparently left over from the Hampstead work, but Constable evidently considered a blue priming unsuitable for seascapes, so he re-primed them all with a dark brown before using them at Brighton. 'Beaching a Boat, Brighton' (no.153) is an example.[45]

The 'finished' paintings of Constable's mid-career were painted on opaque reddish-brown or 'mushroom-pink' primings. By contrast with the 1802 studies, in 'Dedham Vale: Morning', 1811 (no.14) very little of the brown priming is visible in the final image. It is entirely covered by opaque paint layers and can only be glimpsed (on close inspection) around the edges of forms in the foreground, where it is heavily glazed. In 'Flatford Mill from the Lock', 1812 (no.54) none of the pink priming is visible at all. This is surprising considering that Constable applied three shades of pink before he got the colour right.[46] The reddish-brown priming of 'Ploughing Scene in Suffolk: A Summerland', 1814 (no.71) is entirely covered by the paint layers, but can be seen in cross-sections to be a mixture of mars reds (synthetic red ochres), charcoal black and red lake. Covering the priming in this manner continued to be Constable's normal practice until c.1817–18 when he painted 'Dedham Lock and Mill' (no.94). In this painting the pink priming (lead white, mars reds and umber) was left visible in many small areas of the landscape. Constable apparently considered that a painting on this larger scale allowed for greater variation in the levels of 'finish'. The priming was used to create a 'simultaneous contrast' between the green of the leaves and the grey-blue sky

around the contours of the large right-hand tree in a manner similar to that used in 1802 (fig.159). It is visible in the distant landscape on the left, and in areas of the foreground where it provides contrast with dabs of green and creates a warm mid-tone in the browns. It can also be seen beneath thin scumbles and glazes in the half-tones and shadows.

In the 1820s Constable began to use a 'stippled' chalk ground, that is, a ground applied in small dots or dabs with the end of a brush. The chalk was bound with egg and probably glue to a stiff consistency, so that a characteristic texture was created. This can be seen in 'Hampstead Heath with the House Called "The Salt Box"', c.1819–20 (no.107). In the landscape areas a dark brown wash of umber and black was applied to tone and seal the ground. The colour settled into the stippled surface, as is clearly visible in the foreground on the left (fig.160). In the sky the paint was dragged directly over the absorbent ground, creating a speckled, textured appearance. The extension on the right-hand side of the painting, referred to above, does not have the stippled ground. A flat lead white ground, with a buff-coloured priming in the landscape area, was applied and the paint laid smoothly over it. The authenticity of the edge strip has previously been questioned partly because of the difference in appearance between it and the rest of the painting, but this difference derives solely from the stippled effect of the ground.

Throughout the 1820s and 1830s Constable also used a smooth white ground. In the skies of many pictures he applied a pink priming over the white ground, while in landscape areas he applied the same dark brown wash that was used in 'The Salt Box'. In Constable's late paintings this dark brown priming forms an integral part of the final image. It gives characteristic colour and tone to large areas of the composition, where it remains visible through sporadic brush and palette knife work in the paint layers. This 'late' ground and priming construction was used for paintings of all sizes and levels of 'finish'. 'The Lock', 1824 (no.158), 'Salisbury Cathedral from the Meadows', 1831 (no.210), 'The Opening of Waterloo Bridge', 1832 (no.213), and 'A Farmhouse near the Water's Edge', c.1834 (nos.214 and 215) are examples. In 1823 Constable wrote to John Fisher, 'I am now working for "*tone*"'.[47] In July 1824 he studied several Dutch and Flemish paintings from Sir George Beaumont's collection: 'Brought away . . . a nice rich upright one like Rembrandt and . . . his lovely little Rubens, & the Teniers'.[48] The influence of Rubens's technique in particular can be seen in the use of a translucent dark brown priming. It is probably one of the most important factors in the creation of a mellow appearance in Constable's late paintings.

Perhaps the most extraordinary example of Constable's use of a preparatory layer was his ability to paint a six-foot sketch without one! Technical examination has shown that the sketch for 'The White Horse', c.1818–19[49] is painted directly over a highly finished version of 'Dedham from Gun Hill' (fig.22 on p.68).[50] Cross-sections revealed that Constable did not reprime the canvas before painting the sketch.[51] This is an exceptional case, however, and does not refute the general conclusion that priming colour was of great significance to Constable, in both sketches and 'finished' paintings. It is likely that when he conceived the idea for 'The White Horse' and wished to make a full-size sketch he did not have an unused six-foot canvas ready. He decided to reuse the 'Dedham' canvas, but could not be bothered to reprime it and wait until it dried before putting his ideas down in paint. There are many examples in Constable's work which reveal a concern with method and materials in some circumstances and, paradoxically, a disregard for them in others.

Paper Supports and their Preparation

In addition to canvas, Constable used prepared paper supports during his periods of intensive oil sketching from c.1810 to 1829. Little information has been published regarding the history of paper as an oil sketching support in England. The technique probably originated on the Continent during the Renaissance but was not popularised until the late eighteenth century. By the 1780s the French landscape painters Valenciennes (1750–1819) and Bidault (1758–1846) were routinely using prepared paper for 'plein-air' sketching.[52] British painters who travelled abroad may have learnt the method in France or Italy and brought it back with them, though Wilson's pupil Thomas Jones had already taken it up before he left for Italy in 1776. The practice appears to have been well established in England by the first decade of the nineteenth century when Constable began to use it.

The superb condition of many oil sketches by both English and Continental artists of this period implies a sophisticated understanding of the properties of paper and methods of preparation.[53] Paper specifically prepared for oil painting is mentioned in artists' manuals of the period, but little information is given regarding its preparation.[54] By c.1832–5 'Prepared paper for sketching in Oil' was sold by Winsor and Newton but with no details as to its manufacture.[55] The most forthcoming account of its construction and use did not appear until 1856: 'Oil Sketching Paper is an extremely serviceable material for the young

artist. It is made of drawing paper, covered in two or three thin coats of oil colour, so as to furnish a ground similar to that of prepared canvas. It is cheap and portable, and serves very well for early attempts and for preparatory sketches . . . This sketching paper is usually made of the imperial size [30 × 21 inches] and, when used, a piece should be cut of the required dimensions, and fastened at the four corners, by drawing pins, to a deal board'.[56]

Paper was well suited to outdoor oil sketching as its availability, relative cheapness, durability and slightly rough surface were the ideal qualities for an inexpensive, lightweight, quick-to-prepare painting support. Constable made his own paper supports. He generally used two sorts of paper – most frequently a coarse 'wove' paper and occasionally a smooth white 'laid' writing paper. The earliest large oil sketch on paper known to the author is 'The Valley of the Stour' (no.7) of *c*.1805–9. It originally measured 20 × 24 inches but it is now slightly smaller due to the loss of paper fragments around the edges. The support consists of two laminated sheets of an off-white 'wove' paper.[57] The paper is made from linen rags (flax fibres) with the addition of a small quantity of unidentified blue fibre. These may be dyed with the blue pigment indigo and could have come from naval uniforms which were readily available as paper-making rags at that date. In the 1810 catalogue of The Repository of the Arts, Rudolph Ackermann's print and stationery shop, there is a specimen of 'brown cartridge paper'[58] very similar to the paper used by Constable for the support of 'The Valley of the Stour'. At that date the technical term 'brown' referred to a cheap paper made from inferior fibres (seams, sackcloth, gaiters, ropes, canvas, wool and silk rags).[59] It ranged from light buff to dark brown in colour. Constable's paper and the sample in Ackermann's catalogue are 'not what we today might consider a brown colour but rather a pale beige or off-white'.[60] 'Cartridge' paper was originally used for wrapping gun cartridges. By 1802 it was advertised by Ackermann as a 'Wove Cartridge Paper for Mountings and Sketches'.[61] It was a popular support for watercolour painting where a rough surface was required.

Constable made the paper support of 'The Valley of the Stour' by pasting the two sheets of wove paper together, probably with a gelatine size or starch paste adhesive. It has not been possible to identify the adhesive by analysis, but paper supports of similar construction used by Richard Parkes Bonington were laminated with gelatine size.[62] The two sheets were probably glued together when wet. The resulting laminate may have been held under tension during drying in an attempt to stop buckling and wrinkling, but

nonetheless, small creases and wrinkles formed in the top sheet. These can be seen under the paint. When it was dry the sheet was probably sized. The individual sheets may already have been sized as 'brown' paper was occasionally sized during its manufacture to give it extra strength, as well as a degree of water-resistance.[63] Isinglass or a purified animal glue may have been used for the sizing.[64] Prior to painting, the laminated sheet was prepared in the same way as Constable's early canvases, with a white oil ground and a rich reddish-brown oil priming. 'The Valley of the Stour' was painted out-of-doors. Small square pinholes can be seen around the edges of the paper where Constable pinned it to a temporary support while painting, and probably later to his studio wall when he was painting the 1828 'Dedham Vale' (no.169).

During Constable's intensive periods of oil sketching (1811–12, 1820–4, 1829) he prepared large numbers of supports in batches. He laminated large sheets of wove paper in the same manner as the support of 'The Valley of the Stour', but instead of applying a white ground and a reddish-brown priming he coated them with one opaque layer of colour. These coloured grounds range from a pale pink to a dark-purplish brown, similar to those used for paintings on canvas. It has not been possible to positively identify the medium of the ground because of the difficulty in sampling. However, indications from media staining tests on cross-sections suggest that these grounds are bound with a water-based medium, possibly gum or size. Isinglass was customarily used as a size prior to varnishing paper and could also have been used as a paint medium.[65] The application of an aqueous preparation was probably common practice. John Harden (1772–1847), an amateur artist and Constable's host in the Lake District in 1806,[66] recorded that Reinagle, one of Constable's first friends at the Academy Schools, painted in oil on paper, having prepared 'the paper with several coats of thickish water color (Oker) by wh. [which] means it absorbs the oils, and dries almost immediately, much sooner than canvass, & lasts equally well'.[67] The use of an aqueous ground would seal the paper in the manner of a size layer. It would also provide an absorbent interlayer between the paint and the paper, preventing the oil from sinking into the paper causing staining and accelerating the natural deterioration of the paper. It has been noted in relation to Turner's use of prepared paper supports that the application of an aqueous ground which is allowed to dry out thoroughly increases the surface strength of the paper.[68] When the ground was completely dry the sheets were cut to a variety of sizes. 'Barges on the Stour', 1811[69] is an example. The support measures 10 × 12 inches, a quarter of a 20 × 24

inch sheet, the sheet size used for 'The Valley of the Stour'.

There is no doubt that the preparation of paper supports with a quick-drying ground, in large sheets subsequently cut to size, is the most practical way to make a large number of sketching supports. The support of 'Dedham Lock and Mill', ?1816 (no.92) was also prepared in this way. It consists of a top sheet of 'brown' wove paper and a lower sheet of a purplish-blue wove paper. The purple paper is made of blue and red flax fibres (from linen rags), a few natural-coloured flax fibres, some woody material, which is probably flax bark and some unidentified fibres (fig.161). The paper may have been the type of blue 'sugar' paper which was used until relatively recently for cheap wrappings. It was certainly available in the early nineteenth century as wrapping paper.[70] The bottom and left-hand edges of the support were cut after the sheets were laminated and the ground applied, showing that this piece was cut from a larger sheet. The top and right-hand edges are the uncut 'deckle'[71] edges of the paper, created during the manufacturing process of the original large sheet. The top edge of the paper appears to have been crimped or flattened by a stretching device which held the paper taut during drying. Artists' colourmen supplied paper stretching boards in a variety of sizes, to fit all possible fractions of a standard watercolour sheet, from early in the nineteenth century.[72] These usually consisted of a backing panel onto which a dampened sheet of paper or laminate was laid. A wooden frame was placed over this and locked in place, sandwiching the paper at the edges between the frame and the panel. Several sheets could be stretched in this way at the same time. Constable may have used a stretching board of this type, which would have been especially advantageous when he was preparing a large number of supports. The characteristic 'flattened' edges (fig.162) of many of the Hampstead (1821–2), Brighton (1824) and Salisbury (1829) sketches on paper suggest his systematic use of some kind of stretching frame.

The ground of 'Dedham Lock and Mill' (no.92) is proteinaceous and may consist of pigment bound in animal glue or size. The painting has never been varnished. The ground has the appearance of a modern gouache-type paint. It is matt in comparison to the glossier oil-bound paint layers. Where sketches *have* been varnished, as is often the case, the subtleties of Constable's original surface (fig.163) are lost forever.

During the period of intensive 'skying' (1821–2), Constable further extended his range of paper supports by using a fine 'tissue' paper, or Japanese paper, over a rough 'brown' wove paper to give a smooth surface. 'Cloud Study with Tree Tops and Building', 1821

fig.161 'Dedham Lock and Mill', no.92, purplish-blue 'wrapping' paper visible on reverse of support; brown stains show where the paper soaked the oil out of the paint at the edges

fig.162 'Cloud Study', no.123, raking-light detail of left edge of support, probably flattened by a stretching device after the lamination of a sheet of wove paper and a 'Japanese' tissue; the edge of the upper tissue sheet is just visible

fig.163 'Cloud Study', no.123, viewed from an angle to show the gloss and matt qualities of the original, unvarnished surface

(no.119) and 'Cloud Study', 1822 (no.123, fig.162) are examples of this type of construction, which continued to be used throughout the 1820s. Constable was probably seeking a smoother surface which was more suitable to the fluid washes of colour he was using in many of the sky studies. Although he could have chosen to use an intrinsically smooth paper, the support was probably more durable and cheaper if made in this way.

Many of Constable's supports during the 1820s are fractions of a 20 × 24 inch laminate (fig.164), for example 'Hampstead Heath, Sun Setting over Harrow', 1821 (no.112) is a quarter (10 × 12 inches), 'Brighton Beach with Colliers', 1824 (no.147) is an eighth (6 × 10 inches). In these paintings the paper was thickly sized and coated with a thin layer of lean (very little medium) oil paint. There is no obvious reason why Constable should have reverted to the use of an oil-bound ground at this time. It would have had much the same handling properties as the earlier aqueous ground. A high proportion of lead white in the pigment mixture would ensure that the ground dried quickly and the lack of medium would make it highly absorbent. We know that Constable was particularly concerned with the preservation of his Brighton sketches. 'I put them in a book on purpose', he told Fisher, '– as I find dirt destroys them a great deal'.[73] Perhaps he thought an oil ground would survive better than an aqueous one, particularly in the humid atmosphere of a seaside resort. Yet the earlier sketches with aqueous grounds, such as 'Dedham Lock and Mill' (no.92), do not appear to have suffered any obvious change in appearance or condition which might have caused Constable to abandon the method.

Constable also made a number of oil sketches on writing paper, notably in 1811. 'A Cart on the Lane from East Bergholt to Flatford', 1811 (no.41) and 'A Lane near Flatford' (no.46) are two examples. The former is painted on white 'laid' linen rag paper.[74] The horizontal and vertical chain and laid lines created during the manufacturing process are clearly visible when the painting is examined in raking light. Part of an oval Britannia watermark is visible in the foreground. This denotes a 'foolscap' sheet (17–16½ × 13½–13¼ inches) which takes its name from the Continental watermark for paper of this size that depicted a fool's cap or jester's cap with its bells.[75] Constable may have chosen to paint on it because it gives a smoother surface, yet there is nothing in the paint application in the 1811 sketches to suggest that he sought a smooth support. It is more likely that he had run out of ready-prepared wove paper supports and could not spare the time to make any more. Instead he used what was at hand – his own good quality white writing paper.

Constable did not prepare the paper with an aqueous ground as was his usual practice at that time. The paper would have been heavily sized during its manufacture, therefore it was unnecessary for him to coat it with a sealing ground layer. Instead he applied a very thin, medium-rich red oil priming. Only a small amount of pigment was used, so most of the colour came from the medium. The luminosity of the white paper would have been more obvious when the sketch was first painted, as the medium has undoubtedly darkened with age. Although it is not disfiguring to the image, this fact is significant in a sketch of this type where the priming is such an integral part of the final image.

Millboard and Panel Supports

Millboard was first manufactured in the seventeenth century from cheap fibres similar to those used for 'brown' paper.[76] It is a type of pasteboard made by casting a mixed fibre pulp as a single sheet onto a mould and then 'milling', or rolling, it under pressure.[77] It is generally mid-to-dark brown in colour and frequently has woody fibres and impurities clearly visible on the surface. By the early nineteenth century millboard was available in standard sizes from artists' colourmen. Later in the century it was sold ready-prepared with a ground for painting.[78]

Constable's early mentor Sir George Beaumont used millboard in 1807 to paint a series of views in the Lake District (see under no.67). In April 1808 he showed these sketches to Joseph Farington who described them as 'small pictures in oil painted upon *paperboard*'.[79] As suggested under no.67, Constable may also have seen them at about this time and decided to use millboard as the support for his own outdoor sketches. This was soon followed by the period of his most intensive use of millboard, between 1808 and c.1810.

Constable's early oil sketching technique, which consisted of thin broad strokes of colour without much impasto, was particularly suited to the smooth surface of millboard as can be seen in the 'View at Epsom', 1809 (no.67) and 'East Bergholt House', c.1809–10 (no.22). The support of the latter contains a mixture of cotton, flax, wood and other unidentified vegetable fibres. An x-radiograph of the painting reveals the presence of a large number of x-ray 'opaque' spots (which appear white on the x-ray image, fig.165). These do not relate to the materials in the ground and paint layers. It is presumed, therefore, that the spots are contained within the millboard support. This phenomenon has also been observed by the author on the x-radiographs of other sketches on millboard by Constable. Analysis of the boards by x-ray fluorescence

spectroscopy[80] has shown a consistently high lead and iron content. This may suggest that the white spots represent a lead-based 'filler' added to bulk out the mixed-fibre pulp. The iron content is probably explained as a residual impurity from the metal beaters and rollers used during the manufacturing process.

In 1809–10 Constable prepared his millboard supports with a viscous medium-rich red ground in the manner described above for 'laid' paper. Thick vertical brushstrokes from its application are visible in raking light on the support of 'East Bergholt House' (no.22). The board may have been sized during its manufacture; nonetheless, the ground saturated and sealed the surface, darkening its colour at the same time. Once it was dry, Constable painted 'East Bergholt House' in a direct manner, leaving the board visible in many areas. The effect is much the same as that achieved with a brown priming over a white ground in Constable's 1802 studies from nature. The colour of the fresh oil medium would have had little effect on the saturated board but, in time, the darkening of the medium with age will have subtly altered the contrast between the board and the paint layers. As the board was initially a dark colour, however, this effect is probably less significant in this painting than in 'A Cart on the Lane from East Bergholt to Flatford' (no.41) mentioned above.

After c.1810 Constable used millboard occasionally for oil sketching, but he did not use any standard methods of preparation. 'The Opening of Waterloo Bridge' sketch (no.103) was painted on millboard in the studio c.1819. The board was prepared with a layer of opaque pink oil ground, applied directly to the surface without a preparatory size layer. Brushmarks from its application are distinctly visible on the surface. Constable rubbed down the ground before starting to paint to roughen it and give it more 'tooth'.

The most intriguing example of Constable's use of millboard seen by the author is the support of 'Weymouth Bay, Bowleaze Cove' (no.84), painted during his honeymoon in 1816. Constable's sketching box[81] has a compartment in the lid for keeping painting supports in position while in transit. The dimensions of the millboard are compatible with the size of this compartment. On the reverse of 'Weymouth Bay, Bowleaze Cove' is evidence to show that before he painted this sketch Constable used the board to lean a support on to paint a tiny sketch measuring 5 × 6 inches. Pinholes can be seen where the tiny sketch was pinned in place and a 'stencilled' rectangle is visible where Constable's brush ran off the edge (fig.167). Constable painted 'Weymouth Bay, Bowleaze Cove' on the other side without preparing the board with size, ground or priming. As suggested in the catalogue entry on no.84, it is

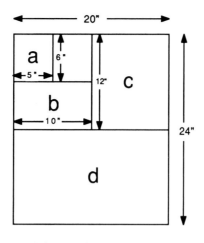

a: 'Flatford Mill from beside the Bridge', no.87
b: 'Brighton Beach with Colliers', no.147
c: 'Cloud Study with Birds', no.121
d: 'Hove Beach', no.149

fig.164 Diagram showing some of the standard fractions of the 20 × 24 inch paper sheet used by Constable (examples a–d chosen to illustrate the point, not to suggest that their supports were cut from a single sheet)

fig.165 'East Bergholt House', no.22, detail of x-radiograph showing 'spots' contained in millboard support

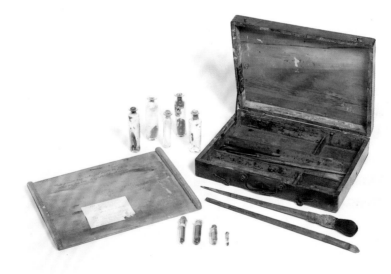

fig.166 One of Constable's sketching boxes (collection Richard Constable)

fig.167 'Weymouth Bay (Bowleaze Cove)', no.84, reverse of millboard support with 'stencilled' outline of a 5 × 6 inch sketch

fig.168 One of Constable's palettes (Tate Gallery)

fig.169 Table I Constable's Pigments 1802–1837

PIGMENT[1]	1802	1805-9	1809	1810	1811	1812	1813	1814	1815	1816	1817-18	1819	1820	1821	1822	1823	1824	1825-6	1828-9	1829	1829-30	1831	1832	c.1834	1837 PALETTE	SKETCHING BOX	COMMENTS[3]
LEAD WHITE	●	●	●	●	●	●	●	●	●	●	●	●	●	●	●	●	●	○	●	●	●	●	●	●	●	●	XRF
CHALK (CALCIUM CARBONATE)	●	●	●	●	●	●	●	●	●	●	●	●	●	●			○	○	●	●	●	●	○	●		●	XRF
VERMILION	●		●	●	●	●	●	●	●	●	●	●	●	●		●	●	●	●	●	●	●	●	●	●		XRF
RED IRON OXIDE/MARS RED	●	○	●		●	●			●	●	●	●	●	●	●	●	●	●	●	●	●			●	●		may be 'indian red' or mars red; XRF
RED LAKE	●		●	●	●	●	●	●	●	●	●	●	●	●	●			●	●		●	●	●	●	●	●	
YELLOW LAKE	●		●	●	●	●	●	●	●	●	●	●	●	●		○	○	●	●	●		●	●	●			?pink or brown pink
NAPLES YELLOW	●	●	●	●	●	●	●	●	●	●	●	●	●	●		○		●	●	●		○	○				XRF
PRUSSIAN BLUE	●	●	●	●	●	●	●	●	●	●	●	●		●	●	●	●	●	●	●	●	●	●	●		●	n.b. not found on palette
NATURAL ULTRAMARINE	●	●			●	●		●	●	●		●	●					●	●		○	●	○			●	EDX, sketching box
SMALT	○	○	○	○		○			○		○		○	○	○	○			○		○	○	○				cobalt identified 1817–21 (XRF); optically similar to ultramarine (light)
'GOLDEN' OCHRE (?)	○			●	●				●																		XRF
UMBER	●			●	●			○	○	●	●	●	●				●			●	●	●	●				very small particles: ?mars
BROWN LAKE	●	●	●	●	●								●	●													?brown pink
CHARCOAL BLACK	●	●	●	●	●	●	●	●	●	●	●	●	●	●	●	●	●		●	●	●	●	●	●	●	●	EDX
ORPIMENT	○		●	●	●	○		○	○																	○	?faded orpiment in paint box; EDX/XRF
PATENT YELLOW	○						○	●		●	○						●			○			○	○	○		EDX 1815–16
IVORY BLACK		○	●		●	●		●	●		●	●	●	○			●		●	●	●	●			●	●	
MARS BROWNS			●	●	●	●	●	●	●	●	●	●	●	●	●	●	●	●	●	●	●	●	●	●	●		XRF
ANTWERP BROWN			●		●				●						●						●	●	●				GC/MS,[4] 1819
'BURNT TERRE VERTE'					●		●					●	○				●			●						●	
ORANGE LAKE				●	●												○										
PURPLE LAKE				●	●																			●			?Field's purple madder
MARS YELLOW			●	●	●	●	●	●		●	●	●	●	●		●	●	●	●	●	●	●	●	●			XRF
ANTWERP BLUE					●				●								●						○				
MARS ORANGE								●	●		●																XRF
CALCIUM SULPHATE									●						●												EDX result only
CHROME YELLOW								●	●	●	●	●		●					●		●	●			●	●	XRF, EDX
'ROSE' MADDER								●	●			○		○				●								●	?Field's rose madder
COBALT BLUE									●	●	●	●	●	○											●	●	EDX 1820, XRF 1817–21
BARIUM/LEMON YELLOW											○	○								○							EDX 1819
MASSICOT												●															EDX result only, 1819
CHROME ORANGE (?)												○									○	○					} no positive identification, visual observation only
ORANGE VERMILION (?)												○									○	○					
BONE BROWN																	○									●	EDX
CHROME YELLOW (DEEP)																				○		○	○				
EMERALD GREEN																						○	○	●			
IODINE SCARLET																								●			EDX
SCARLET MADDER																								●	●		?Field's 'carmine' madder
NATURAL ULTRAMARINE (LIGHT)	○	○	○	○		○		○												○		○	○			●	EDX (optically confused with Smalt)
OXIDE OF CHROMIUM (GREEN)																										●	EDX
MANGANESE BROWN																										●	EDX

KEY:

● POSITIVE IDENTIFICATION

○ VISUAL IDENTIFICATION ONLY

fig.170 **Table II Constable's Binding Media 1802–19, 1837**

PAINTING	DATE	SAMPLE	LINSEED OIL	LINSEED+EGG	LINSEED+PINE RESIN	HEAT TREATED LINSEED	WALNUT OIL	UNIDENTIFIED OIL+PINE RESIN	?RESIN (NO OIL)	?GUM/GLUE	MASTIC/DAMMAR+OIL
DEDHAM VALE, EVENING (no.32)	1802	a) chalk + lead white ground	●								
		b) pale blue	●								
DEDHAM VALE (no.2)	1802	a) chalk + lead white ground	●								
		b) lead white highlight						●			
THE VALLEY OF THE STOUR (no.7)	c.1805–9	a) chalk + lead white ground	●								
		b) lead white highlight						●			
		c) brown	●								
WILLY LOTT'S HOUSE (reverse of no.42)	c.1810	a) lead white highlight	●								
		b) dark brown	●								
A CART ON THE LANE FROM EAST BERGHOLT TO FLATFORD (no.41)	c.1811	a) lead white highlight						○			
BARGES ON THE STOUR (Reynolds 1973, no.104)	c.1811	a) brown priming	●	○							
A VILLAGE FAIR, EAST BERGHOLT (Reynolds 1973, no.101)	1811	a) lead white ground	●								
		b) lead white highlight						○			
FIGURES AND A DONKEY ON THE LANE FROM EAST BERGHOLT TO FLATFORD (no.42)	c.1811–12	a) lead white highlight	●	○							
		b) dark brown				●					
FLATFORD MILL FROM THE LOCK (no.53)	?1811	a) lead white highlight		●							
		b) dark brown			○			○	●		
BOAT-BUILDING (no.72)	1814–15	a) pale blue		●							
		b) mixed green	●	○							
DEDHAM LOCK AND MILL (no.92)	?1816	a) lead white and black		●							
		b) lead white highlight	●								
		c) mixed green	●				○				
		d) dark brown	●				○				
SKETCH FOR 'THE OPENING OF WATERLOO BRIDGE' (no.103)	c.1819	a) lead white highlight	●								
		b) mixed green	●				○				
		c) dark brown (Antwerp Brown)							○	○	
PALETTE (Tate Gallery)	?1837	a) white						●			
		b) yellow							● (+ pine resin)		
		c) red					●				
		d) spilled medium only (?varnish)									●

KEY:

● POSITIVE IDENTIFICATION

○ TENTATIVE IDENTIFICATION

NOTES FOR TABLE I

1 Pigment names in this table are those used in the essay. Explanations of terminology and nomenclature are given in the notes at the end of the essay.

2 In some years only outdoor sketches have been examined; therefore the pigments identified represent the sketching palette only (1809, 1810, 1819, 1822, 1823, 1824, 1829). For 1829–30 and c.1834 only studio sketches were examined.

3 Pigments have been identified using polarising light and surface microscopy and cross-sections. X-ray flourescence spectroscopy (XRF) has been carried out routinely. Where pigments have been positively identified by XRF analysis or by energy dispersive x-ray flourescence (EDX) this is noted, with the date of sample where appropriate.

4 Identified by gas chromatography/mass spectrometry.

NOTE FOR TABLE II

All medium analysis carried out for the Constable Research Project by Raymond White, Scientific Department, National Gallery, London, except analysis of the palette which was carried out by John Mills for the Tate Gallery in 1982. All media analysed using gas chromatography/mass spectrometry.

likely that while he was working on another version of the scene, possibly the National Gallery picture (no.85), Constable felt inspired to paint this stormy landscape. Without anything else to hand, he used the spare piece of millboard that was usually kept in his paintbox lid as a temporary support to paint this brilliant sketch.

Constable used wooden panel supports rarely and intermittently, during the first half of his career. 'Anglers at Stratford Mill', 1811 (no.97), 'Dedham Vale with a Shepherd', 1812 (no.15) and 'Brightwell Church and Village', 1815 (no.75) are examples in the current exhibition. Another well-known example is 'Spring, East Bergholt Common', ?1819.[82] It has not been possible for the author to examine any of these sketches in detail; however, some general observations can be made.

The panels are all quite small and different in size and format. 'Anglers at Stratford Mill' (no.97) is the smallest ($7\frac{3}{8} \times 5\frac{3}{4}$ inches), 'Spring' is the largest ($7\frac{1}{2} \times 14\frac{1}{4}$ inches). Constable does not appear to have had a standard approach to their preparation. The surface of 'Brightwell Church and Village' (no.75) is relatively smooth. The panel may have had an intrinsically smooth surface, but it was probably also prepared with a ground in the traditional manner. By contrast, the surfaces of 'Anglers at Stratford Mill' and 'Spring' are disrupted by the strong horizontal grain of the wood. 'Spring' is painted on the back of a sketch of a row of houses.[83] The edges are slightly bevelled. No ground appears to have been applied at all. Instead the natural reddish-brown of the wood itself was used in place of a coloured ground or priming.

No characteristic methods emerge from a superficial examination of these works, except that Constable was apparently not concerned with the preparations of the panels in the way that he was with canvas, paper and millboard. He did not exploit the surface of the wood in a way that explains his choice of support in these sketches. It seems most likely that he used panels occasionally, as a last resort, when he had nothing else at hand. As he used them so rarely he did not develop a standard method of preparation.

Pigments and Media

The paints Constable used changed between 1802 and 1837. Developments took place both in the pigments that he used and in the media he used to bind them. This is not surprising since Constable was painting at a time when the chemical industry was constantly discovering new materials and the growing number of artists' colourmen and colourmakers were developing them into pigments for artists' use. Constable was also chasing new 'effects' throughout his career. Unlike Turner, Wilkie and many of his contemporaries, he did so with a certain amount of caution, but was still tempted to use many of the new colours and media.

As early as c.1710 artists' pigments were sold 'ready ground at the colour shops in London, tied up in bits of bladders about the bigness of walnuts; and are done much finer and cleaner (and almost as cheap) than anyone can possibly do them himself. All painters generally have them thus'.[84] Pigments could also be bought ready-ground to a powder that only needed to be mixed with a binding medium. In 1797 De Massoul listed seventy-nine 'Principal Colours' sold at his 'Manufactory' at 136 New Bond Street.[85] The pigments were sold in powder form, sealed in glass bottles to 'preserve' and 'shelter' them from 'sulpherous and philogistic vapours'.[86]

Constable's preference was for pigments bought in powder form from which he prepared his own paint (five glass phials of powdered pigment are among the contents of his sketching box; see below). He was no doubt aware of the 'adulterate and imperfect preparation of colours'[87] by unscrupulous colourmen, which was notorious by the early nineteenth century. In preparing his own paint he could control not only the quality, but also its consistency, opacity and texture. By varying his binding media he could obtain crispness, gloss or quick-drying properties, according to the effect that he wished to create with a particular pigment. In addition, daily or weekly preparation would ensure that the colours did not 'grow fat' in the bladders as 'all colours are undoubtedly the best, and work with greater freedom, which have been most recently prepared'.[88]

Information on Constable's pigments and media has been gathered from four sources: from the examination of the paintings themselves; from a sketching box in the Constable family collection, reputedly used in 1824 (fig.166); from examination of the 1837 palette in the Tate Gallery collection (fig.168);[89] and finally from Constable's correspondence. The following roughly chronological discussion highlights the main points of interest (refer to the tables of pigments and media, figs.169–70).

In 1802 Constable used the following pigments: vermilion; a red iron oxide; a red lake; Naples yellow; a yellow lake; a yellow iron oxide;[90] Prussian blue; natural ultramarine; burnt umber; a brown lake;[91] lead white; charcoal black (ivory black, smalt and Patent yellow have also been tentatively identified).[92] This list represents a standard late eighteenth-century landscape palette. It closely resembles both the list of 'Principal Colours' recommended by Bardwell[93] and the palette suggested by Williams of Bath (see below).[94] The mixtures in which these pigments are employed are similar to Bardwell's 'Principal Teints used in Landscape'.[95] With the exception of Prussian blue and Naples yellow (the latter popularised in England during the late eighteenth century but used in Europe a century earlier)[96] Constable's early palette consisted of pigments that had been used in oil painting for centuries.

Prussian blue has been identified in all the paintings examined by the author to date.[97] The introduction of Prussian blue as an artist's pigment in c.1710[98] provided painters for the first time with a cheap blue pigment that combined strong tinting strength with reasonable covering power. It is listed among Bardwell's 'Principal Colours' and is the only blue pigment recommended by Williams of Bath.[99] Prussian blue is the principal colour used by Constable for sky painting, where it was mixed with lead white and charcoal black to create a range of blues and greys. Constable also used a red lake and vermilion to add warmth to the colour. Ibbetson, writing in 1803, mentioned this practice, suggesting that in painting skies Prussian blue wanted 'breaking with a quantity of lake . . . which brings it very near ultramarine'.[100] Ultramarine is made from the semi-precious stone lapis lazuli and consequently was, and still is, exceedingly expensive. Constable used it throughout his career, but reserved it for final scumbles over a sky and horizon and for adding foreground details to 'finished' paintings.

Prussian blue was also used throughout Constable's career for mixing greens. Bardwell recommended its use in five of his 'Principal Teints' to make a range of opaque and semi-opaque greens in mixtures with 'Light Oker' (yellow ochre), white, 'Terravert' (green earth) and 'Brown Pink' (a transparent brown lake).[101] He also specifically recommended it for 'Dead-colouring', together with ochres, ivory black and 'Common white'.[102] Constable used it in much the same way, substituting Naples yellow for yellow ochre in his early paintings. After the introduction of brighter opaque yellows (mars yellow c.1814–15 and chrome yellow 1816, see below) Prussian blue was used to create bright 'acid' greens that are a feature of Constable's later works.

fig.171 'Dedham Vale', no.11, photomicrograph (175 ×) from area of brown in foreground, showing the 'intimate' mixture of pigments resulting from grinding them together to form a 'tint'

fig.173 'Hampstead: Sunset through Trees' (Christie's 26 April 1985, lot 53): a stroke of pure chrome yellow (35 ×)

fig.174 'Sketch for "The Opening of Waterloo Bridge"', no.103, cross-section from a yellow highlight (175 ×): 'sparkling' Patent yellow particles mixed with massicot, an opaque dull yellow

fig.172 'Dedham Vale', no.11, detail of right foreground showing colours mixed on palette and applied wet-in-wet

fig.175 Glass phials from Constable's sketching box, labelled (top to bottom) 'Red Oxide of Manganese', 'Protiodide of Mercury', 'Sesquioxide of Chromium', 'Sugar from Liquorice'

Naples yellow appears to have been used by Constable in place of the 'Light [yellow] Oker' recommended in Bardwell's list. This may not be surprising in the light of the comment, made by De Massoul, that 'Naples Yellow is a softer and fatter colour than either the Orpiments, Massicots, or Ochres. It unites with all the other colours, may be used both for backgrounds and fore-grounds, either with gum or oil, and does not change'.[103] Constable owned a first edition of De Massoul's treatise and it may have influenced his choice of Naples yellow over an ochre. He consistently used Naples yellow as the primary opaque yellow pigment on his palette until *c*.1820 when it was largely replaced by, or mixed with, mars yellow, chrome yellow and Patent yellow.

A notable difference between Constable's pigments in 1802 and Bardwell's list of colours is the absence of a *true* green among Constable's pigments. Bardwell recommended 'Terra-vert',[104] a relatively transparent dull green earth, but Constable does not appear to have used it. In fact he did not use a true green pigment until the 1830s. Instead, from 1802 to *c*.1815, he mixed greens from Prussian blue and a yellow. The hue, tone and

transparency of the paint was adjusted by the addition of Naples yellow, a yellow lake, vermilion, charcoal black and lead white. Constable usually employed three distinct shades of green; a dark bluish-green for shadows, a mid-toned olive green and a light yellowish-green for highlights. To make each colour the necessary pigments were ground together in oil in the studio. Constable may have ground the colours in batches and kept the paint fresh in bladders or glass phials. Prior to painting, whether in the studio or out-of-doors, during these years the ready-mixed paint would be laid out on the palette, with the primary colours, in the traditional manner. Paint prepared in this way, from a pre-ground mixture of pigments, appears as a kaleidoscopic galaxy of coloured particles at high magnification (fig.171) and can be distinguished from paint that was only cursorily mixed on the palette during the painting process. In the latter, the pigments do not form an 'intimate' mixture, but have a streaky appearance where they are not evenly dispersed. This is often easily visible on the surface of the painting (fig.172).

In his early paintings Constable also used

similar 'mixed' browns, instead of traditional brown earth pigments which tend to be granular in texture and do not have good covering power unless laid on thickly. By mixing the opaque red pigment vermilion with black and finely ground umber, Constable made a smooth brown paint with good body and covering power. He adjusted the hue and opacity with small additions of a red lake, a yellow lake, lead white, Prussian blue and Naples yellow. Bardwell's 'Teint no.10', 'a charming Colour in the Trunks and Bodies of Trees',[105] is a dark brown similar to that used by Constable, made from ivory black, indian red and a red lake.

In his early paintings Constable consistently used his pigments ground in linseed or walnut oil.[106] Later in his career he employed more complicated mixtures of mediums in his search for a greater variety of effects. Linseed is a strong drying oil that darkens with age. To avoid the effects of a yellowing medium Constable routinely used walnut oil to bind lead white and light colours such as the pale blues of a sky (although linseed was used in the whites of a few pictures). Walnut oil is paler in colour than linseed, and yellows less on ageing, but it does not dry so well and was frequently mixed with a 'drier' such as 'oxide of lead'.[107] A slow-drying medium was recommended for sky painting in artists' manuals, so that a painter could continue to work wet-in-wet to achieve softness in the clouds and allow the use of a single blue tint, avoiding the metameric problem of matching fresh mixtures of blue with those already dry.[108]

For oil sketching from nature *c*.1808–14 Constable used a refined version of the 1802 palette: vermilion; mars red;[109] a red lake; Naples yellow; a yellow lake; Prussian blue; lead white and charcoal black. In addition to these pure colours he also used two or three pre-mixed shades of green and brown. In addition a thick glossy purple lake and an orange lake appeared, both neat and in mixtures, in the sketches of 1810 ('View on the Stour', no.48). They disappeared from the palette the following year. Linseed oil was used for the darks and walnut oil for whites in these sketches, such as 'A Cart on the Lane from East Bergholt to Flatford', 1811 (no.41).

Several new pigments appeared in both oil sketches and 'finished' paintings in 1811–12. A glossy dark brown, tentatively identified as Antwerp brown,[110] and a finely ground dark-brown iron oxide (presumed to be a mars pigment) took the place of the dark 'mixed' browns on the palette. A bright orange crystalline iron oxide, tentatively identified as 'Burnt Terre Verte',[111] was introduced in 1811, mixed into greens and browns. Orpiment appeared briefly, but very prominently in *c*.1810–12. The latter two pigments are both found in large granular particles, fre-

quently projecting from the paint surface. They were soon replaced by brightly coloured synthetic orange and yellow iron oxides (mars pigments). A form of Prussian blue with large spherical particles, probably Antwerp blue,[112] appeared c.1812. It continued to be used intermittently throughout Constable's career.

In late 1811 or early 1812 Constable adopted a new medium for the whites in his oil sketches. The lead white highlights and clouds in 'Flatford Mill from the Lock', c.1811–12 (no.53) are bound with an emulsion of linseed oil and egg. Field mentioned that the use of egg white ('albumen') in a medium would impart a 'gelatinous texture' to paint.[113] Constable's new viscous medium produced a quick-drying paint, perfectly suited to his rapid oil sketching technique. It retained the mark of the brush perfectly as can be seen in this sketch (fig.207 on p.526).

In 1814–15 mars yellow, mars orange and several new shades of mars brown were introduced in both 'finished' paintings ('Boat-Building', 1814–15, no.72) and oil sketches ('Dedham Lock and Mill', ?1816, no.92). These pigments have small particles which, when ground in oil, give a generally smooth opaque paint. Mars browns immediately replaced the residual 'mixed' browns on Constable's palette. At the same time mars yellow was mixed with Prussian blue to make a lurid green. Constable began to use another new binding medium in his sketches at about this time. A heat-treated linseed oil was used in the darker colours together with the egg/oil emulsion (mentioned above) in the whites. Analysis has shown that a small amount of pine resin was also present in the medium.[114] This was a cheap component of oil-resin varnishes at this time and was often used, instead of the more expensive copal resins, to make a 'false' copal varnish.[115] No copal resin has been identified in Constable's medium, but its presence cannot be ruled out as it may not be detected in the small samples available for analysis. Constable possibly believed that he was using pure copal varnish mixed with his oil medium, whereas it may have been copal adulterated with pine.[116] The pine resin may also have been an adulterant in the linseed oil. The new medium, whether linseed oil/copal resin/pine resin or simply linseed oil/pine resin, when used in conjunction with the new mars colours gave Constable a luscious quick-drying paint with good body and excellent covering power. The difference in character between the sketches 'The Rectory from East Bergholt House', 1813 (no.24) and 'Dedham Lock and Mill', ?1816 (no.92) is largely due to the effects Constable achieved with his new paints.

Perhaps the most significant newly invented pigment found in Constable's paintings is chrome yellow. He appears first to have used it

in 1816. It became available in England c.1814 and, according to Field, was available from several sources by 1815.[117] It has been identified in Turner's paintings of 1814, although he may have obtained the pigment the previous year.[118] It has not been identified by the author on Constable's paintings of 1814–15, but appears in 'The Wheatfield' (no.76) which was shown at the Academy in 1816. Mars yellow, Naples yellow and a crystalline yellow (possibly Patent yellow) were used to work up the painting to an almost complete state. A few of the 'finishing' touches, such as flowers and highlights on leaves, were added using chrome yellow. This may suggest that Constable only obtained the pigment for the first time when he was finishing 'The Wheatfield' in February and March 1816. Alternatively, he may have been cautious about using such a new and vivid colour for anything other than small details.

Although it was introduced into the palette in 1816, the visual effect of chrome yellow was not immediately evident in Constable's paintings. He used it tentatively at first in both sketches and 'finished' works. It was used as a glaze over Naples yellow in 'Weymouth Bay (Bowleaze Cove)', 1816 (no.84) and 'Dedham Lock and Mill', 1817–18 (no.94). The first major visual impact of the new pigment can be seen in the Salisbury and Hampstead paintings of c.1820. In 'Hampstead Heath with the House Called "The Salt Box"' (no.107) and 'Hampstead Heath (The Vale of Health)' (no.108) chrome yellow was mixed with Prussian blue to make a vivid green, quite unlike the comparatively muted colours created with Naples and mars yellow in Constable's earlier works. In 1820 Constable was apparently unaware of the dangers regarding the permanence of chrome yellow that preoccupied later writers on artists' pigments.[119] They warned that it would 'ultimately destroy Prussian and Antwerp blue, when used therewith in the composition of green'.[120] It was also thought to lose its colour.[121] This does not appear to be the case in Constable's paintings, as is particularly evident in the Salisbury sketches of 1820 and 1829 and the Hampstead sketches of 1821–3, where he applied startling touches of the pure pigment (fig.173). A good example is the foreground of 'Hampstead Heath, Looking towards Harrow' (no.110). In 'finished' paintings of the 1820s Constable tended to restrain himself from using too much chrome yellow in pigment mixtures. He probably realised that its brilliance might lead to a lack of harmony in a large picture, as Field later commented: 'In general they [chrome yellows] do not accord with the modest hues of nature, nor harmonize well with the sober beauty of other colours'.[122] In 'The Lock' of 1824 (no.158) chrome yellow was used for tiny 'finishing' touches, such as the highlights on

leaves, the scarf of the lock-keeper and flowers close to the bottom edge of the painting, where the tiny flecks of pure yellow are used to add sparkle to the picture surface.

By about 1819 Constable was using Patent yellow, which has been identified in 'Sketch for "The Opening of Waterloo Bridge"' (no.103, fig.174).[123] Field described it as 'a hard, ponderous, sparkling substance, of a crystalline texture and bright yellow colour; hardly inferior when ground, to chromic [chrome] yellow'.[124] Patent yellow was first manufactured in England c.1781 and was soon mentioned by Williams of Bath in *An Essay on the Mechanic of Oil Colours* published in 1787.[125] It is listed in his instructions for setting the palette: 'Place the white next to the thumb . . . patent yellow next, ranging them in the following order, next to patent yellow, ditto oaker, Siena earth, vermilion, red oaker, purple brown, lake, burnt umber, Antwerp brown, black, prussian blue'.[126] Patent yellow has been tentatively identified, mixed with Naples yellow, in the opaque yellow highlights on the fields in 'Dedham Vale, Evening', 1802 (no.32). The extent of its use between 1802 and 1819 is not clear. After 1819, however, Constable used it for the rest of his life. It has been visually identified on both his palette and in flecks of paint on the sketching box.[127] The esteem in which he held the pigment is illustrated by a statement in one of his 1836 lectures to the Royal Institution: 'For the light of the sun he [the artist] has but patent yellow'.[128]

Massicot, a dull yellow similar in appearance to Naples yellow, was also used c.1819, mixed with Patent yellow, in no.103.[129] Insufficient analysis has been carried out to show whether this is the first occurrence of the pigment in Constable's paintings, or whether he continued to use it.

It is interesting to note that most of the new colours that Constable used were in the yellow-orange-red area. The same is true of Turner's pigments – of the sixty-one pigments found in his studio at his death, five were shades of chrome yellow. There was also a chrome orange and more than half the pigments were organic yellow, red, brown and purple lakes.[130] This not only reflects artists' preoccupation with these colours, but also developments that took place in the chemical industry and the interests of colour-makers, such as George Field, in the early nineteenth century.

The colour-maker George Field is first mentioned in Constable's correspondence in 1825,[131] but it is possible that they knew each other before that. Their friendship ensured that new or rare colours were readily available to Constable soon after their introduction as artists' pigments. Field was particularly well known for his madder lakes. By the time

Chromatography was published in 1835, he manufactured a range of madder pigments including 'rose', 'carmine, a superior transparent red', brown and purple shades.[132] The brightly coloured purple and orange lakes that appeared in Constable's palette in 1810 could have been supplied by Field who mentions such colours in his 'Practical Journal', 1809.[133] The two madders found on Constable's palette are pink and red in colour, and may well be Field's 'rose' and 'carmine' shades (see below). He could also have been the source of Constable's chrome yellow in 1816.

Constable's sketching box and palette have provided information about the pigments and media used in his late paintings. Although the sketching box was reputedly used in 1824, the powdered pigments found among the contents date from the 1830s and were probably supplied by Field.

An unusual pigment has been identified both on Constable's palette and in the sketching box. On the palette it is a dull yellow. In the paint box it is found in powder form in a glass phial labelled 'Protiodide of Mercury'. Here it has darkened from yellow to black in places. This pigment was also known during the nineteenth century as Scarlet Lake or Iodine Scarlet.[134] Originally it was a 'scarlet colour brighter than vermilion'.[135] Field suggests that it was 'used to dress or give unnatural vividness to true vermilion'.[136] He warned that it was not permanent ('impure air soon utterly destroys its colour') and should be used with an ivory palette knife as contact with metal affected the colour.[137] Merimée, working in France, also 'made several trials of its [Periodide of Mercury's] solidity . . . and found that in a few months it became yellow'.[138] Constable may not have been aware of the impermanent nature of the colour when he used it, although this would be surprising as he probably obtained it from Field.[139] If he used the pigment in significant amounts, either on its own or to brighten vermilion, the colour change from bright scarlet to dull yellow, such as has taken place on the palette, will have distorted his pictorial intentions in the late paintings in which it was used.

Together with 'Protiodide of Mercury', a purplish-brown pigment labelled 'Oxide of Manganese' (manganese brown), a dull green pigment labelled 'Sesquioxide of Chromium' (transparent oxide of chromium) and two shades of natural ultramarine (deep and light) are in the sketching box in powder form (fig.175). 'Sesquioxide of Chromium' is what Field described as the 'true Chrome Green'.[140] He manufactured this newly discovered pigment in 'various degrees of transparency or opacity . . . which are all rather fine rather than brilliant greens'.[141] By the mid-nineteenth century 'Sesqui-oxide of Chrome' was mentioned in several painting manuals which

suggest that its high price limited its use.[142] Manganese brown, a rare manganese oxide pigment was also manufactured by Field.[143] It is very likely that Field supplied Constable with the iodine scarlet, manganese brown and oxide of chromium found in the sketching box, particularly as he was the sole source of the latter two colours at this date.[144]

Constable used natural ultramarine throughout his career. In 1825 he obtained several shades from John Allnutt, who brought it from France: 'Mr. Allnutt of Clapham called . . . Brought me some very beautifull ultramarine according to his promise. There was three sorts – I dare say there was 5 guineas worth. He promised me a little more of another kind'.[145] In the mid-1820s Allnutt asked Constable to redo the sky of his 1814 Academy exhibit 'Ploughing Scene in Suffolk: A Summerland' (no.71) which Allnutt had bought. The original sky had been painted over, according to Allnutt's wishes, by John Linnell. Perhaps Allnutt hoped to appease Constable by supplying him with a large quantity of natural ultramarine, the most expensive ingredient of a new sky. The pigment found in the paint box may be that provided by Allnutt. Alternatively it may have been bought from Field who is known to have supplied Constable with various shades of both natural ultramarine 'and the lovely greys known as ultramarine ash'.[146]

In Constable's late paintings (after *c*.1829) a new orange pigment can be seen. It has not yet been identified by analysis, but it may be chrome orange which was introduced into Turner's palette *c*.1830.[147] Alternatively, it may be Field's Orange Vermilion, a new colour manufactured by the colour-maker by an undivulged method.[148]

The following pigments have been identified on the Constable palette at the Tate Gallery: vermilion; mars red; a red lake; iodine scarlet; madder lake (pink and red shades); orange iron oxide (?Burnt Terre Verte); chrome yellow; Patent yellow; cobalt blue; emerald green; mars brown; a dark brown (?Antwerp brown); lead white and bone black. Cobalt blue was first used in the sky of 'finished' paintings *c*.1820. Prussian blue is notably absent from the palette. However, the presence of Emerald green, first used *c*.1830 (see 'The Opening of Waterloo Bridge', no.213), and a 'mixed' green containing orange iron oxide, a yellow (?Patent yellow) and bone black may indicate that Constable was no longer routinely using Prussian blue and a yellow to mix greens at this date.

The dark brown pigment which covers much of the palette may be Antwerp brown, a pigment with 'great body' made by heating asphaltum in a sealed crucible until it turned to cinders.[149] It was then mixed with sugar of lead and ground with a strong drying oil.[150]

The preparation of asphaltum in this manner was meant to render it less likely to crack and 'crocodile' than natural asphaltum or bitumen.[151] This pigment was first used by Constable in the sketches of 1810 and continued to be used throughout his career as the principal dark brown glazing colour in both sketches and 'finished' paintings. Constable's use of Antwerp brown, rather than pure asphaltum or bitumen, was probably intended to avoid the disastrous cracking associated with the use of these materials. It has recently been suggested that bitumen was the cause of the unsightly cracks that appear on many of Constable's 'finished' paintings, particularly the late works, such as 'The Valley Farm' (no.216).[152] However, this seems unlikely as no bitumen has been identified on any of the paintings examined by the author. The cracks may have resulted from poor technique. In areas where Constable used a thick glaze over semi-dry paint, or where he applied quick-drying paint over a slow-drying glaze, cracks have often occurred. These are particularly evident in many of Constable's exhibition paintings, which were 'finished' before the underlayers were dry, notably in his 'late' works where liberal 'toning' glazes were applied.

The Tate Gallery palette is almost certainly that which Constable was using immediately prior to his death in 1837. The presence of rather more transparent pigments than would be expected in the early stages of a painting, accords with the fact that he was in the process of 'finishing' his forthcoming Academy exhibit 'Arundel Mill and Castle' (no.220). If this is indeed the last palette, we should not be surprised that it lacks natural ultramarine, which was reserved for the very last scumbles over the sky and the 'finishing'. Constable's sudden death deprived the picture of these final touches.

Preparing to Paint

Having considered the range of materials found in Constable's paintings, the following section will discuss how these materials were used. As has been described above, Constable would first have prepared his support with a ground or coloured priming. The next stage was not necessarily the direct application of paint to the prepared surface. This was the practice in Constable's outdoor oil sketches where no under drawing was necessary.

The composition of a 'finished' picture usually required some preparation before painting commenced. In many cases this took the form of oil sketches or studies. Constable

generally used one of two methods to transfer the design from a preparatory work to a larger canvas – using either a grid made of threads stretched over the painting and held by tacks at the edges or a 'squaring-up' frame.[153] The larger support was squared-up in the same proportions as the sketch or study, either with a grid drawn onto the priming or with threads stretched from tacks at the edges. Constable then used various media to outline the composition.

Very little underdrawing has been identified on Constable's paintings in general, and what there is appears most frequently during the 1820s when John Dunthorne Junior was working as his studio assistant. During this period Constable apparently left much of the technical work to Dunthorne, whom he frequently mentioned in his correspondence: he 'is squaring and working hard'; 'He forwards me a great deal in subordinate parts such as tracing, squaring &c &c'.[154]

Underdrawing

No underdrawing has been detected on Constable's early 'finished' paintings. This strongly suggests that if any underdrawing *is* present it was carried out in chalk, which is rendered transparent by subsequent oil paint layers. Artists' painting manuals of the early nineteenth century 'were remarkably consistent in calling for *white chalk* or *pipe clay* for the first drawing on the canvas'.[155] Several varieties of white chalk were available from artists' colourmen including 'Spanish chalk' and 'French chalk'. Chalk was also recommended for rectifying the image during painting.[156] We know that Constable used it for this purpose from John James Chalon who wrote to him in November 1814 regarding a painting of his own: 'I Shall require one of your Scrutinizing looks, and will take care to have White Chalk ready'.[157]

In 'Flatford Mill from the Lock', 1812 (no.54) there is a layer beneath the paint which could broadly be described as underdrawing. Infra-red reflectography reveals broad strokes of a half-inch brush outlining the composition (figs.210–11). Bardwell advised the use of 'burnt umber drove with drying' oil' for 'Sketching, or rubbing in the Design . . . in a faint, slight, scumbling, free Manner as we shade with Indian Ink and water'.[158] This appears to be a technique that Constable used in this case. Having fully worked out the composition in a studio study (no.53) he apparently felt sufficiently confident to 'draw' in the composition, in paint, directly onto the priming.

The earliest evidence of underdrawing proper (identified by the author) is in 'Boat-Building', 1814–15 (no.72). No overall outline has been detected and it appears that Constable first broadly laid in the composition with opaque paint. He then carefully drew the elliptical shape of the top of the barge's hull using a lead pencil.[159] The upper paint layers closely follow this line and it is visible only through microscopic examination of the paint surface. 'Boat-Building' was probably started out-of-doors on the final canvas and worked up in front of the motif. Presumably Constable found it necessary to draw in the top of the hull because of the difficulty in achieving the correct perspective.

During the 1820s Constable made a number of replicas of certain compositions. During this period there is a considerable increase in the use of underdrawing, apparently associated with the copying procedure. The purpose of the underdrawing was to facilitate the exact transfer of a composition from one canvas to another. For example, the detailed outline of 'Dedham Lock and Mill', 1817–18 (no.94) was copied in pencil and black ink onto the priming of the canvases of the two copies made in 1820 (nos.95 and 96).

Although there is no documentary evidence for John Dunthorne Junior being employed as a studio assistant before 1824, examination of paintings from the earlier 1820s suggests that he may have been involved at this period. His help in the preparatory stages of Constable's paintings in the early 1820s would partly explain the dramatic increase in the amount of underdrawing. For, as well as helping with the transfer of a composition, it would assist a less competent painter in the achievement of a reasonable copy. This is especially obvious in the second replica of 'Dedham Lock and Mill' (no.96), painted in 1820, which has significantly more underdrawing than the first (no.95). Ruled pencil lines are visible on the horizon to the left of the mill, as is the ink outline of the lock-keeper, who was only crudely coloured-in. Similarly, the second version of 'Ploughing Scene in Suffolk: A Summerland',[160] has extensive underdrawing copied directly from the 1814 original (no.71). It was certainly painted when Dunthorne was working as Constable's studio assistant. Both paintings follow the drawn outlines in such a laboured fashion that they may have been largely worked up by Dunthorne.

In 1822–3 Constable painted 'Salisbury Cathedral from the Bishop's Grounds' (no.140) which was exhibited at the Academy in 1823. In July 1824 he wrote to Maria commenting that 'Johnny has done a delightfull outline of my Cathedral same size for me to copy'.[161] Dunthorne's pencil outline is visible by infra-red reflectography[162] in the Metropolitan Museum's version of the subject.[163] Viewers will now see a marked difference between the handling on the left-hand side and foreground and that in the unfinished tree on the right and the thickly painted sky. Microscopic examination of the paint surface by the author together with x-radiography of the top of the picture[164] has revealed that the painting was originally a precise copy of the 1823 picture, with the trees still meeting in an arch. It was probably worked up by Dunthorne in his relatively crude, tight manner. The sky and sketchy trees on the right were subsequently masterfully reworked by Constable to effect a change of composition in preparation for the version now in the Frick Collection, which was finished in 1826.[165]

In many of Constable's late paintings it is easy to see underdrawing with the naked eye. The combination of a thin brown priming and paint applied in patches frequently allows the drawing to show through quite clearly. In addition to lead pencil Constable often used a dilute brown paint or ink. It was used with a pen or quill giving a thick, dense line that is much easier to see than a pencil line. These two drawing media were often used together. In most cases the underdrawing is rapid and free except in areas with architectural elements where straight lines were often ruled. Good examples can be seen in the left-hand side of the full-size study for 'Hampstead Heath with London in the Distance', c.1827–30 (no.128) in which a pencil was used, and the tree tops in 'A Farmhouse near the Water's Edge', c.1834 (no.215) where ink with a quill pen was used. In 'The Opening of Waterloo Bridge' (no.23) both drawing media were used. The outline was initially drawn onto the white ground before a brown wash was applied in the landscape areas. Thinned paint or ink was used with a quill pen. Drawing is clearly visible on the architectural forms of the buildings on the left-hand side and the arches of the bridge. The underdrawing in the landscape areas may have become more visible with the increased transparency of the brown priming with age, but it would certainly have always been visible in the thinner and lighter areas of paint. During the painting process pencil lines were drawn over and into the wet paint to reinstate the horizontals and verticals of the bridge, towers and buildings in general. These lines were mostly ruled, those on the tower on the far right can be seen clearly (fig.176).

Transferring the Composition: Squaring-up

Squaring-up techniques for the transfer of an image from an oil sketch to a larger canvas have not been found on Constable's paintings before the middle of his career.[166] There are,

fig.176 'The Opening of Waterloo Bridge', no.213, detail of Shot Tower with pencil lines ruled in the paint down its sides

fig.177 'Branch Hill Pond, Hampstead', no.106: regularly spaced ink marks drawn with a quill pen on the tacking edge and used for squaring-up the composition

fig.178 'Sketch for "The Opening of Waterloo Bridge"', no.212, detail of buildings on the left showing thick ink squaring-up lines and drawing of architectural features

however, two large compositional drawings for the 1813 Academy painting 'Boys Fishing' (no.57) which are 'squared-up and more or less on the same scale as the painting' (see under no.56). This implies that squaring-up techniques are likely to have been used on the final canvas; this has not been confirmed as the painting has not yet been examined microscopically nor with infra-red imaging techniques.

The earliest example of a squaring-up technique seen by the author was used on the small sketch of 'Weymouth Bay (Bowleaze Cove)' made in 1816 (no.84). It is painted on millboard (see above, p.501) which has small notched score-marks on the back, evenly spaced one and a half inches apart, perpendicular to the edges. The notches match up from top to bottom and from left to right across the painting. They were probably intended to hold fine threads stretched across the front of the painting to create a grid. The threads could be removed after the design had been copied. In this manner the outline of the composition was transferred to a larger support leaving the original sketch unmarked.

A similar device was probably used to square-up the sketch of 'Branch Hill Pond', 1819 (no.106), which is the earliest version of this composition. On the tacking edges there are tiny, regularly spaced lines drawn onto the priming with ink and a quill pen (fig.177). For the transfer of the composition the painting may have been laid onto a board with pins tacked into it around the edges of the painting, aligned with the ink marks. Threads tied around the pins could then be stretched over the surface in line with the ink marks creating a grid on the front of the picture. Alternatively, a wooden squaring-up frame with threads stretched across it may have been laid over the front of the painting, aligned with the ink strokes.

Another example can be seen in the first finished version of 'Dedham Lock and Mill', 1817–18 (no.94). In this case five small, regularly spaced, pencil lines divide the bottom edge into six. Unusually, there are no such lines along the side edges. The lines may have been part of the squaring-up procedure used to transfer the composition to the two 1820 copies. Constable probably used vertical threads aligned with the pencil marks stretched over the front of the picture so that he did not mark it. Both copies were squared-up with threads stretched from pins tacked around the edges of the canvas. The composition was then copied directly onto the priming using pencil and a washy brown medium, which may be diluted paint or ink, after which the threads were removed.

Constable occasionally used a grid drawn directly onto a primed canvas in ink or graphite. Notable examples of this technique can be seen in the sketches for 'The Opening

of Waterloo Bridge' (no.213). In the 1819 sketch (no.103) a grid was drawn in pencil onto the pink priming whereas in the larger study (no.212) lines were drawn in brown ink directly onto the white ground (fig.178). In the latter there is also detailed underdrawing in ink outlining the composition. Surprisingly, no squaring-up lines have been identified on the exhibited picture (no.213) although such a large and elaborate work would almost certainly have been squared-up in order to draw the detailed 'outline' of the composition. Constable may have disliked the rather disfiguring effect of the grids in the sketches and as a result squared-up the large canvas with threads which were later removed to leave no trace.

The Painting Process

As we have seen, apart from the introduction of new pigments, Constable's basic painting materials changed relatively little throughout his career. By contrast, his painting technique altered radically between 1802 and 1837. His earliest works demonstrate a sound understanding of traditional oil painting technique. From this starting point he evolved his own methods resulting in a range of techniques for different types of painting. These were gradually altered and refined in his search for new 'effects'.

In terms of technique Constable's paintings fall into three main categories – 'finished' paintings, studies and sketches. In the nineteenth century a 'finished' painting was one in which the artist paid careful attention to perfection of design, form and detail when adding the final touches. This was in contrast to the 'rough' or spontaneous treatment that might be found in a sketch. In 'finishing' a landscape the artist was also responsible for creating a 'harmony' (apparently not found in nature) 'according to his intuitive knowledge, or that which he may have acquired through study and practice'.[167] Paintings exhibited at the Royal Academy were expected to display a high degree of 'finish'. Success or failure in the final stages of a work would be reflected in its reception. In Fairholt's *Dictionary of Terms in Art* (first published in 1854 but presumably reflecting earlier usage), the 'Finishing' of a painting is even described as 'the difference between excellence and mediocrity'.[168]

The terms 'study' and 'sketch' were often used interchangeably by artists and the authors of books on art in the nineteenth century.[169] Nevertheless, a subtle distinction was made by Fairholt who defined a 'Study' as 'a finished sketch from nature . . . which

merely secured locality and general effects for more detailed finishing in the atelier of the artist'.[170] A 'Sketch' was 'the first embodiment of an artist's idea . . . a copy from nature only sufficiently finished for the artist to secure the materials for a picture'.[171] In other words a 'study' could be worked up, or 'finished', in the studio.

Fairholt's definition of a 'Study' accurately describes the technique used in Constable's 1802 paintings from nature (nos.2–5) since they can be readily distinguished from his sketches by their high level of 'finish'. Constable apparently considered these early studies sufficiently highly 'finished' for exhibition as in 1803 he showed two paintings at the Academy entitled 'A Study from Nature'. These were probably chosen from the 1802 group.

Constable regularly used outdoor oil sketching to gather pictorial material from c.1808 to 1829. His oil sketches were personal notations, unpretentious and unaffected by convention. They were never intended for exhibition and were only shown to relatives and close friends during his lifetime. They can be distinguished from both 'finished' paintings and 'studies' in terms of technique.[172] They are small in size and were painted very rapidly, in one sitting. The paint was applied wet-in-wet, with the direct mixing of colours on the palette. There was no attempt at academic 'finish'. Occasionally sketches were later altered or reworked, often with the addition of foreground figures or animals. This usually took place during the evolution of a larger work, an exhibition painting or a mezzotint.

Whether painting from the motif or in a studio Constable usually painted by daylight, for he was especially conscious of the effect that it had on his paintings. This may have been due to his early experience of painting out-of-doors with John Dunthorne Senior. In 1801 he wrote from London to Dunthorne in East Bergholt: 'I paint by all the daylight we have, and that is little enough, less perhaps than you have by much . . . imagine to yourself how a purl must look through a burnt glass'.[173] Although the poisonous smogs of the later nineteenth century had yet to develop, the effects of the Industrial Revolution were clearly evident in the London sky. At this time Constable was living and painting in rooms at 50 Rathbone Place. 'My large room has three windows in front', he wrote, 'I shall make that my shop, having the light from the upper part of the middle window, and by that means I shall get my easel in a good situation'.[174]

Constable meant his paintings to be viewed in the light in which they were painted. He was quite aware that in certain weather conditions, or at different times of the day, his paintings looked better or worse; in 1826 he wrote to a prospective client, 'You see my little picture to a disadvantage, as the day is dark'.[175] John Fisher was also aware of how Constable's paintings altered through the day: 'The Cathedral looks splendidly over the chimney piece. The picture requires a room full of light. Its internal splendour comes out in all its power . . . The only criticism I pass on it, is, that it does not go *out* well with the day. The light is of an unpleasant shape by dusk'.[176] To the latter comment he soon received Constable's ironic reply, 'Have you done anything to your walls? They were of a colour formed to destroy every valuable tint in a picture'.[177] As this remark illustrates, Constable was not only fully aware of the effects of light, but he was also sensible to the coloured background on which his paintings were hung. In 1813 he redecorated his lodgings in Charlotte Street with this in mind: 'The paper will be a sort of salmon color and the sofa & chairs crimson (by Lady Heathcote's advise). I think they will suit pictures'.[178] The colour of his studio walls was also of primary importance to him: 'My front room where I paint shall be done with a sort of purple brown from the floor to the ceiling – not sparing even the doors or doorposts, for white is disagreeable to a painter's eyes, near pictures'.[179]

Constable did not usually paint after dark. In February 1816 he wrote to Maria, 'I never begin to write 'till it is dark and I can no longer see to paint'.[180] This restricted painting time in winter months when the hours of daylight are fewer. In December 1825 he wrote that it was 'So dark that we had a candle on the table at 10. In the morning could not paint'.[181] At this time of the year Constable was usually working in his studio, much of the time employed on paintings intended for the forthcoming Academy exhibition. Fisher found this a matter of concern, chiding Constable in September 1829: 'I yearn to see you tranquilly & collectedly at work on your next great picture . . . when the glands of the body are unobstructed by cold . . . You choose February & March for composition; when the strongest men get irritable & uncomfortable . . . Sept: Oct: & Nov: are our healthiest months in England . . . The season you select for composition is the chief reason of the unfinished, *abandoned* state of your surface on the first of May. Your pictures look then like fine handsome women given up to recklessness & all abominations'.[182]

Constable may occasionally have painted by artificial light, for in April 1825 Fisher wrote to him suggesting that they might 'wander home from the shore about dusk to the remnants of dinner as heretofore; & spend the evening in filling up sketches'.[183] This suggests that they habitually worked at night, although they did not necessarily paint. No evidence of 'filling-up' oil sketches has yet been seen by the author. This perhaps suggests that Fisher was referring to drawn, rather than painted, sketches. Constable was similarly reticent about viewing paintings by artificial light. In 1814 he commented that he had been to the British Gallery and 'was disappointed in the effect by candlelight, I prefer it infinitely by day'.[184]

From the very beginning of his career painting out-of-doors from nature was particularly important to Constable. In 1802 he set out to create a 'pure and unaffected representation' of the Suffolk countryside by making 'laborious studies' from the motif (see nos.2–5). He probably worked on each painting at the same time of day so that the light and shadows were consistent from one sitting to another. He developed this practice when painting with John Dunthorne Senior. According to David Lucas, who must have heard it from Constable, he and Dunthorne were 'very methodical in their practice taking with them into the fields their easels and . . . painted one view only for a certain time each day when the shadows from objects had changed their position the sketching was postponed until the same hour, the following day'.[185]

Some of Constable's exhibited paintings were started out-of-doors. 'Boat-Building', 1814–15 (no.72), 'Flatford Mill', 1816–17 (no.89) and 'Dedham Lock and Mill', 1817–18 (no.94) appear to have been laid in in front of the motif and 'finished' in the studio. For paintings of this type Constable generally used relatively small canvases that could conveniently be carried across the fields each day. However, the latter two canvases are rather larger than the others ('Flatford Mill', the largest, measures 40 × 50 inches). These would have been cumbersome to transport, along with the easel, paint box and other paraphernalia required for a day's painting. Constable may have been ferried back and forth in a farm cart to his venue each day. Alternatively, when painting at Flatford or Dedham mill he could have left his canvas and materials on the premises.

During the 1820s Constable painted 'cabinet' pictures from nature. These were relatively small, highly 'finished' paintings often with less formal compositions than his larger exhibited works. They were worked up out-of-doors and 'finished' in the studio (for example 'Hampstead Heath with the House Called "The Salt Box"', c.1819–20, no.107, 'Gillingham Mill', ?1823–7, no.144). Many were exhibited and sold, both in England and in France, to collectors who could not accommodate the larger canvases on their walls.

After 1829, when he made a number of brilliant oil sketches at Salisbury, Constable gave up painting from nature. He then relied

to a considerable extent on sketches and drawings made in earlier years, or painted Stour-inspired scenes from his imagination, always in the studio.

After his permanent move to London in 1816 Constable painted his most important exhibited works entirely in his studio.[186] Painting in a studio with a fixed light source, rather than out-of-doors, affected both the character of his paintings and his technique. He began to use much larger canvases. Between 1819 and 1825 he produced his famous series of 'six-footers', Stour scenes on canvases which measure approximately four feet high by six feet wide (see nos.100, 101, 162). In 1823 he stated 'I do not consider myself at work without I am before a six-foot canvas'.[187] After 1825 he continued to paint large exhibition pictures, but generally not Stour views. Although size was no longer dictated by the ease with which a painting could be carried out-of-doors, before 1822 Constable was instead restricted by having to take large canvases out of the house through a window on his staircase![188] The increased dimensions of many of the works of the 1820s was not only a result of painting in the studio. It was also linked to Constable's serious bid for recognition at the Academy. After his election as an Academician in 1829 he outdid himself and painted his largest exhibited work 'The Opening of Waterloo Bridge', shown in 1832 (no.213).

'Finished' and Exhibition Paintings

> The sky should be done first; then the Distances; so work downwards to the middle Group, and from that to the Fore-ground, and nearest Parts.[189]

Technical examination has shown that Constable's painting technique in 'finished' works before the mid-1820s closely follows these instructions. They come from *The Practice of Painting and Perspective Made Easy* published in 1756 by Thomas Bardwell, a professional painter. His book was immensely popular and influential – thirteen legal and pirated editions were printed before 1840.[190] It contains instructions for portraiture and landscape painting. When it was first published 'landscape' painting was only just emerging as a genre in England.[191] The techniques Bardwell advocated did not reflect practices used by other eighteenth-century landscape painters such as Stubbs, Gainsborough and Wilson. Instead, they looked back to Dutch and Flemish painting techniques of the seventeenth century. The book remained popular with both professional painters and amateur artists until well into the nineteenth century. Edward Edwards commented, in his *Anecdotes of Painters* published posthumously

in 1808, 'that the instructions contained in that short work [Bardwell], so far as they relate to the process of painting, are the best that have hitherto been published'. James Ward, a contemporary of Constable, is known to have copied out the book in full as a young artist.[192]

It may be coincidental that Constable's materials and techniques accord so closely with Bardwell's instructions. Yet, Constable owned a 1782 edition, and, of all the books contained in his library,[193] this appears to be the most relevant regarding his actual painting practice. In the absence of formal tuition in oil painting it appears to have been a 'standard text' for any aspiring painter at that date. Given the widespread popularity of the book it seems reasonable to assume that Constable read it early in his career, possibly before his arrival in London in 1799.

The system with which Constable painted a 'finished' work changed relatively little from 1802 to the mid-1820s. Before starting to paint he may have outlined the composition on his coloured priming using one of the methods described above. The first layer of paint applied to the surface was the 'dead-colouring' of the sky. This was laid in with a large brush, using thin washes consisting mainly of lead white and Prussian blue, around contours roughly corresponding to the intended outline of trees and horizon. In 'Dedham Vale', 1802 (no.2) a mushroom-shaped 'reserve' of priming is visible in the final image despite the large tree painted over it. Constable used the warm colour of the priming to add depth to the sky by varying the thickness of the brushstrokes. In this way he created a range of effects that cannot be obtained by painting a blue or grey layer directly over a white ground. Farington noted this technique as early as 1801 on seeing a painting by Constable that was 'painted on a coloured ground which He has preserved through the blue of his sky as well as the clouds'.[194] The 'dead-colouring' of the sky would have taken very little time to paint and it was then left to dry before the rest of the landscape was begun. Walnut oil ground with mastic resin and sugar of lead was recommended for 'dead-colouring' the sky as it would dry in 'about two hours'.[195] Constable may have begun several paintings in a day or had them at different stages and worked on them sequentially. The 'dead-colouring' of the landscape came next. Working broadly over the canvas Constable laid in the forms thinly using opaque pigment mixtures. This layer was allowed to dry.

Having thus established the composition, the distant landscape and middle-ground were worked up wet-in-wet according to Bardwell's instructions for the 'Second Painting': 'the greatest Distances are chiefly made with the colour of the sky; as they grow nearer and darker, we should glaze and scumble the Parts

very thin'.[196] In the 'second painting' of the sky the main cloud formations were worked up using several layers of semi-opaque greys, blues and pinks scumbled over each other to create depth. Highlights were applied in stiffer white paint. Although this system was generally used in all 'finished' works, the sky in the 1802 studies (nos.2–5) has no 'second painting'. Constable went straight from the 'dead-colouring' to the 'finishing'. During the 'second painting' of the landscape, branches, foliage and foreground details were added. For example, in the Yale Center 'Dedham Vale', 1802 (no.4) brambles were added in the foreground and a figure was painted in. A certain amount of glazing was also carried out at this stage.

In his early paintings Constable's approach to modelling was partly based on what he had learnt from copying Claude, particularly the 'Hagar and the Angel' (fig.19 on p.60) which he admired greatly and had copied in 1800.[197] In 1802 Constable's brushwork was also inspired by the landscapes of Richard Wilson and Gainsborough's Suffolk period. Leaves were described literally, working from dark to light, using numerous feathery strokes from a small brush 'with a good body of colour, as stiff as the Pencil can agreeably manage to character'[198] (fig.179). The unfinished 'Dedham Lock and Mill' (no.93) shows the 'dead-colouring' and a partially completed 'second painting'. 'Osmington and Weymouth Bays', 1816 (no.83) is a brilliant example of a painting brought to the end of the 'second painting'. Having taken a painting this far in front of the motif Constable could carry out 'Third' and 'Last Painting' ('finishing') back in his studio.

Before 'finishing' a painting Constable frequently made alterations to the composition (pentimenti). These sometimes consisted of minor adjustments, such as refining the contours of the tree tops in the 1802 studies 'Dedham Vale' (no.4) and 'A Lane near Dedham' (no.5). Often pentimenti involve the removal of, or changes to, figures and animals. Many of these are now visible due to the increased transparency with age of the covering paint layers (for example: the man opening the lock gates in 'Flatford Mill from the Lock', no.54, see figs.211, 213; a large cow facing to the right behind the foremost animal in 'Summer Evening', no.33, fig.180; a man stirring the cauldron on the left of 'Boat-Building', no.72, fig.181). Sometimes more radical alterations were made. The x-radiograph of 'The Wheatfield', 1816 (no.76) shows that the composition was changed on at least two occasions, with the landscape background initially depicting a totally different view across the vale of Dedham. Sometimes Constable laid aside a half-finished picture. 'Fen Lane', 1817 (no.91) was brought to the end of the 'second painting' in front of the motif. Constable evidently had

fig.179 'Dedham Vale', no.2, detail of main tree showing feathery brushwork

fig.180 'Summer Evening', no.33, detail of infrared photograph showing pentimento of cow in foreground

fig.181 'Boat-Building', no.72, macro-detail of pentimento of man stirring cauldron

fig.182 'Dedham Lock and Mill', no.94, raking-light detail of trees on right showing individual brushstrokes of granular paint used as highlights on the leaves

trouble with the foreground. He apparently worked it up quite fully before deciding to paint out the left-hand side with broad strokes of brown paint. He did not allow the underlying paint enough time to dry before doing this, resulting in the formation of numerous drying cracks in the upper paint layers (these are presently subdued by retouching). The painting was never completed, presumably because he could not resolve the foreground.

Constable closely followed Bardwell's instructions for the 'finishing': once the 'Middle Teints and Shadows' had been improved the 'Lights and Finishing Colours' should be added with 'a better Body of Colour . . . Thin near Trees [trees in the foreground that should be thinly painted] of different Colours, will do better, if we let the under Parts dry before we add the Finishing Colours . . . we should remember to use a great Variety of Teints, very near to the same Colour; but most of all when we are finishing Trees: This gives a Richness to the Colouring, and produces Harmony . . . What I have said of Trees, answers the same to all Kinds of Shrubs and Bushes'.[199] Bardwell also stressed the importance of 'sweetening' the picture, a term described by Fairholt as 'a certain clearness of drawing or colouring, which is agreeable to the eye, like a head by Carlo Dolci or a landscape by Claude'.[200] This reference to Claude is particularly significant, as we know Constable held his work in the highest esteem as a perfect example of the art of landscape: 'Only think that I am now writing in a room full of Claudes . . . almost at the summit of my earthly ambitions'.[201]

As instructed by Bardwell, Constable carried out the glazing and 'finishing' only when the painting was properly dry. As early as 1800 he wrote to Dunthorne Senior mentioning this practice regarding a Ruysdael copy he had recently finished, 'all but the glazing, which cannot be done till the picture is dry. It has been roasting in the sun these two or three days'.[202] Constable used transparent brown and green glazes to 'harmonise' the composition and saturate the colours, particularly in the shadows and the foreground. Bardwell recommended '[red] Lake, Terrevert, Prussian [blue] and Brown Pink' as the four 'Principal Colours' for glazing.[203] Constable used Prussian blue and an unidentified yellow lake (possibly 'Brown Pink') for green glazes. For brown glazes he used a medium-rich mixture of black and umber, with the addition of vermilion or mars red, dispersing only a little pigment in a large quantity of medium to give transparency to this mixture of relatively opaque pigments. These pigment mixtures are identical to numbers '6' and '10' respectively in Bardwell's list of 'Principal Teints used in Landscapes'.[204] To 'sweeten' the colour in the

bluest areas of the sky and along the horizon, a scumble of the expensive blue pigment natural ultramarine (lapis lazuli) was laid on, followed by a scumble of vermilion over the whites of the clouds.

Constable created highlights with strokes of stiff opaque paint. In 'Boat-Building', 1814–15 (no.72) the 'dead-colouring' and 'second' painting were done in front of the motif using smooth opaque paints and a restricted palette. The finishing touches – highlights on leaves, the ground and foliage in the foreground and the little girl on the right – were painted in thick granular paint which stands up from the surface. In the trees on the right tiny specks of thickly textured white paint, applied with a brush, were used to create an effect of shimmering light and movement (a technique that Constable made famous in the 1820s). These 'finishing' layers employ a wider range of better quality pigments than the preceding layers (including natural ultramarine, orpiment and vermilion). They were only coarsely ground which adds to the textured effect of the brushwork. The 'finishing' of 'The Wheatfield' of 1816 (no.76) and 'Dedham Lock and Mill', 1817–18 (no.94) was also carried out in this way. In the latter, the leaves of the large right-hand trees are painted with thickly impasted, individual strokes of granular paint (fig.182).

Constable used glazes to subdue the highlights in many paintings. This technique was known as 'glazing-down' and it was mentioned by George Field in *Chromatography*. Although this technique was also used by other artists, Turner for example,[205] Field associated it with Constable in particular and stated that he used copal varnish for this purpose.[206] It has not been possible to identify the medium of Constable's glazes due to the difficulty of sampling the paintings. However, obvious examples of this practice can be seen in 'Dedham Vale', 1802 (no.2), the foreground of 'Flatford Mill from the Lock', 1812 (no.54, see fig.214) and 'The Wheatfield', 1816 (no.76).

If Constable left a picture for an extended period of time during the painting procedure, or if he intended to make alterations, it was his usual practice to 'oil-out' the surface in order that fresh paint could be readily applied to the dry areas. Constable probably 'oiled-out' paintings he brought partially complete from Suffolk to London to work on them in the studio and when he reworked a painting some time after its completion. 'Stratford Mill', 1819–20 (no.100) is an example. Before repainting areas in 1824 Constable wrote, 'After dinner washed Tinney's picture & oiled it'.[207] Bardwell suggested that 'If Oiling is necessary, lay the least Quantity that can be . . . Then wipe the whole Place that is oiled, with a Peice of Silk Handkerchief'.[208]

In the early 1820s Constable began to introduce variations to this basic technique. In 'Hampstead Heath (The Vale of Health)', c.1819–20 (no.108) he used a new technique in the upper paint layers. The 'dead-colouring' and 'second' painting were done as before. Then, instead of carrying out the 'third' painting and 'finishing' as described above, Constable liberally applied thick transparent glazes over the landscape areas (not the sky). This is particularly obvious in the foreground on the left where a green glaze was applied. On top of this he painted the foreground details (ferns, grass, figures and animals) in opaque paint (fig.183). The thick glaze layer separates the opaque paint layers one from the other, as if a sheet of glass had been placed between them, so that the details appear to be floating in front of the picture plane. This creates an illusion of three-dimensionality.

Constable's 'six-foot' Stour landscapes (1819–25) were attempts to recapture the sensations of the Suffolk countryside, on a large scale, in the London studio. 'The Hay-Wain', 1821 (no.101) shows the 'finishing' technique Constable developed to depict fleeting effects of light, movement and texture. Using a palette knife he applied stiffly textured white and coloured specks over the surface of the picture. The Academician Solomon Hart described this process in his *Reminiscences*: 'Calling upon Constable one day, I found him with a palette-knife, on which was some white, mixed with a viscous vehicle, and upon which he touched the surface of a beautiful picture he was painting. Upon expressing my surprise, he said "Oh! my dear Hart, I'm giving my picture the dewy freshness" . . . he contended that the apparent crudeness would readily subside, and that the chemical change which would ensue in a short time would assume the truthful aspect of nature'.[209] Constable was evidently expecting a chemical reaction to occur between the lead white pigment and the impure London air for such changes were a major preoccupation of artists throughout the nineteenth century.[210] This would have caused the paint to darken, dulling the white flecks. Although a subtle change may have occurred, certainly, at the time of their exhibition, the paintings were criticised for their 'specky or spotty'[211] appearance and apparent lack of 'finish'. The technique was soon ridiculed and became known as 'Constable's snow'. Nevertheless, he continued to use it with minor variations until the 1830s when he commented that artists were 'adopting the palette knife just as I have laid it down – but which I did not do 'till I had cut my throat with it'.[212]

In the late 1820s Constable changed his technique radically. 'Salisbury Cathedral from the Meadows', 1831 (no.210) and 'The Opening of Waterloo Bridge', 1832 (no.213)

fig.183 'Hampstead Heath (The Vale of Health)', no.108, photomicrograph (10 ×) showing foliage applied in opaque paint over a thick green glaze

fig.184 'The Opening of Waterloo Bridge', no.213: dramatic brushwork depicting crowds on a balcony of the bow-fronted house

fig.185 'View on the Stour', no.48, detail of right edge showing fluid strokes of medium-rich paint

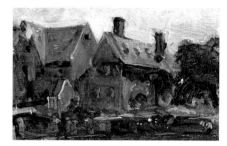

fig.186 'Flatford Mill from the Lock', no.52, detail of mill buildings (note the use of pink priming in the roof of the mill)

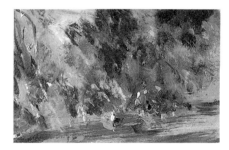

fig.187 'View at Salisbury from Fisher's Library' (see fig.73 on p.261), macro-detail of left foreground showing Constable's economy of brushwork and palette in the outdoor sketches of 1829

fig.188 'A Farmhouse near the Water's Edge', no.214: detail of brush and palette knife work in a late studio sketch

are fine examples of his 'late' technique for 'finished' pictures. The composition was laid in with a thin 'dead-colouring'. The sky was painted first and worked up using sweeping strokes from a large bristle brush. Once the composition was established the landscape was built up by dragging thick opaque paint over dry or semi-dry paint, to create a heavily textured 'lattice-work' effect. The paint was initially applied by brush but in the later stages a palette knife was also used. The paint is barely mixed on the palette; bright red, yellow, green and blue were used neat in many places. On close inspection the paint appears to consist of numerous 'abstract' splashes of colour. The modelling is not explicit, instead the emphasis is on giving an 'impression' of the scene. This can be seen in the brushwork of the figures on the balconies of the bay-fronted house on the left of the 'Waterloo' (fig.184). The architectural forms were emphasised by drawing into the wet paint with a pencil during the painting process. The sky was worked up with numerous scumbles of semi-transparent paint and may have been scraped down in areas during painting. Highlights were added in broad strokes of stiff white paint.

Unlike earlier paintings, the 'finishing' layers are not distinct in these late works. They

generally consist of richly coloured glazes, particularly in the foreground, where bright opaque colours were 'glazed-down' with browns, greens, reds and yellows. Many of Constable's late paintings appear less 'finished' than his earlier works but they are in fact highly refined. The unfinished appearance is due in part to the extent of the exposed brown priming and to the apparently coarse brush and palette-knife work. The priming plays an important part in the final image. It is visible in large distinct areas, reminiscent of the 1802 'studies', particularly in the foreground and trees where it is only covered by intermittent dashes of opaque colour. In the shadows it is only thinly glazed and scumbled. A comparison of the sketch for 'Salisbury Cathedral from the Meadows', c.1829–31 (no.209) with the exhibited painting (no.210) shows just how much further Constable took the 'finishing' in the exhibited work.

Oil Sketching

Constable's sketches can be divided into two groups; the rapid outdoor notations he made between c.1808 and 1829 and the studio sketches he made in preparation for 'finished' paintings in the 1820s and 1830s. He used different techniques for each type of sketch.

In order to paint out-of-doors Constable had to carry his materials with him in a sketching box. Such boxes were sold by artists' colourmen, in a range of sizes, for both oil and watercolour painting. One of Constable's sketching boxes (fig.166)[213] measures $9\frac{1}{4} \times 12$ inches, with internal measurements of $8\frac{1}{2} \times 11\frac{1}{4}$ inches. The lid of the box has a flat compartment separated from the rest of the box by a removable wooden panel. Many of Constable's sketches are small enough to fit inside this compartment which would have held them in place as he carried the box to and from painting.

The lower part of the paint box is divided into five sections of varying sizes. It now contains four bristle brushes, a Cumberland lead pencil, a palette knife, a double-ended metal pencil holder or *porte-crayon*[214] and nine glass phials of various sizes containing powdered pigments and paint. This cannot be the whole contents of the box as Constable used it, for there are no bladders of paint. There is only one phial of ready-prepared oil colour containing the dried remains of a transparent dark brown (unfortunately, it is not possible to analyse it as the cork stopper is impossible to remove from the phial).

Constable took great care over the quality and consistency of his sketching paints and certainly prepared many of his own colours. In 1812 he wrote that Johnny Dunthorne 'has been grinding colors for me all day'.[215] In 1819

Fisher wrote trying to entice Constable to visit: 'I have a painting apparatus complete. Brushes clean & pallet set. Colours fresh ground every morning'.[216] As collapsible metal tubes were not used for storing oil paints until the 1840s, Constable would have kept most of his colours in pigskin bladders bound with twine at the top.[217] These were pierced with a tack to let out the paint. In July 1821 Dorothea Fisher wrote to Constable asking him to send her some colours to replenish her paint box: 'if you think they will keep well when the bladders are opened'.[218] Certain colours, for example asphaltum, were sold and stored in glass phials.[219] The transparent brown paint in the phial in the sketch box may be asphaltum or Antwerp brown (mentioned above, p.507). It was originally very fluid as can be seen by the way it has settled in the phial. It would not have kept well in a bladder as it would have dried up, or oozed out into the paint box.

The small size of the sketching box limited the number of bladders and phials Constable could carry at one time. His use of a variety of priming colours for oil sketches was probably evolved to make the most of the few essential colours that such a box would hold.

During painting Constable would rest the box on his knees and fix the lid open at a convenient angle with the metal 'stay' which is attached to the side of the lid. He described this practice to Fisher in January 1825: 'I have enclosed . . . a dozen of my Brighton oil sketches . . . they were done in the lid of my box on my knees as usual'.[220] The painting support would be pinned to the lid. The edges of the lid are covered in splashes of paint where the brush ran off the painting. The removable wooden panel may have been used as a palette as it is covered in traces of paint. It could also have been laid on the ground to provide a flat surface to stand bottles of oil, resin or turpentine on.

When a sketch was finished Constable would pack it back into the lid of the box, held in place by the removable panel. As he often painted several sketches in one day without returning home, by the end of the day the lid would have contained several wet paintings. Many of the sketches have blobs of paint stuck to the backs and the impression of paper or canvas in the impastos, showing that they were piled up and compressed when only partially dry.

The paucity of both documentary and pictorial evidence before 1808–9 makes it difficult to assess how Constable's outdoor oil sketching technique evolved. The earliest works Constable is known to have painted out-of-doors are the rudimentary 'studies' of 1802 (nos.2–5). By 1809 he was markedly more confident and proficient. This can be seen in the 'View at Epsom' 1809 (no.67) which is

painted on millboard. The board was prepared with a thin reddish-brown priming. The paint is generally opaque and smooth in texture. It was mixed on the palette to the correct shade from a minimal range of colours. There is no preparatory drawing. Instead, the composition was laid in directly with bristle brushes in broad areas of flat colour. There is little tonal modelling and the forms were described in one or two paint layers, applied wet-in-wet. The priming is visible around the contours of the coloured areas, sharply contrasting with the greens of the landscape and blue-greys of the sky. Details were added wet-in-wet in acute strokes of a soft-haired brush (probably sable). There is a small amount of glazing in the foreground and shadows, applied to increase the saturation of the darker areas.

Constable continued to develop this technique during the summers of 1810 and 1811. He used redundant canvases cut into pieces and began to paint regularly on paper supports in 1811. He extended his range of priming colours from the earlier translucent dark reddish-brown to opaque mid-to-dark browns and pinks. His palette was slightly enlarged with the introduction of a few additional pigments, including a number of brightly coloured 'lakes'. A fine example, 'View on the Stour', 1810 (no.48) preserves the immediacy of its execution in the final image. It is painted on a canvas fragment primed with a rich dark brown. The paint was thinned on the palette with turpentine and extended with additional medium giving considerable gloss. Sweeping strokes of a loaded bristle brush were used to rapidly cover the priming, which remains visible in places, showing through thin paint and giving an underlying glow to the colours. With the minimum of effort the landscape was described in dashing strokes of almost pure colour. Brilliant flecks of opaque and transparent red, yellow and blue were used to draw the eye around the canvas (fig.185). In general the paint is rich and fluid due to the extra medium. In 'Flatford Mill from the Lock' (no.52), from c.1811, the paint is creamy and opaque and may have been used direct from the bladder with little diluent (fig.186). The whites are particularly chalky and lean and clearly retain the mark of the bristle brushes used in their application. Only the dark glossy browns, added at the end of the painting process with a soft-haired brush, are medium-rich like the paint used in 'View on the Stour'. Such differential areas of matt and gloss paint are readily distinguishable in sketches that have never been varnished, for instance 'Dedham Lock and Mill', ?1816 (no.92).

By 1812 Constable had evolved the 'virtuoso' oil sketching technique he used with little alteration until the late 1820s. During his major periods of outdoor sketching (Hampstead 1821–2 and Brighton 1824) he painted

mostly on paper primed with pinks and browns. His palette was reduced to very few colours, especially for skying and seascapes which were predominantly blue and grey. Brushwork was further refined; a few accurate strokes could perfectly describe a gig moving at high speed, as can be seen in 'Brighton Beach with a Gig', 1824 (no.146). The annotations on the backs of some of the Hampstead sketches show that by this time he could paint a skyscape in an hour to catch fleeting effects of weather and light: '25th. Septr 1821 about from 2 to 3 afternoon looking to the north – Strong Wind at west, bright light coming through the Clouds which were lying one on another' (no.120). In his Salisbury sketches of 1829, the last oil sketches he was to paint out-of-doors, Constable used the same technique with even greater refinement of both palette and brushwork (fig.187, and 73 on p.261).

After his move to London in 1816 Constable began regularly to make preparatory sketches in the studio for 'finished' and exhibition paintings. The technique he used for these was a broader, less highly worked version of that which he used for the final work. It is quite unlike the economic, single-sitting, sketching technique that he used outdoors. The sketches ranged in size and were painted in several sittings. The most famous of these are the 'full-size' sketches for the six-foot Stour scenes of the early 1820s.[221]

Constable's studio sketching technique in the 1820s and 1830s developed alongside that used in the 'finished' works. The small version of 'A Farmhouse near the Water's Edge', c.1834 (no.214) is a superb example of this 'late' technique. It is an imaginary composition painted entirely in the studio. The canvas has never been lined, the surface is unvarnished and it is generally in excellent condition. A buff-coloured ground and a pink priming were first applied to the canvas which was then stretched onto a small four-membered stretcher. The priming is a mixture of lead white, vermilion, red lake, black and possibly ochre. A dilute dark brown wash of umber and black was then applied, roughly corresponding to the contours of the landscape. The sky was laid in first using rapid strokes which allow the pink priming to show through in places. The landscape and foliage were painted next, with thin dark washes over the brown priming. The priming was left entirely uncovered in many areas, creating a warm mid-toned background colour in the trees and foreground. The landscape was worked up with both brushwork and flecks of coloured impasto applied with a palette knife (fig.188). A limited palette was used with the colours applied without much pre-mixing. The stiff brightly coloured paint was applied and allowed to partially dry before the next layer was laid on. This was carried out in

several sittings. Finally, the edge of a palette knife and the pointed end of a brush were used to draw into, and texture, the paint. Dark brown glazes were liberally applied to the foreground and trees, with branches painted in a cursory fashion, emphasised by lines incised into wet paint.

The use of a palette knife is characteristic of many of the 'late' studio sketches as well as the 'finished' paintings. Constable was apparently very fond of a particular knife (which may be that contained in the sketching box). He reputedly refused to swap it with De Wint for a silver knife of the same size.[222] Judging from the works examined by the author, Constable did not use a palette knife in his outdoor sketches and it does not appear to have been used much in his studio sketches before the mid-1820s (but see under no.89 for a contrary view). However, the foreground of an earlier outdoor sketch, 'Branch Hill Pond', 1819 (no.106), is painted in a technique similar to that just described. The rest of the painting is entirely in keeping with Constable's outdoor sketching technique. The sketch was the basis for a larger version of the composition which was exhibited at the Royal Academy in 1829. Constable probably reworked the foreground of the sketch with a palette knife in his 'late' manner some time before painting the 1828 version. The composition was then transferred to the larger canvas by 'squaring-up' with threads (see above, p.509). The reworked foreground must have had time to dry completely before this took place since there is no impression in the paint where the squaring-up threads were laid over the thick impasto. The presence of later palette knife work on Constable's outdoor sketches is not particularly surprising as during 'the last years of his life he, at times, also touched upon some of his earlier pictures in this way [with a palette knife] as they hung on the walls of his studio'.[223]

Varnishing

The idea of 'finish', as described above, implies the very final adjustments to colour, composition and effect using transparent glazes and opaque scumbles of paint. At this stage of the painting process, however, there is a further consideration – the way in which the surface of a painting reflects light. We are used to seeing Old Master paintings with a more or less evenly reflective surface. This is usually because they have been varnished. The surface is matt or glossy according to the type of varnish, the way it was applied, its age and condition.

Oil paints, whether prepared by the artist himself or by an artists' colourman, do not dry to give evenly glossy or matt surfaces. Different pigments and binding media and their

relative proportions give considerable variations in glossiness on drying. In addition, these effects are not immediately apparent, but may appear slowly over a number of days, months or even years. Changes of this kind in the surface of a painting can seriously influence its appearance, particularly when the lighting is not carefully arranged. Areas of dark, saturated and glossy paint can appear inappropriately light, matt or 'washed-out', affecting the tonal relationships throughout the picture.

Varnishing Days at the Royal Academy supposedly gave painters the opportunity to compensate for undesirable effects of drying and lighting. In theory, pictures finished many months before could be locally or generally revarnished to correct disturbing variations in gloss and restore transparency and saturation where necessary. In practice, as we know, many painters took the opportunity to do a great deal more, sometimes repainting entire passages.

What was Constable's practice regarding the varnishing of his paintings in general and specifically his exhibited works? He is known to have been regularly ill-prepared for Academy exhibitions. He often began his paintings too late and sent them to the Academy unfinished: 'I am rightly served – I should not have sent my scrambling affair' ('The Opening of Waterloo Bridge', 1832, no.213).[224] He worked furiously on Varnishing Days – 'I have yet much to do to it ['The Hay-Wain'] – and I calculate for 3 or 4 days there'[225] – but frequently regretted the way the paintings looked during the exhibition and reworked them afterwards. We can be fairly sure that Constable's paintings were often exhibited wet, unfinished and, in the conventional sense, unvarnished. He was probably obliged to leave his work with disturbing variations in surface gloss. Although many painters, notably Turner, worked extensively on their pictures on Varnishing Days, it is probable that Constable's work would have appeared especially unfinished to the Academicians and critics of the time, not only because of his individual painting technique but because of his failure to achieve a unified surface.

In the longer term, and when not faced with an Academy deadline, Constable was well aware of the benefits associated with varnishing and it is clear that he always intended his 'finished' paintings to be varnished – in 1833 he commented that a version of 'The Lock' 'looked beautifully fresh when it was varnished'.[226] He was also aware of the dangers of premature varnishing. In 1815 his uncle David Pike Watts passed on some advice he had heard 'in company': 'Many of our modern Pictures will feel the Effects of too early varnishing; the Artists lay on varnish before the paint is actually dry, as soon as it feels dry

and is only set. It mixes with the paint & eventually cracks and comes off. It should be two years at least before a picture is varnished'.[227] Constable generally left his paintings at least a year after completion before varnishing them. For example, 'Salisbury Cathedral from the Bishop's Grounds' (no.140) was varnished in June 1824, just over a year after it was finished and exhibited at the Academy.[228]

Constable was certainly aware of the various optical changes which paintings undergo after completion (mentioned above, p.513, particularly in relation to the darkening of lead white highlights). There is, however, no specific reference to the changes arising from yellowing and opacification of natural resin varnishes. At the same time, there is no reason to assume that Constable would have approved of a discoloured and deteriorated varnish film between the viewer and his work. In fact he was particularly scathing about the nineteenth-century preference for dark and heavily 'toned' paintings. In 1822 he wrote to Fisher concerning a copy of a Teniers, recently completed for a client in Salisbury, 'I have grimed it down with slime & soot – as he is a connoisseur and of course prefers filth & dirt, to freshness and beauty'.[229]

Constable's sketches were, as far as we know, never intended to be varnished although the majority of those we see today have been so treated. Many of those donated by Constable's daughter Isabel to the South Kensington Museum (now the Victoria and Albert Museum) in 1888 have remained unvarnished since their acquisition. Others, however, were probably first varnished during the nineteenth century, possibly before they were given to the museum. At that date there would have been little ethical debate about the appropriateness of varnishing a sketch. They were treated simply as small paintings – cleaned, lined or laid onto board, varnished, mounted and framed for exhibition. Today we appreciate, and consciously try to preserve, the freshness and spontaneity of the unvarnished surface.

Conclusion

We have seen that the materials that Constable used changed from the beginning to the end of his career. He clearly took advantage of the rapidly expanding range of artists' materials that were increasingly available from London colourmen. Following closely behind Turner, he adopted many newly invented pigments soon after their introduction as artists' colours. There are notable differences between the materials Constable used for outdoor sketching and those used in 'finished' paintings. However, these variations are of much less significance to the appearance of his pictures than his painting technique. In his early works he used standard late eighteenth-century materials and a derivative technique. As his skills and ambitions developed he evolved his own, sometimes idiosyncratic, methods. The incidence of new techniques usually accompanied his attempts to achieve a new 'effect' in his paintings.

One of the most fascinating aspects of the study of Constable's painting technique is the way in which it vividly illuminates his personality, in particular his passionate involvement with the physical act of painting. As we have seen, he began his career with a good knowledge of materials and a sound basic training. However, his desperation to paint at moments of inspiration often led him to ignore these early lessons and to use technically questionable practices, showing little concern for the long-term survival of his work. Technical examination has suggested that he intended his exhibited paintings, at least, to be lasting works. Nevertheless, in examples such as 'The Cenotaph' his good intentions were compromised once the painting was underway.

Constable expressed few opinions regarding the permanence of his paintings. In general, thanks to his initial training, his work has survived relatively well, especially by comparison with the works of Turner, Wilkie and other contemporaries. Where paintings have deteriorated, it has usually been through the intervention of a later hand. The sketches, particularly those on paper and millboard, were particularly susceptible to damage by early restorers. In many cases, their thin, delicate ground and paint layers blistered and flaked off during harsh lining treatments. The losses were then crudely repainted and the pictures varnished, destroying the original surface. Fortunately, Constable's paintings on canvas have suffered little by comparison. In a few cases, there is some evidence to suggest that soluble paint layers have been removed, probably during nineteenth-century 'restorations'. Today, the appearance of Constable's paintings may be most radically affected by crude restoration and discoloured varnish. Many of the paintings in the present show have been recently cleaned and restored. Hopefully this brings them as close as possible to the way in which Constable wanted his pictures to look. It is important to remember that he expected his paintings to change with time and he painted, to a certain extent, with this in mind: 'It is much to my advantage that several of my pictures should be seen together, as it displays to advantage their varieties of conception and also of execution, and what they gain by the mellowing hand of time, which should never be forced or anticipated. Thus my pictures when first coming forth have a comparative harshness which at the time acts to my disadvantage'.[230] We may now be seeing Constable's landscapes in the best possible circumstances.

Notes

In addition to the abbreviations listed on pp.46–9, the following are used here:

Bardwell 1756 Thomas Bardwell, *The Practice of Painting and Perspective Made Easy: In which is Contained, the Art of Painting in Oil, with the Method of Dead Colouring; Second Painting; Third or Last Painting; Painting Back-Grounds; on Copying; Drapery-Painting; Landscape-Painting; and a New Short, and Familiar Account of the Art of Perspective*, 1756

Bower 1990 Peter Bower, *Turner's Papers: A Study of the Manufacture, Selection and Use of his Drawing Papers 1787–1820*, exh. cat., Tate Gallery 1990

Carlyle (thesis) Leslie Carlyle, 'A Critical Analysis of Artists' Handbooks, Manuals and Treatises on Oil Painting Published in Britain between 1800 and 1900: with Reference to Selected Eighteenth-Century Sources', unpublished Ph.D thesis, Conservation and Technology Department, Courtauld Institute of Art, University of London 1991

Field 1835 George Field, *Chromatography; or, A Treatise on Colours and Pigments and of their Powers in Painting*, 1835

Hackney 1982 Stephen Hackney (ed.), *Completing the Picture: Materials and Techniques of Twenty-Six Paintings in the Tate Gallery*, 1982

Harley 1982 Rosamund D. Harley, *Artists' Pigments c.1600–1835: A Study in English Documentary Sources*, 2nd ed. 1982

Krill 1987 John Krill, *English Artists Paper: Renaissance to Regency*, exh. cat., Victoria and Albert Museum 1987

1 David Bomford, Christopher Brown, Ashok Roy, *Art in the Making: Rembrandt*, 1988–9; David Bomford, Jill Dunkerton, Dillian Gordon, Ashok Roy, *Art in the Making: Italian Paintings before 1400*, 1990; David Bomford, Jo Kirby, John Leighton, Ashok Roy, *Art in the Making: Impressionism*, 1990–1.
2 The Constable Research Project was established at the Victoria and Albert Museum in 1986 in collaboration with the author and a private sponsor. The information published in this essay will be presented as part of a Ph.D thesis, 'The Materials and Techniques of John Constable's Oil Paintings 1802–1837', Conservation and Technology Department, Courtauld Institute of Art, University of London.
3 It is not possible to list here all the works examined to date. However, the author would like to thank in particular the Victoria and Albert Museum for allowing the examination of 25 works, David Thomson for allowing the examination of 15 works and the following for allowing the examination of works in their collections or care: Museum of Fine Arts, Boston; National Gallery, London; Sotheby's, London; Tate Gallery, London; Currier Gallery of Art, Manchester, New Hampshire; The National Trust; Metropolitan Museum of Art, New York; Philadelphia Museum of Art; W.H. Proby, Esq.; National Gallery of Art, Washington; Phillips Collection, Washington; Yale Center for British Art, New Haven.
4 The sketching box, reputedly used on Constable's Brighton trips in 1824, now belongs to Richard Constable, great-great-grandson of the artist.
5 Tate Gallery; presented by Isabel Constable to the National Gallery 1887 and transferred 1953; repr. as colour frontispiece to Parris 1981.
6 Carlyle (thesis).
7 Beckett I–VI 1962–8; Beckett 1970; Parris, Shields, Fleming-Williams 1975; the author has relied heavily on Charles Rhyne's selection of references, *Comprehensive Archives of Information on the Working Procedure of Individual Artists and on the Visual Appearance and Physical Character of their Art: John Constable, a Trial Study*, Portland, Oregon 1990.
8 Beckett II 1964, p.26.
9 Carlyle (thesis).
10 Farington IV, p.1553.
11 Beckett II 1964, p.2.

12 ibid., p.24.
13 Carlyle (thesis).
14 Parris, Shields, Fleming-Williams 1975, pp.27, 199–200.
15 ibid.
16 Beckett II 1964, p.5.
17 Francesco Algarotti, *An Essay on Painting Written in Italian by Count Algarotti F.R.S. F.S.A.*, 1764.
18 Bardwell 1756; Constable had an edition of 1782.
19 Constant De Massoul, *A Treatise of the Art of Painting and the Composition of Colours*, 1797.
20 Field 1835; Constable's copy has not survived.
21 For the definitions used in this essay refer to p.496. For technical terminology in general consult the glossary in Hackney 1982, pp.11–15, or Edward Lucie-Smith, *The Thames and Hudson Dictionary of Art Terms*, 1984. For more detailed technical reference material consult Rutherford J. Gettens, George L. Stout, *Painting Materials: A Short Encyclopaedia*, New York 1966, or Ralph Mayer, *A Dictionary of Art Terms and Techniques*, New York 1981.
22 Beckett II 1964, p.29.
23 Farington IV, p.1228.
24 Kindly communicated by Leslie Carlyle.
25 Rica Jones, 'Wright of Derby's Techniques of Painting' in Judy Egerton, *Wright of Derby*, exh.cat., Tate Gallery 1990, pp.263–71.
26 Reynolds 1973, no.101, pl.60.
27 Rhyne 1990b, p.72.
28 ibid., p.75. A composite x-radiograph of 'A Wooded Bank' is illustrated as fig.3. The author would like to thank the Paintings Conservation Department of the Metropolitan Museum of Art, New York, for supplying a copy of the Conservation Report on this painting.
29 Reynolds 1984, no.21.2, pl.214.
30 Reynolds 1984, no.36.1, pl.1052. The author would like to thank Janet Brough, formerly of the Conservation Department, National Gallery, London, for a copy of the Conservation Report and for discussing her findings regarding this painting.
31 See 'Figures and a Donkey on the Lane from East Bergholt to Flatford' (no.42), Case Study 1.
32 Hackney 1982, p.21.
33 Survey carried out by Rica Jones and Anna Southall, Conservation Department, Tate Gallery; see 'The Artist's Training and Techniques' in [Elizabeth Einberg], *Manners & Morals: Hogarth and British Painting 1700–1760*, exh.cat., Tate Gallery 1987, pp.19–28.
34 Kindly communicated by Rica Jones.
35 Meryl Johnson, Elizabeth Packard, 'Methods Used for the Identification of Binding Media in Italian Paintings of the Fifteenth and Sixteenth Centuries', *Studies in Conservation*, 16, International Institute for the Conservation of Historic and Artistic works (IIC), 1971, pp.141–64. Also, Elizabeth Martin, 'Some Improvements in Techniques of Analysis of Paint Media', *Studies in Conservation*, 22, IIC, 1977, pp.63–7.
36 Carlyle (thesis).
37 Joyce H. Townsend 'Turner's Oil Paintings: Changes in Appearance' in *Appearance, Opinion, Change: Evaluating the Look of Paintings*, United Kingdom Institute for Conservation 1990, p.54.
38 Bardwell 1756, p.36.
39 'Landscape', T 01148, undated oil sketch on paper. 'Jaques and the Wounded Stag', N 00119, 1819, oil on canvas.
40 For definitions and discussion of 'finish' see p.509.
41 For a detailed discussion see Case Study 1.
42 Kindly communicated by Rica Jones, Conservation Department, Tate Gallery, from her unpublished research on Gainsborough's Suffolk paintings.
43 See Case Study 1.
44 Reynolds 1984, no.23.14, pl.403.
45 Technical examination carried out by Rica Jones, Conservation Department, Tate Gallery.
46 For a detailed discussion see Case Study 2.
47 Beckett VI 1968, p.124.
48 Beckett II 1964, p.356.
49 Reynolds 1984, no.19.2, pl.69.
50 Technical examination carried out in 1984 by Charlotte Hale, Paintings Conservation Intern, National Gallery of Art, Washington D.C.; see Rhyne 1990a.
51 ibid., p.115.
52 John Lishawa, *The Art of the Landscape, Classical, Neo-Classical & en plein-air 1650–1900*, 1988.
53 Bower 1990, p.42.
54 Carlyle (thesis).
55 ibid.

56 J. Edwards, *The Art of Landscape Painting in Oil Colours*, published by Winsor & Newton, colour-makers, 1856; see Carlyle (thesis).
57 Bower 1990, glossary of paper terminology, pp.127–8.
58 Krill 1987, p.132.
59 ibid., p.51.
60 ibid., p.132.
61 ibid., p.126.
62 Kindly communicated by Pauline Webber, Paper Conservation Section, Victoria and Albert Museum.
63 Krill 1987, p.53.
64 Carlyle (thesis).
65 ibid.
66 See under no.232.
67 Daphne Foskett, *John Harden of Brathay Hall 1772–1847*, Kendal 1974, p.34.
68 Bower 1990, p.13.
69 Reynolds 1973, no.104, pl.63.
70 Bower 1990, p.40.
71 ibid., glossary, p.127.
72 Marjorie B. Cohn, *Wash and Gouache: A Study of the Development of the Materials of Watercolour*, The Center for Conservation and Technical Studies, Fogg Art Museum 1977, pp.24–5, figs.5–6.
73 Beckett VI 1968, p.189.
74 Bower 1990, p.127.
75 ibid., p.46.
76 Krill 1987, p.55.
77 ibid.
78 Carlyle (thesis).
79 Farington IX, p.3260.
80 Analysis carried out by Josephine Darrah, Conservation Science Section, Victoria and Albert Museum.
81 Collection Richard Constable.
82 Reynolds 1984, no.21.13, pl.222. Reynolds notes: 'This side has bevelled edges and is of rough unprepared oak grain. A row of notches at the top and the bottom indicates a grid for the engraving made by David Lucas.'
83 Reynolds 1973, no.122a, pl.94.
84 Hackney 1982, p.23.
85 Constant De Massoul, *A List of the Principal Colours Sold at the Manufactory of Messrs. Massoul and Co. No. 136, New Bond-street. Gentlemen may be furnished with every Article necessary for Painting and Drawing*, 1797; see Carlyle (thesis).
86 ibid.
87 Robert Dossie, *The Handmaid to the Arts*, 1758; see Carlyle (thesis), Introduction.
88 Theodore H. Fielding, *On Painting in Oil and Water Colours, for Landscape and Portraits; Including the Preparation of Colours, Vehicles, Oils, &c. . . . also on the Chemical Properties and Permanency of Colours . . . &c.*, 1839, p.149; see Carlyle (thesis).
89 Sketching box, collection Richard Constable; Constable's palette, Tate Gallery, see n.5 above.
90 Visual identification only. From surface microscopy and in cross-sections pigment particles are large, spherical, opaque and 'egg-yolk' coloured; possibly 'Golden Ochre'.
91 Lake not identified by analysis; possibly 'Brown Pink', recommended by Bardwell, included by De Massoul in 1797 *List*.
92 Identified by visual means only. It has not been possible to carry out elemental analysis of individual pigments on a routine basis. Where pigments could not be identified by another means, analysis has been carried out by Aviva Burnstock in the Scientific Department, National Gallery, London, using energy dispersive x-ray fluorescence (EDX) with a scanning electron microscope, working on pigment cross-sections. Where a positive identification has been obtained by this method, it is often possible using polarising light microscopy and cross-sections in conjunction with x-ray fluorescence spectrometry (XRF) to make a comparative 'tentative' identification from a visual examination only. Pigment analysis (unless otherwise stated) has been carried out by the author and Josephine Darrah, Conservation Science Section, Victoria and Albert Museum.
93 Bardwell 1756, p.35.
94 W. Williams of Bath, *An Essay on the Mechanic of Oil Colours, Considered under These Heads, Oils, Varnishes, and Pigments, with Respect to Their Durability, Transparency and Force, in Which Is Communicated Some Valuable Secrets, Particularly, a Method of Preparing the Oils, so as to Give Them a Strong Drying Quality, Perfectly Limpid and Colourless*, Bath 1787, p.57.
95 Bardwell 1756, p.35.
96 Harley 1982, pp.70, 95.

97 Also found in nos.89 and 153: technical examinations carried by Anna Southall and Rica Jones, Conservation Department, Tate Gallery.

98 Harley 1982, p.71.

99 Williams of Bath, op.cit.; see Carlyle (thesis).

100 Julius Caesar Ibbetson, *An Accidence or Gamut, of Painting in Oil and Watercolours, Part I*, 1803, p.18; see Carlyle (thesis).

101 Bardwell 1756, p.35.

102 ibid.

103 Constant De Massoul, *A Treatise on the Art of Painting*, 1797, p.139; see Carlyle (thesis).

104 Bardwell 1756, p.35.

105 ibid.

106 Medium analysis for the Constable Research Project kindly carried out by Raymond White, Scientific Department, National Gallery, London, using gas chromatography/mass spectrometry.

107 Field 1835, p.206.

108 Leslie Carlyle, 'British Nineteenth Century Oil Painting Instruction Books: A Survey of Their Recommendations for Vehicles, Varnishes, and Methods of Paint Application' in *Cleaning, Retouching and Coatings*, International Institute for the Conservation of Historic and Artistic Works, 1990, pp.76–80.

109 'Mars' colours are synthetic iron oxide pigments; see Harley 1982, pp.120–3, and Carlyle (thesis).

110 Harley 1982, p.151. For more detailed information see Raymond White, *Brown and Black Organic Glazes, Pigments and Paints*, National Gallery Technical Bulletin, 1986, pp.58–71.

111 Also found in a paint box said to have belonged to Turner (Victoria and Albert Museum, P.65.1920). Two bladders of oil paint labelled 'Gebr. Terra Di Verte' and 'Gebr. Grune Erde', from the box, have been identified as orange iron oxide pigments, presumed to be 'Burnt Green Earth'. 'Gebr.' on the labels is an abbreviation for 'gebrannt', the German for 'burnt'. Kindly communicated by Josephine Darrah, Conservation Science Section, Victoria and Albert Museum, from her unpublished research into the nineteenth-century artists' paintboxes in the Victoria and Albert Museum Collection; see also Carol A. Grissom, 'Green Earth' in Robert L. Feller (ed.), *Artist's Pigments: A Handbook of their History and Characteristics*, 1, National Gallery of Art, Washington D.C., 1986, pp.141–67 (Burnt Green Earth, p.145).

112 Harley 1982, pp.74–5.

113 Field 1835, p.202.

114 Analysed by Raymond White, Scientific Department, National Gallery, London.

115 Analysis Report on the Tate Gallery palette by John Mills, Scientific Department, National Gallery, London; analysed by gas chromatography/mass spectrometry.

116 ibid.

117 Harley 1982, p.101.

118 Joyce H. Townsend, 'Turner's Painting Materials: A Preliminary Discussion', *Turner Studies*, vol.10, no.1, Summer 1990, p.26.

119 Carlyle (thesis).

120 Field 1835, p.77.

121 ibid.

122 ibid.

123 Analysis kindly carried out by Aviva Burnstock, Scientific Department, National Gallery, London.

124 Field 1835, pp.77–8.

125 W. Williams of Bath, *An Essay on the Mechanic of Oil Colours . . .*, Bath 1787, p.57.

126 ibid., p.57; see Carlyle (thesis), also Harley 1982, p.99.

127 Microscopic powder samples were removed from the dried oil paint on the sketching box and from the palette. Pigments were tentatively identified in dispersion by polarising light microscopy. The author would like to thank Josephine Darrah and Joyce Townsend for their kind assistance.

128 Beckett 1970, p.53.

129 Analysis kindly carried out by Aviva Burnstock, Scientific Department, National Gallery, London.

130 Joyce H. Townsend, 'Turner's Painting Materials: A Preliminary Discussion', *Turner Studies*, vol.10, no.1, Summer 1990, pp.24–5.

131 Beckett II 1964, p.386 also Beckett IV 1966, pp. 170–3; see also John Gage, *George Field and his Circle: From Romanticism to the Pre-Raphaelite Brotherhood*, exh.cat., Fitzwilliam Museum, Cambridge, 1989, p.49, and Ruth Bubb, 'A Study of the MS. Notebooks Concerning Pigment Manufacture with Particular Reference to Madder, its History and Cultivation, Including Some Biographical Notes', unpublished

132 Harley 1982, p.143.

133 ibid.

134 Carlyle (thesis); this pigment was identified using EDX by Aviva Burnstock, Scientific Department, National Gallery, London.

135 J.F.L. Merimée, *The Art of Painting in Oil*, trans. W.B. Sarsfield Taylor, 1839, pp.120–1.

136 Field 1835, pp.93–4.

137 ibid.

138 Merimée, op.cit., p.120.

139 The glass phials in the sketching box containing iodine scarlet, manganese brown and oxide of chromium are identified by paper labels handwritten in ink in an identical script. As Field is known to have been the sole manufacturer of the latter two pigments, it is presumed that these were supplied by him. As the labels suggest that all three pigments came from the same source he probably also supplied the iodine scarlet.

140 Field 1835, p.129. This pigment was identified using EDX by Aviva Burnstock, Scientific Department, National Gallery, London.

141 Field 1835, p.129.

142 Charles Martel, *On the Materials Used in Oil Painting, with a Few Remarks on Varnishing and Cleaning Pictures*, G. Rowney & Co., 1856, p.27; also Henry F.C.S. Seward, *Manual of Colours, Showing the Composition and Properties of Artists' Colours, with Experiments on Their Permanence*, G. Rowney & Co., 1889, p.58; see Carlyle (thesis).

143 Harley 1982, p.156. This pigment was identified using EDX by Aviva Burnstock, Scientific Department, National Gallery, London.

144 Harley 1982, pp.86, 156.

145 Beckett II 1964, p.398.

146 R.C. Leslie recorded that in later life Constable kept a supply of Field's powdered pigments, 'including various shades of ochres, madders, ultramarine and ultramarine ash' (C.R. Leslie, *Life and Letters of John Constable, R.A.*, ed. Robert C. Leslie, 1896, p.281).

147 Joyce H. Townsend, 'Turner's Painting Materials: A Preliminary Discussion', *Turner Studies*, vol.10, no.1, Summer 1990, p.26.

148 Harley 1982, p.128.

149 Raymond White, *Brown and Black Organic Glazes, Pigments and Paints*, National Gallery Technical Bulletin, 1986, p.62.

150 ibid.

151 ibid.

152 Rhyne 1990b, p.78.

153 '. . . because the original could seldom be divided into squares by drawing directly onto it, a frame with squares marked off with threads could be constructed and laid over the original': William Kingston, *The Kingstonian System of Painting in Dry Colours, After the Ancient Greek Method; A Descriptive Account is Given of the Materials, and Where They May be Purchased*, Weymouth and London 1835, pp.45–6; see Carlyle (thesis).

154 Beckett VI 1968, pp.161, 181.

155 Carlyle (thesis).

156 ibid.

157 Parris, Shields, Fleming-Williams 1975, p.190.

158 Bardwell 1756, p.36.

159 A 'Cumberland Lead' pencil is among the contents of Constable's sketching box.

160 Reynolds 1984, no.24.81, pl.559.

161 Beckett II 1964, p.360.

162 The author would like to thank Dr Maryan Ainsworth, Metropolitan Museum of Art, New York, for carrying out an infra-red examination of this painting in December 1989 and for providing infra-red reflectograms.

163 Reynolds 1984, no.26.19, pl.629.

164 The author would like to thank Charlotte Hale, Paintings Conservator, Metropolitan Museum of Art, New York, for her kind assistance with the x-radiography and technical examination of this painting in December 1989.

165 Reynolds 1984, no.26.18, pl.628.

166 Cove (thesis).

167 F.W. Fairholt, *A Dictionary of Terms in Art*, 1854; 1903 ed., p.229.

168 ibid., p.190.

169 Carlyle (thesis).

170 Fairholt, op.cit., p.418.

171 ibid., p.402.

172 Cove (thesis).

173 Beckett II 1964, p.26.

174 ibid., p.25.

175 Beckett IV 1966, p.137.

176 Beckett VI 1968, p.222.

177 ibid., p.222.

178 Beckett II 1964, p.109.

179 ibid., p.110.

180 ibid., p.175.

181 ibid., p.421.

182 Beckett VI 1968, p.252.

183 ibid., p.199.

184 Beckett II 1964, p.126.

185 Parris, Shields, Fleming-Williams 1975, p.54.

186 For diagrams of Constable's studio at 35 Charlotte Street see figs.14–15 on p.43.

187 Beckett VI 1968, p.76.

188 ibid., p.65.

189 Bardwell 1756, p.36.

190 M. Kirby-Talley, Karin Groen, 'Thomas Bardwell and his Practice of Painting: A Comparative Investigation between Described and Actual Painting Technique', *Studies in Conservation*, 20, IIC, 1975, p.49.

191 Leslie Parris, *Landscape in Britain c.1750–1850*, exh.cat., Tate Gallery 1973.

192 Kirby-Talley, Groen, op.cit., p.49.

193 Parris, Shields, Fleming-Williams 1975, pp.25–52.

194 Farington IV, p.1576.

195 Carlyle (thesis).

196 Bardwell 1756, p.38.

197 Parris, Shields, Fleming-Williams 1975, pp.143–4.

198 Bardwell 1756, p.39.

199 ibid., p.40.

200 F.W. Fairholt, *A Dictionary of Terms in Art*, 1854; 1903 ed., p.419.

201 Beckett II 1964, p.290.

202 ibid., p.24, also Parris, Shields, Fleming-Williams 1975, p.144.

203 Bardwell 1756, p.38.

204 ibid., p.35.

205 Joyce H. Townsend, 'The Materials and Techniques of J.M.W. Turner R.A., 1775–1851', unpublished Ph.D thesis, Conservation & Technology Department, Courtauld Institute of Art, University of London, 1991. Sponsored by the Tate Gallery and the Leverhulme Trust.

206 Field 1835, p.361.

207 Beckett II 1964, p.317.

208 Bardwell 1756, p.40.

209 Alexander Brodie (ed.), *The Reminiscences of Solomon Hart R.A.*, 1882, p.58.

210 Leslie Carlyle, 'The Artists' Anticipation of Change as Discussed in British Nineteenth Century Instruction Books on Oil Painting' in *Appearance, Opinion, Change: Evaluating the Look of Paintings*, United Kingdom Institute for Conservation (UKIC), 1990, p.63; for a more detailed discussion see also Leslie Carlyle, Joyce H. Townsend, 'An Investigation of Lead Sulphide Darkening of Nineteenth-Century Painting Materials' in *Dirt and Pictures Separated*, UKIC, 1990, pp.40–3.

211 Beckett IV 1966, p.113.

212 Beckett III 1965, p.87.

213 Collection Richard Constable.

214 James Ayres, *The Artist's Craft: A History of Tools, Techniques and Materials*, Oxford 1985, p.60.

215 Beckett II 1964, p.79.

216 Beckett VI 1968, p.44.

217 *Paint and Painting*, exh.cat., Tate Gallery 1982, p.68.

218 Beckett VI 1968, p.69.

219 Carlyle (thesis).

220 Beckett VI 1968, p.189.

221 For a full discussion of Constable's six-foot sketches see Rhyne 1990a.

222 Parris, Shields, Fleming-Williams 1975, p.62.

223 C.R. Leslie, *Life and Letters of John Constable, R.A.*, ed. Robert C. Leslie, 1896, p.xiii.

224 Beckett III 1965, p.69.

225 Beckett VI 1968, p.65.

226 Parris, Shields, Fleming-Williams 1975, p.85.

227 Beckett IV 1966, p.43.

228 Beckett II 1964, pp.154, 265.

229 Beckett VI 1968, p.106.

230 Beckett IV 1966, p.129.

CASE STUDY 1

'Willy Lott's House' and 'Figures and a Donkey on the Lane from East Bergholt to Flatford' (no.42)

This case study examines a double-sided oil sketch in the Victoria and Albert Museum, 'Willy Lott's House' (fig.189, Reynolds 1973 no.329a) and 'Figures and a Donkey on the Lane from East Bergholt to Flatford' (fig.191, ibid., no.329). The latter side is shown in the present exhibition as no.42.

The canvas support

The support is viewed from the side of 'Willy Lott's House' in the following description and in the diagram (fig.190). The dimensions of the canvas are $13\frac{1}{8} \times 9\frac{1}{2}$ inches (335×242 mm). It is a medium-fine-weight plain weave canvas, at present unstretched and unsupported, although during its history it *has* been stretched as part of a larger canvas. Cusping is visible along the top edge in raking light where it appears that there were tacks holding the canvas whilst the ground was applied. The tacks were spaced roughly $3\frac{1}{2}$ inches apart as can be seen by the cusping on the x-radiograph. The tack holes are not now evident in the support, which suggests that they were placed just beyond the present edge of the canvas at the apex of each peak of the cusping. The cusping continues to be visible up to $3\frac{1}{2}$ inches into the canvas near the top edge. There is only slight cusping along the right edge which suggests that the original right edge, when the ground was applied, was a few inches further to the right. There is no evidence of cusping along the bottom or left edges.

The x-radiograph (fig.192)

The image of the canvas shows most clearly. This is due to the thickness and x-ray opacity of the ground which has settled into the weave of the canvas. The cusping along the top edge is very clear, as are slubs, knots and unevennesses in the woven cloth. The image of the paint layer is very confused. Most of what is visible is an impression from the 'Willy Lott's House' side. Only a few very thick lead white brush strokes are visible that relate to 'Figures and a Donkey', for example the highlight on the shoulder of the woman standing on the left. There are some amorphous shapes on the x-ray which must be areas of dense, probably lead white, paint. They do not correspond to the present images on either side of the canvas. However, they may arise from a previous

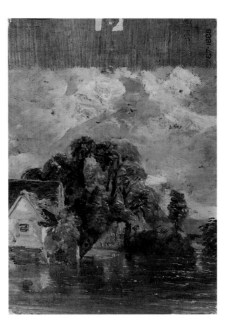

fig.189 'Willy Lott's House', reverse (as exhibited) of no.42

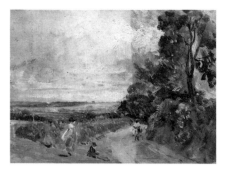

fig.191 'Figures and a Donkey on the Lane from East Bergholt to Flatford', no.42

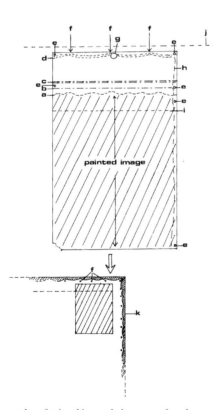

fig.190 Diagram of support of no.42, viewed from 'Willy Lott's House' side

a. edge of painted image; b. lesser set of cracks; c. cracks; d. cusping; e. pinhole; f. tacks (position of tacks when primed); g. hole in paint/ground; h. slight cusping; i. end of cusping; j. proposed dimensions of canvas when priming applied; k. loom used for stretching and priming canvas

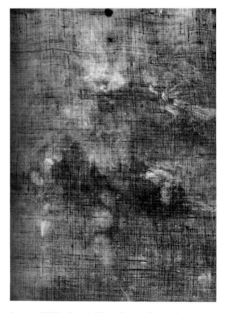

fig.192 'Willy Lott's House', x-radiograph

composition on this canvas. There is an opaque blue/grey/brown layer that appears in cross-sections from 'Figures and a Donkey' on top of two white ground layers. It is likely that this layer relates to the shapes on the x-ray. The previous composition may have been a tree and skyscape of some description, although there is no way of confirming this.

'Willy Lott's House' (fig.189, Reynolds 1973, no.329a)

Dimensions of vertical image: $10\frac{3}{4} \times 9\frac{1}{2}$ inches (273 × 242 mm).

Ground (figs.193–4)

The brown priming which is visible in many areas of this composition is typical of Constable's oil sketching technique *c*.1810–11. However, cross-sections taken from the edges of the painting revealed that untypically there are five ground and priming layers. The layer structure is as follows – beginning with the layer nearest the canvas:

(a) Pale salmon pink: lead white + chalk + vermilion
(b) White: lead white (possibly plus chalk)
(c) Dark brown: very finely ground black and vermilion
(d) White: lead white
(e) Reddish brown: vermilion, red lake and black; very medium rich.

The pale pink layer (a) was the first layer applied to the canvas. It must have been vigorously brushed and has pushed through the interstices of the canvas weave. It appears as the layer adjacent to the canvas on some of the cross-sections from the other side, i.e. 'Figures and a Donkey'. Each layer of ground covers the entire surface of the canvas but some layers are much thicker than others. The thickness of these layers led to the cracking that is visible on the surface and which has transferred to the other side of the canvas. Above the painted image is a strip of primed but unpainted canvas. Roughly corresponding to the bottom of this area there is a series of broken horizontal cracks running across the painting, parallel to the top edge but approximately $1\frac{3}{4}$ inches from it. There is another lesser set of cracks beneath these approximately $2–2\frac{1}{2}$ inches from the top edge. These roughly correspond to the top of the painted image. Both lines of cracks can also be seen on 'Figures and a Donkey'. There is a large circular loss of paint and ground with a hole through the canvas in the centre of the top edge. There are also small holes, presumed to be pinholes, in the top right and bottom right corners, two on the right edge $2\frac{1}{4}$ and 3 inches from the top edge, and on the left edge, $1\frac{3}{4}$ inches from the top edge (fig.190).

Paint Layers

Stylistically, this side has now been judged as the earlier of the two compositions.[1] Certainly the use of the red-brown brushy priming over

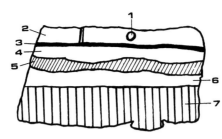

1. Red lake; 2. Brown layer: red lake/earths/lead white/orpiment/yellow lake/vermilion/a few Prussian blue particles; 3. Brown priming; 4. White layer; 5. Dark brown layer; 6. White layer; 7. Pink layer

fig.193 'Willy Lott's House', diagram of cross-section from the dark brown/green of water

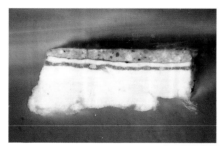

fig.194 'Willy Lott's House', photomicrograph (175 ×) of cross-section shown in fig.193

a white ground agrees with Constable's usual painting practice *c*.1802–11.[2] The brown priming gives a warm tonality to thin scumbles of paint, for instance in the sky, and makes a vivid contrast with the greens of the trees and foliage. The only area where the ground has been totally obliterated is in the water of the foreground. The handling of the paint is confident and vigorous. There is no apparent 'drawing' with either graphic media or brush, and it appears that he has worked over the whole picture surface uniformly. The speed with which this sketch must have been painted is reflected in the dramatic brushwork effects, especially in the sky and trees. He has worked up the composition from broad flat strokes of local colour to smaller touches indicating surface texture. The colours used are relatively desaturated but it is worth noting that, unlike other sketches, this painting has never been varnished. There are some bright touches of opaque colour and brilliant glazes, but these are only a few accents here and there in the trees and on the house. There appears to be a dirty brown glaze-like layer applied liberally over areas of the sky. It was probably brushed on to tone down the colour of the sky, some time after the opaque paint layer of the sky was finished, but it seems likely that it has discoloured or darkened. It may have been a 'temporary' varnish.

'Figures and a Donkey on the Lane from East Bergholt to Flatford' (fig.191, no.42)

Ground (figs.195–6)

The initial impression of the ground/priming colour in this painting is that it is subdued and plays a less important role than in the early oil sketches. Here, although still visible, the colour is not easily distinguishable from the paint layers. From a closer examination of the edges of the picture and cross-section samples, it was found that there are six layers of ground/priming on this side of the canvas, and that the layers are not identical over the whole picture surface (fig.197).

The surface is as follows (starting with the layer adjacent to the canvas):

(a) Chalk/size ground layer, off-white, over entire canvas
(b) Lead white ground layer, opaque white, over entire canvas
(c) Light blue/light grey/brown opaque layer, over entire picture surface but varying from bluer shade at the bottom to pale grey near the top
(d) Light pinkish-brown, over entire picture surface
(e) Dark brown over entire picture surface
(f) Colours brushed on blended from the left: pale blue underlayer to the sky and left-hand area of the foreground; lemon yellow (faded) on the right of the sky; dark grey/brown; mushroom brown; olive green and light pinkish-brown, in roughly vertical stripes across the right-hand third of the picture surface.

On top of this last variegated priming layer, the paint layer creating the image has been applied. There are some flake losses of ground and paint along two sets of cracks on the left-hand side of the composition. These reveal the two brown layers (d & e) indicating that the top layer (f) and the paint layers have consistently flaked from these lower layers.

Paint layers

As with the sketch of 'Willy Lott's House' the paint has been applied in loose, rapid strokes. The artist is confident and there is an economy in the brushwork and in the amount of paint actually applied to the surface which reflects his familiarity with the scene and forms he is representing. The main difference between the two sketches is in the tonality of the overall composition. This painting lacks the fiery red priming and instead has a cool and airy atmosphere. Vivid contrasts of hue are almost wholly absent from this picture. However,

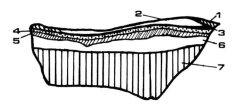

1. Dark grey layer; 2. White layer; 3. Dark brown layer; 4. Mid pinkish-brown layer: lead white/vermilion/red earths; 5. Greenish brown layer: lead white/red lake/black/mineral red/Prussian blue (?); 6. Lead white priming; 7. Chalk ground

fig.195 'Figures and a Donkey on the Lane from East Bergholt to Flatford', diagram of cross-section from the grey priming at top edge

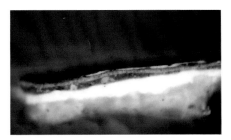

fig.196 'Figures and a Donkey on the Lane from East Bergholt to Flatford', photomicrograph (175 ×) of cross-section shown in fig.195

fig.197 'Figures and a Donkey on the Lane from East Bergholt to Flatford', diagram showing areas of different coloured primings: a. sky blue; b. lemon yellow; c. dark grey-green; d. mushroom; e. olive green; f. light pinkish brown

stylistically the two paintings are quite similar. The composition has been laid in wet-in-wet using broad strokes of a bristle brush. The speed with which this was done is indicated by the sweeping green strokes to the left of the foreground and the broad brown upward strokes in the foreground. The details have then been added with a selection of smaller brushes, both bristle and soft-hair, with some impasted highlights. Indications of foliage and branches are quick, spontaneous brush-strokes, some curling, some hatched in parallel strokes, some broad and flat. The people in the foreground and the person on the donkey consist of no more than a few rapid strokes. This shorthand is, nevertheless, extremely readable; the donkey is instantly recognisable as such.

The paint of the sky appears to go into and cover much of the cracking in the ground/priming layers on the left of the painting (fig.191). This suggests that the crack was well formed and flakes had already been lost prior to the paint application. Some more recent losses show that the paint layer and striped ground layer (f) has continued to flake away from the brown priming layers along the cracks.

The sequence of painting

A hypothesis can be formed thus:

1 A piece of canvas was stretched onto a loom or temporary strainer using tacks spaced approximately $3\frac{1}{2}$ inches apart. The canvas may have then been sized. A size layer has not been identified but that does not necessarily mean it is absent.
2 A pale pink ground of lead white, chalk and vermilion was applied to the canvas, probably quite vigorously, as it has pushed through the interstices of the canvas weave onto the other side (this may indicate that there was no size layer). The cusping caused by the stretching of the canvas and locked in by the ground is visible on the x-ray.
3 The canvas may, at this point, have been cut from the stretching frame, or it may have remained on the frame for the application of subsequent ground/priming layers. The lines of cracks across the top half of the canvas could have been made by stretching the canvas at any point during the re-priming, although there are no tack holes visible at present. On top of the pink ground a white lead layer, a very dark brown layer, another white layer and then a very thin reddish-brown priming were applied. The very dark brown layer relates

to the priming of other paintings by Constable ascribed to $c.1810-15$. However, in this instance, the artist seems to have been dissatisfied with it and has reverted to the use of his earlier ground/priming construction, i.e. a white underlayer with a thin, brushy red-brown priming.
4 After cutting a rectangular piece from one corner of his primed canvas, Constable painted the sketch of 'Willy Lott's House'. This is thought to have been $c.1810$ as this composition corresponds in materials and style with other works of this date. One can surmise that he used this fragment of canvas pinned into the lid of his paint box or onto a painting frame. The pinholes are still visible.
5 At a later date, Constable primed the other side of the canvas with two layers of white ground; a chalk layer and a lead white layer. He then painted a now indecipherable composition. A layer to suggest this can be seen in cross-sections (figs.195–6) and shapes unrelated to the top paint layers are visible in the x-ray. It may have been a landscape, as the colours seen in cross-sections are blue, grey and brown.
6 At a later date still, probably during $1811-12$, Constable applied two further ground layers on top of the unidentified painting. These are both opaque browns and correspond to those in use $c.1811-12$ in other works. However, Constable continued to be dissatisfied with his ground/priming colours and he experimented with 'Figures and a Donkey'. He applied six vertical stripes in one layer of opaque colour, brushing them on from left to right across the canvas: blue, yellow, dark grey-green, mushroom brown, olive green and light pinkish-brown. Some time must have elapsed before this final layer of priming was applied. The lower layers had already begun to crack and flake in areas corresponding to cracks in the thick ground on the other side of the canvas. The transference of the cracks was probably due to poor handling and lack of support. It is likely that a grease or dirt layer may also have formed which later caused the upper priming layer to flake away from the lower layers. After painting the composition 'Figures and a Donkey', it is likely that the canvas was subsequently left lying around in the studio, as a lot of dust is embedded in the paint surface and the impastos have been scratched and squashed.

Conclusions

The sketch of 'Willy Lott's House' can almost certainly be dated by its materials and techniques to the year 1810. It appears that although Constable had several changes of mind during the initial preparation of the canvas for this composition his final decision was to use a brushy reddish-brown priming over a white ground. The structure and most of the pigments he used are identical to those found consistently before 1812. However, the paint layers contain some pigments that have not yet been found in his palette before 1810 such as a variety of brightly coloured lake pigments.[3] This suggests that the sketch was not painted prior to this date. The economy in the handling of the paint suggests that Constable was sufficiently technically advanced and familiar with his subject and materials to provide a virtuoso display of brushwork. These conclusions concur with the latest art historical opinion which is based upon a purely stylistic judgement of the painting.

'Figures and a Donkey' poses a more complicated problem of interpretation. The chalk and lead white grounds are not unusual, but were always followed by a reddish-brown priming. However, in this case, directly over the white layers is a layer which appears on all the cross-sections but is coloured from blue to grey to brown. As has been mentioned this is likely to be a painting which Constable disregarded. Although there is some evidence on the x-radiograph to support this idea it is not possible to decipher any distinct form nor to identify the composition. On top of this Constable applied a light pinkish-brown layer followed by a dark brown layer. It is likely that he prepared canvases in batches of one priming colour and if they did not get used he simply reprimed them later with a different colour. This is a likely explanation in this case. In the years after c.1810 he showed a preference for a wide range of opaque reddish-browns and dull pinks for priming. The two shades seen here have been identified on many other paintings dating from 1811–12 and contain mixtures of lead white, brown earths and vermilion.

Although this technical information is interesting in itself, more important implications for the dating of 'Figures and a Donkey' and other associated sketches are suggested by the 'experimental' nature of the next layer, the striped priming. It is thought to be 'experimental' because none of these colours have been found in use for grounds or primers in oil sketches dated before c.1812. However, in the collection at the Victoria and Albert Museum there are a number of sketches ascribed to, or dated by the artist to,

the summer of 1812.[4] They show different times of the day; daytime; evening; sunset. The earliest of those dated is inscribed 'July 4 1812', the latest 'Aug 6, 1812'. Two of them are painted on blue grounds, identical to the first stripe of the 'experimental' priming.[5] No sketches judged to pre-date 1812 on a stylistic basis have yet been found to have primings coloured other than shades of reddish-brown or dull pink. Therefore, it seems likely that the striped priming colours on 'Figures and a Donkey' pre-date or are contemporary with these sketches on blue grounds. This suggests a new date for 'Figures and a Donkey'; later than 'Willy Lott's House' of 1810 but probably not later than the summer of 1812. It is tempting to think that during the spring or summer of 1812 Constable was assessing the development of his oil sketches. For some reason he felt discontented with what he saw and decided to experiment a little in his studio. The resulting experiment is 'Figures and a Donkey' and the fruits of this experiment are the oil sketches of the summer of 1812.

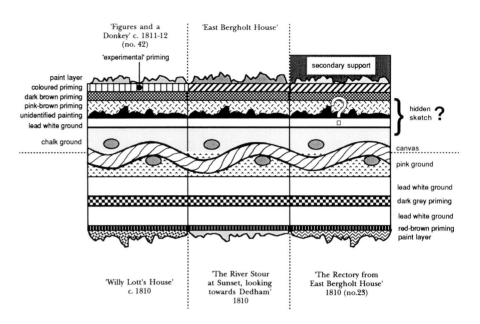

fig.198 Diagram showing identical ground and priming constructions found in sketches on canvas dating from 1810 to c.1812. Although undoubtedly cut from the same primed canvas, the supports have been aligned for the sake of clarity: the diagram is not meant to suggest that they were originally adjacent fragments

Addendum (see fig.198)

The above is a slightly revised version of the paper 'An Experimental Painting by John Constable R.A.', published in *The Conservator* in 1988 (vol.12, pp.52–6). Since its publication, several more sketches dating from c.1810–12 have been examined by the author. A comparison of cross-sections from 'The Rectory from East Bergholt House' (no.23) with those from 'Willy Lott's House' (fig.189) shows that they have identical multi-layer ground and priming structures. This, together with the similarity of the canvas, visible in x-radiographs, suggests that the two supports were originally part of the same primed canvas. The painting techniques, in particular the pigments and their methods of application, are also alike. Since the 'Rectory' sketch is dated by the artist 30 September 1810, a new dating of 'Willy Lott's House' to the late summer or autumn of 1810 is suggested.

'The River Stour at Sunset, Looking towards Dedham' (sold Sotheby's, 14 March 1990, lot 104) is also painted on a fragment of canvas. Until recently it was mounted on panel. This has now been removed revealing a seriously damaged, but recognisable, view of East Bergholt House on the back of the canvas. There may also be a hidden sketch on the back

of 'The Rectory from East Bergholt House', which is at present laid onto panel, although there is nothing to suggest this on x-radiographs of the painting. However, the thick layers of lead-white containing ground and priming would make the detection of a painting on the back unlikely, as has been the case with similar double-sided works by Constable.

Microscopic examination of 'The River Stour at Sunset' shows the same multi-layer ground and priming structure, the lowest layer of which is a pink ground. This has pushed through the interstices of the canvas weave to the other side, and can be seen in damaged areas of the 'East Bergholt House' painting. This same phenomenon is described above with regard to 'Willy Lott's House'. Examination of the paint surface shows that the materials and techniques are also similar. It seems likely, therefore, that this is another fragment cut from the same canvas as the supports of 'Willy Lott's House' and the dated 'Rectory' sketch. This suggests a date close to the autumn of 1810 for the 'River Stour' painting.

Cross-sections from the damaged 'East Bergholt House' composition on the back, reveal that after the Stour landscape was painted, the canvas was turned over and systematically reprimed with the same colours (except for the upper layer of striped priming) as the 'experimental' painting, 'Figures and a Donkey on the Lane from East Bergholt to Flatford' (fig.191, no.42). The two canvases were probably reprimed together each time. 'East Bergholt House' may, therefore, have been painted in late 1811 or 1812, the suggested date of 'Figures and a Donkey'. It is slightly surprising to find that Constable treated the backs of two earlier sketches in an identical manner, but tends to confirm the idea that he primed his sketching supports in batches.

Three sketches have now been positively identified as having originated from the same primed canvas that Constable cut up and used in the late summer of 1810. Undoubtedly other pieces have yet to be discovered.

Notes

(for abbreviations see pp.46–9)

1 Verbal opinion of Ian Fleming-Williams and Leslie Parris, June 1987.
2 Cove (thesis) and see p.497 above.
3 ibid. and see p.505 above.
4 Nos. 34, 35, 181 above, and Reynolds 1973, no.119 (6 August 1812).
5 Nos.35 and 181.

CASE STUDY 2

'Flatford Mill from the Lock', 1811–12: Preparatory Sketch (no.52), Study (no.53) and 'Finished' Picture (no.54)

Only a year separates 'Dedham Vale: Morning', 1811 (no.14) and 'Flatford Mill from the Lock', 1812 (no.54, fig.199) yet they are strikingly different in style. Why? 'Dedham Vale: Morning' is considered to be the culminating masterpiece of Constable's early career. David Lucas noted that Constable 'often told me this picture cost him more anxiety than any work of His before or since that period in which it was painted. that he had even said his prayers before it'.[1] In exhibiting this work at the Royal Academy in 1811 Constable had high hopes of gaining recognition from both critics and Academicians. He was disappointed, however – the picture failed to make a mark. Farington reported that Constable 'called in much uneasiness of mind, having heard that his picture – a landscape, "A View near Dedham, Essex" was hung very low in the Ante-room of the Royal Academy. He apprehended that it was proof that he had fallen in the opinion of the members of the Academy. – I encouraged him & told him Lawrence had twice noticed his picture with approbation'.[2] Few others seem to have noticed it. Did this disappointment make Constable try a new style for the exhibition painting of 1812, 'Flatford Mill from the Lock'?

Detailed technical examination and scientific analysis have revealed that although these two paintings appear on the surface to be very different, the materials and techniques used to paint them are almost identical.[3] This case study examines in detail the materials and techniques used in the exhibited painting, no.54, and one of its preparatory sketches (no.52). This is followed by a discussion of the evolution of the composition, from the initial sketches, via the 'compositional' study (no.53) to the final image.

Sketch for 'Flatford Mill from the Lock' (no.52, fig.200)

Constable planned both 'Dedham Vale: Morning' and 'Flatford Mill from the Lock' with a series of plein-air sketches. Differences in style between the exhibited paintings are reflected in their respective sketches. Those for 'Dedham Vale: Morning' are light in tone. They are broadly painted over a reddish-brown priming in thin washes with little specific detail of form. By contrast, the sketches for 'Flatford Mill from the Lock' are painted over a light pink priming, are dramatic in their brushwork and have strong contrasts of tone with sharp contours delineating the forms.

There are four known outdoor sketches for 'Flatford Mill from the Lock': three are

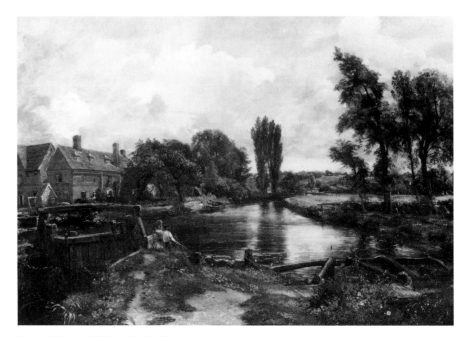

fig.199 'Flatford Mill from the Lock', no.54

fig.200 'Flatford Mill from the Lock', no.52

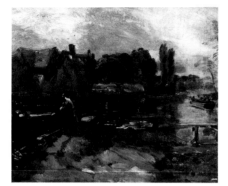

fig.201 'Flatford Mill from the Lock', no.50

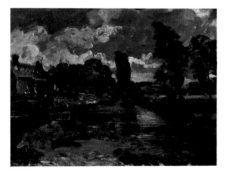

fig.202 'Flatford Mill from the Lock', no.51

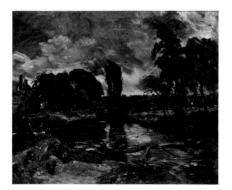

fig.203 'Flatford Mill from the Lock' (Henry E. Huntington Library and Art Gallery, San Marino)

fig.204 'Flatford Mill from the Lock', no.52, raking-light photograph showing unfolded tacking edge and tack holes in the sky

fig.205 'Flatford Mill from the Lock', no.52, and 'A Village Fair at East Bergholt' (Victoria and Albert Museum), x-radiograph mosaic of details showing that the supports are adjacent fragments of the same primed canvas

fig.206 'Flatford Mill from the Lock', no.52, photomicrograph (15 ×) of pink priming with the brown 'wash' that has settled in the hollows

included in the exhibition (nos. 50–52, figs.200–2). The fourth is in the Huntington Library and Art Gallery (see under no.51, fig.203). Stylistically, they form a discrete group. The author has examined several sketches of this date (though only one from this group). They are similar in materials and technique and the 'Flatford Mill from the Lock' sketch discussed here (no.52, fig.200) can be considered typical of Constable's approach to outdoor oil sketching at this time.

The support is a fragment of plain weave canvas, measuring $6 \times 8\frac{1}{8}$ inches (152 × 202 mm), laid onto a strawboard secondary support. The weave count is 14 threads per centimetre. It is not possible to differentiate the warp and weft. The fragment was cut from a large stretched, primed canvas. Before it was cut up to provide the support for no.52 the large canvas was tacked to a temporary strainer and given two full coats of white ground (lead white and chalk in oil). A line of 'cusping' along the top edge of no.52 (visible on the x-radiograph) shows where the canvas was tacked to the strainer during this process. Constable may have bought the canvas with the ground already applied, rather than doing it himself. The dearth of information relating to canvas preparation in early nineteenth-century oil painting manuals suggests that artists no longer needed this information as they could buy canvas ready-prepared from artists' colourmen.[4] The use of a characteristic canvas and double-layer white ground throughout his early career may indicate that Constable regularly bought prepared canvases from a single supplier at this time.[5]

When the ground was dry the canvas was stretched, either by Constable or a colourman. Cracks formed in the ground where the canvas was turned over the stretcher edge. These can now be seen running horizontally across the sky of no.52. Tack holes are also clearly visible (fig.204). A coat of pink priming (containing lead white, vermilion and brown earth) was then applied to the stretched canvas. This layer is about half as thick as the white ground. It did not cover the tacking edges, which remained white. Some time later Constable removed the canvas from its stretcher, crudely flattened the tacking edges, cut it into smallish pieces and used one of them to paint this sketch.

The practice of cutting up ready-prepared canvases and using the resulting pieces for oil sketching is not unusual in Constable's work, particularly at this date.[6] 'A Village Fair at East Bergholt' (Reynolds 1973, no.101), dated July 1811, has the same cracks running through the sky and identical ground and priming layers to the 'Flatford' sketch (no.52). An x-radiograph 'mosaic' of the two supports shows that they were originally adjacent pieces of the same primed canvas (fig.205). 'Dedham

Lock' (Philadelphia Museum of Art, Johnson Collection no.863) and 'West Lodge' (no.31) form a stylistic group with no.52 and 'A Village Fair' and were probably painted in the summer of 1811. They have the same ground and priming layers and parallel cracks running horizontally across the sky.[7] It seems very likely that they are also pieces of the same dismembered canvas.

Before starting to paint no.52 Constable probably pinned the canvas fragment to the lid of his sketching box. He then applied a dark brown wash over the entire surface. Although it is only just visible with the naked eye, this extremely thin layer, which contains umber and black, shows clearly with infra-red examination techniques and in cross-sections (fig.206). It appears to have been applied and then partially removed with a cloth or brush, leaving a trace of brown in the texture of the priming. Constable probably used it to deaden the contrast between the white stripe across the top of the canvas (the flattened tacking edge) and the pink priming on the remainder. This technique is not typical of his sketching practice at this date.[8]

Constable's dynamic approach to plein-air sketching can be seen in the way he boldly laid in the composition with no preparatory drawing. By this time his powers of observation and dexterity were highly refined. He worked over the surface with rapid, vigorous brushwork, covering large areas with opaque strokes of paint applied with small bristle brushes. The details were added with soft-haired brushes (sable or similar). Colours were barely mixed on the palette. Some of the details are highly impasted, for example the lock-keeper, highlights on the foliage, the water and the clouds. There was no attempt to cover all of the pink priming. Instead, it was used to add warmth to thin scumbles and to unify the surface through numerous exposed areas. It was also cleverly employed as the colour of the mill roof.

Although it has not been possible to analyse the medium of the paint, certain areas, especially the glossy dark browns of the foreground, appear particularly medium-rich. When examined in ultraviolet light, the trees and foliage in the foreground fluoresce an overall bright green. The rest of the painting fluoresces differentially according to the pigments and media used. 'Partial' cleaning[9] and varnish residues cannot be responsible for the differences in fluorescence since the painting was recently cleaned and restored and selective cleaning methods were not used.[10] The green fluorescence may be related to the use of a particular binding medium, possibly one containing a natural resin.

The following pigments have been identified by optical mineralogy, cross-sections, x-ray fluorescence spectroscopy (XRF)[11] and

energy dispersive x-ray fluorescence with a scanning electron microscope (EDX)[12]:

Red: Vermilion, red iron oxide, a red lake, a bright orange iron oxide (?Burnt Terre Verte)
Yellow: Orpiment, Naples yellow, a yellow lake, an orange lake
Blue: Prussian blue
Brown: brown iron oxides (natural ochres and umber), a transparent brown (possibly Antwerp brown)
White: Lead white, chalk
Black: Charcoal black and a finely ground black

This palette is a version of that generally used by Constable for oil sketching c.1809–12.[13] In 1811 his usual range of yellow and orange pigments was increased by the addition of a bright orange iron oxide, an orange lake and orpiment. The orange iron oxide is particularly distinctive. It has also been identified in Turner's oil paintings from c.1796.[14] It may be 'Burnt Terre Verte' (burnt green earth), a pigment that has recently been identified in several early nineteenth-century paint boxes.[15] The use of orpiment in Constable's pigment mixtures is particularly characteristic of paintings dating from c.1810–12. He used a good quality mineral which was coarsely ground, probably to retain its depth of colour. Large particles often protrude from the surface of the paint. It may seem unusual to find orpiment in use at this comparatively late date. However, frequent references to it are found in painting manuals throughout the nineteenth century.[16] Field refers to it as 'Chinese Yellow', probably because it was supplied through new trade routes that brought such materials from the Far East early in the century.[17] The mixture of orpiment with Prussian blue gave Constable a new range of bright 'acid' greens in addition to the dull greens he had previously achieved with Prussian blue and Naples yellow.

The absence of a true green pigment is notable, but not particularly surprising, as those available to Constable at this date were highly toxic and had poor covering power.[18] Orpiment was used despite its toxicity because it was such a valuable addition to the palette. Constable had no reason to use a toxic green pigment as he could mix a wide range of opaque and transparent greens from Prussian blue, Naples yellow, orpiment, a yellow and a red lake, vermilion, lead white and black. The pigments were used in differing proportions according to the desired hue and tone and, apart from the addition of orpiment to the selection, this system is typical of paintings dating from c.1809 to c.1814.[19]

The element copper, which is often present in green pigments, was in fact positively identified in green areas of the painting,[20] but

no pigment containing copper could be found. A copper-containing 'drier', added to the binding medium, may explain its presence.

Mixtures of vermilion, a red lake, Naples yellow, a yellow lake, lead white and black were used to mix browns in preference to natural earth pigments which are generally more transparent and granular. Orpiment and Prussian blue were occasionally added to adjust the hue. By mixing opaque and transparent pigments Constable could carefully control the colour and covering power of his paint. In no.52 it is relatively smooth, extremely opaque and could obliterate the pink priming in one stroke if necessary.

Study for 'Flatford Mill from the Lock' (no.53, fig.208)

Having painted four preparatory sketches Constable used them to create a 'compositional' study, now in the Victoria and Albert Museum (no.53, fig.208). The materials and techniques used in this study are very similar to those described above for the outdoor sketch, no.52. The canvas measures $9\frac{3}{4} \times 11\frac{3}{4}$ inches (245 × 295 mm), not significantly larger than the sketches. It is now lined and stretched. The original tacking edges were removed, probably prior to the lining. The canvas was prepared with the same double-layer white ground as no.52 but in this case the priming is a rich reddish-brown. The pigments are the same as those used in the sketch and the paint is applied in thick opaque strokes, leaving the priming exposed in many areas.

Several paint samples were analysed by gas chromatography/mass spectrometry[21] and two binding media were identified. Linseed oil with a trace of pine resin was used in the greens, while in the whites of the sky, a linseed oil and egg emulsion was used. The latter was particularly effective in retaining the rapid strokes of the brush over the surface as can be seen in the highlights of the clouds (fig.207).

fig.207 'Flatford Mill from the Lock', no.53, raking-light detail of clouds showing strokes of bristle brush in stiff paint

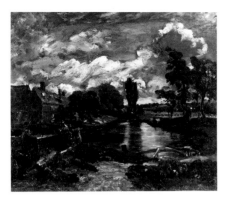

fig.208 'Flatford Mill from the Lock', no.53

fig.209 'Flatford Mill from the Lock', no.53, diagram showing how Constable used elements of no.52 (a), Huntington sketch (b), no.50 (c) and no.51 (d); the dotted lines mark the edges of the later strips at the top and bottom

The most significant feature of this study, by comparison with the sketches, is that it is not a 'real' view. It was probably painted entirely in the studio using elements taken from each of the four sketches and combined into an 'idealised' landscape. The diagram (fig.209) shows which areas were taken from each of the four preparatory sketches:

(a) no.52 (fig.200)
(b) Huntington sketch (fig.203)
(c) no.50 (fig.201)
(d) no.51 (fig.202)

As it is now exhibited, the dimensions of the study are enlarged by strips of non-contemporary paint, approximately an inch wide (25 mm) along the top and bottom edges. Analysis by x-ray fluorescence spectroscopy (XRF) indicated the presence of cobalt in the upper strip.[22] To date, the pigment cobalt blue has only been positively identified on Constable's palette in the Tate Gallery,[23] thought to have been used in 1837, although he may have used cobalt blue as early as c.1820. In the lower strip chrome yellow was identified. This pigment appears not to have been used by Constable

before 1816.[24] Therefore, although Constable may have added the strips at a later date, they were certainly not part of his original conception. More significant, however, is the fact that without the additional strips the proportions of the study are identical to those of the 'finished' picture.

The Finished Picture: 'Flatford Mill from the Lock' (no.54, fig.199)

The support is a plain weave canvas measuring $25 \times 35\frac{1}{2}$ inches (635×902 mm). The weave count is 12–14 threads per centimetre vertically and 14–15 threads per centimetre horizontally. The painting has been lined on at least two occasions. The original tacking edges have been removed although in places slivers remain, flattened and incorporated into the picture plane. Slight cusping is visible in the top right corner of the canvas on the x-radiograph. There is none on the other edges, indicating that the first layer of ground was applied before the canvas was stretched for this composition. Again, this may suggest the use of a colourman's 'prepared' canvas.

Two layers of white ground and four layers of coloured priming were applied to the canvas in the following order (starting with the first layer applied, fig.212):

(a) two layers of white ground
(b) a thin reddish-brown priming containing red particles (vermilion or red iron oxide) and some black particles. This preparation is typical of Constable's canvas paintings between c.1802 and 1810/11[25]
(c) an opaque pale pink priming containing lead white, red iron oxide, vermilion and black. A first layer of sky was painted on top of this layer (see below)
(d) an opaque 'rose' pink priming containing lead white, vermilion and a red iron oxide
(e) an opaque 'mushroom' pink priming containing lead white and iron oxides.

Layers (a) and (b) were applied to the canvas before it was stretched for this painting as they are present on the original tacking edges. The other layers were applied after the canvas was stretched for this composition. A 'lip' of paint built up around the edges of the paint layer from the repeated applications of priming and, in places, brushstrokes of the hidden pale and 'rose' pinks are visible at the edges.

The numerous layers of priming indicate that Constable changed his mind about the colour several times. Unhappy with the initial

reddish-brown layer, he reprimed the canvas with a pale pink (c). Over this, he laid in the sky. He must have been dissatisfied with this first attempt for he primed the entire surface again, this time with a 'rose' pink (d). Either because it did not sufficiently cover his first sky, or because he was still not satisfied with the colour of the resultant surface, he reprimed the surface with a pale 'mushroom' pink (e) before proceeding with the painting. Strangely, having gone to such lengths, the colour of the priming is not discernible in the final image. It is entirely covered by the paint layers and there are no areas where the priming colour is left exposed in order to unify the picture surface. This is quite unlike the preparatory sketches and study.

No squaring-up devices or underdrawing have been detected. This suggests that the outline was drawn in chalk which can no longer be seen. The composition was laid in using broad strokes, probably of umber and black, precisely following the outlines of the study, no.53. This can clearly be seen by infrared reflectography (fig.211).

The paint was applied in many thin layers working from dark to light. The handling is considerably smoother and more meticulous than in the sketches and there is a noticeable absence of texture. Constable was not only worried about the suitability of his composition for the Academy, but whether he would attain an acceptable level of 'finish'. There is almost no impasto (even taking into account flattening of the paint during lining) and little of the 'shorthand' brushwork seen in the sketches, although this can be glimpsed in the hills and fields on the horizon. Trees are painted in small dabs of colour, imitating the texture of leaves. The effect is more precisely detailed than in the sketches, more individual in handling than earlier exhibited paintings, which were more heavily influenced by Gainsborough.[26] The river, painted in a system of blended horizontal strokes, is reminiscent of late Gainsborough landscapes.[27] Much of the fine detail has been painted using a small brush in a highly descriptive manner. In this, Constable was probably influenced by Ruisdael and other seventeenth-century Dutch painters whose works he had copied.[28] In many ways, the overall 'effect' and detail in this painting closely follow the Dutch idiom. The foliage, spiky grass, water plants, reeds and posts that Constable loved to put in the foregrounds of his paintings can be seen, similarly depicted, in the works of Ruisdael and Hobbema.

Figures, such as that of the lock-keeper seen on the left of the study, were added towards the end of the painting process. Having worked-up the painting reasonably fully, at least to the point of adding figures, Constable made significant alterations to large areas of

the composition. Pentimenti (changes in composition) have been identified by surface microscopy, x-radiography and infra-red reflectography. They can be summarised as follows:

1 The position of the buildings on the left was altered so that they are now $\frac{1}{2}$–$1\frac{1}{2}$ inches (15–40 mm) lower in the picture (fig.210). Corresponding to this change, the lock gates and banks on the left were also moved downwards. Obvious pentimenti above the roof of the mill have now been reduced by a conservator's retouching.

2 The lock-keeper, seen winching the lock gates in all the sketches and the study, was painted out. He is now slightly visible with the naked eye through abrasion to the upper paint layers (fig.213) and is clearly revealed by infra-red reflectography (fig.211).

3 A 'ghost' figure, visible on the x-radiograph and on infra-red reflectograms, can be seen standing on the right of the painting in an area that is now covered by the river. Part of this figure is also visible through abrasion to the upper paint layers. No figure in this position is seen in any of the sketches.

4 Alterations were made to the trunks of the trees, the cows and the fields on the far right. These are indicated by the scraped and confused condition of the paint layer. It is not possible, however, to tell precisely what changes have occurred.

5 Changes were also made to the cloud formations in the sky. The x-radiograph reveals pentimenti that may relate to the 'first' sky and to changes in the upper paint layers. The tops of impastos visible through abrasion in the upper paint layers are clearly visible as pentimenti on the x-ray.

6 In the left of the foreground was a mooring post, now painted out, but visible on the x-radiograph. There were also minor changes to the foliage and flowers all over the foreground. These are indicated by coloured areas, now visible through drying cracks in the upper paint layers.

It is interesting to note that the same lock-keeper in a red jerkin appears in 1817–18 in the background of 'Dedham Lock and Mill' (no.94). In 1824 he became a primary subject in 'The Lock' (no.158). Constable may have used the preparatory sketches and study for the 'Flatford' composition, which he still possessed, as inspiration for these later depictions of the figure.

The numerous drying cracks visible in areas of pentimenti suggest that Constable did not allow the paint sufficient drying time before reworking. In addition, recommendations in contemporary artists' handbooks and painting manuals advised that areas intended for repainting should be 'oiled-out' with pure linseed oil.[29] The application of the wrong quantity of oil could also cause problems. We know that Constable painted the picture over a period of at least seven months, with numerous reworkings. It was well under way by October 1811 when his mother noted 'Your pretty View from thence [Flatford] is so forward – that you can sit by the Fireside and finish it'.[30] Constable later removed the painting to his London studio, where in February 1812 it was seen by his uncle, David Pike Watts, six weeks before the exhibition.[31] It is likely that he made the major compositional changes after the move to London. We know he was working on the painting until just before its exhibition from Farington who, having seen the painting in March, noted on 6 April that 'Constable called wishing me to look again at his Exhibition pictures which he had been painting on in consequence of my remarks'.[32] Since Constable routinely washed and oiled-out paintings before reworking them,[33] this practice, in combination with the considerable reworking of large areas, is probably responsible for the extensive drying craquelure on the surface of the work.

As with the preliminary sketch (no.52), it has not been possible to identify the medium used in this painting. However, the same green fluorescence in the areas of foliage and trees is visible in ultraviolet light. Many of the plants and flowers in the foreground, where the paint is lightly textured, have the remains of brown and green glazes over the highlights (fig.214). This may be the 'glazing down of the lights' which is mentioned by George Field as part of Constable's technique for unifying the surface of his paintings.[34] He is supposed to have used copal resin as the medium for this purpose. It is possible that the green fluorescence is related to the use of such a medium.

The following pigments have been identified by cross-section and XRF analysis:[35]

Red:	Vermilion, red iron oxides, a red lake
Yellow:	Orpiment, Naples yellow, a yellow lake, yellow iron oxide
Blue:	Prussian blue, natural ultramarine, an unidentified blue (smalt or a 'light' shade of natural ultramarine)
Brown:	Iron oxides, a transparent brown (probably Antwerp brown)
White:	Lead white, ?chalk
Black:	?Charcoal (large irregular shaped particles)

The most notable addition to the palette is natural ultramarine, found in the sky. Constable used both Prussian blue and an unidentified blue (smalt or natural ultramarine 'light') mixed with lead white, vermilion, red lake and black to lay in the sky. In 'finishing' the sky he scumbled a deep shade of natural ultramarine over the surface such that the particles have settled distinctively into the grooves of the brushwork. This technique has been found on all 'finished' and exhibited paintings examined by the author, dating from c.1802 onwards.[36] Constable restricted the use of this expensive pigment to the upper layers of the sky only and did not use it to mix greens.

fig.210 'Flatford Mill from the Lock', no.54, infra-red reflectogram of pentimenti in mill buildings

fig.211 'Flatford Mill from the Lock', no.54, infra-red reflectogram of lock gates with pentimento of lock-keeper: the broad 'drawing' strokes around the figure and gates are part of the initial lay-in

fig.212 'Flatford Mill from the Lock', no.54, photomicrograph (175 ×) of cross-section from sky showing the numerous priming layers: the pale grey-blue layer in the middle is the 'first' sky

fig.213 'Flatford Mill from the Lock', no.54, macro-detail of pentimento of lock-keeper, now visible through abrasion and cracking in the covering paint layers

fig.214 'Flatford Mill from the Lock', no.54, photomicrograph (10 ×) of a flower in the foreground, showing Constable's practice of glazing-down the highlights

Evolution of the Final Image

The technical examination of a preparatory sketch, a 'compositional' study and an exhibited work clearly illustrates the differences in Constable's approach to oil sketching and to painting a 'finished' picture. The sketch was painted on a scrap of unsupported canvas, while the exhibited work had an elaborate preparation, including one false start. Although the pigments and mixtures used in all three paintings are almost identical, the paint was applied in radically different ways; the virtuoso display of economic brushwork in the sketch and study contrasting with the meticulous, layer-by-layer sequence in the 'finished' work. Technical examination illustrates Constable's concern with gaining a sufficiently high level of 'finish' to be accepted among the academic painters.

Although the technical data is interesting in itself, it also contributes to our understanding of the evolution of the exhibited painting, from its initial conception to the final image. It was important, in particular, to establish the original format of the study, in relation to the finished work, and to discover that the 'first' version of the composition on the large canvas was copied directly from the study.

The iconography of the five preparatory works was fully discussed and a chronological sequence suggested for the first four sketches by Ian Fleming-Williams in his 1980 article.[37] The most significant development in the sequence is described by him as 'the "pan" to the right, a shift that brings into view the right-hand line of trees and the hayfield beyond'. What has not previously been noted is the fact that the compositional study, no.53, is a collage of discrete areas from each of the four sketches. The scale of the sketches and their viewpoints were all different, so the combination of 'cut-out' elements did not fit together without some artistic licence. In formulating the final composition Constable subtly altered the natural topography of Flatford lock. He evolved a composition based upon linear perspective and heightened colour (rather than tone) to create space, incorporating compositional devices learnt from copying Claude and Rubens. The adjustments to the perspective (lowering the buildings on the left) and the numerous pentimenti clearly illustrate his concern to perfect the final image. Technical examination has now detailed the precise number and extent of the changes, many of which were not previously documented. Some of these concern the representation of movement. Replacing the labouring lock-keeper with the wistful fisherman is in Ian Fleming-Williams's words 'an attempt to invoke something of the timeless air to be found in the then

most admired form of landscape, the historic'.[38]

After the painting was accepted for the Academy exhibition of 1812, Constable wrote to Maria Bicknell saying that he had met the President, Benjamin West, and had asked him whether he considered 'that mode of study as laying the foundation of real excellence'. West had replied: 'Sir . . . I consider that you have attained it'.[39] Despite this apparent success, during the summer of 1812 Constable was back in Suffolk, again cutting up old paintings and using the same materials and techniques to make oil sketches in yet another new style.

Notes

(for abbreviations see pp.46–9, 517)

This essay was first published as 'The Constable Project: Current Research into Materials and Techniques' in the preprints to the 30th Anniversary Conference of the United Kingdom Institute of Conservation (UKIC) in October 1988. This extensively revised version includes the results of subsequent research and previously unpublished material presented in lectures at the UKIC 30th Anniversary Conference and to the Colour Group of Great Britain at the National Gallery in November 1988.

1 Parris, Shields, Fleming-Williams 1975, p.55.
2 Farington XI, p.3916.
3 Cove (thesis).
4 Carlyle (thesis).
5 Cove (thesis); see also pp.494, 496.
6 ibid.; see also p.495.
7 ibid.
8 ibid.
9 For a discussion of the cleaning of paintings see Gerry Hedley, 'Long Lost Relations and New Found Relativities: Issues in the Cleaning of Paintings' in *Appearance, Opinion, Change: Evaluating the Look of Paintings*, United Kingdom Institute for Conservation, 1990, pp.8–13.
10 Conservation notes from John Bull who undertook the cleaning and restoration.
11 XRF analysis kindly carried out by Graham Martin, Conservation Science section, Victoria and Albert Museum.
12 EDX analysis kindly carried out by Aviva Burnstock, Scientific Department, National Gallery, London.
13 Cove (thesis); see also pp.505–6.
14 Joyce H. Townsend, 'The Materials and Techniques of J.M.W. Turner R.A., 1775–1851', unpublished Ph.D thesis, Conservation & Technology Department, Courtauld Institute of Art, University of London, 1991.
15 Josephine Darrah, 'Nineteenth-Century Paint Boxes in the Collection of the Victoria and Albert Museum', unpublished research in progress, Conservation Science section, Victoria and Albert Museum.
16 Carlyle (thesis); see also Harley 1982, pp.100–2.
17 Field 1835, p.80.
18 Harley 1982.
19 Cove (thesis); see also pp.505–6.
20 as n.11.
21 Medium analysis kindly carried out by Raymond White using GC/MS at the Scientific Department, National Gallery, London.
22 as n.11.
23 Cove (thesis). Technical examination carried out with the kind assistance of Rica Jones and Stephen Hackney, Tate Gallery Conservation Department, June 1990.
24 Cove (thesis); see also p.506.
25 ibid.; see also pp.496–7.
26 For example 'Dedham Vale', 1802, no.2.

27 For example 'A Wooded Landscape with Cattle by a
 Pool', 1782, acquired in 1987 for Gainsborough's
 House, Sudbury. Examined by the author during
 cleaning and restoration by Ruth Bubb in 1987.
28 A.G.H. Bachrach, *Shock of Recognition: The Landscape
 of English Romanticism and the Dutch Seventeenth-
 Century School*, exh.cat., Tate Gallery 1971.
29 Carlyle (thesis).
30 Beckett I 1962, p.67.
31 Beckett I 1962, p.77.
32 Farington XI, p.4104.
33 Journal entry for 26 May 1824: 'After dinner washed
 Tinney's picture & oiled it', Beckett II 1964, p.317.
34 Field 1835, pp.361–2. I am grateful to Leslie Carlyle
 for passing this information on to me.
35 as n.11.
36 Cove (thesis); see also pp.504, 512.
37 Fleming-Williams 1980, p.216–19.
38 ibid., p.219.
39 Beckett II 1964, p.65.

Acknowledgments

First, I would like to thank Jonathan Ashley-Smith, John Murdoch and Peter Young of the Victoria and Albert Museum, David Thomson and John Bull, all of whom were instrumental in establishing the Constable Research Project in 1986 and whose continued support and encouragement has been invaluable.

Since 1986 many people in both England and the United States have been involved with my research. I would like to thank the following for allowing me to examine the works in their care, for practical assistance with technical examination and for help of other kinds: Maryan Ainsworth; Hugh Belsey; David Bomford; Janet Brough; Robert Bruce-Gardner; David Bull; Mary Bustin; Marigene Butler; J. Carter-Brown; Richard Caspole; Richard Constable; Paul Cooper; Malcolm Cormack; Ellen Cummings; Nicholas Eastaugh; Susannah Edmunds; Stan Eost; Teresa Fairbanks; Brian Gilmore; Chris Green; Stephen Hackney; Charlotte Hale; Meryl Huxtable; Judy Ivy; Evelyn Joll; Michael Komanecky; Alastair Laing; Susan Lambert; Lionel Lambourne; Rhona MacBeth; Inez MacDermott; Graham Martin; Catherine Metzger; Peter Northeast; Kathy Pederson; Roy Perry; the Phillips Collection, Washington D.C.; William Proby; Charles Rhyne; Joseph Rishel; Paul Robins; Lucia Scalisi; Anna Southall; John Sunderland; Mark Tucker; Caroline Villers; John Wagstaff; Pauline Webber; Michael Wilson and Martin Wyld.

I would like to thank Aviva Burnstock and Raymond White for the analysis of pigment and media samples, for their interpretation of the results and the benefit of their experience. I would also like to express my gratitude to Josephine Darrah for the many hours spent examining my cross-sections and pigment samples, for days spent grappling with the XRF machine and for her generous contribution to my research over the last five years.

I am grateful to Leslie Parris and Ian Fleming-Williams for giving me the opportunity to publish some of the results of my research in this catalogue and for editing my contributions. I am indebted to Leslie Carlyle for providing me with vast tracts of her unpublished Ph.D material and for allowing me to use it freely in my text. My thanks go also to Rica Jones and Joyce Townsend for their contributions; like Leslie Carlyle, they have also assisted with editing.

Finally, I would like to acknowledge the considerable contribution made by Alan Cummings, who helped with the editing of the essay and the two case studies and assisted in the preparation of the diagrams. Without his support, encouragement and tolerance my work would not have been possible.

Sarah Cove
March 1991

Maps

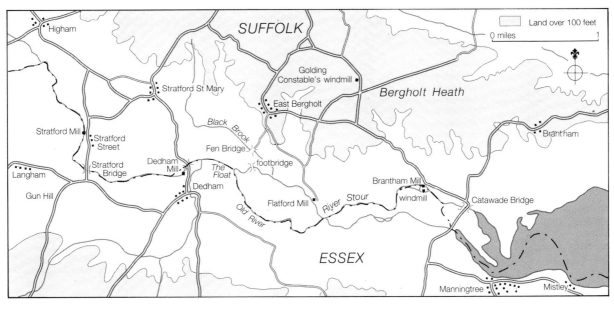

fig.215 The Stour valley

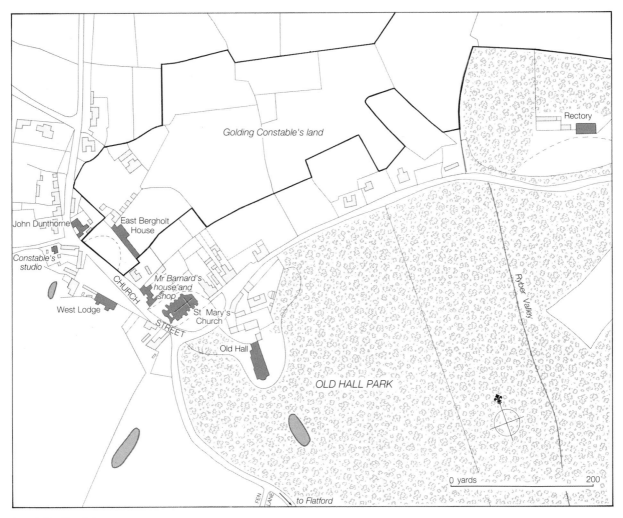

fig.216 East Bergholt

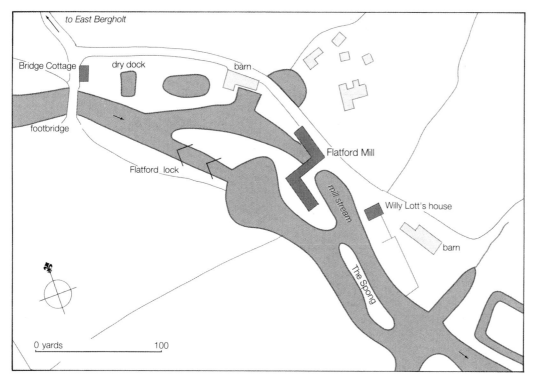

fig.217 Flatford

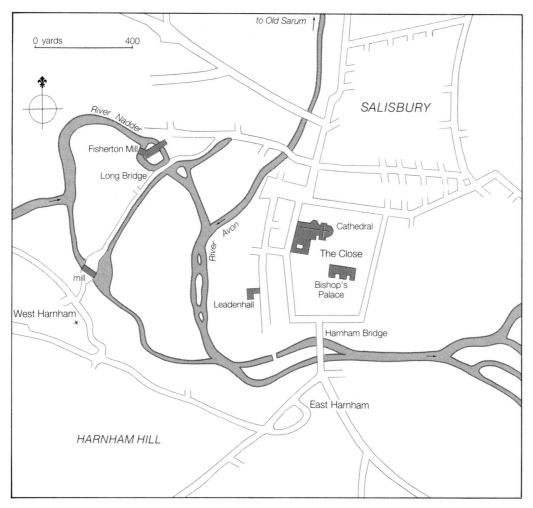

fig.218 Salisbury

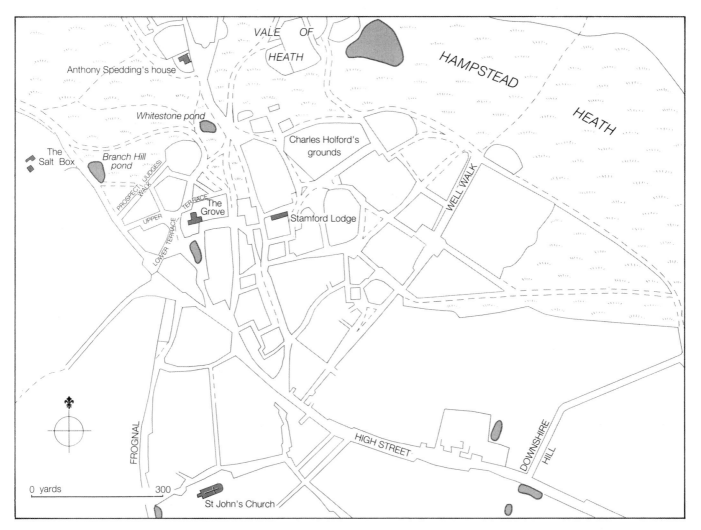

fig.219 Hampstead

Figs.215–19 are based on early nineteenth-century maps, redrawn by John Flower

Lenders

PRIVATE COLLECTIONS

The Dowager Lady Ashton 210

Richard Constable 211, 259, 299

Mr Julian W. Glass, Jr, USA 258

Hart Collection 97, 206

Mrs J. Katz 279

Paul Mellon Collection, Upperville, Virginia 27, 49, 80
Merz Collection, Pal, Andorra 55

Private Collections 10, 12, 13, 15, 29, 38, 44, 56, 60, 65, 66,
 68, 69, 76, 82, 87, 91, 98, 102, 117, 126, 138, 142, 163, 198,
 207, 223, 224, 227, 229, 237, 238, 244, 245, 250, 261, 262,
 265, 275, 286, 309, 310, 323, 339
W.H. Proby, Elton Hall 14

Salander-O'Reilly Galleries, Inc., New York 9, 240

Mr and Mrs David Thomson 11, 24, 31, 36, 37, 39, 47, 52, 54,
 71, 88, 94, 111, 112, 119, 123, 127, 128, 132, 133, 146, 173,
 221, 226, 228, 230–3, 236, 241, 246, 252, 253, 260, 264, 266,
 268, 271, 272, 274, 289, 290, 292, 294–6, 303, 305, 306, 312,
 318, 324, 329, 331, 334, 342
Mr and Mrs Richard M. Thune 81
Thyssen-Bornemisza Collection, Lugano, Switzerland 158

The Duke of Westminster 50

PUBLIC COLLECTIONS

Anglesey Abbey, Fairhaven Collection (The National Trust) 57
Atlanta, High Museum of Art 328

Bedford, Cecil Higgins Art Gallery 332
Berlin, Staatliche Museen Preußischer Kulturbesitz, Nationalgalerie 130
Boston, Museum of Fine Arts 74, 83

Cambridge, Fitzwilliam Museum 174, 175, 177–80, 182–9, 191, 192, 194–7, 199–204
Cardiff, National Museum of Wales 78
Chicago, Art Institute 218
Cincinnati, Art Museum 105
Copenhagen, Royal Museum of Fine Arts 249

Detroit, Institute of Arts 151, 167
Dunedin, Public Art Gallery 152
Durban, Art Museum 90

Edinburgh, National Galleries of Scotland 169

Glasgow, Art Gallery and Museum 129

Indianapolis, Museum of Art 164
Ipswich, Museums and Galleries (Ipswich Borough Council) 25, 26, 61, 62

Kansas City, Nelson-Atkins Museum of Art 172

La Chaux-de-Fonds, Musée des Beaux-Arts 20
Leeds, City Art Galleries 73, 239
Liverpool, National Museums and Galleries on Merseyside (Lady Lever Art Gallery) 217
London, British Museum 176, 190, 287, 297, 313–15, 325–7, 330, 333, 335
London, Courtauld Institute Galleries 124, 278
London, Guildhall Art Gallery 209
London, National Gallery 85, 100, 101, 137, 165
London, Royal Academy of Arts 51, 104, 116, 150, 160, 162
London, Tate Gallery 8, 19, 30, 46, 59, 67, 70, 75, 89, 93, 107, 153, 156, 168, 170, 205, 208, 213, 216, 219

London, Victoria and Albert Museum 2, 3, 7, 17, 22, 28, 32–5, 40–2, 53, 58, 63, 64, 72, 77, 84, 92, 96, 103, 106, 108, 114, 115, 131, 135, 140, 141, 144, 145, 147–9, 161, 166, 181, 193, 214, 225, 234, 235, 243, 247, 248, 254–7, 269, 276, 277, 280–4, 288, 291, 293, 298, 300–2, 304, 307, 308, 316, 317, 319–22, 336–8, 340, 343–5

Madrid, Museo Lázaro Galdiano 43
Manchester, USA, Currier Gallery of Art 95
Manchester, Whitworth Art Gallery, University of Manchester 251, 270
Marseille, Musée Grobet-Labadié 273
Melbourne, National Gallery of Victoria 109, 122, 159

New Haven, Yale Center for British Art, Paul Mellon Collection 4, 5, 16, 45, 99, 110, 113, 120, 121, 143, 212, 285
New Haven, Yale University Art Gallery 118

Oxford, Ashmolean Museum 18, 222
Oldham, Art Gallery 242, 311
Ottawa, National Gallery of Canada 139

Paris, Musée du Louvre 86, 134, 171, 341
Philadelphia Museum of Art, John G. Johnson Collection 23, 48, 154; William P. Wilstach Collection 155, 157

Stanford, University Museum of Art 267
Stuttgart, Staatsgalerie 21

Tochigi, Prefectural Museum of Fine Arts 6
Toledo, Museum of Art 220
Toronto, Art Gallery of Ontario 1
Truro, Royal Institution of Cornwall, County Museum and Art Gallery 263

Virginia, Museum of Fine Arts 125

Washington, National Gallery of Art 79, 136
Washington, The Phillips Collection 215

Photographic Credits

Michael Agee; Jörg P. Anders; Ashmolean Museum, Oxford; Atlanta High Museum of Art; Bany & Cotton; Staatliche Museen Preußischer Kulturbesitz, Nationalgalerie, Berlin; Birmingham Museum & Art Gallery; Museum of Fine Arts, Boston; Scott Bowron Photography; Bridgeman Art Library; British Museum; Browse & Darby; National Museum of Wales, Cardiff; Richard Caspole; Cecil Higgins Art Gallery, Bedford; Musée des Beaux-Arts de la Chaux-de-Fonds; Art Institute of Chicago; Christie's Colour Library; Cincinnati Art Museum; City Lab; Richard Constable; A.C. Cooper; Royal Museum of Fine Arts, Copenhagen; Courtauld Institute Galleries (Witt Collection); Prudence Cuming & Associates; Currier Gallery of Art, Manchester, New Hampshire; Davis & Langdale; Detroit Institute of Arts; Dunedin Public Art Gallery, New Zealand; Durban Art Museum; National Galleries of Scotland, Edinburgh; Mike Fear (White Bros. Ltd.); Fitzwilliam Museum, Cambridge; Freeman & Co.; Frick Collection, New York; Glasgow Art Gallery and Museum; Studio Patrick Goetelen; Musée Grobet-Labadié, Marseille; Guildhall Art Gallery, London; The Hart Collection; Hawkley Studio Associates; Henry E. Huntington Library and Art Gallery; Indianapolis Museum of Art; Ipswich Museums and Galleries; National Museums and Galleries on Merseyside (Lady Lever Art Gallery); Laing Art Gallery, Newcastle upon Tyne; Larkfield Photography; Museo Lázaro Galdiano, Madrid; Leeds City Art Galleries; Richard Littlewood; National Gallery, London; Musée du Louvre, Paris; Kevin Lovelock; Eric E. Mitchell; National Trust Photographic Library; Nelson-Atkins Museum of Art, Kansas City; Oldham Art Gallery; Art Gallery of Ontario; National Gallery of Canada, Ottawa; Philadelphia Museum of Art; The Phillips Collection, Washington; Phillips Fine Art Auctioneers; Photographic Records Ltd.; Photo R.M.N.; Push One; Rollyn Puterbaugh; Royal Academy of Arts, London; Royal Institution of Cornwall, County Museum and Art Gallery, Truro; Salander-O'Reilly Galleries, Inc., New York; Schopplein Studio; Sotheby's; Stanford University Museum of Art; Staatsgalerie, Stuttgart; Tate Gallery Photographic Department; Mr and Mrs David Thomson; Mr and Mrs Richard M. Thune; Thyssen-Bornemisza Collection, Lugano, Switzerland; Tochigi Prefectural Museum of Fine Arts, Japan; Toledo Museum of Art; V&A Photographic Department; V&A Picture Library; Virginia Museum of Fine Arts; National Gallery of Art, Washington; Whitworth Art Gallery, University of Manchester; John Webb; Yale Center for British Art, Paul Mellon Collection; Yale University Art Gallery

All colour technical photography on pp.494–528 supplied by Sarah Cove from thesis material

The Friends of the Tate Gallery

BECOME A FRIEND AND ENJOY:

** FREE entrance to all Tate Gallery exhibitions with a guest

** Invitations to exhibition Previews

** 10 per cent discount on current exhibition catalogues and in the Tate Gallery Shop

** Special openings of the Gallery with lectures

** *Preview* magazine mailed three times a year

** *Friends Events* mailed three times a year

** Friends Curator who attends special events

Friends may bring two guests and children under sixteen to SPECIAL OPENINGS.

Friends' subscriptions help to purchase works of art to add to the National Collection of British and Modern Art in the Tate Gallery. Works acquired include 'The Snail' by Henri Matisse, 'Mr and Mrs Clark and Percy' by David Hockney and Pablo Picasso's 'Weeping Woman'.

PATRONS

The Patrons of New Art promote a lively and informed interest in contemporary visual art. They participate in the Tate Gallery's acquisitions of contemporary art through the purchase of works by artists such as Anselm Kiefer, Julian Opie, Sean Scully and Lothar Baumgarten. The works are chosen by a committee of Patrons in consultation with the Director of the Tate Gallery and are offered to the Trustees as gifts from the Patrons of New Art.

The Patrons of New Art are associated with the Turner Prize, one of the most prestigious awards for the visual arts. Prize winners include Malcolm Morley, Gilbert and George, Howard Hodgkin and Richard Long.

The Patrons of British Art have a particular interest in British painting from the Elizabethan period through to the twentieth century. Their donations are used to make important acquisitions for the Tate Gallery, for example, 'Equestrian Portrait of George II' by Joseph Highmore and 'A Classical City' by John Varley.

The Patrons of New Art and the Patrons of British Art are automatically members of the Friends of the Tate Gallery.

For further information on the Friends of the Tate Gallery, please telephone 071-834 2742 or 071-821 1313

or write to The Friends of the Tate Gallery, Tate Gallery, Millbank, London SW1P 4RG

Tate Gallery Sponsors since 1 April 1988

Academy Editions
Ashton–Tate UK Ltd
AT&T
Australian Bicentennial Authority
Barclays Bank PLC
BASF
Beck's Bier
British Gas plc
British Gas North Thames
The British Land Company PLC
The British Petroleum Company p.l.c.
British Steel plc
British Telecom
Carroll, Dempsey and Thirkell
Daimler-Benz AG
Digital Equipment Company Ltd
Donaldsons
Drexel Burnham Lambert
Drivers Jonas

Global Asset Management Ltd
Henry Ansbacher Holdings
The Henry Moore Foundation
Hepworth and Chadwick
ICI Chemicals and Polymers Ltd
Linklaters and Paines
MoMart
Montblanc
PA Consulting Group
Phillips and Drew
P&P Micro Distributors Ltd
Pro-Helvetia Foundation
Reed International P.L.C.
Save & Prosper Educational Trust
Swissair
Ulster Television plc
Unilever PLC
Volkswagen
Westminster City Council

Index

[539]